NORTHERN PAINTING

NORTHERN PAINTING

From Pucelle to Bruegel/*Fourteenth, Fifteenth, and Sixteenth Centuries*

CHARLES D. CUTTLER
University of Iowa

HOLT, RINEHART AND WINSTON, INC.

New York Chicago San Francisco Atlanta Dallas Montreal Toronto London

PHOTOGRAPHIC SOURCES

References are to figure numbers unless indicated Pl. (plate).

A.C.L. ©, Brussels (21, 53, 55, 61, 92, 104, 106, 107, 108, 109, 113, 115, 119, 136, 137, 147, 149 right, 153, 154, 163, 165, 167, 168, 169, 170, 171, 174, 177, 179, 181, 182, 186, 187, 189, 190, 194, 195, 196, 208, 210, 212, 213, 214, 218, 219, 220, 221, 223, 224, 233, 234, 240, 248, 250, 266 right, 288, 492, 559, 560, 561, 562, 573, 579, 586, 591, 592, 593, 594, 595, 596, 625, 626, 628, 632, 634, 636, 650, 652, 653, 657, 661, 662, 669); Alinari–Art Reference Bureau, Ancram, N.Y. (188, 209, 292, 435, 498, 555, 575, 589, 637, 641, 646, 656); Annan, Glasgow (191, 192); Archives Photographiques, Paris (10, 415, 418, 547, 582, 603, 629); Arlaud, Jean, Geneva (46, Pl. 21); Art Reference Bureau (255, 256, 257, 258); Blauel, Joachim, Munich (Pls. 6, 10, 22, 26, 27, 30); Blinkhorns, Banbury, Oxon., England (668); British Museum, London (383, 384, 385, 386, 387, 388, 389, 390, 391, 392, 393, 395, 396, 397, 406, 416, 417, 420, 421, 425, 426, 429, 430, 431, 432, 433, 443, 451, 452, 453, 454, 455, 456, 459, 461, 462, 463); Bruckmann–Art Reference Bureau (363, 466, 471, 472, 473, 474, 475, 476, 477, 479, 481, 503, 504, 568); Brunel, Lugano (99); Bulloz, Paris (24, 43, 44, 90, 132, 134, 135, 281, 282, 286, 291, 293, 294, 338, 356, 419, 478, 565); Busch-Hauck, Gabriele, Frankfurt (93, 94, 95, 96, 111, 138, 157, 178, 185, 440, 468, 489, 494); Castelli, Wilhelm, Lübeck (222, 354); Cooper, A. C., Ltd., London (604); Deutsche Fotothek, Dresden (116, 370); Ding jan, A., The Hague (609, 610, 617, 623, 630); Edelmann, U., FFM, Frankfurt (328); Frequin, A., The Hague (102); Fyman, Vladimir, Prague (60, 62, 63, 64, 445, 670); Germanisches Nationalmuseum, Nuremberg (67, 524); Giraudon, Paris (13, 25, 29, 30, 31, 32, 33, 34, 35, 36, 37, 78, 244, 265, 269, 270, 271, 273, 287, 290, 644); Giraudon, Paris, and Ségalat, Roger-Jean, Paris (Pl. 3); Held, André, Paris (20); Held, Louis, Weimar (499); Imprimeries Réunies, Lausanne (Pl. 9); Kleinhempel Fotowerkstätten, Hamburg (69, 70, 71, 80, 81, 82, 83, 84, 414, 537); Kunsthistorisches Museum, Vienna (346); Kunstverlag Wolfrum, Vienna (525); Library of Congress, Washington, Rosenwald Collection (408); Marburg–Art Reference Bureau (56, 57, 58, 74, 75, 76, 77, 326, 330, 331, 332, 334, 335, 344, 359, 360, 361, 369, 485, 514, 521, 552, 614, 622); MAS, Barcelona (88, 89, 97, 128, 162, 229, 249, 259, 260, 296, 297, 299, 301, 303, 305, 306, 307, 308, 309, 311, 312, 313, 315, 316, 317, 318, 320, 321, 323, 324, 325, 496, 569, 570, 572, 631, 640, 663); Metropolitan Museum of Art, New York (436, 437, 441, 488, 526); Meyer, Erwin, Vienna (Pls. 19, 23, 31); National Gallery of Art, Washington, Rosenwald Collection (398, 407, 422); New York Public Library, Astor, Lenox and Tilden Foundations (458); Pfauder, Dresden (114); Photohaus Hirsch, Nördlingen (365, 366); Photo Studios Limited, London (643); Radnický, Viktor, Prague, and SCALA, Florence (Pl. 5); Rheinisches Bildarchiv, Cologne (73, 327, 329, 351, 352, 353, 585); SCALA, Florence (Pl. 13); Ségalat, Roger-Jean, Paris (Pls. 1, 2); Service Photographique, Paris [Clichés des Musées Nationaux] (6, 22, 23, 110, 125, 139, 140, 200, 242, 254, 264, 267, 274, 289, 314, 410, 557, 567, 642, 647, 649); Sibbelee, Hans, Utrecht (204); Soprintendenza alle Gallerie, Naples (682); Staatliches Amt für Denkmalpflege, Karlsruhe (367); Staatliche Graphische Sammlung, Munich (374); Stearn & Sons (Cambridge) Ltd., Cambridge, England (624); Steinkopf, Walter, Berlin (130, 141, 142, 144, 148, 156, 184, 193, 261, 266, left 268, 333, 341, 342, 343, 375, 376, 377, 378, 379, 381, 382, 394, 412, 428, 439, 497, 500, 536); Steinkopf, Walter & Staatliche Museen, Berlin (511, 513, 518, 520, 522, 523, 538, 599, 600, 602); Vanhaelewyn, H., Bruges (Pl. 15); Verlag Karl Alber, Freiburg (357, 480, 515); Villani, A., Bologna (246).

Library of Congress Catalogue Card Number: 68-20103
Trade ISBN: 0-03-072500-3
College ISBN: 0-03-089476-X

Editor: Dan W. Wheeler
Designer: Marlene Rothkin Vine

Composition: Les Presses Centrales, Lausanne, Switzerland
Black-and-white photolithography: Les Presses Centrales, Lausanne, Switzerland
Black-and-white printing: Capital City Press, Inc., Montpelier, Vt.
Color separations: Les Imprimeries Réunies, Lausanne, Switzerland
Color printing: Intelligencer Printing Co., Lancaster, Pa.
Binding: Capital City Press, Inc., Montpelier, Vt.

234 046 987

PREFACE

It HAS BEEN my purpose in writing *Northern Painting* to offer in English an historical survey and analysis of the great artistic tradition that developed north of the Alps from the 14th to the 17th century. The period is one of extraordinary achievement in the history of Western art, and no book on it can begin without the author's immediate acknowledgment of the enormous debt that all interested in the field owe to Max J. Friedländer and Erwin Panofsky. Their important works have been solid foundations for subsequent research and understanding of the painting of this time. Within the limits of a more general work than theirs, I have attempted to present the history of Netherlandish painting and assess recent contributions since the books of Friedländer and Panofsky first appeared. In addition, I have considered certain artistic expressions omitted by one or both of these writers. I have, therefore, commented on French, Spanish, Bohemian, and German painting and illumination preceding or contemporaneous with the influential Flemish developments; on the rise of the graphic arts; as well as on the later rise of a powerful art in Germany, which in part has been largely unavailable to those without a knowledge of the German language. Then follows a study of 16th-century Flemish and Dutch art and French art of the same time expressing a northern spirit. The final chapter deals with Bruegel's art, which brings the period to a brilliant close.

For each chapter I have cited a number of major bibliographical aids at the end of the text. I have included significant articles yet to be incorporated into catalogues, corpuses, and encyclopedias. The bibliographies are not intended to be complete; rather, my objective has been to provide the essential minimum for those interested to explore further. Within the bibliographies I should like especially to direct the reader's attention to the many excellent exhibition catalogues that have been published in recent years.

I should also like to point out certain usages than I have adopted. When a city is named in the text as the location of a painting, it indicates that the work is in the chief art museum in that city. Thus, Paris means the Louvre, London means the National Gallery of Art, New York means the Metropolitan Museum of Art, and so forth. With reference to manuscript, drawing, and print collections, the name of the city indicates the major library or archive. Otherwise, collections are identified by name as well as by city. Full identification for the works reproduced is given in the figure and plate legends. References to left and right are in relation to the viewer.

Dimensions to the nearest eighth of an inch are included in the legends whenever this

information has been available. The dimensions given are those of the area shown in the reproductions unless otherwise noted. The first dimension is for height, the second for width.

Northern Painting originated in lectures I have given and discussions I have had with students at the School of Art of the University of Iowa. My hope is that the material presented here will be useful to those who have followed the lectures in the past and to students of art everywhere who follow comparable lectures and discussions. I should also like to think that the text and its illustrations will excite amateurs of art about a field that has been difficult of access from the standpoint of the written word in English but easily assimilated by the eye and the spirit. The aim of the book is to provide knowledge of the governing concepts and art-historical developments of the period and to aid understanding of and delight in the individual achievements of its artists.

In my mind's eye I have conceived the order of presentation as journeys to the centers of artistic creation in the period under consideration. At the many repositories of the artistic monuments, the amicable and obliging sacristans, curators, and librarians—too numerous to mention by name—have been most kind in aiding me, and thereby the reader, to know the splendid works of art under their care.

In preparing this book, I have been constantly reminded of the intellectual stimulation and training I have been privileged to receive from such outstanding teachers and scholars as the late Walter W. S. Cook, Ralph S. Fanning, the late Richard Offner, the late Erwin Panofsky, and the late Martin Weinberger—to name those of great-est importance for me—and of the challenges in and out of the classroom from my students. To a number of friends and colleagues I owe a debt of gratitude I am happy to acknowledge here; in particular, to Robert L. and Margaret A. Alexander, Richard A. Braddock, and Frank A. Seiberling, of the University of Iowa, and John H. B. Knowlton of the Connecticut College for Women. To the Belgian-American Educational Foundation, under the direction of Perrin C. Galpin and E. Clark Stillman, and to the University of Iowa, my debt is also large, and I am grateful to be able to record it here. To Julius S. Held, Barnard College, and Robert A. Koch, Princeton University, I extend my great thanks for their constructive comments on the manuscript. To Theresa Brakeley goes my warm gratitude for the many and good editorial suggestions to smooth the reader's path, and to the staff of Holt, Rinehart and Winston I offer a like expression of appreciation. The extensive search for the best possible photographs to illustrate the text, although not always crowned with the desired success, has been immeasurably aided by the efforts of the staffs of many organizations and institutions, particularly that of the Archives Centrales Iconographiques in Brussels. I also wish to thank Harlan Sifford for his aid in preparing the Index.

Finally, my largest debt of gratitude is to my wife. She has typed and retyped and has endured with patience innumerable discussions of content, style, and organization.

No one mentioned above can be blamed for any statement or omission from this book. Its shortcomings are my own; its good points are indebted to many.

Iowa City, Iowa

June, 1968

C. D. C.

CONTENTS

VIII

INTRODUCTION

Art informs life, fixes its flow momentarily and crystallizes an attitude and an ethos at the moment of creation. The lover of art—whether he be amateur, student, or teacher—is fascinated by the variety within its flow and by the sheer delight and understanding it evokes. Art enriches our understanding and makes our own relation to life more profound and meaningful. By making us aware of the past aspirations of the human spirit, art endows the life about us with enhanced significance.

Art is a continuum. On the first of January or the first year of a new century the world does not turn about and act in a new way. We may be acutely conscious of the new year or the turn of the century, but that consciousness must be constantly stimulated by a reminder of the past and by the experience of new circumstances, each (ideally) stronger than the last, for discernible change. It is a truism that circumstances are never repeated exactly. Each time a similar set of circumstances arises, we ourselves are different, so that change is constant. What varies is its rate and its magnitude.

The rate and magnitude of change in the early years of the 14th century were sufficient for historians to mark out the period as significantly different from what had gone before and from what was to come. In architecture high Gothic was becoming late Gothic. Literature was discovering the popular genres. And under the influence of a growing empiricism, the philosophers' encyclopedias summing up all knowledge of God and man were being replaced by popular treatises on moral conduct. An impetus to change was added by the Great Plague, which decimated Europe in 1348 and recurred to scourge it again and again in the following two centuries, though each time with less intensity.

The general came to have less importance than the specific, and a variety of specifics arose. In religion, mysticism sought to establish highly personal, individual contacts with God. In philosophy, nominalism, with its distrust of abstractions, led to direct observation and inductive research. In literature, empiricism aided the rise of the tale, the romance, the satire, the poem, the song, and historical writings. In painting, artists observed the forms and variety of nature with a new eye.

Mysticism in painting led to devotional themes: the *Pietà*, Christ as Man of Sorrows and the *Andachtsbild*, or image for worship. Empiricism led to the portrait of the individual, the landscape, the still life, and the genre motif that in time became the genre painting. Direct observation led artists to an interest in the natural object and its concomitant atmosphere as components of a new kind of pictorial space. Inductive research led to a new conception of objects in space, arranged according to a perspective in

which orthogonals arrived at a single point on the horizon line. The new perspective was arrived at intellectually in 15th-century Italy, intuitively in the north.

During the 14th century north and south both changed. At the beginning of the century a new spirit had arisen in Italy and taken form in the painting of Giotto and Duccio, and in the literature of Dante, Petrarch, and Boccaccio. The north preferred Duccio to Giotto, Petrarch and Boccaccio to Dante. Italian forms and iconography were adapted to northern tastes, and the Trecento painting of Siena dominated all Europe north of the Alps as well as Spain. By the end of the century, however, the distance between the objectives in painting north and south of the Alps had so diminished that the resultant art was a mutual creation—the courtly style of 1400, the International Style, the soft style, the international Gothic, to give it a few of its titles. Overflowing narrow cultural borders, this art was a confluence of the new feeling for illusionistic space and the pictorialization of form. Northern artists softened the edges of their rhythmical plastic volumes and loosened the bonds of their relief space. They created a stage for forms with fluid and ornamented surfaces under what approached naturalistic lighting, occasionally with real cast shadows. Southern artists took the illusionistic inheritance from Byzantium, superimposed it upon a Gothic concept of volumetric form, and imbued it with an emotional drama that, though never lost in the course of the 14th century, was attenuated and overlaid more and more with a richly decorative and fluid surface. As a result of courtly demands, an amazingly similar art was produced on both sides of the Alps. The consonance of elegance and aesthetic beauty that was achieved marked both a moment of poise—though it lasted for almost a generation—and a starting point for a divergence and a parallelism. The International Style balanced fluid space against idealized form, naturalistic surfaces against ornamentation, and flat against atmospheric tones, both in delicate color.

By the first quarter of the 15th century, the Flemish led by the Master of Flémalle, little interested in elegance and delicate expression, had transformed the International Style into a new and forceful pictorial naturalism. The Flemish style dominated northern Europe in the 15th century and even won Spain away from Italy with its new vision (painted in warm, glowing oil colors) of a serene natural beauty in the service of a religious, mystic unity. At first Flemish art was strongly plastic, angular, and inherently monumental; then it became less plastic and more rhythmical and linear, with a slightly less pervasive luminosity. After the 1460s two currents appeared. One was expressive, dramatic, and emotionally challenging; the other fluid and more graceful, peaceful and contemplative. Though each can be paralleled in other media and each can be found in and outside the Netherlands, each shared and continued the spirit of religious mysticism. The essential religiosity of Flemish art was grudgingly acknowledged by Michelangelo in the middle of the 16th century, if Francisco de Holanda quoted him accurately in *De Pintura Antigua* (1548):

> Flemish painting pleases all the devout better than Italian. The latter evokes no tears, the former makes them weep copiously. This is not the result of the merits of this art; the only cause is the extreme sensibility of the devout spectators. The Flemish pictures please women, especially the old and the very young ones, and also monks and nuns, and lastly men of the world who are not capable of understanding true harmony. In Flanders they paint, before all things, to render exactly and deceptively the outward appearance of things. The painters choose, by preference, subjects provoking transports of piety, like the figures of saints or of prophets.... [This art]... aims at rendering minutely many things at the same time, of which a single one would have sufficed to call forth a man's whole application.

Not in sympathy with Flemish art, Michelangelo recognized its power, as it was recognized all through the 15th century by many Italians, some of whom went north to learn its way.

Flemish painting of the 15th century has been called a Renaissance art, yet its painters have been called the Flemish "primitives." It was neither Renaissance in the Italian sense nor primitive, except in a purely chronological sense. All too often it is said that the Renaissance took place in Italy in the 15th century and that the north continued in religious piety until the 16th century, when Italian ideas penetrated the north, ruptured its cohesive tissue, and inserted Humanistic ideas based upon antiquity. Then came confusion, according to this view; the

artistic world of Flanders fell apart, and the 16th-century art of the north became nothing but a poor, tasteless shadow of the greater art of Italy. These are half-truths at best: Italy had its Renaissance, but so did the north, if we do not look for an exact parallel. With a different outlook and different means—atmospheric space and rich, pure, deep, warm color—Flemish painters of the 15th century sought and found aspects of nature that excited their contemporaries in Italy as much as those in the north. And the search took place by interchanges and parallel expressions in the cultural milieus. How else can we explain the similar development toward and outcome from the International Style in both Italy and the north, or the frequent parallels in stylistic means? Jan van Eyck can be linked with Masaccio, the sculptor Claus Sluter with Donatello, Hugo van der Goes with Piero di Cosimo and Botticelli; and the linear, less luminous expression used by northern artists of the third quarter of the century appeared at the same time with like strength in the south. The north continued in religious piety through the 15th century, but so did Italy, for Christian piety in both produced a "Neo"-Gothic movement at the end of the 15th century that was in actuality a heightened Gothic; the Gothic did not die for several centuries.

Italian ideas of decoration and Italian figure types penetrated the north by the last quarter of the century, and by the 1480s Flemish ideas had overwhelmed Ghirlandajo, the Medici owned Van Eycks, and Venetian painting already owed an incalculable debt to the Flemish technique. There was no creation of mutually exclusive polarities. The turn to Italian motifs, style, and conception (in that order) seemed to correlate with the disappearance of the Grand Duchy of Burgundy as a political entity after the death of Charles the Bold in 1477. The fiction of Burgundian autonomy upholding chivalric ideals disintegrated, and the Netherlands was reluctantly drawn into the Hapsburg orbit to become part of that empire which by 1519 under Charles V was spread from the Netherlands to Sicily, from Austria to Spain, and west to the New World, an empire more vast than any political entity since Charlemagne. The political realignment of the Netherlands demanded a reorientation of thought and art, and an autonomous, autochthonous Flemish art declined almost concurrently.

The orientation toward Italy (which the Reformation only heightened) had its parallels in art. By the end of the century changes were visible in the northern outlook, and in the 16th century northern artists joined the Italians to create a new international style. Italy had developed the High Renaissance before that; whereas the north, except for a brief period in the career of Albrecht Dürer, never achieved a like balance of the monumentalized ideal with the natural.

A subjective individualism arose to anticipate the Reformation's goals of justification through faith and the individual's direct relation to God. It was manifest early in Flemish art in Hugo van der Goes and in the unconscious, imperfectly realized search for artistic autonomy in Hans Memlinc. The search continued with his successor, Gerard David, who turned to southern concepts of monumentality, and to sentiment. Monumentality had been inherent in the art of the early 15th-century Flemish painters. Thus it was no accident that Jan van Eyck was revived at the end of the century (as it was no accident that the more Gothic art of Rogier van der Weyden lived on). Bosch, though "Neo"-Gothic, is a supreme example of subjective individualism, and Metsys's expression of sentiment and individual psychology was highly personal. To the subjective spirit may be attributed the rise of specific modes and genres of art in the 16th century. The Flemish "primitives" are often said to end with David and Bosch. This apparent termination, however, is merely the mark of a broader change than had taken place in the course of the previous two centuries.

Growing out of this subjective individualism was the conscious recognition in Italy, under the stimulus of Neoplatonism, of the creative processes of the artist. A transformation of art from mechanical to liberal art, and the artist from craftsman to creator, had progressed on the surface in Italy; in the north it was, so to speak, subterranean, but it was just as inexorable. In the north the concept of the artist as creator was united with Christianity in Dürer, that most self-conscious of northern artists, and less consciously in others. This concept was to throw

the artist into a whole new set of circumstances that endowed him with new and very different possibilities undreamed of by his craftsmen predecessors. Dürer, product of a German art that through much of the 15th century meekly accepted Flemish dictation (except for the volatile art of prints and printing after mid-century), was truly on the border between the Gothic and Renaissance worlds. At the same time Grünewald revived with all the expressive power of his genius a symbolic orientation that Dürer had essentially abandoned in Venice in favor of analytical thought and intellectual theory. Altdorfer transformed 15th-century symbolic naturalism into a fervent pantheistic poetry, and Cranach evolved a consciously exaggerated view of antiquity with more than a tinge of hedonistic sensuality. By mid-16th century, however, the political and religious excesses of the Reformation period had effectively eradicated Germany's distinctive, vitally expressive art.

The international style of Mannerism, early manifested in Cranach, is now recognized as a distinctive artistic expression that was neither Renaissance nor Baroque. Mannerism was a complex, contradictory movement. It built upon its immediate past and upon antiquity in a conscious Humanistic search for the ideal. It was practical and highly theoretical, realistic and idealistic, personal and impersonal, humanistic and pietistic, spiritual and sensual, aesthetically elegant and emphatically naturalistic. It was also a revival of the Gothic and a forecast of the Baroque. Intuitively conceived naturalistic space in the Flemish manner continued side by side with logically constructed Renaissance space. However, the mathematically defined space of the Renaissance soon became fluid and ambiguous under Frans Floris's Mannerism, and ambiguity was also extended to the subject, so that sometimes the major theme became the visually minor theme. All was in flux, movement was cherished almost for itself, and feeling in general was becoming secularized. Flux was manifest in

the discoveries in science, in the new geography, and in the musical forms of the motet and the madrigal. The scientists and musicians closest to Mannerist painting of the 16th century were the astronomer Copernicus, the geographer Ortelius, and the composers Adrian Willaert and Roland de Lassus, in the north, and Palestrina and Tomas Luis de Victoria in the south.

The volatility of the age opened the door to specialization, which aided the further development of the new genres of landscape (both epic and intimate), peasant life (both monumentalized and analyzed), and still life (both symbolic and natural). Through the medium of the portrait an aristocratic, aesthetically oriented court art gave distinctive form to the conception of modes of formal and informal portrayals based on a theory of decorum. (It is remarkable that the genres and the modes had been forecast in that earlier court style of 1400.)

Hand in hand with the volatility there arose an increasingly formal conception of life. This formality prepared for the absolutism of the next age and left its mark on the portrait. Stylistically these conceptions were expressed in two manners, one a strong linearity with bright, even light and with elegant, generalized surfaces and idealized forms, and the other a conscious continuation of Flemish pictorial naturalism. The rich color of the 15th century, however, fell victim to formalization and was often replaced by varied shades of brown.

These new attitudes enabled an artist to choose consciously the style in which he would paint, style having lost its organic meaning for him, but by then the rate and magnitude of change had become so strong that a new era was at hand.

The chapters in this book chart the course of painting and the graphic arts as they emerged from the Gothic to develop a distinctive expression before the coming of the Baroque. The development leads from Pucelle in 14th-century France to Bruegel in 16th-century Flanders.

PART I THE FOURTEENTH CENTURY AND THE INTERNATIONAL STYLE: Exploitation and Discovery

At the beginning of the 14th century there were at work forces whose origins can be traced back to the 13th century and in some cases even earlier, but by the end of the century the northern world was very different from what it had been at the beginning. In those one hundred years three distinctive forces had received an astounding impetus in the direction of a more modern world—nationalism, capitalism, and science (used in a sense broad enough to include the arts). All three continued to change in the two succeeding centuries, but none more than the arts. In 1302 Pope Boniface VIII issued his bull, *Unam Sanctam,* which declared that to obtain salvation every human being should be subject to the Pope and that all temporal powers should be united under the spiritual authority. Yet in the next year the Pope was roughly handled by the adherents of Philip IV of France, and within a few more years the seat of the papacy had been moved to France, beginning what was later called its "Babylonian captivity."

Monarchical power was growing, and its subjects were called upon to approve its course and actions and to support its extranational activities by subsidies and taxes. In the previous century representative assemblies had been called in England, Germany, and Spain; in France the first meeting of the Estates General occurred in 1302. The appearance of such assemblies upon the European scene was rather close in time. The various classes of society met for the first time to give their approval to actions that marked on the world calendar what would be the demise of feudalism.

Hand in hand with the rise of such political instruments (which declined later in the century, having for the most part served the monarchical purpose) was the decline of the Church as a political entity. Indeed, it was, through most of the 14th century (1305–78), a vassal of the French king. The papacy in its Babylonian captivity was endangered by decentralization, a trend opposed to what was in store for the governments of the European nations. At the century's end the Church was embroiled in the Great Western Schism; two prelates called themselves Pope of Christendom and successor to the keys of St. Peter, marshaling adherents to their standards in Avignon and Rome. The climax was to come in the next century, when churchmen met in the councils of Constance (1414–17) and Basel (1431–37)—the Church's own representative assemblies—to enunciate the theory of the supremacy of the Council of Cardinals to the Pope. This theory lost some of its potency once a strong Pope such as Nicholas V came to power, but the initial decentralization was to have its effect in the 15th and 16th centuries.

As in all periods, there were forces operating in directly opposing directions. The Hundred Years' War between France and England broke out before mid-century. The conflict grew out of Edward III's discomfiture at having to declare himself a vassal of the French king for his fiefs on the Continent. More important was the discomfiture of the English people for the same reason. National pride was still intermixed with feudalism, but in Italy the 14th century was witness to a different kind of pride, that of rising city-states. The Emperor was powerless to subject these to any central authority, for the Empire was nòt yet dynastic, its head being elected by the German prince-bishops and the secular electors. Not until the end of the 15th century was there to be a dynastic monarchy of any strength in German lands.

By the end of the 14th century four of the regions of modern France not in English hands—Anjou, Provence, Brittany, and Burgundy—were largely independent of the parent body, and not until the fourth quarter of the next century was France to assume a shape on the map roughly comparable to what we see today. The promise of the popular assemblies of the early years of the 14th century by then was farther than ever from fulfillment.

Much happened during this century. The Great Plague of 1348 was a Europe-wide catastrophe that has loomed large in the popular imagination, for it decimated the Continent and returned often in the second half of the century. Yet its effect was not so great as popular thought would have it, for other forces were stronger. Capitalism was one of these. The 14th century furthered earlier beginnings, as did the next two, so that by the end of the 16th century the Western world was radically changed. Trade increased enormously. Because conflicts with the French had endangered overland routes to the fairs of Champagne and the Netherlands, the Venetians in 1317 assembled a fleet of galleys that sailed out of the Straits of Gibraltar to reach England and the Netherlands, thus making the longest western sea voyage since antiquity. After this initial voyage Venice's Flanders fleet made the voyage every year, and Bruges, already the leading center of Flanders, saw Venetian merchants permanently established in that focal point of northern trade.

The Hanseatic League, a corporation of North German cities, allied for purposes of mutual advantage in trade, had already obtained rights in Bruges in the previous century. The members of the Hanse, as early as 1293, had adopted a common code, the "law of Lübeck," a series of agreements for the regulation of trade and its protection from the depredations of pirates and feudal lords. In 1360 there were 52 cities, some of long standing, on the earliest record of its membership. In all, at various times, 96 towns were members of the Hanseatic League. It exerted pressure to obtain concessions and protection for its members, even conducting military and naval operations in Denmark, climaxed

by the Treaty of Stralsund in 1370, which gave the League the commercial rights it sought. When Charles IV went to Lübeck in 1375 (and one of the painters of nearby Hamburg, Master Bertram, may have been there to work on the decoration of the city), he formally recognized the Hanseatic League; the result was a further expansion. At the height of its power the League not only regulated the commerce of its members but also settled disputes, established common weights and measures, and issued coinage, like city-states in Italy, of which Florence, with its gold florin, is the most renowned.

In the 14th century Bruges, the western point of greatest importance for Venice and the Hanse, was the chief commercial center of western Europe north of the Alps. In time its merchants and those of the Hanse and other cities of northern Europe saw some of their number achieve positions of outstanding wealth. A land-buying urban patriciate was being established, and it gradually controlled its surrounding countryside to ensure a steady supply of food. Merchant princes became bankers, and the foundations of modern banking were laid in this period. With the increase in wealth came an increase in coins, for at this period, though credit existed, much of the trade was on a cash basis. In addition, more coins were needed to pay the increasing numbers who worked for a wage. Enlargement of commercial activity was accomplished by industrial growth. Beginnings of large-scale industries appeared, employing wage-earners who were never to go through the guild systems, who never became masters of a craft. Typical of this new class in society were the weavers of Flanders, the miners of the Tyrol (supplying an increased demand for metals, particularly to satisfy the great need for more coins), the wool-carders of Florence, and, in the building trades, the laborers who, as carriers of brick, stone, and mortar, never were to alter their status.

Rural society, which furnished many of these laboring people, was in flux during the 14th century, as is indicated by the increasing number of revolts: the Jacquerie of 1358 in France, the Peasant Revolt of 1381 in England, and the revolt of 1395 in Catalonia. The Flemish peasants had revolted as early as 1322, and in Germany the peasants were to revolt all through the 15th century. Half religious and half social in character, the revolts signalized the early stages of a change from an agricultural to an industrial society, the course of which was to extend far beyond the period under discussion. In many places serfdom was disappearing from the countries of western Europe, and a new sense of freedom was abroad. There were revolts in the towns as well as in the country.

In short, the Western world was in ferment in this 14th century far more than ever before. It was reaching in new directions, forming contacts with the East: Marco Polo had returned to Venice in 1295; by the turn of the century the account of his voyages was being circulated in Europe and laying the groundwork for later voyages of discovery of the following century. Even before that the missionary zeal of the Franciscan and Dominican orders had resulted in the establishment of churches as far east as Peking, where Catholic services were held in 1340. Though these contacts with the East were broken by the end of the century, there resulted a body of travel literature, one among the many new types of literature that developed during these hundred years.

In literature the 14th century marks a new beginning, for Dante began his *Divine Comedy* about 1307. The first and the greatest work in the vernacular, *The Divine Comedy,* written in the Tuscan dialect, started a stream that became a flood of writings in popular tongues. As the first great poetic combination of Christianity and classicism its sublimity of subject, magnificent imagery, and almost Gothic structure contrast with the *Decameron* of Boccaccio, published in 1353. The *Decameron* plunged the reader into the contemporary world, whereas Dante rose above it. The telling contrast is in keeping with the times, and, indeed, with all times for it is historical distortion to consider that life has only one path to follow. As Dante had drawn upon the antique past for some of his characters, so Boccaccio drew upon the past for outlines of some of his tales.

His contemporary Petrarch (1304–74) was the giant of early Humanism, which, in the 14th century, was characterized by an overwhelming interest in and veneration for the classics. Petrarch's infectious enthusiasm had much to do with the spread and growth of classical knowledge, particularly in Rome and Florence. Fourteen of his mature years were spent near Avignon, and it was there that he communicated

his interests to the members and visitors to the papal court, among whom was that outstanding patron of Bohemian manuscript illumination, Chancellor John of Neumarkt. Early Humanism also developed in the north, but northern efforts were characteristically concentrated on works that could be related to feudal and chivalric ideals, for example, the translation of Livy by Pierre Bersuire (1290–1352). Humanism as a philosophy of life, which it became in Italy in the next century, had no part to play in the north until the 16th century. The northern road was philosophically separate from the Italian, but this separation is more readily apparent in the following century, when Italy developed what is now called the Renaissance, a term that has tended to spill over its proper geographical limits and improperly color our view of developments outside the Italian peninsula.

In the north, as in Italy, the developments in language and literature brought new literary forms into existence. In addition to didactic moralizing works and condensed translations of the lives of the saints for popular consumption, such as the *Golden Legend* of Jacobus de Voragine, written before mid-century, there were chronicles of the activities of men, such as those by Froissart (1333?–?1400). He chronicled the demise of chivalry, which maintained its fictions by dominating courtly ideals. The ideas of chivalry invaded and controlled the literary genres. One of the most popular works of the period was the allegorical—and satirical—love poem the *Roman de la Rose* of Guillaume de Lorris and Jean de Meung. The poetry of Guillaume de Machaut, Eustache Deschamps, and the Maréchal de Boucicaut expresses the same chivalric ideal. Counter to it was the appearance toward the end of the century of the older fabliaux in more modern guise, the *Cent Nouvelles Nouvelles,* which were short, comic prose tales. In addition, the miracle and mystery plays must be considered as a part of the variety and vogue of literary genres that developed in the 14th century. Didactic allegories were the prevailing mode of the age, but they shared with the secular and religious tales the attention of an ever larger reading public.

Philosophically the dominant spirit of the 14th century was mysticism. Medieval mysticism of the monastic type had developed an intellectual aspect leading earlier speculation to scholastic thought and to St. Thomas Aquinas. On the other hand, in the 14th century there arose a more popular, intuitive mysticism, which was spread by vernacular writings and the mendicant orders. The Franciscan and Dominican orders made religion more human and by their work aided the growth of a personal mysticism. In the Rhineland the Neoplatonism of Master Eckhart and his followers, Johannes Tauler and Suso (Heinrich Berg), created the pantheistic doctrine of the divine nature of the soul, and in effect they substituted religious experience for religious authority. Mysticism both democratic and communal spread in the northern countries in the 14th century, the writings of Jan van Ruysbroeck (1293–1381) being converted by Gerhard Groote (1340–84) into the simplistic *devotio moderna,* which was centered in the rapidly spreading religious communities known as the Brethren of the Common Life. Groote founded the first of these lay communities at Deventer, Holland, in 1381.

Parallel to the rise of mysticism—and apparently expressing exploratory aspects of the spirit of the 14th century and a dissatisfaction with things as they were—arose the development of science in terms of the analysis of individual phenomena, as in the writings of Roger Bacon; the systematic organization of natural phenomena in the arts; the philosophical nominalism of William of Ockham, who held that the real is individual, rather than universal; and the growth of heresy within the Church. The freedom of contemporary life had not been paralleled by a freedom in religious thought within the Church, nor was the Church at all interested in combating the most widespread criticism of the era—that its possessions were its curse. Mystics turned away from the possession of lands and property to seek answers in the Bible and in personal relations between man and God. Under such conditions temporal possessions and temporal office played no part, and there was no need, if such thoughts were carried to the logical conclusion that many carried them, for temporal organization. The movement was aided by translation of the Bible into French, English, German, Bohemian, Catalan, and Castilian. This was an age of translations, and these translations were a part of the changing pace and restlessness in all forms of thought and life at the time.

In the arts especially appeared a new view of the world that has lasted with few interruptions until the present day, when it seems that another new view is appearing on the historical stage. The exploration of the visual nature of matter in pictorial space by Duccio in Italy and Master Honoré and Pucelle in the north and the subsequent developments in the conquest of the visual, perceivable world have still not completely ceased in our own day.

The exploration of the third dimension led to perspective as we know it. In time it was scientifically developed in Italy, whereas in the north it was only intuitively discerned. Related to the discovery of perspective was the replacement in Italy—particularly in Giotto's art—of what Vasari called the *maniera Greca,* or the older Byzantinizing style, by a psychological drama of human bodies interacting in pictorial space. But this was not to affect the north strongly for over a hundred and fifty years. The northern artist, nurtured on Gothic emotionalism, preferred the realism of limited aspects of time and experience and the realism of space as the expression of the infinite and of eternal values.

New subject matter accompanied the intensification of emotion in the fourteenth century. The subjects, vehicles for new emotional attitudes, are the artistic equivalent of new modes in literature. The portrait was one of the areas with a stronger concentration, and the century saw a multiplication of individualized portrayals, beginning with the very heavily damaged portrait reputedly of Dante and supposedly by Giotto. Artists on both sides of the Alps began to emphasize the particular and thereby to run parallel with the course of nominalist thought. They increasingly concerned themselves either with a psychological or an intensely personal mystic drama. An extreme example of the new subject matter is the theme of the blood of the crucified Christ streaming from His side to strike the breast of the Virgin. This theme, conceived by the Rhenish mystic Suso, was often illustrated. Such themes as the Man of Sorrows, the Lamentation, and the Madonna of Humility, to name but a few, became popular. These themes, particularly those of pain and sorrow, tended to become iconic subjects for mystic contemplation. But joyous themes also came into vogue; the Adoration of the Magi, for instance, enjoyed increasing popularity for more than two centuries. On the secular side the preference for battle scenes is found with greater frequency, and works with this subject were prepared in more significant numbers for the many chronicles. Hunting scenes and tournaments appeared in manuscripts created for the nobility, who carefully guarded their exclusive rights to these pastimes. The new romances and tales were also illustrated, as was the new travel literature, especially the accounts of travel to the exotic realms of the Orient. Manuscripts poured in accelerating quantities from the pens of scribes and the brushes of illuminators in the leading cities of Europe.

The new leaven in society gave an impetus to the growth of cities, and Paris established its primacy in painting for the succeeding centuries. More than ever before, art works were produced in cities and were intended for the people who by preference or necessity occupied them and gave them new life and vitality. From the beginning of the fourteenth century artists were city trained and city oriented, and this is reflected in their art.

The 14th century was an age of exploration long before Columbus, as art and science coalesced in the common goal of the discovery of nature. The age was intellectually alive, commercially active, mentally restless, and artistically experimental, with a new volatility in almost all aspects of life.

FRANCE
AND THE NETHERLANDS

THE IMPORTANT INNOVATION OF THE 14TH century was the creation by French art of a new attitude toward natural appearances, which, step by step, led to increasing conquests in the representation of distinct visual aspects of nature. Concepts of space, atmosphere, and light, proportions of the figure, and backgrounds gradually changed in response to a new interest in precise images. As the general gave way to the specific, the groundwork was being laid for the great Netherlandish artists who were to follow in the succeeding century.

The increasingly perceptual outlook in art corresponded to the sweeping changes in the political, commercial, literary, and religious climate, as discussed in the preceding pages. St. Thomas Aquinas might be cited as an example of the influences toward naturalism. His conclusion that the physical is the corporeal metaphor of the spiritual established the philosophical basis for the turn toward observation of nature in late Gothic art. Within fifty years of his death, about 1274, ideas appearing in the art of manuscript illumination were carrying his conclusion farther than he could have imagined.

That France, and particularly Paris, should have been foremost in the flowering of the new art is related to the historical and social events of the period and especially to the personalities of several royal patrons of the arts, who con-

trolled the status of artists and commissioned their output.

On the historical scene the year 1300 in itself marked no major event in France. Philip the Fair had been king since 1285, energetically pursuing the goals of a powerful monarchy by means of secular judicial and legal procedures, rather than ecclesiastical or feudal ones. After the end of his reign, in 1314, his sons, Louis X, Philip V, and Charles IV, continued his policies. But the death of Charles IV without a male heir, in 1328, brought about the accession of Philip VI, of the Valois line, which remained in power for 170 years. Under the Valois rulers the arts, which had already enjoyed the royal patronage of Philip the Fair and his successors, were given a powerful stimulus by the enthusiasm of Charles V (1364–80), grandson of Philip VI, and his brothers, the dukes of Anjou, Orléans, Berry, and Burgundy, all of whom shared a passion for books. The most notable patron, John, Duke of Berry, spent almost all his vast fortune in the acquisition of art. The commissions and the collections of these and other nobles resulted in an outpouring of illuminated manuscripts that are a mark of the International Style in France. The last decades of the century were rich in courtly art, a close relationship existing between royal patronage and high artistic production.

The International Style (about 1380–1430) achieved its greatest sumptuosness in Paris during the first quarter of the 15th century. It was truly an international art, its spirit being found all over western Europe. Spreading to England, the Netherlands, Germany, and Italy, Parisian developments drew upon artists from Paris and artists from the provinces; Netherlanders from Flanders, Brabant, and Guelders; Germans from the Rhineland; and Italians from Lombardy and Tuscany. They traveled from Brittany to Paris, from Alsace to Paris, from Bruges to Paris, and even from Florence to Paris—to Paris and from Paris. They went to Milan, to Florence, to Barcelona, to the Rhineland, to the Netherlands, and to northern Germany. They went everywhere with and without their patrons.

John, Duke of Berry, traveled frequently, going from one of his châteaux to another, and his artists traveled with him, as may be seen by the representations of various castles in their miniatures. He also spent much time in Paris indulging his passion for art objects.

Other princes came and went in Paris, and monarchs as well, the most notable being Emperor Manuel II, who left Constantinople to travel the Western world for aid against the Turks. His visit to Paris in 1399 is probably responsible for the wave of Oriental costume that can be found in miniatures and paintings of the succeeding decades.

Yet the truly vast and largely superb artistic production must be set against a conflicting social and political picture. The accession of Philip VI of Valois resulted in the Hundred Years' War with England, and though France eventually won the war, she lost the battles—Crécy in 1346, Poitiers in 1356, and Agincourt in 1415. The cost was great. At Agincourt the outmoded French chivalry, mounted on heavy battle chargers, was decimated by the mobile English longbowmen. Economically that decisive turning point of the war ruined Paris. However, not until the late 1420s did art production in Paris decline in both quantity and quality, and before the decline the art was brilliant. The production of sumptuous manuscripts reached its apogee as shops headed by artists of high talent turned out more and more in a final surge that has permitted almost every major modern library to acquire, despite inevitable losses, at least one fine work of this period. Such monumental collections as the Bibliothèque Nationale, the Bibliothèque de l'Arsenal in Paris, the Bibliothèque Royale in Brussels, the Bodleian Library in Oxford, the British Museum in London, and the Morgan Library in New York number their exceptional manuscripts by the score. But with Paris under English control, the capital moved to Bourges, and not until 1436 was Paris liberated from English rule. During the "interregnum" Paris was starved, besieged, and in misery. Conditions were entirely unfavorable for the production of any form of art.

The internal political situation under the Valois kings was also marked by strife. The son of Philip VI, John (1350–64), though called the Good, was not good for France. John's successor, Charles V, was one of the two able Valois rulers (the other was Louis XI), and he did much to restore France's position; but after his death his brothers all fought for control of France. All wanted power over its purse and, in time, over its ruler, Charles VI, who came to the throne in 1389, after a regency under his four uncles, but was subject to attacks of insanity to the end of his life, in 1422. The main contest was between the Orléans and Burgundian parties for control of the mad king and the treasury. Only the dynastic struggles in England saved France for a generation from losing what Charles V had gained for it. However, just as the nobles vied among themselves for political power, they also contended for supremacy in the splendor of their courts and their possessions, with the result that artists were in great demand.

In discussing the art of the period, the major emphasis must, of necessity, be placed on the manuscript illumination, because it has survived, while panel paintings, with one exception, have disappeared. It cannot be doubted that panel painting, as well as the other visual arts, was vigorously pursued, and there are records to prove that manuscript painting was not necessarily considered the most important of the arts of the time. The Parisian tax roll of 1292 [1] provides a key to the relative importance of the various fields of art, to the extent that importance can be measured by earnings. In that year Master Honoré, who worked for the court, paid 10 sols, the highest tax of any illuminator, but the highest tax for a painter in any medium was 58 sols. The highest tax paid by a sculptor was

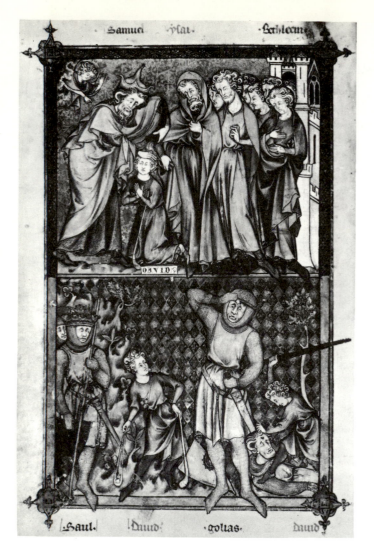

left: 1. MASTER HONORÉ. Scenes of the life of David, *Breviary of Philip the Fair.* c. 1296. Illumination, c. $6^{7}/_{8} \times 4^{1}/_{2}''$. Bibliothèque Nationale, Paris (Ms. lat. 1023, fol. 7v).

paintings and numerous grisailles, or "stone-colored" pictures.)

Painters also decorated banners, coaches, leather for furniture or saddles, and other courtly accouterments. Even when working for the court as a painter or illuminator, the artist's role was still that of a craftsman. In 1371 Jean Bondol portrayed Charles V in a miniature with an unusual and elaborate inscription, in which the artist is referred to as the king's "painter," not his illuminator. Bondol also designed tapestry cartoons, and his younger contemporary, the sculptor André Beauneveu, turned his hand to the illumination of a magnificent Psalter for the Duke of Berry.

In view of these facts and of the evidence of the tax rolls, the painter's role in the late Gothic period cannot be defined in terms of the supremacy of one painting medium over another; court painters painted or illuminated according to the demands of their patrons.

On the other hand, it is undeniable that great artistic effort was concentrated on illumination in the last quarter of the century and that the interest of Charles V and the growing interest in objects of small format were strong factors in the increase of illuminated manuscripts.

In the absence of panel paintings of the period, the credit for the new perceptual attitude in French art must go in large measure to the illuminator Jean Pucelle.

MASTER HONORÉ
AND JEAN PUCELLE

The major advance by Pucelle was a logical step beyond the work of his immediate predecessor, Master Honoré,[3] who probably illuminated the *Breviary of Philip the Fair* (Paris, Ms. lat. 1023), for which, it seems, he was paid in 1296. In creating the David and Goliath scene (Fig. 1), Honoré had conceived of forms existing in a milieu more naturalistic than that used by any of his predecessors, and his figures show a stronger modeling, even though he continued the earlier practice of executing the faces, hands, and hair with the pen. Further, Master Honoré

23 sols; a stonecutter paid 70; and the architects paid most of all, one Pierre de Montreuil paying 4 pounds, 7 sols, and Raoul de Montreuil 7 pounds. The enormous difference between the taxes on architects and those on other artists is what one would expect, but the tax scale shows that illuminators were paid less than any other artistic trade. No comparable figures are available for later periods, but it is not plausible that any radical change in the relative financial status of artists took place for many decades. Not until the third quarter of the 14th century, when Charles V and his brothers began to collect books and art objects, did the illuminators assume special importance. Even then these artists performed additional functions, working for the court as *valets de chambre* and painting objects other than books. (An inventory of Charles's possessions in 1379[2] listed over twenty

2. FRENCH. St. Denis preaching, *Legend of St. Denis*. 1317. Illumination, *c.* 9 1/4 × 5 1/2″ (page). Bibliothèque Nationale, Paris (Ms. fr. 2091, fol. 111).

de-emphasized the previously strong sense of contour by his tendency to equalize the tonal values of figures and supporting landscape; though the spatial volume is slight, he implied it by projecting his forms forward from the margins. The result is almost like a relief in color. This effect and the swaying movement of his figures remind one of the mannerisms of contemporary Parisian sculpture.

Intimations of a greater naturalism to come were taken up by the next generation within Honoré's own lifetime. (He probably died shortly before 1318.) In a manuscript of the *Legend of St. Denis* (Paris, Ms. fr. 2090–2092),[4] executed in 1317, there are scenes of Parisian life along the Seine and people in boats pursuing their daily activities. These scenes seem to establish a locale for the religious events shown above them in the illuminations (Fig. 2). They are freshly observed—painted reflections in the water appear for the first time—and they are different from the naturalistic *bas-de-page* (figured scenes below the text) scenes that appear in a Parisian *Songbook*[5] in Montpellier (Bibliothèque de la Faculté de Médecine, Ms. 196) and in the manuscripts from scriptoriums in England, Artois, and the Meuse region, because the main action in the St. Denis legend is not separated from these genre scenes. At this point the artist's conception began to be equivalent to a painter's approach to his panel as a total surface. However, progress was not made evenly. The full-page miniature, here only in germ, was yet to come.

Subsequent developments followed two lines, one progressive, the other conservatively following the first at a distance and reluctantly accepting the innovations of such miniaturists as Jean Pucelle.

Pucelle's approach to nature and to the concept of the total surface was more conservative than that of the painter of the life of St. Denis, though his art is qualitatively finer. He was also an innovator; in the third decade he introduced Italian ideas of space and iconography into the illuminations of the *Belleville Breviary* (Paris, Ms. lat. 10483–10484), of 1323–26; the *Hours of Jeanne d'Evreux* in the Cloisters, New York, of 1325–28; and the *Bible of Robert de Billyng* (Paris, Ms. lat. 11935), completed on April 30, 1327.[6] Based on the art of Duccio, his settings were converted into Italianate spatial boxes in perspective, with tops, bottoms, sides, and backs, revealing Pucelle as the first of many 14th-century northern artists to fall under Italian influence, though there are intimations of perspective construction in Honoré's art. The tide had changed, and France had become a receiver. France continued to receive artistic ideas from Italy throughout the 14th century, to some extent conveyed through Avignon (pp. 25–26).

On the other hand, Pucelle's new spatial feeling was also allied to non-Italian elements. Tonal values were used to give a luminous enrichment to draperies, forms, and surfaces, and there is a distinctly French feeling for elegance. The *Hours of Jeanne d'Evreux* (Fig. 3), for example, was executed in an exceedingly delicate grisaille (with occasional color washes), which serves to emphasize the tonal and, less strongly, the plastic values. In the *Belleville Breviary,* where color was used freshly, the Saul and David scene (Fig. 4) was set in a darkened architectural interior in perspective, from which the figures emerge by the strength of their color, an achievement recalling the innovations of Master Honoré. Furthermore, Pucelle enriched both the pictorial surfaces within the scenes and the pictorial content of the drolleries that fill the borders. Pictorial enhancement of the *bas-de-page* scenes in the *Belleville Breviary* shows that Pucelle viewed the surface of the page as a whole, in which text and illustration are united.

above: 3. JEAN PUCELLE. Annunciation, *Hours of Jeanne d'Evreux*. 1325–28. Illumination, $3\frac{1}{2} \times 2\frac{7}{16}''$. The Metropolitan Museum of Art, New York (The Cloisters Collection, fol. 16).

left: 4. JEAN PUCELLE. David before Saul, *Belleville Breviary*. 1323–26. Illumination, *c.* $1\frac{3}{4} \times 1\frac{3}{4}''$ (scene). Bibliothèque Nationale, Paris (Ms. lat. 10483, fol. 24v).

5. JEAN PUCELLE(?). Scene from Gautier de Coincy, *Miracles of the Virgin. c.* 1330. Illumination, *c.* 3 ³/₄ × 2 ³/₄″ (scene). Bibliothèque Nationale, Paris (Ms. nouv. acq. fr. 24541, fol. 119).

There are other ideas in Pucelle's work which, so far as is known, are not Italian. The chief of these ideas subsequently had a long life: The *bas-de-page* scenes of the calendar (or what remains of it) of the *Belleville Breviary,* preceded by a commentary, present a new treatment of the concordance of Old and New Testaments. In these scenes, as we know from copies, the apostles convert the sayings of the prophets into the creed as the prophets, month by month, remove stones from the synagogue, represented as a whole building on the January page, and give them to the apostles; on the December page the structure is shown as a complete ruin. Another surprising artistic innovation appears at the top of the calendar pages, where the months are illustrated as landscapes without figures, rather than in the time-honored fashion of showing the human labors and pastimes traditional to the months. Pucelle characterized the months by showing trees bare in January, under a heavy rain in February, putting out buds in March, and so on through the year, until a single peasant appears in December to cut wood. However, except for numerous copies of Pucelle's model, pure landscape did not reappear so prominently in manuscript art until the 1370s.

Pucelle's shop merely repeated his inventions, without enlarging upon them. Other works that date into the 1340s have been attributed to him, partly on the basis of the representation of a dragonfly (or *pucelle,* a pun on the master's name) in the decorated borders. Certain elements of his elegant, almost mannered style appear in later works. Closely related to one of the three hands in the *Billyng Bible* are illuminations found in the *Miracles of the Virgin* (Paris, Ms. nouv. acq. fr. 24541), of about 1330. Though the background rinceaux of its folio 119 (Fig. 5) can be traced back to Master Honoré, the elegance and elongation of the figures surpass Pucelle's earlier work. Luminous qualities have been accentuated and painterly qualities heightened by modeling with the brush instead of delineating the features with fine pen lines. The *Miracles* may be a later work of Pucelle himself, as Morand believes. Italianisms are less prominent (as in his later works), and the naturalistic tendencies continue in works made before he died in 1334.

Pucelle's increased surface luminosity was not favored by the average Parisian illuminator of the second quarter of the century; the conservative, linear, contoured style persisted through the second half of the century.

Allied to this conservative style is the earliest panel portrait known in northern art, a profile, bust-length portrait of King John the Good, attributed to the court painter Girard d'Orléans

below : 6. GIRARD d'ORLÉANS (?). *King John the Good.*
c. 1356–59(?). Canvas on panel, 21 ⁷/₈ × 13 ³/₈″.
Louvre, Paris.

bottom : 7. AUSTRIAN. *Archduke Rudolf IV of Hapsburg.*
1358–65. Parchment on panel, 15 ³/₈ × 8 ⁵/₈″. Erz-
bischöflich Dom- und Diözesan-Museum, Vienna.

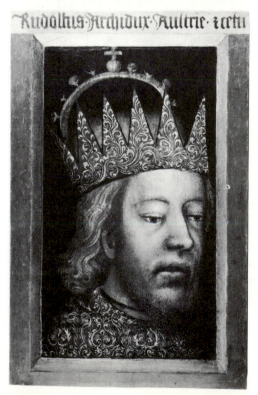

(Fig. 6). It may have been painted shortly before
the monarch was taken prisoner by the English
at the Battle of Poitiers in 1356, or in England
about 1359, when the king went voluntarily into
captivity to honor his chivalric obligations. This
is the first preserved portrait in the modern sense,
that is, an objective portrayal of an individual
without reference to religious or social institu-
tions. King John is neither a donor in a religious
setting nor a monarch in a courtly one, and the
painter has focused on his subject's distinct and
seemingly crafty personality. The profile attitude
of the portrait has led some scholars to over-
emphasize the Italian element. The profile view
was characteristically an Italian trait, whereas
northern painters preferred the three-quarter
view. That this distinction cannot always be
maintained for this period is indicated by the
later portrait of the Duke of Anjou (Fig. 42) and
by the developments in Bohemian art (see Chap.
2). Stylistically, the eye treatment recalls contem-
porary Italian formulas, but no Italian portrait
of the period is so precisely individualized.

Another northern panel portrait of this period
(Fig. 7) has come down to us. Painted in Austria
between 1358 and 1365, it is a three-quarter view
of Archduke Rudolf IV of Hapsburg, shown
wearing his crown (now in the Diocesan
Museum in Vienna).

Stylistically, iconographically, and formally,
it is very different from the portrait of John the
Good.

JEAN BONDOL
AND THE "BOQUETAUX" MANNER

The *Bible of Jean de Sy* (Paris, Ms. fr. 15397)
shows a further stage in the development of
luminosity and a new concept of the figure.
Begun about 1356, it was never completed.
Porcher thought the illumination was begun
under Girard d'Orléans before 1356, but its
luminosity far surpasses the concept of light seen
in the portrait of John the Good attributed to
Girard. Panofsky concluded that the Flemish
artist Hennequin de Bruges (or Jean Bondol,
or Boudolf, or Jean de Bandol), who was active
in Paris between 1368 and 1381, added illumi-
nations to the manuscript about 1370. This
opinion is probably correct, since the style of
this Bible appears in several other works close

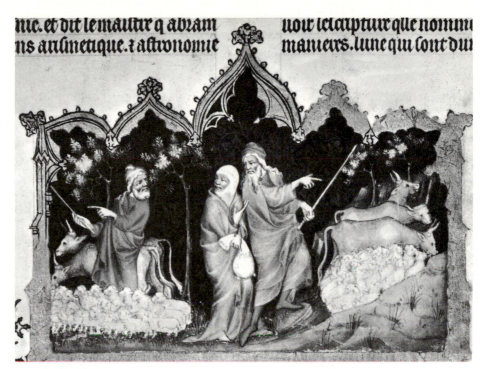

nic. et dit le maiſtiz q abram
ns ariſmetique. z aſtronomie

uour leſcaiptuiz que nommi
manieis. lune qui ſont dui

8. JEAN BONDOL. Parting of Lot and Abraham, *Bible of Jean de Sy.* c.1380. Illumination, 16½ × 11¾″ (page). Bibliothèque Nationale, Paris (Ms. fr. 15397, fol. 14).

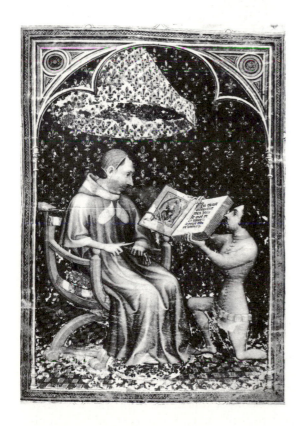

9. JEAN BONDOL. Charles V and Jean de Vaudetar, *Bible Historiée.* 1371. Illumination. Rijksmuseum Meermanno-Westreenianum, The Hague (Ms. 10 B 23, fol. 2).

to this date. In addition, Paris produced, during the period following Jean Pucelle, chiefly works in the conservative, contoured manner. Probably only a few of the miniatures in the *Bible of Jean de Sy* are Bondol's work, though the remainder are stylistically close to his hand. The parting of Lot and Abraham, on folio 14 (Fig. 8) is particularly characteristic of his art. The ground has been deepened to contain his stocky figures, which lack the elegance of the conservative, attenuated manner but make up for it in their heartier vitality. A nonlinear, pictorial rendering of the figures stresses delicately colored, subtle, and luminous surfaces. Depth is still achieved, as it had been earlier, by overlapping shapes, but the shapes themselves are rounder. As they move in a slightly deeper space, they give an intimation of actual space and actual forms, particularly noticeable in the more naturalistic treatment of the animals. This new interest in nature may have connections with the naturalistic but decorative frescoes of Avignon (pp. 25–26), for nothing comparable existed in Flanders. However, the shorter proportions of Bondol's figures are paralleled as far away as Bohemia by Master Theodoric (see Chap. 2).

A decisive advance in the conquest of rational space is observed in Jean Bondol's portrait of Charles V, of 1371 (Fig. 9), the dedication

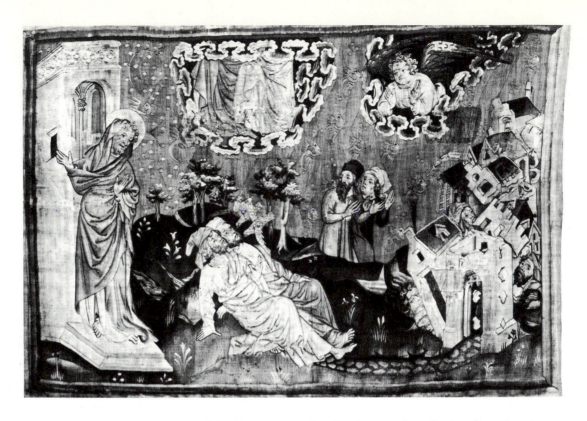

10. JEAN BONDOL. Resurrection of the two witnesses and earthquake, scene from the *Apocalypse Tapestries*. After 1375; woven by Nicolas Bataille, 1377–79. Musée des Tapisseries, Angers.

miniature tipped into a *Bible Historiée* (historiated Bible) in the Meermanno-Westreenianum Museum in The Hague (Ms. 10 B 23, fol. 2). Charles V is dressed as a Master of Arts of the University of Paris and receives the manuscript from the hands of its kneeling donor, Jean de Vaudetar. The monarch sits in a chair placed diagonally in the narrow space provided by a foreshortened standing plane, an Italianate device at least twenty-seven years old in the north, having appeared in a lost painting of John the Good, now known only from a 17th-century copy. The product of a one-point perspective, Bondol's presentation scene is viewed through an arch. The space, which is limited but definite and seemingly architecturally constructed, is very much at odds with the conservative, decorated background. The earlier emphasis on contours has disappeared here, and the two naturalistic portraits show no reminiscence of courtly elegance.

The naturalistic spatial and pictorial manner seen here and in the *Bible of Jean de Sy* was hardened in those illuminations by others than the main master. Trees took on a mushroom-like shape when grouped together as "boquetaux" (copses), a term once used to designate the assumed master of this and other works showing the same tree forms, for the fashion for such trees became widespread. It is now generally assumed that the "Maître aux Boquetaux" was in actually many masters.

This hardening of style also appears in the famous Angers Apocalypse tapestries (Fig. 10, taken from Revelation 11:12-14) designed by Jean Bondol for the king's brother, Louis of Anjou, to whom the artist was loaned for the project. A manuscript of the Apocalypse from the king's collection (Paris, Ms. fr. 403) served as a model. Designed between 1375 and 1379, the tapestries were woven between 1377 and 1379 in Paris by Nicolas Bataille. Despite the advance in perspective in the architectural forms, the occasional tilting of forms in space, and the naturalism of plant forms, the combination of a Gothic model and the translation of Bondol's design into tapestry produced a reappearance of the old linearism. The style reappears in a related

work attributed to the Bondol shop, a *Cité de Dieu* manuscript (St. Augustine's *City of God*) of 1376 (Paris, Ms. fr. 22912–22913).

Also close to the "Boquetaux" style, but very different in the new conception of the background, are two remarkable drawings heightened with colored inks in a manuscript of the works of Guillaume de Machaut, created about 1370 (Paris, Ms. fr. 1584). On folio D (Fig. 11) Machaut, seated, receives Amour, whose children, Doux-Penser, Plaisance, and Espérance, are presented to the poet. On folio E Nature presents three of her children, Sens, Rhétorique, and Musique to guide the poet. Spatially the foreground is conceived in a manner related to Jean Bondol's narrow stage, but it recalls Italian frescoes even more strongly. Entirely different, however, is the background behind the two presentation scenes. The elements, including "Boquetaux" trees, are similar in the two miniatures, with such delightfully naturalistic notes as the heads of ducks emerging from ponds, a man driving a laden horse before him (in one miniature, up a steep hill at about a 70-degree angle), clumps of trees, windmills against the blue sky, and charming houses with arched openings facing the spectator. This is a city-dweller's view of the countryside, an evocative, idyllic image rather than a naturalistic one, and as elegant as the figures placed before it. It is a bucolic fantasy. Nevertheless, the unknown artist, even though he borrowed his shepherd from an earlier David and Goliath scene and presented his perspective piecemeal, so to speak, was concerned with nature as a subject worthy of representation. His delight in nature is evident, as is his progressive point of view.

The "Boquetaux" style, however, was transmitted only after modification by the essentially conservative Parisian miniaturists. In the *Information des Rois et des Princes* (*The Judicial Inquiries of Kings and Princes*; Paris, Ms. fr. 1950), of 1379, made for Charles V, the dedication miniature (Fig. 12) shows Charles receiving the book from its translator, Jean Golein. It repeats the theme seen in Jean Bondol's Hague Bible of 1371; but though the same ideas are present, the stylistic and iconographic changes are significant: Charles V still wears his Master of Arts gown, but here it is covered with a pattern of fleurs-de-lis, the sign of the royal house. He is also shown wearing his crown, so that no one can mistake

him. Though the king is clearly individualized, the naturalism of the miniaturist did not extend so far as to represent the space in which the presentation takes place.

Numerous paintings and manuscripts were produced for Charles V. Production in Paris reached a new peak, but most of the preserved works, painted in delicate colors or in grisaille, present an elegant calligraphic style in which

below: 11. "Boquetaux" Style. Amour presents her children, *Works of Guillaume de Machaut. c.* 1370. Illumination, *c.* 12 5/8 × 8 5/8 (page). Bibliothèque Nationale, Paris (Ms. fr. 1584, fol. D).

bottom: 12. French. Charles V and the translator, Jean Golein, *Information des Rois et des Princes.* 1379. Illumination, *c.* 9 × 6 1/2" (page). Bibliothèque Nationale, Paris (Ms. fr. 1950, fol. 2).

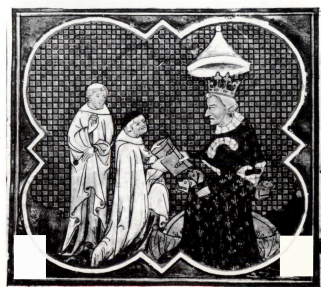

13. FRENCH. *Parement de Narbonne. c.* 1375. Silk, 2′ 6 3/4″ × 9′4 5/8″. Louvre, Paris.

line dominates the delicate contouring of form. For such a style grisaille is an ideal medium, and there are varied examples.

Among these is an altar frontal painted in grisaille on silk, known as the *Parement de Narbonne* (Fig. 13), of about 1375. In compartments on either side of the central Italianate Crucifixion scene are Charles V and his queen, Jeanne de Bourbon, who died in 1378. The anonymous master of this work reintroduced Italianate ideas combined with the conservative style. Not so atmospheric as Jean Bondol's work, the *Parement* is conservative in style and iconography. The *Noli me tangere* scene at the

extreme right is based on a 1311 model of Master Honoré (*La Somme le Roi,* Paris, Arsenal, Ms. 6329).[7] Other elements were derived from Siena but seemingly had been resident in France long enough to be transformed into much less dramatic scenes than their Italian originals. The forms are attenuated and elegant in the manner characteristic of French illumination of this period.

Toward the end of the century the same spirit was expressed in slightly more sumptuous manner in a much debated work in London, the *Wilton Diptych* (Fig. 14). Its left wing represents Richard II of England, accompanied

14. FRENCH. *Wilton Diptych.* 1400–10(?). Panel, 20 7/8 × 14 5/8″. National Gallery, London.

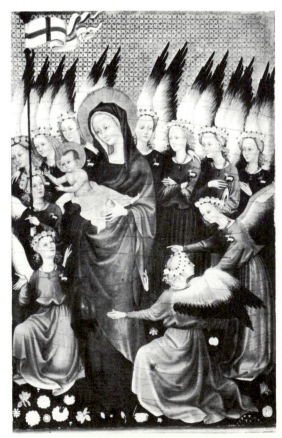

by his patron saints, Edward the Confessor, St. Edmund, and St. John the Baptist; on the right are the Madonna and Child surrounded by angels. Possibly painted in Paris, rather than in England (there is none of the Netherlandish influence so characteristic of English work at this time), it combines a Mother draped like a piece of French sculpture and an Italianate Child, presented with the same elegant and melodic linearity noted in the *Parement de Narbonne,* and the saints and donor are seen in a style that eschews naturalistic tendencies, as is evident in the portrait of the young monarch. The gentle idealization of the angels in their Tuscan draperies and the decorative garments of the saints, the floral and courtly atmosphere, the pure blue garments and rich gold background show the luxury of the regal courts imprinted upon the religious theme, amalgamating all the precious elements seen before into a highly refined whole. Here is the final phase of conservative French 14th-century painting. We have arrived at the International Style in one of its aspects.

CHARACTERISTICS
OF THE INTERNATIONAL STYLE

Three essential characteristics distinguish the style (as defined by Sterling [8]): a passion for outline and Gothic drapery arabesques, a feeling for luxury and studied elegance reflective of aristocratic taste, and such marked uniformity that works can be ascribed to several centers and varying dates with equal validity. Certainly the *Wilton Diptych* fits this definition (Wormald [9] has argued for an English artist and a date of about 1413). However, there is more than this to the International Style. Accepted and contributed to by all the nations, it was dominantly but not exclusively fostered by the royal and ducal courts. An antimonumental style, its courtly manner sometimes verging on the artificial, it was an art that dealt in small forms and in that which is individually pleasing.

The overthrow of previous values (with a philosophic parallel in the rise of nominalism) turned people in two directions: one toward a revival of the past, artistically expressed in the conservative, linear, contoured style; the second, a turning to the immediate data of sensory impressions, which in art took the form of an increasing naturalism. The International Style expressed a tension between the two directions. Side by side with the abnormally elongated, linear figures, sumptuously garbed and placed in resplendent settings, either ornamented or naturalistically perceived (as will be seen in the art of the Limbourgs), appeared an interest opposed to the courtly. Low types had already appeared in Pucelle's drolleries and in the *Parement de Narbonne.* Figures of this nature were multiplied in the succeeding decades, often accompanied by an interest in the macabre. The theme of the Dance of Death exemplifies this interest, as in that series of frescoes (now destroyed) on the walls of the Cemetery of the Innocents in Paris, beneath which Parisian couples strolled on Sundays. Courtly allegory and melancholy were paired in the literature.

The nobility created new orders whose basic purpose was social, rather than military or religious, and the most famous of these was the Order of the Golden Fleece, founded in 1429. Another, lesser order, the Order of St. Anthony, founded in the late 14th century, had statutes that regulated the material of the collar of the order. The collar, with a T cross and bell attached (the symbols of the saint) was of either gold or silver, depending upon the wearer's rank in society. Doctors were admitted to the order, but only those who had "made themselves noble by their science." These doctors, of course, were not medical men, the typical medical man of the day being the village barber, though the courts had their physicians. The doctors admitted to the Order of St. Anthony were theologians who had learned their "science" at the University of Paris or at a comparable institution. Such distinctions as these served to accentuate an already strong competition and rivalry between the nobility and the bourgeoisie, a rivalry also found among the princes, who vied among themselves to acquire objects of richness and rarity.

This rivalry was reflected in art by the overwhelming increase in the production of *manuscrits de luxe.* More and more, following the lead set by Charles V, the nobility commissioned illuminated Books of Hours, Chronicles, historiated Bibles, and the like. The purpose was frequently ostentation, as is indicated by the fact that the illuminations are often numerous at the

15. ANDRÉ BEAUNEVEU. The prophet Isaiah, *Psalter of the Duke of Berry*. c. 1380–85. Illumination, c. 5 × 4". Bibliothèque Nationale, Paris (Ms. fr. 13091, fol. 11v).

beginning of the volumes but decline rapidly in number and quality toward the end. In many cases the illumination of a work was never completed; yet the inventories reveal that, even so, unfinished books were elaborately bound with rich velours covers, hung with pearls and rubies, and closed by clasps of gold or enameled silver. The books were often objects to be shown rather than read.

The general exception to this incomplete illumination is the category of the Book of Hours, the most important religious book in the hands of the laity. At the beginning of the period the Psalter or Book of Psalms was combined with certain prayers from the Offices of the Virgin and expanded to include a church calendar and other elements, thus beginning a development that reached a peak at the end of the 14th century. Almost 80 per cent of the books written in the north in the late 14th and 15th centuries were Books of Hours. They were bilingual, partly in the vernacular and partly in Latin (as opposed to liturgical books—missals, breviaries, sacramentaries, and so on—which

were entirely in Latin), personalized, and richly illustrated. Those made for princes and the high nobility are veritable encyclopedias of religious illustration. The zenith of illustration in manuscript was reached by the painters who worked for John, Duke of Berry. Fortunately, some of his finest manuscripts have been preserved.

BEAUNEVEU
AND JACQUEMART DE HESDIN
AND HIS FOLLOWERS

A part of the *Psalter* of the Duke of Berry (Paris, Ms. fr. 13091) was illustrated in the early 1380s by André Beauneveu, the Duke's sculptor turned illuminator, who came from Valenciennes in Hainaut and was in Paris as early as about 1360. He worked for Charles V until 1374, after which he entered the service of Louis de Male, Count of Flanders. About 1380–81 he entered the service of the Duke of Berry, remaining until his death sometime before 1402.

Beauneveu painted 24 illuminations of prophets and apostles, all very solidly enthroned in essentially the same manner (Fig. 15). The tendencies toward naturalism seen in Jean Bondol were repeated with a more sculptural firmness and solidity and a less pictorial but luminous surface.

Beauneveu's stouter proportions and interest in volume are not, however, characteristic of other illuminations in the *Psalter*, contributed by a fellow worker in the ducal service, who also painted illuminations for at least three other works of importance. This artist was Jacquemart de Hesdin, also from the Flemish border, who was in the Duke's employ at Bourges about 1384.

In 1398 he was in a fight in Poitiers and in 1399 was again in Bourges. He died about 1413, while in the Duke's service.

The illustration for Psalms 53:1, "Dixit incipiens...." ("The fool hath said in his heart, there is no God...."), probably from Jacquemart's hand, shows the fool dressed in the medieval version of shorts, holding a club and eating a stone (Fig. 16). The style approaches that of the *Parement* master, showing similar tendencies toward elegance and delicacy. Jacquemart was a conservative master, employing a Pucelle model, but his innate sense of refinement was unequaled in manuscript illumination.

below: 16. JACQUEMART DE HESDIN. The fool, *Psalter of the Duke of Berry*. *c.* 1380–85. Illumination, *c.* 4 1/4 × 3 1/2″. Bibliothèque Nationale, Paris (Ms. fr. 13091, fol. 106).

bottom: 17. JACQUEMART DE HESDIN AND SHOP. Lamentation, *Book of Hours (Les Petites Heures) of the Duke of Berry*. *c.* 1385. Illumination, *c.* 3 1/4 × 2 1/2″. Bibliothèque Nationale, Paris (Ms. lat. 18014, fol. 94v).

Jacquemart's style, and in certain examples his hand as well, is connected with five more manuscripts done for the Duke, all of them Books of Hours and all sumptuously illuminated. The earliest is the *Petites Heures* (Paris, Ms. lat. 18014) of about 1385. It contains a "Belleville" calendar and shows a further influence of Pucelle in the setting of the Annunciation scene. (The "Heures de Pucelle" was then owned by the Duke.) Influences more directly Italian also appear in the *Petites Heures,* as in the charming scene of St. John in the Wilderness (Pl. 1, after p. 180). The saint is seated before a cave surrounded by a variety of animals and birds, all rendered with a supreme delicacy and a keen sensitivity to varying tones of light and dark. High in key, the color is predominantly a muted pink.

More delicate than the *Parement* master's style, that of the Jacquemart atelier was also closer to Italian models. The Lamentation over the Body of Christ is based on a model from the Pucelle shop and indirectly on a version of the theme by Simone Martini. Though formally following the Italian model, the Lamentation here is very different in its delicate coloration and gentle movement (Fig. 17). For the dramatic crimsons and strong vermilions of Italy, the Jacquemart shop substituted light orange tones and delicate light purples set against a blue decorative background covered with foliage of a type derived from Pucelle and Master Honoré. The original Italian dramatic narrative has been transformed into a courtly refinement of color and line in a less naturalistic setting.

The Jacquemart atelier added to the *Très Belles Heures de Notre Dame*, begun before 1385–90. The manuscript was given while still incomplete to Robinet d'Etampes, the Duke's secretary, before 1413; he divided it into two parts, keeping for himself the portion completed in the earlier manners. This portion of the manuscript is now partly in the Cabinet des Dessins in the Louvre (four leaves) and partly in the Bibliothèque Nationale (Paris, Ms. nouv. acq. lat. 3093). The second part, unfinished, was added to at an uncertain later date. It, too, was separated into two portions. One was in Turin, where it was burned in the library fire of 1904, and the other was in Milan but is now in the Museo Civico in Turin. This second part of the original manuscript, now famous as the Turin-

Milan *Hours,* has a problematical relationship with the Van Eycks (see Chap. 5). Several artists in the Jacquemart shop worked on the manuscript even before the first division, one of them apparently a Netherlander, and this earlier portion presents a heavier version of the *Petites Heures* style, as in the Marriage at Cana miniature.

From the scholarly point of view, the most problematical of all the Duke's manuscripts is the Brussels *Hours* (Brussels, Ms. 11060–11061).[10] From the historical point of view it is important, for it contains full-page miniatures. The border ornamentation carries the Duke's devices (the entwined letters *VE,* a bear, and a swan) and the lilies of France. The Duke is presented twice at the beginning of the manuscript. First, in an inserted double-page dedication (Fig. 18), the Duke, kneeling, on the left page, is presented by his patron saints, Andrew and John the Baptist, facing a delicate grisaille of the Virgin and Child enthroned on the right page. In the second occurrence, a single page, the Duke, seemingly younger, is again presented by his patron saints to the Virgin and Child enthroned at the left.

The second dedication is stylistically related to the rest of the manuscript. The first two pages, resembling in organization but not in detail the slightly later *Wilton Diptych,* are subsequent additions to the manuscript.

The painter of the double-page dedication is unidentified. A Virgin and Child in a sketchbook in the Morgan Library, New York, is closely related in time and design to the Virgin and Child in the Brussels insert.

In the late 19th century Leopold Delisle identified the Brussels manuscript with a work known from the inventories of the Duke to have been completed by 1402 by "Jacquemart de Odin." Later given to John the Fearless, Duke of Burgundy, it is traceable in Burgundian inventories until 1423, but no later, even though the core of the Brussels collection is the former Burgundian ducal library. The identification of the Brussels *Hours* with Jacquemart's work of 1402 has been accepted and rejected by scholars on stylistic or documentary grounds, or both. The resolution of the problem may be that the work was carried out under Jacquemart's direction but without his participation. That it

18. JACQUEMART SHOP(?). The Duke of Berry presented to the Virgin, *Book of Hours (Les Très Belles Heures) of the Duke of Berry. c.* 1400(?). Illumination, *c.* 10 ⅞ × 7 ½″ (page). Bibliothèque Royale, Brussels (Ms. 11060–61, fols. 10v and 11).

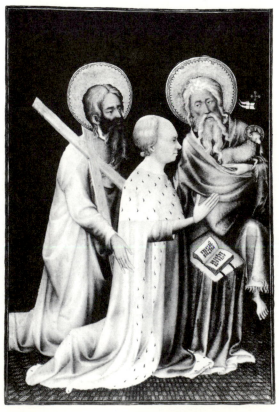
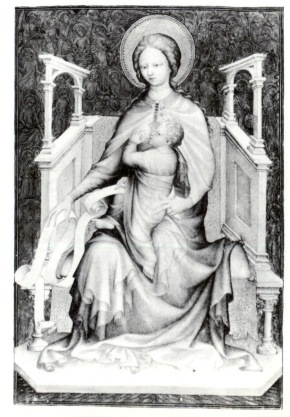

was made for the Duke of Berry is presumed, and Jacquemart, until he died, was the chief illuminator for the Duke. Meiss [11] has detected an Italian hand in the initial letters, and Italian compositions, both Florentine and Sienese, are evident in the full-page illuminations; thus the work on the Brussels *Hours* seems to indicate a typical Parisian situation, that is, several illuminators working on various parts of a single manuscript.

The transformation of Italian color schemes into delicate northern pastels is visible here, as it was in the *Petites Heures,* but there are distinctly northern innovations. In the Annunciation to the Shepherds and in the Flight into Egypt, there is an idea expanded from Pucelle. Both scenes take place before a wintry landscape with barren ground and trees against a gray sky. In the Flight into Egypt (Fig. 19), ships with half-raised sails scud before the wintry wind. Particularities of time, though not of place, are now lent to the religious theme for the first time in preserved northern illumination. The shape of the land forms is still Italianate, but the new perceptual sense of nature, which is possibly Flemish in origin, is amplified in the scene of Christ Carrying the Cross and in the Betrayal of Jesus by the suggestions of a deeper space than heretofore. As Lyna has remarked, the Brussels *Hours* presents a hybrid but homogeneous style. The elegance of the International Style is enhanced by the greater, apparently Flemish, naturalism of tattered shepherds' garments and wintry landscapes so that the sumptuous and the lowly are effectively contrasted.

One thing more sets the Brussels *Hours* apart from its predecessors—the concept of the illumination as a full-scale painting, filling a whole page and equal in size to a very small panel. As a result of this divorce of text and illustration, the border has lost its logical function and has begun to lead an independent life.

The tendency to overelaborate the border was carried further in the *Grandes Heures* of the Duke of Berry (Paris, Ms. lat. 919), a work identifiable as the inventoried manuscript illuminated in 1409 by "Jacquemart de Hodin et outre ouvriers de Monseigneur." The Marriage at Cana scene from the *Très Belles Heures* is repeated here with only a slight variation, and other elements are also borrowed, such as Pucelle's drolleries and the *Belleville Breviary*

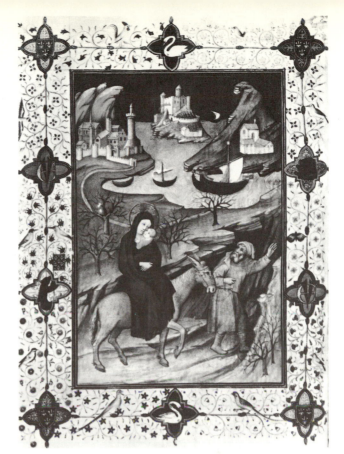

19. JACQUEMART SHOP(?). Flight into Egypt, *Book of Hours (Les Très Belles Heures) of the Duke of Berry. c.* 1400(?). Illumination, *c.* 10 ⅞ × 7 ½″ (page). Bibliothèque Royale, Brussels (Ms. 11060–61, fol. 106).

type of calendar. The *Grandes Heures* now lacks its full-page illuminations; the remaining pages are heavily ornamented by a weightier and less tasteful version of the Brussels *Hours* type. As a whole, however, the Jacquemart style has no peer in elegance and refinement.

BROEDERLAM AND DIJON

The union of courtly and realistic strains, of Italianate and Flemish traits, that appeared in illumination by the end of the century is also traceable in panel painting. Many works in this medium once thought to be Parisian have more recently been attributed to Spanish, German, and other centers. Historical evidence can support such attributions. The dukes of Burgundy, for example, began to show their growing power (in large part due to the acquisition of wealthy Flanders in 1384) by moving their seat to Dijon, which they embellished with works of art. The

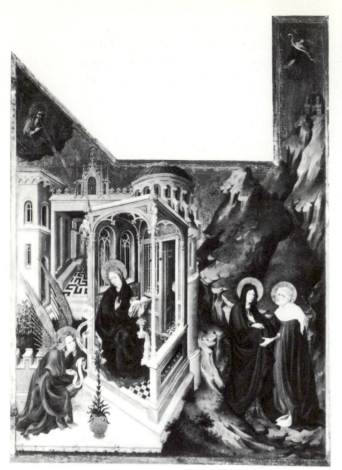
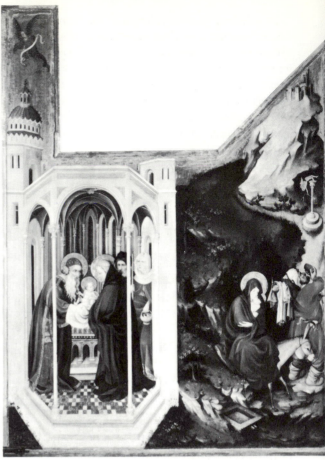

20. MELCHIOR BROEDERLAM. *Annunciation and Visitation* and *Presentation and Flight into Egypt*. 1394–99.
Panel, 65 ³/₄ × 49 ¹/₄″ (each). Musée des Beaux-Arts, Dijon.

most important of these is the late 14th-century Carthusian monastery, the Chartreuse de Champmol, with its portal decorated by the sculptor Claus Sluter and its *Well of Moses* by the same artist, who came from Haarlem and had worked in Brussels before being called to Dijon. Other works, such as the tomb for which Sluter had made his famous monumental mourning figures, with their naturalistic draperies but simplified outlines, and the two altarpieces with numerous small figures carved and gilded by the Flemish sculptor Jacques de Baerze of Termonde, are in the museum at Dijon.

For one of these altarpieces, wings (Fig. 20) were painted by Melchior Broederlam of Ypres, who entered the services of Philip the Bold in 1378, working at the ducal castle of Hesdin and at Ypres, where the wings were sent to be painted. They were paid for in 1394 but not installed until 1399. Within the irregular shape pre-established by the sculptured altarpiece, Broederlam painted the Annunciation and Visitation on the back of one wing and the Presentation and Flight into Egypt (Pl. 2, after p. 180) on the back of the other wing. He was not a miniaturist in his conception. The sculptural feeling of his forms and the solidity and depth in his color harmony are very different from the decorative, soft effect of Jacquemart's art. Further, Broederlam's work shows a sense of chiaroscuro and of surrounding atmosphere, despite the conventional high horizon. These characteristics, combined with a sense of actuality of form shown in such details as the drinking Joseph in the Flight into Egypt, are the very opposite of the emphasis on grace characteristic of French art.

Broederlam was a Fleming, and thus, it seems, a realist. His art epitomizes the insistent naturalism encountered in other Flemings, which had gradually made its way into purely French manners of artistic formulation. In the Presentation scene the hexagonal structure, supported by spindly columns, is strongly projected forward, showing a close relationship to Bartolo di Fredi's 1388 panels of the life of the Virgin (in Siena). Broederlam's indebtedness to Italy is also seen in the stylized rocks of the landscape in the Flight into Egypt. The relationship to Italy is seemingly more direct and possibly more recent than that of French painters. However, certain details are quite un-Italian, such as the greater sense of spatial movement achieved by putting a rocky shape in front and by projecting the architecture on the left, thereby setting the Virgin and Child deeper into the landscape. In both panels round buildings were introduced to suggest an Eastern milieu. The toppling figure in the landscape derives

from the Apocryphal Gospel of Pseudo-Matthew and illustrates the popular belief that pagan idols toppled during the Flight into Egypt. A greater spatial sense, despite the gold background, is also evident in the right wing panel, where Broederlam has emphatically projected the architectural forms forward, while setting the Annunciation in a portico before a sanctuary seen through the open door, all rendered with a strong interest in perspective movement. This panel also presents a recondite system of "disguised" symbolism (in fact, just extremely complex [12]). The circular building implies Jerusalem and the old dispensation; the Gothic forechapel represents the new.

As painting became more naturalistic, "disguised" symbolism offered to the painter a compensatory association of the commonplace object with transcendental ideals and forms. Since the medieval mind did not hesitate to associate the commonplace with the divine, the step from illustrative allegory to natural symbology was smooth and easy; thereby the artist retained the natural and the religious at one and the same time.

The great innovations are the superb union of Italian ideas, the recondite iconography, and a realism more forceful than that of any previous artist.

No other work by Broederlam is known. Works have been attributed to what might be called his "entourage"; there is no school of Broederlam in any strict sense. Similar elements of iconography and even of stylistic aspects appear about a decade later in four panels, now divided between the Musée Mayer van den Bergh in Antwerp and the Walters Art Gallery in Baltimore, and in later manuscripts (attributed by Panofsky to an assumed "school of Ypres" [13]). The Nativity panel in Antwerp shows the Virgin resting on a richly decorated mattress, an element derived from Byzantine iconography. She watches Joseph, who is seated in a decidedly awkward position and is cutting up his black hose to make swaddling clothes for the Child, according to a legend popular in the Aachen region. [14] In the background a midwife, wearing an apron to protect her beautiful brocaded vermilion dress, lays the Child in his wattle crib.

In the St. Christopher panel in Antwerp (Fig. 21) the saint in his beautiful crimson garment walks through the water toward the

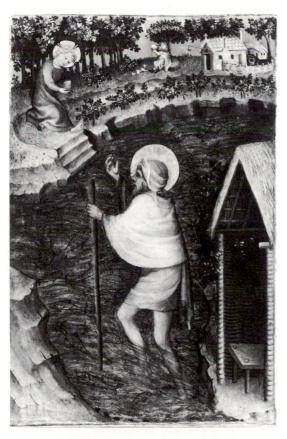

21. NETHERLANDISH. *St. Christopher.* c. 1400–10. Panel, 13 × 8 ³/₈″. Musée Mayer van den Bergh, Antwerp.

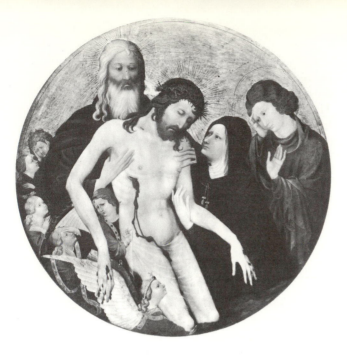

was also more naïve and provincial. Seemingly the work is Flemish, though it may possibly come from the region of nearby Aachen.

In Dijon itself Broederlam's art apparently inspired no followers, though a group of Entombment and Pietà scenes, possibly from Dijon, reveal marked Flemish influence in figural types and modeling. A circular *Coronation of the Virgin* in Berlin is apparently the latest member of the group.

Also ascribed to Dijon is a large, round *Pietà* (Fig. 22) in the Louvre, with the arms of France and Burgundy painted on the reverse. This panel has been thought possibly to be the work of Jean Malouel (or Jan Maelwael) of Nijmegen, uncle of the Limbourg brothers, first recorded in Paris in 1396.[15] He was painter to Philip the Bold and the Burgundian house until his death in March, 1415. In 1398 he was commissioned to paint five large pictures for the Chartreuse de Champmol, and in 1401, assisted by one Herman of Cologne, he began the painting and gilding of Sluter's *Well of Moses*. With intensified emotive qualities very different from the lyrical Parisian style, he united the Pietà and the theme of the Trinity with the connotations of the Lamentation and the Crucifixion, from which the figure types of the Virgin and John are taken. The Virgin looks into the dead eyes of Christ, a motif taken ultimately from Giotto. John sorrowfully holds his hand to his head. A naturalistic, somber, and macabre note is given by the blood streaming down the body and

Christ Child, to whom he beckons. The water is identified in good medieval fashion by the innumerable fish and the presence of a mermaid holding a mirror. Mermaids were suspect in the Middle Ages. They were linked to sirens, whose beautiful voices lured men to destruction, and thus were embodiments of evil. The implied moral is the world's salvation by Christ, who, with His saints, takes its evils on His shoulders. Against a vermilion background the painter has placed the hermit who is always present in St. Christopher scenes, but here the hermit is drinking out of a jug like Broederlam's St. Joseph. Using gayer color than Broederlam, the artist

above: 22. JEAN MALOUEL (?). *Pietà. c.* 1400. Panel, diameter 20 1/2″ (painted surface). Louvre, Paris.

right: 23. JEAN MALOUEL AND HENRI BELLECHOSE (?). *Martyrdom of St. Denis. c.* 1416. Panel, 63 3/8 × 82 5/8″. Louvre, Paris.

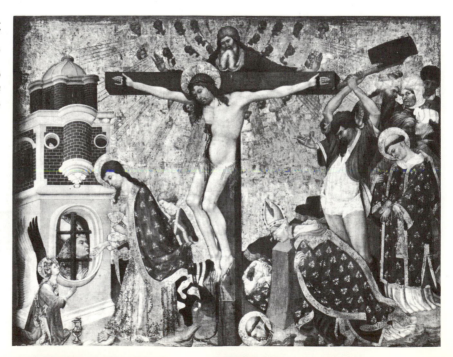

hands of Christ. The small, delicate, sorrowing angels provide an emotional relief, for their soft forms contrast with the almost wiry linearity of the main figures.

Related to the Malouel style is a *Martyrdom of St. Denis* (Fig. 23) in the Louvre. Possibly this is the work for which Henri Bellechose, Malouel's successor, received, in 1416, colors to finish a picture of the life of St. Denis. According to a fairly late tradition, it came from the Chartreuse de Champmol. In size it corresponds to one of the five paintings (of unspecified subject) for the chapel of the Chartreuse, noted before as the commission to Malouel. [15a] The last communion of St. Denis is at the left and his martyrdom at the right. St. Rusticus has already met martyrdom, and St. Eleutherius waits his turn. The two scenes are placed on either side of a large crucified Christ with God the Father above. Though not all other elements are identical, the figure of Christ on the Cross is particularly close to that in the *Pietà* discussed above. The prison structure in particular reminds one of a miniature enlarged, and miniaturistic decorativeness is strong. The descending diagonals of forms on either side fail to suggest unity or coherence of space. Animation is created in the group at the right by the naturalistic heads; the heads of God the Father and the executioner seem to have been inspired by Sluter's *Well of Moses.* The use of "Kufic" lettering (here and in the round *Pietà*) adds a pseudo-Oriental decoration to the garments. Above the crucifix the gold background is filled with another miniaturistic device, red and blue angels. Thus narrative and devotional ideas are combined in a manner close to miniature painting but less successfully than in the Louvre tondo.

Another painting somewhat related to the Malouel style, yet embodying the sense of intimate contact seen in Broederlam's *Flight into Egypt,* is the *Virgin and Child* (Fig. 24) in the Louvre. The face shows the more linear style of Malouel and of the *Wilton Diptych.* Though far more modeled than the latter work, it is like it in using Sienese conventions in the rendering of the Child. In its charming naïveté, it introduces a greater sense of natural identity that can well be characterized as Franco-Flemish. [16] The Malouel manner exemplified the idealized Italian style, whereas Broederlam exemplified the realistic Flemish manner.

From the foregoing it seems that Dijon had no school in the true sense of the word; its art was a reflection of the dominant courtly manner. The importing of Flemish artists, some of whom had previously worked in Paris, made Dijon, under ducal patronage, a center of artistic activity, but there is no evidence of locally trained artists to perpetuate a tradition. When the ducal court moved to Flanders in 1420, intense artistic activity ceased in Dijon to all intents and purposes.

AVIGNON

A somewhat related situation characterizes the production of art in Avignon. [17] Seat of the papacy from 1305 to 1378 during the "Babylonian captivity," the city was an active center with widespread European contacts. Prelates from all over northern Europe went to Avignon, and many other persons whose business with the papal courts was more secular were to be found there. Artists went there from Italy. The most notable, Simone Martini, arrived about 1335 and stayed until his death in 1344. Simone

24. FRANCO-FLEMISH. *Virgin and Child. c.* 1400–10. Panel, 8 1/4 × 5 1/2". Louvre, Paris.

was followed by another Italian, Matteo da Viterbo, who was in Avignon at the latest by 1343 and remained there as general works superintendent through most of the papal court's sojourn. The fresco fragments in the Tour de la Garderobe of the papal palace at Avignon remain to show the work of French artists under Italian direction. There are thoroughly French themes of hunting and fishing (Fig. 25) paralleling those in French and Flemish tapestries and yet retaining their French spirit despite the presence of Italian artists and Italian pictorial models. This spirit of "coexistence" is also characteristic of manuscript illumination, in which French and Italian styles are found with little intermingling. Avignon's role thus seems to have been that of intermediary in transmitting Sienese style and iconography to France, the Netherlands, Austria, and Bohemia, and to Catalonia as well, though in the last region the influence of Siena may have been direct. By the end of the century Avignon exerted no more influence than any other province, for Paris was still the important center.

THE LIMBOURGS

French art of the first quarter of the 15th century was still dominated by Paris, and still

top: 25. FRANCO-ITALIAN. *Fishing Scene. c.* 1350(?). Fresco. Papal Palace, Avignon (Tour de la Garderobe).

above: 26. LIMBOURG BROTHERS. St. Jerome in his study, *Bible Moralisée. c.* 1405–10. Pen and ink, *c.* 12 × 9 ½″. Bibliothèque Nationale, Paris (Ms. fr. 166, fol. 1).

the artists of the Duke of Berry were outstanding. The Limbourg brothers, Pol, Herman, and Jean (or Jehanequin),[18] at least two of whom were in Paris by 1399, apprenticed to a goldsmith, entered the service of the Duke of Berry after earlier employment (1402–04) by Philip the Bold. Whether they entered the Duke's employment immediately after Philip's death in 1404 is not known, but they were on such good terms with their patron that their New Year's present to him in 1410 was, as is known from the inventory of the Duke's possessions, "a counterfeit book made of a piece of wood painted in the semblance of a book in which there are no leaves nor anything written, covered with blue velours with two silver-gilt clasps enameled with the arms of Monseigneur [the Duke], which book Pol de Limbourg and his two brothers gave to the Duke...."[19] What the Duke gave them in return is not recorded, but he willed them a ruby ring.

Possibly the earliest work attributable to the Limbourgs is a moralized Bible[20] (Paris, Ms. fr. 166), executed before 1410. Only the first three gatherings (folios 1–24) were illustrated by the Limbourgs, which suggests that the manuscript is identical to one commissioned from them by Philip the Bold before his death. The illuminations are sketchy in character and not fully painted. Delicate washes of color are employed to set out the figures in scenes viewed through framing arches. The pen-and-ink frontispiece, St. Jerome in his study (Fig. 26), undoubtedly done by Pol, is framed by elaborate architecture, probably derived from a northern Italian or Lombard model. The saint, at his writing desk, is accompanied by his faithful lion, here waiting like a dog for his master's commands.[21]

The Cloisters in New York possesses one of the most richly decorated manuscripts of the period, the *Belles Heures of John, Duke of Berry* (formerly known as the *Heures d'Ailly*), completed by 1410. Winkler[22] pointed out that the ornamentation of the full-page Annunciation miniature includes Italian ideas in the use of

acanthus rinceaux (Fig. 27) instead of the northern ivy leaf. The scene of the flaying of St. Bartholomew depicts the executioner with his knife in his teeth. This motif is found in Lorenzo di Niccolò's 1401 treatment of the same theme in the Pinacoteca in San Gimignano, and it reappeared at the end of the 15th century in the art of Gerard David (see Chap. 12). A series of seven subjects was considered by Porcher[23] to be unique inventions of the Limbourgs; however, one of these, the St. Anthony cycle, is modeled on Italian predecessors, and it is likely that the same is true of the six other series of illuminations. The Limbourgs' iconography was not new (as the St. Bartholomew scene shows); what was new was the superb quality of their painting. This quality is evident in the Cloisters *Book of Hours,* where the color is light in key and fresh in effect; it is evident again in their later works.

right: 27. LIMBOURG BROTHERS. Annunciation. *Book of Hours (Les Belles Heures) of the Duke of Berry.* c. 1410. Illumination, 9 3/8 × 6 5/8". The Metropolitan Museum of Art, New York (The Cloisters Collection, fol. 30).

A characteristic and late work of the brothers is the scene of the Duke starting out on a journey, inserted into the *Petites Heures* (Fig. 28). A marshal in red and white goes before him, a little greyhound runs on ahead, and a third figure makes up the foreground group emerging from the castle at the left. In the distance is a village and to the right a hilltop landscape of Sienese inspiration. Above, set against a patterned blue background with gold rinceaux, an angel hovers, transforming the subject into a scene like that of the Magi beginning their journey and recalling that recondite symbolism introduced by Broederlam, whose conventions are suggested by the background. The work seems to combine the sculpturesque feeling of Broederlam with the elegance of Jacquemart.

28. LIMBOURG BROTHERS. The Duke starting on a journey, *Book of Hours (Les Petites Heures) of the Duke of Berry*. *c.* 1415. Illumination, *c.* 6 × 3 ½″ (scene). Bibliothèque Nationale, Paris (Ms. lat. 18014, fol. 288v).

The figures are almost silhouettes, moving on tiptoe but without the willowy delicacy of Jacquemart's forms. It is as though the sculptural intent and the monumentality of Italy have informed the northern style, solidifying it without robbing it of its decorative qualities. Now the style has a firm base, due, no doubt to the chief of the three Limbourg brothers, Pol. To him is also due the simplified facial type that distinguishes the major works of the Limbourgs —a smoothly rounded cheek and squarely proportioned face with a simple straight nose. The general idealization of the type was derived from Italian art.

The last and greatest work of the Limbourgs, the *Très Riches Heures,* was possibly begun about 1413. Work stopped on it in 1416. In that year the Duke and his artists died. He left behind a collection of over a hundred and fifty manuscripts, though the earlier inventories list only 78 books which were gifts or exchanges, 32 purchases, and, surprisingly enough, only three executed according to the Duke's orders.

The calendar of the *Très Riches Heures* received elaborate full-page illustration, the first time a calendar had been so treated. The January page (Fig. 29) shows the Duke at table before a fire screen that acts as a halo. His seneschal orders the servants to "*approche, approche*" and set their dishes on the already heavily laden table. A tapestry of a battle scene covers the wall behind the fireplace, enriching the scene. Vermilions, blues, and delicate greens costume the attendants. Courtly luxury reaches an epitome in this glorification of the Duke.

In contrast, the illustration for February (Pl. 3, after p. 180) when, according to tradition, the peasant sat by his fire warming his feet, shows peasants in an interior, one wall of which has been removed, in Italian fashion, to permit the observer to look in upon the scene. Outside is one of the earliest snow landscapes, into which we are led by the diagonal movement, the wattle fence, and the sheepfold. At the right a storage bin is visited by a peasant, whose breath hangs in the cold air, and in the background a tree is being cut for firewood, while a man drives a donkey before him over the snow. The scene combines old and new, the new visible in the snowy world outside the hut. It presents a complete contrast with the courtly richness of the January scene.

The same naturalism reappears in the March page, where a peasant plows his field before the Duke's castle of Lusignan, casting a real shadow. In March the peasant goes out of doors, but not until April (Fig. 30) does the court go out to enjoy itself in the midst of flowers and rich green fields. Courtly figures in elegant garments are charmingly represented in social intercourse, joyfully partaking of the pleasures of the season. In the background is seen Dourdan, another castle of the Duke. Rich in color and form, the figures are elegant and elongated, even the males. Like the women, they taper toward the head, their decorative delicacy accentuated by flowing drapery lines and rich surfaces ornamented with reds, tans, blues, and greens. A rudimentary perspective and the lightening of the sky at the horizon create a suggestion of distance and space that almost achieves an aerial perspective.

In May the court promenades before the castle of Riom, a richly attired courtly group on richly caparisoned fat horses. The hunters blow their

left: 29. LIMBOURG BROTHERS. January page, *Book of Hours (Les Très Riches Heures) of the Duke of Berry*. 1416. Illumination, 9 3/8 × 6 ". Musée Condé, Chantilly (fol. 1v).

right: 30. LIMBOURG BROTHERS. April page, *Book of Hours (Les Très Riches Heures) of the Duke of Berry*. 1416. Illumination, 8 1/2 × 5 3/8 ". Musée Condé, Chantilly (fol. 4v).

horns, but the courtiers pay little attention, for they are more interested in the narrow-waisted, almost shoulderless ladies accompanying them. The month of June again shows peasants working in the fields, outside the walls of Paris, with the Seine and the Sainte-Chapelle visible in the background (Fig. 31).

The calendar ends with a December boar hunt (Fig. 32), which was copied later in miniatures of the early 16th century. A roughly contemporaneous drawing of the scene appears in the notebook of Giovannino de' Grassi, in Bergamo. The theme of the mastiffs attacking the cornered boar is identical, even though the Limbourgs omitted one of the dogs and added hunters,

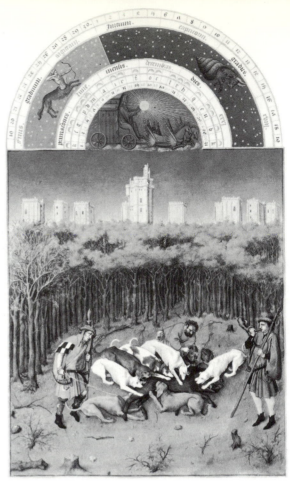

left: 31. LIMBOURG BROTHERS. June page, *Book of Hours (Les Très Riches Heures) of the Duke of Berry.* 1416. Illumination, 8⁷/₈ × 5³/₈″. Musée Condé, Chantilly (fol. 6v).

right: 32. LIMBOURG BROTHERS. December page, *Book of Hours (Les Très Riches Heures) of the Duke of Berry.* 1416. Illumination, 8³/₄ × 5¹/₄″. Musée Condé, Chantilly (fol. 12v).

trees, and the castle of Vincennes in the back-ground. It is possible that the Limbourg work and Giovannino's drawing had a source in common, which may have been a Roman sarcophagus. The December hunter, blowing his horn to indicate the kill as the other hunters move in to pull off the dogs, is a characteristic peasant type of the Limbourgs, comparable in delicacy to those warming themselves in the February scene.

The Limbourgs enriched the calendar scenes with a magnificent sense of display. As in the calendar pages, so in the remainder of their work on this manuscript, the illuminations fill the page, often with beautiful floral decoration.

Their pictorial account of the Fall of Man (Fig. 33) takes place in a circular form that moves upward, rather than backward, in space. Small mountains ring the edge, and a low wall allows a view into the Garden of Eden, where Adam reaches up and behind him to take the apple, in a gesture like that of Marsyas defeated in his musical contest with Apollo, and undoubtedly derived from antique sculpture. The perspective is not so advanced as in Italian work, and the northern spirit is evident in the proportions and form of Eve, whose large stomach reflects the ideal type of beauty of the period. The fantastic character of the architecture has induced many scholars to search for an Italian source, but so far no Italian precedent for this aspect of the illu-mination has been convincingly demonstrated.

The circular form is also employed for the view of Rome. This view cannot be taken as a reliable guide, because monuments have been moved around, demonstrating thereby that its maker, not actually having been in Rome, had copied another plan.

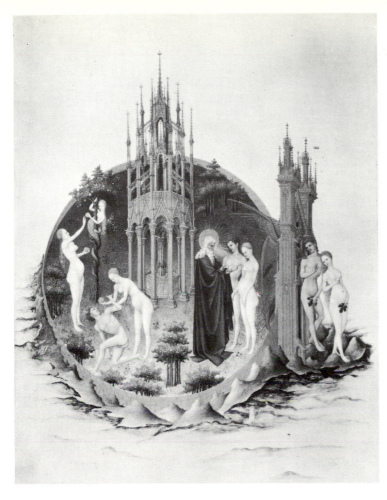

left: 33. LIMBOURG BROTHERS. The Fall of Man, *Book of Hours (Les Très Riches Heures) of the Duke of Berry.* 1416. Illumination, 9 ¹/₂ × 8 ¹/₄ ". Musée Condé, Chantilly (fol. 25).

below: 34. LIMBOURG BROTHERS. Hell, *Book of Hours (Les Très Riches Heures) of the Duke of Berry.* 1416. Illumination, 8¹/₄ × 6". Musée Condé, Chantilly (fol.108).

Oriental costumes clothe the figures in the scene of the meeting of the Magi, possibly a pictorial souvenir of the Paris visit of the Byzantine emperor Manuel II, mentioned earlier in this chapter, or possibly derived from an Italian memento, as is the costume of the victorious angels in the miniature of the Fall of the Rebel Angels. Similar costumes with similar helmets can be found in several Florentine frescoes of a decade earlier.

The miniature of Hell (Fig. 34), in which Satan lies on his fiery grill inhaling and exhaling souls as other demons stoke the fire and energetically torture the damned, parallels the famous medieval Irish account of the voyages of the monk Owen into the nether regions, a tale antedating the *Divine Comedy* of Dante. The late medieval belief in demons was shared on both sides of the Alps. The demonic iconography is strongly Italian in this miniature, but it is presented with an attention to detail that is thoroughly northern and seemingly Flemish in its enthusiastic specificity.

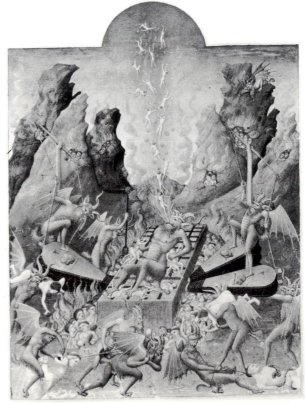

right: 35. LIMBOURG BROTHERS. St. John on Patmos, *Book of Hours (Les Très Riches Heures) of the Duke of Berry.* 1416. Illumination, 6 ³/₄ × 4 ³/₈ ″. Musée Condé, Chantilly (fol. 17).

below: 36. LIMBOURG BROTHERS. Multiplication of the Loaves and the Fishes, *Book of Hours (Les Très Riches Heures) of the Duke of Berry.* 1416. Illumination, 6 ¹/₄ × 4 ³/₈ ″. Musée Condé, Chantilly (fol. 168v).

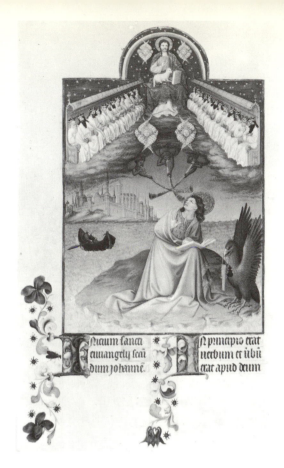

A similar combination of ideas characterizes the figure of St. John on Patmos (Fig. 35). The figure of John is thoroughly Italian, in the manner of Giotto, but the man rowing a boat over the choppy water in the background is an instance of observation of nature comparable to that of the calendar landscapes of March and June.

Such naturalistic elements are scattered through the pages of the *Très Riches Heures.* The Temptation of Christ is staged at Mehun-sur-Yèvre, the Duke's favorite castle, where swans swim in the moat and boats sail the background sea (despite the location of the castle far from the coast). Details such as windmills and weathercocks turn the painting into a portrait of the castle rather than a religious scene. The scenes of the Multiplication of the Loaves and the Fishes and the Betrayal of Christ have been transformed into night scenes done in dark gray with flecks of gold; not truly representations of night light, they emulate it by the lowered tonality of the whole.

The Multiplication scene (Fig. 36) is also remarkable for the illusionistic, highly naturalistic border ornamentation of night-crawling snails out of whose shells grow symbolic columbine of a beautiful blue. Here is further evidence of delicate stylized drawing and clearly observed nature existing side by side. Throughout, Italian idealization of the late 14th century is allied to a northern naturalism with symbolic overtones.

Different hands are recognizable in the scenes. The styles vary from the sculpturesque, as seen in the Purification in the Temple (Fig. 37) perhaps copied from Taddeo Gaddi's fresco of the Presentation of the Virgin (Sta. Croce, Florence), to the almost mannered elegance of the decoratively conceived and flatly executed forms in the April calendar scene. Nevertheless, a unifying crispness of outline, a richness of costume, and a delicacy of tone, form, and color lessen the

gravity of the religious themes and accentuate their poetry. The formal borrowings from Italy have been transformed by temperaments attuned to the elegance, richness, variety, and natural poetry of the International Style, seen so clearly in their chief innovation, the full-page calendar illumination. The Limbourgs close the period of Italian influence and dependence. Not for almost a hundred years did Italian ideas again have the strength to coexist with or assert dominion over the northern spirit.

The Limbourgs had their influence on other masters, but their influence was not strong enough to change the direction of northern painting. Their dominant stylistic methods of simplified modeling and their painterly tendencies, it must be realized, were not innovations. From a stylistic standpoint, their art was an adaptation of a fresh approach introduced into Paris from the north early in the century.

THE CLIMAX
IN PARISIAN ILLUMINATION, 1400–25

By 1400 Parisian illumination had begun to dry up, stylistically speaking, for the innovations of the Flemings working for the courts had little effect on the general run of book illustration. Thus the stage was prepared for a strong new spirit that would pull illumination out of its tendency to fall into an elegant mannerism. Such a spirit did appear, though it is still a scholarly question whether it was due to an individual or to that group which has been identified as the "Master of 1402." [24] That it was not Parisian is proved by a Dutch inscription in the key manuscript, *Des Claires et Nobles Femmes,* a French translation of Boccaccio's *De Claris Mulieribus* (Paris, Ms. fr. 598). This inscription appears on the scroll held by Cassandra, who is about to be slain, on folio 48v (Fig. 38).

The new spirit brought with it stockier figure types, a greater feeling for lively (sometimes violent) movement, interest in light as a modeling device, and vigorous new color harmonies. Yellows, blues, vermilions, and greens predominate, though in time the contrasts were softened more and more by pastel tones.

The style was taken up rapidly by Parisian illuminators and well patronized by such discerning collectors as the Duke of Berry.

below: 37. LIMBOURG BROTHERS. Purification in the Temple, *Book of Hours (Les Très Riches Heures) of the Duke of Berry.* 1416. Illumination, 8 ¼ × 5 ¾". Musée Condé, Chantilly (fol. 54v).

bottom: 38. "MASTER OF 1402." Cassandra, from Boccaccio, *Des Claires et Nobles Femmes. c.* 1402. Illumination, *c.* 3 × 2 ½". Bibliothèque Nationale, Paris (Ms. fr. 598, fol. 48v).

39. BEDFORD MASTER (?). Master of the hunt, from Gaston Phébus, *Book of the Hunt. c.* 1405–10. Illumination, *c.* 6 × 6″. Bibliothèque Nationale, Paris (Ms. fr. 616, fol. 13).

Porcher's suggestion that the Limbourgs were associated with this movement is far from being an impossibility. [25]

Italians were also active in Paris at the same time, one of whom, Zebo da Firenze, signed his name in minute letters in the *Book of Hours of Charles the Noble,* [26] King of Navarre, of about 1410 (now in Cleveland, Ohio). Another was the woman illuminator Anastasia, mentioned in accounts as working for the leading feminist of the day, Christine de Pisan, who wrote and had illuminated highly popular allegories, which she presented to members of the court.

Christine de Pisan is one of the most interesting figures of the epoch. Daughter of Charles V's court astrologer, widowed in 1389 with three children to support, she turned to literature as a means of livelihood, writing love poetry and allegorical prose of a semimythological character, as well as histories and moral works. She was the champion of her sex, and her works, exalting the abilities of women, were enthusiastically accepted by the nobility, with whose chivalric ideals her attitude was spiritually attuned. Christine de Pisan catered to the artificiality of a way of life soon to be plunged into a widespread and long-lasting misery.

However, the dominant expression in Paris for the next generation was established by the new wave of Netherlanders. From this milieu emerged three distinct artistic personalities, the Bedford Master, the Boucicaut Master, and the Master of the Rohan Book of Hours. All three are clearly disengaged from the trend of the Master of 1402.

THE BEDFORD MASTER

The style of the Bedford Master seems to be discernible first in a copy of a very popular book on hunting by Gaston Phébus (died 1391). Illuminated about 1405–10, or possibly a little earlier, this manuscript (Paris, Ms. fr. 616) presents the varied activities of the hunt and illustrates the lives of the game animals as a guide to their capture. Its frontispiece is a large painting of the enthroned master of the hunt surrounded by huntsmen and dogs (Fig. 39).

A certain naïveté characterizes the treatment in various scenes. The attendants stalk, rather than walk; horses gallop in awkward fashion; and figures and landscape elements reveal an impossible scale relationship. Gold backgrounds and stylized trees appear, but the trees are more naturalistic than ever before, with a green and blue base for the form, over which yellow brush strokes pick out leaf forms. The tree type became as popular as the earlier "boquetaux" had been. Rich yet subtle color gives a vivacity of spirit to the work and to the Bedford style. The master's characteristic interplay of strong and pastel colors gives a painterly effect, with the startling innovation of colored shadows, as in the use of blue shadows on green garments.

This style eventuated in the *Bedford* (or *Salisbury*) *Breviary* (Paris, Ms. lat. 17294), begun in 1424 for John of Lancaster, Duke of Bedford, who was regent in France for the youthful Henry VI of England, following Charles VI's death in 1422, and was ruler in Paris until 1435.

The change to English, rather than French, patronage and the frequent appearance of the figure of St. George, England's patron saint, are the only indications in the manuscripts of the sweeping changes that resulted from the decisive Battle of Agincourt in 1415.

The *Bedford Breviary* and its companion *Book of Hours* (British Museum, Add. Ms. 18850)

represent the latest and final style of the Bedford Master. The *Breviary* contains 46 large paintings and 4,300 small ones, not counting the decoration of the capital letters.[27] Obviously the quality varies. Typical is folio 448, with St. George slaying the dragon (Fig. 40). The details of the foreground scene in which the princess leads a tame dragon by her girdle are based on the *Golden Legend*, but the background scene is the most frequent type. The spatial construction is typical of the Bedford Master's developed style. On one side there appears an illogical but charming piling-up of architectural forms enlivened by figures, with an ascending landscape alongside the fanciful construction. His usual coloration for walls and turrets is either light pink or light bluish white.

The proliferation of marginal scenes appears not only in the work of the Bedford Master but in that of his contemporaries as well. It is related to the increasing enrichment of the margins that began with the drolleries of Pucelle. In the Bedford style the marginal scenes achieved the status of ancillary religious themes separately framed (usually by acanthus foliage). The effect is painterly but airless.

In the course of his long career the Bedford Master developed his rich ornamentation but did not go beyond his early works in the pursuit of naturalistic elements. Extensive production also brought about a loss of delicacy, as lesser hands were given an increased share of the work. However, of all the styles developed in Paris after 1400, that of the Bedford Master was longest lived and most influential upon contemporary and subsequent illuminators. Though he probed no further into the variety of naturalistic effects, he perfected a decorative approximation of appearances that was easily formalized and imitated.

Only a few of the many illuminators working in the Bedford manner have been rescued from anonymity by modern research; even so, the artists' names are still unknown.[28] One such figure is the Egerton Master, a creation of Rosy Schilling.[29] Another artist, still to be disengaged from that anonymous web, illustrated *The Book of the City of Women* by Christine de Pisan[30] (Paris, Ms. fr. 607). The ladies charmingly go about their tasks dressed in the latest court fashion, which lends a gay artificiality to their enterprise (Fig. 41). Undoubtedly illustrated

below: 40. BEDFORD MASTER. St. George, *Bedford Breviary*. After 1424. Illumination, 10 × 7 ⅞″ (page). Bibliothèque Nationale, Paris (Ms. lat. 17294, fol. 448).

bottom: 41. BEDFORD STYLE. Building the city, from Christine de Pisan, *The Book of the City of Women. c.* 1407. Illumination, *c.* 4 ¾ × 7 ⅛″. Bibliothèque Nationale, Paris (Ms. fr. 607, fol. 2).

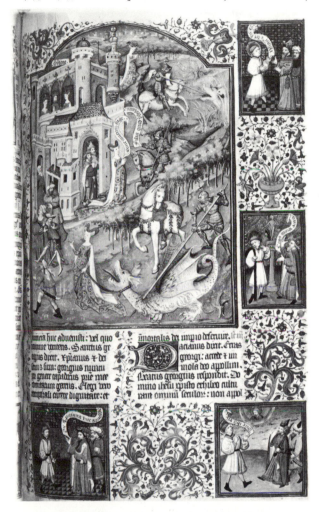

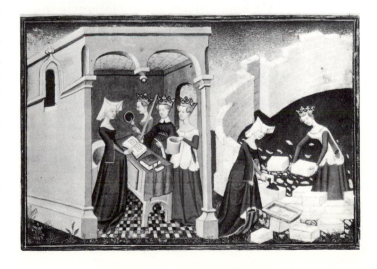

under Christine's direction, this copy belonged to John, Duke of Berry, who owned several of her books and who probably received this one from her about 1407. Her writings were much admired, being bought or received by the rulers of the day.

Among her admirers was Louis, Duke of Anjou, whose profile portrait of 1412 (Paris) in pen and water color is one of the few preserved from this period (Fig. 42). Painterly space has been eschewed in this portrait, which satisfies the demand for a likeness in terms of a decorative calligraphic line and the subtle tonalities of the conservative style of miniature painting. In the north the profile portrait type was soon replaced by the three-quarter view, to be popularized by the Flemish painters. Their search for form as an outgrowth of the environment contrasts with the continuation in Italy of the profile portrait as a form abstracted from the environment.

Form as an outgrowth of the environment may be said to be the one aspect of the International Style that the Flemings brought with them and took back to Flanders when the style had run its course. Like all styles, it reached its apogee and declined, but not before the Bedford Master had made his contribution and those associated with his transformation of the style of the Master of 1402 had made theirs.

THE BOUCICAUT MASTER

The Boucicaut Master, who worked for a time with the Bedford Master, far surpassed the Bedford Master in sophistication and elegance and especially in understanding of the new realistic spirit. He takes his name from the *Hours of Jean le Meingre, Maréchal de Boucicaut,* in the Musée Jacquemart-André, Paris. The Maréchal, a striking figure in French history of this period, poet and soldier, fought against the Turks and was captured at Nicopolis in 1396; after two years in captivity he fought them again at Constantinople in 1399. Genoa put itself under French rule and in 1401 requested the Maréchal as its governor, a position he filled until made governor of the provinces of Guyenne and Languedoc in 1409. Taken prisoner at the Battle of Agincourt,

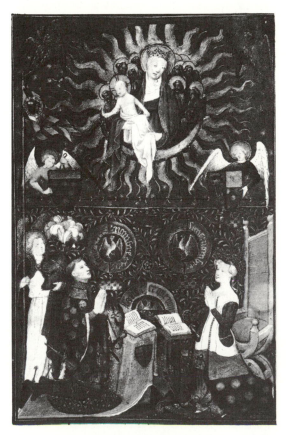

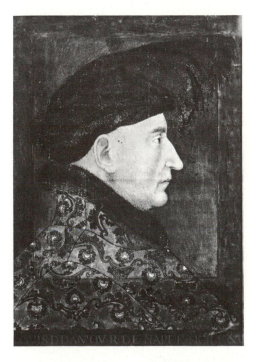

left: 42. FRENCH. *Duke Louis of Anjou.* 1412, Pen and water color, $8\frac{1}{2} \times 6\frac{3}{4}''$ (without added inscription). Bibliothèque Nationale, Paris.

above: 43. BOUCICAUT MASTER. Maréchal de Boucicaut and his wife kneeling before the Virgin, *Boucicaut Hours*. c. 1409. Illumination, c. $11\frac{7}{8} \times 7\frac{1}{2}''$ (page). Musée Jacquemart-André, Paris (Ms. 2, fol. 26).

he died in England in 1421. His wife, Antoinette de Turenne, who is portrayed with him in his Book of Hours, had died in 1415.

This extremely sumptuous manuscript, probably begun in 1409, contains 45 full-page miniatures, in many of which the arms of the Maréchal appear. On folio 26 (Fig. 43) he himself appears with his wife, kneeling before the Virgin. In the dragon-slaying scene the features of St. George are those of the Maréchal. Many of the coats of arms were effaced by a later owner of the manuscript, Aymar de Poitiers (from whom it passed to his famous granddaughter Diane), but they occurred so often that several of them have survived intact.

A thoroughly characteristic miniature in the *Boucicaut Hours* is the Visitation (Pl. 4, after p. 180). Whereas the Limbourgs alternated the courtly and the naturalistic, as in the calendar pages, the Boucicaut Master combined both aspects in his conception. However, like the Limbourgs, he used low trees of miniature scale to border the foreground, above which the principal scene takes place. The Virgin, her train held by two angels as if in a courtly ceremony, is greeted by a St. Elizabeth as elongated as the Virgin, but neither is as paper-thin as the Limbourg figures in the April scene (Fig. 30). The immediate setting for the religious theme here differs little from those of his contemporaries, who also employed the conventional hills and trees, but the major distinction between the Boucicaut Master and his fellow illuminators appears in the background landscape, where a swan swims in a pond, a man is fishing, sheep graze on the far side, and a man drives a donkey before him. These and other everyday motifs can almost all be found in earlier manuscripts, but the proportions here are far more exact; the modulated sky is warmer in color than those the Limbourgs painted, and its tones gradually lighten; there is a softening of the edges of the hazy distant forms.

In short, the Boucicaut Master achieved true aerial perspective. He united observation of nature with the courtly style in a step beyond the Limbourgs and the other Flemings in Paris. The Limbourgs may be said to have decided in favor of the Italianate idealized style. The Boucicaut Master, though heightening the basic elegance of the International Style rather than superimposing the naturalistic elements upon a derivative point of view, constructed his scene from those elements. He integrated the whole with an aerial perspective that makes the background an extension of the foreground space.

This large step forward formerly led historians to link the Boucicaut Master with Jacques Coene, an illuminator from Bruges known to have been working in Paris about the turn of the century. Unfortunately, not a single work can be associated with Jacques Coene; he remains a name without works, whereas the Boucicaut Master remains a distinct artistic personality whose actual name is unknown.

In general the Boucicaut Master's iconography was that of his contemporaries, and the Limbourgs' marked Italianisms found little place in his art, though the introduction of the acanthus into the margins is, if not directly, at least ultimately of Italian origin. His interests lay in the naturalistic scene, even when symbolic elements occasionally transform simple narrative. A case in point is the Nativity from the *Boucicaut Hours,* here an essentially exterior scene (Fig. 44). The Virgin kneels on a cushion beside a bed made regal like the *lit de justice* from which the monarch gave his judgments. Though the Child

44. BOUCICAUT MASTER. Nativity, *Boucicaut Hours.* *c.* 1409. Illumination, *c.* 11 $^7/_8$ × 7 $^1/_2$ ʺ (page). Musée Jacquemart-André, Paris (Ms. 2, fol. 73v).

is naturalistically presented, the setting is royal, as the rich canopy clearly establishes.

The master's most important innovations, however, lie in the realm of the naturalistic image. Panofsky has called attention to what he calls the "diaphragm arch" as a device interposed between spectator and pictorial space to suggest that "what is in view seems to be removed from the painting surface; and what is kept from view seems to extend in all directions." [31] The acuity of the master's perspective vision came from his ability to conceive his spaces as seen from a single viewpoint, a concept never clearly grasped by his contemporaries in Paris. Anticipating the later perspectives of Flemish panel painting, the Boucicaut Master, in such miniatures as the St. Catherine from the *Boucicaut Hours,* had already developed a concept of the natural continuity of space, but his technical means for achieving his aim had yet to keep pace with his vision.

The diaphragm arch, however, is occasionally dispensed with entirely, as in a Book of Hours (Paris, Ms. lat. 1161) in which the illustration on folio 212 (Fig. 45) for the Offices of the Dead presents not a catafalque in a chapel, as in the *Boucicaut Hours,* but a burial scene, seemingly in the Cemetery of the Innocents in Paris. In its realism the actual burial of a corpse is highly descriptive, but types are generalized, the clergy all showing the Boucicaut Master's heavy, straight-nosed, squared faces, some with the typically small mouth. The color is light and cheerful; the gravedigger's headgear and trousers are pink and his overgarment is blue. The oblique perspective is inexact, but the realistic architectural forms are neither decoratively heaped on top of each other nor are they fanciful Lombard Gothic types.

The master's naturalistic bent is visible in numerous works, two of which raise the interest in spatial continuity to an unprecedented level. The first is the scene of the author presenting his book to John the Fearless in the *Livre des Merveilles* (Paris, Ms. fr. 2810), a book illustrated in conjunction with the Bedford Master. The second is the presentation miniature (Fig. 46) in the *Dialogues of Pierre Salmon* (Geneva, Ms. fr. 165), in which John the Fearless again appears (at left), in an interior scene depicting Pierre Salmon in audience with Charles VI. By means of a window showing blue

top: 45. BOUCICAUT MASTER. Burial scene, *Book of Hours. c.* 1410–15. Illumination, 8 5/8 × 5 7/8″ (page). Bibliothèque Nationale, Paris (Ms. lat. 1161, fol. 212).

above: 46. BOUCICAUT MASTER. Pierre Salmon in audience with Charles VI, *Dialogues of Pierre Salmon. c.* 1410–15. Illumination, 5 3/8 × 4″. Bibliothèque Publique et Universitaire, Geneva (Ms. fr. 165, fol. 4).

sky beyond, the master has given the interior the same feeling of space extending to infinity that is found in his exterior scenes. As the master had discovered aerial perspective in open landscape, so he discovered chiaroscuro in the interior.

The Boucicaut shop produced a great number of manuscripts. Possibly the earliest manuscript that can be connected with the shop is a Book

47. BOUCICAUT MASTER. *Reception of the Duke of Berry into Paradise, Book of Hours (Les Grandes Heures) of the Duke of Berry*. 1409. Illumination, 15 3/4 × 11 3/4″ (page). Bibliothèque Nationale, Paris (Ms. lat. 919, fol. 96).

of Hours in Oxford (Bodleian Library, Ms. Douce 144), which contains an inscription relating that it was made and completed ("factum et completum est") in 1407, "the year in which the bridges broke up in Paris," during a long, cold winter. The inscription is in black, indicating that it was copied from another manuscript with the same text, because such dating inscriptions are normally in red ink. However, the copy was probably written not much more than a year later. The figure style is characterized by blocklike rounded forms that contrast strongly with the slim, svelte, elegant, and more softly handled figure style of the developed Boucicaut manner. Stylistically these figures precede those in the scene of the reception of the Duke of Berry into Paradise (Fig. 47), the only miniature (folio 96) by the Boucicaut Master in the *Grandes Heures,* which was completed in 1409.

Once he achieved his developed style, it was little altered. As in the Bedford style, the chief change was the elaboration of the borders, which were almost excessively enriched, as in a Book of Hours of the latter half of the second decade (Paris, Bibliothèque Mazarine, Ms. 469). His color, however, was consistent throughout his career, once the harder qualities of the early

style (shared with the Bedford Master) had been replaced by delicate, subtle interplays of pastel tones and stronger primaries, particularly vermilion. His color is much like that of the Bedford Master, except that his feeling for its interrelationships seems finer, and the forms it adorns are more fluid and less angular in movement and gesture than those of his contemporary and occasional coworker. The Boucicaut Master's more subtle color, aerial perspective, chiaroscuro interiors, and less idealized concept of nature and man took the art of painting a long step beyond its previous limitations.

THE ROHAN MASTER

The third member of the dominant triumvirate of Parisian illumination in the first quarter of the 15th century is known as the Master of the Rohan Hours, who may have made his appearance in the shop of the Master of 1402; the figure of Amalthea (Fig. 48) on folio 36 of the *Boccaccio of Philip the Bold* (Paris, Ms. fr. 12420), of about 1402, seems to be from his hand. He collaborated with the Bedford and Boucicaut masters as late, according to Porcher, as 1415–20, when he seems to have passed into the service of the dukes of Anjou. Porcher would like to

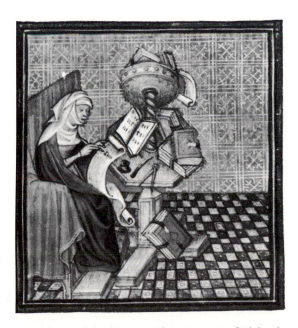

48. ROHAN MASTER(?). Amalthea, *Boccaccio of Philip the Bold.* c. 1402. Illumination, c. 2 3/4 × 2 5/8″. Bibliothèque Nationale, Paris (Ms. fr. 12420, fol. 36).

In the intensely dramatic and moving scene of the Lamentation (Fig. 49) the Virgin's arms hang in agonized lines, reaching for the ema-ciated, awkwardly rigid body of her dead Son, as her limp form is supported by John. The apostle stretches his neck and looks under lowered eyelids at the larger, sorrowing figure of God the Father, who lifts his hand to his head as if in a salute to the fallen. Angels' wings make a tapestry background for the scene, but these are not little angels decoratively and delicately placed. Instead, a large, sweeping movement of their linear forms across the surface creates a shifting, volatile screen, before which the expressive drama is placed. The greenish color of Christ's body accentuates the realistic drama of the sacrifice. Parallels occur in late medieval literature and in art, as in the Tomb of Cardinal de Lagrange in Avignon, where the body is represented as a moldering cadaver. The limits of restraint and sophistication characteristic of French court painting have been disregarded; unusual iconography and even scale are used for expressive purposes.

In the Annunciation to the Shepherds (Fig. 50) the big, sad-faced shepherd, fluting in clumsy dance, dwarfs the milking shepherdess and the angels intent on reading their message. Through-out the manuscript explosive movement and angular effects vie with swinging lines and flat, delicate molded surfaces, and soft pastel tones contrast with strong blue and gold backgrounds. The supernatural effect is the creation of an enigmatic, expressionistic spirit conveyed with-in the artistic limits of the International Style.

The Rohan Master is the only Parisian miniaturist whose art can be readily conceived as translatable into panel painting. (A panel in the Laon Museum has been attributed to him by Grete Ring. [33]) His later career found an outlet at the Anjou court, where apparently he worked in the third decade.

THE NETHERLANDS

English control, war, and famine combined to stifle French illumination in the 1420s, as the

make him a Catalan, as his iconography suggests. He was concerned with the life of the emotions in a way unprecedented in Parisian illumination.

His masterpiece, for which he is named, the *Rohan Hours* (Paris, Ms. lat. 9471), [32] has been dated between 1414 and 1418. Its 11 full-page miniatures, 54 half-page illuminations, and almost five hundred marginal illustrations testify to the richness of the manuscript. Their occasion-ally macabre spirit has no parallel in the art of his contemporaries, even though in iconography and color they do not differ strongly from the prevailing manner. However, there are differences in the expressive drawing, the action, the scale relationships, and the flattened space in which his dramatic scenes are set. The technique is broader, coarser, and attuned to the expression of a dramatic content absent in the art of his contemporaries. Archaistic notes may be found in the varieties of scale within the scenes.

50. ROHAN MASTER. Annunciation to the Shepherds, *Rohan Hours. c.* 1414–18. Illumination, *c.* 10 × 7″. Bibliothèque Nationale, Paris (Ms. lat. 9471, fol. 85v).

work that can be easily overlooked because of the naïveté of the features.

In actuality the "Gold Scroll style" of this master applies to a group of artists, apparently working in the southern Netherlands as early as the beginning of the 1420s and definitely related to Dutch painting as practiced in England by a known contemporary artist, Hermann Scheere. The name of the master, or preferably the group, derives from the dense gold rinceaux that prominently deck many of the backgrounds.

The "Gold Scroll style" flourished in the southern Netherlands through the second quarter of the century concurrently with that of the Master of Guillebert de Mets,[35] who was Flemish and, according to Winkler, worked in Paris before 1410. This master takes his name from the copyist responsible for the text of a translated *Decameron* (Paris, Arsenal, Ms. 5070), in which the illuminator's style, of about 1420, is clearly seen. (A second style in the manuscript is that of the later Mansel Master.) The style of the *Decameron* illuminations of the Master of Guillebert de Mets differs little, if at all, from

below: 51. MASTER OF THE GOLD SCROLLS. Flight into Egypt, *Book of Hours. c.* 1430. Illumination, 9¼ × 6¼″ (page). Bibliothèque Royale, Brussels (Ms. 9798, fol. 86v).

artists dispersed in search of clients and settled conditions. However, before the dispersal of the Paris artists a new generation of Netherlanders had gone there to learn the Parisian methods and take them back to their homelands. One of this generation was the Master of the Gold Scrolls, who completed a Book of Hours[34] begun by the Limbourgs (now in the collection of Count Seilern in London). His manner is far less sophisticated than normal Parisian work; his figures are almost childlike, resembling rather fragile but stubby dolls (Fig. 51). This artist did not have the awareness of artistic problems and of innovations that characterized the leading Parisian masters. Employing iconographic types that were almost a generation old, his Flight into Egypt is dependent in figure action on the Brussels *Hours.* Though his settings are occasionally naturalistic, in the manner of the Boucicaut Master, his forms tend to be somewhat harder in their modeling, though this is an aspect of his

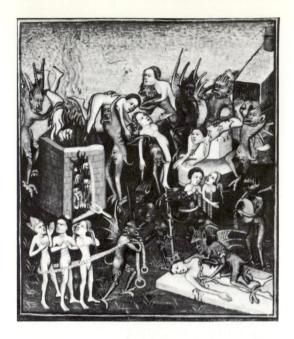

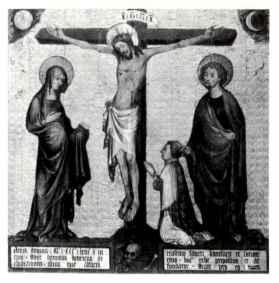

be concluded from the numerous followers working in this style in and around Lille, where the master's shop may have been located.

This "pre-Eyckian realism," as the style has been termed,[36] calls for a step backward in time to discover whether there is a background in the Netherlands for such insistent naturalism as has been seen to date. The *Calvary of Hendrik van Rijn* (Fig. 53), of 1364, in Antwerp, combines strong plasticity, decorative treatment of drapery ends, an effect of light, a gentle pathos, and pervasive mystic feeling. The portrait of Hendrik van Rijn is in profile, clear but slightly soft. Uniting naturalistic elements and pathetic expression, this work is distinctly different from contemporary French art. It suggests that in the region of the lower Rhine and the Netherlands there was a basis for the development of such realism as has been discussed above.

Another example may be found in the emphatic naturalism that informs a portrayal of an emperor (Charles IV?) and his court (Brussels, Ms. 15652–15656), executed close to the turn of the century, in which, despite evident Gothic traits in figural representation, there is a strong insistence on naturalistic appearance in both character and modeling of features. Further evidence for a native basis for Netherlandish realism appears in illustrations for a copy in French of Guillaume de Deguileville's popular *Pilgrimage of the Life of Man*[37] (Brussels, Ms. 10176–10178), a work possibly executed at Arras in the last decade of the 14th century. A moralizing treatise, its theme is to be found earlier in Dante and later in John Bunyan. In the meeting of Pilgrim and Envy (Fig. 54) and in the Crucifixion, among other scenes, the ugly low types are represented with large jaws, upturned noses, and squat forms in a sketchy, linear style accentuating the dramatic content. Even the pattern of the background is rough and strong, suggesting that the artist was not primarily a miniaturist.

The *Calvary of the Tanners' Guild* of about 1400, in the Cathedral of Saint-Sauveur in Bruges,

that found in his Hell scene (Fig. 52) in the French translation of St. Augustine's *City of God* (Brussels, Ms. 9005–9006), of twenty years later.

The atmospheric quality of the Boucicaut style on which the master based his art was hardened in his work so that the edges are clearly marked but the forms are flattened. His style is marked by a stronger linearity, and his types show less variety, having become somewhat like puppets. However, in the process of hardening and clarifying, a step was made toward insisting upon the object *qua* object, even though the result is less pleasing than the fluid, atmospheric art of Paris. This trend appears to be the expression of a different and popular outlook, as may

adds a slightly more sophisticated note to the same realistic outlook (Fig. 55). This is visible in the Crucifixion scene and its attendant figures, rather than in the flanking figures of fluffy-haired Sts. Catherine and Barbara placed before little houses (like those seen in a 16th-century mystery-play representation known from a manuscript in Valenciennes). The central theme presents a dramatic angularity in the movement of the blue angels against the gold background and a strong naturalism in attitudes and features of the soldiers at the foot of the Cross.

Panofsky's study of the regional schools of Flanders, Holland, and the Lower Rhine area indicates everywhere, and particularly in Flemish art, a directness and a sense of realism that occasionally drew upon the ugly and the grotesque.

Farther east stronger contacts by the nobility with Paris and the French court resulted in a more sophisticated art that centered in Guelders and Limbourg and is exemplified in the *Prayerbook of Mary, Duchess of Guelders* (Berlin, Staatsbibliothek, Cod. germ. 4°42). The art of these local courts influenced the surrounding art centers, notably that of Utrecht, where a number of masters were actively engaged in manuscript illumination.

left: 54. NETHERLANDISH. Meeting of Pilgrim and Envy, from Guillaume de Deguileville, *Pèlerinage de la vie humaine, c. 1390–1400(?)*. Illumination, 12 $\frac{1}{2}$ × 9″ (page). Bibliothèque Royale, Brussels (Ms. 10176, fol. 68; detail).

below: 55. NETHERLANDISH. *Calvary of the Tanners' Guild. c. 1400.* Panel, 28 $\frac{7}{8}$ × 56 $\frac{1}{4}$″. Cathedral of Saint-Sauveur, Bruges.

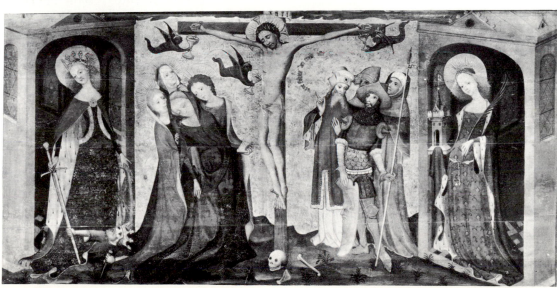

BOHEMIA

THE ARTISTIC LEAVEN AT WORK IN FRANCE IN the 14th century contributed by example, and to some extent by direct influence, to the rise in Bohemia of a distinctive lyrical mysticism without a parallel in France. Bohemia's artistic flowering came about through the encouragement and patronage of one of its greatest rulers, Charles IV, King of Bohemia and Holy Roman Emperor, who was basically French in his sympathies, having been raised in France. He married Blanche of Valois. His father, King John of Luxembourg, was culturally and politically allied with the French and died at Crécy in 1346, fighting a French battle. Charles IV was as important a patron of the arts in Bohemia as his contemporary, Charles V, was in France. He encouraged local customs among the nobility and respect for the national tradition, fostering the use of the Czech language in collections of laws and in literary and scientific works. He founded a university at Prague in 1348 and greatly enlarged the capital. The result was a tremendous growth of national consciousness and, in literature and art, the rise of Bohemia's golden age.

Through the efforts of Charles IV and those of his art-minded chancellor, John of Neumarkt (Czech: Středy), western art entered Bohemia. Charles called Matthias of Arras, architect of Narbonne Cathedral, to build his new cathedral in Prague in 1344, after separating Prague from the religious jurisdiction of Mainz. Charles also looked to Italy for aid and inspiration, as did his chancellor, who was Italian-trained, had visited Avignon, and had corresponded with Petrarch. He brought artists from Venice to create a mosaic Last Judgment over the south porch of the cathedral, and Tommaso of Modena may have worked at the castle of Karlštejn, near Prague, begun by Charles about mid-century, for a triptych from his hand was set into the wall behind the altar of the Chapel of the Holy Cross at Karlštejn (consecrated in 1365). Italian influences came to Bohemia through direct and indirect sources.

Both French and Italian traits are evident in the art of the Master of Hohenfurth (Czech: Vyšší Brod). The style of his altarpiece (Fig. 56), dating about mid-century, now in Prague, suggests certain parallels with Pucelle's David and Saul miniature in the *Belleville Breviary* (Fig. 4). Like Pucelle, the Hohenfurth Master was interested in space, modeling, and architectural forms, and, like Pucelle, he elongated the forms, but there are marked differences. The architectural forms, ultimately Tuscan in origin, suggest a greater solidity, and the heavier modeling is given further weight by the darkened faces. Space is somewhat indeterminate but fluid in feeling (almost as if space is winning out over matter), because the Gothic linear rhythms control the forms. The elongation of forms

seems to be expressive, rather than elegant in
the manner of Pucelle. In place of Parisian
sophistication a feeling of Eastern mysticism
underlies the master's synthesis of French and
Italian currents. In the Gethsemane, or Mount
of Olives, scene, the master added piquancy by
contrast in naturalistic elements such as the
carefully delineated trees, on each of which a
bird perches (Fig. 57). Luminosity in the
modeling of smooth surfaces, spatial fluidity, and
a gold background all contribute to the mystic
spirit that underlies this work, so distinctly
different from both Italian and French art,
despite the obvious relationships.

A comparable indigenous Bohemian spirit had
been seen even earlier in the *Passional* of the
Abbess Kunigunde (Prague, University Library
Ms. XIV A 17), of about 1314–21, and it per-
sisted as a subterranean current in Bohemian

above: 57. MASTER OF HOHENFURTH (Vyšší Brod). *Christ in
the Garden of Gethsemane,* detail. *c.* 1350. Panel, 37 ³/₈ ×
33 ⁵/₈ ″ (over-all). National Gallery, Prague.

below: 58. BOHEMIAN. Christ Appearing to the Virgin, *Passional of Abbess Kunigunde. c.* 1314-21. Illumination. University Library, Prague (Ms. XIV A 17, fol. 16).

bottom: 59. FOLLOWER OF THE MASTER OF HOHEN-FURTH (Vyšší Brod). *Glatz Madonna. c.* 1344-64. Panel, 73 ¼ × 37 ⅜″. Gemäldegalerie, Staatliche Museen, Berlin-Dahlem.

delicacy of gay color animates the surfaces, which are highly decorative in the garments of the angels and extremely naturalistic in the wooden shutters next to the two angels swinging censers. (What these angels stand on is an unanswerable question.)

The chief decorations of the Chapel of the Holy Cross at Karlštejn (in addition to its band of precious stones set into the stuccoed wall) are 127 panels of saints, prophets, and angels, a mural cycle of Apocalyptic themes, and a gold ceiling dominating the whole. The 127 panels are attributed to Master Theodoric (or Theodoricus),[1] who was the first head of the painters' guild, founded in Prague in 1348, and is recorded as royal painter in Prague and at Karlštejn between 1359 and 1367. A coworker was Nikolaus Würmser of Strasbourg. These

painting (Fig. 58). Examples of the Hohenfurth style appear in other works. The *Madonna of Veveri* in Prague, also dated about mid-century, is a typical Bohemian Virgin and Child type with a bird, which combines the Hohenfurth style with strong decorative tendencies and Italo-Byzantine reminiscences.

Another related work is the *Glatz Madonna,* in Berlin (Fig. 59), dated by the regnal dates (1344–64) of its minuscule donor, Archbishop Ernst of Pardubice, shown kneeling at the foot of the throne, on which he has placed his gloves, crozier, and miter. Like John of Neumarkt, the archbishop had reinforced his Humanistic leanings at the papal court in Avignon and was also a patron of manuscript illumination. Neither Italian nor French, yet related to both styles, the work is indeterminate in space conception. Lighting is universal and, as in the work of the Hohenfurth Master, is used to model the forms and define the lines of the complex drapery. A

figures exhibit a new style that later spread into Austria and Germany. Linearity is replaced by an overwhelming sense of volume, so that the stout figures almost overflow the frame, and surfaces are generalized and luminous, with little articulation of the folds (Pl. 5, after p. 180). New interest in volume is combined with softer edges and a naturalism that is particularly evident in the faces, with their almost completely round eyes. This volumetric style is a striking break with the preceding calligraphic style and with Italian concepts. Parallels were widespread in Europe, for Theodoric's art is expressive of the general northern European movement toward a plastic naturalism already seen in the work of Bondol and Beauneveu. What particularly distinguishes Master Theodoric's part in this movement is the tendency toward chiaroscuro and the ambiguity of his space.

His influence can be seen in the *Votive Panel of Archbishop Očko of Vlašim* (Fig. 60), in Prague, painted about 1370. The upper scene represents St. Sigismund, Charles IV, the seated Virgin and Child, King Wenceslaus IV, and St. Wenceslaus, arranged before a gold background. Below, from left to right, are Sts. Procopius and Adelbert, before whom kneels John Očko, Archbishop of Prague, then Sts. Vitus and Ludmilla. The portraits, somewhat naïvely presented, are seen in three-quarter view, except for John Očko, who is shown in profile. This variation demonstrates that at this period the portrait had not been fixed in the formula "Italian equals profile; northern equals three-quarter view" that has been applied by some writers in discussions of the French portrait of John the Good (Fig. 6), discussed in Chapter 1. A certain delicacy in the handling of garments and other details suggests that the artist may also have been a practicing miniaturist. A later and cruder version of Theodoric's style can be seen in the Mulhouse altarpiece of about 1385, in Stuttgart.

The art of manuscript illumination received as much royal favor in Bohemia [2] as painting. The manuscripts illuminated during Charles's reign, particularly those made for John of Neumarkt, give evidence of Tuscan and Bolognese

influences in motifs and organization, as well as a new conception of the plasticity of forms, which, in more spaciously conceived works of the late 1360s, takes a position roughly intermediate in style between the Hohenfurth Master and Theodoric of Prague. Under Wenceslaus IV, the weak son of Charles IV who came to the throne in 1378, outstanding workshops were created for the production of luxurious manuscripts. [3] The Wenzel (i.e., Wenceslaus) workshops, which inherited the tradition of the preceding generation of illuminators, came into being in the late 1380s and continued on into the beginning of the 15th century, developing an International Style close to Beauneveu's prophets and Jacquemart's landscapes.

Though not produced exclusively for King Wenceslaus, the work of the shops was oriented

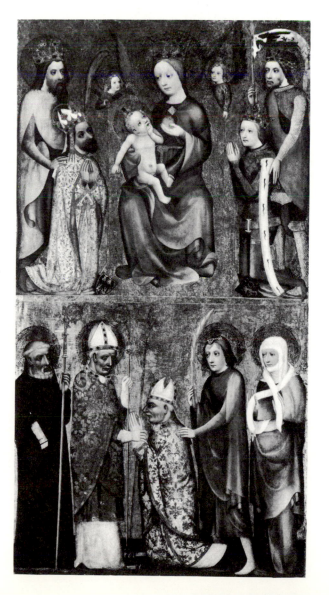

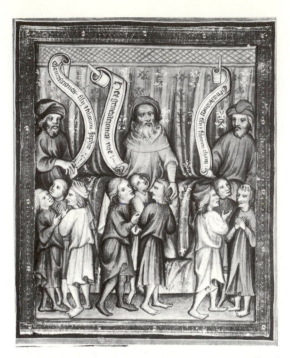

61. WENZEL WORKSHOPS. Noah's descendants, *Bible of Wenceslaus*. 1402. Illumination. Musée Plantin-Moretus, Antwerp (fol. 20).

Museo Diocesano). Closely related is the *Hasenburg Missal* (Vienna, Ms. 1844), written in 1409 for Archbishop Sbinko von Hasenburg.

The shops may have held together until the death of Wenceslaus in 1419, but by that time conditions for artistic production were already becoming hazardous. Uprisings that followed the burning of John Huss in 1415 led to a virtual cessation of works of high quality.

Painting on panel was equally affected by the chaotic political conditions. This may explain the restricted influence of the outstanding Bohemian painter of the last decades of the century, the Master of Wittingau (Czech: Třeboň), also known as the Master of the Třeboň Altarpiece, for Bohemian painting rapidly turned from his innovations to a poetic idealism under marked French influence. Displaying a distinctly Bohemian spirit, rejecting the voluminous, inarticulated naturalism of Master Theodoric, the Wittingau Master transformed naturalism into pictorialism in his panels of Christ on the Mount of Olives and of the Resurrection (Fig. 62), now in Prague, both from a dismembered altarpiece. Male and female saints are shown standing under arcades on the backs of the panels (Sts. Catharine, Mary Magdalene, and Margaret on the reverse of the Gethsemane scene; Sts. James the Less, Bartholomew, and Philip on the reverse of the Resurrection panel, Fig. 63). A third panel, depicting the Entombment, is stylistically related but was probably painted by an assistant. Painted shortly after 1380, these figures show a return to Gothic elongation but without an equal recourse to linearity. There is no insistence on modeling, but a heavy chiaroscuro, a richness of color and tone, an interest in spatial intervals, a variation of silhouette, and an emphatic distinction between ideal and low types contrast with what has gone before. Yet the Wittingau Master abandoned neither the linearity of the Gothic nor the naturalism of Theodoric; instead, he combined them (and even exaggerated them in the plebian faces and contemporary costumes in the Resurrection), employing his dark chiaroscuro and his subdued yet glowing color (as in the starred red backgrounds) as the unifying elements. An almost Oriental mysticism seems pervasive and suggests a Byzantine mystic contemplation united with a delicacy and an elegance that is expressed in the gentle swing of the draperies. Broederlam's

toward the court and filled the demands made by the bibliophilic monarch, whose interest in sumptuous manuscripts has been compared with that of John, Duke of Berry, in France. Both stylistically and iconographically there are strong relations with French illumination, but the use of acanthus foliage bordering scenes in medallions is Italianate. In and around the acanthus are scattered birds, animals, and pretty young girls in bathing shifts, the girls and the kingfisher being emblems of allegory and chivalry. This use of acanthus decoration in the borders antedates by several decades the adoption of similar forms in French illumination. Bohemian artists even influenced English illumination of this period, for example, in the *Liber Regalis,* Westminster Abbey Library, of about 1382. (It must be remembered that Richard II married Anne of Bohemia in that year.)

Characteristic examples of the workshops' style are: the Wenzel Bibles, originally in three volumes but now in six volumes, in Vienna (Ms. 2759–2764), begun about 1389; the *Bible of Wenceslaus* in Antwerp (Fig. 61), dated 1402 (Musée Plantin-Moretus); the *Golden Bull of Charles IV* (Vienna, Ms. 338), about 1400; and a *Martyrology* [4] of about 1402 (Gerona, Spain,

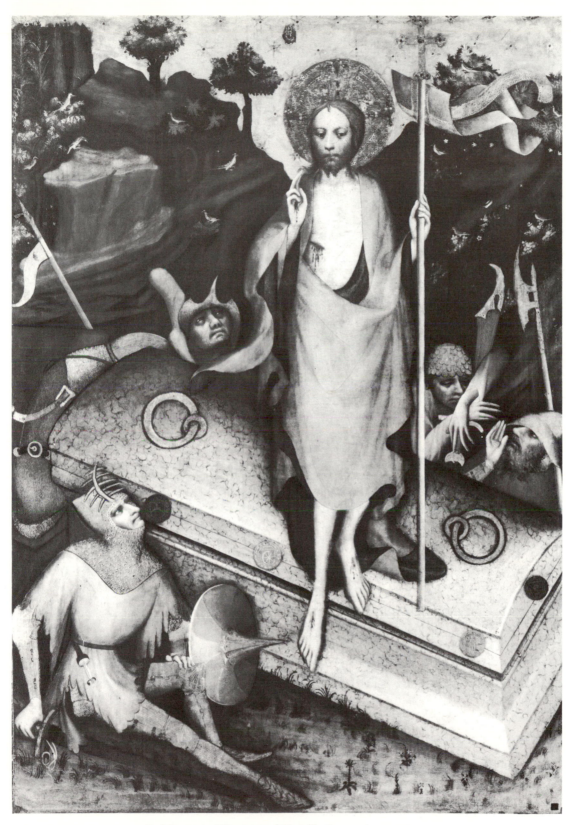

62. MASTER OF WITTINGAU (TŘEBOŇ). *Resurrection. c.* 1380–90.
Panel, 52 × 36 ¼″. National Gallery, Prague.

below: 63. MASTER OF WITTINGAU (TŘEBOŇ). *Sts. James the Less, Bartholomew, and Philip,* reverse of Fig. 62.

right: 64. WORKSHOP OF THE MASTER OF WITTINGAU (TŘEBOŇ). *Crucifixion. c.* 1390–1400. Panel, 49 ¼ × 37 ⅜″. National Gallery, Prague.

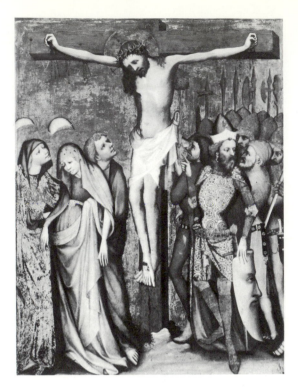

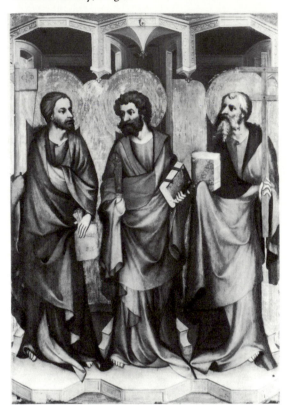

style (which the Wittingau Master antedates by at least a decade) has been suggested as a parallel (Fig. 20), but this expressive mysticism has no counterpart in the western countries, though it is interesting that a *Crucifixion* (Fig. 64) of about 1400, in Prague, having a workshop relationship to the master, presents several striking similarities in conception and detail to the central theme of the *Calvary of the Tanners' Guild* (Fig. 55). Thus, the distinctive emotive style and mystic naturalism of the Wittingau Master have affinities, and possibly even connections, with the art of western Europe.

Bohemia's stylistic development parallels that already seen in France, progressing from linearistic to volumetric and then to spatial concerns, in which chiaroscuro plays a strong part. Bohemian art differs from that farther west in its emphatic accentuation of a native mystic expression. Attuned to more Eastern temperaments, its splendor was to exert a strong influence in central Europe, particularly in southern and eastern Germany and in Austria, reaching as far north as Hamburg. In Bohemia itself the great flowering of art left no effective heirs because of the chaos of religious warfare that followed the burning of John Huss. Prague lost its prestige as the leading court of central Europe with Wenceslaus' death in 1419.

AUSTRIA AND GERMANY

THE INTERNATIONAL STYLE WAS A COURTLY ART, as has been seen in the preceding chapters, and it was from the courts and their entourage of nobles and clergy that art commissions emanated. Interchanges between the courts explain the appearance of court art in the provincial centers subject to them. In effect, Austria and southern and eastern Germany came within the Bohemian orbit until 1419.

AUSTRIA

Vienna became the leading cultural center of Austria, having a university founded in 1365 by Rudolf IV, in emulation of his father-in-law, Charles IV. The political ambitions of the Hapsburgs came to fruition in 1438, when Duke Albert was elected emperor, but even before that Vienna had taken precedence over Prague because of the Hussite wars.

The portrait of Rudolf IV (Fig. 7) is an Austrian expression comparable in style to the Bohemian manner of Theodoric, as seen in Archbishop Očko's votive panel (Fig. 60). Executed between 1358 and 1365, Rudolf's portrait, like the French portrait of John the Good (Fig. 6), carries no sacred or sepulchral meaning. The stark naturalism of the partially opened mouth and the general closeness to the picture plane are counterbalanced by the decorative patterning of crown and gown.

The remainder of the 14th century in Vienna was dominated by the style of Theodoric.

About 1410 appeared the Master of Heiligenkreuz, who may have been French and is possibly identifiable with a Master André, traceable in Vienna between 1411 and 1434. Two panels in Vienna are attributed to him: one, the *Annunciation* (Fig. 65), has a richness and clarity of presentation, without the mystic imagination of the Wittingau Master, and an expressive quality that has been linked with the Rohan Master; the other, a *Mystic Marriage of St. Catherine,* completes the right-hand portion of the architectural setting and balances two female saints above the wall with the two male saints. (Two other panels ascribed to the master are in Washington, D.C., and Cleveland.) French ideas were brought to Vienna by the Heiligenkreuz Master in such paintings. A symbolic idea nowhere else evident in Middle Europe at the time, but destined to develop into a full-fledged, though disguised, symbolism in Flanders, is playfully expressed by the two small angels at the upper left of the *Annunciation;* their action in setting a capping molding on a structure adorned with the figure of Moses signifies the end of the old dispensation (the era "under law") and the beginning of the new dispensation (the era "under grace") implied by the Annunciation.

French influence (and possibly that of Cologne) is visible in the throne-of-mercy (German:

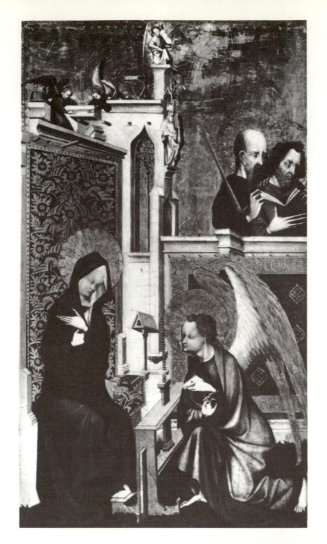

Gnadenstuhl) motif of the *Trinity* (Fig. 66) of about 1430, in London. The artist is close in style to the Master of the St. Lambert Votive Panel (now often equated with Hans von Tübingen[1]), whose style is identified by a work in the Steiermärkisches Landesmuseum Joanneum in Graz, Austria. The motif of the London panel goes back at least to Abbot Suger and St. Denis and is presented in the form most commonly found in manuscript illuminations. Stylistically the panel is ultraconservative; the throne suggests the type visible in the *Glatz Madonna* (Fig. 59), and there are parallels in France in the style of Beauneveu and Jacquemart. The mixture of linear and plastic elements is of such high quality that the panel was formerly thought to be French.

The facial type of the angels also appears in other Austrian works of this period. A fine example is a devotional picture in Berlin of the dead Christ against the foot of the Cross, flanked by the seated figures of Mary and John in mourning. A city gate at the right probably symbolizes Jerusalem. Here the darker brown tones and general spirit suggest the influence of the Wittingau Master. Several other works by the unknown painter of this Berlin panel (identified as the Presentation Master) seem to have been created under the influence of a Boucicaut-style manuscript.

above: 65. MASTER OF HEILIGENKREUZ. *Annunciation. c.* 1410. Panel, 28 3/8 × 17 1/8″. Kunsthistorisches Museum, Vienna.

right: 66. STYLE OF THE MASTER OF THE ST. LAMBERT VOTIVE PANEL. *Throne of Mercy (Trinity). c.* 1430. Panel, 46 1/2 × 45 1/4″ (with frame). National Gallery, London.

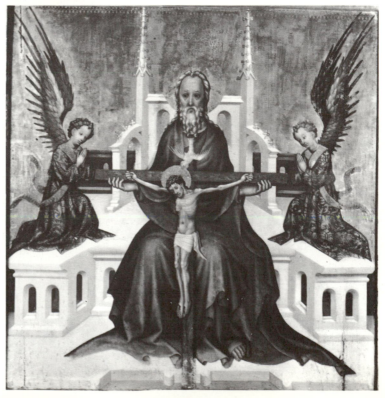

GERMANY

The markedly conservative character of the Viennese school has a parallel in the art of Franconia, in whose center of Nuremberg the Master of the Imhoff Altarpiece [2] painted his masterpiece in the church of St. Lorenz, between 1418 and 1422. The central panel, the Coronation of the Virgin (Fig. 67), shows a mixture of forms reminiscent of Theodoric and tonalities close to those of the Wittingau Master. A modernized version of the style, that is, with less soft modeling, more naturalistic proportions and detail, but Italian composition, is seen in his *Bamberg Altarpiece* (Munich, Bayerisches Nationalmuseum), of 1429.

In Bavaria, strong influences from Bohemia (without the lyricism) may be seen in the *Pähler Altarpiece* (Fig. 68; Munich, Bayerisches Nationalmuseum), of about 1400. The Wittingau influence may have been transmitted by a Viennese painter. It is even stronger in the violent pathos of a *Crucifixion* from the church of St. Augustine in Munich. Clearly Bohemia exerted the dominant influence in these regions.

MASTER BERTRAM

In the prosperous Hanseatic center of Hamburg a style parallel to Master Theodoric's made its farthest northern advance, appearing in the art of Master Bertram. [3] This master, from Birde, near Minden in Westphalia, is first mentioned in the Hamburg accounts in 1367. Listed as a master in 1373, his name appears more often in the accounts between 1367 and 1387 than that of any other artist, an indication that he must have been the leading master of the day. In 1375 he went on city business to Lübeck, possibly for the reception of Charles IV.

In 1383 Master Bertram's high altar of the church of St. Peter in Hamburg was set up. This is probably the work now in the Kunsthalle, Hamburg, known as the *Grabow Altarpiece*.

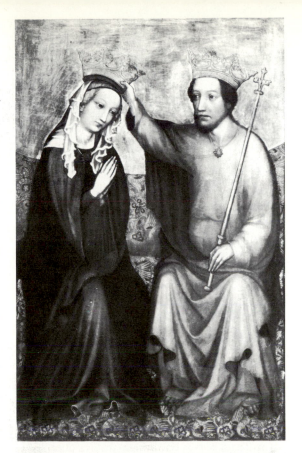

top: 67. MASTER OF THE IMHOFF ALTARPIECE. Coronation of the Virgin, *Imhoff Altarpiece*, center. *c.* 1418–22. Panel, 46 1/2 × 30 1/4". Church of St. Lorenz, Nuremberg.

right: 68. MASTER OF THE PÄHLER ALTARPIECE. Crucifixion, *Pähler Altarpiece*, center. *c.* 1400. Panel, height 41". Bayerisches Nationalmuseum, Munich.

It is dated 1379 on the sculptured shrine, which is protected by painted wings with 24 scenes. The central group of the Crucifixion, with Mary and John below Christ on the Cross, is flanked by 44 small sculptured prophets, apostles, and saints in two rows extending onto the wings. The type is an apparently free adaptation of a popular text, the *Speculum Humanae Salvationis,* or *Mirror of Human Salvation* (German: *Heilspiegel*), represented in four groups: six (actually seven) scenes to the creation of Eve; six (actually five) scenes to Adam digging and Eve spinning after the Expulsion; six scenes from the sacrifice of Cain and Abel to Isaac's blessing; and six scenes from the Annunciation to the Flight into Egypt. Sculptured in the predella are ten figures, including the Church Fathers. The Annunciation is directly below the Crucifixion. In a band above the main sculpture, more prophets appear in medallions. The wise and foolish virgins are shown above the center shrine.

The painted panels begin with the scene of the separation of light from darkness (Fig. 69). God appears standing beside a Heaven made from cloud forms, in which the head of God appears again, looking from under His eyelids at the falling angels about to disappear into the globe below. One of them, Lucifer, wears a

crown and holds a scroll that reads: *Ascendero super altitudinem nubium similis ero altissimo* ("I will ascend above the heights of the clouds; I will be like the most High"). This quotation of the fourteenth verse of Isaiah 14 implies the fifteenth verse: "Yet thou shalt be brought down to hell, to the sides of the pit." More than a narration of the Creation, the scene also shows the contrast of good and evil, between which man must decide with the aid of Christ. Thus the idea of mankind's salvation is conceived to have existed from the very beginning.

The panel of the creation of Heaven and earth shows God standing on a checkerboard floor in rough perspective. A circular Heaven contains the head of Christ, the second person of the Trinity. Surrounded by scalloped clouds, He looks sideways out of the corners of His eyes toward the Creator, thereby suggesting the coming sacrifice as agreed upon.

From this point on, Master Bertram follows Genesis, with a panel for each day except that the creation of the sun, moon, and stars precedes the creation of the plants and animals. The creation of mankind is represented on two panels, one for the creation of Adam and one for the creation of Eve.

Stylistically Bertram was close to Master Theodoric in his voluminous figures with their soft modeling and stout proportions. Luminosity is evident in the modeling of the stylized garment folds, and a chiaroscuro treatment gives form to the woods in the creation of the plants. This suggestion of an observed nature, with a darkening of the wood as it recedes, contrasts with the charming but visually naïve scene of the creation of the animals. Obviously taken from a model book similar to that in Vienna (Sammlung für Plastik und Kunstgewerbe, 5003-04), possibly of Bohemian origin, the birds are stacked vertically against the gold background, without any attempt to relate them to their surroundings.

Though somewhat naïve conceptually, Master Bertram was not artistically naïve, as is evident in the panel of Eve's creation (Fig. 70). The generalized nude figure of Adam is inter-

left: 69. MASTER BERTRAM. Separation of light and darkness and fall of the rebel angels, *Grabow Altarpiece,* detail of wing. 1379. Panel, 68 1/8 × 66 1/2" (over-all; detail *c.* 33 1/2 × 22 1/2"). Kunsthalle, Hamburg.

70. MASTER BERTRAM. Creation of Eve, *Grabow Altarpiece,* detail of wing. Cf. Fig. 69.

mediate in size between the much smaller figure of Eve growing out of his rib and the larger figure of God, whose dramatic actions dominate the scene. This medieval conception of size also governs an essentially symbolic architecture, which, in the Expulsion scene, provides just enough setting for the action. Master Bertram was a master of the drama of movement in contained, simplified forms. Exactitude in figural proportions or articulation was neither attempted nor necessary, as in the scene of Adam digging in the stylized rocky soil.

Certain ideas appearing in Master Bertram's *Grabow Altarpiece* are found in later French and Flemish work. In the Annunciation scene the Christ Child descends bodily from Heaven carrying the Cross over his shoulder, a motif then much condemned by theologians. It was, however, popular in Germany and the Netherlands and was used in painting as late as the Master of Flémalle's *Mérode Altarpiece* (see Chap. 4). Of Italian origin, the motif was apparently avoided in French art; here it appears

for the first time in northern art. Also, the *Grabow Altarpiece* shows an early stage of Joseph's transformation into a comic figure; in the Nativity scene he hands the Child to Mary with an extremely dour look on his face, and in the Flight into Egypt he pulls the stopper out of the water bottle with his teeth.

Master Bertram's color is brighter than that of Bohemian painting, for he used a color scheme of slightly higher value; however, the general relationship to Bohemia is so close that some kind of contact must have taken place. There are also differences, including a greater monumentality of composition, stronger plasticity of the forms, and simple directness of the narrative.

In 1390, as is known from a will he wrote in that year, Bertram took a trip to Rome, and in 1410 a second will left money for the nunneries at Harvestehude and Buxtehude. He died between February 20, 1414, and May 13, 1415, probably close to the latter date, when his estate was put on file. A *Passion Altarpiece* of the 1380s, in the Landesmuseum in Hannover, is probably from his hand.

The *Buxtehude Altarpiece* in Hamburg, made before 1410, is the work of a follower of Bertram. By adding more detailed narrative to his designs, the painter of the *Buxtehude Altarpiece* attempted to modernize the style. He multiplied small movements, added greater complexity to a more logical architecture, and agitated the surface and space in general. A more ornate and complex painterly surface appears in the draperies, which lack the earlier largeness of movement and simplicity of sculpturesque form; more flickering light and a greater number of curling drapery ends appear. The attempt at modernization was qualitatively not a resounding success; what was needed was a new style with its own integrity, not the transformation of an old one into a later phase of the International Style by complicating its surfaces (as in the Coronation of the Virgin, Fig. 71). In the Nativity the figure of Joseph drinking out of a canteen is used as a space-filling device. The motif, with far greater logic in its use, had appeared earlier in Broederlam's Flight into Egypt (Pl. 2), another instance of the attempt to modernize and enrich.

Both the *Passion Altarpiece* and the *Harvestehude Altarpiece* (in Hamburg) are closer in style

to the *Grabow Altarpiece* than to the *Buxtehude Altarpiece*. Two other works, the *Apocalypse Altarpiece* in London (Victoria and Albert Museum) and, particularly, six panels of scenes from the life of the Virgin and Christ, in Paris (Musée des Arts Décoratifs), datable in the 1390s at the earliest, seem very closely related to the works of Bertram, possibly issuing from his shop.

COLOGNE, THE LOWER RHINE, AND WESTPHALIA

Along the Rhine, and particularly at Cologne, the International Style appeared under French influence and was transformed into a distinct local expression that carried over well into the 15th century. Cologne, enormously rich and powerful, member of the Hanseatic League, site of a university founded in 1389, was in close communication with the Netherlands, England, and France and throughout the century transmitted artistic ideas to the rest of Germany. [4]

Cologne's commercial prosperity was reflected in an artistic "prosperity" that gathered in the early 15th century about an artist known as the Master of St. Veronica, from the painting of this subject in Munich. During the first third of the century, he was the head of a busy workshop. His luminous style grew out of the softer,

more Gothic style of the painter of the later portions of an altarpiece of St. Clare, now in Cologne Cathedral. A serene St. Veronica in the master's painting (Fig. 72) holds a tremendous cloth, on which a very large, dark brown head of Christ is frontally placed. Variety is given to the theme by the slight inclination of the saint's head and by the two groups of chubby angels in the lower corners. Softly molded by light and delicate color, the figures parallel in panel painting the work of Parisian miniaturists of the later decades of the 14th century but transform French sophistication into a charming, mystical naïveté. Rosebud mouths, softly rounded features with heavy eyelids, and smooth, high-key surfaces against a gold background give a gentle feeling that was much emulated and paralleled in the surrounding

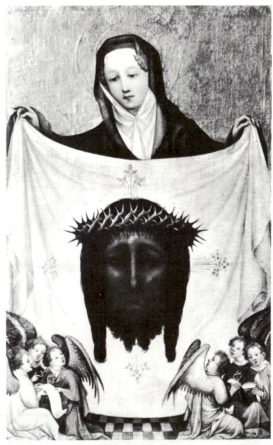

top: 71. FOLLOWER OF MASTER BERTRAM. Coronation of the Virgin, *Buxtehude Altarpiece,* exterior of right wing. Before 1410. Panel, 43 1/8 × 37″. Kunsthalle, Hamburg.

above: 72. MASTER OF ST. VERONICA. *St. Veronica. c.* 1400. Panel, 30 3/4 × 18 7/8″. Alte Pinakothek, Munich.

regions on the other side of the Rhine. Even the "Gold Scroll group" and other Flemish artists seem to have been touched by this spirit. It appeared early in the Cologne area and corresponds to the gentle spirit of the German Rhenish mystics Tauler and Suso.

A master working in the same style (possibly identical with the Master of the Golden Panel, known for his name work in Hannover) is responsible for the *Madonna and Child with the Bean Blossom* (Fig. 73), the central panel of a triptych, in the Wallraf-Richartz-Museum in Cologne. Here the calm serenity of the Veronica Master is more blandly presented and the modeling is even softer. There is some exaggeration in the enlarged foreheads.

Across the Rhine from Cologne in Westphalia,[5] a parallel style, though somewhat less luminous in its expression, can be found in the art of Konrad von Soest. Known to have been working in Wildungen in 1403, he is probably the Master Konrad who, between 1413 and 1422, was a member of the St. Nicholas Church Brotherhood in Dortmund. He was married in 1394 and may have worked in Dortmund before 1403, which is possibly the date of his *Niederwildungen Altarpiece,* though the rubbed inscription has been dated ten and eleven years later by some writers.

The central panel of the altarpiece represents the Crucifixion (Fig. 74), its treatment recalling

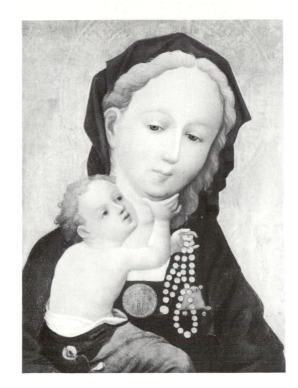

above: 73. MASTER OF THE GOLDEN PANEL(?). *Virgin and Child with the Bean Blossom,* center. *c.* 1410 (?). Panel, 20 7/8 × 13 3/8″ (inside painted surface). Wallraf-Richartz-Museum, Cologne.

below: 74. KONRAD VON SOEST. Crucifixion with scenes of the Passion and the Ascension, *Niederwildungen Altarpiece,* center. 1403(?). Panel, height 78 3/4″. Church, Niederwildungen, Germany.

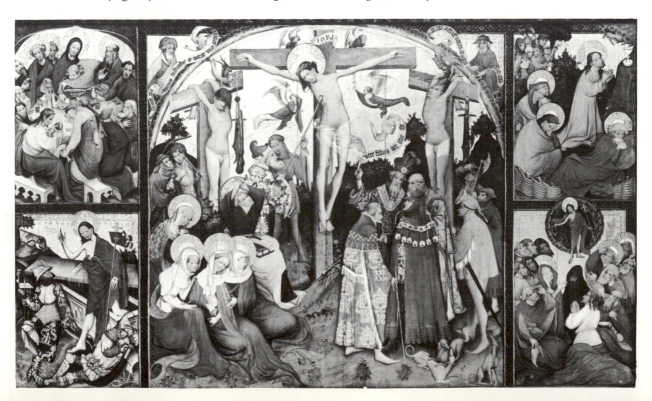

at a remove what has been seen in Parisian painting. A trip to France by Konrad von Soest has been postulated, but French influence could have come through manuscript illumination. The elegantly attired, strongly profiled group of officials at the lower right, who have come to witness the death of Christ on the Cross, and the seated group of the Virgin and her companions at the left are so prominently placed yet so little involved in any emotional drama that the whole seems to be constituted of charming areas of fine drawing, rich costume, decorative pattern, and gay color; the Crucifixion itself appears almost an afterthought. As in Parisian painting related to Jacquemart, the color is high in key and the pastel tones are delicate and delightfully handled. What is un-Parisian is the comparatively raw use of actual gold, as in the ornaments of the mantle of the foremost official. Delicacy in color and delicacy of form go hand in hand, even in the gently curved and modeled body of Christ on the Cross. Characteristically German are the haloes, large as dinner plates. In the central panel the Crucifixion is flanked by two scenes on each side (left, Last Supper and Resurrection; right, Gethsemane and Ascension).

75. KONRAD VON SOEST. Nativity, *Niederwildungen Altarpiece,* scene on left wing.

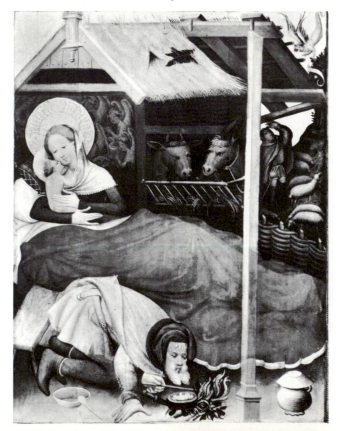

Four scenes in two superimposed rows adorn each of the wings (left, Annunciation and Nativity above and Adoration of the Magi and Presentation in the Temple below; right, Christ before Pilate and the Crowning with Thorns above and Pentecost and Last Judgment below). When fully opened, the altarpiece is over 24 feet wide by 6½ feet high; it is the chief work in Westphalian painting of this era, in size as well as quality. The Nativity (Fig. 75) shows a charming mixture of refinement and genre. The tender sentiment expressed by the close contact between Mother and Child, further enhanced by the delicate tapestry of angels around her head (suggestive of the Brussels *Hours*), is contrasted with an intentionally comic treatment in the hunched figure of Joseph, who seems to be in danger of setting his beard on fire. Intent on keeping the fire going, he puffs out his cheeks to blow on it. Konrad von Soest's spatial construction is not so advanced as in the Parisian art he emulated. Despite the inclusion of elements that could convey spatial depth, he flattened his forms with strong silhouettes and arranged them parallel to the picture plane in a manner that suggests a composition in layers.

The Death of the Virgin, from his *Dortmund Altarpiece* of about 1422 shows a host of tiny angels who have come to minister to the Virgin during her last moments as the apostle John puts the palm leaf in her hand (Fig. 76). Like little butterflies, the angels surround her, close her eyes and lips with soft, delicate hands, and remove any sense of sorrow from the scene. They make it seem a joyous occasion, from which the apostle at the left, energetically blowing on the lamp, turns away in his concentration.

Konrad von Soest brought to his art a largeness of conception and formal unity, which he combined with the delicacy in color and form of Parisian art of the last decades of the previous century. The Veronica Master in Cologne was his close contemporary, but Konrad von Soest was more incisive. As a result, his art dominated the painting of Westphalia and the lower Rhine region in the first third of the century.

MIDDLE AND UPPER RHINE

In the region of the middle Rhine the outstanding work of the period 1410–20 is the *Ortenberg Altarpiece,* in the Hessisches Landes-

museum in Darmstadt, from the high altar of the church in Ortenberg. The subject is the Holy Kinship (Fig. 77), or group representation of the family connections of Christ, a popular theme of the genealogically curious medieval period. In the center is Mary with the Christ Child; in the upper row to the far left is Mary Cleophas, with her youngest children, Simon and Joseph, in her arms and James the Less and Judas Taddeus at her feet; then between her and the Virgin are Mary Alpheus, St. Anne, and St. Joseph. Immediately to the right of the Virgin is St. Elizabeth with the young John the Baptist; then, continuing to the right, are Ismeria, the sister of St. Anne, and her great-grandson, St. Servatius. In the lower row Mary Salome is seated with St. James the Great and John the Evangelist; then Sts. Agnes, Barbara, and Dorothy complete the grouping, with the addition of two angels below the Virgin and Child. Combined with the Holy Kinship theme is a *conversatio mystica* (or *sacra conversazione,* an iconic representation of the Virgin and Child with saints of a later period), though this is insufficient explanation for the absence of certain male members normally present.

AUSTRIA AND GERMANY 59

Possibly the work of a Mainz master, for the figure style seems related to the Memorial Portal sculpture of Mainz Cathedral, the work is a technical tour-de-force in its use of materials. The figures are set against a gold background, into which their large halos are tooled. Color is very limited, being principally tones of yellow, gold, tan, and white with black, yet there is no feeling of a lack of color, since the master has so skillfully rendered his forms. The yellow garments are painted over a silver base, and the very difficult feat of producing a convincing painting of shaded forms over gold is also handled with perfect ease. This remarkable technical accomplishment, recalling work in enamel, is in the service of a style unrelated to miniature painting. The decorative patterning of the whole and its limited spatial effect are, however, conditioned by the artist's technique. A complication of formal movement in the drapery is counterbalanced by the naturalism of the somewhat full faces. Lively glances, movement, and animated rhythms create a real sense of conversation, markedly different in its immediacy from the serenely sweet mysticism of much contemporary German work.

78. UPPER RHENISH. *Joseph's Doubt.* c. 1420. Panel, 44 ⁷/₈ × 44 ⁷/₈″. Musée de l'Oeuvre Notre-Dame, Strasbourg.

At this same period, in the upper Rhine region, a more spatial feeling was also attempted in the fine *Joseph's Doubt,* of about 1420, in Strasbourg, a representation of Joseph's momentary doubt about the miraculous Virgin Birth of Christ (Fig. 78). The artist modeled himself on French miniature painting and created a highly convincing interior space on the basis of such works as those of the Boucicaut and Bedford masters, using perspective and light, though still in a rudimentary manner, to accomplish his aim.

The Master of the Frankfurt Paradise Garden (Pl. 6, after p. 180) took a different approach to space about this time. His painting is a tapestry transformed into delicate color. Ultramarines, vermilions, warm siennas, and greens are used freshly and delicately to produce a naïve gaiety within a garden that symbolizes both Mary's virginity and the world of God. The Christ Child plays with St. Cecilia's psaltery, and Sts. Michael and George engage in conversation, while St. Sebastian is an interested listener. St. George's now harmless dragon lies quietly on his back, and Michael's demon also rests. Evil and man's base passions, symbolized by these animals, have no power in a paradise filled with beautiful flowers, trees, and birds. Though here too the perspective is rudimentary, one disregards it in appreciation of the mastery of pattern and color and the delightful, yet almost scientific, portrayal of flowers (some of which convey distinct symbolic meaning in relation to the Virgin). The elegance of the work suggests a connection with the International Style in Paris at the height of its luxuriance.

A work of somewhat related spirit but more plastically conceived is the *Madonna with the Strawberries,* of about 1430, in Solothurn, which offers, in its increased plasticity, a hint of future developments.

MASTER FRANCKE

Hamburg, in the first quarter of the 15th century, was won from Bohemian influence by a master, probably trained in Paris, who brought a new spirit to displace that of Master Bertram and his followers in the expression of the International Style. With Master (or possibly Frater) Francke [6] the final phase of the International Style in Paris reached Hamburg. His small existing œuvre includes an altarpiece devoted to

the life of St. Barbara, in Helsinki; the documented *Altar of the Englandfahrer,* in Hamburg; and two renderings of Christ as Man of Sorrows, one in Hamburg and one in Leipzig.

The *St. Barbara Altarpiece* (Fig. 79), with scenes from the legend of her life, shows an interest in narrative realism that goes far beyond the art of Master Bertram in this direction. Dating to the second decade of the 15th century, the work is connected in spirit with the Limbourgs. While Barbara flees from her father (she is seen at the right as her father asks directions), the two shepherds show by gestures and actions a relation to the peasants in the August minia-

ture of the Limbourgs. On the other hand, Francke's snub-nosed peasants are represented in a social perspective, for they are much smaller than Barbara's father. The oversized grasshoppers are the transformed sheep of the shepherd who basely betrayed Barbara's hiding place. The naturalism of the rendering is especially noticeable in the tattered clothing. Insistence on the distinction of types is a constant in the art of Master Francke. Thick lips and broadened, coarse faces with bulbous noses are common devices in his art, though the dramatic effect is tempered by the light and gentle color scheme.

The *Englandfahrer* (or *Thomas*) *Altarpiece,* his major work, was completed late in 1424 for merchants who traded with England and was set up in the church of St. John in Hamburg. Stylistically it follows his *St. Barbara Altarpiece.* Its nine paintings of the life of Christ culminate in the Crucifixion, of which only a fragment remains; the other scenes are from the life of St. Thomas à Becket, patron saint of the trading company. In the scene of the Flagellation of Christ before Pilate (Fig. 80) the contrasts between elegance and realism are even stronger than in the *St. Barbara Altarpiece.* Christ's pose

above: 79. MASTER FRANCKE. Pursuit and betrayal of St. Barbara, *St. Barbara Altarpiece,* scene from the right wing, *c.* 1415. Panel, 36 × 21 1/4″. Nationalmuseum, Helsinki.

right: 80. MASTER FRANCKE. Flagellation before Pilate, *Englandfahrer Altarpiece,* scene. 1424. Panel, 39 × 35″. Kunsthalle, Hamburg.

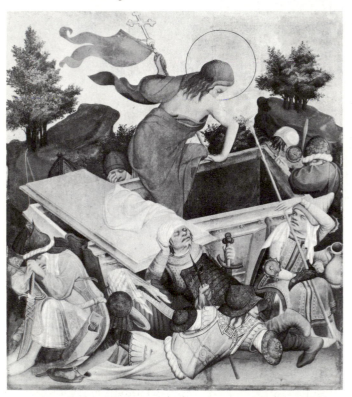

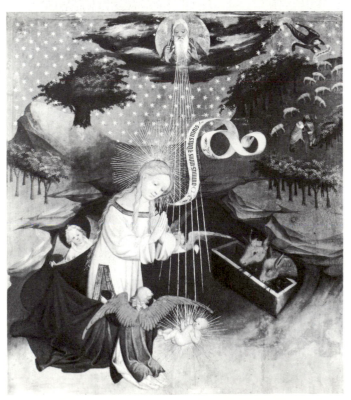

is in actuality very elegant, yet the body is blood-spattered. This realistic emphasis is repeated in the men with flails surrounding Christ. Rich apparel and an interest in space go hand in hand in the elaboration of naturalistic detail to add conviction to the drama. Its pathos is further enhanced by the facial type of Christ, the inher-ently pathetic expression owing much to the diagonal placement of the eyes and brow and to the slender head shape. By comparison the other figures are brutish and mean.

The same base types appear in the Resurrection scene (Fig. 81). Master Francke's conception is far removed from the invocation of the super-natural in the floating figure of the Wittingau Master's *Resurrection* (Fig. 62), for Master Francke's Christ climbs out at the back of the tomb, pushing hard against the edge in the process. Everything is more overtly dramatic and closer to natural procedures and appearances. Yet the artist did not go so far as to imitate natural acts; smooth surfaces, strong silhouettes, and flat color areas give a rhythmic stylized design in which actual space is merely hinted at and never explored.

Francke's identification with the delicacy and elegance of the International Style is never in doubt, appearing, for example, in the theme of the Nativity (Fig. 82). The scene takes place in a cave, as described in the *Revelations* of the 14th-century Swedish mystic St. Birgitta (Bridg-et), but Joseph and his candle, which is to be outshone by the divine light emanating from Christ, is absent. The type had appeared briefly in Paris, also without the candle, but, as Panofsky has argued, Master Francke's version may derive from Netherlandish sources. (This point relates to the belief that Master Francke was a native of Guelders.) The figure of Joseph with his candle is also lacking in the Nativity page of an illuminated Bohemian missal, and it is even possible that Master Francke was partially influenced by the Wittingau manner, for the background is closed off by a dark red Wittingau sky regularly studded with golden stars. Behind the white-clad kneeling Virgin is the cave setting, ultimately derived from Byzantine models but now flattened to agree with hills and trees in the manner of French miniatures.

Connections with the Netherlands are, how-ever, firm. In the scene of the Adoration of the Magi there is a motif frequently found in

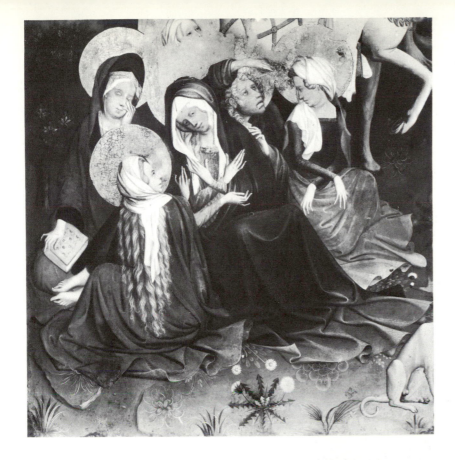

Netherlandish representations—the youthful Magus in the long trailing gown, who shades his eyes to look at the star being pointed out to him by the second Magus. Here, as well as in the scenes from the life and martyrdom of St. Thomas à Becket and in the beautifully colored Crucifixion fragment of the holy women, the drama is set on a narrow stage under a pictorial, almost chiaroscuro, lighting, which Francke used to accentuate the human aspects. A new informality, as in the woman seated with her back to the spectator in the fragmentary Crucifixion (Fig. 83), is expressive of Francke's realistic bent.

Netherlandish connections are also visible in the *Man of Sorrows* (Fig. 84) in Hamburg, an *Andachtsbild,* or devotional picture, with three diminutive angels holding Christ's robe and two more, also small, holding the sword and the lily (a reference to the Last Judgment). The hand of Christ is placed not to stem the flow of blood from his side but to call attention to it. Francke stressed Christ's suffering by the angularity of the hand. A naturalistic accentuation is apparent in the chiaroscuro that shades the mouth, concentrates on the eyes, and darkens around the head to set out the crown of thorns. This latest

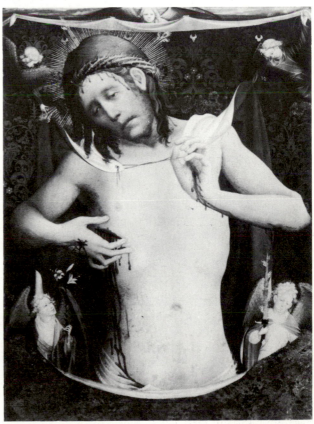

work by Master Francke, about 1430, asserts a richer pictorial sense of shading. The figure almost exists in real space with the suggestion of a surrounding atmosphere. The forms on the left side are almost lost, and sharper outlines accentuate the right side. The light in which Christ emerges emphasizes the immediacy of the theme and its direct connection with the physical world. Here is the culmination of the naturalistic tendencies in Francke's style; these naturalistic tendencies were carried even further in the art of the great Flemish masters to whom he was related.

As Master Bertram by the force of his personality carried all before him, so Master Francke exerted an overwhelming influence upon the areas to the east of Hamburg, replacing the Bertram and Bohemian styles with his own new naturalism, which ruled for several decades until the stronger artistic expression of Flanders swept out all older modes.

Art in Austria and Germany at this period gives ample evidence of an energetic practice of panel painting. It makes even more regrettable the destructions that have taken place over the centuries in France, where panel painting must have had an equally vigorous life, for the developments in surviving French and Bohemian art find their echoes up and down the Rhine and across the Germanic lands. Each powerful center had its distinct zones of influence, the strongest being geographically closest, except for Bohemia's far-reaching influence in Hamburg. In this area, if anywhere in the art of the period, is visible the strength of the development of national points of view. Germany's weakness as a national entity and its lack of autonomy made it receptive to the strong, self-reliant outlook of its neighbors.

Like France and Bohemia, Austria and Germany in the late 14th and early 15th centuries progressed from a volumetric linearism through a transformation of soft volumes, as in Bondol, Beauneveu, Theodoric, and Bertram, into greater richness, delicacy, and elegance, the marks of the International Style. But everywhere the transformation into that style was conditioned by local preferences, as the style found in Cologne makes abundantly clear. Master Francke in Hamburg, with his union of French elegance, central European mystic expression, and the dominant Netherlandish realism, was the exemplar of what was possible.

PART II

THE FIFTEENTH CENTURY: Observation and Exposition

The year 1400 quietly entered the chronology of European history. Monarchy in 1400 was, if anything, not so advanced as it had been at the beginning of the previous century; the insane ruler of France was the prey of the nobles; in England the monarch was a child; in Bohemia Wenceslaus, who had succeeded his father as king of the country and as Holy Roman Emperor, had not inherited his father's ability. Yet by the end of the 15th century France had a powerful ruler governing a territory close in size and scope to that of modern France, thanks to the consolidating efforts of his great predecessor, Louis XI; England had overcome its internal struggles and was being ruled by its first Tudor monarch, Henry VII; and the Catholic monarchs of Spain, Ferdinand of Aragon and Isabella of Castille, had consolidated their territories by marriages and alliances to such an extent that their grandson, the future Charles V, was to become the ruler of Spain,

the Netherlands, Germany, Austria, and the newly discovered lands of America.

Concurrent with the growth of monarchy by the end of the century was the decline of the power of the nobles. In Spain and the Netherlands they had become subservient to the court; in France, however, their position was far from comparable. Though the Italian campaigns of the last decade of the 15th century occupied their energies, they were to become troublesome indeed in the following century. A corollary to the decline of the nobles was the rise of educated administrators within the monarchical councils, which were the chief means of government; the earlier representative assemblies, except in England, had not been revived. The administrators were usually members of the upper bourgeoisie, and many followed the practice of their rulers in commissioning works of art, among them the powerful chancellor of Burgundy, Nicolas Rolin, Pierre Bladelin, and Jean de Gros, all officials of Duke Philip the Good and all patrons of Rogier van der Weyden. Their position in government is an indicator of the continuity of change in the society of the day, in which the gulfs were becoming greater between rich and poor, between high and low clergy, between rich and poor nobility, between rich merchant princes and petty burghers. It was, however, a more dynamic society than that of the previous century, for the possibility of rising through the classes had increased. By the end of the century artists also participated in the dynamics of the possibility for change, though exceptional artists, such as Jan van Eyck, had already achieved high positions in the third decade. In Italy the change was more open, as the *condottieri* had already proved in the previous century.

Even more than in the 14th century great banking families came to the fore. In Florence the Bardi and Peruzzi families of the 14th century were succeeded by the Medici, who, under the direction of Cosimo de' Medici turned economic power into political power. Such a transformation could not be achieved by France's greatest 15th-century financier, Jacques Cœur; despite the great wealth he had amassed by his enterprise, and despite his services to France, he was despoiled of almost all his properties, and with the consent of the monarch. In Germany the Fugger family began its great banking career, attaining prominence toward the close of the 15th century and continuing in the next under Jacob Fugger II, called "the Rich."

The most volatile forces of the previous century remained volatile in this, while the declining force of the 14th century, the Church, continued its downward fall. Of all the institutions in existence at this period the Church was in greatest peril. Though it had survived the Great Western Schism and, in mid-century, had been headed by good leaders, such as Nicholas V and Pius II, its basic ills had been left essentially untouched. With the ascendance to the papacy of Sixtus IV, in 1471, the situation worsened rapidly. Early in the century the French had almost broken away from Rome to come more and more under control of the monarchy, as the Pragmatic Sanction of Bourges (1438) demonstrated by its limitation of the power of the papacy in France. Control of the Spanish clergy was similarly achieved after 1478 by Ferdinand and Isabella, who were successful in having the Inquisition established in their lands to combat heresy. Its officials combined ecclesiastical and civil authority, and, though in theory they were responsible only to Rome, in practice they were under monarchical control. Thus the fundamental strength of the only international organization of the time lay in a unity that was rapidly becoming a fiction. Heresy continued, for example, in Bohemia, a country that was at war through much of the century, following the burning of John Huss in 1415 and the onset of the Hussite wars, which lasted for the next twenty years. The last six years of the reign of Bohemia's native Czech king, George of Podebrad, who died in 1471, were under the ban of excommunication by Rome.

This was the most extreme situation faced by Rome, but throughout Europe there was dissatisfaction with an institution whose secularism, extravagance, and moral degeneration were not only visible in Rome but were widespread at all levels and in all countries. Economic pressures and a rising standard of wealth only aggravated a situation in which the popes, increasingly involved with temporal control of Italian territory, acted like temporal rather than spiritual rulers. Outside Italy reforms were instituted in the regular orders, but their extent and their effect were not large enough to alter the course

of events. The abuses and failures of the Church, however, are not sufficient to explain the coming storm of the Reformation; in addition, the Church did not accommodate sufficiently the new thinking of the period. Defeat of the conciliar reform programs earlier in the century left only faith to fall back upon. This was to prove inadequate.

The efforts toward reform were intensified in the latter part of the century. Savonarola (1452–98) in Florence is a good example, while in the north Denis the Carthusian (1402–71), often called the last of the Scholastics, and Cardinal Nicholas of Cusa (1401–64), who had been trained at Deventer, were particularly influential in their writings. Reform also crept into the popular literature of the day, as Sebastian Brant's *Narrenschiff* (*Ship of Fools*) well indicates. Brant was far from being the only one to attack the vices of the Church's representatives; indeed, a whole literature grew up about the subject. Such reform efforts may have had their corollary in the "Neo"-Gothic art of Hieronymus Bosch in Flanders or the late works of Botticelli in Florence.

Fifteenth-century literature in the north continued what had been begun in the previous century. In contrast to Italy, where a new and vital expression was to be found, the north repeated the older forms. The chronicles of Olivier de la Marche in Burgundian territories and the *Mémoires* of Philippe de Commines, with their personal accounts of events of their own lifetimes formed an exception to the general continuity of older modes. These modes are best represented by that monumental work, the *Nuremberg Chronicle,* an account of the world since Creation, written by Hartmann Schedel and published at Nuremberg in 1493. Profusely illustrated, it was an outstanding example of the older ways of thought.

The dissemination of the *Nuremberg Chronicle* was aided by the most revolutionary force of the age—printing. No other technological innovation of the period was so radically to alter communication and to transform a medieval into a modern world. All areas of human endeavor were to be strongly affected by the printing press. Correct texts widely disseminated meant that the leading ideas of the times, whether political, religious, philosophical, or scientific, could be conveyed to greater numbers of readers

than ever before. (There were over two hundred presses at work by the end of the century.) Though the presses printed the perennial favorites of the medieval world—lives of the saints, liturgical and other religious books—they also published travel literature, astrological works, and the translations of the scholars to enrich the lives and libraries of all Europeans.

The great movement in literature in the 15th century was, without doubt, Humanism, which by the end of the century had developed a philosophy of life based on a mystic assumption that knowledge itself would lead to truth. It took form at the Neoplatonic Academy in Florence under the patronage of the Medici and the direction of Marsilio Ficino. Neoplatonism as a faith and a program affected the life of the last quarter of the century in Italy, but it had little effect upon the north until the next century. Even in Italy the Humanist movement had only a restricted effect upon art for over half of the century, the chief manifestation being seen in the externals of decorative detail in painting, sculpture, and architecture.

In art the 15th century was a great period both north and south of the Alps. In both regions there were progressive and conservative tendencies—a striving for a new concept of form and a dependence upon the older feeling for narrative brought up to date in detail and costume. In treating the individual the north generalized the typical, whereas Italy tended toward idealization. The north preferred to study each element in isolation within a pictorial whole and then to unite all within a spatial, continuous milieu flooded with light and color. The serenity of outlook achieved by Netherlandish painters in the first three quarters of the century was not to be matched in Italy until the first quarter of the 16th century, but during these hundred years Italian artists further explored the world of created forms and movements. An intuitive approach governed the northern artist, who formed his practice on perception and then created his pictorial world according to the dictates of a mystic concept of unity. Far more consciously analytical, developing a rational perspective and an intellectual view of form, his Italian counterpart extracted a theoretical basis for his art from the natural elements and united them according to his understanding of and interest in a classical norm.

The 15th-century transformation of the International Style had its vital center in the Netherlands. Politically subject to the Duchy of Burgundy, the Netherlanders were, through their industry and commerce, chiefly responsible for the eminence of the duchy in the 15th century. The foundations for Burgundy's power had been laid in 1363, when Philip the Bold received it as an appanage in return for saving the life of his father, King John the Good of France, at the battle of Poitiers. The gift was a political error; in time the duchy came to threaten the power of the kingdom itself. Philip married Margaret, widowed daughter of Count Louis de Male II of Flanders, in 1369. When his father-in-law died in 1384, Philip acquired the Flemish lands. However, to control his new territories he had to quell revolts, because the Flemish towns tended to gravitate toward England (then powerful and to be even more powerful later).

English and Spanish wool was a basis of Flemish wealth, for the Flemish towns wove it into cloth, which they sold back to England, Spain, and other countries. The towns had already achieved a large degree of autonomy, ruling themselves and the surrounding countryside. They had been frequently in revolt against Louis de Male, and from time to time they rebelled against his successors, Philip, John the Fearless, who became Duke of Burgundy on the death of Philip the Bold in 1404, and John's son, Philip the Good, greatest of the dukes of Burgundy.

In the course of his long reign (1419–67) Philip the Good added territories (Brabant and Holland in 1433, Auxerre and part of the Pas de Calais in 1435, Luxembourg in 1443). At the Treaty of Arras, in 1435, he withdrew his support of the English, in return for which, among other concessions from Charles VII of France, he was relieved from all homage to the King for his estates during his lifetime. Secure externally, Philip turned to his internal affairs and established a firm government, which encouraged trade and industry and patronized the arts. His example was followed by his court, his administrators, his jurists, the clergy and the rich bourgeois of the towns, the religious confraternities, and the extremely powerful trade corporations.

These professional organizations regulated the flow of supplies, established conditions of labor, salaries, and standards of production, stifled competition, and prohibited advertising. The artists' own corporations were very important, because their regulations governed the training of apprentices, set the standards of quality, established prices, and adjudicated disputes.

When Philip's son, Charles the Bold, became Duke of Burgundy in 1467, he tried to unite Burgundy and the Netherlands by the acquisition of the intervening territories and create a separate kingdom, but his ambitions were laid to rest with his death in 1477 at the Battle of Nancy, and the Grand Duchy of Burgundy disintegrated. Louis XI of France claimed guardianship over Charles's daughter and heiress, the young princess Mary, and French troops occupied Burgundy. In 1477 Mary married Archduke Maximilian (later Emperor Maximilian I) of Austria, but she died in 1482, and the Burgundian lands inherited by her children, Margaret and Philip, fell into new political alignments. Louis XI again intervened; at the Treaty of Arras in 1482 he arranged for Margaret to be promised to the Dauphin of France, so that Louis was confirmed in the possession of her dowry lands of Burgundy, the Franche-Comté, and Artois. Philip's territories—Brabant, Hainaut, Limbourg, Guelderland, Namur, and Holland—were joined, under his rule as successor to Maximilian, to the Hapsburg dominions. Philip, called the Handsome, married Joanna (or Juana) the Mad, daughter of Ferdinand and Isabella, and became the founder of the Hapsburg dynasty in Spain as Philip I. Thus the Netherlands became a part of that vast empire united under Philip's son, Emperor Charles V, and subject to the long period of Spanish domination that was to provoke such turmoil in the following century.

The new political orientation of the last quarter of the 15th century had little immediate effect on the art of painting. The old centers of Bruges and Ghent continued to create art for their citizens and for numerous foreign merchants and bankers; Tournai, Brussels, and Louvain were also important artistic centers in this century and the next.

France had continued to be the artistic focus of the Netherlands through the first quarter of the 15th century, but with the decline of French power during the Hundred Years' War the lead in art passed to the Lowlands by the

end of the third decade. Then arose a style—or, rather, a culture—that was autonomous, splendid, and profoundly creative.

The new style, pioneered at Tournai by the Master of Flémalle, combined a rational approach with an outlook that stressed values beyond the limits of human knowledge. The unification of these essentially contrary points of view into a coherent whole has been characterized as a mystic naturalism. A persuasive pictorial reality permeated with symbolic meaning was created by means of perspective space and resplendent color and light, with a wealth of minutely observed detail, all painted in glowing oil pigments. Almost immediately this new style produced one of its greatest achievements, the *Ghent Altarpiece*, completed in 1432 by Jan van Eyck. His genius in uniting mystic, spatial, and plastic aims was emulated by Petrus Christus and given a new direction by Rogier van der Weyden. Rogier, too, created a coherent world of atmospheric space, light, and color, but his preference for a Gothic spirituality was attuned to the outlook of the second and third quarters of the century. His influence fell even on Petrus Christus but was strongest on Dirk Bouts and Hans Memlinc. Bouts, in Louvain, was the epitomizer of the "style of the long lines,"

a variant within the over-all development stemming from Rogier himself that was widespread in the third quarter of the century. It affected artists inside and outside of the Netherlands, particularly the artists of Germany. Hans Memlinc, at Bruges, dominated its art during the last quarter of the century with a style derived from Rogier van der Weyden but altered by artistic innovations.

Not until the third quarter of the century, in the art of Hugo van der Goes, was there a break in the northern chain of development. His attempt to unite psychological awareness, perceptual unity, and conceptual grandeur of form anticipated the crisis that was to confront northern artists in the next century. The century ended in the Netherlands with David, who continued and reinforced the vision of Memlinc, while Hieronymus Bosch at the same time created visually and iconographically complex orthodox allegories that were a modern return to the simpler expressions of the early decades of the century. Yet in Bosch's last work, the Ghent *Carrying of the Cross,* he too, like Albrecht Dürer in Germany, wrestled with the problem of the intellect and intuition. This was the major problem that was to beset artists everywhere in Europe in the next century.

THE MASTER OF FLÉMALLE

THE INTERNATIONAL STYLE, IN THE HANDS OF Master Francke had been on the borderline between a stylized elegance and a new pictorial naturalism that eschewed elegance and esthetic values as ends in themselves. The resolution was achieved in Flanders by the Master of Flémalle. Pioneer of the new style, discoverer and formulator, he was immersed in the world of appearances and the Gothic world of symbolism. His goal was the presentation of the symbolic themes of Christian belief in a style that gave them

volume and form within the framework of an unidealized, particularized continuity and the portrayal of religious themes as seemingly natural events within an essentially unframed, tangible world filled with space, light, and color. His magnificent formulation of the new outlook was refined by later artists, but the basic premises of this art determined the course of 15th-century painting in the Netherlands.

A large step in the new direction was taken in the second decade of the 15th century in a small folding altarpiece called the *Norfolk Triptych* (after a previous owner), now in the Boymans-Van Beuningen Museum in Rotterdam. Sterling's conception of the work as partially Parisian and partially of Cologne style [1] led Panofsky to a more precise localization. He thought it came from the Meuse River valley, and Maastricht in particular, because St. Hubert of Liège, St. Martin of Tongres, and Sts. Lambert, Servatius, and Remaclus are included. The last three were titular saints of Maastricht itself. Germanic aspects do appear in the facial types of angels, but figure conceptions are more robust. In spatial feeling the work bears out Sterling's comment. The backgrounds of the exterior scenes (Fig. 85) show a contemporary relationship to Parisian

left: 85. NETHERLANDISH. *Norfolk Triptych,* exterior. *c.* 1415. Panel, 13 × 12 3/4". Museum Boymans-Van Beuningen, Rotterdam.

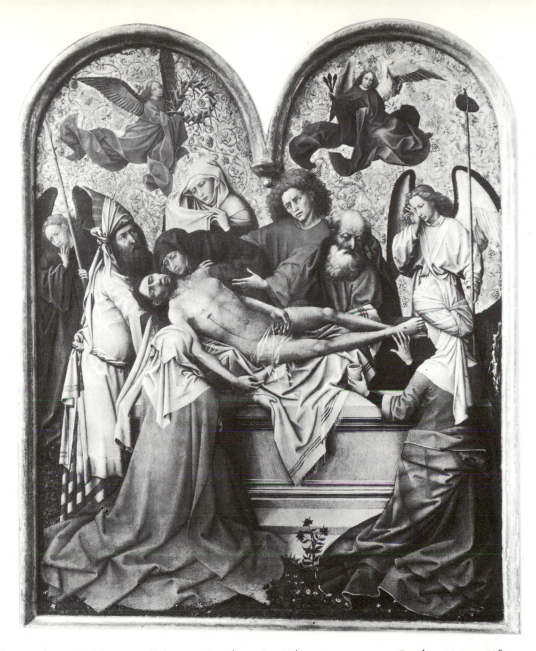

above: 86. MASTER OF FLÉMALLE. *Entombment Triptych,* center. *c.* 1415–20. Panel, 23 5/8 × 19 1/4".
Collection of Count Antoine Seilern, London.

illumination but also suggest the greater natural-
ism to come, particularly in the shed of the
Nativity and in the simplicity of dress and form
of the Annunciate Virgin of Humility at the
top left. Her head type and hair style and the
over-all tendency toward plasticity of form
recall the sculpture of the great Dutch-Bur-
gundian master of the close of the previous
century, Claus Sluter, and foreshadow the forms
of Jan van Eyck. It is just this naturalism and
sculptural conception that depart from the
spirit of the International Style dominating the

expression of the whole work; thus the altar-
piece becomes one of the most apposite examples
of the few preserved works of transition from
the International Style to naturalism.

The new style burst upon the scene with
dramatic force in Tournai. After the gradual
preparation through the increase in naturalistic
modes and motifs, tending toward pictorial
realism, a new concept—the consideration of the
object *qua* object—first appears in the *Entomb-
ment Triptych* (Fig. 86), in the Collection of
Count Seilern in London. Dated between 1415

THE MASTER OF FLÉMALLE 71

and 1420 and attributed to the Master of Flémalle, it is separated by only a few years from the *Norfolk Triptych*, but the psychological gulf between the two works is that of a whole ethos. The *Entombment Triptych* is neither aristocratic nor elegant, but dramatic, forthright, emphatic, eloquent, and austere. Its dramatic angularity reacts against the fluid grace of courtly modes and by contrast is harsh and abrupt. It is as sculptural as a Sluter carving. With this spirit and this work began the great drama of the Flemish style.

The name of the Master of Flémalle is derived from three panels in Frankfurt, supposedly from a putative abbey of Flémalle in the Liège area. However, this artist is now generally identified with a master by the name of Robert Campin, traceable in Tournai between 1406 and his death in 1444. Campin was born about 1375, possibly in Valenciennes. He did not acquire citizenship in Tournai until 1410, though he had bought a house there two years earlier. After 1415 he had numerous pupils. He was elected dean of the painters' guild in 1423, and when the guilds came to power in that year, he became a member of one of the three city councils, keeping his council post until the bourgeoisie returned to power in 1428. Charged in 1432 with leading a dissolute life with one Leurent Polette, he was sentenced to banishment for a year and an enforced pilgrimage to St. Gilles in Provence; the sentence was commuted to payment of a fine of 50 sols, thanks to the intervention of Jacqueline of Bavaria, daughter of William IV, Count of Holland. The intervention of Jacqueline is an indication of the master's artistic importance.

Other records are extremely interesting and problematical and have given rise to an extensive controversy involving the identification of the master, the attribution of important works, and the problem of relationships among the great artists of the period (Flémalle, or Campin, Van der Weyden, the Van Eycks, and others). The reasons for the disagreement among art historians will become clearer in the course of discussion of individual works and painters. For the moment it may be sufficient to cite some of the facts given in the documents.

The Tournai records state that Rogelet de la Pasture and Jacquelot Daret began their apprenticeship with Campin on March 5 and April 12,

1427, respectively. When Daret became a free master in the guild on October 18, 1432, he was immediately elected its dean. Rogelet, his fellow apprentice, had become Master Rogier two months earlier, on August 1; his career was spectacular, as will be shown in Chapter 6.

The iconography of the Entombment was not sheer invention by the master; it can be traced ultimately back to Italy, for the device of placing the face of the Virgin close to that of Christ and the kneeling figures of two women whose backs frame the visual approach can be found in Giotto's fresco in the Arena Chapel, Padua. What is new and different is to be found in the conception and execution of the accessory elements and in the organization. The wings (Fig. 87) show a penetration into space that has hardly been seen in the most advanced work of Parisian illumination. As a whole the triptych is somewhat awkwardly designed, because the plasticity of the central panel is overaccentuated in this earliest work, and the wing figures are not entirely consonant either within themselves or within the over-all design. In compensation, however, a gravity of conception and a weightiness of form, combined with a mastery of lights and darks, place the work in a line with the achievements of Melchior Broederlam. Though the background terminates in a golden "wall" that now seems to be an anachronism, the drive for perspective depth and naturalistic detail is far stronger and more conceptually united than ever before.

A certain feeling of the exotic may be observed in the draperies and in the Hebrew lettering on the robe of one of the sleeping guards. Even in this there is a new spirit. The use of Hebrew lettering has few earlier parallels (though instances may be seen in the simulated Kufic lettering on the garments of Christ in Giotto's work in Padua, and, closer in time, in the Malouel-Bellechose *Martyrdom of St. Denis* (Fig. 23), and its appearance here is significant as evidence of what must be viewed as a scholarly approach on the part of the artist to his subject. In addition, one of the guards is awake to be overwhelmed by the miracle, so that it may be concluded that the Master of Flémalle also adapted the popular *Revelations* of St. Birgitta to his treatment.

The Entombment scene itself is also different, for its iconography is not the common Jacque-

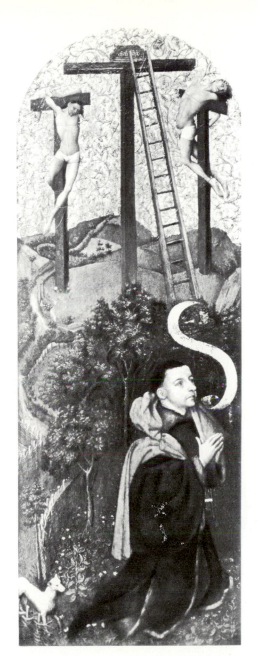
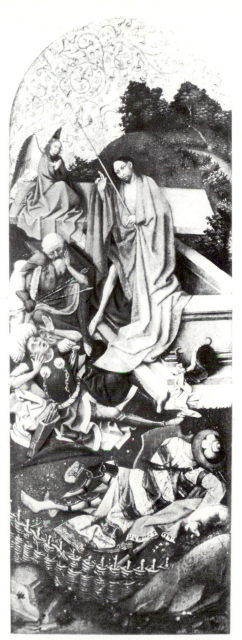

87. MASTER OF FLÉMALLE. Thieves on the Cross and Resurrection, *Entombment Triptych,* wings.
c. 1415–20. Panel, 23 $^5/_8$ × 8 $^7/_8$" (each wing).
Collection of Count Antoine Seilern, London.

mart type, in which one of the women kisses the dead hand of Christ; it may have been influenced by a type current in sculpture. (Tournai was an important center of sculpture, even having an export business to England in fonts of the famous black Tournai stone.) The close view of the central panel, its lack of depth in the background, and the angularity in the garment folds seem to suggest such a sculptural

influence upon the master; and the wattle-fence motif seen on the wings (particularly that of the left wing) had appeared earlier in one of Jacques de Baerze's Dijon altarpieces. Whatever the influence may be, a sculptural massiveness of conception is prominent throughout the *Entombment Triptych.*

In addition, the over-all and marked naturalism even goes so far as to create what seem to be

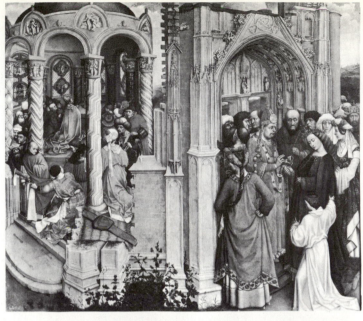

88. MASTER OF FLÉMALLE. *Betrothal of the Virgin,* interior. *c.* 1420. Panel, 30 ¼ × 34 ⅝″. Prado, Madrid.

89. MASTER OF FLÉMALLE. St. James and St. Clare, *Betrothal of the Virgin,* exterior. *c.* 1420. Panel, 30 ¼ × 34 ⅝″. Prado, Madrid.

new emotive types. A heretofore unparalleled vigor in the angular garments of the angel gives a sense of purposeful movement, which may be seen also in St. Veronica holding up her veil and the Magdalene applying ointment from her jar. John appears to have cast aside the cloak in which he was usually seen, Nicodemus and Joseph of Arimathaea express their grief in more restrained fashion, but the angel at the right wipes his eyes on the back of his hand. Relegation of overt emotional reaction to the angels only had been an innovation of Giotto. The Master of Flémalle understood as well as Giotto, though within a different context, the value of expression.

The master's next work, the Prado panel of the *Betrothal of the Virgin* (Fig. 88), also shows the miracle of the flowering rod of Joseph, an event prior to the Betrothal, and thus was probably a panel from an altarpiece depicting the Joseph cycle, for the composition is repeated, along with other scenes from Joseph's legend, in a later painting now in the church at Hoogstraaten. That the Prado panel is not complete in itself is clear from the grisailles of St. James and St. Clare (Fig. 89) on the reverse side. As in the Seilern triptych, discrepancies in scale exist between the two scenes. Again there is an expressive plainness of features, and the "schol-

arly attitude" is seen in the architecture, which reveals a significance also developed in later work into what Panofsky has called a "disguised symbolism." The miracle of the rods takes place in a circular structure, which to the Middle Ages implied Jerusalem and the old dispensation (as in Broederlam), but the Betrothal takes place before—not in—a Gothic church under construction, sign of the new dispensation to come with the birth of Christ. Old Testament scenes appear in the sculpture of this incomplete portal, all of which, according to the *Speculum Humanae Salvationis,* are prefigurations of events from the New Testament; however, it is not certain whether the artist intended them as prefigurations of the events depicted or merely as historically correct depictions. Soon in the art of the Master of Flémalle such ideas were to be made explicit.

The feeling for monumentality, combined with an atmosphere created by naturalism in light and shade, in appearances, in proportions, and by a suggestion of receding space beyond the strong foreground action, creates a greater sense of immediacy than that of the *Entombment.* Even the grisailles on the reverse, the first appearance in preserved Netherlandish painting of the illusion of stone sculpture on the exterior of an altarpiece, augment and deepen the illusion. Clearly, the rapprochement of sculpture and painting suggested at the Chartreuse of Champmol in Dijon (see Chap. 1) was further advanced in the sculptural center of Tournai.

The small *Nativity* (Fig. 90) in Dijon carries illusionism and symbolism even further. It accords with St. Birgitta's description of the Nativity, the kneeling Virgin in white corresponding to the similar figure in the later art of Master Francke. Joseph, dressed in a fine crimson garment, shields the artificial light from the candle, because the true light comes from the infant Christ on the ground. The idea is further developed in the landscape beyond by the rising sun, a nature symbol for Christ. Symbolism appears also in the motif of the two midwives, one of whom, according to a popular legend, had doubted Mary's virginity after the birth and was punished for her impiety by having her hand withered; one of the angels told her to touch the Child, and the touch restored her hand. Again the Master of Flémalle has accentuated and dram-

atized his naturalism, as in the rough shepherds, one of whom carries that lugubrious instrument the bagpipe. Joseph and the figure seen from the back are types used earlier in the master's work.

Space is deeper here. Whereas the depth-defining landscape elements were presented as separate overlapping layers in the *Entombment Triptych,* here they are more continuous, forming a closer approximation of a natural scene. Choosing a high viewpoint, the master created a more convincing perspective; we look over the mud-and-wattle hut drawn in reverse perspective. Beyond, the soft lighting of the landscape shows a response to the rising sun in the shadows cast by the trees, the road bank, and figures on the road. An attempt has been made to suggest the season of the year, thus carrying further what had been seen in a more primitive form in the Brussels *Hours.*

The silvery, wintry effect, however, does not extend to the more crowded foreground figures,

90. MASTER OF FLÉMALLE. *Nativity. c.* 1420. Panel, 34 1/4 × 28 3/4". Musée des Beaux-Arts, Dijon.

whose colors are richer than anything seen heretofore in his predecessors. The master has begun to replace light, airy colors with a more painterly application, as in the vermilion of the shepherd's hood, the crimson of Joseph's cloak, and the yellow and purple tones in the garments of the midwives. More full-bodied middle tones, opaque highlights, and a greater transparency in the shadows are part of the new painterly technique that characterizes the splendor of the Flemish style in the 15th century. This oil technique, which Vasari, in the following century, thought to be an invention of Jan van Eyck was in actuality well known to the medieval period. What is different here is the masterly use of accentuated middle tones without admixture by a method that is still unknown in exact detail. Flemish panels are free of dust, which would have accumulated had the painters used slow-drying glazes. Minute details have all the fineness and clarity seen in the work of the miniaturists.

The improved but still inexact perspective arrangement of the Dijon *Nativity,* with its obliquely placed hut, and its stylistic aspects have led to a dating in the early years of the third decade, somewhat earlier than the *Mérode Altarpiece,* of about 1426, in the Cloisters, New York.

The main theme of *Mérode Altarpiece* (Pl. 7, after p. 180) is the Annunciation. An Annunciate Virgin of Humility is seated on the floor in front of the bench before the fireplace, holding in her hands a sacred, draped book. The angel's movement has blown out the candle, whose smoke rises in the still air. The candle is only one element of Marian symbolism; the blue and white jug contains another symbol, the lilies, and the laver in the niche with the towel on its rack constitute a third reference. The Child, carrying the Cross, slides down the light rays toward the womb, implied by the star pattern of light on the folds of the Virgin's crimson dress, visual exposition of the *Revelations* of St. Birgitta, in which Christ said to the saint: "I took a body without sin or lust, entering the maiden as the sun shining through a clear stone. For as the sun entering the glass hurts it not, so the Virginity of the Virgin abode uncorrupt...." [2] Here again we find the expression of recondite symbolism.

Seemingly the *Mérode Altarpiece* shows a naturalistic interior; however, a rather violent one-point perspective tends to assert by over-emphasis what is already a very strong note, the active surface patterning. The middle-class character of the setting is different from the more explicit religious setting of Broederlam, with its allusive architectural background.

On the left wing the earnestly devout donors kneel in a spring garden before an open door, which permits them to witness the religious drama. They are members of the Ingelbrechts family and possibly of the Calcum family, whose coats of arms appear in the windows of the back wall and who are the commissioners of the work. Farther back, next to the doorway that gives a view onto a Flemish street, is a figure standing before a rosebush, hat in hand.

On the right wing Joseph, dressed in a superb, full-toned purple garment, plies his trade, as can be seen from the display sample on the window shelf. The beautifully painted object is a mousetrap! Here is more recondite symbolism, for this illustrates the statement of St. Augustine that the Incarnation was a trap set by God to catch the Devil.

Through the open windows, with their magnificently painted shutters held in place by wooden catches, is a view of a city, but from a different perspective viewpoint, for now the observer's eye is elevated high above the ground level of the donors on the left wing. The elevation of Joseph's chamber, and by implication that of the Annunciation panel, in which the windows show only the sky, accords with the medieval treatment of the Danaë myth. Danaë in her tower was a medieval symbol of chastity, and her relationship with the Annunciation is found in Italy as early as the 13th century.

The wall closing off the back of the left wing is a further Marian symbol; the enclosed garden of the Song of Songs, in which grows the rosebush, is another symbol; and the man close to the narrow gate holding his hat in his hand is doing so because he stands on holy ground. More symbolic flowers grow before the donors. The progressions and relationships in the three panels are, however, more united artistically than symbolically. The left panel was conceived by Tolnay as related to spring and March 25, the date of the Annunciation. The darker color of the right wing he thought characterized December 25, the day of the Nativity. [3]

In the *Mérode Altarpiece* the conception of the master once again outran his ability to unite perfectly his major and minor themes with the donor portraits. His new but intuitive concept of one-point perspective, clearly an advance from the oblique type of the Dijon *Nativity,* is still not firmly established. Thus his objects recede violently, and the table tilts so much that the objects on it defy the law of gravity. The head of the rider in the street on the left wing reaches only to the sidewalk. The master set himself distinct problems in varieties of natural lighting, the most challenging being the back lighting of Joseph's chamber. This attempt to signalize the material by the use of light establishes the position of the Master of Flémalle as a true pioneer and "primitive" in the creation of a symbolic reality.

The *Virgin and Child before a Fire Screen* (Fig. 91) in London may be dated several years after the 1426 date assigned to the *Mérode Altarpiece*. In the desire to accentuate the reality of his forms the Master of Flémalle had created in the Mérode work a round-faced, almost moon-faced, type of Virgin. The striving for realism is further accentuated here, as is the symbolism implicit in the height of the view from the window and in the fire screen used to suggest a halo for the Virgin. Another version of the Virgin and Child, now in Leningrad, slightly later in date and by the master's workshop, shows the domestic intimacy of the Virgin warming her hand at the fire before she touches the Child. In both works there are other inconspicuous symbolic elements, and perspective recession is still extreme.

Close in sentiment and type to the Leningrad figure of the Virgin is the *Virgin in Glory,* in the Granet Museum at Aix-en-Provence (Fig. 92), probably painted about 1430. Less moon-faced, though still strongly sculptural, the Virgin appears as the apocalyptic woman, with the sun and clouds behind her and the crescent moon at her feet. She is seated on a bench that, by a prodigious feat of levitation, has been

above: 91. MASTER OF FLÉMALLE. *Virgin and Child before a Fire Screen. c.* 1428. Panel, 24 3/4 × 19 1/4". National Gallery, London.

right: 92. MASTER OF FLÉMALLE. *Virgin in Glory,* with St. Peter, donor, and St. Augustine. *c.* 1428–30. Panel, 18 7/8 × 12 1/4". Musée Granet, Aix-en-Provence.

posed above the heads of St. Peter with his key, the donor, and St. Augustine. There is a greater formal unity and logic in the placing of forms. (The flattening of the foreground space suggested to Panofsky that the work came from the hand of Rogier while still in Campin's shop.)

Measurement of spatial intervals is handled with greater mastery, particularly in the coulisse (or stage flat) system of landscape construction, which has progressed from the obvious overlapping in the Seilern *Entombment* to the continuous serpentine road penetrating the distance in the Dijon *Nativity* (a feature more crudely handled in the left wing of the *Entombment,* where the road is broken by the overlapping hills) and finally to the union of the two systems in this work. The city prospect here animates the background and disguises the conjunction of the two earlier methods.

To this period may be attributed a drawing in the Louvre (possibly a copy after a lost work) of the *Virgin and Child* flanked by saints and

93. MASTER OF FLÉMALLE. *Thief on the Cross,* fragment of an altar wing. *c.* 1428–30. Panel, 52 ³/₈ × 36 ³/₈″. Städelsches Kunstinstitut, Frankfurt.

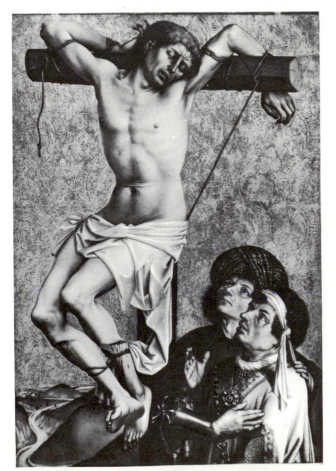

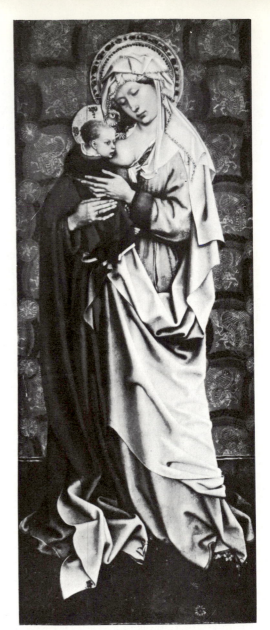

above: 94. MASTER OF FLÉMALLE. *Virgin and Child. c.* 1430–34. Panel, 63 × 26 ³/₄″. Städelsches Kunstinstitut, Frankfurt.

donors; the now lost original of the *Mass of St. Gregory* (of which a close copy survives in the Musées Royaux, Brussels); and the *Trinity* in Leningrad, apparently a companion to the *Virgin and Child* panel, also in Leningrad.

A Deposition altarpiece is known only by a mediocre copy of the whole in Liverpool and by a panel in Frankfurt (probably a portion of the right wing) known as the "unrepentant thief," who may in actuality be the repentant thief (Fig. 93). The largeness of conception and the strong plasticity of the figure are similar in

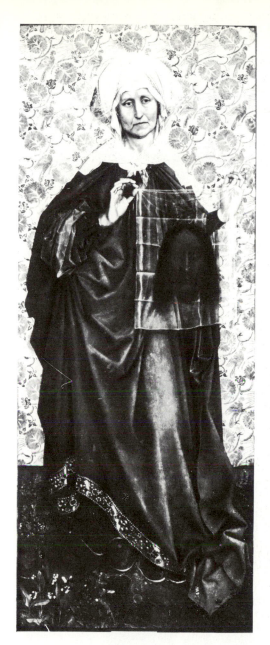

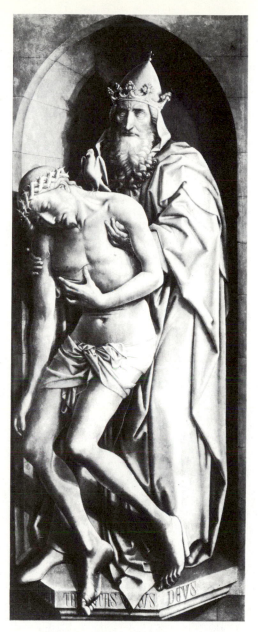

above: 95. MASTER OF FLÉMALLE. *St. Veronica. c.* 1430–34. Panel, 59 ⁵/₈ × 24″. Städelsches Kunstinstitut, Frankfurt.

right: 96. MASTER OF FLÉMALLE. *Trinity. c.* 1430–34. Panel, 58 ⁵/₈ × 24″. Städelsches Kunstinstitut, Frankfurt.

spirit to the *Virgin and Child before a Fire Screen,* and the work is probably contemporaneous with it. The simplified movement and unified light, the marked but simplified silhouette of the forms, the restraint in the expressions on all three faces, and the calm monumentality produce an augmented yet restrained drama. This is aided by the color treatment of the unrepentant thief, the grayness of the face being heightened by contrast with the dark color of the bloody cuts

on his legs and with the intentionally lifelike color of the two Romans below. The largeness of dramatic conception has tempered the severity characteristic of earlier work.

This direction is also seen in the other three panels in Frankfurt, from which the artist takes his name: the *Virgin and Child* (Fig. 94), the *St. Veronica* (Fig. 95), and the *Trinity* in grisaille (Fig. 96), which was originally the back of the *St. Veronica*—all said to be from Flémalle. These large panels (approximately 5 feet high), whose monumentality makes them seem even larger than their actual size, are deeper in color than earlier works attributed to the master. The figures of the Virgin and Child and St. Veronica

stand on flower-covered ground. Close behind them hang deep red brocades, against which the cool, light-gray and white garments of the Virgin, with bluish shadows, and the green and deep red-brown garments of St. Veronica make strong yet solemn notes that accord with the quiet inherent in the balanced poses. The simplified drapery folds also contribute to this sense of quiet, breaking into more animated movement only at their feet. The over-all effect is one of solemnity, stillness, and contemplation.

The naïveté seen in earlier works has disappeared. Drama results from combining varied outlines with largeness of movement. The sheer

power of naturalistic characterization in the heads of these Frankfurt figures demonstrates their relationship in time to the panel of the thief: it cannot have been painted much before 1427 (probably somewhat later), and the other figures cannot date much after 1434. Moreover, these works share a tendency in Flemish art of the early 1430s that, so far as it can be demonstrated in the preserved works, stresses plasticity and monumentality of form.

In the 1430s the approach of both Jan van Eyck and Rogier van der Weyden was at its most plastic (see Chaps. 5 and 6), and even in the work of Jacques Daret, the Master of Flémalle's pupil and follower, this quality appears as an emphatic isolation of the figures in a comparatively barren landscape. The same tendency is found in the miniatures of the Master of Guillebert de Mets (Fig. 52) and many others.

below: 97. SHOP OF ROGIER VAN DER WEYDEN. St. John the Baptist with Heinrich von Werl and St. Barbara, *Von Werl Altarpiece,* wings. 1438. Panel, 39⅜ × 18½″ (each). Prado, Madrid.

98. Master of Flémalle and shop. *Portraits of a Man and a Woman.* c. 1425-30. Panel, 16 1/2 × 11 1/2". National Gallery, London.

What Panofsky has called the "Januslike nature of the master's style," that is, a combination of innovative and conservative elements, makes the 1438 *Von Werl Altarpiece* in the Prado (Fig. 97) the knottiest of all problems related to the master; it is also the only dated work. Influences from Van Eyck and Van der Weyden have been noted in both wing panels (the central panel has been lost). On the right St. Barbara, in a deep green robe, is seated reading on a bench within an interior that recalls the room of the Annunciation of the *Mérode Altarpiece.* Through the open window in the landscape beyond can be seen her symbol, a tower. It is incomplete, as is that in Jan van Eyck's *St. Barbara,* of 1437 (Fig. 113). The carafe on the mantel is also an Eyckian device. The basin and pitcher are so like those in Van der Weyden's Louvre *Annunciation* (Fig. 125) that their correspondence, despite minute differences, has been made one of the key arguments by those scholars who identify the Master of Flémalle as the youthful Rogier. The left wing shows analogous resemblances: John the Baptist makes a gesture that seems to have little meaning here but is possibly related to the gesture of Christ appearing to his mother in Rogier's Granada-Miraflores altarpiece (Fig. 130). Furthermore, the mirror, which reflects the extraneous figures of a man and a boy, is a device owed to Jan van Eyck, who had used it in his double portrait of Giovanni Arnolfini and his wife, of 1434 (Fig.

112). Correspondence to the *Mérode Altarpiece* has been the strongest element in the attribution of the *Von Werl Altarpiece* to the Master of Flémalle, for it is obviously different from the Flémalle panels. Thus some historians have concluded that the splendid monumentality of the Frankfurt panels gave way here to an aping of the art of Rogier van der Weyden and Jan van Eyck.

Against such a conclusion must be set the instability of pose and the uncertain articulation of the form of John the Baptist, the flabbiness of undifferentiated surface and insecure form in the donor, the myopic aspect of St. Barbara, and the fussiness in the draperies, all of which are hard to ascribe to a master who could achieve the grandeur of drawing and monumentality of conception demonstrated in the Frankfurt panels. The use of light to create a far more emphatic spatial ambient, together with a different conception of the human form, would seem to imply the hand of a different master working in Rogier's shop, an opinion the present writer formed many years ago when face to face with the *Von Werl Altarpiece.* [4]

The portraiture of the Master of Flémalle is best represented by the *Portraits of a Man and a Woman,* in London (Fig. 98). These portraits (that of the man painted by the shop) seem to date from the late years of the third decade because of their emphatic plasticity. They contrast strongly with the *Von Werl Altarpiece,* the

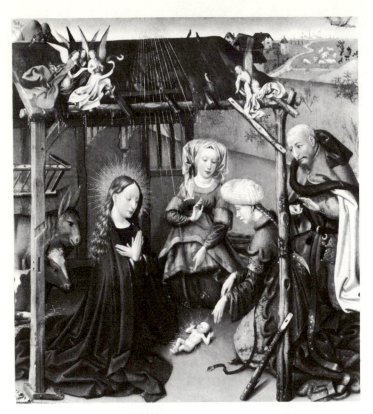

99. JACQUES DARET. *Nativity,* detail. 1434–35. Panel, 22 ½ × 20 ½″. Thyssen-Bornemisza Collection, Lugano-Castagnola.

In addition to other paintings by the Master of Flémalle himself, such as the frontalized half-length figures of Christ and the Virgin, in Philadelphia, which repeat a type known to have existed a century earlier, there exist numerous copies of his works produced by his shop, some of which are known only through the copies. Such an example is the Virgin standing in an apse (New York), which is most likely an early shop copy.

His one-time apprentice Jacques Daret copied the Dijon *Nativity* in a version in the Thyssen-Bornemisza Collection, Lugano-Castagnola, Switzerland, in which he reverted to the traditional placement of the shepherds in the background (Fig. 99). The Virgin, with crossed hands before her breast, is the Italian type of the Virgin of Humility. Daret employed a large, undifferentiated, and little-animated space in his attempt to achieve a naturalistic recession beyond the immediate action, a characteristic device visible in the other three panels of his altarpiece of 1434–35 for Arras, of which the Lugano *Nativity* was a part. The related panels are in Berlin-Dahlem (*Adoration of the Magi* and *Visitation*) and the Petit-Palais in Paris (*Presentation in the Temple*).

The Master of Flémalle's sculptural, realistic art made him the great innovator of early Flemish painting, as was first pointed out by Charles de Tolnay [6] in 1939. Though formerly he was even considered to have been influenced by his pupil, Rogier van der Weyden, his strong influence on the art of Rogier and on Jan van Eyck is now widely recognized.

Using the oil medium to create a new, dramatic pictorial naturalism, insistent upon the monumentality of form, the Master of Flémalle built upon the Tournai tradition of sculpture and turned away from courtly art to assert the character of the unidealized object, animate or inanimate. All the elements of natural appearance—perspective, space, light, color, and form—were subjected to the vigor and intensity of his pioneering objective, to convey in paint the symbolic reality of the natural world. Though in the 1430s he shared with his near contemporaries north and south of the Alps an involvement with sculptural monumentality, he was their predecessor. In the north he was also their guide, and his impact on the painters of the Netherlands cannot be overestimated.

even, nonspatial lighting in the London portraits being used to create an emphatic sense of form rather than a spatial environment. The man is turned three quarters to his left and lighted from his right; the woman turns toward her right and is lighted from her left. Here is the typical portrait type that is to dominate in Flemish painting through the century, the approximately three-quarter, bust-length portrait, with or without the hands. Both profile and three-quarter portrait had existed earlier, but the profile portrait was dropped, apparently because it did not accord with the nominalistic outlook of a century which stressed the individuality of the particular. The striking and even insistent accent upon clarity in these London portraits responds to the spirit of the age. The figures are large in relation to the area they occupy, almost overfilling it in their closeness to the picture plane. Individual characteristics in the London portraits are firmly presented, but the generalized light flattens what otherwise might be an overpowering plasticity. [5]

THE VAN EYCKS

IF ANY ARTIST OF THE 15TH CENTURY ACHIEVED a perfect harmony of the real and the supernatural, it was Jan van Eyck. In his art the life of the spirit was truly embodied in its metaphorical vehicle, the physical world. The profundity of his intellect and the sublimity of his artistic expression, which combined an overwhelming verisimilitude with a spatial continuum, all painted in glowing colors, was swiftly acknowledged on both sides of the Alps. In Italy about eight years after his death the art-loving antiquarian Cyriacus of Ancona called him famous. A few years later Bartolommeo Fazio, a Humanist from Genoa, writing about 1456, called him the foremost painter of the age. Antonio Averlino Filarete, architect and sculptor of Florence, honored him in his treatise on architecture composed between 1460 and 1464, and in the 1480s he was praised by Raphael's father, Giovanni Santi. In the north the Humanistic tradition did not appear in literary biography until the 16th century, but artists praised him by emulating his work. Jean Lemaire de Belges, writing at Malines in 1504, called him the king of painters. Dürer in 1521 recorded in the diary of his Netherlands trip that in Ghent he was taken to see the "Johannes Tafel," the famous *Ghent Altarpiece* completed by Jan in 1432. In the middle of the 16th century Vasari called Jan the inventor of oil painting, whose secret he taught to his "pupil," Ruggiero da Bruggia (i.e., Roger of Bruges, or Rogier van der Weyden), and to Antonello da Messina, who, Vasari said, expressly made a journey from Naples to learn it. In 1604 Carel van Mander, painter of Haarlem, and first northern art historian, began his account of the lives of the Dutch and Flemish painters *(Het Schilderboeck)* with the life of Jan van Eyck. (Like Vasari, on whom he modeled his *vitae* of the northern painters, he attributed the invention of oil painting to Jan, and also called Rogier Jan's pupil, an error traceable to Bartolommeo Fazio.) Jan van Eyck's name recurs in all accounts of painting down to the present day, when the flood of literature has reached tidal proportions. A significant part of this enormous literature [1] concerns the problems related to his brother Hubert and the respective parts of the brothers in the creation of the *Ghent Altarpiece*.

Before considering that key work, however, it will be helpful to survey the surviving records and to examine the chief paintings that may have preceded the great altarpiece.

Jan's career is well documented [2] from his appearance at the court of John of Bavaria, Count of Holland, at The Hague in 1422. At this time he already had apprentices. He left The Hague September 11, 1424, after the death of the Count and settled in Bruges, where he immediately came to the attention of Philip the Good, Duke of Burgundy, who appointed him his

official painter on May 19, 1425. Until his death on July 9, 1441, Jan served the Duke as both painter and confidant, being sent on secret missions for which there are records of payments from 1426 to 1436. It is known that he held a preferred position in the Duke's employ, for when salaries were revoked in 1428, in what must have been an economy measure, Jan van Eyck received his salary by special order of the Duke, and in 1435, when the Duke's treasury officials raised difficulties over the granting of a life pension to "bien amé varlet de chambre et paintre, Jehan van Eyck" and Jan therefore thought of leaving the Duke's service, Philip wrote a letter that leaves no doubt of his reaction:

> This would very greatly displease us, as we are about to employ Jehan on certain great works and could not find another painter equally to our taste nor of such excellence in his art and science. Therefore we bid you, on receipt of this, to register our letters granting the pension, without further argument, delay, alteration, variation, or difficulty whatever, under pain of incurring our displeasure and wrath.

Earlier in 1427 Jan van Eyck had made a journey with an embassy to Catalonia to portray a possible wife for the Duke; this embassy was not successful, but another journey to Lisbon late in 1428 had a favorable conclusion with the signing of the contract of marriage between Philip the Good and Isabella of Portugal on July 23, 1429. The fleet, with Isabella aboard, sailed for Flanders on October 8 to arrive at Sluis on Christmas Day.

After the ducal marriage on January 7, 1430, the records are sparse. Until 1428 Jan had lived in Lille, but in 1432 he was recorded as owning a house in Bruges. Except for certain further secret journeys, Jan spent the rest of his life in Bruges, where his wife Margaret bore him ten children. (The marriage date is unknown, but Margaret was born in 1406.) The Duke, who had visited Jan in Bruges in 1433, in the following year gave him six silver cups at the baptism of what was probably his first male child. A year after his death in 1441 another brother, Lambert, who is also recorded in Philip's service, received permission from the Chapter of St. Donatian at Bruges to have Jan's body interred inside the church near the font. Philip gave a generous gift to Margaret van Eyck on Jan's death and made a further gift in 1450 to enable Jan's

daughter Livinia to enter the convent at Maaseyck, from which town, apparently, her father originally came. Other records exist, the most interesting being the payment made to Jan in 1435 for painting and gilding six statues and their tabernacles for the façade of the Bruges Town Hall.

Documents relating to Hubert van Eyck, also, it seems, from Maaseyck, are so meager that his existence has been vociferously doubted by some art historians. Not a single work exists that is unquestionably by Hubert. Only four documents pertaining to Hubert exist in the archives at Ghent, the last, dated after his death on September 18, 1426, being a tax receipt paid by the heirs on the property of "Lubrechte van Heycke." His epitaph was destroyed in 1578 but is known from two independent copies. In 1495 a German physician was shown the grave of the painter in front of the altarpiece in Ghent, and in 1517 Cardinal Louis of Aragon was told by the canons at Ghent that the work had been painted by a German master named Robert and completed by his brother, also a great painter.

One piece of evidence, a quatrain painted on the frame of the *Ghent Altarpiece,* which refers to Hubert as the greatest painter and Jan, his brother, as second in art, has been considered a forgery by those who doubt Hubert's existence. But, if not original, it probably copies the original, for Panofsky has shown that some of the letter forms appear elsewhere on the altarpiece.

Artistic documentation, as well as biographical record, is far more voluminous and more certain for Jan van Eyck than for Hubert. Nine paintings bear Jan's signature and the date of their execution. The earliest work related to Jan van Eyck is the Berlin *Madonna in a Church* (Fig. 100), of about 1425. Painted as larger than life size, the Madonna fills the nave of the church, a richly jeweled crown on her head gleaming and sparkling in the soft light falling from the upper left. Though the external outline suggests a bulky figure, the very high waist, delicate hands, and generalized facial type of the Virgin are suggestive of the International Style, as is the small size of the Child. The conception of the figure is conservative, but the delicate, subtle, and flowing light that makes the figure exist in space and atmosphere is new.

There is a wonderful excitement in the creation of the fluid architectural space; one looks

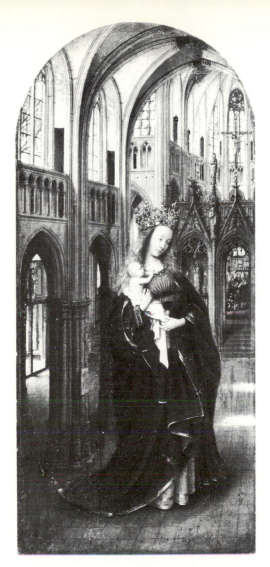

left: 100. JAN VAN EYCK. *Madonna in a Church*. c. 1425. Panel, 12 1/4 × 5 1/2″. Gemäldegalerie, Staatliche Museen, Berlin-Dahlem.

to the period, is allied with a disguised symbolism in the seemingly naturalistic but physically impossible sunbeams coming from the north. [3] Jan van Eyck has employed the device to refer to a light above that of the physical world, the never-setting light of Christ. The light has another aspect, which is revealed by the words on the edge of the Virgin's robe and the verses painted on the original frame: both refer to a popular Marian hymn, also reflected in St. Birgitta's visions, in which Mary's virginity is compared to the passage of the sunbeam through glass without damage to the vessel.

How much of this disguised symbolism is owed to the Master of Flémalle is a question. Probably none of it, for this work of the early or mid-twenties must have been painted either in Holland or at Bruges, probably the latter, because it was copied there several times toward the end of the century. What Jan did was to combine a conservative conception of the Virgin, based on the popular *Schöne Madonna,* or "beautiful Madonna," type (best seen in the sculptured Krumau *Virgin* in Vienna, of Bohemian workmanship of c. 1400), with a modernized architectural setting naturalistically presented. The modernization consists not only in the superb painterly illusionism but in placing the perspective vanishing point very close to the edge of the scene (note that the St. Barbara in the *Von Werl Altarpiece* has its vanishing point well outside the actual panel), thus augmenting the subjective sense of spatial actuality.

The sense of verisimilitude within the context of both an open and a disguised symbolism governs the *Annunciation* in Washington (Fig. 101). Kneeling before her *prie-dieu* with upraised hands and inclined head, the Virgin, dressed in deep blue, humbly receives the youthful, charming angel adorned with rainbow-colored wings and a rich red and gold robe. The lettering of Mary's reply to the angel's salutation is seen to be upside down and thus is meant to be read by God, not the spectator. The setting has been solemnized by reverting to an ecclesiastical interior, with the figures and the architecture in grave accord. As Panofsky has shown, even the floor, with its Old Testament

beyond the nave into the aisle and is carried back to the altar, where two angels chant the mass. Natural light fills the space above. One is convinced that the light of the apse is the mystic focal point of the medieval church, at the terminus of the characteristic and inevitable movement of the eye in a Gothic church. To accent this effect Jan van Eyck elevated the choir of his painted church. A carved Crucifix is seen above the screen, on which simulated carvings present figures from the Old Testament, the Annunciation, and the Coronation of the Virgin.

This new union of the elements of the natural world with an equally natural space goes far beyond the sharply clarified world of the Master of Flémalle; yet Jan achieved it within a framework obviously and essentially medieval, as in the large figure of the Virgin, who is a symbol of the Church and its personification at the same time. This meaning, so well known

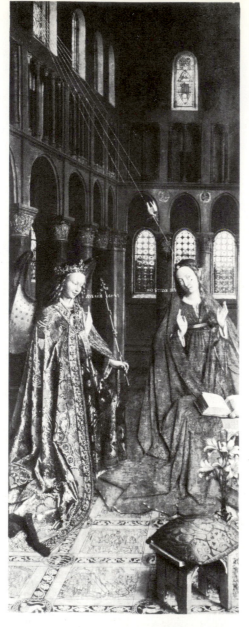

prefigurations and its zodiacal signs, enters into the organization of the scene, for the Virgin kneels in the area where March, the month of the Annunciation, would logically be placed. Disguised symbolism recurs in the architectural forms, which are Romanesque above, where the Old Testament scenes of Moses appear in the upper zone, and Gothic below, where the incarnation of the New Moses is shown at the lowest level.

Behind the Virgin are three arches, symbolizing the Trinity. They are filled with superbly painted bottle-glass windows, in a magical rendering of detail that repeats its spell in the treatment of the capitals, the crimson footstool (Jan van Eyck well knew that objects painted in red seemingly advance toward the spectator), the Old Testament scenes on the floor, and the beautiful lilies. The detail is as fine as in the Berlin *Madonna,* but there is a basic advance in the conception of space, which is more simplified, and in the lesser idealization but greater solemnity of the Virgin. The date of the *Annunciation* is possibly 1428; one feels that Jan van Eyck had been influenced by Campin's monumentality during his visits to Tournai on October 18, 1427, and on March 23, 1428. Acquaintance with the Flémalle style may have caused Jan to turn away from the spirit of the International Style still visible in the Berlin *Madonna.*

The attributions to Hubert are as sparse as the documents related to him. Disagreement is more common than the contrary. A case in point is the *Three Marys at the Sepulcher* (Fig. 102), in Rotterdam, often attributed to Hubert, with the hand of Jan seen prominently in the type of angel on the sharply receding tomb lid and in the different painting technique of this figure. However, F. Lyna[4] has read the name "DU MONT" (which is quite legible) in the pseudo-Hebraic letters adorning the hat of the sleeping guard at the right. The hand of an artist whose abilities as a faithful emulator have misled many is also suggested by the archaic conception of

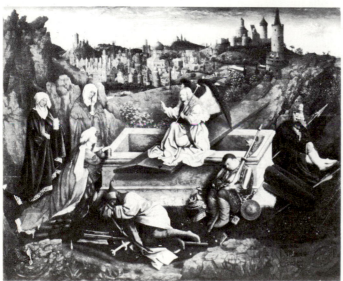

above: 101. JAN VAN EYCK. *Annunciation.* c. 1428, Panel (transferred to canvas), $36\frac{1}{2} \times 14\frac{3}{8}''$. National Gallery of Art, Washington, D.C. (Andrew Mellon Collection).

left: 102. ADAM DUMONT (?). *Three Marys at the Sepulcher.* c. 1450(?). Panel, $28\frac{1}{8} \times 35''$. Museum Boymans-Van Beuningen, Rotterdam.

the landscape as a foil; the poor perspective of the tomb slab; the decorative linearism of the three Marys; the two lighting systems, one for the foreground and one for the background; details of armor that are posterior to 1440; and such Eyckian details as the angel type, the umbrella pine, snow-capped mountains, and birds in flight.[5] The grisaille escutcheon of

Philippe de Commines, datable between 1469 and 1472, at the lower right, seems a later addition.

An equally problematical work, with which Hubert's as well as Jan's name has been associated, is the New York diptych, a *Crucifixion* and *Last Judgment* (Fig. 103). The 19th-century art historian Johann David Passavant was told by

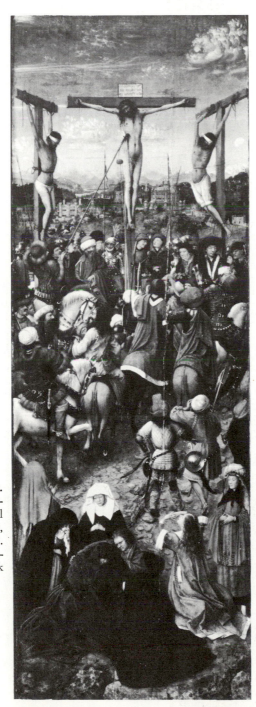

103. Bruges Painter. *Crucifixion* and *Last Judgment* c. 1430–35. Panel (transferred to canvas), 22¼ × 7¾″ (each panel). The Metropolitan Museum of Art, New York (Fletcher Fund).

the Russian owner of the diptych that the panels were the wings of a triptych, of which the center panel, the Adoration of the Magi, had been stolen. A drawing of the Adoration of the Magi, in Berlin, is stylistically related and corresponds proportionally to the remaining wings. However, the combination of the Adoration in the center and the Crucifixion and Last Judgment on the wings would be most unusual, since it is not found in any preserved work of the period.

The complicated attribution problem of the diptych revolves around certain figure types and compositional elements that resemble specific features in unquestioned Van Eyck works and around certain anomalies of composition, miniaturistic tendencies, and datable internal details that would appear to suggest a different artist. Among the figural similarities that may be cited are the turbaned woman standing at the lower right of the Crucifixion panel and the St. Michael standing on the back of Death in the

Last Judgment panel. The woman, an observer of the scene of mourning, closely resembles the Erythraean sibyl, similarly turbaned, on the exterior of the *Ghent Altarpiece* (Fig. 104) and thus is clearly related to the work of Jan van Eyck. The St. Michael figure is similar to the St. Michael in Jan van Eyck's Dresden altarpiece (Fig. 114), which is discussed below. In addition, the penetration into depth of the landscape behind the crucified figures is consistent with the atmospheric rendering in accepted Eyckian works.

On the other hand, contradictory to the evidence of these similarities, there is the significant feature of the upward and then backward organization of the composition in both panels. This is particularly noticeable in the Crucifixion, which builds on the device of back-view figures, as in Campin's early *Entombment* (Figs. 86, 87), and employs them as strong spatial and compositional unifiers, for example the figure

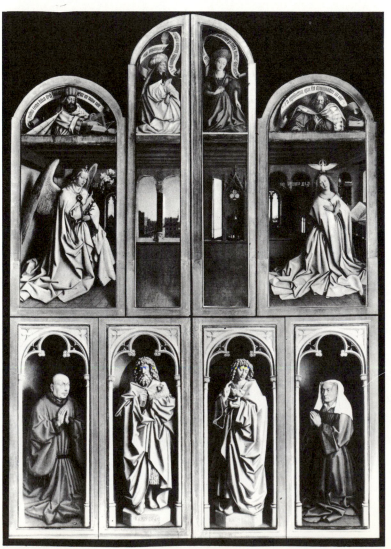

104. Van Eyck Brothers. *Ghent Altarpiece* (closed). *c.* 1425–32. Panel, height 11′5 ³/₄″. Cathedral of St-Bavon, Ghent.

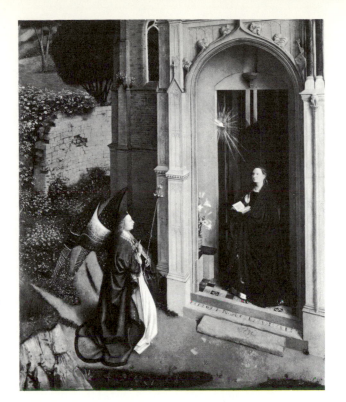

right: 105. HUBERT VAN EYCK. *Annunciation.* Before 1426. Panel, 30 1/2 × 25 3/8″. The Metropolitan Museum of Art, New York (The Michael Friedsam Collection).

of the Magdalen here. This vertical organization, however, stops at the level of the crosses, where the movement turns back into depth. It seems that to meet the demands imposed by the long vertical composition the artist has put two different aspects of the Calvary theme into a new relationship by combining two previously existing compositions. The upper part of the Crucifixion composition was copied by the miniaturist of the early 16th-century *Grimani Breviary,* and one may guess that he followed a working drawing from the original model rather than the panel now in New York. Furthermore, it is significant that the up-and-back movement in the organization of the Last Judgment panel was largely suppressed when it was copied by Petrus Christus in his 1452 panel of this theme in Berlin (Fig. 156).

Stylistic analogies have been seen between these diptych panels and the illuminations in the famous Turin-Milan *Hours;* this problem, which involves other documentary and stylistic implications, will be considered later in this chapter. Apart from that discussion, however, it may be observed that miniaturistic aspects are visible in the proportions of the group immediately below the Cross in the Crucifixion panel, the heads being too large for the bodies. A similar miniaturistic character prevails in the upper zone of the Last Judgment panel, an All Saints picture, which, as Panofsky has shown, illustrates Chapters 21 and 22 of St. Augustine's *City of God.* The torments of the damned, at the bottom of the same panel, are depicted in a manner that exceeds in complexity and horror the Hell scene of the Limbourgs (Fig. 34), zoomorphic demons having replaced the anthropomorphic tormentors of the Italianate miniature. The emphatic naturalism here matches that seen in the figures below the crosses in the other panel.

Finally, the lighting in these two panels is more nearly universal than the localized and focused illumination seen in Van Eyck's work up to this point. This lighting is a conservative element in relation to a date which, on the basis of costume alone, cannot be prior to the early 1430s.

Therefore, though the painter of the New York diptych clearly was acquainted with Jan's compositions, the panels cannot be claimed as the work of either Hubert or Jan van Eyck. Undoubtedly the artist was one of the 70 painters traceable in the Bruges records in the first half of the century.

Of all the works attributed to Hubert van Eyck, the *Annunciation* in New York (Fig. 105) seems to be conceptually the most archaic and thus most likely to be the work of a master who died in 1426. The plunging oblique perspective has been startlingly exaggerated by the trimming of the panel edges, but it must have been comparable to that in the Dijon *Nativity* of Robert Campin (Fig. 90), where an equally high viewpoint was used. Panofsky called attention to the tree forms like those overpainted in the *Ghent Altarpiece* and the white flowers also to be found there, both appearing in those parts of the altarpiece attributed to Hubert and worked over by Jan. The profile presentation of a standing—not kneeling—angel, in its somewhat flattened, decoratively conceived form, recalls Broederlam's angel of the Annunciation (Pl. 2). An unusual aspect is the glance of the Virgin, which is neither down in modesty nor at the angel but up, possibly to a figure of God the Father now cut away from the panel. Also unusual in Flemish painting is a standing Virgin Annunciate on an interior panel, though the pose does occur in two exterior Annunciation grisailles by Jan

van Eyck (one on the Dresden triptych, discussed below, and the other in the Thyssen-Bornemisza Collection, Lugano-Castagnola, painted about 1437), and in both cases the Virgin is looking upward. A disguised symbolism appears in the contrast between the Romanesque side of the portal on the Virgin's left and the Gothic side on her right. What seems most unusual of all is the artistic use of the wall and the landscape, not as a foil but as an active contrast to the foreground action. If this is a work by Hubert, it is in sharp stylistic opposition to other works attributed to him, such as the New York diptych and the Rotterdam *Three Marys at the Sepulcher*. The New York *Annunciation* shows both a sense of monumentality in the conception of human form and a superb naturalism in achieving it and its supporting detail.

We now turn to that major work, the *Ghent Altarpiece,* having surveyed the attributions to both Hubert and Jan of works that could antedate it, and leaving to one side for the present the miniatures attributed to the Van Eycks. The physical size, visual splendor, and complexity of iconography and detail of the *Ghent Altarpiece,* as well as the magnificent harmony of the monumental with the infinitesimally small, are unparalleled in northern painting of the period. It was famous early. Despite a checkered career as prey to fire and as booty of war, it remains today much what it was when it came from the shop of Jan van Eyck—an expression of the genius of early Flemish art.

The quatrain inscription mentioned earlier, which may be accepted as more than an invention of Ghent patriots, states that the work was begun by Hubert van Eyck, greater than whom none was to be found ("maior quo nemo repertus"), that Jan, second in art, completed it on May 6, 1432, and that Jodocus Vyd (Vijd) paid for its completion. Vyd, elected burgomaster of Ghent in the following year, is kneeling in adoration on one exterior panel; his wife, Isabella (Elisabeth) Borluut, is shown on another.

Just when Jan took over the work on the altarpiece is not certain; he maintained a house in Lille, for which the Duke paid rent, until the midsummer of 1428. The summer and early fall months of 1427 were spent on Jan's journey to Catalonia; from October 19, 1428, until January, 1430, he was again engaged in the Duke's services making the trip to Lisbon and traveling in Spain

before the return voyage. As court painter Jan was undoubtedly busy with the preparations for the ducal marriage on his return, so that the middle of January, 1430, is the earliest date on which he could have begun in earnest on the *Ghent Altarpiece.*

One may hazard that before 1430 he would have dispensed with apprentices, because he was constantly moving about in the Duke's service. He did not buy a house in Bruges until 1431 or 1432. That he received an enormous increase of 40 times his previous salary in 1434–35 and the award of a life pension cannot be explained solely by the fact that he was no longer living in the Duke's household. Oddly enough, not one of the extant works of Jan van Eyck can be identified as executed for the Duke. If the ducal commissions were in the form of frescoes, these have disappeared, as have the pageants Jan undoubtedly designed for the festivals so well beloved by the rulers of that period. Our firm knowledge, then, of the works of Jan van Eyck, except for the Berlin *Madonna in a Church* and the Washington *Annunciation,* begins with the *Ghent Altarpiece.*

The work may not originally have been in its present position (the first chapel past the crossing on the south side of the cathedral of St-Bavon, Ghent) but was apparently placed in the crypt chapel directly beneath its present location. This provides a logical explanation for the double hinging of the wing panels, which could be folded back upon themselves in the limited space. Closed (Fig. 104), the altarpiece presents in the lower row the figures of the donors, Jodocus Vyd and his wife, Isabella Borluut, adoring the two saints in grisaille, John the Baptist and John the Evangelist. Above is seen the Annunciation, a common scene for altarpiece exteriors, surmounted by the prophets Zechariah and Micah and the Erythraean and Cumaean sibyls.

Set into deep niches, illumined from the right as they kneel in their piety, the donors (Fig. 106) are revealed in a gentle chiaroscuro. Jodocus looks up to the Annunciation, and his wife looks at the two saints, to whom the church was dedicated when the work was painted.

Many art historians consider that the exterior was painted entirely by Jan. One of its finest parts is the portrait of the donor. Jan's sublime honesty of portrayal shows Jodocus clearly in

106. Van Eyck Brothers. *Ghent Altarpiece* (Fig. 104), donor panels. 58 $\frac{5}{8}$ × 21 $\frac{7}{8}$″ (left), 58 $\frac{5}{8}$ × 21 $\frac{1}{2}$″ (right).

need of a shave, with a wart between his eyes and another under his right nostril. Though one eye may have had a cast, the raising of the pupil to the top of the eye imparts an intense, mystical quality, in marked contrast to the earthy portrayal of all the details of the face. Despite the soft edges, a superb clarity of dispassionate observation is achieved without sacrificing the totality of the form. The faint expression of devout emotion is given by the eyes alone, a restraint characteristic of all Jan's portraits.

The wife's face is turned from the light, which comes from the right, as it does consistently on the exterior panels, but it is back-lighted by the reflection from her headdress. The light reflected on her face outlines the side incisively and aids the sense of actual form existing in space. The two saints in the center of the bottom zone, whom she regards so intently, are treated with such sharpness as to convince the spectator that these are sculptured forms. The angularity of the smoothly modeled, stone-colored drapery is tempered by gradual transitions from light to dark, as are the features, so that the result is a magnificent illusion of sculptural, stereometric forms. The naturalism of the donors, as contrasted with the generalization of the saints, lends a sense of actual existence.

Above the four niches of the lower story, separated by broad moldings, the Annunciation scene occupies four panels. (X-rays have shown that these were underpainted as arched like the lower row.) The sense of actuality so forcefully seen in the "sculptured" saints appears again in the realistic shadows painted on the floor. This gives the frame substantiality and provides a transition from actual space to pictorial space, with a blurring of the limit between them. Obviously Jan van Eyck conceived of painting as the creation of a reality that extends the visible world. Thus the frame has a real existence, which explains why the frames on some of Jan van Eyck's other works are marbleized, and some even have the marbleizing on the back of the picture.

Within this extension of the real world, which accords so well with nominalist philosophy, Jan has set his scene, and, as the two central panels clearly indicate, borrowed from the Master of Flémalle the forms for his disguised symbolism. The Virgin in her tower room, seen as a Virgin of Humility, replies to the angel salutation as she did in the Washington *Annunciation,* and again her reply is lettered upside down. Here the angel holds lilies, an Italianate feature that goes back at least to Simone Martini's 1333 *Annunciation,* in the Uffizi, Florence. Both figures are dressed in ivory white, but the hands and faces are in natural color, thereby creating a seemingly magical transformation from the sculptural world of the two Sts. John below into a natural one. The perspective is not completely unified. That Jan is creating another reality rather than making an exact copy of nature is very clear. It is doubly clear when one considers what would happen if the Virgin were to rise to her feet. Obviously Jan van Eyck's reality merely has reference points to an exact nature.

The two upper central panels of the exterior are adjustments conditioned by the interior panels; they do not conform in dimensions with the four panels of the lower level. In a lunette above the angel, the half-length figure of the prophet Zechariah, seen from below, points to a text expressed in the scroll behind him (Zechariah 9:9). Opposite him on the right the prophet Micah, a closed book beside him, seems to look down at the Virgin Annunciate, and the scroll behind him refers to his prophecy (Micah

5:2). Both texts are Old Testament prophecies of the coming of the Messiah. The Erythraean and Cumaean sibyls, framed in half arches at left and at right respectively above the central interior scene, also have scrolls related to their oracular statements. The names of the prophets and sibyls are inscribed on the frames below them, and the famous quatrain is on the frame of the lowest row. The two sibyls present a marked contrast of form in the accented sculptural effect of the Erythraean sibyl and the smoothing out of surfaces in her fellow seeress. This contrast was undoubtedly intentional in the context of the panels immediately below them, where the contrasts are of spatial character, close and distant. As a result the upper central panels are a part of the whole, yet separate, the contrasts serving both to bridge and to articulate the relatively empty space between the Virgin and the angel Gabriel. The measure of Jan van Eyck's ability as a creator, even in the face of the almost impossible task presented by the interior panels, is nowhere more convincingly demonstrated.

At first glance the interior (Fig. 107) overwhelms the spectator by the richness and purity of its glowing colors, the majesty of its forms, and the grandeur of their depiction. When the work is examined in detail, that mastery becomes even more evident. However, a close study shows marked discrepancies, the chief being the dwarfing of the lower panels by the upper and the lack of correspondence of the upper wing panels to the lower wings. It is evident that there are problems. What was painted by Hubert? What was painted by Jan? What are the differences in style? What is the unifying theme?

The iconography of the lower panels is dominantly an Adoration of the Lamb, an Apocalyptic theme probably inspired by the liturgical Office for the Feast of All Saints, rather than directly from the Revelation of St. John. In the center panel are the saints mentioned in the liturgy of the Feast of All Saints. In the foreground, left of the Fountain of Life, are the patriarchs and prophets from the old dispensation with Vergil(?); and on the other side are the apostles (seven of whom are kneeling), with Sts. Paul and Barnabas and the martyrs led by St. Stephen and St. Lievin, patron saint of Ghent. In the middle ground of this scene set in Paradise are the bishop confessors, at left, and the

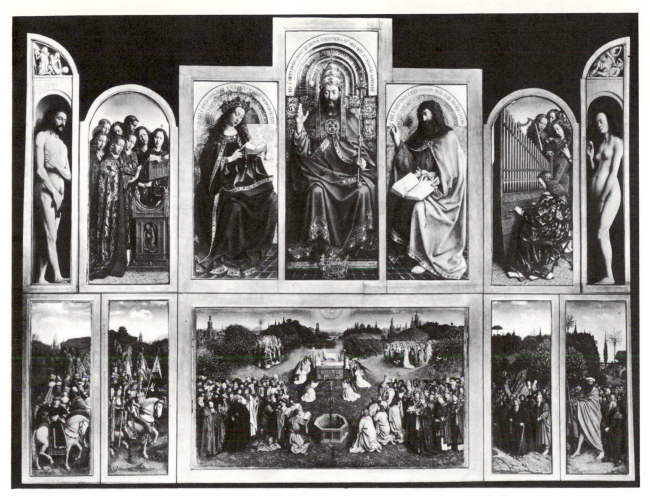

107. VAN EYCK BROTHERS. *Ghent Altarpiece* (open). *c.* 1425–32. Panel, 11′5¾″ × 15′1½″.
Cathedral of St-Bavon, Ghent.

(much repainted) virgin martyrs, at right, led
by Sts. Agnes, Barbara, Catherine, and Dorothy.
In the background is the Heavenly Jerusalem.
All adore the Apocalyptic lamb standing on the
altar and bleeding into a chalice. Angels kneel
on either side, some holding the instruments of
the Passion, and two angels cense in front of the
altar. An echo of the design of the fountain
appears in the arrangement of the figures about
the altar of the lamb. [6]

High above the landscape hovers the dove,
symbol of the third person of the Trinity. In
relation to the Adoration of the Lamb and the
adoring saintly chorus it is an anomaly, and the
rays spreading from it accentuate that fact. But
if the altarpiece is read vertically, the figure
above is God the Father (so identified by Dürer),
completing the Trinity.

There are further anomalies in the lower zone
if it is read horizontally. The central panel is

flanked by two narrow panels on each side. On
the inner right panel the holy hermits are led by
St. Paul(?) and St. Anthony Abbot, identifiable
by the T cross on his garment. Two famous
female hermits, Sts. Mary Magdalene and Mary
Egyptiaca, join the procession. (Both were
additions to the original panel, as x-rays have
proved.) The outermost panel shows the holy
pilgrims led by the giant figure of St. Chris-
topher; one is St. James, identifiable by the
cockleshell on his hat.

To the left of the central panel the knights of
Christ appear, headed by St. Martin(?), St.
George, and St. Sebastian. The outer panel has
been replaced by a recent copy of the original,
stolen in 1934 and still unrecovered. Its subject
is the just judges, an unusual addition to an All
Saints picture, for judges in the late medieval
period were often less than just, as the numerous
prayers of the period against unjust judges and

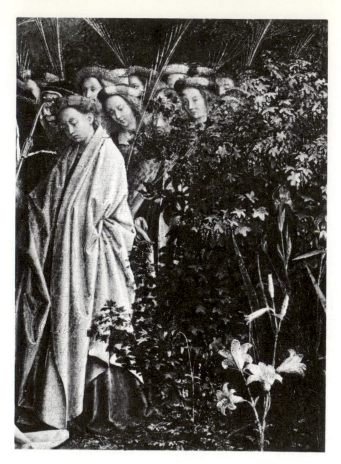

flanking Him, smaller in size and lower in position.

Beyond them the round-headed wing panels (the central panels also have the arched design but are actually rectangular) contain singing angels at the left and music-making angels at the right, all of them lacking wings.

At the extreme left and right are the strongly lighted nude figures of Adam and Eve, painted as if seen from below. Their sin is indicated by the action of both figures and by the pomegranate (the medieval apple) held by Eve. It was, of course, that sin which made Christ's sacrifice necessary. Shown in grisaille above Adam is the offering of Cain and Abel. Above Eve the theme of the grisaille is the killing of Abel by his brother. Adam and Eve, whose angled positions and glances pull the eye of the spectator back to the center so solemnly marked out by the glowing color and hieratic pose of God the Father, are shown larger than the angels but smaller than the central trio.

The angles of the heads of Adam and Eve were designed by Jan (to whom most historians attribute these outermost figures in their entirety) to echo the placement of the heads in the angelic groups and those of Mary and John, thereby uniting the heroic nudes with the other figures. This echoing rhythm is enhanced by the lowered viewpoint, which is accentuated by the way Adam's foot slightly overlaps the frame. Jan's naturalistic vision is revealed by the contrast in color between Adam's hands, tanned by exposure, and the whiter skin of his body. Eve's stomach protrudes in a fashion comparable to the ideal type in works of the International Style.

The angels, in their rich dalmatics, are not generally considered to be entirely from Jan's hands but repainted by him. However, like the Eve, the Marys in the panel of the hermits, and the Virgin of the exterior Annunciation, they are close in type to the Virgin of the Washington *Annunciation*. The expression of the angels has been frequently commented upon. Let it suffice to say that such emphatic naturalism of a particular moment is not to be found again in Jan's preserved works, for it is basically foreign to his almost mystical feeling for the continuity and unity of all matter. One may assume that in

the paintings of justice amply demonstrate. It happens that the magistrates of Ghent were recorded as visiting Hubert's shop in 1425, at which time they made a gift to his apprentices. This suggests that the panel of the judges, and possibly others of the polyptych as well, were part of an entirely different scheme adapted to Jodocus Vyd's desires after Hubert's death. The figures of the judges themselves have been variously identified, with a singular lack of agreement among scholars. An instance is the young man cocking his head to look at the spectator: 19th-century writers identified him as Jan van Eyck.

In the center of the upper zone the hieratic, frontally placed, red-robed figure in a papal tiara with a worldly crown at His feet, His hand raised in blessing, has already been considered as God the Father, the first person of the Trinity, when the altarpiece is read vertically. When it is read horizontally, the figure is Christ, the second person of the Trinity. In isolation the figure represents all three in one, as the inscriptions on the robe indicate. This figure is the center of the deësis group, with Mary and John the Baptist

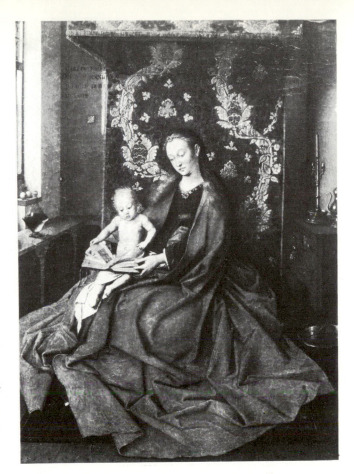

right: 109. JAN VAN EYCK(?). *Ince Hall Madonna.* 1433. Panel, 8⅞ × 5⅞". National Gallery of Victoria, Melbourne (Felton Bequest).

reworking these panels Jan followed Hubert's model.

Laboratory analyses have proved that the central figures were repainted (probably by Jan), particularly the figure of God the Father. Originally the floor tiles were alternately light and dark, and this was changed in the repainting. The less plastically treated draperies differ from the more emphatic modeling of Jan's documented work.

The lower panels were also reworked, as laboratory investigation has clearly proved, confirming what had long been asserted, especially by Max Dvořák.[7] On the outer wings the landscape was modified by Jan, and southern vegetation was added; over thirty different types of vegetation are identifiable in the lower panels, again proof, if it be needed, of the acuity of vision of the Van Eycks. Umbrella pines, date trees, palms, and cypresses are witness to Jan's trips to Spain and Portugal, and the verdant landscape of the central panel, particularly the vegetation close to the virgin martyrs, shows forms native to the Netherlands (Fig. 108).

It is clear that Jan reworked all the panels, but Hubert's design undoubtedly governed the basic construction of the center panel, which has two perspectives, one for the Fountain of Life, the other for the altar with the lamb. The altar and the surrounding angels are entirely by Jan's hand. In the foreground the strong use of profile in the apostles around the fountain and the sharper silhouette seen there are probably signs of Hubert's design. Furthermore, the design of the entire lower row is probably attributable to him, because it shows tendencies to flatten forms and to emphasize the profile, particularly in the panel of the just judges, and these traits are not characteristic of the authentic works of Jan.

Not all the elements visible today are due either to Hubert or to Jan, for the altarpiece has been repainted at least seven times in its history. For example, the tower to the left of center in the Adoration panel, identified as that of Utrecht Cathedral, has been shown by laboratory investigation to be an ancient addition. It was undoubtedly added by Jan van Scorel, who, with Lancelot Blondeel, repainted the work in 1550, after it had been severely damaged by a heavy-handed scrubbing, which, according to legend, had completely ruined a predella bearing a Hell scene. Other buildings were later added on the right side of the skyline. The greatest damage to the work was due to a fire in 1822, necessitating heavy restoration.

In sum, the interior of the *Ghent Altarpiece* presents two scenes of Heaven, one above the other, both reworked by Jan van Eyck. He adroitly organized the disparate panels into a coherent and magnificent artistic unity. The theological redundancy of the central panel does not detract from Jan's monumental achievement.

Jan and his shop were at work on the altarpiece from mid-January, 1430, to May 6, 1432. (The altarpiece could have been completed within this time, because Michiel van Coxie spent two years, 1557–59, copying it, and copying takes much longer than original painting. Furthermore, historians usually allot two years to Van der Goes's enormous *Portinari Altarpiece*.)

The *Ince Hall Madonna* (Fig. 109), in Melbourne, if original, is the first independent work

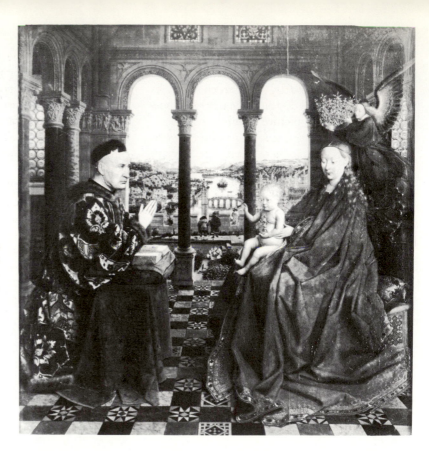

110. JAN VAN EYCK. *Madonna with Chancellor Nicolas Rolin* ("Virgin of Autun"). *c.* 1433. Panel, 26 × 24 3/8". Louvre, Paris.

by Jan van Eyck to be signed and dated. On the back wall at the left are the date and signature, and to the right of the brocaded hanging is Jan's motto "Als ick kan" ("as best I can"), which demonstrates the princely attitude of the artist, who, like his patrons, has adopted a personal motto. (These elements may have been copied from the now lost original frame.) Not until almost a century later was there a similar case in Flemish art, except for Jan's follower Petrus Christus, who signed and dated his works but used no motto. Despite the signature, the work has been doubted as an original by Jan van Eyck, but it does fit logically into his development.

In this painting a drastic shortening of the pictorial space is seen, apparently to create an intimate effect. Even though there is repainting on the face of the Virgin, both conception and execution are of high quality.

The intimate setting is an innovation, but the development toward monumentality visible in the *Ghent Altarpiece* finds its logical continuation here. Jan has subtly regalized the theme by his transformation of the domestic interior by means of a rich brocade and canopy. This seemingly intentional unification of the hieratic and the intimate is animated by strong S-shaped

movements that begin at the lower right and are repeated in the design of the hanging. The almost exact bilateral symmetry of the interior space has been slightly varied to increase informality and solemnity in equal measure. All gently illuminated by the soft light from the left, the objects in the room are related to the conception of disguised symbolism.

Not much later, and possibly of the same year, is the *Madonna with Chancellor Nicolas Rolin*, also called the "Virgin of Autun" (Fig. 110), probably donated to the Cathedral of Autun in 1437, when the chancellor's son Jean became bishop there, and now in the Louvre. Nicolas Rolin, the powerful administrator of Burgundy, born at Autun in 1376, is apparently a man in his fifties in Jan's painting. (Rogier van der Weyden painted his portrait on the exterior of the *Last Judgment Altarpiece* in Beaune when Rolin was about seventy years old. See Chap. 6.) He died at the age of eighty-six. Jan shows the chancellor within the Virgin's sacred chamber, kneeling with utter devotion at a *prie-dieu*. He is not presented by a saintly sponsor, as was usual. The room's sacred character is seen in its isolation from the external world, which is seen beyond the parapet in the middle distance, over which

two small figures lean. The sacredness of the environment is also indicated by the triple archway (the Trinity) and by the garden, with its birds, iris, and lilies (disguised Marian symbolism). The result is a picture within a picture.

The landscape is so wonderfully painted, with such a seeming exactitude of detail, that various writers have attempted to identify the town as Bruges, Liège, Lyons, Utrecht, Prague, or even Brussels and the river as the Meuse, the Rhine, and so on. A bridge and a castled island animate the river, and the background terminates in snow-capped mountains. This background was copied for a miniature (a man riding a donkey symbolizing Sloth) in a Book of Hours very close to the Bedford Master, now in the British Museum. Count Jean Dunois, Bastard of Orléans, companion of Joan of Arc, and liberator of Paris in April, 1436, probably commissioned the manuscript at this time from a master who obviously had become acquainted with Jan van Eyck's panel at an earlier date.

On the pier capitals at the left side of the Virgin's chamber are Old Testament scenes, beginning with the Expulsion. On the right is a classical scene, seemingly the Justice of Trajan. All the elements exist within a magnificent spatial chiaroscuro. The Virgin, in a blue dress and dark-red mantle, holds an almost dour Child on her lap. Her expression is quiet, and the type is gentle, though neither the Virgin nor the Child is as doll-like as in the Ince Hall painting. To the right an angel is about to put a large and elaborate crown on the head of the Virgin. Both mother and Child reveal a greater stereometric quality than Jan had achieved before; the Child obviously shows greater rotundity and stability of surface, while the solid construction of the seated Virgin is somewhat less obvious.

Further progress in monumental construction is seen in the *Lucca Madonna* in Frankfurt (Fig. 111), which takes its name from a former owner, the Duke of Lucca. The type is that of the *Ince Hall Madonna* but clearly later (about 1433–34), for the firm support of the Child in the *Rolin Madonna* has been changed into a solidified shelf, on which the Child sits in profile as He nurses. A more angular disposition of the

drapery heightens the effect of monumentality, further augmented by the restricted space of the rigorously balanced composition. The Virgin's glowing red mantle is set against a subdominant green brocade and canopy. Increased solemnity is achieved in this work by more compact composition with stronger horizontals and verticals than before.

The growing tendency toward immobility and monumentalization marks the double portrait of *Giovanni Arnolfini and His Wife, Giovanna Cenani* (Fig. 112), in London, dated by the unusual inscription on the back wall above the round mirror: "Johannes de eyck fuit hic, 1434." Panofsky has concluded that this is more than a marriage portrait; it is a marriage document. Jan van Eyck, seen in the mirror entering the room with a companion, has not only represented himself as a witness to the betrothal but has signed, "Jan van Eyck was here, 1434," with the calligraphic flourishes of a legal signature of the day.

Arnolfini, a merchant of Lucca, in a purple velvet tunic, and his Paris-born Italian wife, in

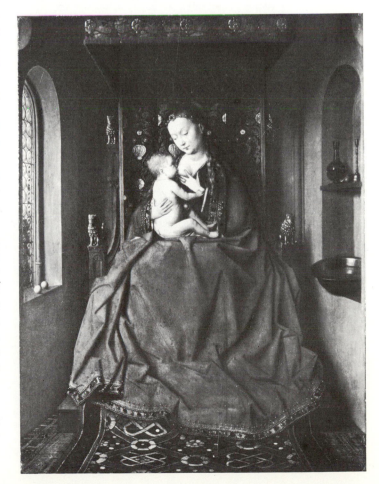

right: III. JAN VAN EYCK. *Lucca Madonna.* c. 1433–34. Panel, 25 ³/₄ × 19 ¹/₂″. Städelsches Kunstinstitut, Frankfurt.

blue dress and green mantle, are solemnly taking the matrimonial vow in a room that has the connotations and some of the appurtenances of the sacred rooms in the Ince Hall and Lucca Madonna paintings. Arnolfini, holding his wife's hand, looks ahead and down as he raises his right hand. He has removed his clogs, for he is standing on holy ground. The little dog is an obvious symbol of faithfulness (dogs were normally represented at the feet of women in earlier tomb sculpture). The magnificent chandelier contains a single burning candle, symbol of the all-seeing Christ, whose Passion is represented in the ten roundels around a mirror that is no larger than a silver dollar. On the finial of the chair by the matrimonial bed is carved St. Margaret, patron saint of childbirth. Light from the window at the left falls softly on the fruit by the window sill and fills the chamber with its soft glow. The spiritual reserve and solemnity of Jan's Madonna paintings are here imparted to a portrait that is more than a portrait, and spatial

chiaroscuro unites all in a mystic atmosphere.

The greatest solemnity and monumentality of form are reached in the Bruges *Madonna of Canon George van der Paele with Sts. Donatian and George* (Pl. 8, after p. 180). Madonna and Child are placed close to the picture plane within a rounded apse at the emplacement of the altar. St. Donatian, dressed in a magnificent blue-and-gold velvet brocaded cope, holds in one hand his symbol (a spoked wheel with five burning candles set around its rim) and in the other a splendid cross staff, and looks toward the Virgin. She is wearing a blue dress and a crimson mantle with angular folds, which form a solid support for the Child. He holds flowers and a parrot as He looks toward the kneeling Van der Paele and his patron saint. The Child is as firmly modeled as in the *Rolin Madonna;* apparently the same child has been used as a model, but here it is clearly older by about a year and a half.

According to the inscription on the original frame, the work was commissioned from Jan

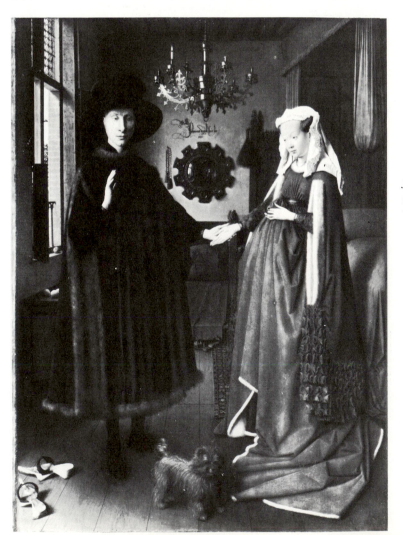

112. JAN VAN EYCK. *Giovanni Arnolfini and His Wife.* 1434. Panel, $32 \frac{1}{4} \times 23 \frac{1}{2}$". National Gallery, London.

van Eyck in 1434, at the time of the founding of two choral chaplaincies at St. Donatian's by George van der Paele. It was completed in 1436, but its design thus goes back to the middle of September, 1434, at the earliest. The greater age of the Child here, as compared with the child in the *Rolin Madonna,* is a basis for dating that work in 1433.

Dressed in magnificent dark armor, on which a reflection of the painter is dimly seen, St. George tips his helmet as he presents the kneeling donor, dressed in a white surplice with an amazingly naturalistic gray fur folded over his arm. The donor's glasses are held so that they magnify the script of the book in his hands, another example of Jan van Eyck's complete mastery of visual phenomena. A mystic sense of contemplation is created by having the donor look toward but not at the Virgin and Child.

The organization of the panel has progressed beyond earlier works in logical structure, so that the scene seems to exist within a completely unified space. The type of the Virgin shows a greater monumentalization than ever before, and balancing elements are more rigorously introduced, as in the line of St. Donatian's drapery and the corresponding angle of St. George's banner.

Jan subtly balanced his strong, fresh colors, avoiding violent contrasts; unity of tone is achieved by dominance of the middle range of values. Thus he created a convincing natural world. There is a deep, resonant glow, depending for its effect on the subtle interplay of primary hues, the warmer tones just outweighing the cooler tones. This is seen in the blue and yellow of Donatian's garments, in the red robe of the Virgin set against the green of the brocade and canopy, in the dominantly warm color of the carpet, in the gray-browns of the architectural setting enlivened by the greenish white of the windows. The group to the right is strongly gray-white and warm black. Here Jan van Eyck achieved a peak not to be surpassed in the few subsequent works either by him or attributable to him in whole or in part.

An unusual work is the *St. Barbara* panel (Fig. 113) in Antwerp, signed on the marbleized

frame: "Johannes de eyck me fecit, 1437." In grisaille, rather than in full color, its extremely detailed drawing indicates that it was never intended to be painted. Support for this conclusion is found in the drawing changes revealed by x-rays of the parts of the *Ghent Altarpiece* that are undoubtedly by Jan and in the Arnolfini portraits. [8] St. Barbara is seated on the slope of a small mound, which separates her from the manifold background activities (there is no middle ground) related to the building trade as then practiced. What is being built is the saint's octagonal tower.

It has been thought that the work is complete as we see it today, but it is difficult to accept the conception of the saint's figure as later than the Van der Paele Madonna, for the Antwerp panel seems to be intermediate between the Ince Hall and Rolin Madonnas in the construction of the drapery and in the type of the saint, with her small, high waist and narrow shoulders. The Rolin, Lucca, and Van der Paele Virgins are all

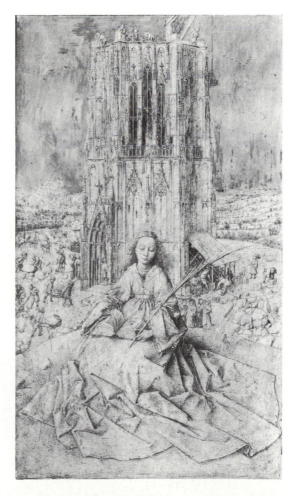

right: 113. JAN VAN EYCK. *St. Barbara.* 1433/34(?)-1437. Panel, 12 1/4 × 7 1/8″. Musée Royal des Beaux-Arts, Antwerp.

heavier, sturdier types. Rather than consider this a return to older forms, a retrogression, or even a new mellowness fused with grandeur, it seems that another answer is possible, admittedly a prosaic one: The visual evidence of the comparatively undefined area below the book on the lap of the saint and of the sharp jump from foreground to background, both of which are gaps that could be filled out in paint (as in the Adoration panel from the *Ghent Altarpiece*), suggests that this work may have been begun by Jan about 1433–34 and never completed as intended. Other commissions and journeys for the Duke may have intervened to delay its execution. The original commissioner may have died, or, tired by all the delay, may have told the painter that he would take it as it was if he would complete the drawing of the tower and landscape, which are extremely detailed (too much so to be the basis for later overpainting) in contrast to the summary foreground treatment. This is not impossible, and it does explain what is a most unusual Flemish painting, an independent grisaille; nothing like it follows.

Possibly one may apply the same reasoning to the *Dresden Triptych* (Fig. 114), a small, portable, folding altarpiece only about 11 inches high, which has recently been discovered to be signed and dated 1437. The date is later than that previously given by most historians. On the left wing St. Michael presents a donor, thought to be Michele Giustiniani of Genoa, to the Madonna and Child enthroned in the central panel. St. Catherine stands reading her breviary on the right wing. A landscape with snow-capped mountains is visible through the window behind her. The Annunciation is presented on the exterior in grisaille.

The inner frame is painted with inscriptions in the illusion of relief carving, that of the center panel taken from the Marian hymn mentioned above. On the throne of the central panel appear symbolic carvings of the pelican, the phoenix, the sacrifice of Isaac, and David and Goliath. The columns on either side have Gothic bases but late Romanesque capitals; they establish the locale as the interior of a church with a square apse. Rich carpets lead the eye of the spectator to the Madonna and Child enthroned at the emplacement of the altar. The richness and delicacy of detail equals the splendor already seen in the Berlin *Madonna in a Church*. In form

114. JAN VAN EYCK. Madonna and Child Enthroned, Dresden Triptych, center. *c.* 1434(?)–1437. Panel, 10 ⁷/₈ × 8 ¹/₂″ (central panel), 10 ⁷/₈ × 3 ¹/₈″ (each wing). Gemäldegalerie Alte Meister, Staatliche Kunstsammlungen, Dresden.

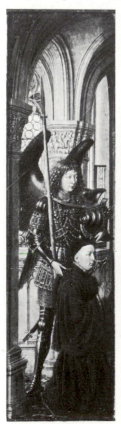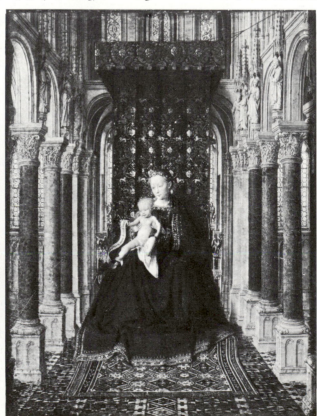

and modeling the figures have been developed beyond those in the earlier works. The Virgin in her deep crimson robe (repainted) is much less doll-like than the Berlin *Madonna* and more solid than the *Ince Hall Madonna*. The fluffy-haired St. Catherine is stylistically related to the virgin martyrs of the *Ghent Altarpiece*. The donor and the St. Michael are delicate in conception, but the details of the armor are very close to those of St. George in the *Van der Paele Madonna*. One may hazard the guess that this triptych was designed about the same time as the Antwerp *St. Barbara,* that is, shortly after the *Ince Hall Madonna*. Since Jan was a court painter, work for the Duke would have taken precedence over private commissions—in themselves exceptional—and completion dates probably did not follow closely on starting dates.

The attempt to create a unified space spreading over the three panels was not entirely successful; both figures on the left wing look at a spot apparently about ten feet in front of the Virgin and Child. Yet the eye is delighted and entranced by the consummate artistry of the luxurious surface ornamentation, and the created world that is still natural, for it is filled with a scintillating yet diffused light and balanced forms. The same spirit is found in the immobilized figures in the light-filled niches on the exterior.

That the work is almost a miniature in spirit as well as in size seems to indicate a movement away from the strongly plastic, sculptural naturalism of the *Van der Paele Madonna*. However, if we conclude that it was designed shortly after the *Ince Hall Madonna,* despite the delay in completion until 1437, we obviate the rather dubious possibility of a very uneven development by the painter, and the work then takes its proper place in Jan's development.

Equally unusual, but for different reasons, is the Antwerp *Virgin at the Fountain* (Fig. 115), which is signed and dated with the explicit information that it was made and completed in 1439. Older ideas are reasserted. The Madonna's robe is again blue. She is standing instead of sitting. The strongly compressed space is not conclusively interior or exterior, and the angels holding the brocaded cloth float, their feet in no way firmly fixed on solid ground. The head of the Virgin, rounder and more doll-like in features than in the works previously discussed, and the very thin, extremely active Child, held by the

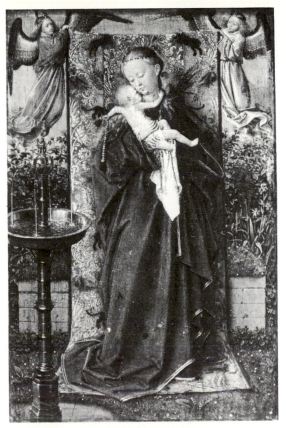

115. JAN VAN EYCK. *Virgin at the Fountain*. 1439. Panel, 7 1/2 × 4 3/4″. Musée Royal des Beaux-Arts, Antwerp.

tiny hands of the Virgin, present characteristics unexpected in Jan's work of this date. Were it not for the signature and date, it is quite likely that the work would be attributed to Petrus Christus, who repeated the composition in several versions (see Chap. 7). Possibly its design is by Jan van Eyck (note the solidity of the left side of the drapery rising from a firm base, a motif which appears in the *Maelbeke Triptych,* Fig. 122, discussed later in this chapter), based on an earlier "beautiful Madonna" type, and its execution is in greater part by the shop. The lack of hesitancy is undoubtedly due to Jan's working over the surface in the normal procedure before letting it leave the shop.

As a portraitist Jan van Eyck's mastery has already been shown in the dispassionate revelation of the individual in the figures of Jodocus Vyd, Nicolas Rolin, Giovanni Arnolfini and his wife, and, to a lesser degree, in Michele Giustiniani(?). Possibly his earliest portrait is that in Berlin of Baldwin de Lannoy, governor of Lille and chief of the ambassadors on the Spanish and

Portugese missions. Baldwin wears the collar of the Order of the Golden Fleece, which he did not receive until November 30, 1431; the award may have been the occasion for the portrait, which is close in approach to the portrait of Jodocus Vyd. The eyes are similarly treated, with upturned pupils, and the mouth is set in a straight line. Lighting is also comparable, falling in both works from above the head. The portrait is not quite half-length, but the hands, holding a chamberlain's staff of office, are included. The background is typically devoid of tonal variation and setting.

In December, 1431, Cardinal Niccolò Albergati visited Bruges, at which time, it seems, Jan van Eyck made a portrait drawing of him (Fig. 116), now in the Kupferstichkabinett in Dresden, with detailed color notes in Flemish ("the nose sanguineous," "the lips very whitish," etc.). A silverpoint drawing on white-grounded paper, it formed the basis for the later portrait of Cardinal Albergati (Fig. 117), in Vienna. In the painting he wears a red garment trimmed with white fur. The execution of the painting seems to have been slightly delayed, but the changes in transposing the drawing into painting are of great interest. The round and fleshy form in the drawing has been changed into a monumentalized view of the surface. For the visual impression of the drawing with its accentuated particularities, the painting substitutes a slightly sharper line that creates a feeling of reserve. Gazing into space, the Cardinal seems to be

endowed with a natural reserve that is Jan's northern equivalent of Italian idealization.

This spirit appears in the portrait entitled *Leal Souvenir,* in London, of October 10, 1432, and signed by Jan van Eyck but without his motto. The subject of this "loyal remembrance" is seen behind an antique parapet on which is the name "Tymotheos." Timotheus was a famous musician of the court of Alexander the Great; the inference has been drawn that the figure represents Gilles Binchois, court musician of Philip the Good, the latter-day Alexander. Flemish music, like painting, made great advances at this time, and the further inference is that Jan van Eyck thus must be the latter-day counterpart of Apelles, Alexander's painter. This conceit is very much in keeping with the courtly taste of the era, which delighted in tracing ancestries back to the Trojans and other great peoples of antiquity, in accord with the euhemeristic spirit defined by Seznec.[9] Here Jan created a figure looming up out of chiaroscuro space, much in the manner, except for the sharper lighting, of the Jodocus Vyd portrait.

Slightly more than a year later Jan painted the portrait of a *Man in a Red Turban* (Fig. 118), also in London, signed with his motto and the date October 21, 1433. The figure turns his eyes directly toward the spectator, but keeps his face in the three-quarter position. Again the light falls from the upper left, revealing an amazing exactitude, as in the veins in the eyes and the subtle details of fur and folds. Yet detail is still sub-

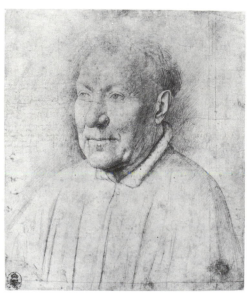

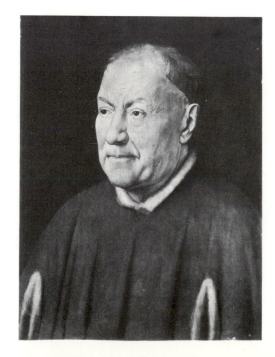

left: 116. JAN VAN EYCK. *Cardinal Niccolò Albergati. c.* 1431. Silverpoint, 8 ³/₈ × 7 ¹/₈″. Kupferstichkabinett, Staatliche Kunstsammlungen, Dresden.

right: 117. JAN VAN EYCK. *Cardinal Niccolò Albergati. c.* 1432. Panel, 13 ³/₈ × 10 ³/₄″. Kunsthistorisches Museum, Vienna.

right: 118. JAN VAN EYCK. *Man in a Red Turban*. 1433. Panel, 10 1/4 × 7 1/2". National Gallery, London.

below: 119. JAN VAN EYCK. *Margaret van Eyck*. 1439. Panel, 13 1/8 × 10 1/2". Groeningemuseum, Bruges.

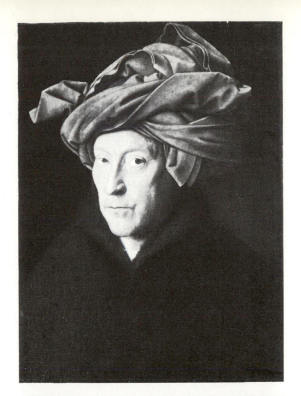

servient to the conception of a whole in which light and shadow play an even more important part in the drama than before, selectively accentuating the face and concentrating attention around the eyes. The lower portion of the face is slightly darker in color, and its shadows are used chiefly as modeling devices. There is a repeated impression of sharpness in the glance, in the compression around the corners of the mouth, and in the treatment of the subdued red turban. Its active folds are less strongly illuminated than the face, and drapery lines are so delineated that the whole swirling form asserts a linear contrast to the chiaroscuro of the face. The collar and chest are subdued in color and value. Had they been as accentuated as in the Albergati portrait, the contrast would have created intolerable conflicts.

The turbaned man has been identified both as the painter himself and as his father-in-law. A strong resemblance may be noticed between this figure and Jan's wife, whom he portrayed six years later, when she was thirty-three. It is equally possible that the turbaned man is his wife's older brother. Whoever the sitter, this is Jan van Eyck's most masterful portrait. Once again we are magically involved with the individual in his spatial reality.

Repetitions and variations on these portrait types appear in the years before 1439, when Jan signed and dated the portrait of his wife, *Margaret van Eyck* (Fig. 119), in Bruges. Her head is placed high in the field and is slightly more frontal than that of the *Man in a Red Turban*. More evenly lighted, the figure is somewhat flatter and thus is close in style to the *Virgin at the Fountain*. The right hand was painted in later and detracts from what must have been a greater monumentality than is now visible. Margaret van Eyck's face emerges from the crisp whiteness of the headdress, with its intricate ruche, to dominate calmly over it and the red wool gown trimmed with a gray squirrel collar.

In all the portraits of Jan van Eyck there is the same sense of objectivity and quiet observation; where the sitter looks out toward the viewer, the latter is the observed, not the observer.

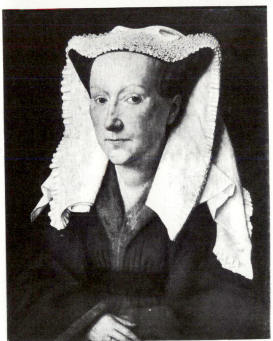

A number of Jan's works are known only through replicas. There are several paintings of the face of Christ frontally presented, an extremely popular image at this period. Two copies of the *Stigmatization of St. Francis* are known, one in Philadelphia, the other in Turin; both show St. Francis completely disregarding the vision, and both have feet that could never

be organically related to the body. Several copies exist of a Crucifixion, with Mary and John before a landscape. There is also a *Christ Carrying the Cross* in Budapest. These are the outstanding replicas and copies.

Three works in a category by themselves bear a closer relationship to Jan van Eyck; his hand has been discerned in all, and in two of them the space has the compressed character visible in the *Virgin at the Fountain* and the portrait of Margaret van Eyck.

Closest of the three to Jan is the *Virgin and Child with Saints and a Donor* (Fig. 120), Frick Collection, New York. The Carthusian donor is possibly Dom Jan Vos, prior from 1441 to 1450 of the monastery of Genadedael, near Bruges. He is portrayed again in the *Virgin and Child, St. Barbara, and Carthusian Donor* (Fig. 150) of Petrus Christus, presented by St. Barbara, as he is in the Frick painting. Vos became prior after March 30, 1441; thus if the Frick panel was immediately commissioned from Jan van Eyck, it is his last work. The excessive smoothness of surface; the repetitive nature of the right background landscape, reminiscent of that in the *Rolin Madonna;* the clumsy, spatially unspecified tower of St. Barbara at the left (with its enigmatic bronze figure labeled "Mars" in the central opening); and the oversimplified internal drapery treatment of the Madonna and of St. Elizabeth of Thuringia

at the right—all seem below Jan's normal level of achievement. As a result, the attribution of the work has been doubted by many historians. The explanation may be that Petrus Christus was then in Jan van Eyck's shop and, after Jan's death, completed the work, which was dedicated by Bishop Martin of Mayo, Ireland, on September 3, 1443. (It may be mentioned in passing that the Flemish were the chief weavers of Irish wool.)

Next in closeness to Jan is *St. Jerome in His Study* (Fig. 121), in Detroit.[10] It is related to a St. Jerome by Jan listed in the 1492 inventory of Lorenzo de' Medici, which inspired two frescoes in the church of Ognissanti, in Florence,

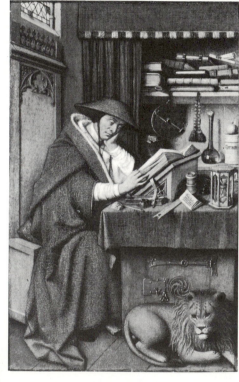

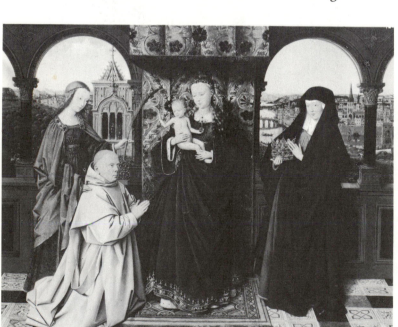

left : 120. JAN VAN EYCK AND PETRUS CHRISTUS. *Virgin and Child with Saints and a Donor. c.* 1441–43. Panel, 18 5/8 × 24 1/8". Copyright The Frick Collection, New York.

above : 121. JAN VAN EYCK AND PETRUS CHRISTUS(?). *St. Jerome in His Study.* 1441–42(?). Panel, 8 1/16 × 5 1/4". The Detroit Institute of Arts.

(the *St. Jerome* by Ghirlandajo and the *St. Augustine* of Botticelli. The three compositions are similar. The Detroit work is dated 1442 on the back wall at the right of the chair, but cleaning has revealed that the inscription is old but not, seemingly, original. On the table is a letter addressed in minute script to St. Jerome, Cardinal-Priest of the Holy Cross of Jerusalem, as deciphered by Panofsky, who discovered that Niccolò Albergati was the titular head of the church of Santa Croce in Gerusalemme (Holy Cross of Jerusalem).[11] St. Jerome was normally associated with the Church of St. Anastasia. Thus this delightful small panel was probably painted for Albergati. In part the informal quality of the work is due to the perspective, which focuses attention on the apple placed on the apothecary jar labeled "Tyriaca" (i.e., "theriaca"), a famous remedy since ancient times for snakebite. The disguised symbolism of the Temptation and Redemption is evident here. The carafe next to the jar and the astrolabe are related to Christ, and by implication to the Virgin, as the true medicine of the Bible. St. Jerome was, of course, known for his translation of Scripture and his commentaries on Mary. This complex relationship, probably referring to a text still unidentified, had been made earlier in the *Boucicaut Hours,* where St. Jerome is uniquely shown with the Marian symbol of a lily in a vase.

The symbolic elements are present in precisely the area of the Detroit picture attributed to Jan by those historians who believe this work to have been completed by Petrus Christus. The red cloak and the lion in particular have been ascribed to Christus, though the cleaning has revealed that both were overpainted; however, as the work is now presented to view, seemingly it may be assigned to Jan, with additions possibly by Christus.

Evoking through this naturalistic interior the spirit of reflection characteristic of the contemplative life, this "occupational portrait" of the saint, showing the scholar in the intimacy of his study, goes far beyond earlier representations of Evangelists sitting at their writing desks. Recognizing the beauty of this expression, Jan's followers in the 1440s transformed the scene into a St. Thomas Aquinas in the Turin-Milan *Hours* and repeated it in another Book of Hours of mid-century in the Walters Gallery in Balti-

more. Italian admiration of the scene is evident not only in the two frescoes in Florence but also in Naples, where Colantonio used the setting for his painting of St. Jerome removing a thorn from the lion's foot, though he may have been influenced by another copy of Jan's work rather than by the Detroit version.

The *Maelbeke Triptych* (Fig. 122), in the collection of the Earl of Warwick, Warwick Castle, England, was commissioned by Nicolas van Maelbeke, provost of St-Martin, Ypres, from 1429 to 1445. The center panel was unfinished at Van Eyck's death, and it is hard to say how much of the wings were executed by him,

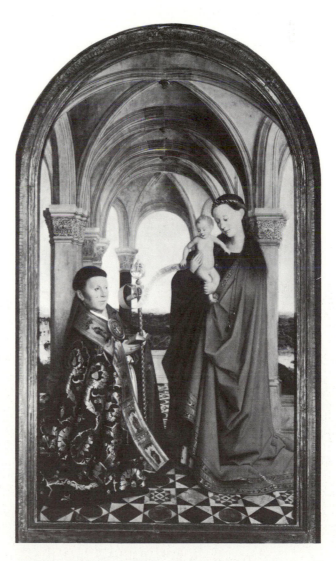

122. JAN VAN EYCK. *Maelbeke Triptych,* center. Panel, 69 1/4 × 39 ". Warwick Castle, Warwick, England (by permission of the Earl of Warwick).

how much by a later hand. A bearded head superimposed on that of the donor in the 17th century has now been removed to show Mael-beke's features. He kneels in the central panel before the standing Virgin with the Child, both turned diagonally toward the center of the panel. The design breaks away from the compressed spatial feeling of the late works by the use of a vaulted portico extending into depth and a landscape beyond the terminating parapet. Compositionally this spatial placement of the figures is an extension of previous types, such as the *Rolin Madonna,* for the walls have been dissolved and only the columns and vault-ing remain to suggest a sacred ambient. More-over, the figures have a greater suggestion of existence in free space than ever before. This final statement by Jan van Eyck of the interrela-tionship of man and the natural world led to the development of landscape painting per se; the conception was repeated by Petrus Christus.

The widest disagreement in relation to the Van Eycks is to be found in the miniatures of the Turin-Milan *Hours.* Originally made for the Duke of Berry in the 1380s, the manuscript was traded by 1413, while still incomplete, with Robinet d'Etampes, who divided it into two parts, as has been explained in Chapter 1. The bordered but unilluminated remainder that d'Etampes disposed of was subsequently illumi-nated and is the portion which has produced the most controversy. These later miniatures were added at two different periods, the last in the 1440s by definitely minor masters who copied earlier works, for example, the St. Jerome transformed into a St. Thomas Aquinas men-tioned earlier.

The major additions made before the 1440s form the Gordian knot. The problem has been made even more difficult because a portion containing the problematical early additional miniatures was burned in 1904; fortunately it had been published two years earlier by Durrieu. [12] The remainder, from the Trivulzio Collection, Milan, is now in the Museo Civico in Turin.

In 1911 Hulin de Loo [13] separated the hands in the work to mark out two distinct and important groups, Hands G and H, which he and Durrieu dated before 1417. More recent opinions have placed the execution of the miniatures in the 1420s, 1430s, and even the 1440s. Panofsky, discerning less unity of style in the Hand H miniatures than did Hulin de Loo, considered the four large miniatures (God the Father in a tent, the Agony in the Garden, the Pietà, and the Calvary scene) to be copies or combinations of earlier work by Van Eyck and the Master of Flémalle and dated them as about 1440–45. The works he attributed to Hand G (the Betrayal, St. Julian and his wife in a boat, the Virgo inter Virgines, the Prayer on the Shore, the Birth of St. John the Baptist, the Mass of the Dead, and the Finding of the True Cross, five initials, and six *bas-de-page* scenes) are considered to have been made for John of Bavaria by Jan van Eyck between 1422 and 1424. Lyna [14] thought these were made for John of Bavaria's widow, Elizabeth of Görlitz, in the late 1420s, and Baldass [15] attributed some of them to a "Chief Master of the Turin-Milan *Hours,*" working in the early 1430s.

The scenes attributed to Hand G are qualitat-ively finer than those assumed to be by Hand H. Characteristic of the Hand G group are the immersion of figures in space (sometimes too large for them) and the achievement of both landscape and interior effects that to many writers have suggested the 17th century rather than the 15th century. The flat landscapes conceived in visual terms have an effect of continuous recession. In the interior scene of the Birth of John the Baptist (Fig. 123), recession is combined with an interest in light that antici-pates the Dutch interiors of Pieter de Hooch in the 17th century. An unprecedented spaciousness is achieved despite an inconsistent and almost violent perspective rendering. It is significant that the vanishing point is within the pictorial space; yet this is not true of Jan's Berlin *Madonna in a Church,* which it supposedly antedates.

No exact antecedents have been found for the Hand G group, and therefore they have—wrongly, one would think—been considered to be distinct originals. However, Lyna has observed that not only is the banner reversed in the scene of the prayer on the shore, but also too many actions are performed with the left hand, thus indicating a reversed copy. Furthermore, the funeral mass extends beyond the frame, indicating the use of a pattern that was both wider and higher. Since copies of some of the compositions were circulating in Dutch work-shops in the 1430s, and since the relatively rare

theme of St. Julian and his wife in a boat also appears in the *Hours of Jean Dunois* (the Bedford shop work of about 1436 in which the background of the *Rolin Madonna* was copied), one is tempted to think that Baldass and Dvořák were on the right track in creating a "Chief Master of the Turin-Milan *Hours*" for these astonishing works.

Yet this thought raises the question of why the drama of light of the birth scene and the flat, atmospheric, *continuous* landscapes appear again only in the authenticated works of Jan van Eyck. In addition, the almost bravura surface quality of some of these miniatures, with loading of the lights that approaches an impasto, can be found in one late work by Jan, the Dresden triptych.

If the 1437 completion date of the Dresden triptych is related to the suggestion made earlier of its inception about 1433–34, and if note is taken of Chatelet's [16] seemingly just comparison of the background of the *Rolin Madonna* with the background landscape of the *bas-de-page* Baptism scene (a comparison he made without allowing for stylistic development by Jan from the early 1420s to the early 1430s), then it is possible to accept some (but not all) of the Hand G miniatures as works by Jan *and* his shop about the time the Dresden triptych was in process. Knowing that Jan and his shop created a less monumental style in his small Dresden altarpiece than in such large panels as the *Van der Paele Madonna,* it is possible to assume that for his miniatures he chose a looser, more atmospheric style. Knowing too that Jan, when employed at The Hague between 1422 and 1424, had painted miniatures with the help of apprentices, one might hypothesize that these outstanding works were produced for Philip the Good from Jan's cartoons, possibly with his direct participation, shortly before the middle 1430s.

The pantheistic vision of these and the other works by Jan van Eyck, a blending of the rich color of the International Style with the delight and involvement in natural detail expressive of the totality of the visual world, reached hitherto unimagined, sumptuous, and sonorous harmonies. The inner brilliance of his mature art was acknowledged and honored by his contemporaries and by succeeding generations.

Though Jan's work was collected and copied, the generation immediately following soon turned away from his objectives, which required

a vision as acute and all-embracing as his own. No artist, not even his most faithful follower, Petrus Christus, climbed to the same heights. In addition, no artist to follow grew out of the same set of circumstances, for by the 1430s courtly art had lost its identity as something separate and distinct. The dominant art form had become that of the prosperous Flemish cities. However, despite, or possibly even because of, its disguised symbolism, Jan's apparent secularization of the setting even of religious art, in which he continued and reinforced Campin's epochal transformation of the past, was not to be set aside.

123. JAN VAN EYCK AND SHOP. Birth of John the Baptist, Turin-Milan *Book of Hours. c.* 1433–35. Illumination, 11 × 7 1/2" (page). Museo Civico, Turin.

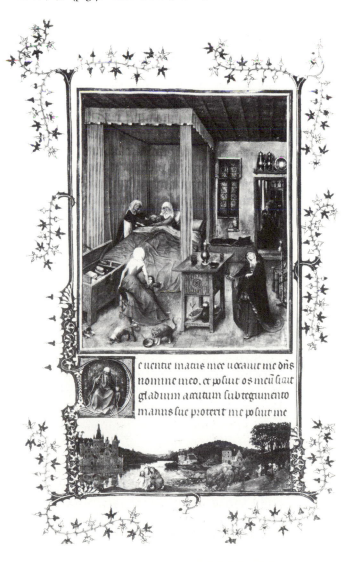

ROGIER VAN DER WEYDEN

ROGIER VAN DER WEYDEN, SPIRITUAL HEIR AND pupil of both Campin and Jan van Eyck, was no pioneer. As Panofsky has remarked, Rogier's world was "at once physically barer and spiritually richer than Jan van Eyck's." [1] Emotionally more Gothic, although far from reactionary, Rogier was less disguised in his symbolism and less exploratory in his expression; therefore he was comprehensible to his contemporaries and followers, and his style was readily assimilated. The possibilities of unified calligraphic surface patterns, inherent in the works of the Master of Flémalle, were developed by Rogier into a rhythmic expression of emotional content that prevailed throughout his life. Direct observation, so much an essential element in the art of Campin and Jan, became less and less a necessity for Rogier. Nothing in his developed work suggests the momentary or the accidental aspects of nature outside the realm of his subject. With an exaggeration of the differences between Jan and Rogier, it may be said that Jan was the painter of lighted forms in space and Rogier was the creator of rhythmic linear forms moving within a planar environment.

Born in Tournai about 1399–1400, son of a master cutler, Rogier (or Rogelet, as he is named in the Tournai records) began his apprenticeship with Campin on March 5, 1427, and was received as a master into the guild on August 1, 1432. Where he lived and where he traveled before he was recorded in Brussels in 1435 is unknown, but from thenon he remained in Brussels, though he made a significant trip to Rome in the jubilee year of 1450. On May 20, 1436, he became the city painter of Brussels, where he died in 1464. In 1436 he was already married and had two children, Corneille, aged nine, and Marguerite, four. Another son, Peter, was born later, apparently in 1437. His wife had the same family name as the wife of Robert Campin, another bit of evidence that links him with Tournai, in which he kept his interest through most of his life. There are records of investments in Tournai securities and other contacts from October 20, 1435, when he was already in Brussels, through the 1440s. When he died, masses were said for him in Tournai. [2] Some confusion has arisen from a notice in the Tournai city archives of the offer of eight lots of wine on November 17, 1426, to a Master Rogier de la Pasture, because the name De la Pasture in Flemish is Van der Weyden. (When Jan van Eyck, referred to as a "painter" and not as a "master," received his offering of wine from the municipality on October 18, 1427, he was given only the customary four lots.) Panofsky has called this coincidence of names "a case of 'fortuitous homonymy'"; the name was not uncommon.

Not one work by Rogier is signed, not one is dated, and most of the paintings mentioned by his contemporaries have disappeared. However,

a fairly clear picture of his artistic personality has been constructed on critical criteria. The general outlines of his development from the manner of the Master of Flémalle to his last and most harmonious unification of line and volume, of depth and surface pattern, are readily discerned. The detailed exposition of that development is far more difficult.

The character of Rogier's *œuvre* is consistent. With the exception of the lost justice panels painted in the late 1430s for the Brussels Town Hall and of his aristocratic portraits, it consists entirely of religious paintings. Little interested in genre, geometry, or the grandeur of nature so visible in the art of Jan, Rogier adhered to a religious mystique in which the world is merely a setting for the Christian drama; the world's beauty resides in its spiritual content, not in its natural aspects. Yet his mode of expression was derived from the Master of Flémalle and from Jan. Over the course of his career the interplay between his inheritance and his basic nature is revealed along with his originality, his mastery, and his genius in the discovery of the forms appropriate for their manifestation.

Possibly the earliest of Rogier's works [3] is the very small panel ($7^1/_4 \times 4^3/_4$ inches) in Vienna of the nursing Virgin in a niche (Fig. 124). Monumental form in the figure is united with delicate surface effects. The crowned Virgin stands as Queen of Heaven before a throne adorned with lions. This is the throne of Solomon, the *sedes sapientiae*. Behind the lacelike architectural framing a gold brocade hangs at the back of the narrow niche and covers the throne seat. On the left molding Adam reflects on the sin that has made him cover his nakedness, as an angel overhead is about to drive him from his pedestal. Paradise is symbolically implied but not visually presented. Eve, on the right molding, holds the apple from the tree of knowledge, which, with the serpent in its branches, forms a canopy over her head. In the center of the upper molding God the Father looks down on the Virgin and Child. The dove is also present, creating a Trinity when the picture is read vertically.

Borrowings from the *Ghent Altarpiece* are obvious. The vertical reading of the Trinity and the figures of Adam and Eve are derived from its interior, and the motif of God looking down is borrowed from the prophet Micah on its

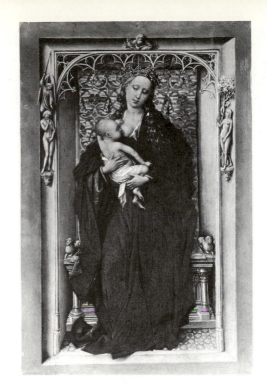

exterior. There is also a more baffling relationship with Jan van Eyck, for the standing Virgin suggests the pose of Jan's 1439 *Virgin at the Fountain* (Fig. 115); however, though the knee is similarly bent, the drapery arrangement is different, and it may be that both reproduce a popular type, a sober variation of the "beautiful Madonna."

The sculptural solidity shows that the artist has not been separated very long from the Flémalle shop, and the slightly atmospheric quality, as well as the motifs mentioned above, shows that Rogier has succumbed to Jan's influence. Distinctly different from both masters is the reserved sentiment, gentle linearity, and softer movement. Evidences of artistic youth appear in the fussy blue drapery over the arm and the unaccomplished perspective of the floor tiles. The work must have been painted either late in 1432 (for Rogier was "graduated" at Tournai on Aug. 1) or in 1433.

A modification of the moon-faced Flémalle type of Virgin characterizes another small panel in the Thyssen-Bornemisza Collection, Lugano-Castagnola, which seems to date from 1434–35. The placement of the crowned Virgin and Child in an architectural niche of more elaborate

above: 124. ROGIER VAN DER WEYDEN. *Virgin and Child in a Niche. c.* 1432–33. Panel, $7^1/_4 \times 4^3/_4''$. Kunsthistorisches Museum, Vienna.

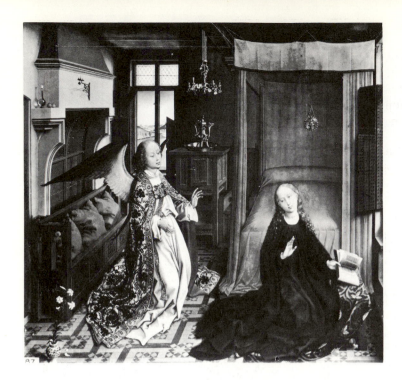

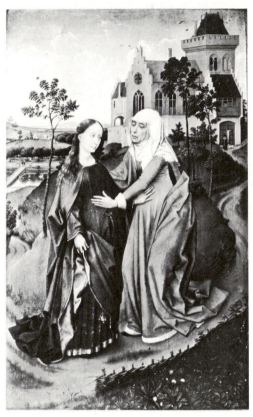

left: 125. ROGIER VAN DER WEYDEN. *Annunciation.* *c.* 1435. Panel, 33 $^7/_8$ × 36 $^1/_4$″. Louvre, Paris.

below: 126. ROGIER VAN DER WEYDEN. *Visitation.* *c.* 1435. Panel, 22 $^5/_8$ × 14 $^1/_4$″. Museum der Bildenden Künste, Leipzig.

character than that in Figure 124 clearly expresses the idea of the Virgin *in* and *as* the Church. Jan van Eyck's influence is suggested by the increased atmospheric quality which sets the figures within the niche rather than before it. Above are seen small grisailles of the Seven Joys of the Virgin, on the jambs are ancestors of Christ and prophets, and the sculptures present the drama of man's redemption; the whole constitutes an undisguised symbol of the Church. Here is the earliest instance of Rogier's discomfort with the concept of disguised symbolism. An explicit statement was more to his liking.

Stylistically further advanced is the magnificent *Annunciation* in the Louvre (Fig. 125), the central panel of a triptych, the wings of which, in Turin's Galleria Sabauda, were added later by the shop. In contrast to the soft, atmospheric aura of the Thyssen-Bornemisza Virgin panel, this work has a crispness of style, but the artistic elements in the panel are still related to Rogier's two great predecessors. The angel is obviously drawn from Van Eyck, as is the right side of the room; the left side is clearly derived from the Master of Flémalle. (The chest, with its *dinanderie* utensils, was to appear three years later in the problematical *Von Werl Altarpiece,* Fig. 97.) So far as color is concerned, Jan is the dominant influence; the angel's gold brocaded garment contrasts with the gray, closed fireplace and its brown screen, and the dark blue garment of the

Virgin, kneeling in her humility, is set against the rich crimson glow of the nuptial bed, on the hangings of which appears a medallion of Christ. Forceful color and value contrasts accentuate the outline. A marked feeling for the silhouette has replaced the earlier plasticity of the Master of Flémalle and Jan's atmospheric softness. Rogier has found his basic style. It is significant that the floating, almost gliding posture of the angel was to be repeated again and again, each repetition marking a further refinement of the motif until the figure achieved its ultimate state in the *St. Columba Altarpiece* in Munich (Pl. 10). The linear emphasis on the figures, with their echoing movements, is almost in conflict with the fluid room space, the Annunciation being staged on a narrow strip before, rather than within, the room.

The new style appears in the contemporaneous *Visitation* (Fig. 126), now in the Museum der

Bildenden Künste in Leipzig. This panel was the model for the scene of the same subject on the right wing later attached to the Louvre *Annunciation*. Though the backgrounds of the Visitation scenes are landscapes, the relationship of the rhythmically interlocked figures to the landscape may be equated with the figure-and-interior relationship of the Louvre *Annunciation*. A delicate Gothic sentiment, hinted at there, is even more masterfully presented in the Leipzig *Visitation*.

This stylistic phase is also reflected in four versions of St. Luke painting the Virgin, of which the Boston version (Fig. 127) is considered by many scholars to be the original. [4] (Actually the saint is shown, not painting, but making a silverpoint drawing.) This is a design reversal of the Louvre *Annunciation*, and spiritually it is very close to that work even in regard to its borrowings from Jan van Eyck. As in the Louvre *Annunciation* he apparently borrowed the bed from Jan's London portrait of Arnolfini and his wife (Fig. 112), so in the Boston *St. Luke* he borrowed from the *Rolin Madonna*, repeating the model in drier fashion, without Jan's formal complexities or atmospheric nuances. For Jan's rich variety and infinite references to natural activities, Rogier has substituted a sparse and inherently monotonous backdrop. In compensation Rogier has created an incomparable spiritualization of the saint, whose reverential attitude and reflective gaze form a telling contrast and complement to the fixed cheerfulness of the Child, gleefully looking up at His indulgent mother. There is sheer delight in the variety lavished on the Madonna and Child, whom Rogier has placed on the footrest of a very shallow, carved wooden throne. One of its arms terminates in a simulated sculptural group of Adam and Eve. Variety is also provided by the little study off to the right, in which the saint's symbol, the ox, calmly rests as though attending the Nativity. Of all the works of Rogier van der Weyden this seems the most reverently joyous.

Something of this same spirit seems to characterize his *Reading Magdalen* in London, which cleaning has revealed to be a fragment of a devotional picture of the Crucifixion, with Joseph standing behind her; it also informs the Duran *Madonna* in the Prado. Beginning with the Louvre *Annunciation*, the period of these

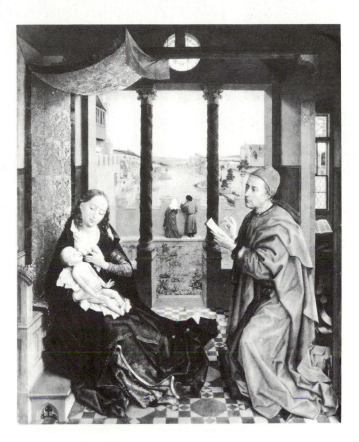

127. ROGIER VAN DER WEYDEN. *St. Luke Drawing the Virgin.* c. 1435–37. Panel, 54 1/4 × 43 3/4". Museum of Fine Arts, Boston (Gift of Mrs. Henry Lee Higginson).

works, which seem stylistically close together and chronologically in the order presented here, probably came to an end in 1437, when Chancellor Rolin must have presented Jan van Eyck's painting of him with the Madonna (on which Rogier based his *St. Luke*) to the cathedral of Autun. All show a complete mastery of expressive means, and they point, particularly the *Reading Magdalen*, to a significant step beyond the evident transformation of ideas from Van Eyck and the Master of Flémalle into conceptions original with Rogier himself.

If our conception of his development is not in error, Rogier's most famous work, the Escorial *Deposition* (Fig. 128), now in the Prado and once the central panel of a triptych, was painted about 1438. It was commissioned by the Archers' Guild of Louvain for Notre Dame hors-les-murs. The earliest copy of the work dates from 1443 and was the first of a multitude of copies and

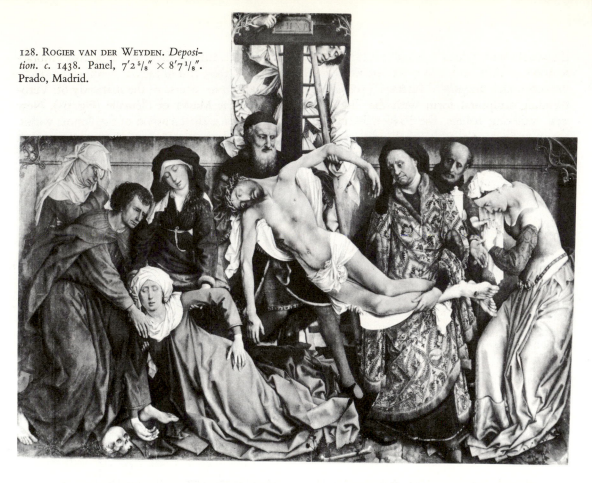

128. ROGIER VAN DER WEYDEN. *Deposition. c.* 1438. Panel, $7'2\frac{5}{8}'' \times 8'7\frac{1}{8}''$. Prado, Madrid.

borrowings. Itself an emendation of the Master of Flémalle's triptych that is known from the Liverpool copy, it is also a painted criticism of his master's outlook, expressed by a compression of the space and a linear sharpening of the drama. The whole action takes place within a shallow niche, like sculpture come to life inside its original frame. Whereas Jan van Eyck, on the exterior of the *Ghent Altarpiece,* brought his simulated sculpture to life within a naturalistic space, Rogier staged his drama within a sculptural relief space. Jan's extension of the natural world *qua* natural world as a setting for religious drama also received its weightiest criticism in this painting.

Rogier conceived the drama of the Deposition as inherent in the emotional reactions of the figures about the body of Christ. In its quiet curves the body becomes almost a symbol at the center of moving lines of individual reactions. The echoing, interlocking rhythms of the forms move across the surface to be stopped and turned inward again by the complementary movements of John on the left and the Magdalen on the right. The design of both figures is in a

direct line of descent from the angel of the Louvre *Annunciation,* but they have been transformed into vehicles of a greater, more overt emotional content, particularly the Magdalen, whose features, swollen with weeping, reveal Rogier as a keen observer of nature when he deemed it necessary. John steps forward in a graceful movement, repeated and refined in later works, to support the fainting form of the Virgin, whose line echoes that of her Son. These interlocking rhythms are so strong that the depth dimension is almost forgotten, and the result is a compression of an already compressed space, despite the light and dark modeling of the forms.

Color too, particularly the reds of John's garment, Joseph's sleeves and hose, and the sleeves of the Magdalen, joins in the curving rhythms. The interlocking of forms creates a highly charged Gothic spirit. Rogier's achievement is at once monumental, linear, dramatic, emotional, and awe-inspiring; the fervency of spirit is overwhelming. No wonder that the work was so often emulated and so often copied. Each figure is restrained, and each contains within itself an emotional life that is distinct and yet part of

the whole with which it is inextricably linked. Isolated in time and space, set against a gold background, sharply delineated yet subtly blending sculptural form with the illusion of real, suffering beings, the Passion is ruthlessly thrust upon us, so that, as Friedländer remarked, there is no possibility of evasion or escape.

In the years between 1438 and 1440, and probably close to the latter year, may be dated the *Calvary Triptych* in Vienna (Fig. 129), which is an amazing blend of old and new ideas. The continuous landscape extending over all three panels is not a new idea, having appeared in the *Ghent Altarpiece,* but the almost regular rounding of the land forms, so different from Rogier's earlier landscapes, suggests the entrance into Rogier's shop of a specialist in landscape painting. The influence of the Master of Flémalle is still visible in the relatively stocky proportions of the figures, except for Christ and the angels; in the type of the Virgin, who is, however, seen

for the first time as the Mater Dolorosa embracing the Cross; and in the St. Veronica, a youthful version in reverse of the matronly St. Veronica by the Master of Flémalle (Fig. 95). New for Rogier is the inclusion of the donors within the sacred space. The feminine costume and headdress accord with a date in the second half of the 1430s. On the right wing the Magdalen lifts her robe to wipe her eyes in a gesture like that of the figure at the extreme left of the Escorial *Deposition.* In the center panel John steps forward, as he did in the *Deposition,* to support the Virgin. Both he and the donor look up to the elongated, slender, emaciated body of Christ. The emotional drama is reinforced by the wind-blown garments of John and the fluttering loincloth of Christ, a logical movement in the first case, without natural logic in the second. In the sky above, the angels, entirely dark blue, reinforce the drama by the subtle design of their sharp silhouettes, their angular movements, and their pointed wings.

In spirit this is very close to the Escorial *Deposition,* particularly if the extreme depth of the landscape is disregarded; the fluid movement

below: 129. ROGIER VAN DER WEYDEN. *Calvary Triptych.* *c.* 1438–40. Panel, 39 ³/₄ × 27 ¹/₂″ (center), 39 ³/₄ × 13 ³/₄″ (each wing). Kunsthistorisches Museum, Vienna.

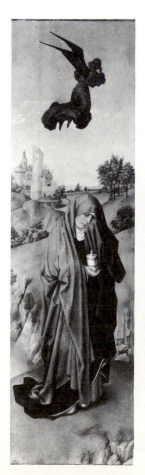
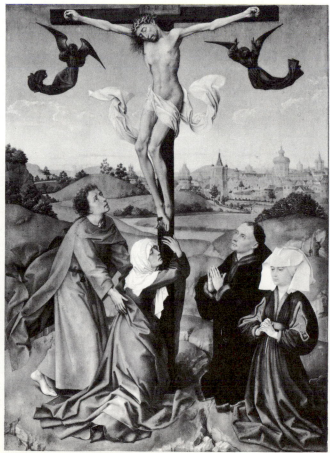
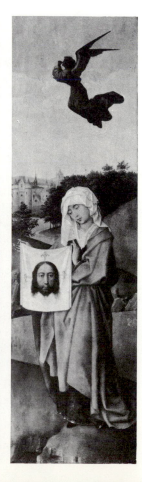

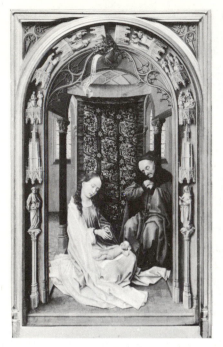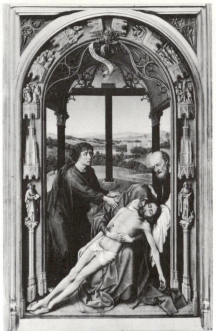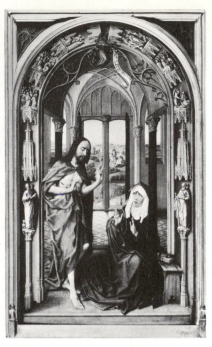

130. ROGIER VAN DER WEYDEN SHOP. *Mary Altarpiece* ("Miraflores Altarpiece"). *c.* 1440–44.
Panel, 28 × 16⅞". Gemäldegalerie, Staatliche Museen, Berlin.

of landscape does not appear again in Rogier's work, for it runs counter to his basic conceptions. Never again did he allow landscape to play so prominent a part. One may speculate that the dramatic innovations in the forms visible above the horizon line, with forceful contrasting curves countering the repeated verticals below, may have been in part the result of an innate dissatisfaction with the prevailing concept of the triptych form.

Certainly in what is here considered to be Rogier's next work, the *Mary Altarpiece* (and its copy from Miraflores, Fig. 130), [5] an expansive background has been avoided. Its three sacred scenes take place within the shelter of three sculptured portals leading, on the sides, to shallow interior spaces. These spaces have neither doctrinal nor historical logic, but in the later *St. John Altarpiece* (Fig. 142) similar spaces are given a narrative logic. (A suggestion that Rogier criticized the increasing naturalism of his time by converting "religious events into historical events... by monumentalizing the devotional image" [6] seems to ignore the fact that for Rogier's time the religious events of Christ's life *were* historical events.) By again taking up the portal as a stage for the religious drama Rogier asserted once more his Gothic spirit.

Dating from the early 1440s, the original *Mary Altarpiece* is now divided: two of its panels are still in the Capilla Real at Granada, while the scene of Christ's appearance to His mother (Fig. 131) is now in New York. These panels are commonly called the "Granada Altarpiece," as distinct from the contemporaneous workshop copy (Fig. 130), now in Berlin, known as the "Miraflores Altarpiece." The upper limit of their dating is given in an 18th-century notice which recorded that the altarpiece by Master "Rogel," then in the Miraflores convent near Burgos, was given to it in 1445 by Juan II of Castile, who was believed to have received it from Pope Martin in 1431. However, Rogier was still an apprentice in 1431, and therefore that date is generally considered untrustworthy.

The basic theme of the Granada-Miraflores altarpieces is devotional. The three panels, with the Holy Family, the Pietà, and Christ appearing to His mother, are explicitly related to the Virgin by the texts on ribands overhead (though the two Granada panels lost these upper portions in 1632, when they were mutilated to form the shutters of a reliquary).

The Holy Family, in which the Virgin is presented as a Madonna of Humility, is conceived as a tableau, its contemplative stillness

emphasized by the sleeping Joseph, and by the descending order of the narrative scenes in the archivolts. These scenes begin at the apex with the Annunciation but terminate at the upper right with the Presentation in the Temple. (In the later St. John triptych the order follows the normal movement from lower left to lower right.) More important is the ordering of the lowest archivolt themes in each panel so that the basic V design of the outer panels and the X of the center panel lead the eye to easily recognizable, doctrinally significant scenes. One may properly suspect a clerical hand in the design of the iconographic program. The result is, as Panofsky has phrased it, "a trilogy of cantos."

The iconography of the Pietà in the center panel derives from Italy, where the Byzantine theme of the last kiss was combined with the Madonna of Humility. Rogier augmented the theme by a severe rigidity in the body of Christ and by the compassionate gestures of John and Joseph of Arimathaea. In the background the

Cross breaks the view of a distant landscape that is flatter and more subordinate to the main theme than that of the Vienna *Calvary*. It is also more accomplished in execution. This central theme was immediately popular, and Rogier's shop was busy in the following years painting variations of it, some with an added donor in sorrowful and reverent contemplation. It was also much copied by later artists.

Christ's appearance to His mother (Fig. 131) replaces a scene that is normal for a Mary altar, [7] the theme of the Assumption of the Virgin, here relegated to the upper right-hand archivolt. The mystic force of the scene has been heightened by Rogier's ever more intense and severe religiosity, particularly visible in the delicacy of Christ's pose. The magnificence of the conception has led many to relate it to the pose of John the Baptist in the *Von Werl Altarpiece* of 1438 (Fig. 97), with a resultant confusion of Rogier's development. To make the Granada-Miraflores altarpieces the model for the *Von Werl Altarpiece,* one must date the former too early, so that Rogier, in Brussels, is considered to have influenced his master in Tournai. Friedländer was the first to propose this chronology but happily abandoned the idea in 1937, though it is still maintained by many. The original source for the pose may be antecedent to both works.

In the background of this panel Rogier has painted the theme of the Resurrection in a flattening pose that was much admired in Bouts's shop and in Germany. The greater delicacy of the figural groups is echoed in a subordinate landscape that is less plastic and more fluid than in the Vienna *Calvary*. There is far less emphasis upon a continuity from foreground to background, and the background lighting is more subdued to avoid conflict with the stronger foreground drama.

Rogier's major work in the late 1440s is the *Last Judgment Altarpiece* (Pl. 9, after p. 180), in Beaune, made for the Hôtel-Dieu. Still in the original building, though no longer in its original position, it has been much restored since its execution. Commissioned by Nicolas Rolin, who founded the Hôtel-Dieu in 1443, it was in

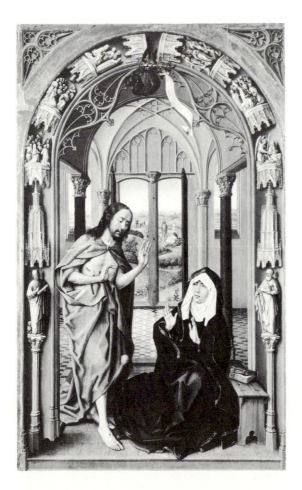

left : 131. ROGIER VAN DER WEYDEN. Christ appearing to His mother, *Mary Altarpiece* ("Granada Altarpiece"), right panel. *c.* 1440–44. Panel, 25 × 15″. The Metropolitan Museum of Art, New York (Bequest of Michael Dreicer).

right: 132. ROGIER VAN DER WEYDEN. *Last Judgment Altarpiece* (closed). *c*. 1444–48. Panel, 7′4⅝″ × 8′11½″. Musée de l'Hôtel-Dieu, Beaune.

below: 133. FLEMISH. Philip the Good receiving the book, *Chroniques de Hainaut,* dedication page. 1446–48. Illumination. Bibliothèque Royale, Brussels (Ms. 9242, fol. 1).

place when the dedication of the hospital, in use ever since, took place December 31, 1451. The immense altarpiece, about 18 feet wide when opened, continues the austere etherealization of the religious drama so poignantly expressed in the *Mary Altarpiece.*

The exterior (Fig. 132) is obviously influenced by Jan van Eyck. The Annunciation, painted by the shop, is seen above. In the left and right panels below Nicolas Rolin and his second wife, Guigonne de Salins, kneel in large cells on *prie-dieux;* their coats of arms are prominently displayed. Dressed in black, these somber figures adore the central grisaille figures of Sts. Sebastian and Anthony. (The latter was replaced as patron saint of the hospital by St. John a year after its dedication.) Nicolas Rolin looks very much as he does in the famous dedication miniature (Fig. 133) of the *Chroniques de Hainaut* (Brussels, Ms. 9242), executed probably at Mons, and not by Rogier, between 1446 and 1448. [8] The mannered elongation visible in the miniature (particularly evident in the new fashion of long-pointed shoes) is shared by Rogier's etherealized figures of Rolin and his wife. This conception of Rolin is unlike Jan van Eyck's portrayal of him in the *Rolin Madonna* (Fig. 110) and foreign to Rolin's own highly unspiritual character.

Such a somber exterior in no wise prepares one for the splendor of the interior. In it, Christ the Judge is seated on the rainbow in majestic isolation (Fig. 134). The archangel Michael is below and slightly in front of Him weighing souls, a virtuous soul rising in the balance as a sinner is weighed down by his sins. Angels in

beautiful, light plum-colored garments blow the last trumpet. Christ and the elongated figure of Michael are isolated in the center panel and are larger than any of the other figures. A hieratic quality is evident in the frontal pose reserved for them alone. At the ends of the rainbow, to the left and right of the center panel, the Virgin Mary (Fig. 135) and John the Baptist adore the figure of Christ high above them. Behind them in the shallow space of the heavenly zone, its floor formed of rose-gold clouds that rise to frame the immaterial gold background, are represented the twelve apostles. They are headed by a magnificently red-robed Peter at the left and by Paul at the right. Behind Peter are a pope, a king, a bishop, and, looking at the spectator, a monk, undoubtedly Nicolas Rolin's confessor, who was probably in charge of the iconographic program. In the miniature just referred to the monk appears behind Rolin and Jean Chevrot, Bishop of Tournai. Behind Paul are seen a virgin, a princess, and a married woman. The resurrected arise from their graves in barren soil set against a blue, cloudless sky and, nude as they were born, move off to Heaven or Hell on the outer wings. No devils are present, nor are they needed. Below John, in his rich but subdued cloak, the damned, having realized the depth of their sin, respond to their condemnation with a soundless shout but of their own volition move toward the fires of Hell on the right. The blessed turn back in adoration even as they move toward the stairway to Heaven.

Saints and sinners are witnesses not to the chaos and terror of a demonic triumph but to a final judgment glorifying the supreme order. The inevitability of the judgment is so clear that Mary and John fill no intercessory role. Beginning at the center, an inexorable movement flows calmly to the left and with greater drama to the right. The strongly rhythmic movement, enriched by essentially nonplastic color, limited relief, and hieratic scale, is the vehicle for a mystic expression that uses but is not dependent upon the particularization of naturalistic detail.

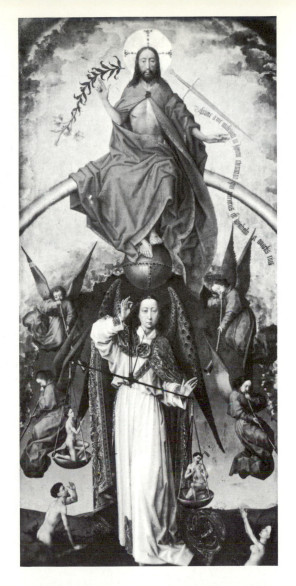

top: 134. ROGIER VAN DER WEYDEN. *Last Judgment Altarpiece,* center. *c.* 1444–48. Panel, height 7′4 5/8″. Musée de l'Hôtel-Dieu, Beaune.

right: 135. ROGIER VAN DER WEYDEN. Detail of the Virgin Mary, *Last Judgment Altarpiece* (Pl. 9).

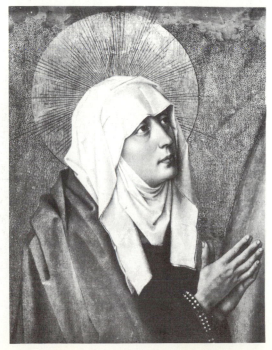

The *Seven Sacraments Altarpiece* in Antwerp (Fig. 136) was certainly designed by Rogier, but its execution seems to show shop participation. Painted for Jean Chevrot, Bishop of Tournai from 1437 to 1460, it displays his personal devices and the arms of Tournai in the spandrels of the central panel, and he himself is represented administering confirmation. The sacraments (baptism, confirmation, and confession in the north aisle, the Eucharist in the center, and ordination, matrimony, and extreme unction in the south aisle) take place within an elongated view of a church which has been recognized as Ste-Gudule, Brussels' most important church. Dominated by the Calvary scene, the rites are performed within the church, a theological expression of the symbolic relationship between the Church and Christ probably inspired by Jan van Eyck's *Madonna in a Church* (Fig. 100). Color symbolism governs the garments of the angels hovering over the sacramental scenes.

Though Panofsky [9] attempted to place this work in the early 1450s, relying strongly on the identification of the canon near Jean Chevrot as Pierre de Ranchicourt, later Bishop of Arras, who is also portrayed as the kneeling bishop in The Hague *Lamentation* (see p. 123), it may be remarked that Ranchicourt's arms are not present, as Panofsky's hypothesis would lead one to expect. It is of far greater importance that the style and organization, the spatial flattening, and the figure types of the Calvary scene can be correlated with the *Last Judgment Altarpiece*. One may conclude that Rogier delegated a large amount of the work on the *Seven Sacraments Altarpiece* to his assistants because he was too busy painting the *Last Judgment*.

Some time after June 15, 1450, Rogier went to Italy and to Rome, for this was a jubilee year. There, as Bartolommeo Fazio records, Rogier admired the work of Gentile da Fabriano. He probably stopped in Ferrara, because he had made paintings for the Este family in the previous year. He also stopped in Florence, as is proved by two works, one in the Uffizi, the other in Frankfurt.

The first of these, the Uffizi *Entombment* (Fig. 137), also identified as the last farewell at

136. ROGIER VAN DER WEYDEN. *Seven Sacraments Altarpiece.* c. 1448. Panel, 78 3/4 × 38 1/4″ (center), 46 7/8 × 24 3/4″ (each wing). Musée Royal des Beaux-Arts, Antwerp.

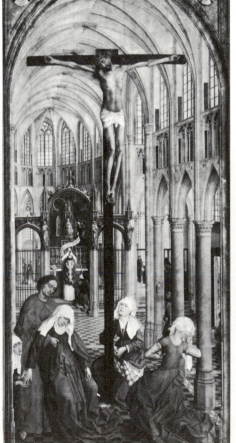
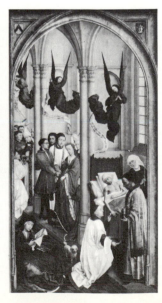

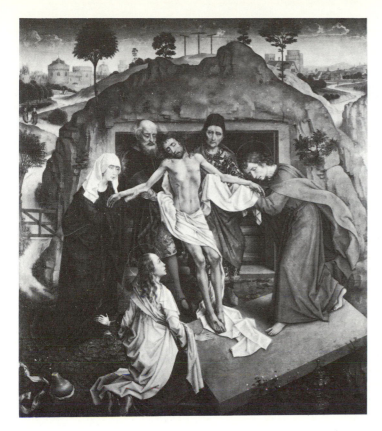

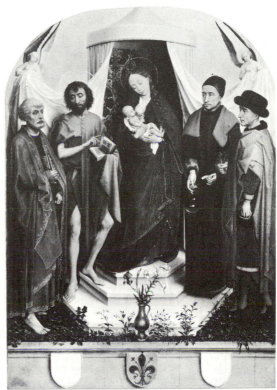

the sepulcher, shows an undeniable influence of Italian iconography, though not of style, in the square, un-northern cave entrance. It also shows Italian composition in the central, semi-erect position of Christ, with Mary and John (a later version of the John of the Vienna *Calvary*) at left and right. Rogier modeled his work on a composition of Fra Angelico, known from a school version in Munich. He modified it by adding the tomb slab in perspective, the Magdalen seen from the back, and an extra figure to support Christ. (Joseph wears the red stockings first seen in the Escorial *Deposition*.) The whole composition is subtly northernized by the strong forward movement of John, which is opposed by the combined movements of Mary and Mary Magdalene, and by the tilting of Christ's body and its balancing element, the tomb slab. Without a middle ground as a transition, the background appears as separated and very much subordinated to the foreground. In sum, a direct, simple devotional work has been transformed into a scene for solemn and mystical contemplation.

The second work made in Italy is a *sacra conversazione* (Holy Family with saints) in the Italian manner (Fig. 138). The Virgin, nursing the Child, stands on a platform before a tent, flanked by Sts. Peter, John the Baptist, and Cosmas and Damian, the last two of whom were the patron saints of the Medici family. Discovered in Pisa in 1833 and now in Frankfurt, the painting bears the arms of Florence on the central escutcheon. It reflects Italian compositional modes in its placement of the figures in an ascending triangular arrangement instead of in the northern isocephalic manner. The floral ground and the figures themselves, however, owe nothing stylistically to Italy or to the possible model, Domenico Veneziano's altarpiece, for the church of Sta. Lucia dei Magnoli, now in the Uffizi.

Italy did have a stylistic influence upon Rogier, but it was manifested only after his return home. It appears in the *Braque Triptych* in the Louvre

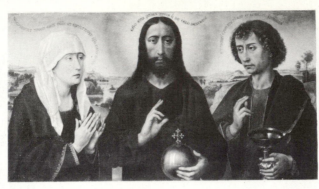
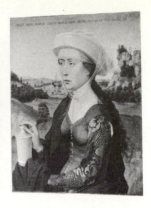

(Fig. 139), painted between 1450 and 1452, when Jean Braque died (or shortly after), repeating in the figure of the Virgin the new model that had appeared in the Uffizi *Entombment*. The figure of John the Evangelist, however, is rendered with greater authority and monumentality. Though the figure of Christ recalls the Beaune *Last Judgment,* there is a new note, a revival of the compositional type of the Master of Flémalle's *Christ and the Virgin,* in Philadelphia. Also different from Rogier's work of the preceding decade are the wing figures. John the Baptist on the left wing, dramatic and vital, asserts the new monumentality that balances by its very contrast the almost sensuous figure of the Magdalen on the opposite wing (Fig. 140). She is so rich and appealing that a number of contemporary drawings were made after her; some have been attributed to Rogier himself. Her headdress is particularly striking for its simple monumental shape.

The complete dominance of the large half-length figures over the unified landscape and pictorial space is also Italian in spirit. The composition itself suggests what could have been seen by Rogier in Italian portraits of the type attributed sometimes to Veneziano, sometimes to Pollaiuolo, and famous particularly in later portraits by Piero della Francesca, in which the figure is set against a landscape so that the spectator looks down and out as from an eminence. Such a high point of view is at complete variance with Rogier's previous practice (though it is reminiscent of Jan van Eyck) even when closest to Jan, as in the Boston *St. Luke.* It is characteristic of Rogier's thoroughly northern spirit that Italianate ideas are expressed in terms for which thoroughly northern precedents existed. Nevertheless, Italian art provided the impetus for their appearance in

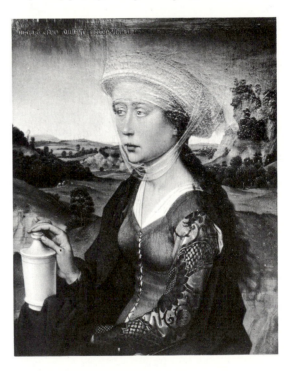

his art; the evidence becomes even more concrete in subsequent works.

The grandeur of this monumental style, with its grave austerity, is next visible in the *Pierre Bladelin Triptych* in Berlin (Fig. 141). Pierre Bladelin, Philip the Good's tax collector, and his wife founded the city of Middelburg, northeast of Bruges. Its castle was begun in 1448 and its church in 1452. The city was largely completed in six years, though the church, for which

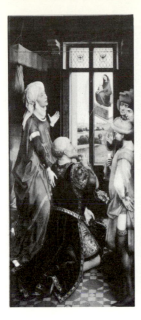
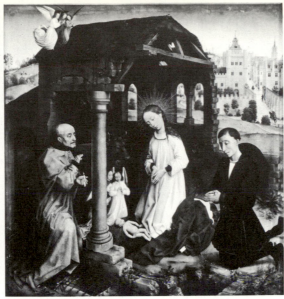
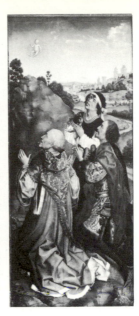

Rogier's altarpiece may have been commissioned not long after its foundation, was not dedicated until 1460.

The theme of the altarpiece is the Nativity and its simultaneous announcement to East and West, according to the *Golden Legend* (the *Legenda Aurea,* a 13th-century hagiology by Jacobus de Voragine). From the Master of Flémalle's Dijon *Nativity* (Fig. 90) Rogier has taken the figure of Joseph shielding his candle, Mary's humility pose, and the placement of the shed (here of stone instead of wood and wattle), whose perspective he improved. For the midwives of the Dijon *Nativity* Rogier substituted the magnificently painted figure of Pierre Bladelin in pious humility outside the shelter of the monumental shed. Its main support is a prominent marble column, which clearly refers to the Flagellation.

The Romanesque style of the building is symptomatic of a recurrence of Eyckian ideas, expressive of the era before the new dispensation (for we cannot expect to find Italian historicity and classical revival in Rogier). Such recurrences are even more evident on the wings, constituting a reutilization of Rogier's earlier memory images at a time when he himself had turned toward monumental expressions recalling the Master of Flémalle. The just balancing of figures in a formal trio and the Romanesque building unite northern and southern ideas. The stone "shed," built upon a ruined but still substantial foundation, has been interpreted as the ruined palace of David, an idea to become explicit in Van der Goes's *Portinari Altarpiece* (Pl. 13). Implicit in the

architectural construction is the conception of the Synagogue as the foundation for the Church, an idea that goes back to the *bas-de-page* scenes of Jean Pucelle.

In the right background is a view of a town, possibly the still-incomplete construction of Middelburg. On the left wing the Tiburtine sibyl, with a gesture like that of John the Evangelist supporting the Virgin, points out to a censer-swinging, richly robed Augustus the vision out the window of the Virgin and Child seated on a bench elevated in space. The perspective lines converge on the vision in the airy distance, its visionary character heightened by the muted, contrasting reds and greens of the foreground figures. The curved organization on the left, closing the triptych's design, is repeated in reverse in the vision of the Child, who appears to the wondering Magi on the right wing. This manner of composing is also seen in the Uffizi *Entombment* and in the Escorial *Deposition.*

As the vision of the Virgin and Child reflects the Master of Flémalle's Aix *Virgin in Glory* (Fig. 92), so the apparition of the Child to the Magi reflects another of his works, the so-called unrepentant thief in Frankfurt (Fig. 93), suggested by the upward gaze and the type of the farthest Magus, with the cloth around his head.

Design, types, monumentality, and rational balance suggest a date between 1452 and 1455, though the work has been dated as before the Italian trip by some, a conclusion based on the omission of Bladelin's wife, cofounder of Middelburg, and the omission of St. Peter, to whom Middelburg's church was dedicated. The inclusion on the left wing of two members of Philip the Good's court may indicate that the work was designed not for Middelburg but for another location and that Pierre Bladelin bore the major cost.

The *St. John Altarpiece* (Fig. 142) in Berlin (of which a reduced version of high quality exists in Frankfurt), often dated in the middle or late 1440s, has been dated by Panofsky in the middle 1450s on cogent iconographic and typological grounds. The costumes agree with the later date. The comparative ambiguity of the *Mary Altarpiece* has been exchanged for a clarity, and especially a spatial chiaroscuro, demonstrating Rogier's new use of Eyckian ideas following the trip to Italy. The scenes of the birth and naming of John the Baptist on the left panel, the Baptism of Christ in the center, and John's beheading (with the Feast of Herod seen in the distant dining hall) in the right-hand panel are presented with an over-all compositional mastery close to that of the *Bladelin Altarpiece* and very different from the repetitive accentuation of the *Mary Altarpiece*.

Again Rogier used earlier ideas; the spatial measurement of the birth scene recalls strikingly the birth scene in the Turin-Milan *Hours* (Fig. 123). Though the flanking interior scenes demanded a high horizon for the central panel, by placing the principal figures before the portals he assured their dominance over the space behind them. Here the architectural frame of the portal is not so much an opening upon a sacred realism as an element of greater immediacy to emphasize the solemnity and force of the religious narrative, in contrast with the devotional intent of the *Mary Altarpiece*.

The theme of the Virgin bringing the infant John to be named was derived by Rogier from the vernacular Italian translation by Domenico Cavalca of the *Vitae Patrum,* the artistic reflection of which he may have seen in Andrea Pisano's doors for the Baptistry in Florence. Also derived from Italy is the executioner, his body twisted in a strong *contrapposto* position.

With the *St. John Altarpiece* there is, however, a lessening of that Italian influence which revived the monumentality of the Master of Flémalle. The return to a strong assertion of surface design, to which even deep space has been subordinated, leads to Rogier's last style. No stronger demonstration of the basic spirit of this artist could be required.

Rogier's last style seems a return to his position before the trip to Italy, but it is more than that. He returned in part to the style of the Beaune *Last Judgment,* almost exaggerating the elongation of form seen there, and then subordinated that elongation to a rhythmic elegance and spiritual refinement surpassing everything seen so far.

142. Rogier van der Weyden. *St. John Altarpiece. c.* 1455. Panel, 30 1/4 × 18 7/8″ (each). Gemäldegalerie, Staatliche Museen, Berlin-Dahlem.

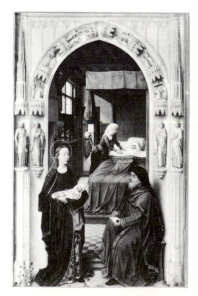
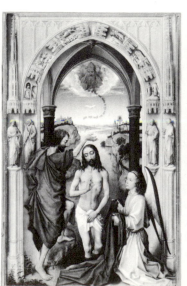
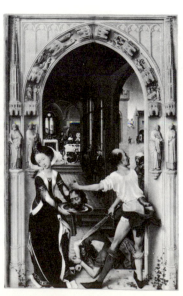

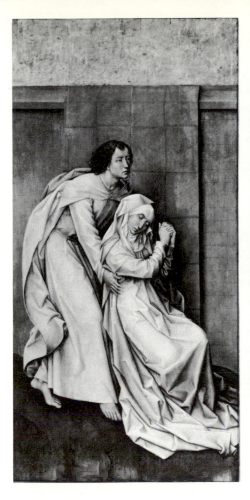

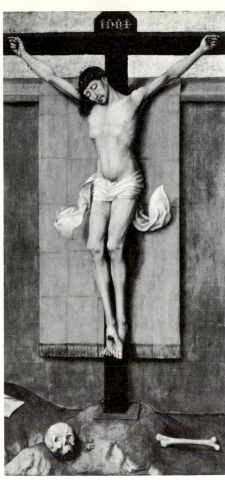

143. ROGIER VAN DER WEYDEN. Christ on the Cross, with the Virgin and St. John, Crucifixion Diptych. *c.* 1455–59. Panel, 70 ½ × 36 ¼" (each). John G. Johnson Collection, Philadelphia.

This first appears in the *Crucifixion Diptych* (Fig. 143) in the Johnson Collection, Philadelphia, probably painted between 1455 and 1459. The figure of John supporting the Virgin is tremendously elongated from the waist down, the drapery echoing and accentuating his movement. The Virgin, fainting from unutterable grief, lifts her hands but not her head to the figure of Christ on the Cross on the opposite panel. In both panels the figures are set on a narrow strip of barren ground before a plain gray wall with scarlet hangings, above which appears a medieval gold ground. The Cross is set against the wall, and the ends of Christ's loincloth are wind-blown, though less violently than in the Vienna *Calvary*. Rogier heightened the emotive quality not so much by the elongation as by the isolation and the barrenness of the setting, visually thrust forward by the wall coping. Extreme simplicity has been achieved by delicate tonal variations contained within forms whose main movements are surprisingly gentle, the over-all effect being a heightened, yet ethereal and inexpressibly poignant drama.

The gentle quality achieved by the rhythmic movements is repeated in the Ferry de Clugny *Annunciation* in New York, of lesser quality, in which the hand of the shop is suspected. Friedländer thought it authentic and called it rather large and empty, asserting that formulism and routine were the dangers inherent in Rogier's method.

Such criticism can be applied to many works by his followers, as it may to the *Lamentation* in the Mauritshuis, The Hague, in which the donor, presented by St. Peter, has been identified as Pierre de Ranchicourt, Bishop of Arras from April 17, 1463. This may be the last work from Rogier's shop, but it is far from the best. Rogier's contribution, if any, must have consisted only of a very general preparatory sketch. The outlining of the body of Christ by the winding sheet and the two female figures close to Joseph are entirely out of keeping with Rogier's late style, as is the Magdalen, lifting a great clump of drapery to wipe her eyes. The pedestrian attitudes of John and Mary are impossible for the creator of the Philadelphia diptych, and the gulf

between the two groups, allowing the eye to concentrate too strongly upon the distant moated castle, is equally impossible. The clumsy gesture of the figure lifting his hand to his head as though he has a migraine headache and the tilting of the foreground into the lap of the spectator are inconceivable in the thinking of Rogier, as is the insufficient space allowed for the action. Thus the work is far more likely to be shop work, drawn and executed without the participation of the master.

Entirely different in character is a much damaged and much repainted *Crucifixion* in the Escorial, modeled on the Philadelphia diptych but following tradition in placing Mary and John on either side of the Cross. The work came to the Escorial from the monastery of Scheut, a foundation of the Charterhouse of Hérinnes, to which Rogier's son Corneille was admitted in 1449. Scheut was not ready for occupancy until 1456. Thus this work postdates the Philadelphia diptych by several years.

The *St. Columba Altarpiece* (Pl. 10, after p. 180) in Munich magnificently concludes a great career. It had been copied by 1462 and so was probably completed shortly before that date. The theme of the central panel is the Adoration of the Magi, with Charles the Bold as the youngest Magus. The Annunciation and Presentation in the Temple adorn the wings. In all, color glows surely and quietly. The repetition of compositional elements is so subtle and so gently moving that even the gesture of Charles the Bold removing his hat seems still. Rogier achieved this sublime serenity through the rhythms and through the relationship of the foreground to the landscape. The hut fills the sky so that the spectator's eye cannot escape into the distance. A light-toned cityscape at the left has an even lighting that flattens the view so that the eye moves to the line of the hill and is thence carried back to the central groups.

The Annunciation presents the ultimate refinement of this theme. Rogier has etherealized and softened the theme by attenuating the form of the Virgin, whose body and hand are almost in profile, the very opposite of the broad view in the earlier work. The angel's garment is white, the earlier earthly luxury of dress having been abandoned. Though the elongated figure follows the same general line as in the Louvre angel (Fig. 125), it now floats, gently swaying as it

echoes the movement of the Virgin. The lower tonality of the simple, subordinated background accomplishes with far greater mastery what had been tenuously achieved earlier only by tensions between aspects of corporeality, such as the room, the bed, the sideboard, and the pitcher. Here the bench is visible as a single cushion, whose color merges with that of the bed; the medallion on the back of the bed has been eliminated; and a closed door has been substituted for the fireplace, creating the impression that Gabriel has materialized before our eyes. No longer is there a view out of the window, which is present merely to relieve the compression of the interior space. Our eyes meet only empty space and not a distracting landscape.

The Presentation in the Temple shows Simeon, instead of the high priest, receiving the Child. Simeon has one foot on the step and the other on the top of the altar platform, so that his genuflection has a natural logic. The Virgin gazes over his head, reflecting on the future; Joseph's gaze is equally reflective and echoes that of the Virgin while reinforcing the idea. The beautiful young maid with the doves, derived from Italian iconography of this scene, wears a headdress like that of the Magdalen in the *Jean Braque Triptych* and gazes into the space of the spectator, and the old woman at the right has a strength that balances the youthful beauty of the girl. The architecture forms a circular foil, referring by its shape to the old dispensation, and contrasting by its lightness with the darker areas surrounding the figures. The beggar in the distance and the figure entering the building from the dimly visible city beyond are filling devices, intended to keep the eye from escaping into space. Rogier has created a consummate union of psychological and rhythmic drama in this latest work.

Rogier's portraits parallel his stylistic development in religious paintings. The earliest portrait that can be attributed to him is an alluring portrait of a young woman (Fig. 144), in Berlin, painted with a delicate modeling of form and clarity of outline. A very subtle suggestion of swelling form makes the breasts the bases of a triangle with its apex at the head, their rounded forms echoing the head in shape and the folded hands reinforcing the triangular conception. The white headdress forms a shield, out of which the face emerges to look at the spectator. Amazing

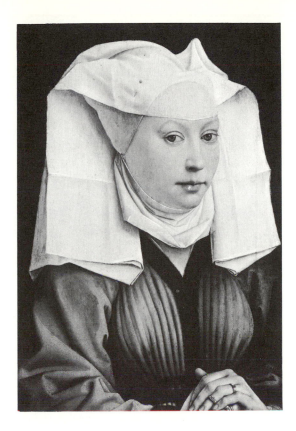

delicacy of crisp line and a soft lighting are employed to present this self-composed young woman, whose vitality is restrained but never in doubt. This portrait is far less brusque than those of the Master of Flémalle. Rogier's more delicate tonality and tendency toward spatial chiaroscuro move in the direction of Jan van Eyck and are paralleled in the Louvre *Annunciation,* which this probably antedates by a year at most.

From the later 1440s comes the portrait of Isabella of Portugal, in the Mrs. John D. Rockefeller, Jr., Collection, New York. Its dark background, the dark cast over the drapery, and the inscription identifying the sitter as the Persian sibyl are all probably later additions. The work is similar in spirit to the portrait of Guigonne de Salins on the exterior of the *Last Judgment Altarpiece* and clearly later than the female donor of the Vienna *Calvary.* The elongation of form and the masterful, restrained modeling accord with the proposed date.

In a portrait of another young woman (Fig. 145), in Washington, possibly painted about 1455, there is a marked change. The forthright, sculpturesque spirit of the alluring young woman in Berlin has been replaced by introspection. The Washington portrait is artistically more exciting, for in place of the simple mounding of forms there is a more exciting interplay of line and shape and a greater sense of drama. The subject appears aristocratic, whereas the Berlin subject is *haute bourgeoise.* This is Rogier's type of aristocracy, however, for the young woman in Berlin seems prettier. There is a similar but weaker portrait in London of about the same date.

Also close in time to the Washington portrait is that of Francesco d'Este (Fig. 146), in New York, identified on the reverse by the Este arms, his name "francisque," and his motto. The illegitimate son of Lionello d'Este, Francesco had been sent to the Burgundian court at Brussels for his education in 1444, when he was fourteen or

fifteen. Here he is portrayed at the age of twenty-five or thirty. Most unusual for a northern portrait is the cream, almost white, background, which isolates the figure and concentrates the observer upon the individual, as opposed to the northern tendency to suggest the milieu in which the sitter exists. Though Rogier generally avoided settings in his portraits, he occasionally suggested one, as here, by positioning the hands as though resting on a ledge before the figure.

In contrast, the *Man with an Arrow* (Fig. 147), in Brussels, identified as Anthony, Grand Bastard of Burgundy, who was born in 1421, or possibly as John of Coimbra, is set against a dark background. Though the calm, even lighting is characteristic of Rogier's developed portrait style, the face and hands seem to reveal a greater attention to particularity, which allies the work with the style of the early 1450s, immediately after the return from Italy.

Later by about five years may be placed the portrait of *Charles the Bold* (Fig. 148), in Berlin. Younger in appearance than in the *St. Columba Altarpiece*, Charles also seems calmer. Yet Rogier's style, with its even illumination of the

below: 148. ROGIER VAN DER WEYDEN. *Charles the Bold.* c. 1457. Panel, 19 1/4 × 12 5/8″. Gemäldegalerie, Staatliche Museen, Berlin-Dahlem.

top: 146. ROGIER VAN DER WEYDEN. *Francesco d'Este.* c. 1455–60. Panel, 11 3/4 × 8″. The Metropolitan Museum of Art, New York (Michael Friedsam Collection).

above: 147. ROGIER VAN DER WEYDEN. *Man with an Arrow.* c. 1452. Panel, 15 3/8 × 11 1/4″. Musées Royaux des Beaux-Arts, Brussels.

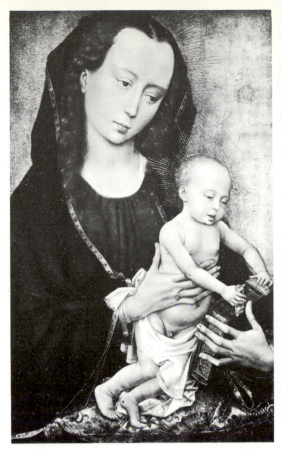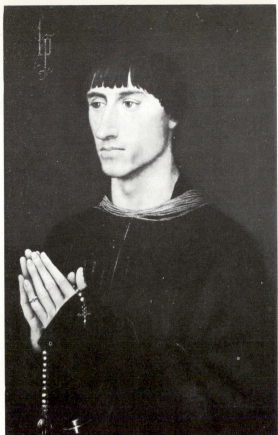

149. Rogier van der Weyden. *Madonna and Child* and *Philippe de Croy,* panels of a divided diptych. *c.* 1455–60. Panel, *c.* 19 ½ × 12 ½" (each). Henry E. Huntington Library and Art Gallery, San Marino, California (*left*), Musée Royal des Beaux-Arts, Antwerp (*right*).

form, does not conceal his discernment of Charles's intense temperament, which is more sharply characterized in the later work, the *St. Columba Altarpiece.*

These portraits indicate that Rogier, though city painter of Brussels, apparently worked for the aristocracy as much as had Jan van Eyck, for whom Rogier created a number of diptychs with half-length figures. All were created within the last style. Typical is the now-divided diptych (Fig. 149) with Philippe de Croy (in Antwerp) and the Madonna and Child (Huntington Gallery, San Marino, Calif.). The Child leans forward to be restrained by the hand of the Virgin, the flat lighting and clarity of design removing any feeling of strain. This is characteristic of Rogier's use of naturalism as a vehicle, rather than as an end in itself. The Child's feet seem to dangle from the supporting hand of the Virgin in order to suggest the helplessness of infancy.

Another diptych originally combined the portrait of Laurent Froimont, now in Brussels, and the *Virgin and Child* in the Mansel Collection of the Musée des Beaux-Arts at Caen. The *Virgin and Child* in Tournai, formerly in the Renders Collection, and the portrait of Jean de Gros in Chicago are from a diptych which was executed with a large amount of shop assistance. The Tournai Virgin and Child painting is based upon the model suggested by the Boston St. Luke painting. The cheery, stiff Child first appeared there and was repeated subsequently in numerous shop works.

For his contemporaries Rogier represented more clearly than any other artist the spirit of his age; he was copied ad infinitum and influenced the greatest number of artists north of the Alps in the 15th century. His influence was far greater than that of Jan van Eyck until the end of the century, when Jan's synthesis came to the fore in a combination of northern reality with Italian Renaissance monumentality in antique guise. Rogier's rhythmic, more Gothic spirit, however, dominated artistic production in the second half of the century.

THE SECOND GENERATION: 7

Christus, Ouwater, Bouts
and His Followers

THE TREATY OF ARRAS, IN 1435, MARKED A turning point in the fortunes of the southern Netherlands. A revival of business and a new prosperity attracted many from far and near to Bruges and Brussels, where the court was more and more often to be found. Possibly Petrus Christus was one of those artists attracted to Bruges, as was Albert van Ouwater of Haarlem, to judge by the style of his single certified work. A third artist, Dirk Bouts, also of Haarlem, is related to them chronologically and stylistically, though he eventually settled in Louvain. All three were probably born in the second decade of the 15th century.

PETRUS CHRISTUS

In the hands of Rogier van der Weyden the art of Jan van Eyck had been assimilated with his Tournai training to emerge in a new form that stressed rhythmic movement and intense religious imagery. In Bruges the inheritor of Jan's shop, Petrus Christus, was artistically less gifted; yet he too transformed his inheritance.

First heard of on July 6, 1444, when he was granted citizenship in Bruges "to be a painter," Petrus Christus is recorded as coming from Baerle, but it is not certain from which of the two towns of this name, one about 34 miles northeast of Antwerp, the other near Ghent. In 1454 he was commissioned by the Count of Etampes to make three copies of a miraculous image of the Virgin in Cambrai. He may be identical with the Piero of Bruges recorded at the Sforza court in Milan in 1457, though his art shows no Italian influence. In 1462 Petrus and his wife became members of the Confraternity of the Dry Tree; in the following year, with Pieter de Nachtegale, he painted a *Tree of Jesse* for the Holy Blood Procession. He died in Bruges in 1472 or 1473, leaving behind an illegitimate son, Sebastian, also a painter, as was his grandson Petrus II. Several of Petrus Christus's works are signed PETRUS XPI.

His position as Jan's pupil and successor has been doubted, and as a result two schools of thought exist as to his development, one considering him as Jan's successor, the other maintaining that he had no actual contact with Jan. The doubts regarding his contact, however, may be regarded as ill-founded, even if he had no part in the Detroit *St. Jerome* (Fig. 121) and the Frick *Virgin and Child* (Fig. 120). His *Virgin and Child, St. Barbara, and Carthusian Donor* [1] (Fig. 150), the so-called Exeter Madonna, in Berlin, based on the Rolin, Maelbeke, and Frick panels (see Chap. 5), shows such a concise, detailed knowledge of Jan van Eyck's work that only as the inheritor of his shop would Petrus Christus have been able to repeat in this work the floor layout of the *Rolin Madonna*.

When the *Exeter Madonna* was painted, whether it be dated about 1444 or 1450, the *Rolin Madonna* was unavailable for detailed copying, because Rolin undoubtedly gave it to Autun Cathedral in 1437.

The *Exeter Madonna,* here considered as close to 1444, shows Petrus Christus at the close of the first phase of his development as the executor of Jan's unfinished work and his conscientious emulator. But his own more simplified and generalized approach is clearly visible in his harder line, in his tendency toward doll-like features and pudgy hands, and in his preference for setting his figures into a greater space than Jan would have employed. The result inevitably is a loss of monumentality and a dispersal of concentration, for both interior and exterior are equally stressed. The architectural frame has become a loggia, within which the viewer

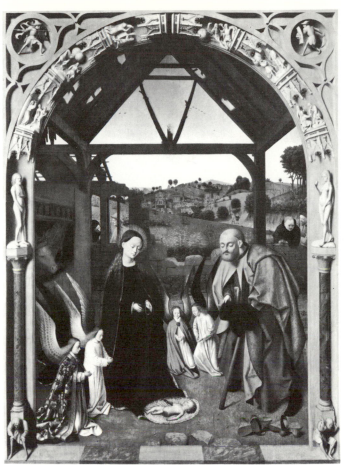

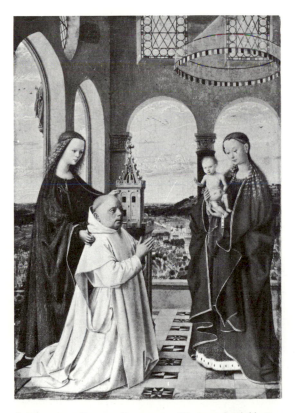

above: 150. PETRUS CHRISTUS. *Virgin and Child, St. Barbara, and Carthusian Donor* ("Exeter Madonna") *c.* 1444. Panel, 7 1/2 × 5 1/2". Gemäldegalerie, Staatliche Museen, Berlin-Dahlem.

above right: 151. PETRUS CHRISTUS. *Nativity. c.* 1445. Panel, 51 1/4 × 38 1/4". National Gallery of Art, Washington, D.C. (Andrew Mellon Collection).

experiences a space that is neither purely internal nor purely external.

A distinct change is exemplified in the *Nativity* in Washington (Fig. 151), which has been dated about 1445. Elements drawn from Van Eyck are united with others from Rogier, a union epitomized by the derivation of Adam (on the left jamb) from the *Ghent Altarpiece* and of Eve (on the right jamb) from Rogier's small standing Madonna in Vienna (Fig. 124). Equally "Tournaisian," and even suggestive of the influence of Jacques Daret, is the Nativity group, though the angel at the left front is probably Eyckian. The Genesis scenes on the archivolts recall Rogier's *Mary Altarpiece,* and the possibility that Rogier could have influenced Christus even earlier becomes credible when it is realized that the *Exeter Madonna* also has a marked emphasis upon the silhouette of the forms. The background of the *Nativity,* however, is different from both its models. The figures beyond the stable, which frames the view, are

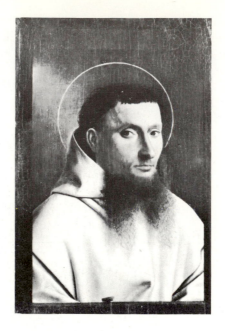

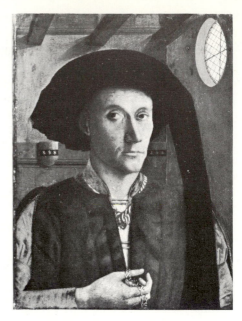

right: 152. PETRUS CHRIS-TUS. *Portrait of a Carthusian.* *c.* 1446. Panel, 11 1/2 × 8″. The Metropolitan Museum of Art, New York (Jules S. Bache Collection).

far right: 153. PETRUS CHRISTUS. *Edward Grimston.* 1446. Panel, 13 1/4 × 9 3/4″. The Gorhambury Collection, St. Albans, England (by kind permission of the Earl of Verulam).

rather flatly treated, and the predominantly shadowless background shows an even illumination, in which the values are closely held to a middle range. Landscape plays an important part in this painting, a large area being opened to the eye and treated, not in the warm, more high-keyed tones of Jan or even Rogier, but in cool, subdued, slightly gray greens that balance the strong foreground reds and greens. This and the delicately graduated blue sky seems to express

an even temperament on the part of the artist himself.

Two portraits are signed and dated in the year 1446. The *Portrait of a Carthusian* in New York (Fig. 152) is astonishing in comparison with the Carthusian of the *Exeter Madonna,* for it shows much higher quality. The organization is Eyckian, but thoroughly non-Eyckian are the *trompe l'œil* effect of the fly on the sill (which may derive from descriptions of antique paint-

154. PETRUS CHRISTUS. *Lamentation. c.* 1448. Panel, 39 3/4 × 75 5/8″. Musées Royaux des Beaux-Arts, Brussels.

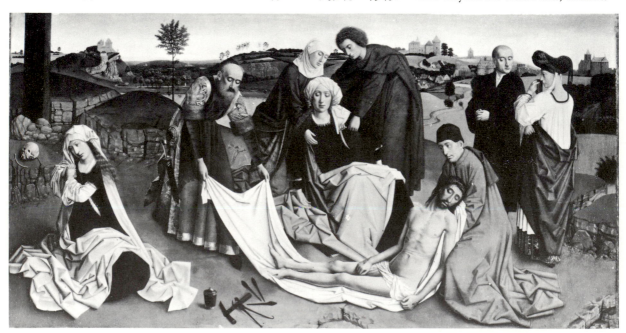

ings,) and the background lighting that suggests a setting for the figure. The setting is carried a large step forward in the other portrait of 1446, that of Edward Grimston, in London (Fig. 153). Here Petrus Christus enlarged the space to specify the sitter's environment and thereby created the corner-space portrait, with a continuation of space suggested by the window. Though the surfaces tend toward generalization and simplification, the painter is still very close to Jan van Eyck in naturalism of glance, illumination, and surface interest, despite a life-long lack of interest in Jan's rich color.

Under Rogier's influence, however, Petrus developed in the following several years an interest in the types of the Brussels master, as is visible in the *Lamentation,* in Brussels (Fig. 154). A more subdued expression is created by wide spacing of the forms and contained moods, in contrast to the taut rhythms of Rogier's *Deposition* (Fig. 128), with its emotional pathos. The motif of the figure of Christ on the winding cloth was either an alternate version of Rogier's (for it appears in a work by his shop, the *Lamentation* in The Hague, previously considered as only tenuously connected with Rogier himself), or it was an invention of Petrus Christus himself. He used it again a few years later (ten at most) in a smaller version now in New York. Both versions present a relatively undifferentiated foreground and a generally lower tonality in the background, and both are terminated by a cloudless sky.

In 1449 Petrus signed and dated two works, one a Madonna and Child in half length, in the Thyssen-Bornemisza Collection, Lugano-Castagnola, based on the type of the *Virgin at the Fountain* (Fig. 115), and the other a painting of *St. Eligius* (Fig. 155), in the Lehman Collection, New York. The latter may be considered the first genre painting in northern art. St. Eligius, a mintmaster martyred in Flanders in Merovingian times, is shown as an unidealized contemporary goldsmith about to sell a wedding ring to a young couple. The depiction of the saint seems to be a portrait, but the couple are more generalized, just the reverse of previous representations. The "occupational portrait" noted in Jan's work has been carried further by Petrus to become an actual portrait in an actual goldsmith's shop. Like the passers-by reflected in the mirror, we are allowed to look past the open

shop front and witness the transaction. Stylistically this painting is close to the Brussels *Lamentation* in the interest in semiplastic forms comparatively evenly illuminated and set into a space which, though clearly small, does not cramp the action.

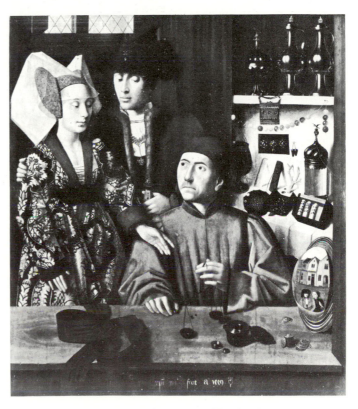

155. Petrus Christus. *St. Eligius as a Goldsmith.* 1449. Panel, 39 × 33 1/2″. The Lehman Collection, New York.

The development toward an exact perspective, in which the orthogonal lines meet at one common point on the horizon line, which was suggested in the *St. Eligius,* reached fruition in the panels of 1452 in Berlin (Fig. 156). The *Annunciation and Nativity* on one panel and, on the other, a *Last Judgment* that is a simplified version of the New York diptych (Fig. 103) may have been part of a series of panels of which a *Pietà* in the Louvre once formed a part. The Annunciation scene unites a Virgin from Rogier and an angel from the Master of Flémalle in a setting that seems to combine Rogier's Louvre *Annunciation* (Fig. 125) with Petrus's own *Exeter*

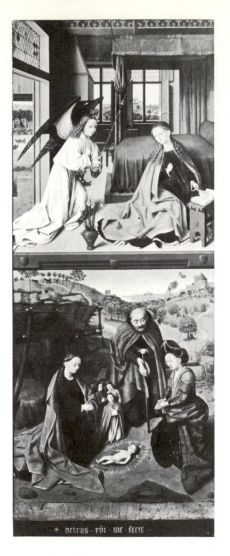

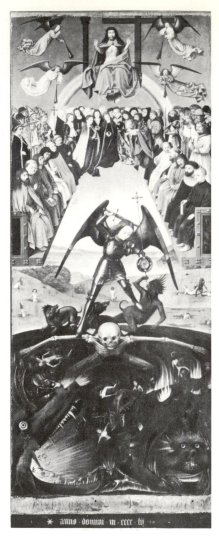

right: 156. PETRUS CHRISTUS. *Annunciation and Nativity* and *Last Judgment,* altar wings. 1452. Panel, 52³/₄ × 22″ (each). Gemäldegalerie, Staatliche Museen, Berlin-Dahlem.

below: 157. PETRUS CHRISTUS. *Virgin and Child with Sts. Jerome and Francis.* 1457. Panel, 18³/₈ × 17¹/₂″. Städelsches Kunstinstitut, Frankfurt.

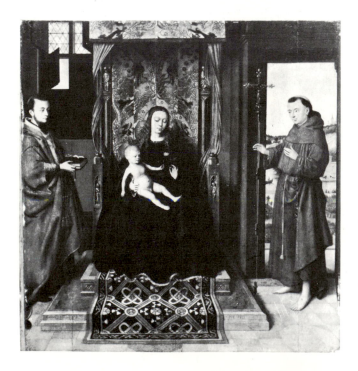

Madonna in the measured pattern of its space, here achieved in perfect perspective. The Nativity scene is more Flémallesque, even to the inclusion of the midwife. (A similar *Nativity* in the Wildenstein Gallery, New York, is very close in date.) In the *Last Judgment* a fine landscape behind the figure of St. Michael in part compensates for the lack of complexity in the lower portion. Over-all, one notes the more distinct quality of each individual, naturalistic form.

Five years later Petrus Christus signed and dated a *Virgin and Child with Sts. Jerome and Francis,* in Frankfurt, for which the *Van der Paele Madonna* furnished the inspiration, with a variation in the landscape seen through a wide doorway behind St. Francis (Fig. 157). Here, as well as in his *Calvary,* Dessau Museum (destroyed in World War II), and in his Berlin panels,

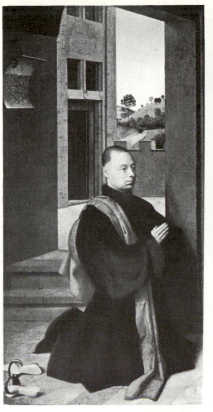

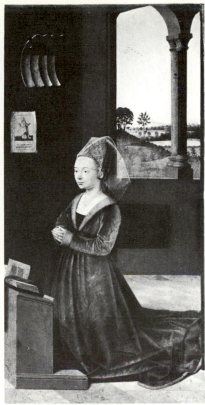

right: 158. PETRUS CHRISTUS. *A Donor and His Wife. c.* 1450–60. Panel, 16 ½ × 8 ½″ (each). National Gallery of Art, Washington D.C. (Samuel H. Kress Collection).

below: 159. PETRUS CHRISTUS. *Virgin and Child in a Gothic Interior. c.* 1457–60. Panel, 27 ³/₈ × 20″. Nelson Gallery–Atkins Museum, Kansas City, Mo. (Nelson Fund).

Petrus Christus's figures show a strong return to Eyckian modes. Their treatment, however, is as summary as that of the *Exeter Madonna.* This is not true of his portraits of this period, a *Young Man,* in London, and the *Donor and His Wife,* [2] in Washington (Fig. 158), which reinforce the trend observed in the earlier portraits, in the *St. Eligius,* and in the artist's development of an exact perspective—indicating that he had a greater interest and understanding of the actual than of either monumentality of form or its rhythmic organization.

Nor was he interested in disguised symbolism. Jan van Eyck's motif of the Erythraean sibyl is found in the Brussels *Lamentation* and in the Dessau *Calvary.* In both she is distinguishable by her turban, and in both she is clearly an accessory figure. In the Dessau panel she no longer observes, and in the *Lamentation* she has joined the mourners, proof that Petrus either did not know or disregarded her symbolic import.

An unusually accomplished painting, the *Virgin and Child in a Gothic Interior,* [3] in Kansas City (Fig. 159), shows St. Joseph entering a room beyond the bedroom occupied by the Virgin and Child. The precision in the treatment of the artistic elements makes one tentatively accept

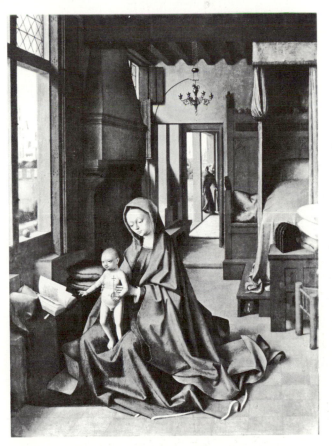

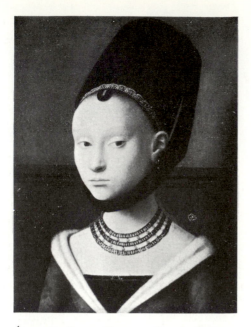

above: 160. PETRUS CHRISTUS. *Portrait of a Young Woman. c.* 1468–73. Panel, 11 × 8 ¼″. Gemälde-galerie, Staatliche Museen, Berlin-Dahlem.

below: 161. ALBERT VAN OUWATER. *Raising of Lazarus. c.* mid-15th century. Panel, 48 × 36¼″. Gemäldegalerie, Staatliche Museen, Berlin-Dahlem.

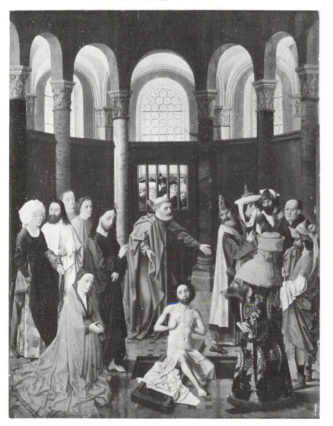

the possibility that Christus was in Milan in 1457 and that there was a consequent influence on his style in terms of a greater clarity and rationality of form and setting. The variety of light and shade shows a new awareness in Petrus Christus of the poetry of natural effects within an interior space. This had been hinted at in the landscape of his Washington *Nativity* and in the loggia of the *Exeter Madonna;* it had been advanced further in the Frankfurt panel; and here it reaches its greatest height.

Less impressive is the *Madonna of the Dry Tree,*[4] of about 1462, in Lugano-Castagnola, based on Ezechiel 17:24, in which 15 letter *a*'s stand for the Aves of the Hail Mary. The small head of the Virgin tends to overmonumentalize the figure, and there is seemingly a decline of his powers. However, this failing is not to be found in a *Portrait of a Young Woman* (Fig. 160), in Berlin, which by its costume may be dated in the late 1460s or early 1470s. Here for the last time appear the typically smooth surfaces and generalized lighting, to which has been added an elegance lacking in his earlier work.

Thus in Petrus Christus two forces were operative: that of Van Eyck, inherited by train-ing, to which he basically adhered all his life, and that of Rogier, which he assimilated, taking, however, only from Rogier's most plastic expression. Though his generalizing and sil-houetting tendencies are non-Eyckian, essentially his style is plastic and spatial, with a limited interest in color.

ALBERT VAN OUWATER

Petrus Christus's name has often been asso-ciated with that of Albert van Ouwater, about whom knowledge is very sparse.[5] Carel van Mander considered him the founder of Haarlem painting, praised him as a landscapist, and mentioned that Geertgen tot Sint Jans was his pupil. Ironically, the only authenticated painting by Van Ouwater is an interior scene, the *Raising of Lazarus,* in Berlin (Fig. 161), identified from a detailed description of a grisaille copy seen by Van Mander. The only document discovered about Van Ouwater refers to the burial of his daughter in 1467. Even this has been questioned. From the Lazarus painting, datable about mid-century, it is evident that he was influenced by

the Van Eyck current but that he was of Petrus Christus's generation. The influence of Jan van Eyck appears in the organization of the scene, which is placed in the church where the altar normally stands. It thereby recalls, as does the choir at the back, the *Van der Paele Madonna*. Jan's influence is also suggested in the architectural details. Figure types, however, are stockier, and naturalism is more insistent, as in the actions at the right and the curious crowd behind the grille. Lazarus turns to the spectator, rather than to the figure of Christ, but the dominant element in the scene is the light that flows over the surfaces in a broad and smooth movement, augmented by the generally light and rather delicate color. Comparatively unidealized forms, sober and naturalistic types, and a spacious, symmetrical Romanesque setting tonally presented are all vehicles for a style that is seemingly contemporaneous with and parallel to the work of Petrus Christus; the subject is hieratically conceived, with the frontally placed Lazarus symbolizing the Resurrection.

DIRK BOUTS AND HIS FOLLOWERS

The early life of Dirk (or Dieric, or Thierry) Bouts (actually Theodorik Romboutszoon) is undocumented and has given rise to much speculation on the part of art historians. [6] He was probably born at Haarlem in the 1420s. When he settled in Louvain and exactly when and where he met Petrus Christus are among the questions that have occupied the scholars. It is known that in Louvain he married Katharina van der Brugghen, nicknamed Metten Gelde ("with the money"). This marriage must have taken place, at the latest, in 1447 or 1448, because his oldest son, Dirk, achieved his majority (at that time the age of twenty-five) in Louvain in 1473. However, the name of Dirk the Elder first appeared in the Louvain documents in 1457. After that year there are numerous documents referring to Dirk's residence in Louvain, whose city painter he became in 1468. His first wife died sometime between 1462 and 1472, for he was remarried in 1472 or 1473 to Elizabeth van Voshem, widow of a butcher. He died, it seems, on May 6, 1475, having made his last will and testament the previous April 17th.

Because of the 1457 documents proving Dirk's presence in Louvain, and because Van Mander had identified Dirk's house in Haarlem, Hulin de Loo and Schöne thought that between his marriage and 1457 he went back to Haarlem, returning to Louvain in 1457. However, it is more likely that he settled in Louvain between 1445 and 1448, because Panofsky has called attention to the mention of a painter Dirk Aelbrechts in Louvain in 1442 and noted that Dirk Bouts's second son was called Aelbrecht.

Bouts's earliest work, the *Infancy Altarpiece*, of about 1445, in the Prado, is clearly related to Petrus Christus. According to Schöne and Tolnay, Bouts worked with Van Ouwater in Haarlem and there met Petrus Christus, who introduced him to the art of Jan van Eyck and Rogier van der Weyden. (Why Christus went to Haarlem is not satisfactorily explained, and the visit is certainly undocumented.) Panofsky, however, considered that Bouts met Christus at Bruges, a belief which accords with probability far more than the previous theory. Whatever the case may be, the influence of Jan and Rogier is evident in works painted by Bouts before 1457, and the influence of Petrus Christus is seen in his early work.

The *Infancy Altarpiece* (Fig. 162), with its scenes of the Annunciation, the Visitation, the Nativity, and the Adoration of the Magi, is strongly related to Petrus Christus's *Washington Nativity* (Fig. 151), in the manner of framing the scenes, even to the warriors seen in the spandrels, and in the composition of the Nativity scene. Rogier's types are combined with Van Eyck's ideas, though the latter may have been transmitted through Petrus Christus. The motif of the open doorway seen behind the angel in a brocaded garment appears also in Petrus Christus's Berlin panel of 1452 (Fig. 156). The lighting is also Eyckian in character, and even more strongly so in the Visitation panel, though that, as well as the Annunciation, suggests Rogier as a model. The Visitation is emphatically dependent on the Leipzig panel by Rogier (Fig. 126). Distinctly different in all, however, are the sense of spatial continuity and the actuality of form. In the Visitation scene it seems as though we are looking through an open doorway at a tableau staged before a landscape. Such a conception is foreign to Rogier, as are the measured intervals creating a foreground,

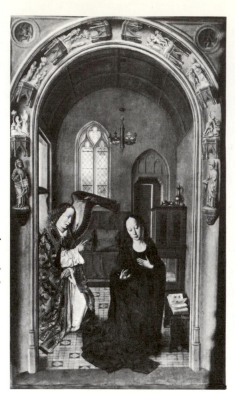
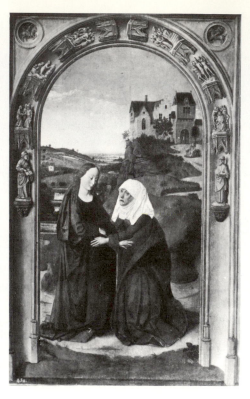

162. DIRK BOUTS. *Infancy Altarpiece.* c. 1445. Panel, 31 ½ × 41 ⅜″ (center, two scenes), 31 ½ × 22″ (each wing). Prado, Madrid.

middle ground, and background in natural succession. And for Rogier's momentarily interrupted continuity in figure movement Bouts has substituted a more monumental and thus more static portrayal. His concept is marked as different in intent by the much older, rather pathetic figure of Elizabeth, who almost kneels before the Virgin.

In the Nativity Bouts seemingly followed Petrus Christus. He compressed the composition of the Washington *Nativity* to fit his panel, cutting down the right side. Curved forms are spotted about to carry the eye into depth. The Adoration of the Magi is also unlike Van Eyck in composition, being derived from Rogier's *Mary Altarpiece* archivolt scene (Fig. 130).

Thus Bouts's early style shows a mixture of elements: Rogier's composition and types, the latter short with massive heads, as in Rogier's early plastic phase; Van Eyck's color, feeling for textures, and spatial chiaroscuro; and Bouts's own concept of a normative nature. This last characteristic is shared with Petrus Christus, though Bouts went further in adherence to Van Eyck's conceptions, particularly in richer color and simpler folds. Natural elements thus had greater meaning to Bouts as things in themselves, landscape forms, for example, being used to

balance the figures, whereas Rogier's tendency was to treat nature as a subordinate decorative device. At this stage of Bouts's career Rogier's art had little stylistic effect on his work, as may be seen in a *Madonna and Child,* in New York, a half-length composition of which several versions exist, including a nearly exact replica in the Carrand Collection, in the Bargello, Florence. Both apparently date from the later 1440s.

As Bouts's art developed, the influence of Rogier became stronger, so much so that Hulin de Loo assumed a period of participation in Rogier's shop. This was not necessarily the case, Louvain being only 12 miles from Brussels, but the growing influence in style as well as in forms is unmistakable. It makes its appearance in the *Deposition Altarpiece* (Fig. 163) in the Capilla Real, Granada, and in a shop copy of the work in Valencia, wherein Rogier has been heavily drawn upon. The scene of the Descent from the Cross borrows from Rogier's famous *Deposition,* the Crucifixion on the left wing from his Vienna *Calvary,* and the Resurrection from the background scene in the Christ Appearing to His Mother, of his *Mary Altarpiece*. Figure types in the *Deposition* are elongated, emotional reactions are more accentuated, and the silhouette is more

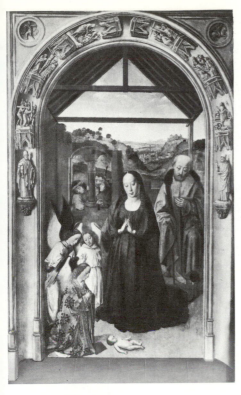

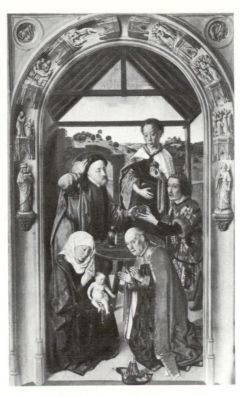

below : 163. DIRK BOUTS. *Deposition Altarpiece. c.* 1450–55. Panel, 75 × 56¼″ (center), 74 × 22⅞″ (each wing). Capilla Real, Granada.

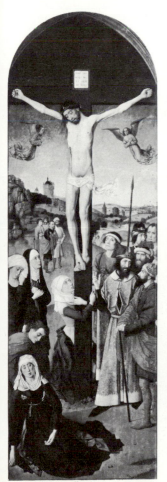

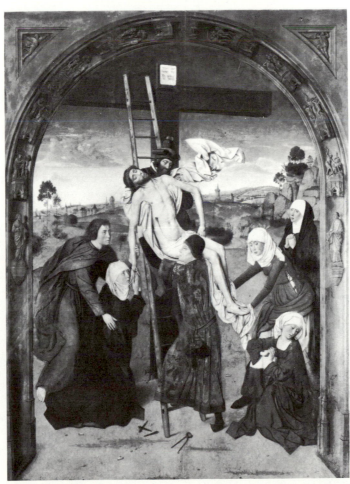

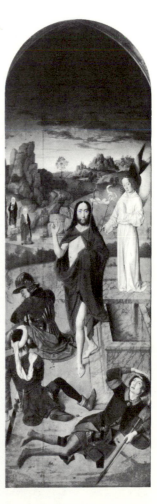

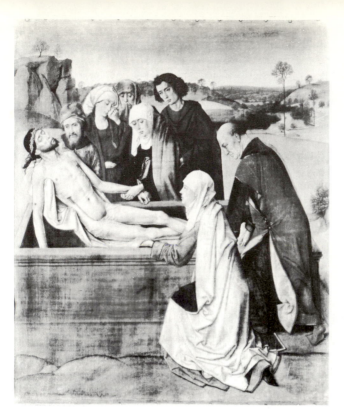

left: 164. DIRK BOUTS. *Entombment. c.* 1455–60. Linen, 33 ⁷/₈ × 28″. National Gallery, London.

(Fig. 164). The composition, derived from an archivolt of the *Mary Altarpiece,* again accentuates the drama not by rhythmic effects but by the increased concentration of the figures upon Christ. Slightly less idealized than Rogier's conception and simpler in the treatment of the garments, the scene shows a greater particularization of form and emotion. Bouts's color has become more subtle, with finer nuances and greater delicacy. His accentuation of the verticals, counterbalanced by the strong horizontal of the sarcophagus, is in keeping with the stylistic development of the later 1450s and the 1460s already seen in Rogier, who stressed the longer line in works of these decades. Bouts's own adherence to this stylistic tendency accords with the general development of the times toward a more painterly conception and an attempt to create convincing spatial illusions and greater color harmony.

The *Martyrdom of St. Erasmus* (Fig. 165), in St-Pierre, Louvain, is undated, despite the large 19th-century inscription on the frame. For this work there is documentary evidence. In the account books of the Confraternity of the Holy Sacrament of St-Pierre, it was recorded that each year until 1469 Dirck de Smet paid for masses to Sts. Jerome, Bernard, and Erasmus.

marked, inevitable consequences of stronger adherence to Rogier's model. However, reminiscences of Petrus Christus's Brussels *Lamentation* appear in the Magdalen and in the woman receiving the feet of Christ. In contrast to Rogier's portrayal of emotional reactions, for which the Deposition itself served as a point of departure, Bouts's figures are more involved in the physical drama of lowering the body to the ground.

Also related to Rogier, but later in date, is the *Entombment,* in London, painted on linen

below: 165. DIRK BOUTS. *Martyrdom of St. Erasmus. c.* 1460. Panel, 32 ¹/₈ × 31 ³/₄″ (center), 32 ¹/₈ × 13 ⁷/₈″ (each wing). Church of St-Pierre, Louvain.

Just these three saints are present, Jerome on the left wing, Bernard on the right wing, and Erasmus in the center panel. In 1535 the work was mentioned as belonging to the Confraternity, but it was not recorded in the account books of the Confraternity, though the Confraternity was founded in 1433 and its account books date back to 1466. Apparently the altarpiece antedates the account books.

St. Erasmus, legendary bishop of Antioch, seems to meet his martyrdom without any sign of inconvenience except the position of his head against the vertical bar, as his entrails are being neatly wound up on a rod by equally calm executioners, the one at the right almost assuming a dancing pose. Despite his facial expression, this executioner and his fellow do not appear to be involved in any realistic actuation of the mechanism, for Bouts studiously avoided any overt emotive quality in order to express a symbolic rather than an actual presentation of the event. The curve formed by Erasmus and his executioners is repeated in the unified background landscape, and the center is stabilized by the central figure of the wicked ruler in his brocaded garment (who appears again in Joos van Ghent's painting of Christ giving communion to the apostles, in Urbino, Fig. 179). The figure in profile at the left is in Italian costume and is definitely a portrait, as is the companion figure on the right. What their relationship was to the Louvain Confraternity cannot be answered.

The work is painted in magnificent, dominantly warm color, rich reds and blues in the foreground and delicate tones of brown and green that give the landscape an aura of natural existence. Yet the design and the immobility in the figures result in an expression of isolated nature, separate and distinct. Avoiding strong actions, for any action that might be strong was consciously negated by simplified line and movement, Bouts moved away from narrative to establish for the first time a feeling of contemplation, a quality more and more to be seen in his subsequent development as the epitomizer of the "style of the long lines."

In conception very close to the Erasmus altarpiece is the *Portrait of a Man* (Fig. 166), dated 1462, in London. Petrus Christus's type of

corner portrait has been taken a step further by enlarging the ambient. Instead of a small, glazed window high up, there is a large, unglazed, simple window opening upon a distant landscape. Natural light comes in the window, leaving the right side of the face in shade and casting a soft shadow on the wall. The motif of the hands resting on the ledge, derived from Rogier, has been given space-measuring connotations, with which the glance, upward and out, is in keeping. The silhouetted figure presses close to the picture plane; by cross-balancing his accents and by the subtle fluidity of his light, Bouts created an animation of the quiet figure. Such a portrait sets out a figure with its own mystique—in the world, yet isolated. On reconsideration of the Erasmus triptych, it seems that the forms are slightly rounder and less dramatic under their more even lighting, which would suggest the work was painted a few years earlier, about 1460.

Shortly after, Bouts began his famous *Last Supper Altarpiece* (Pl. 11, after p. 180), in St-Pierre, Louvain. Four prefigurations of the theme occupy the wings; Abraham's meeting with Melchizedek at the upper left, the sacrifice of the Paschal Lamb at the lower left, the gathering of the manna at the upper right, and Elijah and the angel below it. Previous representations had normally treated Jesus's prophecy of Judas's betrayal. The central panel, however, presents the Institution of the Eucharist, which explains

right: 166. DIRK BOUTS. *Portrait of a Man*. 1462. Panel, 12 ³/₄ × 8 ³/₈". National Gallery, London.

167. Dirk Bouts. Meeting of Abraham and Melchizedek, *Last Supper Altarpiece*. 1464–67. Panel, 34 7/8 × 28 1/8″. Church of St-Pierre, Louvain.

the solemnity and frontality in the figure of Christ. The reason for the different interpretation is explained by the contract for the work (which survived until two world wars successively made a shambles of Louvain and its archives), given by the same Confraternity on March 16, 1464. Two professors of theology of the University of Louvain, Jan Varenacker and Aegidius Baelwael, dictated the theme to the painter, who agreed not to undertake further work until he had fulfilled the contract. There is little doubt that this practice was common; artists of this period did not create independently for an open market. Three payments were made between 1465 and 1467, the last receipt being signed in February, 1468. Thus the work was completed in 1467, for according to the contract, the last hundred gulden were to be paid one year after completion of the work.

The solemn liturgical import of the dictated theme has been expressed by the artist in a hieratic, balanced manner, as in the table drapery, whose curve is repeated in the dish above it. The red-garmented figures on the near side of the table form the bases of a triangle leading to the priestly and central figure of Christ (Judas forms the lower left-hand base of the triangle). A rigorous arrangement of the figures is expressed especially by the back line of the capped figure at the lower right. The regularity and order underlying the 1462 London portrait has here become even more severe and more geometrically exacting, notably in the portrait of the man by the sideboard, possibly Laureyse van Wynghe, as Van Gelder thought. [7] The identification is based on his age as compared with the other men portrayed, because the four masters cited in the contract have been equated with the four portraits in the central panel. Erasmus van Baussele may be the figure next to Christ, and the figures seen in the pantry window have been identified as Reyner Stoeps and Stas Roeloffs. Hulin de Loo had earlier identified the two figures as sons of Bouts. It is far more likely that Van Gelder is correct.

The construction has been given a rational aspect, even though the eye level is high, for Bouts employed a one-point perspective, probably learned from Petrus Christus, which has the perspective lines meeting on center above the fireplace. Yet the high eye level creates a feeling of unreality which contrasts with the clearly presented richly colored forms, the even illumination, and the views toward the exterior seen at right and left. Despite its rational construction, this scene still expresses a spirit which utilizes nature, no matter how sumptuously colored and naturalistically presented, merely for the expression of religious ideas. The large Christ is a continuation of medieval conceptions, whereas the various attitudes of the figures are essentially animating elements. Austerity and evasion of overt action or close contact between figures are more and more to be identified with Bouts's approach. His progressively elongated figures show that he gradually abandoned his softly rounded early forms in favor of a more emaciated type, with what Panofsky tellingly called a "congenital stiffness."

The wing panels are also solemn in theme, but there is a greater freedom, evident (Fig. 167) in the angular gestures in the meeting of Abraham and Melchizedek (Genesis 14:17–20). Melchizedek, king of Salem, who brought bread and wine to Abraham after his victory over Chedorlaomer and his allied kings, has been regarded as a prefiguration of the Last Supper since the 6th century. The scene appears frequently at this

period in such typological works as the *Speculum Humanae Salvationis* and the *Biblia Pauperum*. There are three definite portraits here, two to the left and the third the standard-bearer behind Abraham. The first two may be the theological professors in charge of the program, and the third may be Claes van Sinte Goerickx, a witness to the signing of the contract, but the identifications are pure suppositions.

Abraham's retinue, like a procession of the Magi, has come to a halt before hills constructed by overlapping coulisses that create diagonal patterns for the eye. A strong foreground light contrasts with the softly lighted, shadowless background, a balancing of elements that is rational in organization even though the eye is made to move in jumps.

The sacrifice of the Paschal Lamb (from Exodus 12:11) appears as a prefiguration as early as I Corinthians 5:7, "et enim pasca nostrum immolatus est Christus" ("For even Christ our passover is sacrificed for us"). Strongly related to the central panel, the scene has the same sense of immobility, with the same lack of contact between the almost symbolic figures (Fig. 168). Dressed for the Exodus, they are about to partake of the paschal meal, their traveling staffs in hand. This scene makes us recognize that the wing panels are compositionally subtle echoes and variations of the center panel, as in the suggested triangularity of the Elijah panel, the related shape in the manna scene, and so forth.

The gathering of the manna (based on Exodus 14) is a common prefiguration of the Last Supper. It takes place at dawn, for when the sun came out, the manna melted away. As though picking up pearls, the Hebrews place the manna in the truly ceremonial vessels they hold (Fig. 169). The ceremonial re-enactment of the Last Supper in church ritual is clearly implied, as God appears above in a window in the gray-blue sky, its lower clouds warmed by a rising sun. Almost pyramidal, the foreground composition is set before a measured space indicated by the diminishing size of the figures as the eye of the observer leaps from the mother and child at the left, to the woman deeper in space at the right, and so on. Diagonal movements of a dramatic nature are implied and paralleled in the transformation of the Biblical desert into an area of rocks, trees, grassy hills, and mountain forms echoing the action of the figures.

below: 168. DIRK BOUTS. Sacrifice of the Paschal Lamb, *Last Supper Altarpiece.* 1464–67. Panel, 34 ⅞ × 28 ⅛″. Church of St-Pierre, Louvain.

bottom: 169. DIRK BOUTS. Gathering of the manna, *Last Supper Altarpiece* 1464–67. Panel, 34 ⅞ × 28 ⅛″. Church of St-Pierre, Louvain.

The lower portion of the right wing shows Elijah in the wilderness, about to be fed by the angel (I Kings 19:4–8). Elijah's relation to the Last Supper is due to St. Thomas Aquinas and is not found in the *Speculum Humanae Salvationis*. Rarely found in the *Biblia Pauperum*, the scene's presence here is without doubt due to the Louvain theologians. About to be awakened, Elijah sleeps in angular position, his form echoed in the landscape behind him (Fig. 170). Fortified by the heavenly food, Elijah, seen again in the background, was able, according to the Bible, to journey for forty days and forty nights. The rocky desert is set off against a serene landscape at the left, and the long-limbed angel is contrasted with the angular Elijah, whose heaven-sent food and drink are carefully and prosaically placed at the left.

This solemn exposition of religious dogma, presented with clear, warm colors, as in the red robe of Elijah and the red garments of the manna gatherers, set against lovely landscapes, thoroughly pleased the Louvain authorities, for in 1468 they made Bouts official painter. Among the works they commissioned was a *Last Judgment* which has disappeared, though the wings, identified by an old copy of the whole, have survived. The wings (both now in Lille) present Hell (owned by the Louvre) and Paradise. The former follows a tradition that can be taken back to the Limbourgs in showing the falling figures described in the *Vision of Tondalus*. A partial inspiration of Rogier's *Last Judgment Altarpiece* is also evident in the action of the woman with her fingers in her eye. The Lille panel (Fig. 171) shows a foreground group striding stiffly off to the terrestrial paradise, led by a richly dressed angel. With devout expressions they approach the fountain of life (a way station, one feels, to the celestial paradise), where they will drink an elixir that will enable them to ascend to Heaven, as they do on the hillside in the background. The theme of the heavenly ascent derives from St. Augustine's *City of God*. These lightly sketched figures in the background must have appealed to Bosch, for they show the germ of

above: 170. DIRK BOUTS. Elijah in the wilderness, *Last Supper Altarpiece*. 1464–67. Panel, 34⅞ × 28⅛″. Church of St-Pierre, Louvain.

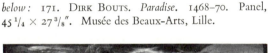

below: 171. DIRK BOUTS. *Paradise*. 1468–70. Panel, 45¼ × 27⅜″. Musée des Beaux-Arts, Lille.

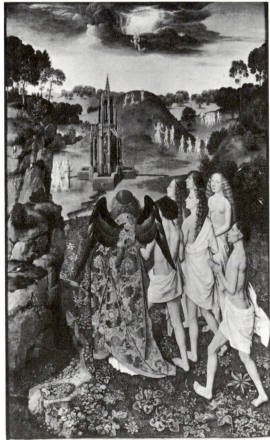

his direct painting technique. Bouts's superlative surface treatment is combined with almost jerky movements in his figures, whose uplifted profiles all express a pious devotion and an intense, reserved inner spirituality.

About the middle of the 1460s Bouts probably painted the enchanting *Virgin and Child* (Fig. 172), in London, in which he transferred the spatial feeling of the 1462 portrait to the Virgin and Child theme by the use of similar devices; the corner is suggested by the rich brocade, and through the window behind we see a landscape over which, significantly, looms a church tower. The Child, though in a different pose, recalls Rogier's *St. Luke* (Fig. 127), the same cheery Child here interrupting his nursing to turn and smirk at the spectator. Schöne has dated the work as about 1467.

Slightly later than the lost *Last Judgment Altarpiece* is the fragmentary *Portrait of a Man,* his hands lifted in prayer (Fig. 173), in New York. Close in date to 1470, it is a deeper revelation of devout, reserved expression executed with the subtle surface modeling of the Paradise scene. It is a prelude to the portraits in the last great work of Bouts.

When Bouts received the commission for the *Last Judgment* in 1468, he was also commissioned to paint four panels on the subject of justice for the Hôtel de Ville. About 1470 he began the first of the two panels that he was to complete and delivered it to the city authorities in 1473, leaving the second panel almost completed when he died in 1475. The second panel, evaluated by Hugo van der Goes in 1480, was finished shortly after Bouts's death by a different hand. The two tall panels (Pl. 12, after p. 180), now in Brussels, called the *Justice of Emperor Otto III,* derive from a tale found in the *Pantheon* of the 12th-century historian Godfrey of Viterbo and elsewhere. According to the story, a count at Otto's imperial court was denounced unjustly by the Empress for making love to her (the theme is obviously a modernized version of the story of Joseph and Potiphar's wife). The count was executed, but, as he had requested before his decapitation, his wife underwent the trial by fire and proved her husband's innocence. The Empress, by order of the Emperor, was thereupon burned at the stake. The Louvain theologian Jan van Haeght was Bouts's advisor for these panels.

above: 172. DIRK BOUTS. *Virgin and Child. c.* 1465. Panel, 15 1/4 × 11 3/8". National Gallery, London.

left: 173. DIRK BOUTS. *Portrait of a Man. c.* 1470. Panel, 12 × 8 1/2". The Metropolitan Museum of Art, New York (Bequest of Benjamin Altman, 1913).

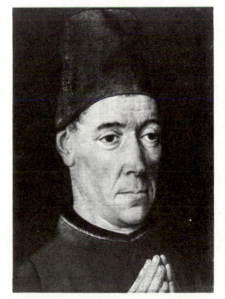

The panel of the countess's trial by fire was completed before that of the beheading of the count but was designed in relation to it; the descending diagonal line in the beheading being countered in the trial scene by a diagonal ascending from the lower left. At the trial an imperturbable silence reigns; the Emperor draws back in shocked disbelief, the only figure to show

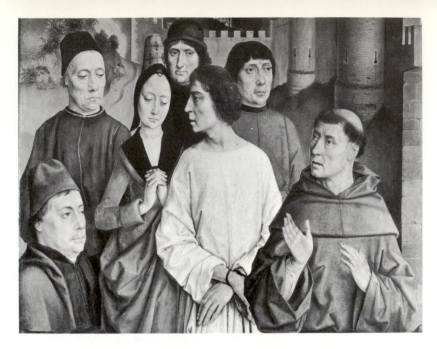

left: 174. DIRK BOUTS. *Justice of Emperor Otto III,* detail showing the count instructing his wife. 1470–75. Panel, 10′ 8 3/8″ × 6′ 1/2″ (each panel, over-all). Musées Royaux des Beaux-Arts, Brussels.

below: 175. DIRK BOUTS THE YOUNGER. *Pearl of Brabant Altarpiece. c.* 1475–80(?). Panel, 24 5/8 × 24 5/8″ (center), 24 5/8 × 10 7/8″ (each wing). Alte Pinakothek, Munich.

emotion, as one out of each of the three pairs of courtiers looks toward the silent countess holding the amazingly realistic, cherry-red iron bar. In faithfulness to the object Bouts almost rivals Jan van Eyck, but the representation of nature is as subservient to his mystic spiritualization of the scene as are the portraits included within it. The countess, for example, is posed like a donor in an altarpiece. Rich color, restrained gestures and glances, geometrical construction, and individualism of form and feature are some of Bouts's devices. Progressively attenuated forms appear in increasingly rationalized space, and a plunging perspective and stronger value contrasts strengthen these late works. Behind the central scene in the decapitation panel the count is shown as he seems to instruct his wife in silent intensity (Fig. 174). Here is Bouts's

equivalent of Rogier's late style; but for Rogier's rhythmic unity Bouts has turned to a rhythmic isolation in a drama of accentuated contrasts.

The problem of the shop's relation to the master is more acute in the work of Bouts than in that of his illustrious predecessors, partly because the shop was large and its production extensive. Undoubtedly assisted by his two sons, Dirk the Younger (1448–91) and Aelbrecht (*c.* 1455–60–1549), and influencing other artists such as the Master of the Tiburtine Sibyl, from Haarlem, Master FvB, probably from Bruges, and the Cologne painters known as the Master of the Life of the Virgin and the Master of the Glorification of the Virgin, Bouts's shop aided that of Rogier in demonstrating, to Germany particularly, the superiority of Flemish artistic conceptions and practice.

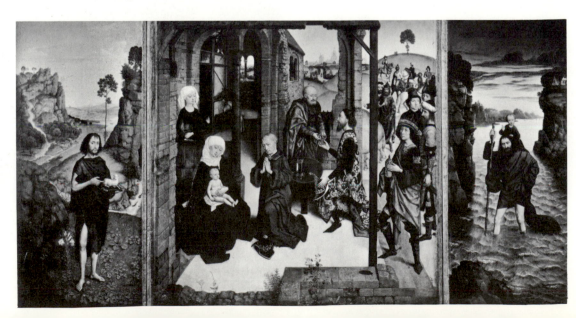

Closest to the known work of Dirk Bouts are three almost distinct styles. The first, to which Schöne attached the name of Dirk Bouts the Younger, is characterized by gentle, more delicate light effects and figure types; his figure movements are never so severe as those of the father, and his landscapes are, like the figures, softer and more fluid—in short, this is a less dramatic and less monumental style. In many cases it seems that Dirk the Younger copied compositions by his father whose originals have been lost. The chief works attributed to Dirk the Younger are the *Pietà* in the Louvre, based on Rogier's *Mary Altarpiece;* the famous *Pearl of Brabant Altarpiece* in Munich (Fig. 175, an Adoration of the Magi, with Sts. John the Baptist and Christopher on the wings); *Moses and the Burning Bush,* Philadelphia; *Christ in the House of Simon,* Berlin; an enthroned *Madonna and Child with Sts. Peter and Paul,* London, probably influenced in its original version by Petrus Christus's Frankfurt panel (Fig. 157); an enthroned *Madonna and Child* against a gold background, now in the Louvre; and a fragment of a *Madonna of Humility* from a Nativity scene, in Berlin, which has a companion fragment of Joseph and two shepherds, in Paris. To Schöne's list should be added the painting entitled *Behold the Lamb of God,* in Munich, the figure types of which are in keeping with the above and which shows a more fantastic and less solid landscape than any in the authentic works of Dirk the Elder. It is almost certain that the compositions were directly derived from Dirk the Elder, and many of the works were undoubtedly made under his direct supervision.

A second style has been discerned in a shop worker, named from his most characteristic work as the Master of the Munich Taking of Christ. Possibly created before 1464, the composition was copied then by the Cologne Master of the Lyversberg Passion. The master of the Munich work, isolated by Schöne and credited with more works than are rightfully his (e.g., a *St. Christopher* in Philadelphia), was extremely able and even closer to Dirk than Dirk the Younger, assuming that the traditional identification is correct. The *Taking of Christ* (Fig. 176)

is rendered as a night scene, though true night lighting is found not in the compact central group but in the background to the right. The moon shining in the dark sky illuminates the scene to translate it from a religious drama into a naturalistic one, an idea to be taken up later by Geertgen tot Sint Jans. The mastery in lighting here and the use of strong color in the central group show the painter as more than a slavish follower. It may be that Bouts had a hand in the conception, as he must have had in another work that Schöne attributed to the Munich Taking of Christ Master, the central panel (Fig. 177) of the famous *St. Hippolytus Altarpiece* in Saint-Sauveur, Bruges, whose left wing with the donor portraits, it is generally agreed, is from the hand of Hugo van der Goes (Fig. 190). The subject of the right wing has not been identified. Panofsky dated the Van der Goes wing as about 1477–78, which agrees with an 1822 record of a date of 1479 on its former frame; thus it may be considered to postdate Bouts's death, probably having been completed by the shop.

The radiating design of the central panel of the *St. Hippolytus Altarpiece* is in keeping with the late style, but though the execution is fine in detail, the scale relationships are poorly handled, the saint's garments seem to hang in mid-air, the horsemen cannot be described as riding; in

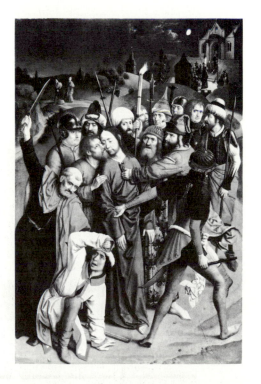

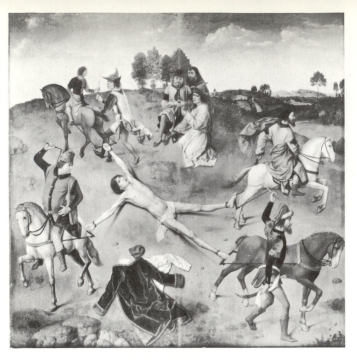

177. MASTER OF THE MUNICH TAKING OF CHRIST. Martyrdom of St. Hippolytus, *St. Hippolytus Altarpiece*, center. *c.* 1474–79. Panel, 35⁷/₈ × 35⁷/₈″. Cathedral of Saint-Sauveur, Bruges.

short, the design called for a concept of space, light, and articulated form that the completer of the work did not possess, for he combined rather than unified elements.

Schöne's third style has been related to Aelbrecht Bouts, who has been identified as the painter of an *Assumption Altarpiece* in Brussels, described by the theologian and historiographer Molanus in the 16th century. Aelbrecht's arms have been recognized on the work, which,

178. MASTER OF THE TIBURTINE SIBYL. *Augustus and the Tiburtine Sibyl. c.* 1475. Panel, 27¹/₈ × 33¹/₂″. Städelsches Kunstinstitut, Frankfurt.

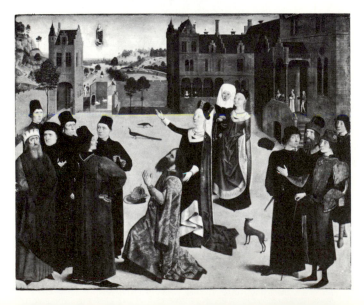

though stylistically of the 16th century, repeats his father's types, and the landscape is also related to the past. Inferior in composition, and also influenced by Van der Goes, the works of Aelbrecht Bouts are mainly confused, crowded, modernized repetitions of the great work of his father. He painted a large number of small devotional pictures and seems to have had a ready clientele for his numerous diptychs of the bust-length Man of Sorrows and the sorrowing Virgin, types based on a now lost original (or originals) by his father.

More distant from Bouts was the Master of the Tiburtine Sibyl,[8] named by Friedländer after a painting in Frankfurt representing the Tiburtine sibyl announcing Christ's birth to the Emperor Augustus (Fig. 178). A number of works have been related to it (*Resurrection of Lazarus,* San Carlo Museum, Mexico City; *Marriage of the Virgin,* Philadelphia; *Crucifixion,* Detroit). All these are stylistically related to Bouts. Though the *Resurrection of Lazarus* has been compositionally related to Ouwater, it is closer to Geertgen tot Sint Jans. The manner of the Master of the Tiburtine Sibyl is reflected in the woodcuts made at Haarlem by Jacob Bellaert between 1484 and 1486, giving rise to the belief that the painter was of Haarlem origin. Such contact as he may have had with Bouts must have come during the later years of Bouts's life, and the Frankfurt panel must be dated very close to 1475. A provincial painter, the artist exaggerated Bouts's mannerisms. His figures have the same rigidity and move without bending their knees. Outline is extremely sharp, and the figures are more isolated in space, an aspect accentuated by a too evenly toned standing plane. Though his backgrounds are atmospheric in treatment, the foreground groupings tend to be too sharply patterned, again an overaccentuation of Bouts's last style. As with many minor masters, narrative became overriding.

Bouts's legacy was large. The pious nobility of his expression made a deep impression on his contemporaries, who found his style generally easier to accept than that of Rogier, whose rhythmic nuances so often escaped them. Bouts's "translation" of Rogier's style into one of fixed forms, rich color, and atmospheric landscape was both more "readable" and more contemporary for many who consequently saw Rogier through the eyes of Bouts.

THE SECOND GENERATION:
Joos van Ghent
and Hugo van der Goes

As though waiting its turn upon the artistic stage, the city of Ghent had quietly pursued its ways since the days of Hubert van Eyck. Documents record artists at work in the city, but over a generation passed while Bruges, Brussels, and Louvain nurtured artistic genius before Ghent again came to the fore. However, its two significant artists of that time, Joos van Ghent and Hugo van der Goes, stayed but a short while, Joos spending only four years and Van der Goes only about ten years there. Ghent was, it seems, too small for genius.

JOOS VAN GHENT

Joos van Wassenhove went to Ghent in 1464 from Antwerp, where he had become a free master in the painters' guild in 1460, and left for Rome some time after 1468. He spent the rest of his life in Italy, where he was known as Giusto da Guanto (Justus of Ghent).

When and where Joos died is unknown, though it is likely to have been in Urbino about 1480.

Joos's birthplace and early training are unknown; Van Mander did not mention him, the only major painter with the exception of Campin omitted from his *Schilderboeck*. Joos served as guarantor twice in 1465, again in 1467, for Hugo van der Goes on his admission to the guild as free master, and once again in 1468–69 for Sanders Bening. He is known to have painted 40 papal coats of arms for the church of St. John (now St-Bavon) in 1467–68. After he went to Rome, there is no further data until he is mentioned in Urbino, on February 12, 1472, in a documented order for a large altarpiece, the *Communion of the Apostles* (or *Institution of the Sacrament*), now in the Galleria, Urbino (Fig. 179). Donated by the Confraternity of Corpus Domini of the Church of St. Agatha, it was completed by October 25, 1474, with the financial aid of Duke Federigo da Montefeltro, who is seen with his young son, and possibly the ambassador to (or from) Persia at the right of the painting. The composition has been thought to derive from a lost scene in destroyed frescoes by Fra Angelico, but it is significant that the subject is a repetition of the central theme of Bouts's *Last Supper Altarpiece*; moreover, the figure thought to be the Persian ambassador repeats in pose and garments the central figure of Bouts's *Erasmus Altarpiece*.

In his biography of Federigo, the Florentine Vespasiano da Bisticci referred to the Duke's extraordinary portrait by an artist he had brought from the Netherlands. This is possibly the portrait in the Ducal Palace at Urbino with his son Guidobaldo, which is Flemish only in the rendering of detail and the use of light. In conception it is Italian.

The problem of the attribution of 28 portraits of illustrious men (half still in Urbino, the

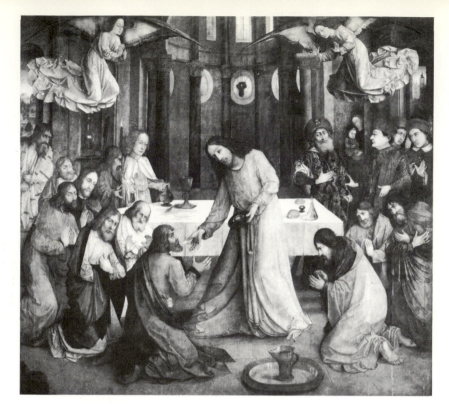

179. JOOS VAN GHENT. *Communion of the Apostles.* 1472–74. Panel, 9′ 5 3/8″ × 10′ 6″. Galleria Nazionale delle Marche, Ducal Palace, Urbino.

remainder in the Louvre), originally for the Studiolo of Federigo, has occasioned much scholarly discussion. Recent opinions have tended to consider the works the combined efforts of Joos, as designer and director of the decorations, and the assistant "Pietro Spagnuolo," recorded in Urbino in 1477 and identified with Pedro Berruguete.[2] Four allegories (two in London; two in Berlin, destroyed in World War II) from a set of seven representing the Liberal Arts made for the ducal library have also been associated with Joos and Berruguete. All the contested works show a far more Ital-ianate, monumental style than the documented *Communion of the Apostles.*

On the basis of the one certified work others have been identified as by Joos. Considered earliest by Lavalleye and Panofsky is the *Adoration of the Magi* in New York. Thought to have been executed between 1460 and 1465, this painting on linen (which accounts for its dull tone) shows certain awkward elements in pose and perspective (Fig. 180). Notwithstanding, an exciting combination of molded and flattened, plain-faced, angular, elongated figures, obviously influenced by Bouts, is achieved within an

180. JOOS VAN GHENT. *Adoration of the Magi.* c. 1460–65. Tempera on linen, 43 × 63″. The Metropolitan Museum of Art, New York (Bequest of George Blumenthal).

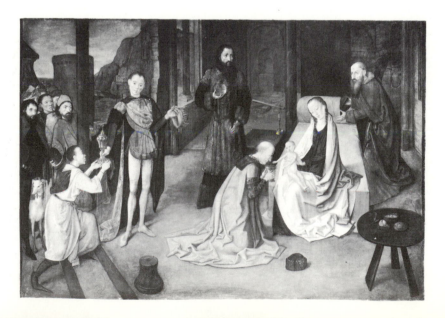

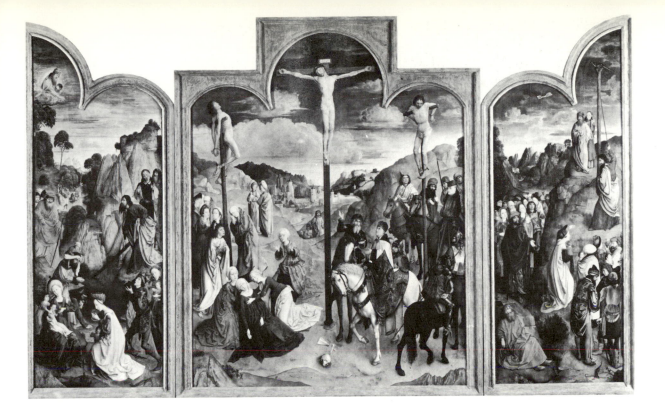

above: 181. Joos van Ghent. *Crucifixion Triptych. c.* 1467–69. Panel, 85 1/4 × 67 1/2″ (center), 85 1/4 × 31 7/8″ (each wing). Cathedral of St-Bavon, Ghent.

unusually ample space. The creation of a deep stage provides a setting for the linear rhythms of the figures moving along flattened diagonals. Despite their stylization, there is a concern on the part of the artist for the actuality of forms and space, the latter conceived as a concrete element important in itself. Almost molded, space is pushed back to provide an ambient. This broad spatial arrangement shows Joos as sympathetic to Italian ideas of a clarified spatial milieu even before his trip.

The *Crucifixion Triptych* (Fig. 181) in St-Bavon, Ghent, first related to Joos by Winkler, is so unusual that attempts have been made to give it to a painter of Ghent known only by name, Daniel de Rijke. Stylistically, however, it is in line with the New York *Adoration,* though its types and the conception of space are further developed. A unified landscape is the stage for a scheme with borrowings from Van Eyck and Rogier. Different is the almost barren, dramatic landscape, its short, swinging curves dotted with figures in the manner of Bouts. The figures coming up from the hidden middle ground in the central panel animate the edge of the deepened foreground platform and aid the illusion of great spatial depth. A radically new element in preserved panel painting is the placing of Passion scenes in town views in the background, where

the Ecce Homo and the Carrying of the Cross are discerned in the distance. Also new is the arbitrary tonal treatment of the far landscape, its forms rendered in single colors.

The Crucifixion scene is flanked, on the left wing, by the scene of Moses sweetening the bitter waters of Marah (Exodus 15:23–25) by casting into them a tree (shown as a beam) designated by the Lord in order that the people might drink, and, on the right wing, by Moses pointing out the brazen serpent (Numbers 21:8–9) so that those bitten by serpents might look upon it and live. These scenes are prefigurations of Christ "hanged on a tree," that is, of the Cross as the instrument of man's salvation. The emphatically barren landscapes seem symbolic reinforcements of the central theme, whose drama is accentuated by the new use of dramatic cloud formations. Their naturalism is in sharp contrast to earlier formulas of striated strings of cumulus clouds; Joos has presented what seems to be an observed wintry Flemish sky.

Color is used in a new manner on the left wing in the headdress of the woman in profile drinking the sweetened waters of Marah. Her blue head-

dress changes to brown within the form, a departure from the older manner of using a single color for each unit. This is the first appearance in the north of a concept of broken color that was to become increasingly popular in the Netherlands in the late 15th century and in the 16th.

The *Communion of the Apostles* carries the sense of formal construction further by uniting Italian spatial logic with a northern apsidal setting. The table occupies the normal altar space, and Christ, like a priest, administers the Host to the kneeling apostles, who are versions of the figures in the Ghent *Crucifixion,* partially transformed under Italian influence. Their greater amplitude and chiaroscuro is curiously like the Italianate transformation of northern types to be met in the work of Quinten Metsys.

HUGO VAN DER GOES

Joos's later career is outside the main stream of Flemish art, but the stronger drama visible in his art, though not copied, was paralleled and later intensified by Hugo van der Goes, his far more illustrious compatriot and friend. A genius of the first rank, the principal figure in Flemish painting of the second half of the century, Hugo infused Flemish painting with an unprecedented, individual, and internal dramatic force of far-reaching effect.

182. HUGO VAN DER GOES(?). *Virgin and Child with St. Anne and a Franciscan Donor.* c. 1468(?). Panel, 12 ³/₄ × 15 ³/₈″. Musées Royaux des Beaux-Arts, Brussels.

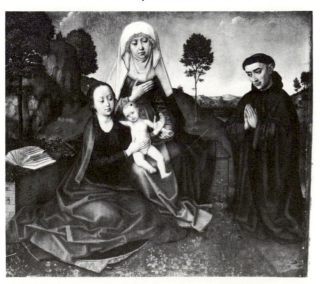

Hugo van der Goes, born at an unknown date, probably in Ghent, became a master there in 1467, Joos and a paint merchant being his guarantors. Between 1467 and 1475 he executed civic decorations in Ghent and Bruges for such public events as the funeral of Philip the Good, the wedding of Charles the Bold to Margaret of York, and the triumphal entry of Charles the Bold into Bruges. He was elected dean of the Ghent painters' guild in 1474. Early in 1478 he entered the monastery of the Red Cloister in the forest of Soignes, close to Brussels. His brother Nicolas was then an oblate at the same monastery, and Hugo entered as a convert brother. Leading a fairly privileged life, he continued to paint, received visitors (among them Archduke, later Emperor, Maximilian of Austria), and even appraised the justice panels of Dirk Bouts at Louvain in 1480. (He decided that the heirs should be paid 306 of the 500 gulden stipulated in the contract.) Returning from a trip to Cologne about 1481, he had an attack of madness that reduced him to a state of melancholic lethargy, in which he humbled himself continually. He died in the following year, 1482. His life in the monastery before and during his illness was recorded briefly by a fellow brother, Gaspar Ofhuys, whose analysis of Hugo's illness copies verbatim a 13th-century treatise but concludes with uncertainty as to the cause of the painter's melancholia.

Some fifteen works have been attributed to Van der Goes, and only one, the *Portinari Altarpiece,* is authenticated (by Vasari). Their chronology is therefore based on stylistic criticism, and opinion is not unanimous concerning their place in Hugo's general development, which is by no means distinct. Not one work by Hugo is signed or dated. A disputed work, which may, however, be Hugo's earliest preserved painting, is the *Virgin and Child with St. Anne and a Franciscan Donor* in Brussels (Fig. 182). More monumentally composed than Bouts's or Joos's work, it shows a strongly Eyckian influence in organization and even in foreground detail; the solid bank on which St. Anne is sitting terminates the foreground platform in typical Flemish fashion. Conceptions based on Rogier seem to be dominant in the treatment of the Child, but the portrait of the wonderfully solid and stable donor differs from all previous conceptions of the portrait. It possesses a sense of simplicity and

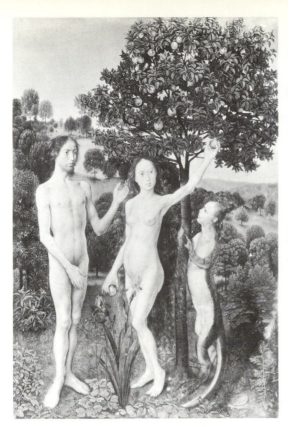
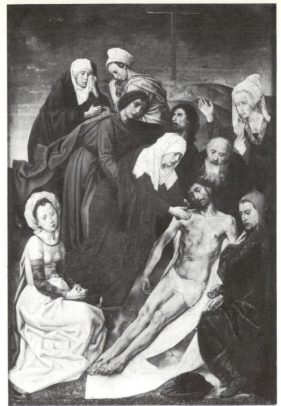

183. HUGO VAN DER GOES. *Fall of Man* and *Lamentation,* divided diptych. *c.* 1468–70. Panel 13¼ × 9″ (each). Kunsthistorisches Museum, Vienna.

largeness that differs from Jan's minute observation, Rogier's aristocratic rhythms, and Bouts's devout intensity and reserve, yet seems to partake of all. Color is also different, a balancing of greens and browns being dominant over the warm tones, a further contrast to such predecessors as Bouts, whose strong red-blue combinations usually won out over the cooler tones.

Formal balances are somewhat obvious, possibly because of Hugo's youth, but the attempt to distinguish between natural and supernatural beings by contrasting cooler abstraction and warmer corporeality is a forecast of the future.

The problematical character of the Brussels panel is immediately sensed if it is compared with the *Fall of Man* and *Lamentation* diptych in Vienna, considered to date before 1470, and often presented as the earliest works of Hugo. (St. Genevieve is presented in grisaille on a panel now detached from the reverse of the panel of the Fall, also in Vienna.) Extremely small in size, the two panels, by largeness of conception, offset their physical minuteness. The *Fall of Man* (Fig. 183) reveals that Hugo was well aware of the *Ghent Altarpiece,* though he did not copy

Jan's Adam and Eve or the landscape. His strongly lit figures are set against rising hills and deep, blue-green valleys, whose softness and tonal unity contrast with the awkward gestures and the dramatic linearity of Adam and Eve. A meticulousness of detail comparable to that of Van Eyck is, however, integrated into a very different conception of landscape. Jan saw landscape as a many-faceted jewel in which the eye moves from facet to facet, for Jan's landscapes are additive, whereas Hugo van der Goes's detailed foreground rendering of such symbolic flowers as the iris and the roses, as well as other natural forms, is subordinated to the sweep of a progressively simplified landscape. Linearity and monumentality of form are contrasted to create a new drama. There is also iconographic innovation in the conception of the serpent in the *Fall of Man* panel. [3]

Though the motifs in the companion panel, the *Lamentation,* are derived from Rogier and Bouts (the Magdalen looks out of the picture as in the Bouts shop *Pietà,* in the Louvre), an extremely adroit and complex composition, employing surface diagonals, triangles, and falling lines, takes up the rhythmic conceptions

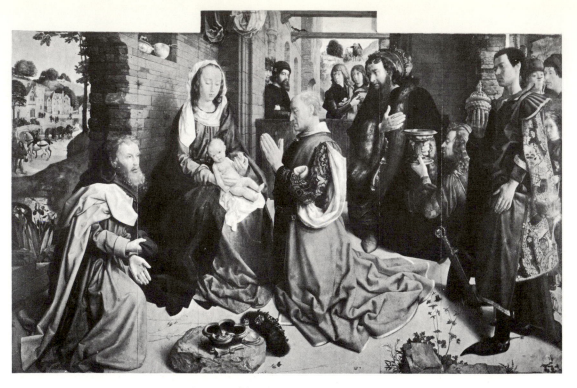

184. HUGO VAN DER GOES. Adoration of the Magi, surviving portion of the *Monforte Altarpiece*, 1472.
Panel, 57 ⅞ × 95 ¼″. Gemäldegalerie, Staatliche Museen, Berlin-Dahlem.

of Rogier. However, it forces them into an Eyckian framework. The gestures and facial drama, the half-plastic and half-calligraphic density of forms and movements, are expressive of an emotional content of unprecedented intensity and realistic immediacy. Though a German doctor, Hieronymous Münzer, in the late 15th century, reported that Hugo van der Goes became melancholy because he could not rival the perfection of Jan van Eyck, he was wide of the mark. He would have been closer had he said it was because Hugo tried to combine Jan and Rogier, for instead of moving the drama of the Lamentation into a mystic and contemplative sphere, Hugo stressed its actuality and thereby made immediate its inherent dramatic content.

Hugo's dramatic realism, in which a departure from earlier concepts of axiality plays an important part, is a constant in his art. When the monumentalizing tendency reached an early consummation, as in the Berlin *Monforte Altarpiece,* from Monforte de Lemos in Galicia, Spain, dramatic realism united with monumentality to present a forceful immediacy. In this work (Fig. 184), thought by many to have been painted about 1472, dominantly warm color takes the place of the cooler tones of the earlier

works, thereby quickening the impression of grandeur. Now lacking its wings, which may have shown the Nativity and the Circumcision, the panel has been cut down at the top, and only the lower drapery portion of the angel floating in the air above the Virgin's head is still visible. The composition may have been suggested to Hugo by the *St. Columba Altarpiece* of Rogier, from whom the idea of the vignetted landscape may also have come, but if this is the source, the interpretation is free indeed, for the main group has been placed to the left of the slightly high vanishing point behind the foremost page boy. The result is a contrast of short spatial diagonals. As in the art of Bouts, the drama is staged on a somewhat tilted foreground.

A trip to Italy has been postulated by some because of the rational organization, the servant in profile, and the retinue of the Magi seen in the distance at the left. However, the disguised vanishing point, the dramatic silhouetting of the shepherds in the background Annunciation scene, and such a symbolic element as the iris, which is related to the sorrows of the Virgin, are thoroughly northern. A closeness of view and compacting of form within an open composition, allowing large spaces between the

groups, and the new interest in perspective movement thrusting into depth are all northern and are directly related to Joos van Ghent (as is the floating angel, which Joos used in his *Communion of the Apostles*). Equally northern are the open and closed sides, a dynamic transformation of the *St. Columba Altarpiece.* The new use of light as a dramatic, emotive element playing a part in the composition cannot be attributed, however, to any other than Hugo himself. Spatial illusionism is carried to a new height by superimposing the frame on a segment of external space.

For the first time in any preserved large-scale, monumental northern altarpiece the youngest Magus has a dark skin, though a record of 1441 states that the father of Hieronymus Bosch, Anthonis van Aken, was paid for painting a costume for a Moor Magus, and earlier examples exist in Germany. The idea soon became very popular.

In the *Monforte Altarpiece* Hugo's concern for the monumental was preeminent. In the slightly later *Virgin and Child* (Fig. 185), constituting the central panel of the Frankfurt triptych (the wings are not by Hugo), and possibly in the Brussels *Virgin and Child,* he was reaching stylistically toward the greater drama to be manifested in the *Portinari Altarpiece*. This direction is visible in the almost spastic gestures of the cheerful, angular Child and the seemingly dour expression on the face of the Frankfurt Virgin.

Hugo's *Portinari Altarpiece* (Pl. 13, after p. 180), in the Uffizi, is one of the greatest monuments of the 15th century. Of immense size, it was originally commissioned for the Portinari Chapel in S. Egidio, Florence, by Tommaso Portinari, Bruges representative of the Medici. Kneeling on the left wing are Tommaso Portinari and his sons Antonio and Pigello, and behind them stand the gigantic melancholic figures of Sts. Anthony and Thomas. On the right wing are his wife, Maria Baroncelli, born in 1456 and married at fourteen, and their daughter Margherita, with their patron saints, Margaret and Mary Magdalene, standing behind them. The central panel combines the Nativity and the Adoration of the Shepherds. In this it recalls the Dijon *Nativity* of the Master of Flémalle (Fig. 90).

The Portinari children have been used to date the work, which is unsigned and undated.

Margherita was born in 1471, Antonio in 1472, and Pigello in 1474. There were other children: a second daughter, Maria, whose birth date is not certain, though it may have been 1475; another son, Guido, born in 1476; and a daughter, Dianora, born in 1479. The work includes all children existing at the time the work was painted, for had Maria been born while the work was in progress, she would have been included, as was Pigello, who is shown without a patron saint and is obviously an addition to the original design. Thus the altarpiece may be dated as executed between 1474 and 1476, despite the clearly older appearance of the children.

Far from quiet, the male saints are troubled, old, and mentally beset. Their large size seems a conscious reversion to older modes and reminds us of Sluter's figures on the portal of the Chartreuse de Champmol. Behind the male saints rises a dramatic, barren, rocky landscape, in which Joseph supports the Virgin, who has dismounted from her donkey.

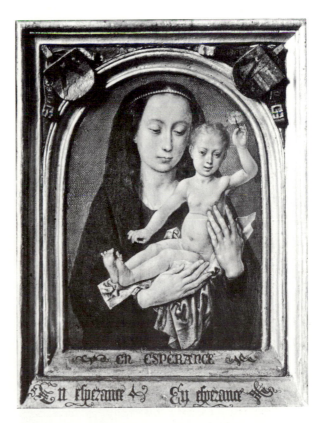

185. HUGO VAN DER GOES. *Virgin and Child.* c. 1472–74. Panel, 11 3/4 × 9 1/4″. Städelsches Kunstinstitut, Frankfurt.

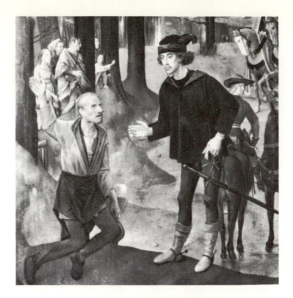

On the opposite wing (Fig. 186) one of the Magi's attendants has dismounted to ask his way of a gaunt peasant, as other peasants, equally gaunt, ominous, and brutish, look on. Behind them a manor is so naturalistically presented that this unexaggerated perspective view, astoundingly direct in its relationship to the observer, impressed Hugo's contemporaries in Ghent. This type of view reappears in the art of the Master of Mary of Burgundy, a miniaturist of exceptional ability who has been thought to be Alexander Bening. (Bening, interestingly enough, was married to a Catharina van der Goes, though there is no way of knowing whether she was related to Hugo.) The particularization of setting, one of the great conquests of Flemish painting, combined with a specific time of year (the trees have lost their leaves, and the wintry sky is clouded), contrasts with earlier representations of an eternal spring landscape.

The winding procession of the Magi, an Italianate motif, moves forward from the compressed coulisses of the background hills toward a flatter, more open middle ground, a vignette framed by the large figures of the female saints. St. Margaret stands on a dragon of incredible ferocity and looks out of the corners of her eyes at Margherita Portinari (Fig. 187). Beside her is Mary Magdalene, richly gowned in white and gold. Hugo's feminine figures carry his characteristic mark of high foreheads and pallid flesh tones. Masterfully painted textures are subordinated to an over-all conception of heightened realism and grandeur.

above: 186. HUGO VAN DER GOES. *Portinari Altarpiece,* detail of right wing. *c.* 1474–76. Panel, 8′ 3 ⁵/₈″ × 4′ 7¹/₂″ (wing, over-all). Uffizi, Florence.

right: 187. HUGO VAN DER GOES. *Portinari Altarpiece,* detail of right wing with St. Margaret. *c.* 1474–76. Panel, 8′ 3 ⁵/₈″ × 4′ 7¹/₂″ (wing, over-all). Uffizi, Florence.

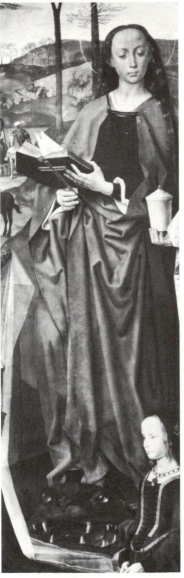

The color organization is also impressive, for Hugo painted the two outer saints in cool colors and the two inner saints in red, so that the eye is carried toward the center panel, augmenting the sense of movement engendered by the donors' glances. Thus through design and color Hugo firmly united the wings with the central panel.

The central Nativity scene is a moving drama of adoration punctuated by expressive hands and glances. Informed by a sense of the colossal, dramatized by chiaroscuro, scale contrasts, and silhouette, and heightened in meaning by a revival of disguised symbolism, Hugo's scene is set on an ample, slanting stage, but the holes in its back wall are rigorously filled to force our gaze forward so that we experience the drama with an unprecedented emotional involvement. By means of linear precision and pictor-

ial richness, of mass and pattern, of unreal, eerie angelic faces of dour mien and realistic, adoring peasants in transfigured ugliness who encircle the Child in both two and three dimensions, Hugo united the seemingly ununitable in form and content.

Close to view, the vase and glass (Fig. 188), their contents, and the sheaf of grain have symbolic meaning. [4] In the Spanish albarello are a scarlet lily and irises, symbols respectively of the blood of the Passion and the sword that pierced the heart of the Mater Dolorosa. In the glass are sprays of columbine, the purple flower of melancholy and sorrow and thus a symbol of the sorrows of the Virgin. The carnations probably symbolize the Trinity. Fifteen angels are seen, symbolizing the fifteen joys of the Virgin, and the sheaf of grain in the foreground is a reference to Bethlehem, the name of which means "the house of bread" in Hebrew. At the back edge of the platform is the ruined palace of David, as we know from the harp in the carved tympanum of the portal, whose inscription refers to the Child born of the Virgin Mary.

A drama of opposites reconciled is everywhere present: the palace and the stable; closed space at the left, open space at the right; divine forms and human forms; the natural and the supernatural in the light, which both comes from the left to light the scenes and, for the first time, emanates from the Child to illuminate

dramatically the angel in the air over the Virgin's head. The small and the large vie and unite in one of the greatest of all paintings.

The power inherent in Hugo's conception is nowhere more readily perceived than in the grisaille Annunciation (Fig. 189) on the exterior. The eerie reality of the descending angel, its hand lifted to suggest the unknowable power of the divine, and the accepting submission of an austerely modest Virgin solemnize Hugo's psychological drama, while the dove, hovering like a hawk with claws outstretched over the Virgin's head, reminds us that, despite their realism, Hugo's figures exist in a separate world of strife, conflict, and inner tension.

above: 188. HUGO VAN DER GOES. Nativity scene, *Portinari Altarpiece,* detail of foreground, *c.* 1474–76. Panel, 8′ 3 ⅝ × 9′ 3″ (center, overall). Uffizi, Florence.

left: 189. HUGO VAN DER GOES. Annunciation, *Portinari Altarpiece,* exterior. *c.* 1474–76. Panel, 8′ 3 ⅝″ × 4′ 7 ½″ (each wing). Uffizi, Florence.

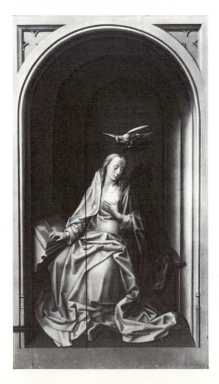 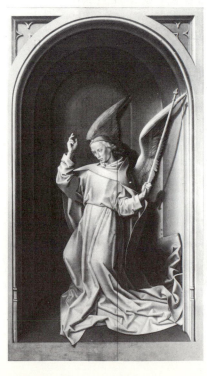

The portrait of Hippolyte de Berthoz and his wife Elizabeth de Keverwyck (Fig. 190) on the left wing of the *St. Hippolytus Altarpiece,* Saint-Sauveur, Bruges, has long been recognized as by a different hand from that of the Bouts shop worker responsible for the central panel (Fig. 177). Bouts's death in 1475 would have canceled the contract and allowed the donor to choose another artist to complete the work. It was, apparently, Hugo who was selected. A development beyond the *Portinari Altarpiece* is visible in the balancing of figures and landscape, and the building in the distance is given a more dramatic role.

The growth in dramatic expression reached its final stage in the later 1470s in the panels for Edward Bonkil (or Boncle) and in the Berlin *Adoration of the Shepherds* and achieved the supreme summation in the Bruges *Death of the Virgin,* probably Hugo's last work.

The panels painted for Edward Bonkil, in Edinburgh, are probably the wings of a triptych that lacks its center panel, rather than organ shutters, as has been suggested. On the exterior, painted in color rather than in grisaille, Sir Edward Bonkil, provost of the Trinity College Kirk, Edinburgh, kneels in the right-hand panel before an organ, whose bench carries his coat of arms (Fig. 191). An elongated angel painted in cool colors is about to play, and another, whose duty is to pump the bellows, looks around the instrument. Set in front of a deep stage suggesting a church interior, Bonkil and the two angels look toward the Trinity in the left-hand panel. Following the composition of the Master of Flémalle (Fig. 96), Hugo has varied the more frontal, earlier composition by displacing Christ to the right, has made God the Father youthful, and has dematerialized the setting with a gold background. Crystal columns on the sides of the throne accentuate by contrast the natural and the supernatural. Clearly, for Hugo the way to the divine could be apprehended only by immersion in the sorrow of the human condition; his Christ seems still alive and still suffering for mankind.

On the obverse sides James III and, apparently, his son, the future James IV, are shown kneeling on the left panel, presented by a giant St. Andrew, patron saint of Scotland, and the queen, Margaret of Denmark, kneels on the opposite panel, with St. Canute dressed in armor standing behind her (Fig. 192). The royal figures are set close to the picture plane before parted draperies that reveal portions of a church's side aisles. Though the coloring of the figures is like that of Hugo, the heads and hands of all except St. Andrew must have been overpainted by another artist. They are qualitatively far below Hugo's standard. This inferior quality argues for the very late dating, and the Bonkil panels may have been in Hugo's mind when, as Ofhuys related, he bemoaned the fact that he had work ahead of him that he could never complete in nine years.

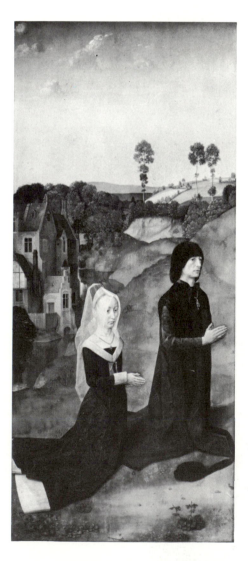

left: 190. HUGO VAN DER GOES. Donor portraits, *St. Hippolytus Altarpiece,* left wing c. 1476–79. Panel, 35 ³/₄ × 15 ³/₄″. Cathedral of Saint-Sauveur, Bruges.

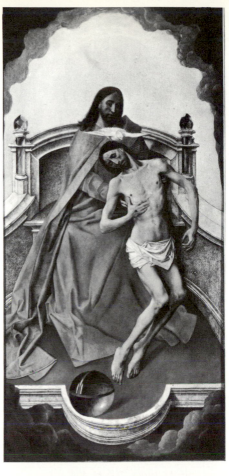

191. HUGO VAN DER GOES. The Holy Trinity adored by Sir Edward Bonkil, *Bonkil Panels,* reverse side (Fig. 192).

192. HUGO VAN DER GOES. The royal family of Scotland, *Bonkil Panels* ("Trinity Altarpiece"), obverse. 1478–80. Panel, 78 × 38″ (each). Copyright H. M. the Queen, on loan to National Gallery of Scotland, Edinburgh.

193. HUGO VAN DER GOES. *Adoration of the Shepherds.* c. 1480. Panel, 38 ¼ × 96 ½″.
Gemäldegalerie, Staatliche Museen, Berlin-Dahlem.

The long, narrow *Adoration of the Shepherds* (Fig. 193), in Berlin, considered to date close to 1480, breaks with the continuity of Hugo's development. We are unprepared for the strange, fantastic spirit revealed in the scene unveiled by the prophets, who pull back curtains at the sides as two awkward peasants stumble onto the stage, one falling to his knees bedazzled by a Child he has not yet seen. The fantastic effect is created in part by the inrushing forms, dramatic lighting, off-center placement of the crowded main theme, and strong diagonal movements, furthered by the strange scale of the two figures in the left background. The gaze of the almost life-size right-hand prophet augments the air of surprise and unreality pervading the whole, despite the viewer's awareness of its artistic descent from the *Monforte* and *Portinari* altarpieces. In color the movement from warmer outer edges to a cooler center is repeated, but there is an unexpected change in the facial types represented in the central group, almost as if Hugo had changed his forms to accord with a new conception. Yet at the same time an artificiality and a disturbing spirit seem to reveal an early onslaught of the painter's illness, a conclusion reached by many critics.

The implication of rigorously restrained tensions underlying the Berlin work comes to its fullest, most majestic and terrifying expression in what must be Hugo's last work, the Bruges *Death of the Virgin* (Fig. 194). Its over-all color effect is predominantly cool and silvery, despite the occasional reds. Thus the expressive content is conveyed chiefly by an intense mastery of line; nowhere else did Hugo van der Goes control his medium to achieve such grandeur and awesomeness.

One has to look back to the Vienna *Lamentation* for a compositional precedent; this builds upon the earlier work but intensifies and develops the emotive elements far beyond the possibilities of the *Lamentation*. Forms are more strongly flattened, foreshortening in the placing of the Virgin is more accomplished, gestures are more expressive, and the two-dimensional design is more important than volume and space. Everything is compressed within such narrow confines that Christ, showing his wounds rather than receiving the soul of the Virgin, and the accompanying angels are flattened and immobilized as though pressed against a window pane. Their frozen movement is echoed in the apostles closest to us in front of the bed. The other apostles reflect this spirit. With strongly individualized features, they are grouped about the bed, not looking at the vision nor at Christ nor at one another but experiencing the vision inwardly. They are foils for the Virgin, whose gray-white face and headdress convey the feeling of death at the center of a melancholic life (Fig. 195). The drama of the quick and the dead is intensified by opposing the realms of the natural and the supernatural, the physical and the spiritual, the temporal and the eternal life.

Van der Goes is unique in the development of Flemish painting. No previous artist had revealed such dramatic intensity; some critics have spoken of imbalance, disproportion, and

uncontrolled movement as reflecting his pathological state, but these qualities appear only in the *Adoration of the Shepherds*. His inner conflicts heightened his sensitivity, but they were controlled and surmounted by the transformation into an artistic expression of tremendous grandeur and spiritual and physical beauty.

Van Mander praised highly several works by Hugo. One of these, a meeting of David and Abigail, has been preserved in copies, and a now lost Descent from the Cross in stained glass may have been one source for a large number of paintings of this subject that reveal Hugo's style. Two distinct versions have been preserved in copies.

A beautiful drawing of *Jacob and Rachel* (Fig. 196), in Christ Church, Oxford, has also been attributed to Hugo, but it seems more likely to be a copy after a lost composition. An *Adoration of the Magi* triptych in the Liechtenstein Collection, Vaduz, has been considered an early work, before 1470, by Friedländer and Destrée [5] but probably is a copy of a now lost later work of the 1470s.

Several portraits have also been ascribed to Hugo, two of which have been accepted almost unanimously. The first, a portrait of a young man, in New York (Fig. 197), probably cut out of a donor panel, seems close in spirit to the period of the *Portinari Altarpiece* or very slightly earlier. Its type derives from Bouts's London portrait of 1462 (Fig. 166), but in the molding of the jaw, the arching of the eyelids, and the

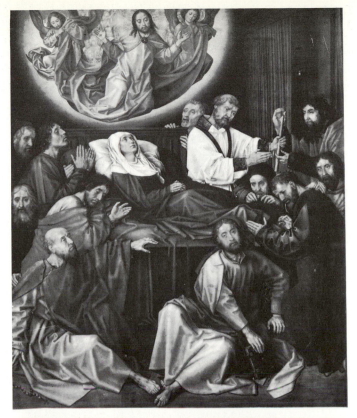

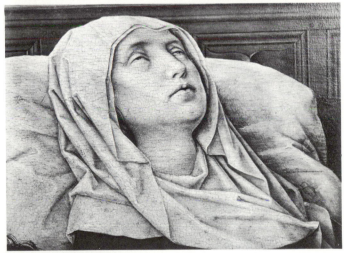

above: 194. HUGO VAN DER GOES. *Death of the Virgin*. *c.* 1481. Panel, 57 ³/₄ × 47 ⁵/₈″. Groeningemuseum, Bruges.

right: 195. HUGO VAN DER GOES. Detail of the *Death of the Virgin* (Fig. 194).

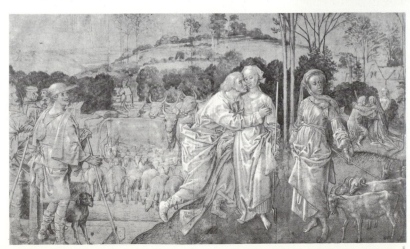

left: 196. COPY AFTER HUGO VAN DER GOES(?). *Jacob and Rachel*. 1475–90. Drawing, 13 ³/₈ × 22 ¹/₂″. Christ Church, Oxford.

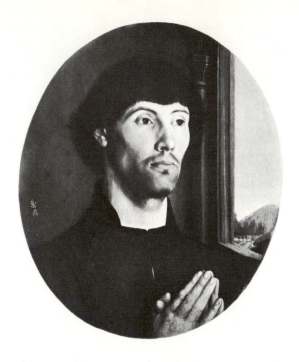

strong structure of the nose the form in this work is more plastic. The dramatic lighting accentuating the upper area of the face creates an almost hypnotic quality of intense and rapt inner concentration. Another fragment is the *Donor with St. John the Baptist* (Fig. 198), in the Walters Art Gallery, Baltimore, a puzzling work because of its intimate quality and softness, particularly noticeable in the St. John, who seems to derive from the *Ghent Altarpiece*. The lower jaw and neck of the donor lack the sense of firmness characteristic of Van der Goes. It is possible that it has been too strongly cleaned. The work may be dated late in Hugo's career, for its spirit, its cold tones, and the use of gray shadows accord with the late style.

Hugo's influence on subsequent artists was so great that in some cases it supplanted and in others paralleled that of Rogier. He viewed the past historically, consciously desiring to assimilate it and investing it with his own sense of psychological drama in realistic terms. In this respect Hugo is the first modern painter among the Flemish artists. The force of his innovatory power was recognized by many. Often copied, his work had the strongest influence on a French painter, the Master of Moulins. Others—Ghirlandajo in Florence, the Benings, the Master of Frankfurt, Memlinc, David, and above all, Geertgen tot Sint Jans—were responsive to his compositions, his forms, and occasionally his dramatic spirit. His outlook remained unparalleled until the 16th century, and then there was no one who attained his level of creative ability, not even Metsys.

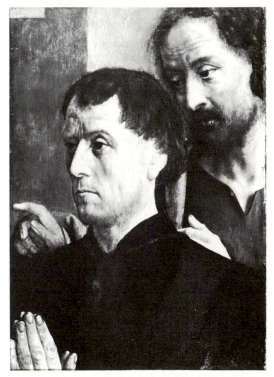

above: 197. HUGO VAN DER GOES. *Portrait of a Man. c.* 1475 Panel, 12 1/2 × 10 1/2″. The Metropolitan Museum of Art, New York (H. O. Havemeyer Collection).

left: 198. HUGO VAN DER GOES. *Donor with St. John the Baptist. c.* 1478–81. Panel, 12 3/4 × 8 7/8″. The Walters Art Gallery, Baltimore.

9 GEERTGEN TOT SINT JANS AND THE MASTER OF THE VIRGO INTER VIRGINES

GEERTGEN TOT SINT JANS

Destruction by iconoclastic movements has almost totally obscured artistic developments of this period in the northern Netherlands. Those works which have survived, notably the single painting by Albert van Ouwater and the works of the Master of the Tiburtine Sibyl, show a strong dependence upon the art of Flanders. Contemporaneous with the latter master was Geertgen tot Sint Jans, or Geertgen van Haarlem. What we know of Geertgen is owed to Van Mander. Born in Leiden, Geertgen, when young, was a pupil of Van Ouwater, lived at Haarlem with the Knights of the Order of St. John (though he was not a member of the order), and painted the altarpiece for the high altar of their commandery (two panels in Vienna survive), as well as works for other monastic orders in Haarlem. Van Mander recorded that Geertgen died at the age of twenty-eight and that Dürer saw and admired his work. A picture of the Groote Kerk in Haarlem, which Van Mander attributed to him, has been denied to Geertgen because it shows a tower that was not built until 1517. A reference discovered by Koch[1] to a Gheerkin de Hollandere apprenticed to a book-binder in Bruges in 1475 may refer to our artist, since both Geertgen and Gheerkin are diminutives for Gerard, and since a miniaturistic character has been ascribed to his early work. His paintings clearly show Flemish influence, and not one can be dated much later than 1490–95.[2] Thus, if Van Mander was correct regarding his early death, an apprenticeship in Bruges about 1475 was entirely possible.

The earliest panel attributed to Geertgen is the *Holy Kinship* (Fig. 199), in Amsterdam, whose popular subject was also used by the German Master of the Ortenberg Altarpiece. The German master's early relief composition (Fig. 77) has been replaced by a composition in depth of great formal regularity and solemnity. Almost doll-like, Geertgen's extremely simplified, generalized, stumpy figures have eyes set into their faces like shoe buttons. There is a charming naïveté that almost makes one forget the strong symbolic meaning underlying the action of the children in the middle of the nave. Little John the Evangelist holds his chalice, which little James the Greater fills from his toy pilgrim's canteen, while youthful Simon holds a saw, the symbol of his martyrdom. On the high altar the prefiguration of Christ's sacrifice is being enacted by Abraham and Isaac. In front of the altar a boy with a long candle snuffer is about to put out a candle on the screen separating the forepart of the church from the choir and apse. The whole interior is painted with a superb mastery over light, perspective, and architectural form. With a knowing mixture of pattern, shape, decoration, spatial fluidity, and warm

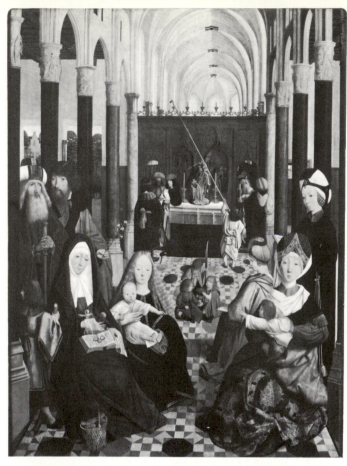

left: 199. GEERTGEN TOT SINT JANS. *Holy Kinship*. c. 1480. Panel, 54 1/8 × 41 3/8". Rijksmuseum, Amsterdam.

below: 200. GEERTGEN TOT SINT JANS. *Raising of Lazarus*. c. 1480–82. Panel, 50 × 38 1/4". Louvre, Paris.

color, the youthful artist, his youth betrayed by his almost too great regularity, achieved a formal unity that transforms the commonplaces of human life into a grave, mystic poetry.

The other works attributed to Geertgen's early period are a miniature of the *Madonna and Child* in the Ambrosiana Library in Milan (probably his earliest work) and the *Raising of Lazarus* (Fig. 200), in the Louvre. The latter is closely related to Ouwater, with the addition of two donors and a bosky landscape beyond the high wall enclosing the foreground.

A new aspect is seen in a series of paintings of the Adoration of the Magi. All reflect the influence of Hugo's *Monforte Altarpiece*. The version in the Oskar Reinhart Collection, Winterthur, is probably earliest, followed in order by the Amsterdam version (probably not entirely by Geertgen), the Prague version, and the latest, seemingly, the Cleveland Museum painting. This chronology is an approximation based on the development of spatial organization and conception of the landscape background, for, except for the Cleveland version, the landscapes are concoctions of coulisse forms peopled with figures after Hugo van der Goes and Joos van Ghent. Geertgen more than his predecessors attempted to piece foreground and background together. At first he used vignettes as Hugo did. Later he extended the foreground elements toward the back, as in the Prague version, where he also employed Petrus Christus's device of the loggia exposed to natural, exterior light. Finally, in the Cleveland *Adoration* (Fig. 201) he projected the trees forward from the background to effect the transition in spatial movement. At the same time he replaced fantastic rock forms with naturally observed forms. The two panels in Vienna mark the mid-point in this evolution, and the Berlin *John the Baptist in the Wilderness* marks the final stage, in which the traditional three zones have been merged into one another so subtly and yet so architectonically that figure and landscape have become one in a continuous movement of spatial recession.

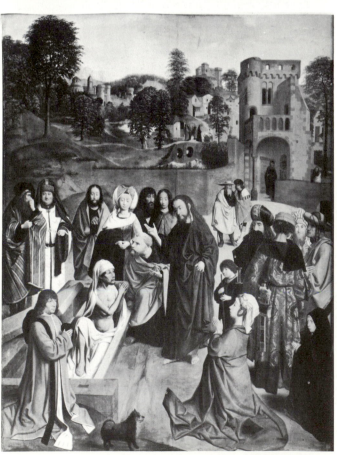

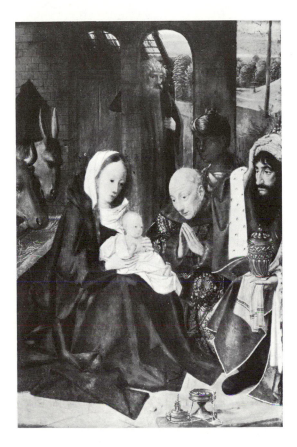

thoroughly arbitrary, but it was intended to create a feeling of warmth and immediacy, to which are united both simplicity of form and quiet composition.

This feeling of deep and innocent devotion is also expressed in the small *Madonna of the Sanctus,* in Rotterdam, which shows the Virgin on the crescent moon, about which is wrapped a demonic figure, the theme being derived from the Apocalypse. She is surrounded by angels bearing scrolls on which "sanctus" is inscribed, while other angels with musical instruments fill the remaining space and, picked out by the graduated light, move from the dark edges toward the bright light surrounding the Virgin. All sound a paean of musical praise to the Virgin; even the Child is ringing hand bells. A later and more plastic work is the large *Madonna and Child,* in Berlin, the extremely simplified volumes of the figures aided again by warm color and a superb landscape space visible through the back window. It differs from the Bouts composition

Implicit in this development is a growth in the lyrical concept of nature that also appears in Geertgen's concern for light. Expressing the supernatural through natural means, the night *Nativity* (Fig. 202), in London, carries further the use of light in Hugo's *Portinari Altarpiece,* in which the angel above the Virgin had been lighted from below. The supernatural light emanating from the Child is the sole source of illumination for the central scene, while the background shows the man-made light of the shepherds' bonfire outshone by a supernatural radiance from the angel overhead. The miraculous has been subordinated to the lyrical devotion of the main action. A worthy ancestor of the art of Georges de la Tour, this painting is also a worthy descendant of the *Nativity* of Gentile da Fabriano. The dominantly reddish color is

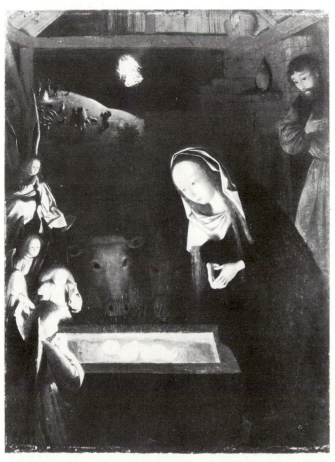

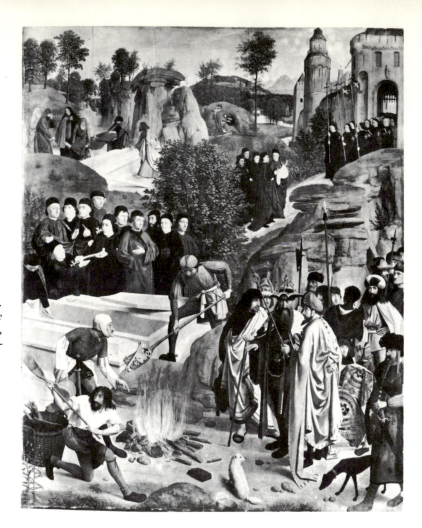

203. GEERTGEN TOT SINT JANS. *Burning of the Bones of John the Baptist*. After 1484. Panel, 67³/₄ × 54³/₄". Kunsthistorisches Museum, Vienna.

that inspired it (Fig. 172), for the ledge has disappeared, being replaced by the Virgin's lap. Thus the effect is more direct.

The *Lamentation* and the *Burning of the Bones of John the Baptist* (Fig. 203), in Vienna, originally constituted the exterior and interior of one wing of the altarpiece for the high altar in the Haarlem commandery of the Knights of St. John. According to Snyder, it was painted shortly after 1484, when the commandery acquired from Sultan Bayazid the relics held by members of the order: parts of a hand and one arm of the saint.

Influenced by Hugo's *Lamentation,* also in Vienna, Geertgen's *Lamentation* is a free adaptation that extends the profiled forms horizontally and accents the artist's concern for a regularized triangulation. The unusual theme of the burial of the thieves, as described in the *Life of Christ* of Ludolph the Saxon, appears in the middle ground on the high hill. (A comparable hill has been seen in the night *Nativity,* and both derive from Van der Goes.)

A quickened pace in landscape conception appears at the right and in the scene of the burning of the bones of St. John by Julian the Apostate, into which a group of portraits has been inserted. To aid spatial continuity Geertgen developed his movements along diagonal lines in a more plastic manner than Bouts had done. Also more plastic is the foremost portrait group, approached over the open foreground, with its magnificently painted fire. The sobriety of the group contrasts with the fantastic and emphatic ugliness of the sharply delineated Orientals, their retinue, and the curiously posed servant at the left.

This artful awkwardness is distinct in the Berlin *John the Baptist in the Wilderness* (Pl. 14, after p. 180), in which John is so lost in reflection that unconsciously one foot scratches the other. His essentially pyramidal shape seems to point into space as the atmospherically rendered trees above, like the group portrait in the burning scene, point forward toward the saint, the

interval between these main forms measured by the trees at the right. The most advanced conception of landscape to appear in 15th-century Flemish painting, this influenced Albrecht Dürer.

Geertgen's artistic sensitivity to the character of his age is decisively expressed in what has often been called his last work, the *Man of Sorrows* (Fig. 204), in the Archiepiscopal Museum, Utrecht. By organizing many ideas into one emotional drama, Geertgen created an *Andachtsbild* that draws upon the emotions associated with the Flagellation, the Road to Calvary, the Crucifixion, the Entombment, and the Resurrection. A gold background negates the intent of the diagonal, space-creating movements, and tension is further heightened by employing figures intentionally cut by the frame. No longer having meaning in themselves, they are anticipations of Baroque *staffage* (scale-setting, silhouetted foreground figures). Geertgen derived the highest emotional content from the sorrowing figures, conceiving them as parts of a flattened design. They recall the drama inherent in Hugo's *Death of the Virgin,* to which the *Man of Sorrows* is spiritually and stylistically akin, though compositionally and formally different.

This almost too pathetic rendering reveals Geertgen even more than Hugo as responding to the heightened emotional outlook of the last two decades of the century. In Germany this spirit produced the late Gothic baroque epitomized in sculpture in the art of Veit Stoss, and in Savonarola's Florence its artistic manifestation is clear in the late works of Botticelli. In the north it was also to appear in the art of Bosch, and a parallel to the revivalism of Savonarola is found in the *devotio moderna,* which was an attempt to reform by turning to a simple, direct Christianity, of which the Brethren of the Common Life were the leading exponents in the Lowlands.

On the whole, the psychological restraint of Geertgen's figures, his warm color, comparatively quiet composition, feeling for harmonious space, calm atmosphere, and equally calm expression are at a decided variance with much of Flemish tradition. Despite the influence of Bouts and Van der Goes, his spirit is different from that of Flanders. To call it Dutch would be presumptuous, because at the time no such distinction was yet possible. What Geertgen reveals is a more humble, unaffected sobriety bordering on naïveté.

THE MASTER OF THE VIRGO INTER VIRGINES

The anonymous Master of the Virgo inter Virgines reveals another side to this provincial expression by his awkward vitality and tendencies toward exaggeration and angularity. Less imaginative than Geertgen and less touched by the subtleties of the Flemish tradition, he was influenced indirectly by Bouts and by Van der Goes. He has been localized in Delft, where his woodcuts appeared in books published by Jacob van der Meer and Christian Snellaert, and is probably to be identified with Conway's Second Delft Woodcutter. [3] Though he may have been working as early as 1470, his earliest dated work is a woodcut published in 1482, at which date he was already a developed master. His woodcuts appeared until 1498. After this there was no new work.

Slightly older than Geertgen, the Virgo Master had an independent style that owed little to his contemporaries in the field of painting.

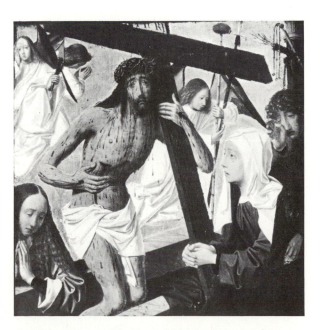

204. GEERTGEN TOT SINT JANS. *Man of Sorrows. c.* 1495. Panel, $9\,^{5}/_{8} \times 9\,^{1}/_{2}''$. Aartsbisschoppelijk Museum, Utrecht.

By dressing his figures in elaborate costumes, possibly derived from Joos van Ghent, he presented the first manifestation of what was to become a commonplace in Netherlandish mannerism. An intensity and a fantasy of naïve expression run throughout his work. With simple sincerity he attempted the utmost in conveying emotional states and achieved a curious success, curious because it was achieved despite some occasionally shocking displays of drawing. Large heads, small hands and feet, heavy-lidded eyes, despondent mouths like slits, and pathetic expressions characterize his often contorted and convulsed forms.

The master takes his name from a representation in Amsterdam of the Virgin and Child surrounded by Sts. Catherine, Cecilia, Barbara, and Ursula, that is, the *Virgin among Virgins* (Fig. 205). Its composition is extremely regularized and almost mechanical. The Virgin and virgin saints appear almost as sisters, with the same high foreheads, shallow eyes, small jaws, and narrow faces. Around this work Friedländer

grouped a number of other paintings of like style. Now twenty works have been attributed to the Virgo Master, of which the most impressive are the *Entombment,* in Liverpool, with reminiscences of Bouts; the *Adoration of the Magi,* in Berlin, showing resemblances to Hugo; and a late *Annunciation* in Rotterdam. A portrait of a Delft canon, Hugo de Groot, in New York, Georges Wildenstein Collection, has also been attributed to the Virgo Master, the only non-religious work in his *œuvre.*

The Virgo Master tended toward warm, and occasionally, as in the Liverpool *Entombment* (Fig. 206), sonorous color, which has been related to Joos van Ghent's *Crucifixion Triptych.* The strength of color is in part due to his tendency to avoid the diluting effect of atmosphere, an aspect of his art which parallels the intense color and nonplastic effect found in the art of leading Dutch miniaturists, especially those of the Utrecht school. The sources of the Virgo Master's style may also lie in the field of miniature painting, which was the strongest

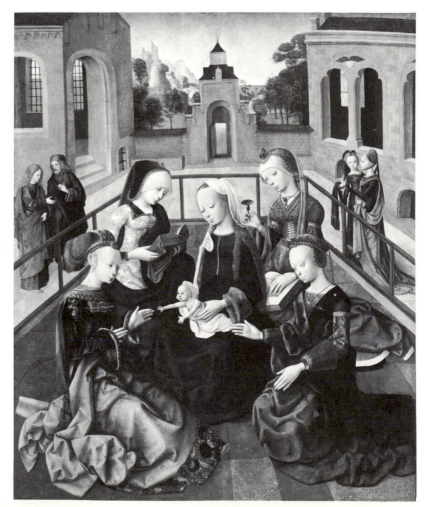

205. MASTER OF THE VIRGO INTER VIRGINES. *Virgin among Virgins. c.* 1480–90. Panel, 48 3/8 × 40 1/8". Rijksmuseum, Amsterdam.

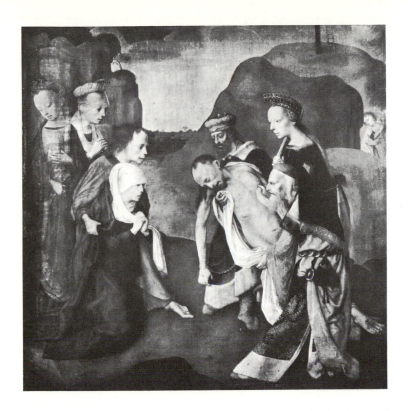

206. MASTER OF THE VIRGO INTER
VIRGINES. *Entombment. c.* 1480–
90. Panel, 21 ³/₄ × 21 ⁵/₈″. Wal-
ker Art Gallery, Liverpool.

influence upon the book illustration he practiced, lending to it not only color but also iconography and formal solutions. His art shows the first signs of what was to develop into Netherlandish Mannerism, for the flattening tendency (because of the use of nonatmospheric color) and the interest in fanciful detail are two of the chief aspects of 16th-century style. Thus it seems that the very essence of the Virgo Master's style is prophetic of the change to come.

Apparently he also worked in Antwerp as a book illustrator, and that city, in which Joos van Ghent is first recorded as a master, gradually came to be the dominant port of the southern Netherlands. When Bruges's channel to the sea silted up, despite unsuccessful dredging opera-

tions which began in the 1470s, the lead passed to Antwerp, and it was there that the succeeding style reigned, leaving Bruges to spin out the older manner. The development of the later style belongs to a succeeding chapter, but it is worth noting that the Virgo Master's style is not far removed from that of the Geertgen followers who play a more leading role in the next century. Such artists as the Master of the Brunswick Diptych, named for a work once thought to be by Geertgen himself, the Master of Delft, and above all Jan Mostaert and the Master of Alkmaar (now thought to be Cornelis Buys) stem from Geertgen but exhibit a spirit and style that seem to be Geertgen's infused with the intensity and strangeness of the Virgo Master.

THOUGH BRUGES WAS TO BECOME IN TIME A *ville morte* in the last quarter of the century, it and Brussels were two centers of a production so intense that the preserved works outnumber by at least four to one those of the first three quarters of the century. The dominant figure in Bruges was Rogier's greatest follower, Hans Memlinc (or Memling), born in Seligenstadt, a small hamlet on the Main between Hanau and Aschaffenburg. He appeared on the Bruges citizen roll for the first time on January 30, 1465. In 1466 he was already a master in the guild and was then living on Wulhuusstraat in the parish of St. Nicholas. When he married is not known, but when his wife died, in 1486, he had three children. By 1480 he was one of the richest citizens and that year had to pay the extra tax levied on the wealthy by Maximilian to support his war against France. At the time Memlinc owned three houses and had pupils, one of whom, Jan Verhanneman, became a master in 1480; another, Passchier van der Mersch, became a master in 1483; and Louis Boels followed in 1485. When Memlinc died on August 11, 1494, Bruges lost its leading master; he was buried in the church of St. Aegidius. He and his shop had created a vast number of works, among which are a large group of portraits.

Much admired in the second half of the 19th century—he was the only 15th-century Flemish artist to be included in the late 19th-century Classics of Art series—he has since been relegated to the lesser position of an amiable eclectic, whose works, full of charm, grace, serenity, harmony, and moderation, are expressive of the spirit of the *détente* (a term used chiefly in regard to French sculpture to characterize the elegance and relaxation of form in the third quarter of the century). In other words, his work has been judged as very able, even excellent, pretty rather than beautiful, and rather dull. It is true that for poignant drama one does not instinctively turn to Memlinc, and the inner turmoil of a Van der Goes is not to be found in his art. On the other hand, this chief follower of Rogier van der Weyden, who was probably trained in a Rhenish shop and completed his training in Brussels before 1464, after which he moved to Bruges, took over the compositions and the models of Van der Weyden, even though he was, as Friedländer remarked, temperamentally not a kindred spirit. He seldom concerned himself with the severe grandeur of pathos expressed by Rogier, even in his earliest work, when he was closest to his master. Memlinc, though indebted to Rogier, and to Bouts and Hugo as well, was basically a painter of rational balance and order. He has been compared to Fra Angelico and more aptly to Raphael, his feeling for clarity and order leading him to Italian art and to Jan van Eyck. Like Hugo, he viewed the past historically,

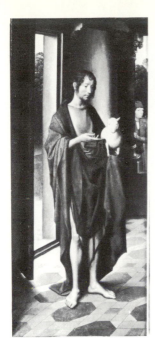
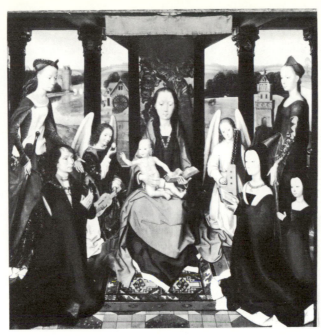
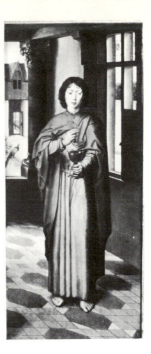

though not so intensely; in consequence his art shows a concern for artistic problems unthought of by his predecessors.

The date of his marriage to Anna de Valkenaere, sometime between 1470 and 1480, and the fact that his sons were all under age when he died make it difficult to conceive of his birth date as earlier than about 1440, and one is led to the conclusion that he was a precocious artist. This conclusion is borne out by his early work, which shows a high degree of mastery. His triptych for Sir John Donne of Kidwelly, in the National Gallery, London, with the Madonna and Child with saints and donors in the central panel and the two Sts. John on the wings (Fig. 207), has been dated about 1468. In this year Margaret of York married Charles the Bold in Bruges, and Sir John (with his wife and daughter, who appear in the painting) is assumed to have gone to Bruges for the event and ordered the painting at that time. But Sir John also had two sons, the elder born in 1466. Even if the first son had been left behind in England, space would customarily have been left for his portrait to be painted in when the triptych was shipped home; since this was not done the painting could have been painted even before the boy's birth. The upper terminus is provided by the death of the donor at the battle of Edgecote in 1469.

Sir John's and his wife's coats of arms are found on the capitals of the columns at the back

above: 207. HANS MEMLINC. *Donne Triptych.* 1468–69 or earlier. Panel, 28 × 27³/₄″ (center), 28 × 11³/₄″ (each wing). National Gallery, London.

of the loggia in which the scene is staged. The open character is further enlarged by the wing panels, on which are seen the two name saints of the donor. The space in which they stand extends that of the central panel, uniting the whole into a single pictorial space in which Memlinc has arranged his vertically accentuated forms without crowding. The contrast with Rogier's tightly knit designs is immediately apparent, as is the markedly Eyckian inspiration of the frontally placed Virgin, the canopy, the rug, and the angels. A gentleness pervades the whole, aided by quiet gesture, dominantly warm color, soft chiaroscuro, and slender forms. Romantic writers have seen Memlinc's own portrait in the figure looking in from the outside behind John the Baptist; Sir John's steward is a more likely possibility. The grisailles on the exterior of the wings show Sts. Christopher and Anthony standing in niches, both revealing the gentle and delicate spirit that distinguishes Memlinc's style from the challenging style of Rogier or Hugo's struggle with emotional problems.

Memlinc's grace, charm, and technical brilliance tend to blind us to his progressive outlook, which is most visible in his treatment of the

background. Whether painted in 1466 or about 1468, the *Donne Triptych* is markedly advanced in conception, possessing the spirit of the intimate, vignetted, natural landscape, with naturalistic buildings in the middle ground, which has also been seen in Van der Goes, but which, so far as we know, did not appear in Hugo's art before 1472.

A similar treatment is found in the engaging *Martyrdom of St. Sebastian* (Fig. 208), in Brussels, which has often been dated about 1470, for its landscape conception reveals a mixture of old, Eyckian ideas in the city in the center background with the new intimate aspect in the

buildings in the middle distance to the left of the saint's shoulder. The layering of the composition, with figures emerging from behind stage flats, suggests the Budapest copy of Jan van Eyck's(?) *Christ Carrying the Cross,* though here the horizon is lower and spatial movement is less obviously constructed. The composition is conceived in an unusual fashion for a northern artist, since the artistic problem demanded the unification of two main centers of interest, the saint and the archers. This Memlinc accomplished by the saint's garment (which recalls those, probably later, in the *St. Hippolytus Altarpiece,* Fig. 177, by the Bouts shop), the outstretched arms of the archers, the direction of the bow of the more distant archer, and the importance given to the arrows piercing the unconcerned victim.

Sebastian, an early Christian saint, did not meet his martyrdom as the result of this treatment by the Roman soldiers whose captain he was; though left for dead, he was revived and succored that night by St. Irene, and his actual martyrdom occurred later by beheading in the Hippodrome. However, the theme of the nude figure shot at by archers appealed greatly to the artists of the third quarter of the century, both north and south of the Alps, for it allowed the

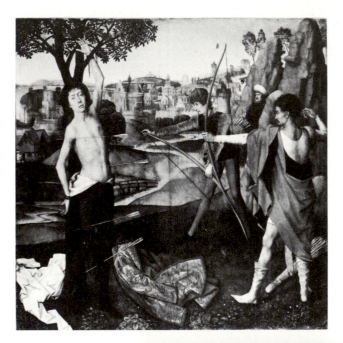

left: 208. HANS MEMLINC. *Martyrdom of St. Sebastian.* *c.* 1470. Panel, 26 3/8 × 26 3/4″. Musées Royaux des Beaux-Arts, Brussels.

below: 209. HANS MEMLINC. *Scenes of the Passion. c.* 1470. Panel, 21 5/8 × 35 1/2″. Galleria Sabauda, Turin.

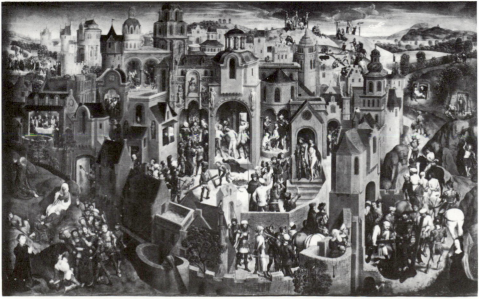

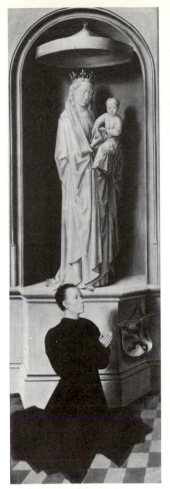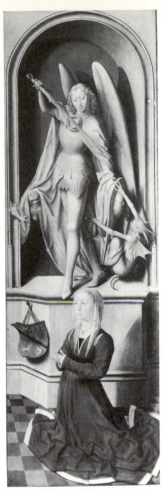

representation of the nude form. The most famous Italian version is the Pollaiuolo painting of 1475 in London. In Memlinc's version he staged the theme as a northern fairy tale, with the unperturbed saint looking down into the audience.

Such delicate fantasy is also visible in another youthful work, the *Passion* panel (Fig. 209) in the Galleria Sabauda, Turin, often dated about 1470. Though he used older motifs, such as placing the Passion scenes before or within houses whose front walls have been removed, Memlinc here approached a problem for which there was no precedent: the organization of numerous scenes of a narrative within a single, unified space. Drawing upon Rogier in many instances for his iconographic models and on Van Eyck for the high point of view of a world landscape (thereby anticipating the later art of Patinir), he created a balanced design that has been called miniaturistic. This comparison is invalid, for no miniaturist had the breadth of vision to organize his forms in the way seen here, where chiaroscuro and color unite to concentrate the eye upon the lighter central pyramid of form and curving avenues sweep around it into depth on either side. This is the ancestor of the "two-hole landscape" developed by Patinir and extremely popular with the landscape painters of the 16th century.

At opposite corners kneel Tommaso Portinari and his wife, married about 1470 and identifiable on the basis of their portraits, now in New York, painted by Memlinc one or two years later. Their identity is further confirmed by Vasari's note of 1550 of a small Passion panel by Memlinc, from Sta. Maria Nuova, Florence, which was then in Duke Cosimo's possession.

In 1473 Angelo di Jacopo Tani, like Portinari a representative of the Medici in Bruges, shipped to Florence by sea a Last Judgment triptych that never reached its destination.[2] Florence and the Hansa were at war, and the triptych, captured by a Danzig corsair, was set up in the church of St. Mary in Danzig (it is now in the Pomeranian Museum in that city). On the exterior (Fig. 210) Jacopo and Caterina Tani, in full color, kneel on a marble pavement adoring the figures of the Virgin and Child

in grisaille (revealing the influence of Hugo's St. Genevieve) and St. Michael (whose combat with the dragon has become a kind of dance) in niches behind and above them. Memlinc has again employed a unified space. It also seems that he was aware of Italian portrait style, for, though not shown in profile, Caterina Tani's features are treated with a clarity, simplified line, and lack of atmospheric chiaroscuro reminiscent of southern works. The body forms, however, follow northern models, and the large amount of space around the figures suggests the large chambers occupied by Nicolas Rolin and his wife in Rogier's *Last Judgment Altarpiece* (Fig. 132), a work that clearly influenced Memlinc. This influence is immediately apparent when the altarpiece is opened (Fig. 211), for it breathes mementos of Rogier in its design, forms, and color arrangement and in the figure of Tommaso Portinari reverently weighing down the scale. On the other hand, St. Michael in armor provides an Eyckian note that may have been transmitted by Petrus Christus.

Memlinc returned to the older conception of the Last Judgment, for devils appear to cast the damned into Hell (as in Lochner's *Last Judgment* in Cologne, Fig. 327), and Rogier's inexorability is lost in the crowding of all three panels with a greater number of shouting, gesticulating figures, a more conventional medieval treatment that Memlinc modernized by the use of a climbing perspective for the side panels of Heaven and Hell. (Rogier's second row of figures has been eliminated.) Again Memlinc expressed his concern for a single, pictorially unified space in his revision of Rogier's conception, which he probably knew from a shop model; shop drawings probably would not have told him the colors.

By 1479 Memlinc's style had coalesced into a thoroughly consistent, fully developed expression, with greatly enriched pictorial surfaces and forms and increased emphasis on drapery folds and architecture.

These qualities appear in his *Triptych of the Mystic Marriage of St. Catherine* (Fig. 212), painted for the high altar of the Hospital of St. John, Bruges, and signed and dated 1479 on the frame. Compositionally it restates the *Donne Triptych,* with the two Sts. John now part of the central space. The wings show the beheading of John the Baptist on the left, a modification of the same scene in Rogier's *St. John Altarpiece,* and the Apocalyptic visions of John the Evangelist on the right, apparently a composition that originated with Memlinc. To organize his space he designed the main movements in a W shape and balanced the deep space on the wings against the close space of the central panel. Antique red-marble columns have been added to increase the sumptuousness of detail and color, to accompany the delicate, slender figures, and to create a majesty midway between Heaven and earth.

On the exterior the donors, members of the Hospital of St. John, kneel under a stone canopy, their patron saints standing behind them against the back wall. The saints seem larger than the donors, and probably their portrayal was influenced by Hugo's monumental saints on the wings of the *Portinari Altarpiece.* The foremost

211. HANS MEMLINC. *Last Judgment Triptych.* 1473. Panel, 88 ³/₈ × 64″ (center), 88 × 28 ⁵/₈″ (each wing). Muzeum Pomorskie, Danzig.

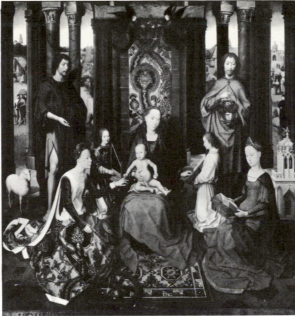
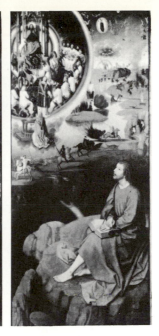

212. HANS MEMLINC. *Triptych of the Mystic Marriage of St. Catherine.* 1479. Panel, 67 ³/₄ × 67 ³/₄″ (center), 67 ³/₄ × 31 ¹/₈″ (each wing). Hospital of St. John, Bruges.

male donor, Anthony Seghers, had died in 1475, and it has therefore been thought that Memlinc began the work in this year.

In 1479 Memlinc also painted a triptych of the *Adoration of the Magi* (Fig. 213) for Brother Jan Floreins, master of the Hospital of St. John, signed and dated on the frame. Kneeling before

a low stone wall at the left, Floreins looks modestly down as his younger brother stands behind him. The Adoration itself is obviously based on Rogier's *St. Columba Altarpiece* (as was another work which Memlinc had executed several years earlier, an altarpiece with the Nativity, the Adoration of the Magi, and the

213. HANS MEMLINC. *Floreins Triptych.* 1479. Panel, 18 ¹/₈ × 22 ¹/₂″ (center), 18 ¹/₈ × 9 ⁷/₈″ (each wing). Hospital of St. John, Bruges.

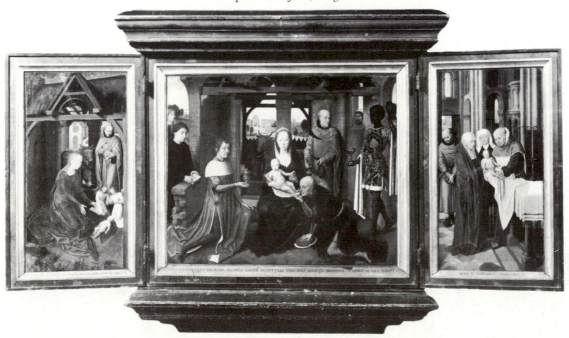

Presentation, now in the Prado). Charles the Bold, older here than in Rogier's paintings, kneels at the left and offers a cup to the Child. Charles is commemorated here, for he had been killed at Nancy two years earlier. His position and pose in the earlier work have been taken here by a Negro Magus, a possible influence from Van der Goes. For the stronger rhythms of Rogier, which carried the eye across the surface, a more gentle, rationalized balance has been substituted. On the wings the Nativity has replaced Rogier's Annunciation. Iconographically the theme has become a triple adoration of Christ—by the Virgin at the left, by the Gentiles in the center, and by the Jews (Simeon and Anna) in the Presentation on the right wing.

On the exterior St. John the Baptist and St. Veronica with her veil are painted as seated within a rich, double, round-arched architectural frame, ornamented with red marble columns surmounted by the simulated sculptured figures of Adam and Eve on the left wing and St. Michael driving Adam and Eve from Paradise on the right (Fig. 214). The organization of this framework recalls Petrus Christus rather than Rogier. A delicate coloration, cooler than that of the interior (St. Veronica's garment is a lightly grayed purple), suggests the effect of the normal grisaille.

In the following year Memlinc painted a *Deposition Altarpiece* for Adriaen Reyns, which, like the foregoing, is in the Hospital of St. John at Bruges. The central theme derives from a Rogier composition, but the drama is quieter and softer; the feeling that this is earlier in style despite its date is probably due to shop collaboration.

In this same year, 1480, Memlinc painted for Pieter Bultinc of the tanners' guild a work, now in Munich, which presents in another long narrow panel scenes from the life of the Virgin and from the life of Christ (Fig. 215). As in the Passion panel in Turin, numerous scenes dot

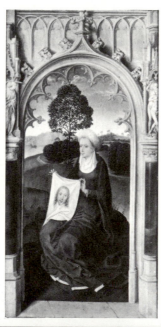

left: 214. HANS MEMLINC. *Floreins Triptych,* exterior. (Fig. 213).

below: 215. HANS MEMLINC. *Scenes from the Life of the Virgin and of Christ.* 1480. Panel, $31\,^7/_8 \times 74\,^3/_8''$. Alte Pinakothek, Munich.

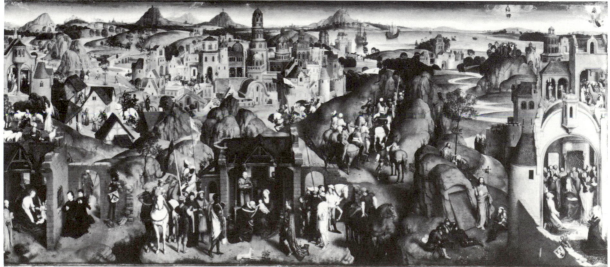

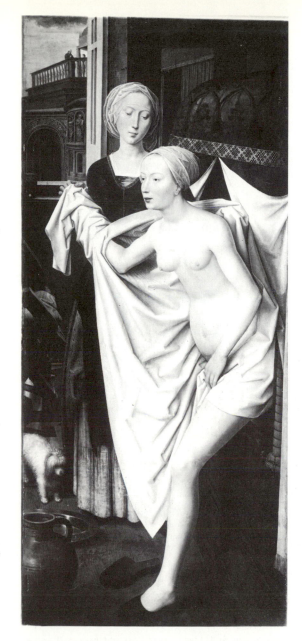

the landscape, which here introduces more land forms and has less fantastic architecture. The earlier central construction has been recessed in space, and spatial movement is more organic. In ten years Memlinc has learned more about perspective. A wider expanse of nature, a truer panorama, is furrowed by diagonal movements that more effectively penetrate the space. Typically disguised by charm and delicacy of treatment, the perspective interest is characteristic of Memlinc's concern for artistic problems.

The harmonious unification observed in the Munich panel is a sign of the artist's mature style, also seen in the *Annunciation* of 1482, in the Lehman Collection, New York. Two angels assist the Virgin, one holding the train of her gown, the other supporting her; the spirituality of Rogier's *St. Columba Altarpiece* is transformed into an exquisite earthly regality and sumptuosness, which appear again in a painting of 1484, in Stuttgart, of Bathsheba emerging from her bath (Fig. 216). A related fragment of King David looking on exists in Chicago. The theme may have been modeled on such earlier work as the now lost nude bathing figure by Jan van Eyck, but Memlinc's figure of Bathsheba has been elongated with a refined grace and a suggestion of monumentality and simplification of surfaces.

The Bruges *St. Christopher Altarpiece* (Pl. 15, after p. 180), of 1484, has a like spirit. The donor, William Moreel, presented by his patron saint, St. William of Maleval, and his five sons are shown on the left wing; his wife, Barbara van Vlaenderberghe, with her patron saint and eleven daughters, appears on the right wing. The central panel seems inspired by a Bouts composition, with a majestic but not burly St. Christopher flanked by the quiet Sts. Maurus and Giles. Reds and blues in the figure of St. Christopher are balanced by browns and greens in the background, suggesting Bouts coloration softened by a rich chiaroscuro, as Memlinc essayed the problem of setting his figures within the landscape.

Monumentality as a formal conception began to develop in Memlinc's painting in the 1480s, and, as in other northern artists who turned in this direction, the concept is expressed in thoroughly northern terms; that is, through the representation of a simplified draped figure rather than of the nude, as in Italy. Memlinc's formal organization is another expression of his search for artistic concepts different from those of his predecessors. It had already appeared in the *Donne* and *Mystic Marriage of St. Catharine* triptychs and is found in a series of formal representations of a like nature, with attendant angels but often without the donors and patron saints. Three representations of this type from the middle 1480s are the panels in Washington

below: 217. HANS MEMLINC. *Madonna and Child with Angels.* c. 1485. Panel, 23 1/4 × 18 7/8". National Gallery, Washington, D.C. (Andrew Mellon Collection).

bottom: 218. HANS MEMLINC. *Descent from the Cross* and *Weeping Holy Women,* diptych. 1480–90. Panel, 21 1/8 × 15" (each). Capilla Real, Granada.

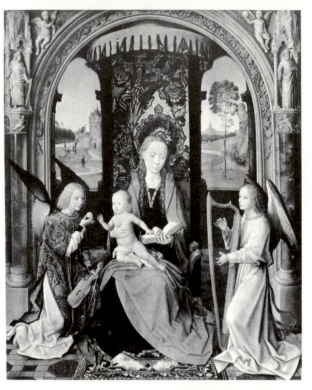

(Fig. 217), in the art museum in Vienna (the two Sts. John are on the wings), and in the Uffizi. In these the throne is placed below a round arch whose spandrels or capitals are decorated with putti and classical swags made of grapes, symbols of the Eucharist. Behind the arch in each work is a darkened loggia. Views of a peaceful, park-like landscape are placed on either side of the rich brocaded hanging. The artistic problems of interior and exterior form and interior and exterior light also concerned the artist. Characteristic of the times, the concept of monumentality is affected by a late Gothic expressiveness visible in somewhat stronger movements in some, but not all, of his later works.

Memlinc's search for different artistic solutions had already produced a conscious leapfrogging of his immediate predecessors back to the first generation in Flanders, an eclectic selection significant in relation to subsequent developments. Like Hugo, Memlinc consciously viewed the past historically. Memlinc's search was not, however, a continuous and persistent one. Open to many ideas, he essayed various directions, as in the several versions of the Descent from the Cross with companion panels of the weeping holy women, the most characteristic being the diptych in Granada, Capilla Real (Fig. 218). Both panels are based on Van der Goes models

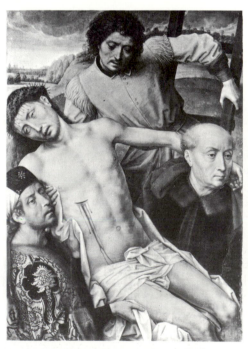

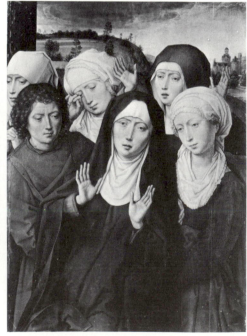

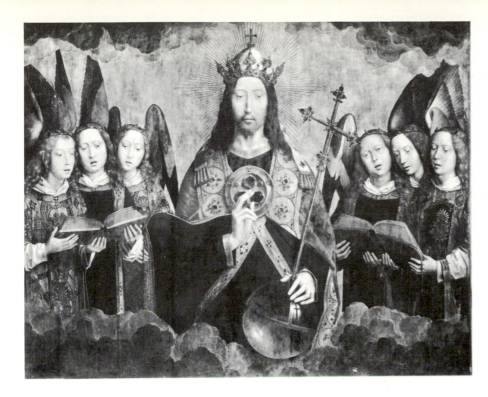

left: 219. HANS MEMLINC. *Christ as Source of Grace with Angel Musicians,* center. *c.* 1485–90. Panel, 65 × 83 ½″. Musée Royal des Beaux-Arts, Antwerp.

below: 220. HANS MEMLINC. *Chasse of St. Ursula.* 1489. Gilded and painted wood, *c.* 34″ high, 36″ long, 13″ wide. Hospital of St. John, Bruges.

(copies on linen have been attributed to Van der Goes himself: *Descent from the Cross,* New York, Wildenstein and Co.; the *Mourning Women,* Berlin), but, as usual with Memlinc, his borrowings were free interpretations, in keeping with his search for different kinds of values.

These characteristics are notable in three wing panels in Antwerp, painted for the organ of Santa María la Real, Nájera, Castile, in which the figure of Christ as eternal source of grace is flanked by music-making angels (Fig. 219), who are spread out onto two side panels. The work is clearly inspired by the *Ghent Altarpiece* in a renewed interest in Eyckian ideas, which included disguised symbolism; monumentalization of form is dominant, being added to the rational balance and order seen before. Even color is used more in terms of solid construction than before in these works of the late 1480s. Again it must be noted that Memlinc's turning to the past is stated in terms very different from those of Hugo, for he was governed by a concern for artistic variety, whereas Hugo, aware of the greatness of the past, tried to reconcile opposites. Memlinc was also aware of Hugo's empirical realism, even possibly anticipated it in his own work, for it reached an artistic peak in his Martin van Nieuwenhove diptych of 1487 and paralleled the growth in monumentality in work of the last decade of Memlinc's life.

The famous *Chasse of St. Ursula,* a reliquary casket in St. John's Hospital, Bruges, of 1489, is probably Memlinc's most famous work (Fig. 220). In some respects it is atypical, for Memlinc obviously eschewed monumentality in favor of a delightful, fairy-tale atmosphere and narrative. Constructed in the form of a Gothic church shrine, it is about 3 feet long. The six round-

arched side panels recount the charming story of St. Ursula, derived from the *Golden Legend* of Jacobus de Voragine. On one end panel are two nuns at the feet of the Virgin and Child, probably the donors, Josine de Dudzeele and Anna van de Moortele, and on the opposite end are St. Ursula and her companions. In brief, the story deals with St. Ursula, daughter of the king of Brittany, whose hand was sought by the son of a pagan king of Britain. Ursula rejected his suit because of his beliefs, but he decided to become a convert. Thereupon they set out for Rome, where the young prince was to be baptized, Ursula being accompanied by ten companions whom the medieval period, with its love for hyperbole, transformed into eleven thousand virgins, a thousand for each of the original ten and another thousand for Ursula. In the left scene the story begins with a stop at Cologne, on their way up the Rhine (Memlinc had been in Cologne, for the city's monuments are

clearly recognizable), where Ursula's subsequent martyrdom was foretold by an angel. After debarking at Basel (center scene), they reached Rome (right scene), where the prince was baptized and they were married by the Pope. On the other side the Pope, obedient to a vision directing that he should accompany Ursula on the return trip, is prominently shown in the scene of the embarkation for the journey down the Rhine from Basel (left panel). At Cologne the company is attacked by the Huns (center panel), and though the Hunnish prince offers to marry Ursula, she refuses and meets her martyrdom (right panel).

Memlinc treated the story in a fairy-tale manner, accomplishing his aim through devices that have led some to call the work miniaturistic, which it is not. He reduced the scale of the architecture and boats in relation to his figures and used light, delicate color and gentle gesture. These devices are particularly visible in the scene of Ursula's martyrdom (Fig. 221), where a sense of social gradations also appears, the chief figures having slenderer proportions than the stumpier and more angular common soldiers. In the background the apse of Cologne's cathedral is seen. Though such realistic detail appears, as well as others such as the shadows cast in the water by buildings in the debarkation at Cologne, the manner is far from Memlinc's norm. Chiaroscuro is not important, monumentality almost nonexistent, and, in short, the work is patterned in form and narrative in intent. A delightful narrative, as Memlinc intended it to be, it has charmed its viewers since its dedication on October 21, 1489.

Memlinc's last important work was the double-winged Passion polyptych for Lübeck Cathedral, commissioned by the Lübeck merchant Heinrich Greverade in 1491 and dated on the frame. The Crucifixion occupies the central panel (Fig. 222), with other Passion scenes on the obverse sides of the inner wings, Sts. John the Baptist and Jerome on the reverse, Sts. Aegidius and Blasius on the inside of the outer wings, and the Annunciation in grisaille on the exterior of the outside wing panels. Though large, this polyptych is not Memlinc's best work, because it includes much shop work and the themes are not those best suited to Memlinc's temperament. Despite the accomplished massing of figures in the central panel, the introduction

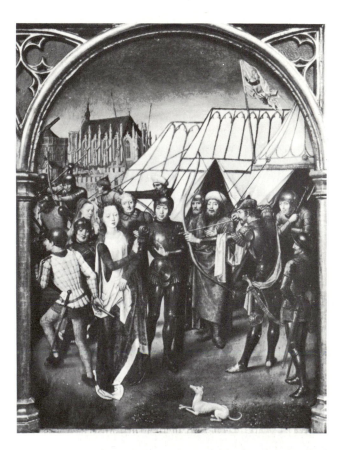

221. HANS MEMLINC. Martydom of St. Ursula, panel of the *Chasse of St. Ursula* (Fig. 220, opposite side).

of portraits, and the greater amplitude of space, the work shows that last is not always best.

Memlinc must have received numerous commissions for portraits, for a large number survive. He gave his normal head-and-shoulders type of portrayals a dignified, elegant aspect. When the hands are pressed together in prayer, it is clear that the portrait derives from a diptych. The portraits of Tommaso Portinari and his wife, of about 1472, in New York, are from a triptych whose central panel has disappeared. The Portinari portraits suggest Rogier in their even illumination and linear clarity but lack Rogier's marked stylization. Less traditional is the portrait, *Man with a Medal* (Fig. 223), in Antwerp, of the later 1470s. Though the names of Niccolò Spinelli and Giovanni di Candida, both Italian medalists working in the Netherlands, have been attached to the work, neither identification can be proved. What seems certain is that the individual is Italian; probably he was a merchant in Bruges who collected coins, for he holds a coin from Nero's reign. Stylistically the work is similar to a large group of portraits by Memlinc in which the head and shoulders of the sitter fill the frame, leaving just enough space for a small amount of distant landscape above the shoulder on either side. The figure is presented as a close-up, delicately modeled but with a generalized surface. The type seems to have been particularly popular among the Italian merchants in Bruges, possibly because the dominance of the figure over space has a relationship with portraits of the Italian Quattrocento.

The type was modified in the portraits of William and Barbara Moreel of 1484, Brussels, by the addition of a loggia whose balustrade is painted in perspective with framing columns. A landscape seen over the balustrade is, as in the other portraits, subdued in tone and subordinated to the lighter tones of the faces. In 1487 Memlinc painted a more traditional portrait, returning to the Van Eyck conception of a figure set against a dark, blank background, with its hands resting on a sill. This is the concept that dominates the figure painting in the Hospital of St. John, Bruges, identified by inscription as the Persian sibyl and thought to represent the Moreels' eldest daughter, Maria.

On the other hand, the turning to Jan van Eyck is in keeping with the development seen

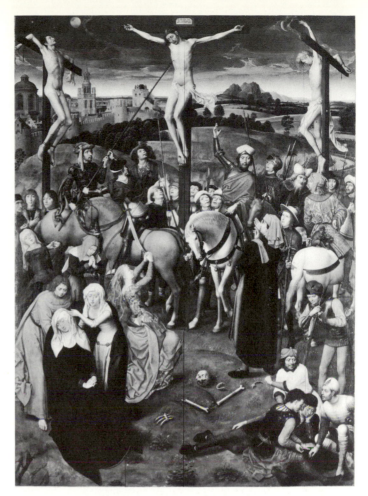

above: 222. HANS MEMLINC. Crucifixion, *Polyptych of the Passion*, center. 1491. Panel, 80 ³/₄ × 59″. Sankt-Annen-Museum, Lübeck.

below: 223. HANS MEMLINC. *Man with a Medal*. c. 1475-80. Vellum on panel, 11 ³/₈ × 8 ⁵/₈″. Musée Royal des Beaux-Arts, Antwerp.

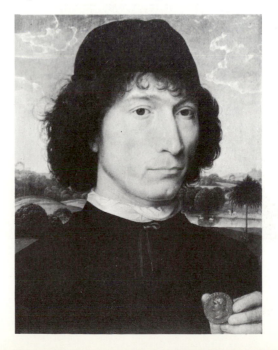

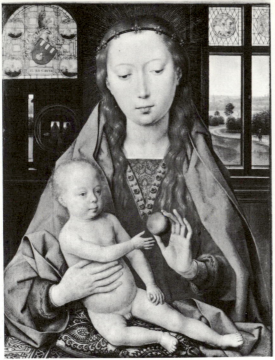

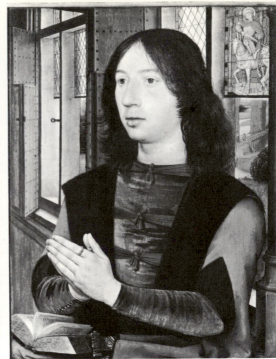

above: 224. HANS MEMLINC. *Diptych of Martin van Nieuwenhove*. 1487. Panel, 17³/₈ × 13″. Hospital of St. John, Bruges.

in Memlinc's other work and in his famous *Diptych of Martin van Nieuwenhove* (Fig. 224), in the same museum, painted in 1487 and dated on the frame. Memlinc's technical abilities are nowhere else more clearly seen. Materials are rendered with an éclat and sense of verisimilitude of such brilliance that one instinctively compares it with Jan van Eyck. Using two different lights for the portrayal of the young donor, one for the figure and one for the perspective scene behind him, the painter so intensified the realistic aspect that this half-length portrait is placed in a different mode from those seen earlier. Here again is an early stage of the Van Eyck revival, but one feels that Van der Goes had shown Memlinc the way, for Jan's chiaroscuro is not emulated, Memlinc's forms being much flatter as well as lighter. Behind the twenty-three-year-old donor is an ingenious allusion to his patron saint, St. Martin, dividing his cloak in the stained-glass window. Slightly bemused, his lips slightly parted, Martin van Nieuwenhove adores a Virgin frontally placed in a room almost without linear perspective. The round mirror on the back wall was undoubtedly inspired by Jan van Eyck. The fron-

tality reinforces the hieratic character of the Virgin and separates the space of an earthly paradise from the purely naturalistic prespective space of the donor. In this work Memlinc's attitude is epitomized: an awareness of and interest in artistic problems, an attempt to define space more solidly in more naturalistic terms, a concern with a rationalistic approach, and a turning toward a greater clarity and monumentality.

Clearly Memlinc was not merely a highly competent, delicate, gentle, and engaging follower of Rogier but an artist whose significant forward steps are disguised by those very qualities which so endeared him to the 19th-century Romantics.

As Bruges's major master of the last quarter of the century, Memlinc influenced most strongly three anonymous painters there, the Master of the St. Ursula Legend, the Master of the Baroncelli Portraits, and the Master of the St. Lucy Legend, and his artistic successor, Gerard David, the only painter to rise above the median in Bruges. Memlinc's works in Danzig and Lübeck influenced local masters in those cities, the most notable being Bernt Notke of Lübeck. Hispano-Flemish painters were also swayed by his art, for the Spanish factors kept their offices in Bruges, whose painters they patronized long after other merchants had moved their operations to Antwerp.

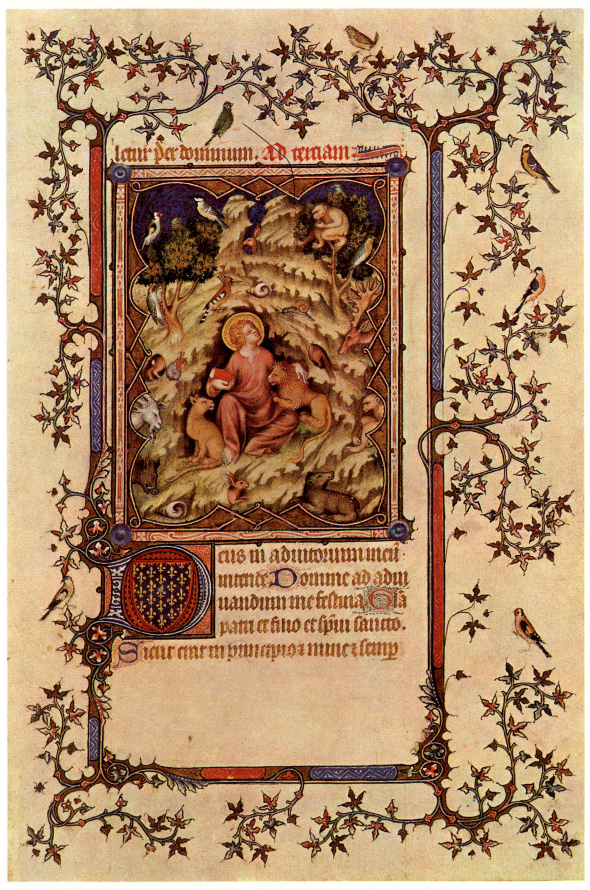

Plate 1. Jacquemart de Hesdin and Shop. St. John in the Wilderness,
Book of Hours (Les Petites Heures) of the Duke of Berry. c. 1385. Illumination, 8 ¹/₂ × 5 ³/₄″ (page).
Bibliothèque Nationale, Paris (Ms. lat. 18014, fol. 208). (See p. 19 and Fig. 17.)

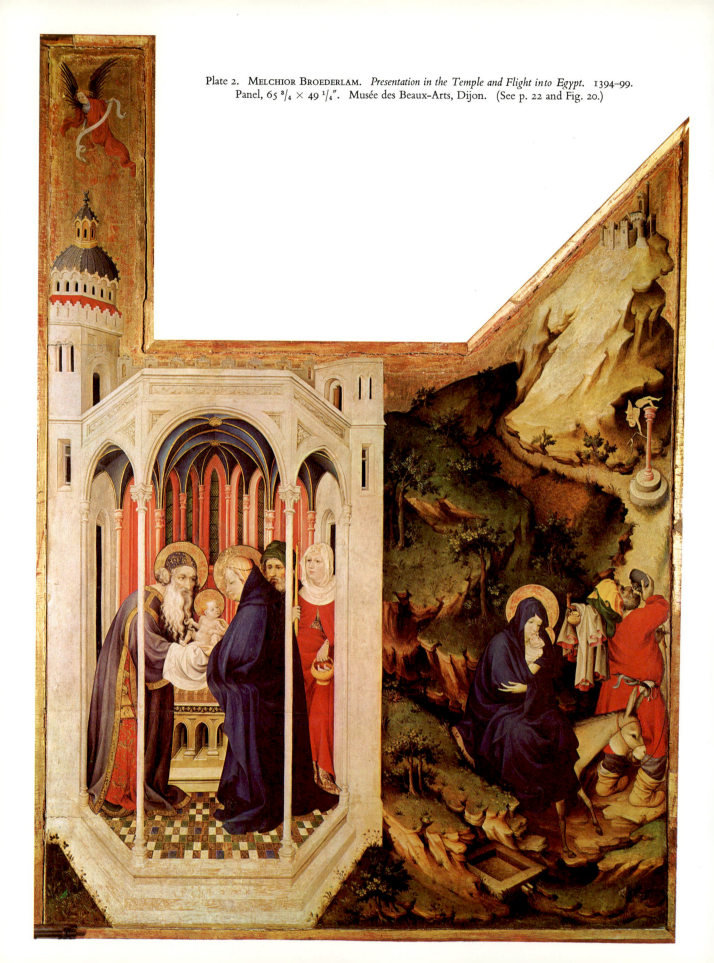

Plate 2. MELCHIOR BROEDERLAM. *Presentation in the Temple and Flight into Egypt.* 1394–99. Panel, 65 ³/₄ × 49 ¹/₄″. Musée des Beaux-Arts, Dijon. (See p. 22 and Fig. 20.)

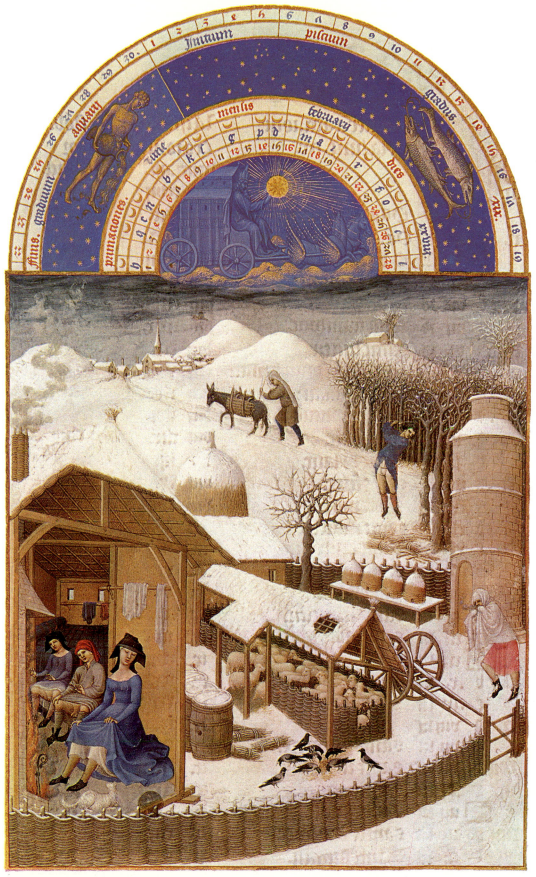

Plate 3. LIMBOURG BROTHERS. February page, *Book of Hours (Les Très Riches Heures) of the Duke of Berry.* 1416.
Illumination, 8 7/8 × 5 3/8″. Musée Condé, Chantilly (fol. 2v). (See p. 28 and Figs. 29–32.)

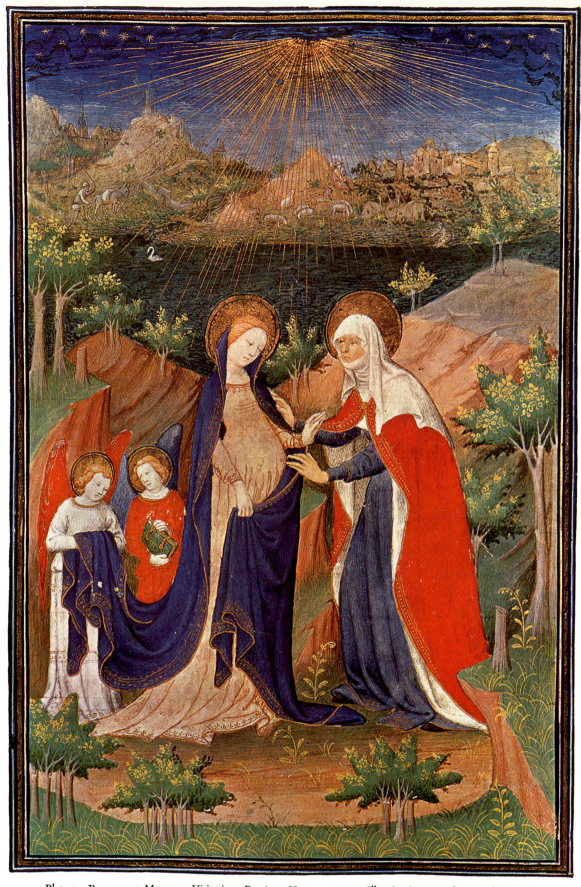

Plate 4. BOUCICAUT MASTER. Visitation, *Boucicaut Hours*. *c.* 1409. Illumination, 10 ¹³/₁₆ × 7 ½″ (page).
Musée Jacquemart-André, Paris (Ms. 2, fol. 65). (See p. 37 and Fig. 44.)

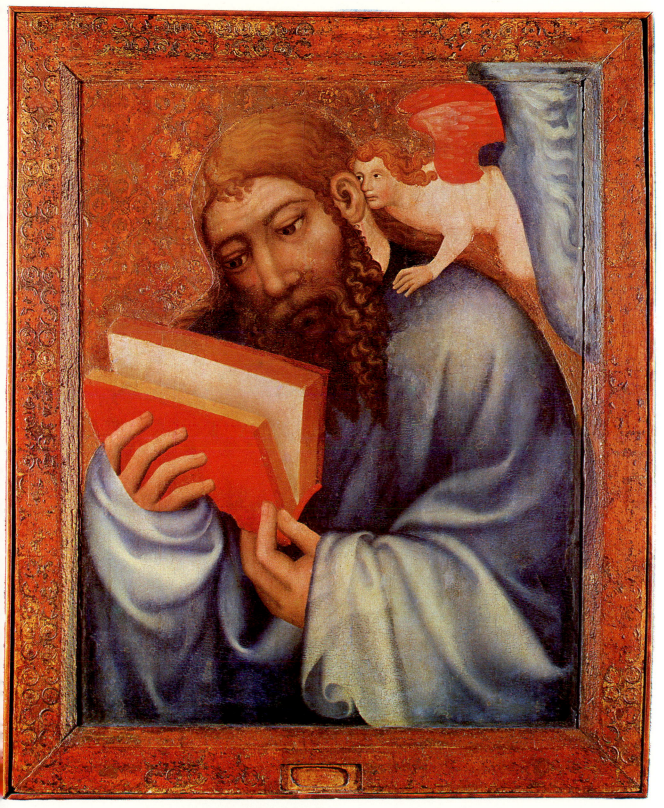

Plate 5. MASTER THEODORIC. *St. Matthew.* c. 1360–65. Panel, 45 ¼ × 37″.
National Gallery, Prague. (See p. 47.)

Plate 6. Master of the Frankfurt Paradise Garden. *Paradise Garden. c.* 1420. Panel, 9 ½ × 12 ³/₁₆ ″.

Plate 7. MASTER OF FLÉMALLE. *Mérode Altarpiece. c.* 1426.
Panel, 25 ³/₁₆ × 24 ⁷/₈″ (center), 25 ³/₈ × 10 ³/₄″ (each wing).
Metropolitan Museum of Art, New York (Cloisters Collection, Purchase). (See p. 76.)

Plate 8. JAN VAN EYCK. *Madonna of Canon George van der Paele with Sts. Donation and George.* 1434–36. Panel, 48 1/8 × 62 1/8". Groeningemuseum, Bruges. (See p. 98.)

Plate 9. ROGIER VAN DER WEYDEN. *Last Judgment Altarpiece*, interior. *c.* 1444–48.
Panel, 7′ 4 ⅝″ × 17′ 11″. Musée de l'Hôtel-Dieu, Beaune.
(See p. 115 and Figs. 132, 134, and 135.)

Plate 10. ROGIER VAN DER WEYDEN. *St. Columba Altarpiece (Adoration of the Magi Altarpiece).* *c.* 1460–62.
Panel, 54 $^3/_8$ × 60 $^1/_4$″ (center), 54 $^3/_8$ × 27 $^1/_2$″ (each wing).
Alte Pinakothek, Munich. (See p. 124.)

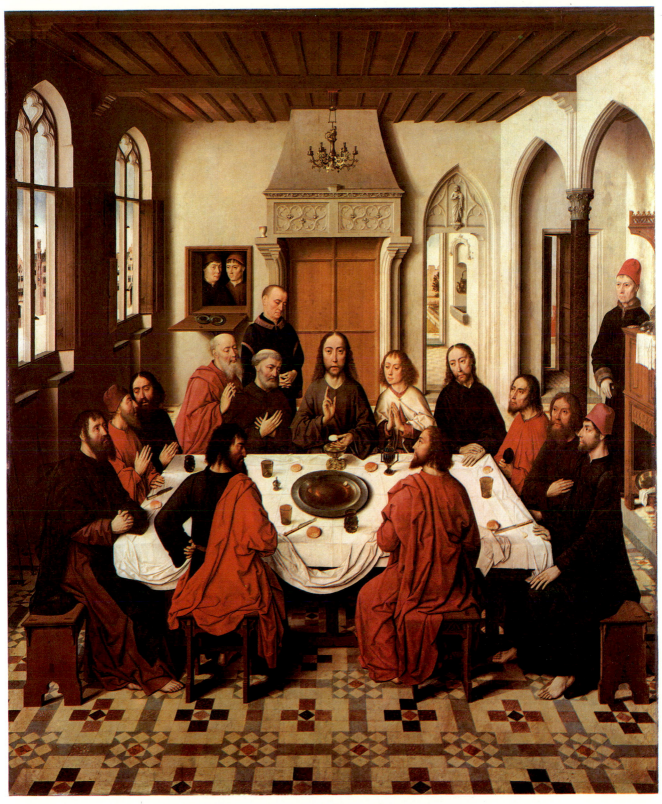

Plate 11. DIRK BOUTS. *Last Supper Altarpiece*. 1464–67.
Panel, *c*. 72 × 60 $\frac{1}{8}$" (center), *c*. 34 $\frac{7}{8}$ × 28 $\frac{1}{8}$" (each wing panel).
Church of St-Pierre, Louvain. (See p. 139 and Figs. 167–170.)

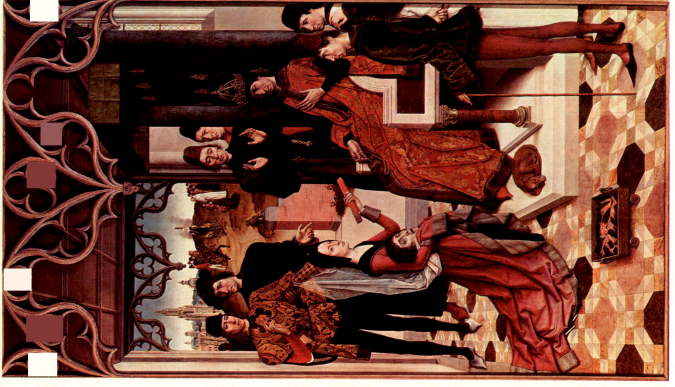

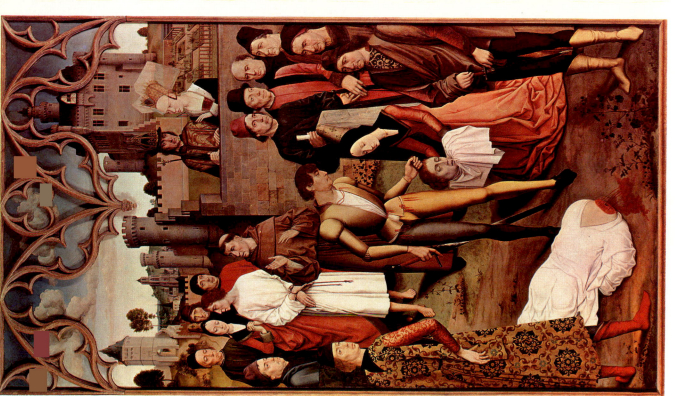

Plate 12. DIRK BOUTS. *Justice of Emperor Otto III.* 1470–75. Panel, 12′ 11″ × 6′ 7 1/2″ (each, over-all). Musées Royaux des Beaux-Arts, Brussels. (See p. 143 and Fig. 174.)

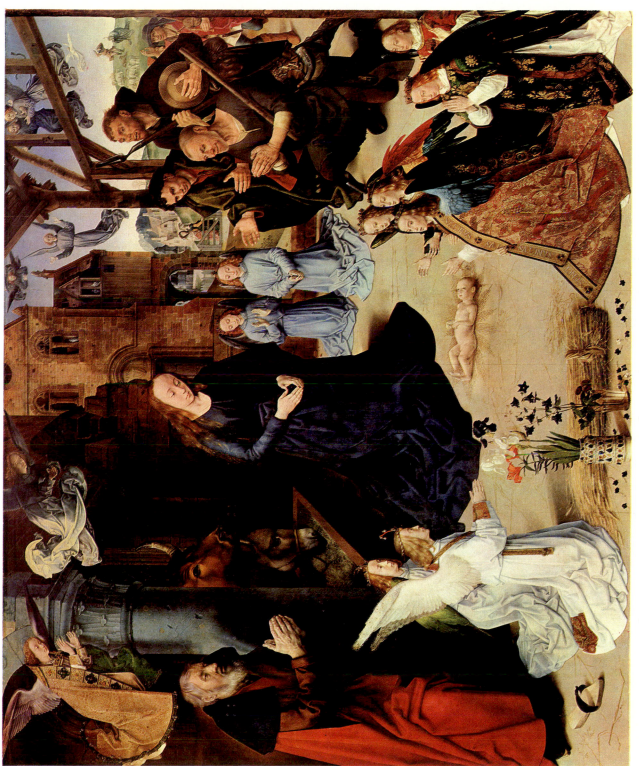

Plate 13. HUGO VAN DER GOES. *Portinari Altarpiece. c.* 1474–76. Panel, 8′ 3 ⅝″ × 9′ 10 ⅝″ (center), 8′ 3 ⅝″ × 4′ 7 ½″ (each wing). Uffizi, Florence. (See p. 153 and Figs. 186–189.)

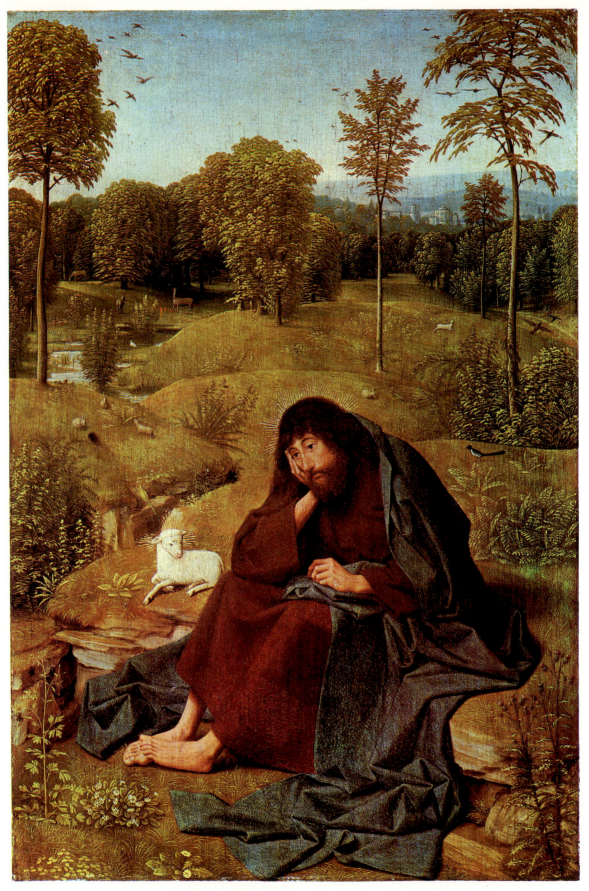

Plate 14. Geertgen tot Sint Jans. *St. John the Baptist in the Wilderness.* *c.* 1490–95. Panel, 16 $\frac{1}{2}$ × 11″. Gemäldegalerie, Staatliche Museen, Berlin-Dahlem. (See p. 164.)

Plate 15. Hans Memlinc. *St. Christopher Altarpiece.* 1484.
Panel, c. 47 3/4" × 60 3/8 (center), 47 3/4 × 27 1/8" (each wing).
Groeningemuseum, Bruges. (See p. 175.)

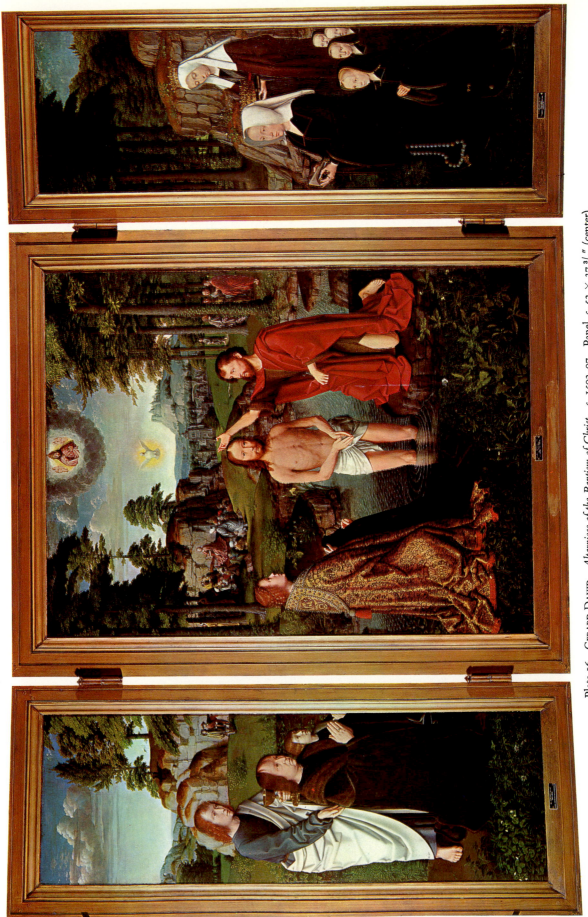

Plate 16. GERARD DAVID. *Altarpiece of the Baptism of Christ. c. 1502–07.* Panel, *c.* 52 × 37³/₄″ (center), *c.* 52 × 16⁷/₈″ (each wing). Groeningemuseum, Bruges. (See p. 194.)

11

THE MINOR MASTERS AND MANUSCRIPT ILLUMINATION IN FLANDERS

THE MINOR MASTERS

Until its demise in the middle of the 16th century, painting in Bruges capitalized on that expression of sentiment which was first discernible in Memlinc's art. To judge from the preserved works, art production increased fourfold in the last quarter of the 15th century. A number of artistic styles have been identified, and works have been attributed to these mainly unknown masters.[1] Only Gerard David was of more than average artistic stature; the others created works with strongly decorative surfaces, often crowded with figures in increasingly shallow space. Movement within these narrow confines became more agitated, line was harder, and depth held less interest for these painters, who substituted narrative and sentiment for drama.

The Master of the St. Ursula Legend (named by Friedländer after an altarpiece devoted to this subject, from the Convent of the Black Sisters, of which the wings are now in the museum in Bruges) has been considered the most important painter of secondary rank in late 15th-century Bruges. His painting of the Ursula legend, which varies from that of Memlinc, antedates the greater master's work by at least six years and possibly more. His style seems to have been independently acquired from

Rogier, who was also his chief iconographic source, but Memlinc's influence is visible in several of his compositions. As with many minor masters, details tend to become overaccentuated, hard, and too sharply defined because of too-careful attention to specific elements. The result is a loss of atmosphere and the hardening of what, in the hands of a major master, is a fluid movement into one that is too precise and mechanical. The Master of the St. Ursula Legend used color similarly; his color has very rightly been called "pungent." His types are derived from his predecessors, though his figures have been given a distinctive character by pointing the chins and broadening the foreheads so that, with their strongly receding hairlines, his heads often have a flat-topped effect. Two of his works bear the dates of 1486 and 1488 respectively. Others have been given upper termini by the faithful rendering of Bruges's famous belfry, which was under construction in the second half of the century. (Its octagonal third stage was added between 1483 and 1487, burned in 1493, and reconstructed between 1499 and 1501.)

A characteristic work of the St. Ursula Master is the *Nativity Triptych* (Fig. 225), in Detroit, in which Joseph has been pushed into the background, contrary to his position of greater importance in Memlinc's composition, from which the central scene derives. (The left wing

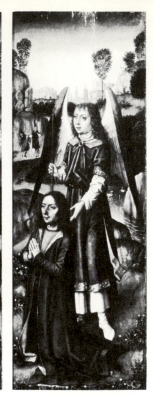

above : 225. MASTER OF THE ST. URSULA LEGEND.
Nativity Triptych. *c*. 1495–1500. Panel, 29 3/8 × 52 1/2″
(over-all, with frame). The Detroit Institute of Arts.

below : 226. MASTER OF THE ST. URSULA LEGEND.
Portrait of a Donor (Lodovico Portinari[?]). *c*. 1490.
Panel, 16 1/2 × 11 3/4″. John G. Johnson Collection,
Philadelphia.

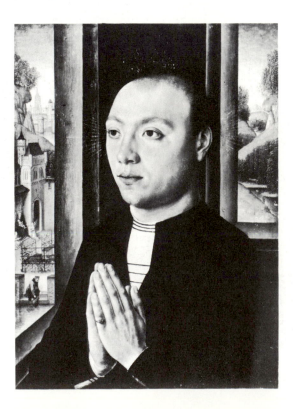

reflects Rogier's Leipzig and Turin Visitations.)
Another is the late *St. Anne with the Madonna and
Child and Saints,* based on Memlinc, in Vienna,
Lederer Collection. The master's best portrait
(Fig. 226), probably representing Lodovico
Portinari, is in the Johnson Collection in
Philadelphia. The accompanying Madonna and
Child of the original diptych is in the Fogg
Museum, Cambridge, Massachusetts. The mas-
ter's formula for faces is evident in the portrait of
the praying donor, who is placed in a corner with
open views of landscape in the background to
the left and right of the painting. This variant of
the corner portrait may have drawn upon the
inventions of Memlinc or Van der Goes; the lack
of perspective agreement in the two views
suggests that the master borrowed, rather than
invented, the motif.

The Master of the St. Lucy Legend, also
named by Friedländer, is responsible for a
painting of three scenes from her legend, dated
1480, in the church of St-Jacques, in Bruges.
Influenced by Rogier, Bouts, and Memlinc, this
master exhibits a marked interest in landscape
as a foil for his figural representations. He too
reproduced the towers of Bruges with accuracy,
thereby permitting the dating of some of his
works on their historical evidence. His concept
of figures is naïve (Friedländer called them

marionettes), and despite a superb handling of materials, which is often the case with minor masters, his treatment of faces, hands, and body postures is awkward.

His preference for floral grounds and rich landscape backgrounds is seen in the Detroit *Virgin and Child with Female Saints in a Rose Garden* (Fig. 227), a work painted before 1483. The landscape is a fantasy of water, hills, and distant rocky mountains, completely unlike the flat terrain of Bruges, whose towers are faithfully reproduced in this lyrical landscape, which somehow mirrors the spirit of the rose garden sharply separated in the foreground.

The *Lamentation Triptych*, in Minneapolis, painted in the last decade of the 15th century, is another characteristic work, and a charming naïveté may be seen in his earlier wing panel of *St. Catherine,* painted about 1480, in Philadelphia, an expression typical of much of the work produced in Bruges in the last decades of the century.

In Brussels many anonymous minor masters continued the style of Rogier van der Weyden in the last third of the century. The Master of the Embroidered Foliage, the Master of the St. Catherine Legend, the Master of Afflighem Abbey (also known as the Master of the Life of Joseph), the Master of the View of Ste-Gudule, and the Master of the St. Barbara Legend are outstanding among those whom Friedländer recognized and for whom he isolated an *œuvre.* Their work is often paralleled stylistically in Brussels tapestries of this period. Characteristic of the period is the work of the Master of the St. Barbara Legend, who takes his name from a triptych of this subject. Its left wing is in the Chapel of the Holy Blood in Bruges, the central panel is in Brussels, and the right wing is lost. The artist's main interest lay in faithful narrative, which he conceived in the manner of a Flémalle follower. Working in the latter decades of the century, he was influenced by Rogier and by Bouts, who may have inspired his angular gestures and homely facial types. The wings of an *Adoration of the Magi Triptych* (Fig. 228) by this master are in New York, the left wing

apparently showing Abner before David,[2] and the right wing showing the Queen of Sheba bringing gifts to Solomon. Here the artist drew on Bouts's panels *The Justice of the Emperor Otto III* (Pl. 12).

Other artists were at work in Brussels. Vrancke van der Stockt, who died in 1495, was Rogier's successor as city painter and possibly the painter of the *Cambrai Altarpiece* (Fig. 229), in the Prado, which is very closely related to Rogier. Though he paraphrased rather than copied Rogier, his art reveals a weaker quality of invention, of design, and of technical handling. The *Cambrai Altarpiece* is his best work, but even here the conceptions of this able minor painter cannot be equated with the genius of Rogier. The difference is most readily seen in the archivolts, whose scenes are painted as actual instead of simulated. This confuses rather than heightens the pictorial logic.

Peter van der Weyden, a son of Rogier, who may have been born in 1437 and who died in

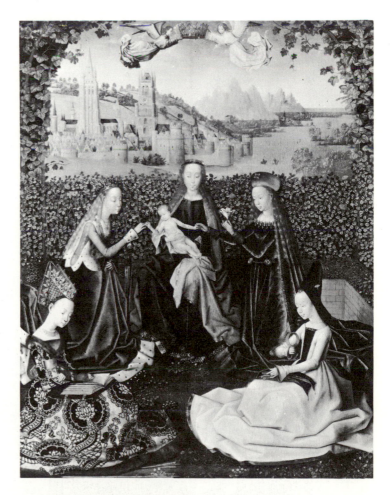

right: 227. MASTER OF THE ST. LUCY LEGEND. *Virgin and Child with Female Saints in a Rose Garden.* Before 1483. Panel, 31 1/8 × 23 5/8″. The Detroit Institute of Arts.

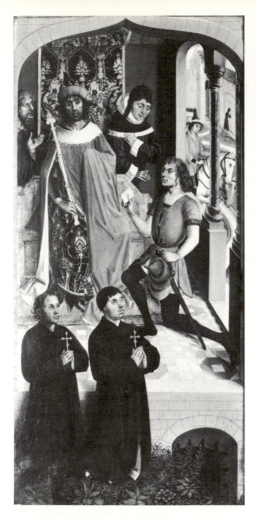

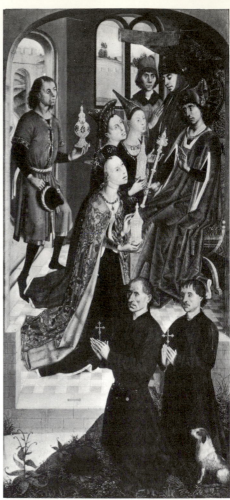

right: 228. MASTER OF THE ST. BARBARA LEGEND. Abner before David, and the Queen of Sheba bringing gifts to Solomon, *Adoration of the Magi Triptych,* wings. *c.* 1490. Panel, 36³/₄ × 17⁵/₈″ (each wing). The Metropolitan Museum of Art, New York (Michael Friedsam Collection).

below: 229. VRANCKE VAN DER STOCKT (?). *Cambrai Altarpiece* (Triptych of the Redemption). *c.* 1460-70. Panel, 76³/₄ × 67³/₄″ (center), 76³/₄ × 30¹/₄″ (each wing). Prado, Madrid.

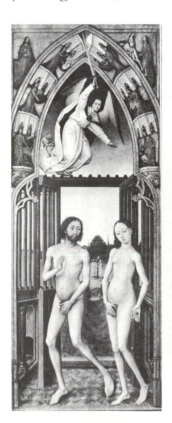

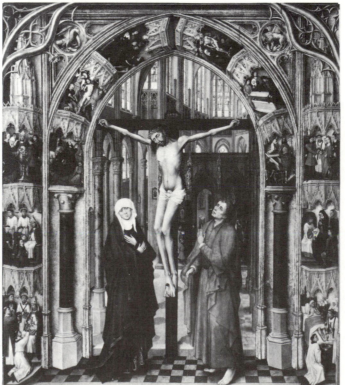

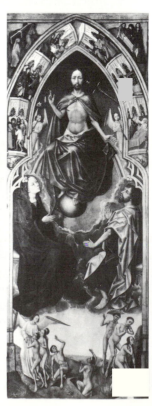

1514, has been identified, though not with certainty, as the Master of the St. Catherine Legend; and Colijn de Coter, already married in 1479 and living until at least 1538, was an archaizing painter depending very directly upon Rogier.

Even though a large number of lesser artists were at work in Brussels and Bruges in the latter decades of the century—artists interested in narrative rather than drama, in colored surfaces rather than spatially constructed color, artists whose concepts of style were dominated by Rogier, Bouts, and Memlinc—they may be viewed cumulatively as an epilogue to the major masters.

MANUSCRIPT ILLUMINATION IN FLANDERS

A decline in quality and leadership characterized the production of Flemish manuscripts in the second quarter of the century, and until the mid-1440s the art may be considered as marking time, awaiting the commissions of Philip the Good.[3] Philip in 1420 inherited several hundred manuscripts from his father, John the Fearless, and gave few commissions in the first 25 years of his reign, but when he died, in 1467, there were over a thousand illuminated manuscripts in the ducal library. Philip's patronage was responsible for the execution of a vast number of works, for the court emulated its ruler. The result was the creation of a distinct style which, though unprogressive in comparison to panel painting, at least followed it closely.

The elegance and attenuation of form seen in paintings of the third quarter of the century, sometimes characterized by the term *détente,* becomes even more evident in manuscript illumination, where the "style of the long lines" had already made an appearance in the dedication miniature of the *Chroniques de Hainaut* (Fig. 133), which some scholars have attributed to Rogier himself.

A semblance of the great achievements of the panel painters, manuscript illumination took over fully and even exaggerated the characteristically elongated proportions and repetitive parallel verticals. In manuscripts of the third quarter of the century the long lines appear often in monotonous compositional rhythms that seem analogous to the formalized, conventionalized ceremonies of court life. Court ceremony and court refinement were mirrored in the dress—the long, pointed headdress, or hennin, of the women and the long, pointed shoes and the tights with short jackets of the men—all well illustrated in the miniaturists' linear Gothic style, which, however, was combined with the command of natural appearance already seen in panel painting. The end product was a courtly art, continuing, despite the lapse of a generation, the chivalric ideals and attitudes of the International Style, but substituting for the earlier poetry a contradiction—a formal naturalism. The dichotomy between court and town, between noble and bourgeois, that prevailed in *manuscrits de luxe* lasted only as long as the power of Burgundy. When Charles the Bold died in 1477, to all intents and purposes an era died with him. Then manuscript illuminators sought and were able to find a new way under the inspiration of the new realism of such figures as Hugo van der Goes.

Three principal writer-translators, acting much like modern publishers, executed the commands of Philip the Good for fine books: Jean Wauquelin at Mons, Jean Miélot at Lille, and David Aubert, who followed the court. Working under their direction, it may be assumed, were a number of illuminators. Particularly notable were Jean le Tavernier of Audenarde, who excelled in painting in grisaille; Jean Dreux, identifiable with the Master of Girart de Roussillon, in Philip's employ after 1449 and working in the 1450s and 1460s in Brussels; Simon Marmion of Valenciennes, renowned as "prince of illuminators"; Loyset Liédet, illustrator of the third volume of the above-mentioned *Chroniques de Hainaut,* among a vast number of other works; Willem Vrelant, illustrator of the second volume of the same chronicles, who went to Bruges from Utrecht before 1454; and Philippe de Mazerolles, who went to Bruges from Paris about 1460.

Liédet, Vrelant, and Mazerolles settled in Bruges and died there, Liédet in 1478, Mazerolles in 1479, and Vrelant between 1481 and 1482. Though sharing the stylistic traits of their epoch, the three masters are clearly distinguishable. Liédet's work was the most patterned, the most mannered, and showed the least interest in

landscape (Fig. 230). Vrelant used the hardest line and color and was also the most prosaic (Fig. 231). Mazerolles was far and away the best draftsman and the most interested in space and atmosphere (his work has been attributed *in toto* to a Ghent illuminator, Liévin van Lathem, but the evidence is still unpublished [4]). His sense of the just relationship between figures and setting (Fig. 232) is unsurpassed by his contemporaries.

Anonymous painters of the period include the Master of Wavrin, who worked in a lively, sketchy pen style with occasional light washes (Fig. 233); the Master of Anthony of Burgundy, interested in character and drama, who is known for his illuminations in silver and gold on black parchment in the Sforza *Hours* in Vienna (Ms. 1856); the Master of Margaret of York; and many others. Book illumination was still a flourishing medium.

The attraction of miniaturists to the southern Netherlands was the outcome of two distinct factors: the vast commissions of Philip the Good and his court and the decline in patronage with the disappearance of the smaller courts elsewhere. As a result of Philip's consolidation of power, local courts lost their autonomy and were absorbed into the greater court of the "Grand Duke of the West." The situation was much like that under Louis XIV in the 17th century. For this reason Dutch artists such as Vrelant and French artists such as Marmion from Amiens

top: 230. *Loyset Liédet.* Baptism of Grimbault and his daughter, *L'Ystoire de Helayne.* 1470. Illumination, 15 × 10 5/8″ (page). Bibliothèque Royale, Brussels (Ms. 9967, fol. 71).

above: 231. WILLEM VRELANT. Annunciation with Philip the Good in Prayer, *Treatise on the Annunciation.* 1461. Illumination, 15 3/8 × 10 1/4″ (page). Bibliothèque Royale, Brussels (Ms. 9270, fol. 2v).

right: 232. PHILIPPE DE MAZEROLLES [or Liévin van Lathem(?)]. Presentation of the manuscript of Aristotle to Alexander, *The Book of Secrets.* c. 1465–70. Illumination, 13 3/4 × 9 1/2″ (page), c. 5 1/2 × 6″ (scene). Bibliothèque Nationale, Paris (Ms. fr. 562, fol. 7).

and Mazerolles from Paris are part and parcel of the history of Flemish manuscript illumination.

As painter, Marmion has been included in exhibitions of Flemish art; here, however, he will be considered Flemish as a miniaturist and French as a painter. As a miniaturist, he apparently stemmed from the Mansel Master (named from the *Fleurs des Histoires* of Jean Mansel, Brussels, Ms. 9231–9232), who organized his architecture and his scenes much in the manner of the Bedford Master (i.e., actions take place within rooms from which the front wall has been removed) but constructed the space more logically and was more realistic in his details. Winkler saw a similarity in his figure types to the paintings of Jacques Daret. The style is continued by another hand in the same manuscript, and this hand has been thought to be that of Simon Marmion, who was born about 1420–25 in Amiens, was recorded as still at Amiens and Lille in 1454, but moved by 1458 to Valenciennes, where he apparently remained until his death, in 1489. He may be the Marmion recorded at Tournai in 1440, but his connections with Tournai are firm at a later date; he was undoubtedly the painter of the *St. Bertin Altarpiece* between 1454 and 1459 for Guillaume Fillastre, abbot of Toul and successor to Jean Chevrot at Tournai from 1460. For Fillastre he also illuminated a *Grandes Chroniques de France,* now in Leningrad. One of his many works is a Crucifixion page (Fig. 234) added before 1467 to an early 15th-century manuscript, the *Pontifical of Sens* (Brussels, Ms. 9215), a very painterly work stylistically close to his panel of the Crucifixion, in Philadelphia.

Marmion's feeling for light and delicate colors, verging on pastel tones, his subtle shading, and his idyllic landscape settings had a strong influence upon subsequent miniatures in Flanders. Liédet, for example, is incomprehensible without a knowledge of Marmion. But the point of view he best expressed for his generation

was replaced by that other "glorious exception" to the inherent conservatism of the miniaturists, the Master of Mary of Burgundy.[5]

This master, traceable in the court milieu as early as 1476, has been named from two Books of Hours probably made for Mary of Burgundy, daughter of Charles the Bold and wife of Archduke (later Emperor) Maximilian of Austria. One of these books is in Vienna (Ms. 1857); the other is in Berlin (Kupferstichkabinett 78 B 12). Not earlier than 1477, they were

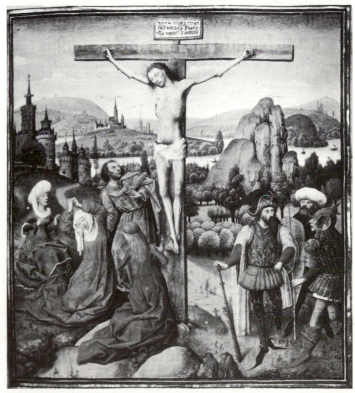

above: 233. MASTER OF WAVRIN. "Loys et la belle ydovye," *History of the Lords of Gavre.* 1456. Colored ink on paper, 11 3/8 × 7 7/8" (page). Bibliothèque Royale, Brussels (Ms. 10238, fol. 142v).

right: 234. SIMON MARMION. Crucifixion, *Pontifical of Sens.* Before 1467. Illumination, 13 3/4 × 9 1/2" (page). Bibliothèque Royale, Brussels (Ms. 9215, fol. 129).

illuminated before the death of Mary in 1482. In the Vienna manuscript one of four inserted leaves by the master is an illumination of a lady, presumably Mary of Burgundy, reading a book before a window (Fig. 235).[6] Giving a view of a church interior, in which the Virgin and Child are being adored, it presents a new concept of the border. Replacing the older floral ornamentation on an abstract nonspatial ground, the reading lady, seen close up, and her immediate environment serve as the border for the scene of worship. The close view seen in Memlinc's portraits seems, like this, to be a further development of the vignetted view introduced by Van der Goes. Brought close to the spectator, the framing scene has its own reality.

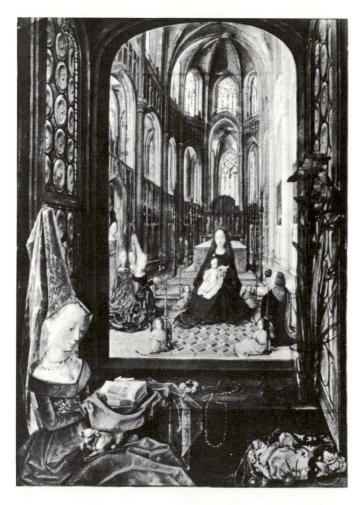

235. MASTER OF MARY OF BURGUNDY. Mary(?) reading by a church window, *Book of Hours*. *c*. 1480. Illumination, 7 1/2 × 5 1/4″ (page, 8 7/8 × 6 3/8″). Österreichische Nationalbibliothek, Vienna (Ms. 1857, fol. 14v).

The further extension of this idea is best seen in another Book of Hours in the Bodleian Library, Oxford (Ms. Douce 219–220), by the same master. Begun for Engelbert of Nassau, it was completed for Philip the Fair about 1480–85. Here the borders are strewn with peacock feathers, shells, and flowers, in an intriguing variety of richly colored still-life elements treated in a *trompe l'œil* fashion. In the midst of this picturesque illusion a frame opens up a vista into the religious scene enacted in the distance by figures of almost stumpy rather than elongated proportions. The frame itself has become a window into deep space, while the illusionistic border ornament performs the same function as the sculptured frame of Rogier's *Mary Altarpiece* and its derivatives, except that the surrounding elements are seen in close-up view. Aiding the strongly naturalistic illusion is a new conception of coloristic forms in space. The spatial illusion is the result of a nonlinear tonal system whose naturalism is furthered by such startling innovations as the figures blocking the spectator's view in the scene of Christ nailed to the Cross (Fig. 236); by the dissolving of the edges in the Last Judgment and the consequent treatment of the resurrected as massed groups shimmering in light (and the back-view figures far above eye level at the top of the frame); and by the reality of the night lighting from which forms emerge in the scene of the Betrayal of Christ.

Though the master borrowed much from Hugo van der Goes, particularly types and the staging of scenes, his concept of depth and pictorial movement was directly opposed, for he made his forms recede, whereas Hugo brought his forward from depth. The master's interest in the optical illusionism of color also led him in the direction of landscape vistas into which figures almost disappear, anticipations of the great landscape paintings of the next century.

The development indicated here was hard on the text. It was at first treated as though it were the framed view surrounded by the illusionistic flower-strewn border. Then, in the latest work of the master (a Book of Hours in Madrid, Ms. E XIV Tesoro [Vit. 25–5]), he reversed the organization to place illusionistic scenes in the border and frame the text, which consequently floats in undefined space, seemingly above our eyes, for illusionistic scenes appear below, above, and on both sides. In one miniature (Fig. 237)

cords are shown tying the block of text to the external frame like a street sign tied to the adjacent houses!

The natural, atmospheric style developed by the Master of Mary of Burgundy dominated subsequent production in Ghent and Bruges (the text of the Oxford manuscript was written in a Bruges shop) to affect *manuscrits de luxe* of the following decades, such as the *Grimani Breviary* (Venice, Marciana Library) and the *Hennessy Hours* (Brussels, II, 158), attributed to Simon Bening, Alexander Bening's eldest son. Alexander, master miniaturist in the guild at Ghent in 1469 (Joos van Ghent and Hugo van der Goes were his guarantors), has been frequently identified with the Master of Mary of Burgundy; against this identification is that Alexander's death occurred in Ghent in 1519, whereas the

left: 236. MASTER OF MARY OF BURGUNDY. Christ nailed to the Cross, *Book of Hours.* Before 1485. Illumination, 5 3/8 × 3 13/16″. Bodleian Library, Oxford (Ms. Douce 219, fol. 74v).

right: 237. MASTER OF MARY OF BURGUNDY. Scenes of the Passion, *Book of Hours.* c. 1490–95. Illumination, 5 1/8 × 3 13/16″. Biblioteca Nacional, Madrid (Ms. E XIV Tesoro [Vit. 25-5]).

hand of the Master of Mary of Burgundy cannot be traced much after 1490.

With the development of this last miniature style, though it continued long into the 16th century (Simon Bening, for example, continued to paint miniatures until he died at Bruges in 1561), the art came to an end, its demise ensured by the development of the printed book and by changing conditions.

THE PRESENTATION OF THE INTIMATE NATURE OF form in a sumptuous pictorial atmosphere governed the output of the later miniaturists, but it was not immediately accepted by the panel painters. The chief successor to Memlinc in Bruges, Gerard David,[1] is both a terminal figure and a transition to the 16th century, for he completes the "primitives" and suggests the Renaissance by a monumental stasis of form almost to the exclusion of the landscape in his late works. Both Winkler and Friedländer considered him a miniaturist. However, David's earliest art shows no acquaintance with the medium of manuscript illumination; thus it is possible that his knowledge was acquired at Bruges, where he painted some works whose compositional aspects are characteristic of miniature painting. (Also in Bruges, shortly after 1496, he married Cornelia Cnoop, a miniaturist and daughter of Jacob Cnoop, dean of the goldsmiths' guild.)

According to the early 18th-century chronicler Sanderus, Gerard David came from Oudewater, near Gouda, in Holland; he was the son of a painter, Jan David, from whom he undoubtedly received his training. David's spacious early style shows some resemblances to the art of his contemporary, Geertgen, so that historians have thought that he was trained at Haarlem. Training under his father is far more likely, however, and it must be concluded, though on very little evidence, that the so-called Ouwater style must have been practiced in several Dutch centers. David appeared in Bruges possibly as

early as 1480, according to Friedländer, but certainly by January 14, 1484, when he was admitted to the painters' guild. As early as 1488 the magistrates commissioned a now lost Last Judgment from him, and when Memlinc died in 1494, David became Bruges's leading painter, having already been elected a member of the guild council in 1488. He occupied this position in 1495–96 and 1498–99, and in 1501 he was made dean of the guild. He was associated with the Bruges Confraternity of the Virgin of the Dry Tree from 1496 on, and though the Master Gerard listed in the Antwerp guild in 1515 is thought to be Gerard David, he was buried in Bruges at Notre Dame in 1523.

As with so many masters whose work has been reconstructed by stylistic criticism, so with David the earliest works are difficult to put in their proper order. The earliest attributed to him that bears a date is one of his most famous, the *Judgment of Cambyses* in Bruges, dated 1498, and it shows a style already mature. Of the works he painted in Bruges, what must be very close to the earliest is *Christ Nailed to the Cross,* of about 1480–85, in the National Gallery in London; its wing panels of the mourning women and the Jewish judges with Roman soldiers are in Antwerp. David crowded his large and rather coarse figures close to the picture plane, and the Jewish judges on horseback were arbitrarily made to conform rather uncomfortably to the principle of isocephaly (i.e., with their heads placed all on the same level). Strong, clear color, static figures, and accentuated verti-

cals characterize this early art, in which one feels that the additive approach has been disguised by interest in facial drama. The feminine types, whose costumes recall the work of the Virgo Master and Geertgen, like the males, owe little to the aristocratic tradition of Rogier van der Weyden transmitted by Memlinc.

The central panel, showing the nailing of Christ to the Cross (Fig. 238), is iconographically related to the contemporary scene in the Oxford manuscript by the Master of Mary of Burgundy (Fig. 236), the miniature being a compressed view of the three scenes combined in David's triptych. Van der Goes's influence on David is sensed in the intent to create a forceful drama, which is not entirely successful. David attempted to move the eye back into space by using diagonals but ran into the same problem that had beset the designer of the Bouts shop *Martyrdom of St. Hippolytus* (Fig. 177)—the creation of a spatial recession without sufficiently varying the ground forms. The diagonal is an improvement over the older radial design, but the perspective diminutions are too rapid. What is unusual, however, is not so much the design by means of which David attempted to capture Hugo's dramatic impact as the concept of the figure of Christ, whose stomach is sucked in and whose eyes look out past the spectator in an anguish that borders on terror. The rendering of the event is no longer symbolic. The artist concentrated upon its actuality, an outcome of Hugo's realism which sets this work apart from the past history of Flemish 15th-century art.

The sense of the particular and the spectator's involvement in it constituted a forward step too drastic for David, who subsequently retreated to a quieter, comparatively dispassionate portrayal, developing the line set out by Memlinc; but in place of Memlinc's more aristocratic spirit David expressed the solidity and rationality of a serene, formal world. This adventure in the nailing scene into the spirit of the late Gothic baroque was not repeated in David's preserved works. The sophistication of the declining city of Bruges acted on David's art to transform his early vigorous drama into a hieratic, solemn monumentality. This was the direction David's art was to take, borrowing in the process from Van Eyck, Memlinc, and, of course, Rogier, so that his initial provincial Dutch vigor was refined and its overt emotionalism excluded.

To this earliest period may also be ascribed two works influenced by Rogier's Vienna *Calvary* (Fig. 129), the *Christ on the Cross* in the Oskar Reinhart Collection, Winterthur, and the same subject, more closely related to Rogier, in the Barnes Collection, Merion, Pennsylvania. The Thyssen-Bornemisza Collection, Lugano-Castagnola, owns another Christ on the Cross with numerous figures at its foot. The work seemingly has its origin in Van Eyck, particularly in its landscape background. A more developed landscape of the variegated type seen in Geertgen's Prague *Adoration of the Magi* appears in three versions of the Nativity. Ultimately derived from Rogier's *Bladelin Triptych* (Fig. 141), the three versions (New York, Budapest, and Cleveland) seemingly were painted (in the order given) over at least a ten-year period that extended into the 1490s. All three have an open quality of space that seems Dutch, all differ in

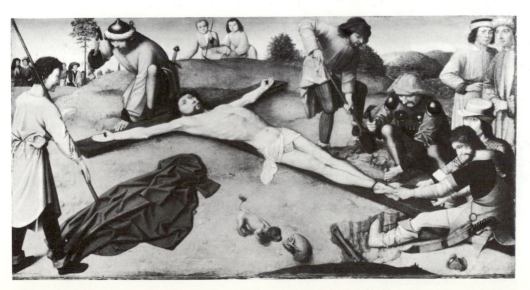

238. GERARD DAVID. *Christ Nailed to the Cross. c.* 1480–85. Panel, $18^7/_8 \times 36^1/_4''$. National Gallery, London.

their naïveté from the more sophisticated, rhythmically interlaced forms of Memlinc and other Flemish painters, but the Cleveland version shows the greatest degree of finish (Fig. 239).

David learned rapidly in Bruges. From Memlinc he borrowed the marked vertical design of the Jan de Sedano triptych of the *Enthroned Madonna,* in the Louvre. This he augmented with motifs from Jan van Eyck, seen in the music-making angels and in the Child. From Rogier came the design for the *Lamentation* in Philadelphia; from the Master of Flémalle, the *Madonna and Child in an Apse* with music-making angels, in the Epstein Collection, Chicago; from Master W with the Key, the *St. Anne, Virgin, and Child, with the Tree of Jesse,* in Lyons; and ultimately from Van der Goes, several Adorations of the Magi (Brussels and Munich). Accompanying this acquisition of a pictorial stock in trade is a feeling for concreteness, exactitude, rational construction, and increasing refinement, the last particularly visible in a subtle modeling that creates soft shade, not shadow, on his increasingly simplified forms.

239. GERARD DAVID. *Nativity.* *c.* 1490–95. Panel, 33 1/2 × 23 1/2″. The Cleveland Museum of Art (Purchase, Leonard C. Hanna, Jr., Bequest).

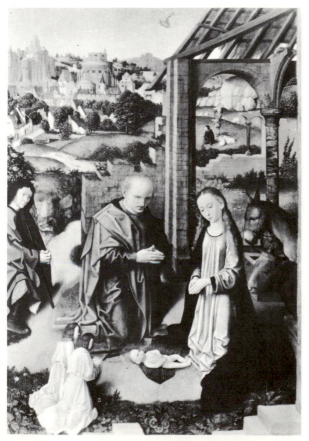

The year 1498 is normally considered a terminus for the early style. In this year he painted for the council room of the Bruges Town Hall the *Judgment of Cambyses,* which illustrates on two panels the theme of justice. The story is taken from Herodotus's account, in the version of Valerius Maximus, of the seizure and punishment of the unjust judge Sisamnes. In the city background of the first panel Sisamnes is shown receiving a bribe, and in the foreground Cambyses ticks off on his fingers the counts against the worried judge (Fig. 240, left). The setting of forms in space is still in the older manner, though the perspective of the strongly patterned floor tiles, the decorative *putti,* and two "antique" medallions representing an allegory of abundance and the Apollo and Marsyas theme (the Medici may have owned the originals) show the further penetration of Italian Renaissance ideas into the north. David at this stage, however, was not so advanced as Memlinc in his total conception of form.

The sequel to Sisamnes's seizure by Cambyses's bailiffs is seen in the second panel; Sisamnes is flayed, and in the right background his son is seated in the judge's chair, which is draped with the skin of his father as a reminder (Fig. 240, right). Gritting his teeth, Sisamnes in the foreground is presented with less concern for individual psychology than was the earlier Christ nailed to the Cross, for the action itself is now most important. The executioners carefully incise and cut to preserve the skin intact under the eyes of Cambyses and a group of Flemish judges acting as witnesses. The executioner at the right, holding his knife in his teeth as he carefully removes the skin from a leg dripping with blood, is a motif with a venerable history in martyrdoms of St. Bartholomew, being traceable in the Limbourgs' miniature in the Cloister *Hours* and before them to Italy (see Chap. 1). Undoubtedly invented by David, the scene is presented as though taking place in an open square in Bruges. Its organization recalls certain Italian compositions, in that the sequel to the main event is added in the remote corner space, but it also shows a response to contemporary flattening tendencies seen in Bruges's minor masters. David's understanding of human forms seems as acute as that of Jan van Eyck in his concept of Adam in the *Ghent Altarpiece.* In subsequent works David combined this

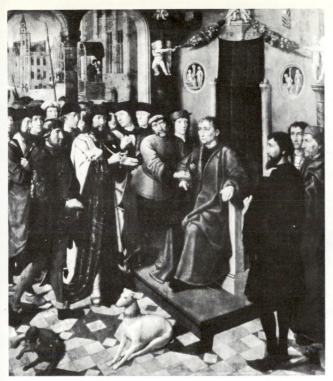

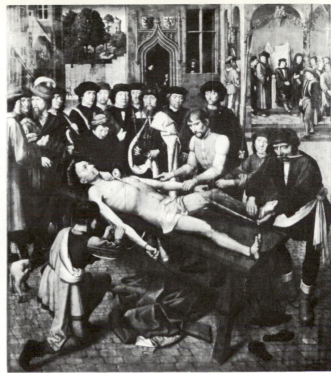

inherited Flemish interest in the natural object, and the ability to portray it, with a developing sense of underlying form. These essentially calm justice panels mark a turning point.

David's second period, thus initiated in 1498, culminated about 1515 and is characterized at first by an increasing formal stasis and monumentality. A signal forward step was taken in the painting in London of Bernardinus de Salviatis, Canon of St. Donatian's, Bruges, presented by Sts. Martin, Bernardino of Siena, and Donatian, the surviving left wing of an altarpiece to John the Baptist commissioned in 1501 (Fig. 241). Four monumental figures are set against a luxuriant and plastic landscape animated by the small, vignetted, scale-setting beggar at the left, an obvious reference to St. Martin. Solemnity and sumptuosity, gravity and clarity inform the arrangement and the restrained action. The *Marriage at Cana* (Fig. 242), in the Louvre, painted about 1503 for Jan de Sedano, breaks with the isocephalism still evident in the justice panels and is a less crowded composition. The view through the portico suggests a reminiscence of Bouts's Louvain *Last Supper* (Pl. 11). David's modeling has become a little harder and sharper, and details are more distinct, but the faces are more generalized, while a greater emphasis upon chiaroscuro animates the surfaces. The flanking donors within the scene

above: 240. GERARD DAVID. *Judgment of Cambyses,* depicting the seizure and flaying of Sisamnes. 1498. Panel, 71 ³/₄ × 62 ³/₄″. Groeningemuseum, Bruges.

below: 241. GERARD DAVID. *Canon Bernardinus de Salviatis and Three Saints. c.* 1501. Panel, 40 ¹/₈ × 36 ⁵/₈″. National Gallery, London.

242. GERARD DAVID. *Marriage at Cana.*
c. 1503. Panel, 37³/₄ × 50³/₈˝. Louvre,
Paris.

and the off-center arrangement do not disturb
the slow, stately circling rhythm, and the dis-
tinctness of the arrangement around the table
gives a feeling of clarified and studied Renais-
sance form. The same spirit appears in the
London *Mystic Marriage of St. Catherine* (Fig.
243), painted about 1505 for Richard de Visch
van Capelle, cantor of St. Donatian's at Bruges.
David's composition is more monumental than
Memlinc's treatment of the subject (Fig. 212).
The figures are strongly modeled sculptural
forms, the Child large and monumentalized
and the Madonna a simplified triangle of form.
(Though there is no direct influence, one is
reminded that Michelangelo's *Moscron Madonna*
of about 1505 was delivered to Bruges on its

completion, and it is still to be seen in the Church
of Notre Dame.) The Magdalen, at the extreme
right, is sharply defined and clearly lighted,
serving as the right forepart of a very evident
U of forms in the composition. Below her
knees the drapery forms a solid, plastic block.

Also of the first decade of the century is
David's famous *Altarpiece of the Baptism of Christ,*
in Bruges. Made for Jan de Trompes of Ostende,
it includes on the right wing his first wife
Elizabeth van der Meersch, who died March 11,
1502, and, on the reverse of the right wing, his
second wife, Madeleine Cordier and her first
child; these figures indicate that the work was
begun before 1502 and completed about 1507.
The internal wings follow previously established

243. GERARD DAVID. *Mystic
Marriage of St. Catherine. c.*
1505. Panel, 41 × 56³/₄˝.
National Gallery, London.

above: 244. GERARD DAVID. *Virgin and Child with Saints.* 1509. Panel, 46 7/8 × 83 1/2″. Musée des Beaux-Arts, Rouen.

conventions, but the central panel (Pl. 16, after p. 180) is astonishing because of David's concern for continuity of figural action and distant space. Three monumental figures press close to the picture plane, the angel in golden garments quite close, its back to the spectator, the figure of Christ gazing out toward the spectator, and John the Baptist performing the baptismal rite. The warm colors of the foreground figures are contrasted in typical Flemish fashion with a cooler background, as in the work of Bouts. David, however, did not use Bouts's devices to achieve depth but proceeded directly to the back of his deep stage in a logical movement that, in the trees at the right, recalls Geertgen. At the left the rock forms have been moved to the edges rather than interlaced across the space. The foreground details are treated with a precision and exactitude reminiscent of Jan van Eyck, while the figures in the continuously receding background are more classically attired than in any previous northern work. At the right John points out the figure of Christ to three of his followers, and at the left John is preaching in the wilderness.

David here has successfully resolved what had been attempted by Memlinc in his *St. Christopher Altarpiece* for William Moreel. Memlinc, too rooted in the past to achieve the dimly perceived goal, was not to construct a smooth transition from foreground to background. It remained for a man of Dutch origin with a greater feeling for continuous movement to create in Flanders what Geertgen had already created in Holland.

The extension into deep space of the Eyckian foreground plateau opened the way to the panoramic world landscape of Patinir (who has been thought by some to have received his early training in Bruges under David). David, however, never repeated this spatial conquest.

On the exterior of the wings Madeleine Cordier and her four-year-old daughter are presented by a turbaned Mary Magdalene to the Virgin and Child set before a deep green tent, with which the rich red garment of the Virgin forms an effective contrast. The figure of the Virgin is simplified, despite the overlaid ornamentation of drapery, and the lower portion of the body is rendered as a solid, sculptural block.

A high point in the sculptural style of David's second period is the *Virgin and Child with Saints* (Fig. 244), in Rouen, a work of 1509 donated to the Carmelite convent of Sion at Bruges by David and his wife, who are also represented. The work is more formally conceived than any earlier *Virgo inter Virgines* scene; a clear, rational balance is visible, with sufficient variation in the parts to give life to the design. The formal gravity is augmented by the act of the Child toying with the bunch of grapes, actually an expression of Eucharistic symbolism.

At the same time a new spirit has appeared, existing side by side with the monumental style of the foregoing works. It is evident in numerous versions and copies of the *Rest on the Flight into*

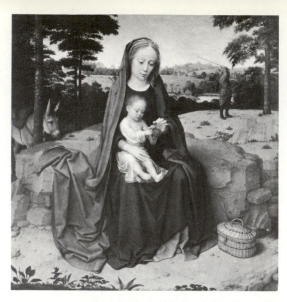

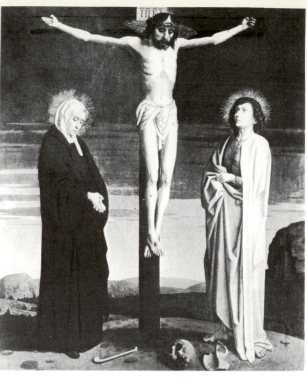

above: 245. GERARD DAVID. *Rest on the Flight into Egypt. c.* 1510. Panel, 17 ³/₄ × 17 ¹/₂″. National Gallery of Art, Washington, D.C. (Andrew Mellon Collection.)

right: 246. GERARD DAVID. *Crucifixion. c.* 1510–15. Panel, 40 ¹/₈ × 34 ⁵/₈″. Galleria di Palazzo Bianco, Genoa.

Egypt, which has justly been considered a gracious and winning picture. David's work on this theme, if not contemporaneous with the Jan de Trompes altarpiece, may have received its initial presentation shortly before. In all the versions the Virgin is seated on a rocky ledge in front of a spacious landscape stretched out behind her. In the distance the travelers are sometimes shown in the woods, or, as in the Washington version of about 1510, Joseph is seen knocking down nuts from the trees. A picnic or clothes basket (seen in several versions) has been placed next to the Virgin and Child in the Washington painting (Fig. 245), making it almost a genre piece. Though the technique and form adhere to the Flemish type, the spirit and sentiment do not. Where the first generation of the 15th century created a disguised symbolism, the last generation tended toward an undisguised naturalism, as in the astonishing scenes of the Master of Mary of Burgundy and here in the incipient genre painting of Gerard David. Indicative of this change in conception is the attitude of the Child. In the New York version He is so aware of the spectator that He hesitates to accept the breast offered to Him by the very youthful, demure Virgin. Though the Virgin is still grave, her increased youthfulness transforms the scene into a less sentimental northern equivalent of the naturalistic relationship of mother and child found in Italian painting of the Quattrocento.

David's new ideas, like those of Memlinc, ran hand in hand with older ones. The *Descent from the Cross* (from the first decade of the century), in the Frick Collection, New York, suggests Bouts in its composition, but it is set diagonally into space and invested with David's characteristic grave monumentality. The same grave spirit is visible in two works in the Palazzo Bianco in Genoa: an altarpiece in which the solemn Virgin and Child of the Rouen panel reappear, and a monumental *Crucifixion* (fig. 246), in which the diagonal placement is restrained, though not entirely suppressed. In the *Crucifixion* the movingly lighted figures have been even more strongly monumentalized by the low horizon against which they are set. David's normal stasis and the light leading to Christ lend to this work the effect of an icon, the evening sky augmenting the solemnity. Such transfigured religious reality, reinforced by the unusual gesture of blessing in the right hand of Christ, suggests that David conceived his religious themes in different modes; when this *Crucifixion* is compared with the genre aspect of the *Rest on the Flight into Egypt,* the differences are seen to be stylistic as well as iconographic. Related to the Genoa *Crucifixion* in style and spirit are the large *St. Anne Altarpiece* panels from the Widener Collection in Washington and the *Annunciation* from the Harkness Collection in New York.

The Genoese works (sometimes explained by assuming a trip to Genoa) have been considered by some scholars to represent a third period in David's work, intervening before his final phase and presumed to have occupied most of the years 1510–15; others consider that the second, or middle, period merges imperceptibly with his last period, which probably began about 1515, when he was recorded in Antwerp. The lack of firm documentation makes both points of view hypothetical; however, the latter seems closer to what is indicated by the later works.

David's last style is characterized by the continued dominance of figures over pictorial space, but two stylistic aspects seem to achieve major status: cooler, almost silvery tones in both foreground and background, and a more diffused atmospheric softening produced by an even greater subtlety of chiaroscuro. Thoroughly characteristic of this last period are the *Adoration of the Magi* in London; the Bache Collection *Nativity Triptych*, in New York, with motifs drawn from Hugo van der Goes, the exterior wings of which (Fig. 247), on loan to The Hague, present the first pure landscape in Flemish art; and various versions of the *Virgin and Child with a Bowl of Milk*, of possibly 1520, the Brussels example being probably the finest. This last work is the most Renaissance in spirit of David's paintings, with its domestic, though monumentalized mother and its generalized, silken-haired Child (Fig. 248). Placed in a narrow interior, the figures are very close to the picture plane in a soft lighting that accentuates their sentiment. By repetition of the formal elements, such as the circle of the bowl, and by the angle of the book, he has created an extremely skillful composition that seems to have what might be called an allusive symbolism.

The last great Bruges painter, Gerard David is occasionally considered the culminator of Flemish 15th-century art, as contrasted with the new movement centered in Antwerp and first dominated by Quinten Metsys. In many aspects, however, David was more a man of the Renaissance than his Antwerp contemporaries, who succumbed to the late Gothic spirit as completely as David excluded it. But his calm sonorities were replaced even in Bruges, by the new spirit, despite the continuation of his outlook and manner by his chief follower, Adriaen Isenbrant, and after 1519 by Ambrosius Benson.

above: 247. GERARD DAVID. *Landscapes,* wings from an altarpiece. *c.* 1515–20. Panel, 35 ½ × 12″ (each). Rijksmuseum, Amsterdam, on loan to Mauritshuis, The Hague.

below: 248. GERARD DAVID. *Virgin and Child with a Bowl of Milk. c.* 1520. Panel, 13 ¾ × 11 ³/₈″. Musées Royaux des Beaux-Arts, Brussels.

HIERONYMUS BOSCH

THE SUBJECTIVE, INDIVIDUALISTIC ART OF Hieronymus Bosch, nurtured on concepts of the past and based on Flemish miniatures and painting in his early work and German engravings and woodcuts later, is one of the most enigmatic in the history of art. In recent years the key has been discerned, though still somewhat dimly, and it is now evident that Bosch was a moralist first and foremost, rather than an inventor of pure fantasy, as he used to be regarded.[1] In the furtherance of his moral narrative he paid little attention to the stylistic achievements of his Flemish predecessors and developed a flat style in which he essentially disregarded natural lighting, chiaroscuro, and plasticity of form. Apparently its mastery came rapidly, and it led to an *alla prima,* or direct-painting, manner. Carel van Mander states: "As other old masters had done, he made his drawing of subjects on the white ground of his panel, over which he painted a transparent layer in a color, or a shade, more or less like flesh. Frequently he used the ground for part of the final effect of the painting."

Such a style was well suited to its purpose, the transformation into paint of moral sermons that constantly reiterate man's folly and its inevitable consequence of punishment in Hell. This moral was either stated or implied in almost all his work from beginning to end. Basically pessimistic, Bosch repeated almost ad infinitum that man's salvation can be achieved through the instrumentality of Christ's sacrifice and the heroic acts·of the saints whose example man must emulate. He stood to one side to comment with sardonic wit that the moral lesson is unread by mankind in general.

Not until late in his career did he become thoroughly involved emotionally in his didactic exhortation. The Ghent *Carrying of the Cross* is his supreme statement. In it he rose to the greatest heights of the great masters. More than David, Bosch deserves to be called the last of the great Flemish "primitives," even though his art was created outside the main current of Flemish art.

His appearance is known to us from his portrait in the *Arras Sketchbook,* which shows him as a man in his sixties, wiry and alert. Probably born in 1453, he died in 1516. His painter grandfather went from Aachen as early as 1399 to the town of 'sHertogenbosch, a prosperous, provincial center in northern Brabant, which is now in modern Holland. He was probably taught by his father, who was also a painter. Very little documentation exists about Bosch's life and career. He was a member of the Confraternity of Notre Dame from 1486 until his death, he was paid in 1504 for a Last Judgment commissioned by Philip the Handsome, and he designed a crucifix and stained-glass windows for his confraternity, in addition to making paintings. His work for his confraternity from 1480–81 and for princely patrons indicates that, despite keeping his shop in 'sHertogen-

249. HIERONYMUS BOSCH. *Seven Deadly Sins.* *c.* 1475. Painted table top, 47 1/4 × 59″. Prado, Madrid.

bosch, he was well known beyond its walls. Many of his ideas were apparently engraved by a fellow townsman, the architect Alart du Hameel, and many of his paintings were copied by his contemporaries and his numerous followers.

On stylistic grounds the painted table top of the *Seven Deadly Sins* (Fig. 249), now in the Prado, Madrid, is considered his earliest work. It was a favorite painting of Philip II of Spain, who also owned its lost companion piece of the Seven Sacraments. That passionate collector of Bosch's works was so enamored of them that they were hung in his bedroom and elsewhere in his palace-office-monastery of El Escorial, outside Madrid. At the center of three concentric circles Christ shows his wounds; below is the injunction, "Beware, beware, God is watching." The Sins are illustrated by genre scenes in compartments about the center, and the corner scenes show their outcome in the form of the "four last things": Death (shown by the death of a man in bed, derived from the popular moral treatise the *Ars Moriendi,* or *Art of Dying Well,* Fig. 376); the Last Judgment; the entry of the saved into Paradise; and, in the lower left-hand corner, the punishment of the Seven Deadly Sins in Hell.

Though the scenes are somewhat awkward in their portrayal, there is a compensatory liveliness to the actions. All the Sins are strongly physical rather than allegorical in conception, borrowed from two iconographic systems. Such a motif as the man being hammered on an anvil in the Hell scene had appeared earlier in manuscript illumination in the Strasbourg *Cité de Dieu* manuscript of the mid-1450s by Jean le Tavernier, and other motifs were also derived from this tradition. There is an occasional use of archaic costume, undoubtedly reflecting the original source, as in the scene of Envy (Invidia), characterized by the dog with the bone at his feet looking up at the bone in the hand of the man leaning over the half-open door. The sleeping theologian in the scene of Sloth (Acedia) was a motif employed later by Dürer in his engraved *Dream of the Doctor* (Fig. 429) in the later years of the century. The iconography of the entry of the saved into Paradise is also archaic, deriving from the Van der Weyden–Bouts tradition, whereas the Last Judgment was modernized to the extent of adorning one of the holy women with a headdress of the type painted by Geertgen and the Virgo Master. Bosch kept the same figure scale throughout, adjusting his borrowed settings to suit. That he borrowed from past representations is crystal clear from the Anger (Ira) scene, which, though staged out of doors, has indoor furniture, showing that Bosch had transformed an interior model into an outdoor scene. Pride (Superbia), in an interior, shows a woman in a headdress, like that of Van Eyck's wife, primping before a mirror held by a devil. Luxury (Luxuria) shows two self-indulgent

couples and a fool beaten by a shepherd's spoon at the right, and Avarice (*Avaricia*) shows a corrupt judge accepting bribes from rich and poor alike.

Whoever the commissioner of the work may have been, it is evident that he chose the right man to paint this didactic concern for man's sins. Immediate, ironic, and realistic, it is a telling introduction to an artist who reverted to the art of the first generation of the northern "Renaissance" to find a religious outlook akin to his own. Notwithstanding the agglomeration of motifs and the mixture of iconography, there is a stylistic unity.

The development of Bosch's style and chronology is probably the most difficult problem in the field of 15th-century Flemish art. The Prado table top, as his earliest work, cannot be dated on the basis of costume any earlier than about 1475. With this as the starting point, the preserved works can be arranged in a rough chronology and stylistic order, proceeding from the rough and clumsy handling of the early work to the more attenuated, expressive patterns of forms decorating his surfaces in the mature style, and culminating in the psychological immediacy and dramatic force of the latest works. Bosch's subjects show increasingly pro-

found expressions of his unique outlook. The inventive faculties he brought to bear are unparalleled, for he touched on all that is irrational and instinctive in human imagination. Though the earlier works show a strong relation to the past, he never stopped being aware of what existed around him in painting and in the popular arts of woodcut and engraving. He undoubtedly traveled as a young man, for his early art shows acquaintance with contemporary and earlier artistic models of the northern and the southern Netherlands. That he chose to live in 'sHertogenbosch thus indicates no taint of provincialism. The breadth of his vision was known to Philip the Handsome, to Margaret of Austria, whose 1516 inventory mentions a St. Anthony by Bosch, and above all to Philip II.

Bosch has been called a surrealist, but this classification does justice neither to the quality of his inventiveness nor to the intensity of his convictions. Though a "modern" painter because of the uniqueness of a subjective, individualistic expression impossible at an earlier date, he was, in the meaning which he intended his iconographic arsenal to convey, the most medieval painter of the 15th century.

The earliest style, seen in the Prado table top, is also reflected in the heavily repainted *Marriage at Cana,* in Rotterdam, and in the *Ecce Homo,* in Frankfurt. The latter is derived compositionally from the Netherlands. Widespread even as late as Titian, the typical arrangement, with the figure of Christ on a platform to the left above the heads of the crowd diagonally below at the right, is a strong constant in the iconography of the theme. Much in the manner of modern cartooning, the cry of the crowd to crucify Christ is lettered across the scene. The emphasis, however, resides in the contrast of the figure of Christ to the world about him, a world summed up in a deriding crowd of ugly, jeering, caricatured forms, entirely evil in character.

A combination of influences from Rogier and Bouts is visible in the *Crucifixion* (Fig. 250), now in Brussels, a work expressive of a new maturity, its vitality stemming from a psychological rather than a physical drama.

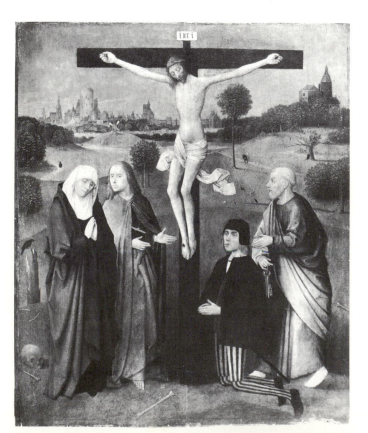

left: 250. HIERONYMUS BOSCH. *Crucifixion. c.* 1475–80. Panel, 27 $^3/_4$ × 20 $^7/_8$″. Musées Royaux des Beaux-Arts, Brussels.

below: 251. HIERONYMUS BOSCH. *St. John on Patmos.* c. 1480–85. Panel, 24 ³/₈ × 16 ¹/₈″. Gemäldegalerie, Staatliche Museen, Berlin-Dahlem.

right: 252. HIERONYMUS BOSCH. *Death of the Miser.* c. 1485–90. Panel, 36 ⁵/₈ × 12 ¹/₈″. National Gallery of Art, Washington, D.C. (Samuel H. Kress Collection).

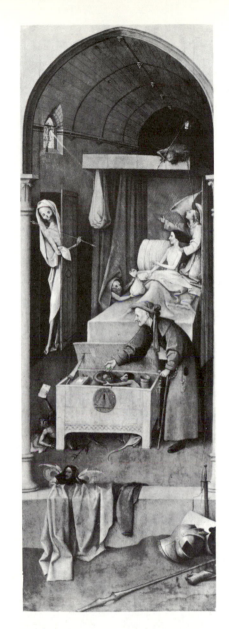

In a direct line from the Brussels *Crucifixion*, the Berlin *St. John on Patmos* (Fig. 251) continues the intimations of a larger development of the landscape in the earlier work. Three distinct eye levels have been put together in its construction, leading us from the St. John in profile to the panoramic river scene, the intermediate perspective zone being occupied by the angel (entirely in blue and with exotic wings), standing on a hill that recalls Bouts's Paradise scene in Lille (Fig. 171). Though the landscape lacks a true middle ground and a consistency, the whole is so masterfully handled that the incredibly tall Bouts-like tree at the right bothers us not at all. Undoubtedly, this work was influenced by Schongauer's engraving (see Chap. 18); the saint's eagle, however, has here become a black crow, which gazes balefully at a fantastic, beautifully painted, armored beetle with a white, pointed, human face, possibly a reference to the human-faced locusts of Revelation 9:7–9 but here given overtones of anticlericalism.

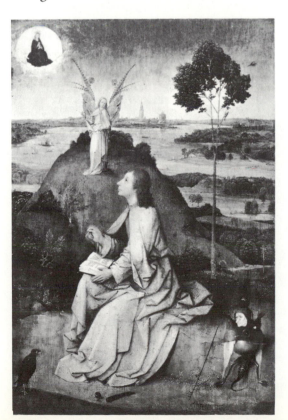

The back of the panel shows a series of scenes of the Passion grouped about the circular central scene of the symbolic pelican tearing its breast to feed its young. Recalling the Prado table top in its circular organization, it is even flatter in treatment, except for the recession above to the three crosses on the background hill. The technique here is the system of direct painting that Bosch developed to give vitality to his painted surfaces.

Bosch's biting commentaries came thick and fast at this time. The *Death of the Miser* (Fig. 252), in Washington presents in no uncertain terms the stupidity and folly of a dying man who, even at the moment of death, reaches for the bag of money offered to him by a demon

appearing from under the bed hangings and does not heed the angel who points out the salvation he could achieve by turning to Christ on the crucifix, shown before the high window. Originally Bosch had gone even further, for X-rays show that the vessel of the last sacrament once was held in the miser's left hand. The meaning is clear: at the moment of death he would sell even the sacraments to the Devil. At the foot of the bed, clutching his rosary, he puts money into his coffer as the moneybag within is obligingly held open for him by a small demon. Another demon holds up a letter, which could be either a letter of indulgence or possibly a mortgage, signed, sealed, and delivered. Thus Bosch comments ironically and pessimistically on human nature and its avarice even at the last moment of life. In style and subject Bosch went beyond his model from the *Ars Moriendi*. Elongation is used as an expressive element in the composition, and its arbitrary organization into three zones parallels that of the *St. John on Patmos*. Originally this was probably the inside right wing of an altarpiece, as the composition and the modern addition of a piece to the upper left-hand corner indicate.

below: 253. HIERONYMUS BOSCH. *Hay Wain Triptych.* c. 1490–95. Panel, 55 1/8 × 39 3/8″ (center), 57 7/8 × 26″ (each wing). El Escorial, near Madrid.

A fully preserved triptych of this early period of his maturity is the *Hay Wain* (Fig. 253), in the Escorial. It is signed on the left wing and seemingly is the original. A very close copy in the Prado, possibly from his shop, is signed in the central panel. The gaily colored central panel shows a large hay wagon, the symbol of earthly goods, which the whole world follows—pope, emperor, nobles, clergy, monks, nuns, the rich, and the poor—some fighting to grab what they can as it rolls by. A group of lovers sits on its crest, flanked by an angel and a demon. The angel looks up to a figure of the Christ of the Last Judgment in the clouds above, while the demon dances to the tune of his elongated nose-trumpet. On the narrow left wing the rebel angels, like a swarm of loathsome insects, are expelled from Heaven as God creates Eve below. Bosch is showing the two ways in which evil entered the world, for the second way, the Temptation and Expulsion from Paradise, in descending order, set the stage for the worldly vanities symbolized in the *Hay Wain*. A metamorphosis of the human into the demonic takes place before our eyes in the figures pulling the wagon toward the Hell scene of the right wing, where the Sins seem to be presented much in the manner of the Prado table top and man's misdeeds build a mighty tower in Hell. An awe-

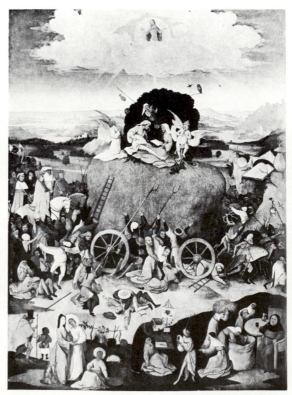
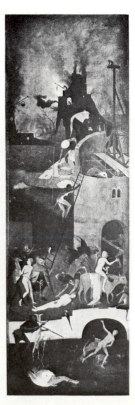

some, fiery landscape, probably based on medieval visionary literature and the manuscript tradition, forms the background.

Sigüenza in the early 17th century related the theme to Isaiah 40:6 and Psalms 103:15, but Tolnay discerned the context of the Flemish proverb that the world is a mound of hay in which each seeks to grab what he can. That greed for the vanities of this world leads man to Hell is clearly Bosch's meaning. He borrowed the organization of the painting from the tradition of Last Judgment triptychs. How unusual the artist's vision had become is now clear to see; no one of his contemporaries even essayed comparable allegories. Despite the present condition of the work, badly damaged and much repainted, the increased mastery of delicate tones and firmness of draftsmanship show Bosch's artistic maturity.

The partially repainted *Ship of Fools* (Fig. 254), in the Louvre, is closely related in time. The theme was popular in Flanders, where it was known as the *Blaue Schuut,* and in Germany as the *Narrenschiff;* Sebastian Brant devoted a highly popular book to it, with woodcut illustrations partially by Dürer, which was published at Basel in 1494 and is thus an aid in dating Bosch's painting. With superb liveliness and vitality it castigates roistering laity and clergy alike. A portion of what may have been a companion panel, *Intemperance,* is in the Yale Gallery in New Haven, Connecticut.

For this writer the Lisbon *Temptation of St. Anthony* (Fig. 255) epitomizes Bosch's unique expression and relation to his age. He lived in a time of pestilence and turbulence, of economic, social, and religious unrest, an age which believed in chiliasm, Antichrist, Apocalyptic visions, alchemy, witchcraft, and the witches' sabbath. Yet it was also an age of rational investigation and humanistic approach. The situation was not alleviated by Johann Stoeffler's famous astrological prognostication, published at Ulm in 1499, that the world would come to an end with a second deluge on February 25, 1524. This was widely believed, for astrology was taught in the universities and its predictions were listened to at court. A heightened interest in astrology was common both north and south of the Alps. It appears in Marsilio Ficino's *De Vita Libri Tres* and in the *Malleus Maleficarum* (the famous *Witches' Hammer*), a handbook on witch-hunt-

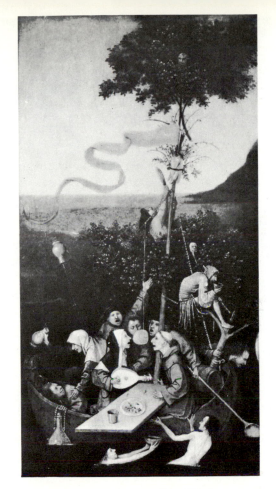

254. HIERONYMUS BOSCH. *Ship of Fools.* c. 1495. Panel, 22 × 12 ⅝″. Louvre, Paris.

ing first published about 1485 at Speier. In both works astrological predestination is given uneasy Christian resolution by the assertion of free will and the grace of God.

It was an age of extreme pessimism, the natural outcome of a belief in demons fostered by the Church itself: Thomas Aquinas had said that all that happens visibly in this world can be done by demons. The fears of the age are confirmed and concretely expressed in a papal bull of 1484:

It has indeed lately come to our ears, not without afflicting us with bitter sorrow, that in some parts of Northern Germany. . . many persons of both sexes, unmindful of their own salvation and straying from the Catholic Faith, have abandoned themselves to devils, incubi and succubi, and by their incantations, spells, conjurations and other accursed charms and crafts, enormities and horrid offenses, have slain infants yet in the mother's womb, as also the offspring of cattle, have blasted the produce of earth. . . afflict men and women. . . with piteous pains and sore diseases both external and internal; they hinder

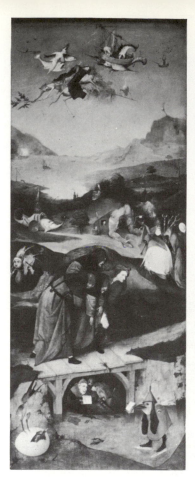
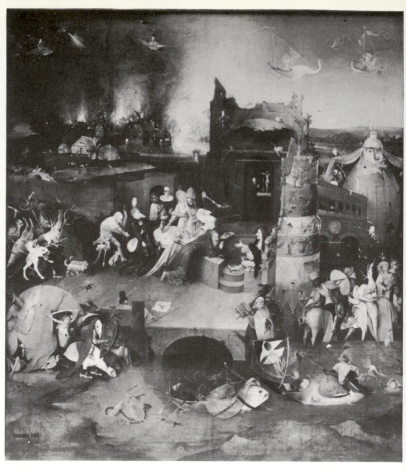

men from performing the sexual act and women from conceiving... over and above this they blasphemously renounce that Faith which is theirs by the Sacrament of Baptism, and at the instigation of the Enemy of Mankind they do not shrink from committing the foulest abominations and filthiest excesses. . . .

Belief in the coming of Antichrist was equally widespread; Sebastian Brant devoted a whole chapter to him, and Bosch later included him in his Prado *Epiphany*.

Pessimism has been seen in Bosch in the reiteration of human folly. He continually repeated the theme of the salvation of a foolish, evil world through Christ's sacrifice. It appears on the exterior grisailles of the *Temptation of St. Anthony* (Fig. 256), the scenes of the Taking of Christ and the Carrying of the Cross, which Bosch equated with the interior scenes of Anthony's temptations. From the account of St. Anthony's life current in Bosch's time it is evident that Anthony represented a type, the heroic and most elevated soul, tempted more strongly than ordinary mortals yet resistant to the fiercest attack upon his belief.

above: 255. HIERONYMUS BOSCH. *Temptation of St. Anthony Triptych.* c. 1500–05. Panel, 51 $^7/_8$ × 46 $^7/_8''$ (center), 51 $^7/_8$ × 20 $^7/_8''$ (each wing). Museu Nacional de Arte Antiga, Lisbon.

Anthony's temptations were of two kinds: *tentatio* in its meaning of a trial, that is, the temptation of the flesh in the form of worldly goods and sexual inducements—always rejected; and *tentatio* in its meaning of an attack. Bosch was a significant innovator; he combined the two meanings into a single representation spread over three panels, organized compositionally along diagonals. He also elevated the saint to a position comparable to that of Christ. Though this was suggested in earlier miniatures of an enthroned Anthony impervious to demonic assault, the conception here receives a more concrete expression, since the Christological scenes are relegated to the exterior. Inversion of the normal relationship is frequent in Bosch. It was inherent in late medieval symbolism that such a correlation should have developed, an example of the double or multiple reference which marks symbolically oriented thinking.

Just below center on the interior left wing Anthony is being returned along the bridge to his cell. His elevation and beating by demons is seen in the sky above. One demon dives under his cloak in the manner seen earlier in a Madrid Book of Hours by the Master of Mary of Burgundy. A fox-headed demon, reminiscent of the demon in the Pride scene on the Prado table top, beats the saint with a branch. A twin-tailed, armored merman riding an open-mouthed fish attacks, using another fish as a lance. The medieval *Physiologus* of Theobaldus equated mermaids with lying men who speak fair but do evil deeds, thereby destroying men's souls, and this merman figure is a close, intended parallel to the goading soldier on the exterior grisaille of the Taking of Christ.

In the middle ground a habitation is created from the back view of a kneeling man with grass growing over his back. He is rooted in earth, which to Bosch meant being rooted in sin. This meaning is emphasized by the rear view and by the woman at the window embrasure at the left, a prostitute waiting for customers. A related idea appears later in the *Vagabond,* or *Peddler,* in

Rotterdam. The staff leaning against the brothel, the barrel, the flag with the swan, whose white exterior was commonly considered to cover black flesh, and the woman at the window appear in both. Clearly Bosch was attacking prostitution, which *La Somme le Roi,* a popular moralizing treatise of the late medieval period, calls the ninth branch of avarice.

A fantastic fish form with a church tower on its back approaches down the path while apparently swallowing another fish. This might seem to illustrate the Flemish proverb that the big fish eat the little fish, but the greedy eyeing of an apparently edible ball, suspended before it as a steering device, suggests, like the greedy dog with the bones at his feet in the table-top Envy scene, greed and envy, combined with an allusion to the rapacity of the Church. The whole figure, however, seems to be Bosch's transformation of an armored elephant with a howdah on its back, a motif found in battle scenes in early 15th-century manuscripts, and the tail in the creature's mouth resembles an elephant's trunk. The elephant with a tower was a medieval symbol of the Virgin, for, according to medieval lore, it was notoriously sluggish in sexual matters and thus was associated with chastity. (The *Physiologus* says that the female elephant cannot conceive unless she first plucks the mandrake from outside the gate of Paradise and then eats and offers it to her mate to awaken his sexual desires.) The moral presents the elephant as the ideal Christian spouse, who will mate without sexual appetite solely for the sake of offspring. Bosch's unvirtuous creature, however, symbolizes the very opposite of such chaste behavior as it advances down the path toward the house of prostitution. It is clear that in this sinful world Christian virtues are transformed into their opposites. The *monde renversé* was a popular motif in late medieval manuscripts.

On the right a curious trio appears. The stag, in a red cloak, was a common symbol of lechery in the moralizing tales of the period. The miter-crowned man holds a staff topped by a crescent, a clear reference to the terrifying, infidel Turks, who were then a strong threat to Europe. The decoration of his miter is abnormal, and flames emerge from it. These details are significant, however, for a heretic handed over to the Inquisition had a miter placed on his head just before burning, as is known from accounts of witchcraft

256. HIERONYMUS BOSCH. Exterior scenes, *Temptation of St. Anthony Triptych* (Fig. 255).

trials at Arras in 1461, where one woman was saved from burning because her miter was not ready. Thus Bosch was portraying a "bishop of witches." This portion of the left wing is related to two existing miniatures that illustrate treatises on witchcraft, each of which shows a group of people adoring the posterior of a goat. The idea is less crudely seen in Bosch's naked man in the boat in the sky above.

The fish-mounted figures in the sky on the right wing repeat a man and a woman in one of the miniatures, who are riding to the witches' sabbath on a flying sheeplike demon. The use of a fish as a mount is in keeping with Bosch's transformations, for the flying boat of the left wing is derived from the whale of the medieval bestiaries, according to which it was normal for sailors to land their ship on an island that turned out to be the sand-covered back of a whale. When they built a fire on the "island," the results were disastrous. Thus the whale was moralized; it became the Devil, who drags the unwary to perdition. Though the whale was never considered a flying fish, another fish in the bestiaries did fly, and this too was eventually linked to the Devil, who controlled the air over medieval Europe. That supreme heretic is, of course, the basic support of all sins and heresies,

and in the guise of the flying fish, outside its natural element, he supports flying witches. Heresy, according to *La Somme le Roi,* is a branch of the sin of pride.

The evil trio beneath the bridge is approached by a funnel-crowned, sleepy-eyed bird on skates. There is a missive spiked on its beak, with an inscription that may be read as "oisuf" with a reversed *f* or "oisuy," variants of modern French *oisif,* an idler, that is, Sloth. In truth this is a lazy bird who prefers skating on thin ice to walking. He slides into sin and sinful company as did the granddaughter described in the *Revelations* of St. Birgitta: "I slide ayene int-to synne as he that slideth upon yse; for my wille was coolde and wolde not aryse and flee froo the thinges that delited me." Bosch points out how man slides into sin by refusal to exercise his freedom of will to resist the Devil.

At lower left, perched on a gigantic egg, a large-beaked, featherless bird with teeth (in type close to the woodcock, well-known for its maternal devotion) eats one of its own offspring as they hatch from the egg. Placed in a position of equal importance with the sleepy, slothful skater, this must be a unique presentation of Saturn, who devours his own child. Late medieval thought allied the planets and the Deadly Sins, and Saturn, being the slowest of the planets to orbit the earth, was allied, as here, with Sloth.

Gluttony is the Deadly Sin castigated on the interior right wing, where Anthony is tempted to indulge in riotous living by the naked woman standing in water, an instrument of the devilish, lolling toad who grasps in one clawed foot her filmy garment that covers but does not conceal. The nude woman was probably inspired by the apocryphal story of the Devil Queen, translated from Arabic in 1342 by a monk, Alphonsus Bonhominis, and first fully illustrated in a manuscript of 1420, now in Malta, originally made for the Hospital Order of St. Anthony. In the tale of the saint's encounter with the Devil Queen, Anthony found her bathing nude in a river with her court. When properly dressed, she discoursed with the saint and invited him to visit her city, where she showed him its riches, demonstrated her miraculous power to heal the sick, and finally invited him to become her husband. Anthony, overwhelmed by all this, as well as by her verbosity, declined, but she persisted and attempted to remove his monk's habit.

This act he recognized as truly devilish and fought her off, whereupon devils flew in from every point and the battle began. After several days of fighting Anthony emerged victorious.

On the table at the lower left appear two loaves of bread. Two loaves also appear on the ground before Anthony in an earlier miniature of his temptation, there borrowed from the temptation of Christ. Their presence here demonstrates again the internal-external relationship between Christ and Anthony, which is even more explicit in the naked figure supporting the table with his knees as blood flows from a wound in his leg. In a gloved hand he holds a damaged sword, no deterrent to a feline demon leaning forward to slit his throat, an illustration of Christ's words from the Gospel of Matthew 26:52, "... all they that take the sword shall perish with the sword." (The action which occasioned the words of the Gospel, the severing of the ear of Malchus, servant of the high priest, is prominently displayed in the foreground of the exterior left wing.) A musician blows smoke from a trumpet-like instrument, from which a sausage dangles. Comparable figures in medieval art represent the acrobat or jongleur and are often symbolic of the fool. A similar figure occurs in a woodcut of Hell of about 1482, by the Netherlander Gherart Leeuw, but without the filmy undergarment of Bosch's figure, which in early 15th-century manuscripts clothes the personification of Vanity, the *imago vanitatis*. Thus Bosch augmented the sin of gluttony, indicated by the sausage, with the lesser sin of vanity. The adjacent figure, with a foot in a pot, and the fantastic creature with both feet in a single shoe, like a pig with both feet in the trough, reinforce the idea of gluttony. In the middle distance appear a porcupine, a common medieval symbol for the temptations of the flesh, and a simple-faced creature in a 15th-century baby walker, to the rim of which is tied a jug; this figure is a castigation of drunkenness, which makes men childish and foolish. Foolish indeed, for the drunkard turns away from the saint whose model he should follow.

The theme of the central panel, ostensibly derived from the Athanasian account of the life of St. Anthony by way of the *Golden Legend*, is that of a kneeling Anthony too weak from demonic beatings to rise, yet able to taunt his demonic tormentors to do their worst. But instead of taunting, Anthony turns to the spectator, his right hand raised in blessing, while the figure of Christ, who has made his victory possible, is almost lost in the shadows of a niche-like chapel. Behind Anthony appears the temptress, the lizard-like tail of her gown revealing her true character. She offers a shallow cup of wine to two fantastic figures. The proffered wine is seemingly the *saint vinage* made annually at the seat of the Hospital Order of St. Anthony in the Dauphiné by pouring wine over the saint's relics. This procedure, we know, was believed to give the wine miraculous curative powers, and the potion was given to those suffering from St. Anthony's fire, the *ignis sacer*. (This disease was probably ergotism, which came from eating poisoned rye and was endemic in medieval Europe.) Bosch alluded not only to the story of the Devil Queen and her pseudomiraculous cures but pessimistically showed also how demonic power to counterfeit all human acts could even make mockery of the good works of the Hospital Order. The lolling toad holding a cup, on the right wing, reinforces the idea.

To the left of Anthony and the temptress in the center panel is a group dominated by Luna, the cold and moist planet of the night, responsible for the nocturnal aspect, and a reminder that Anthony's foul and troubling dreams came to him at night. Portrayed with yellow garments and face, Luna herself stands behind the table at Anthony's back, beside a young gambler, cup in hand, who is the gullible victim of the gesturing owl-crowned conjuror opposite. (The conjuror is one of the children of Luna, and the conjuring theme was treated separately in a work known only in copies, the best version now in the museum at Saint-Germain-en-Laye.) The source of this group lies in a Florentine astrological engraving of Luna from a planet series of about 1460, in which a swindler in fool's attire cheats a gullible public before his table; a monkey, southern equivalent of the northern dog on a leash (shown here), clings to his leg. Further borrowings from the engraving are seen in the double-arched bridge at the right, which here forms the base of a prison; the "clock" on the wall is a transformation of the sundial on the bridge in the engraving. Since this 1460 engraving is the only version of the theme that includes the sundial, it may be accepted as Bosch's source. He also borrowed the swimming

and diving figures from it and he made use of other engravings in the 1460 planet series as well: from the Saturn engraving he derived the prison, a monkish almsgiver offering a cup in the foreground, a prisoner behind bars, a mother and child, and a butchered pig—all thoroughly transformed.

The mother and child of the Saturn engraving have been transformed here into the weird woman holding a swaddled child as she rides a rat in the water at center right (Fig. 257). Her body ends in a fishy tail like that of a strange mermaid, with its connotations of evil. However, with her associates she also suggests the compositional type of a Flight into Egypt combined with an Adoration of the Magi, both themes conceived as antitypes, which are understandable in relation to the prevailing belief in Antichrist. Parallel events from the life of Christ and Antichrist appear in 15th-century manuscripts.

The Jupiter engraving in the planet series provided the motif of the thistle-headed hunter riding a metamorphosed jug beside the rat, and mastiffs of the same engraving have become the armored lap dogs preceding the tree-crowned, armored man in red stockings at the far left, clearly personifying Mars, the warlike planet. Other images relate to the planet Venus, such as the monk roistering to the left of the onion tower and surely representing Lust.

Not all the images constitute a castigation of astrological beliefs. At the front of the platform is the blasphemer who had cursed the saint and lost a foot for his impiety, and behind the central

group a Negro heretic holds aloft a tray with toad and egg, both having demonic associations, particularly the toad. The list of associations is too long to be enumerated here. Taking the group in front of the platform as a whole, we find a parody or rather a castigation of the vanity and folly of love tourneys, knights, and chivalrous ideals. The figures suggest stupidity, pugnacity, stubbornness, and folly; all lead to Death, and all are led by it. At the right of the platform a pig-snouted, demonic priest reads from Anthony's book (Fig. 258), a motif related to paintings of the temptation of St. Anthony by two contemporaries, Bernardo Parentino in Italy and Matthias Grünewald in Germany; the origin of the motif is Italian and traceable to a manuscript of 1410. Here Bosch has presented the general outlines of a further denunciation of corrupt clergy and corrupt monks.

On the ruined tower appear other scenes, in simulated relief. The figures dancing about the Golden Calf and the worship of the ape (i.e., false gods) show a renunciation of that faith given to man through the Sacrament of Baptism, represented in prototype on the band below by the return of the emissaries to Hebron carrying a gigantic cluster of grapes. The incompleteness and error of the Old Testament reign, even though there is no apposite construction to symbolize the new dispensation; however, it may be discerned in the figure of Christ within the chapel. In giving artistic prominence, and therefore greatest attention, to Anthony, Bosch seemed to be elevating him above Christ; that

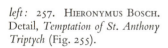
left: 257. HIERONYMUS BOSCH. Detail, *Temptation of St. Anthony Triptych* (Fig. 255).

right: 258. HIERONYMUS BOSCH. Detail, *Temptation of St. Anthony Triptych* (Fig. 255).

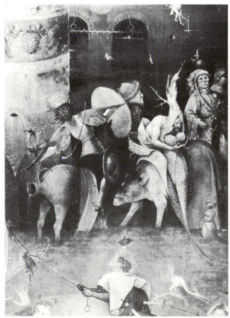

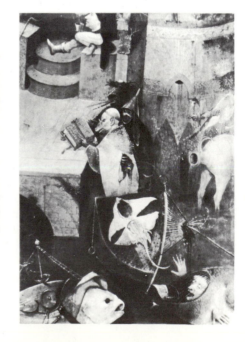

Bosch was reputed in the 17th century to be a heretic may be due to this.

In the sky above, devils are in full control. Some burn a village at the left and others topple the church tower, possibly a warning of the coming of Antichrist. High in the sky to the left a strange cavalcade is led by a gaunt demon mounted on a flying fish, with a bow over his shoulder. He can be recognized as probably inspired by Dürer's famous woodcut of the Four Horsemen of the Apocalypse and thus aids in dating this work as about 1500.

The cosmic character of this conception of the temptation of St. Anthony is overwhelming; air, earth, fire, water, wet and dry, heat and cold —everything in the heavens and on earth was Bosch's concern in this grand pictorial *summa* of all the beliefs and fears of medieval man, to which astrology and the theme of the Seven Deadly Sins, allied with the theme of Antichrist, contributed the chief elements. The synthesis was carried further: the planets were related to specific sins, Saturn with Sloth, Luna with Envy, Mars with Wrath, Mercury with Avarice, Venus with Lust, Jupiter with Gluttony, and Sol with Pride. Synthesis is also seen in the unification of the two major themes of Anthony's temptations.

It is evident that Bosch represented the saint as prey to all that frightened his contemporaries but pointed out the road to salvation traveled by that knight of Christ, St. Anthony Abbot. Though under the influence of Saturn, and thus astrologically predestined to an unfortunate life, Anthony had nevertheless overcome the Devil, been victorious against the Seven Deadly Sins, and surmounted the evil effects of the planets.

Bosch's extraordinary ability to organize disparate metamorphosed forms into a unified whole achieved its peak in the triptych called the *Garden of Earthly Delights* (Fig. 259), now in the Prado. Like the *Hay Wain,* it shows Paradise and Hell scenes flanking the central panel. In the St. Anthony panels the world is almost exclusively peopled by demons; here nude mankind either disports itself in paradisiacal innocence, according to one explanation, or, what is more likely, expresses in its tapestry of innumerable tiny, naked figures the sinful activities of humanity, as Sigüenza in 1605 and almost every writer since has concluded. Axially diagrammatic, gay and light in color, this proliferation of symbolic and actual sinful behavior

takes place in a landscape whose reality is as illusive as it is allusive. In it giant fruits, bubbles, and birds are occupied, penetrated, and ridden as mounts. Worldly pleasures and worldly edifices lack substantiality; "all flesh is grass, and all the goodliness thereof is as the flower of the field" were the words from Isaiah 40:6 that Sigüenza applied to the *Hay Wain* and to this work as well, but that Bosch illustrated this specific text is not at all certain. A more detailed text probably underlies the imagery, and scholarly efforts have been devoted to its discovery, with little agreement except in the interpretation of certain details, such as the devouring bird-monster, whose defecation of souls accords with the visionary journey of Tondalus.

Yet so great is the delightful variety of shapes and colors that the appeal of the work is immediate and its effect evocative, despite our inability to read clearly what is obviously a moral narrative. The work has appealed greatly to the surrealists because of such images as the rock in the shape of a man's face on the left wing, the meaning of which has a moralizing intent; the devouring head made up of human bodies, which is actually a Hellmouth, located exactly on center one third of the way up on the central panel, a surrealistic double image visible when one squints at it; and the human monster on the right panel, with an egglike body, blasted tree trunks for legs, and large boats for feet. A balancing element in the Hell panel for the pink fountain of the Paradise panel, this last figure is surrounded by condemned souls in varied actions. Their frantic activities are as devoid of purpose in Hell as in life. Again Bosch's sardonic pessimism colored his portrayals; even the scene of the third day of Creation, on the exterior, shows the incipient proliferation of all organic forms over the earth's surface.

As in the St. Anthony panels the interior forms are arranged in three zones; here they are lighter, more linear, more graceful, and more like fanciful arabesques but governed by a sublime conceptual logic in which the reality of the allegorical images sweeps away all questions based on natural logic.

The *Garden of Earthly Delights* is the high point in Bosch's creation of imaginative, autonomous, fantastic allegorical organisms. Undoubtedly created in the last decades of his life, it stands at the brink of his late style, which may be introduced

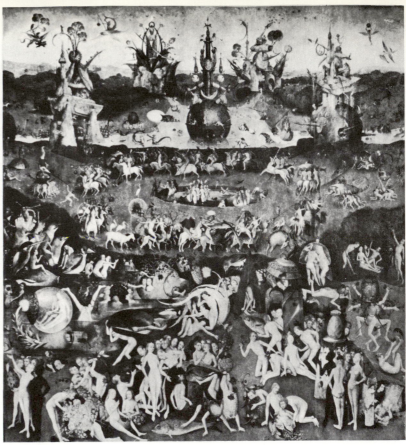

with the Prado *Epiphany* (Fig. 260). This too has a recondite iconography discovered in the figure symbolizing Antichrist, half in and half out of a shed seemingly derived from the Master of Flémalle's Dijon *Nativity* (Fig. 90). The shed is set against a high horizon, in front of which warring armies move back and forth, a theme related to the Magi and the armies of Herod. Shepherds climb the roof of the shed to observe the Magi's adoration, while the donors, presented by their patron saints, kneel in adoration on the wings. Joseph has been relegated to the background of the left wing, where he dries diapers, which recalls the mockery of Joseph in art a century earlier. The larger areas of local color and general simplification of forms and landscape contrast with the *Garden* triptych. The shape of the frame also indicates the later date.

Possibly Bosch's last work is *Christ Carrying the Cross* (Pl. 17, after p. 308), in Ghent, its compacted composition presenting a climax to earlier treatments of this theme by the painter. The Ghent panel parallels the concentration on emotive fragments found in Geertgen's late *Man of Sorrows* (Fig. 204). Bosch employed the compacted form for a mordant commentary on the evil world. Even the good thief is not good in the ordinary sense, and only Christ in the center and St. Veronica have any real sense of goodness about them. The world is a fantastic place in which goodness is difficult to discern and obviously rare. Diagonally organized in a cross form, with a triangular group at the lower right about the thoroughly unrepentant thief to balance the strong diagonal of the cross, this crowded composition has little depth. Bosch masterfully varied flat and plastic form, spatial chiaroscuro and the lack of it, surface enrichment, often of a fantastic type, and rich, glowing, resplendent color opposed to areas low in value but fresh, after cleaning, because of the *alla prima* technique. Added to this variety is the telling use of silhouette. Indeed, all the potentialities of style that an artist can be capable of seem to have been united in this last great outpouring of Bosch's reaction to a world that has become completely evil. This is the ultimate refinement of Bosch's treatment of this theme, in which the spectator is now psychologically involved, as Bosch himself had finally became involved. He has brought the spectator so close that the painted forms seem to exist within our own actual space.

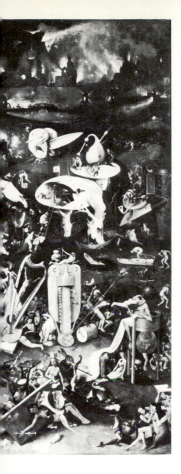

The "Neo"-Gothicism of the *Garden* triptych has disappeared, and one wonders whether the reason for the new quality seen in the Ghent painting's variety of forms, colors, lights and darks, active and passive figures is that Bosch had seen Leonardo's caricatures (which were known to Metsys) and had used them in the pursuit of his highly personal art. Thus far Bosch's art was in opposition to the direction taken by his contemporaries, whose approach to the natural world was becoming organic under the influence of Italian ideals and objectives; his last work, with its concentration upon the heads as the chief emotive focuses, would have been impossible without the contemporaneous development of the portrait as revelatory of the psychology of the individual.

Though Bosch had denied the Renaissance by asserting a truly medieval outlook, in the end he responded to the new spirit, his very individualism showing that he could not transcend the rising forces of his day. The ultimate conclusion from Bosch's art is that like Sophocles's Oedipus, Camus's Sisyphus, or Faulkner's Dilsey, man must endure.

above and left: 259. HIERONYMUS BOSCH. *Triptych of the Garden of Earthly Delights.* c. 1505–10. Panel, 86 5/8 × 76 3/4″ (center), 86 5/8 × 38 1/4″ (each wing). Prado, Madrid.

right: 260. HIERONYMUS BOSCH. *Epiphany Triptych.* c. 1510. Panel, 54 3/8 × 28 3/8″ (center), 54 3/8 × 13″ (each wing). Prado, Madrid.

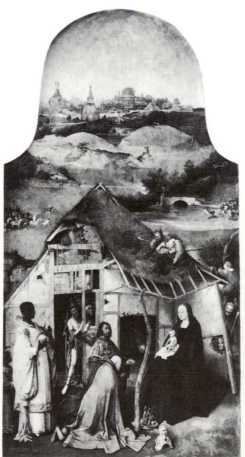
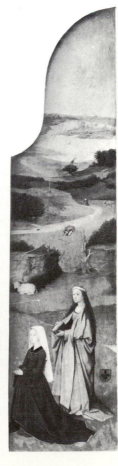

THE PAINTERS OF FRANCE 14

To speak of a French art of the 15th century is to give a false impression of unity. As elsewhere in Europe, the Gothic was not supplanted in the 15th century by a totally different style; it lived on, in some regions subterranean but in France clearly visible on the surface, as has been seen, for example, in the discussion of the later stages of the International Style. French *continuité* and French ability to assimilate foreign achievements may be considered positive conservatism, in the sense that the greater forces of Flemish mystic naturalism and Italian rationality were acknowledged, as they had been already in the later years of the 14th century. For over a hundred years more France was not to resume the lead it had attained in the 13th century. During the 15th century it was open to a sophisticated choice by which it demonstrated its capability for assimilation and synthesis.

However, the lack of artistic unity and leadership is at least partially to be explained by the historical and political developments of the first half of the 15th century, which, by their continuing turmoil, compounded the difficulties in the path of artistic advancement.

When Charles VI died in 1422, the nine-month-old king of England, Henry VI, was proclaimed king of France, with the support of Philip the Good of Burgundy, and Paris was ruled by the regent, John, Duke of Bedford. The Dauphin, the future Charles VII, had to retreat to Bourges as the English consolidated their gains in Normandy. By 1428 they had penetrated as far south as Orléans. Then Joan of Arc appeared to free Orléans and lead a reluctant Dauphin to his coronation at Reims in 1429. Though she was captured and burned at Rouen by the English in 1431, able generals took her place, and the war took a new turn with a treaty with the Burgundians in 1435, the recapture of Paris in 1436, and the gradual expulsion of the English. By 1453, with the end of the Hundred Years' War, they retained only Calais of all their vast possessions on the Continent. France was finally free and victorious, but she had paid a terrible price in depopulation, destruction, famine, and lawlessness, all of which throttled the production of art.

The consolidation of French monarchical power, begun under Charles VII, was continued after his death in 1461 by his son Louis XI, who gradually reduced the power of the nobles. The death of Philip the Good in 1467 and of his successor, Charles the Bold, in 1477 ended the threat of the Burgundian house, and by diplomacy rather than warfare Louis XI, who during his reign almost doubled France's territory, laid a solid groundwork for the monarchical absolutism of the succeeding centuries. His able daughter, Anne of Beaujeu, who was married to Pierre of Bourbon, served as regent during the minority of her brother, Charles VIII, and continued her father's policies. When the Valois line came to an end with the death of the childless Charles VIII in 1498, his successor was a

member of the Bourbon family, who became Louis XII. By this time a consolidated France could and did meddle in Italian affairs. Though this meddling produced no territorial gains, it opened the door to Italian influence, so that by the second decade of the 16th century French art was following a new course.

From such a recital of events one would expect little to have been created in France before mid-century, and, indeed, little can be found even in the provinces before the 1440s. Even at that time, to create a national art was an impossibility. What appeared was a series of local styles created by distinct artistic personalities. One can scarcely say even that there were regional styles, except possibly in Provence, then ruled by King René of Anjou. In northern France, Burgundy, the Touraine, Anjou, central France, and Provence the artistic *trait d'union* was a lack of interest in the spatial chiaroscuro of Flemish art and an avoidance of its mystic drama; yet there was a dominance of Flemish conceptions of naturalism. In short, the art of France in the 15th century absorbed a portion of the artistic outlook of its two powerful neighbors, Flanders and Italy, which it wedded to its pre-existent Gothic models.

No longer in the forefront of art developments, France could not, even in its greatest productions of 15th-century art, surpass the great Flemings and Italians, though in literature François Villon (1431-63?) was one of France's greatest figures. Nevertheless, there emerged during the course of the century certain qualities of logic, balance, coolness, and clarity in art that have come to be considered typically French and have been carried over into the great French art of succeeding centuries. The masters, both known and unknown, who brought these characteristics to the fore in this unsettled period made a contribution that cannot be overlooked, for among their works are many of high quality and great iconographical interest, whose artistic vocabulary is unmistakably French.[1]

NORTHERN FRANCE

The artist often considered the outstanding French painter in the north was Simon Marmion, whose manuscript illumination has already been considered as Flemish. His painterly style,

though he was most strongly influenced of all by Flanders and by the conceptions of Rogier, differed in the idyllic view of nature and the extremely refined, soft, almost pastel tones of pink, delicate olive-green, and blue-gray. Gentle, in contrast to Flemish art, and often elegant, his paintings are governed by the restraint and balance that had appeared in his miniatures, that conservatism of outlook which accorded so well with the outlook of the Flemish court miniaturists.

His chief work is the *St. Bertin Altarpiece* in Berlin (Fig. 261) painted for Abbot Fillastre of the abbey of St. Bertin at St-Omer. Commissioned in 1454 and completed by 1459, it deals with the events of the life of the patron saint of the abbey. The work may have been influenced by Rogier's *Seven Sacraments Altarpiece,* though a like penetration of interior space is also visible in the work of the Mansel Master, whose relationship to Marmion has been mentioned. However, the figure types are like those of the miniaturists, and Marmion further differs from Rogier in flattening space by setting his figures as foils to landscapes. His light is as gentle as his coloring, shadows are never intense, and peaceful landscapes with tender blue tones that verge on the misty are only settings for the gentle interplay of figures and architecture flowing across the surfaces of his panels.

This spirit is also visible in the Philadelphia *Crucifixion* (Fig. 262), which is more advanced in conception than the painterly miniature of the same theme from the *Pontifical of Sens* (Fig. 234). As in his other works he omitted the snow-capped mountains of so many Flemish landscapes. When he used strong color in the foreground, he localized and restrained it by surrounding it with pastel tones and closely related values. These are generally light and set against the merged tones of the background.

In portraiture the attributed *Canon with St. Jerome* of about 1459, in Philadelphia, seems harder in character and sharper in modeling. Not so dramatic as Flemish works, its figure style seems somewhat distant from Marmion, though the setting of the figure against the interesting landscape is very much like his work.

The representative of late 15th-century painting in northern France second in importance to Marmion is the Master of St. Giles, who takes his name from a series of panels devoted to that

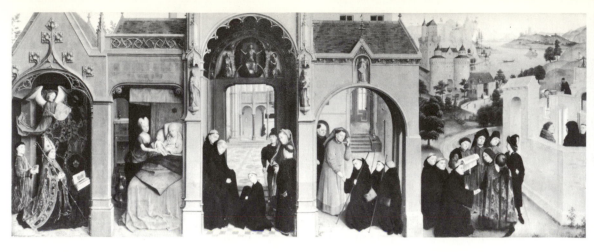

above and right: 261. SIMON MARMION. *St. Bertin Altarpiece,* wings. 1454–59. Panel, 22 × 57 ⁷/₈″ (each). Gemäldegalerie, Staatliche Museen, Berlin-Dahlem.

saint. His panel in London of the saint saying mass at the altar of the church of St. Denis has been useful to art historians, for it reproduces the Carolingian altar that was destroyed in the French Revolution.[2] The scene of the saint protecting a hind (Fig. 263), having been shot through the hand in so doing, is also in London. It reveals a generalized Flemish influence, a standing figure at the left suggesting Bouts's

Justice panels as a possible model, but there is almost a return to early 15th-century art in presenting the foreground like a *millefleurs* tapestry with an evenness of handling that is dominant throughout. Without the dramatic spatial grandeur of the Flemish, it shows instead a delicacy, a balance and rational ordering of form, and almost a sophistication in the portrayals. Another work is the *Conversion of an Arian by St. Remi,* in Washington. In all this artist's work the color is delicate and rather decorative, and there is a feeling for large, simplified surfaces. His figures normally cast no shadows and thus exist in a

below: 262. SIMON MARMION. *Crucifixion.* c. 1470–80. Panel, 35 ³/₄ × 37 ¹/₂″. John G. Johnson Collection, Philadelphia.

right: 263. MASTER OF ST. GILES. *St. Giles Protecting a Hind.* c. 1480–90. Panel, 24 ¹/₄ × 18 ¹/₄″. National Gallery, London.

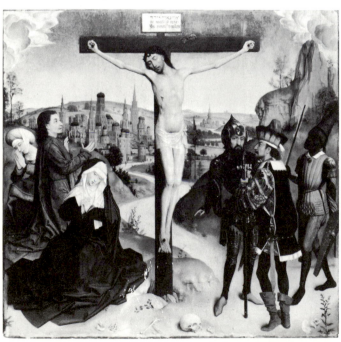

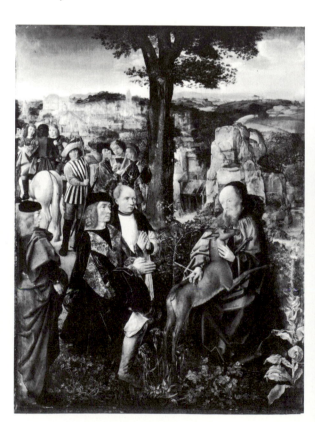

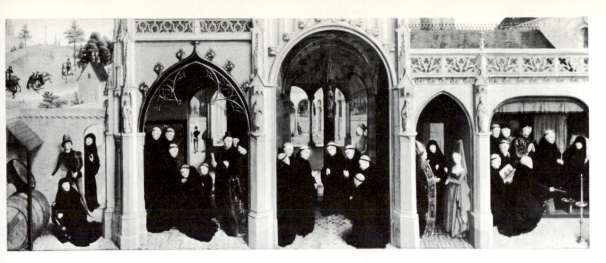

patterned relationship that stresses outline and delicacy of surface. As a result one feels that the artist abstracted his forms, governed in his selections by a rational approach, an intellectual clarity, and a fine sense of balance. Thus one feels that composition, a rational element, is clearly present, something that never strikes one first in Flemish art, where the forms seem to exist naturally; here the bones of the composition seem to stick out more strongly, in part due to the intentional elimination of atmospheric effects.

JEAN FOUQUET
AND HIS FOLLOWERS

Elsewhere in France the artistic developments followed at a remove the larger Flemish developments, for Flanders, in greater or lesser degree, dominated all Europe beyond the Alps in the 15th century. From the Touraine came France's chief 15th-century artist, Jean Fouquet.[3] The first well-known French artist, he created a measured, harmonious unification of northern and southern ideas. Compared to the Flemings he was a draftsman with clean, cool colors; compared to the Italians he was fluid and atmospheric. Neither dramatic nor mystic, his works show a laconic, sober, ordered style, never visionary and never exuberant. Hierarchy, order, poise, balance, and restraint are his outstanding traits.

Born at Tours about 1420, he may have been a priest's illegitimate son, for there is a record of a Jean Fouquet, clerk of the diocese of Tours, who applied in 1449 to have his birth legitimized by papal decree. That our Jean Fouquet came from Tours is a striking coincidence. Where he was trained is not known, though his early work

shows a plasticized Bedford style that might have been acquired in Paris. He was famous early, for in Rome sometime between 1443 and early January, 1447, he painted Pope Eugenius IV with his two nephews, as is known from Antonio Filarete's comment in his book on architecture of 1461. Eugenius IV died on February 23, 1447, and it is possible that Fouquet accompanied a French mission sent to Rome in the summer of 1446. On his return he set up his shop in Tours, where it remained until his death sometime before November 8, 1481, when the parish records refer to his widow and heirs.

Unknowns do not make papal portraits, and it may be that he had already painted the French monarch before he went to Rome. A painting in the Louvre of the King (Fig. 264), undoubtedly by Fouquet, bears an inscription informing us

264. JEAN FOUQUET. *Charles VII. c.* 1445. Panel, 33 $^{7}/_{8}$ × 28 $^{3}/_{8}$". Louvre, Paris.

265. JEAN FOUQUET. *Self-portrait.* *c.* 1450. Enamel, diameter *c.* 3". Louvre, Paris.

that this is the "very victorious" Charles, "seventh of this name." (The victory referred to is probably the Truce of Arras, rather than the victories of 1450, for no Italian influence is yet seen in the style.) The unidealized monarch looks far more sad than victorious; stylistically the work resembles a large miniature, with an incisive use of line, little sense of space or plasticity in the generalized face, garment, and setting, and a fluid animation of the surface by light. Fouquet's sober clarity of vision and calm

below: 266. JEAN FOUQUET. *Melun Diptych* (now divided). *c.* 1450. Panel, 36 ⅝ × 33 ½" (each). Gemälde-galerie, Staatliche Museen, Berlin-Dahlem (left); Musée Royal des Beaux-Arts, Antwerp (right).

expression are notable both in this portrait and in his *Self-portrait,* a small enamel of about 1450 in the Louvre, showing head and shoulders flanked by the decoratively animated signature of the artist (Fig. 265). This is the first preserved independent northern self-portrait that was designed as such, rather than as a portrait in the guise of St. Luke. It was painted from a mirror, which explains the intensity of value contrast around the eyes, for these were painted in after-ward. There is a greater contrast of light and dark than in the Charles VII portrait but no increase in modeling. Otherwise the method is much the same: description of a generalized sur-face, airless space, clarity of outline, and a vitalizing concentration around the eyes.

Fouquet's most famous panel painting is the *Melun Diptych* (Fig. 266), now divided between Berlin and Antwerp but known to have been together in the 18th century. Etienne Chevalier on the left-hand panel (Berlin) is being presented by his suppliant name saint to the enthroned Virgin and Child on the right panel (Antwerp), who are surrounded by large, rounded, red and blue nude seraphim and cherubim. It has been thought that the Virgin is a generalized portrait of Agnes Sorel, the king's mistress, who died in 1450. This may be a commemorative work, for Etienne Chevalier, then controller general, who in 1452 became treasurer of France, had worked very closely with Agnes Sorel in govern-ing the kingdom. Underlying the perspective-nonperspective treatment of the two panels (an

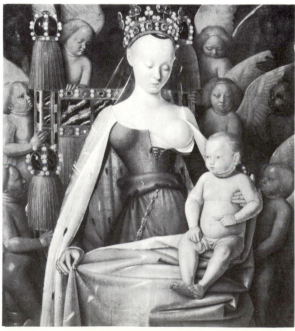

right: 267. JEAN FOUQUET. *Guillaume Jouvenal des Ursins.* c. 1455. Panel, 36 1/4 × 29 1/8″. Louvre, Paris.

below: 268. JEAN FOUQUET. *Guillaume Jouvenal des Ursins.* c. 1455. Drawing, 10 1/2 × 7 5/8″. Kupferstich-kabinett, Staatliche Museen, Berlin-Dahlem.

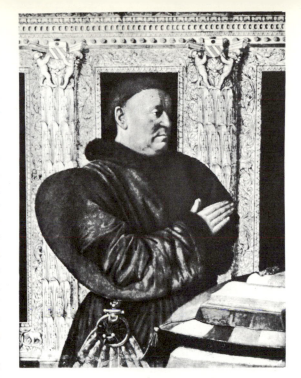

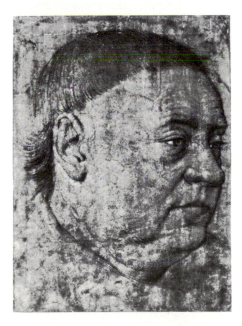

idea to appear later in Flanders in Memlinc's *Martin van Nieuwenhove Diptych* of 1487, Fig. 224) is the conception of natural space and celestial space. Thus the Virgin exists in an undefined, abstract setting, an abstraction also evident in the emphatic rounding of the generalized forms. The impossibly widely separated breasts, the rounded face and high forehead (the fashion of the time, achieved by shaving back the hairline), rounded angels and Child, heavy jewels and tassels are all presented with a dispassionate, detached clarity which vies with an almost insouciant stylized delicacy.

Fouquet's art has been called monumental, but it lacks the weightiness of truly monumental form. Etienne Chevalier is not actually a monumental figure. Set against a light-colored Renaissance architectural backdrop, the figures, cut off below the waist, present an abstraction of volumes and generalization of features of a type little evident in Flanders; Fouquet did not feel the necessity so common in Flanders, even in Rogier, to suggest the existence of the rest of the body in an airy space continuous with external space. The Flemish often provided a balustrade or ledge at the bottom of the painting; Fouquet's airless pictorial space is thus only an allusion to natural space, whereas the Flemish artist was far more concerned with the extension of nature into the pictorial form, with an interrelationship between the spaces—in short, with the illusion. To this end Jan van Eyck had treated his frames illusionistically; Fouquet and the French, more abstract and intellectual in their approach, did not. They conceived pictorial space as quasi-independent of natural space.

This spirit also animates the portrait of *Guillaume Jouvenal des Ursins* (Fig. 267), in the Louvre. Painted about 1455, the figure is conceived as close to the picture plane, much like Etienne Chevalier, though there is no patron saint as in the earlier painting. The figure is abstracted, much in the manner of a modern photograph, to which it is also related by the artist's characteristic velvety undulation of surface. The highly ornamented background creates

a masterful effect of richness as well as an allusion to power, for the coat of arms supported by bears on the capitals of the pilasters is that of the Orsini family, to which the Ursins family pretended a relationship. Guillaume's brother was archbishop of Reims. He was chancellor of France under Charles VII and Louis XI and was granted the privilege of displaying the Orsini arms ("Ursin" meaning bear cub).

The preparatory drawing (Fig. 268) for the portrait in Berlin (Kupferstichkabinett) has often

been compared to Van Eyck's preparatory drawing for the Albergati portrait (Fig. 116). The comparison is instructive, for Jan van Eyck conceived his figure as a whole and subordinated the details of the features to the expression of a living form in a spatila milieu; the result is an incisive portrayal of the individual as well as a strong drama because of the spatial involvement. Fouquet, more abstract and concerned with the fluid surface character of his form, emphasized the contours by concentrating on the area of the nose, eyes, and mouth and generalized the area immediately adjacent to create the form by alluding to its characteristic elements.

Between 1452 and 1460 it is assumed that Fouquet and his shop made for Etienne Chevalier a now-dismembered Book of Hours, forty of whose illuminations are in the Musée Condé in Chantilly. Seven more are in other public and private collections, and approximately eleven are still missing. The work is attributed on stylistic grounds and by analogy with the portrait of Etienne Chevalier from the *Melun Diptych*. In a double-page miniature, Etienne Chevalier and his patron saint are set in the midst of Italianate architecture. They adore the Virgin and nude Child placed before a Gothic portal closed by a Renaissance shell niche (Fig. 269). Garland-holding putti crown the architraves on the wall, and crowds of angels join in the adoration.

A similar response to Italian ideas appears in other miniatures from the book, with perspective construction often based on Alberti's treatise, though there is also a continuation of older ideas. The Vespers scene (in the Lehman Collection, New York) shows the west façade of Notre-Dame, Paris, in the background, and the Carrying of the Cross shows the Sainte-Chapelle. The St. John on Patmos (Fig. 270) is descended from a model comparable to that in the *Très Riches Heures* of the Limbourgs (Fig. 35), the little waves dancing about the saint's island recalling the earlier treatment. Other miniatures seem to reflect theatrical performances, the scene staged on an elevated platform before which half-Italian, half-northern putti cavort in the orchestra pit and hold up Chevalier's coat of arms to view. These are occasionally replaced by wild men who perform the same function. Landscape construction varies from the conventional movement by diagonals into depth to newer constructions,

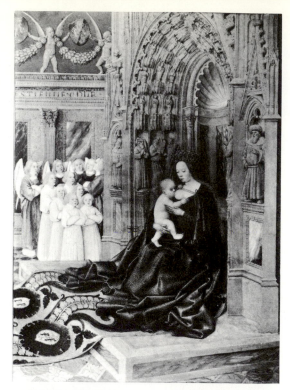

top: 269. JEAN FOUQUET. Virgin and Child, *Book of Hours of Etienne Chevalier.* 1452–60. Illumination, 6 1/4 × 4 3/4" (page). Musée Condé, Chantilly.

above: 270. JEAN FOUQUET. St. John on Patmos, *Book of Hours of Etienne Chevalier.* 1452–60. Illumination, 6 1/4 × 4 3/4" (page). Musée Condé, Chantilly.

as in the scene of Job on his dunghill (Fig. 271), in which movement is directly back into space; this dramatic recession is not always perfectly handled, however, as in the Adoration of the Magi scene. The over-all luxuriance of the manuscript make it and the *Antiquités Judaïques* the chief masterpieces of 15th-century French illumination.

Fouquet and his shop were responsible for other manuscripts. A Boccaccio, *Des Cas des Nobles Hommes et Femmes Malheureuses (Stories of Noble Men and Unfortunate Women,* Munich, Ms. fr. 6, Cod. Gall. 369), donated by Laurens Gyrard, controller general of finances, was executed in 1458. It is notable for its strongly patterned, linear frontispiece (Fig. 272) of the trial of the Duke of Alençon at Vendôme in 1458, at which the Duke was condemned to death. Fouquet united a bird's-eye view with vanishing-line perspective, for the problem was too large for him to handle with his apparently incompletely assimilated Italian perspective concepts. The *Grandes Chroniques de France* (Paris, Ms. fr. 6465) was offered to Charles VII by his secretary Noël de Fribois in 1458 and contains 51 miniatures by Fouquet and his assistants. One of its scenes, the entry of Charles IV into St-Denis, is interesting for its spatial conception; the lines of the paving blocks are organized to create a curved stage for Fouquet's typical pageant, which is more strongly conceived in terms of a stage space than in the *Hours of Etienne Chevalier.*

Though Fouquet did not receive the title of court painter until 1474, he was often busy working for the court. In 1461, on the death of the monarch, he painted the leather effigy of Charles VII, and in the same year the city council of Tours commissioned decorations for a triumphal entry by Louis XI, though these were never executed. Other work at Tours is recorded: Archbishop Jean Bernard, in his will of 1463, provided 70 *écus* for an altarpiece by Fouquet for the church at Candes, the summer residence of the bishops of Tours, and Fouquet was to take back a Madonna worth 25 *écus,* clear evidence that Fouquet was also a panel painter. In collaboration with Michel Colombe he designed the tomb of Louis XI; in 1476 he was commissioned to design the canopy used on the visit of the King of Portugal to Tours; in 1472 he went to Blois to paint a prayer book for Mary of

below: 271. JEAN FOUQUET. Job and his comforters, *Book of Hours of Etienne Chevalier.* 1452–60. Illumination, 6 1/4 × 4 3/4" (page). Musée Condé, Chantilly.

bottom: 272. JEAN FOUQUET. Trial of the Duke of Alençon, from Boccaccio, *Des Cas des Nobles Hommes et Femmes Malheureuses. c.* 1458. Illumination; 13 3/8 × 11". Bayerische Staatsbibliothek, Munich (Cod. Gall. 369, fol. 2 v).

Cleves; in 1476 he painted another prayer book for Cardinal Charles de Bourbon; and there is another record (which has been questioned) that in 1477 he had to sue the chronicler Philippe de Commines for the balance of payments on two prayer books he had made. The picture is thus one of an active artistic life extending over more than thirty years.

For Louis XI he probably illustrated the frontispiece to the *Statutes of the Order of St. Michael* (Paris, Ms. fr. 19819), an order founded by Louis at Amboise in 1469. It is known that Fouquet was commissioned to make paintings for members of the order, but these have not survived.

He is recorded in the early 1470s as adding illuminations to the two-volume translation of Josephus's *Antiquités Judaïques* (Paris, Ms. fr. 247), whose illumination had been begun about 1410 for the Duke of Berry and left incomplete. Fouquet here expanded the limits of the miniaturist's art, achieving a grandeur and sweep of architectural and natural form not to be found in his earlier works. Strong local color and distinct outline are used for the foreground figures (as in the scenes of the Hebrews carrying the Ark of the Covenant and Joshua blowing his trumpet in the fall of Jericho) and opposed to the almost amorphous, soft gray host of soldiers behind them. By leading the eye slightly down upon the hordes beyond the foreground and out to the distant, lighter blue, almost idyllic Touraine landscape of beautiful placid hills and river, Fouquet conveyed the sense of an immensely extended space, yet succeeded in retaining

by evenness of tone the unity of the page (Pl. 18, after p. 308). In his town scenes the same evenness of tone governs the Gothic construction of the Temple of Jerusalem, which fills the space almost to overflowing, its varied activities seized with superb clarity and drawing.

A *Descent from the Cross,* commonly called the "Nouans Pietà," discovered as recently as 1931 in the church at Nouans, has such power that it was immediately attributed to Fouquet (Fig. 273). Considered to date between 1470 and 1475, it is remarkable for its sense of strength and containment. The calm, quiet figures mourn almost without mourning, as though they are observers and Christ is only asleep; the Virgin's grave face shows no outpouring of grief, sorrow, or anguish. Subject to linear rhythms, the forms are pressed together close to the picture plane, almost as a tableau, yet they possess a tremendous variety of artistic drama, a potential but restrained emotionalism, and the simplified draperies achieve an almost independent monumentality. The whole seems a summation of the outstanding elements of Fouquet's art.

Fouquet's shop was large and important. The outstanding masters who were trained under him were Jean Colombe, who completed the calendar pages of the *Très Riches Heures,* and Jean Bourdichon. Other masters such as Master François (active 1463–81), possibly Fouquet's son, also worked with him (miniatures in Paris, Mss. lat. 1405, of about 1450; lat. 2258; lat. 1577, of 1457, with its representation of Charles VII and his councilors; fr. 18, 19, of about 1475), but Master François's style is more awkward and

273. JEAN FOUQUET. *Descent from the Cross* ("Nouans Pietà"). *c.* 1470–75. Panel, 57 7/8 × 92 7/8". Church, Nouans.

lacks the logic and clarity of Fouquet.[4] The dated triptych from Loches (1485), now in the Louvre, is probably a work of his school.

Two outstanding portraits of the period were once added to Fouquet's *œuvre* but are now recognized as by two different artists. The *Man with a Glass of Wine* (Fig. 274), in the Louvre, seems datable shortly past mid-century but is very different from Fouquet, who at an earlier date was painting better hands. The general influence of the French ideal as expressed by Fouquet is clear, and the silhouetting of the figure is highly effective, with an able catching of individual expression in the face. The balustrade form is replaced by a table, thus revealing an earlier and essentially Flemish conception. This spirit also characterizes the portrait of a man, of 1456, in the Liechtenstein Collection, Vaduz, in which the numbers serve as highly ornamental elements animating the back wall of the enclosure, and one hand is placed on a ledge before him. The conception of the hand is inferior to that of Fouquet, and the whole is a little sharper and more wooden than in his art.

Jean Bourdichon,[5] born about 1457, was the chief pupil of Fouquet and, to all intents and purposes, the terminator of French illumination. He was working for Louis XI and his wife, Charlotte of Savoy, by 1479 at the latest. Made court painter to Charles VIII in 1484, he later became the preferred painter of the Bourbon monarch, Louis XII, and his wife, Anne of Brittany, for whom he painted the Book of Hours for which he is best known. He was also patronized sometime before 1485 by Charles of Angoulême and later by Charles's son, Francis I. He died in 1521. Though he was a portraitist and a panel painter, as well as a miniaturist, his style is best seen in the *Book of Hours of Anne of Brittany* (Paris, Ms. lat. 9474), illuminated with 51 large paintings between 1500 and 1507. The characteristics of his style are clearly visible in the portrait of Anne of Brittany kneeling in prayer on folio 3 (Fig. 275): very hard in outline, very smooth and enamel-like surfaces, a general rounding of forms, and extremely detailed representation of drapery. One feels a cosmetic quality in the treatment of the rounded features and stocky figures. His even, soft illumination creates a cold, immaculate perfection that has a measure of monotony unalleviated by his preference for large areas of pure color, particularly

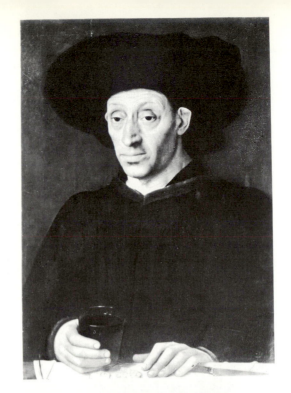

above: 274. FRENCH. *Man with a Glass of Wine*. c. 1450–55. Panel, 25 × 17 1/8″. Louvre, Paris.

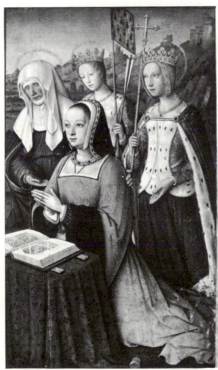

below: 275. JEAN BOURDICHON. Anne of Brittany in prayer, *Book of Hours of Anne of Brittany*. 1500–07. Illumination, 11 3/4 × 7 5/8″ (page). Bibliothèque Nationale, Paris (Ms. lat. 9474, fol. 3).

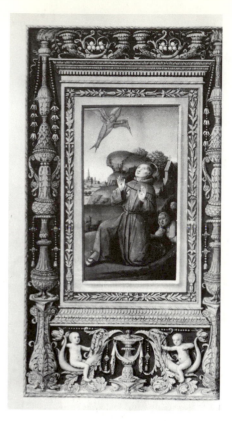

net, moved to Provence, where he occupied a guild position and took many apprentices, including the son of his Dijon colleague, Adam Dumont.

Two of the finest works from Burgundy, by the Master of Saint Jean de Luz, are the portraits of about 1475 of Hugues de Rabutin and his wife, Jeanne de Montaigu (Fig. 277), New York, John D. Rockefeller, Jr., Collection, shown against a green background adoring small statues in niches before their eyes, an unusual conception. Animation is given by a fine rendering of surface textures, though a slight woodenness in eyes and mouth tends to immobilize the figures, as do the clear outline and vivid contrast of red garments against the green background. Strongly dominated by Flemish conceptions, the portraits are nevertheless decidedly French in the pronounced linearism so well accentuated by the color contrast and in the normal French tendency to avoid atmosphere; the result is a clarified plasticity.

Even more Flemish is the retable of Ambierle, which may be Flemish, by a Rogier disciple.

A pair of portraits (Fig. 278) of high quality, in Worcester, Massachusetts, wings of an altarpiece whose center has been lost, were until recently assumed to be Claude de Toulongeon and Guillemette de Vergy, presented by their patron saints. They have been dated in the 1470s, but doubt has been raised on the basis of costume, which may be of later date, so that the identification of the portraits is not certain.

Robust clarity and volumetric strength, with less of the surface emphasis found farther west in France, characterize these rather sculpturesque paintings. They are witness both to strong Flemish influence and to the continuation of a tradition of plastic strength in Burgundy. This tradition has often been cited as an adherence to the concepts of Sluter; it is, rather, the persistence of the conservative outlook of monumental plasticity that was widespread in the 1430s. The conservative style, however, does not affect the excellence of the unknown artist's achievement, representative of what little is known of Burgundian painting of the second half of the century. Though subsequent destruction has

ultramarine. Not all Bourdichon's work is this hard, particularly the Book of Hours for Charles VIII (Paris, Ms. lat. 1370), of the last decade of the century. But the generally heavy loading of the illumination with pure color and the attempt to create aerial perspective by using a strong blue background rather than by softening the distant edge (characteristic of Bourdichon and followed in the works of lesser miniaturists) were carried too far for the self-sufficiency of miniature painting.

In the end—and it was very close—the miniaturists, including Bourdichon, began to emulate the aesthetics of panel painting. Bourdichon's *Book of Hours of Frederick II of Aragon* (Paris, Ms. lat. 10532) shows the last step; the chiaroscuro scenes are panel paintings transferred to parchment and given a heavy Italian frame flanked by classical columns (Fig. 276). Entirely unrelated to the page on which it is painted, the miniature as such has disappeared.

Burgundy, recipient of Flemish masterpieces such as Rogier's *Last Judgment Altarpiece* and Jan van Eyck's *Rolin Madonna,* through the third quarter of the century was a Flemish province and a disseminator of Flemish style. Artists from the north settled in Dijon in the second half of the century, and one Dijonnais, Jehan Change-

taken its toll, as has been the case everywhere in France, the thoroughly provincial role of Burgundy, subordinated as it was in comparison to the Netherlandish holdings of its dukes, was apparently not conducive to the production of important works. Nevertheless, bourgeois patronage was stronger than anywhere else in France except for Anjou and Provence, which were also politically independent of the rule of French monarchy for much of the century.

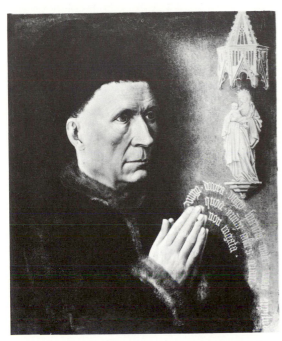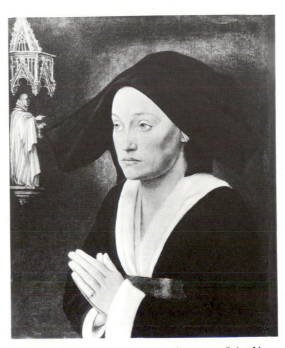

277. MASTER OF ST. JEAN DE LUZ. *Hugues de Rabutin* and *Jeanne de Montaigu. c.* 1475. Panel, 60 × 49″ (each). John D. Rockefeller, Jr. Collection, New York.

278. BURGUNDIAN. *Donor Portraits* ("Claude de Toulongeon and His Wife"[?]). 1470–81. Panel, *c.* 41 × 31″ (each). Worcester Art Museum, Worcester, Massachusetts.

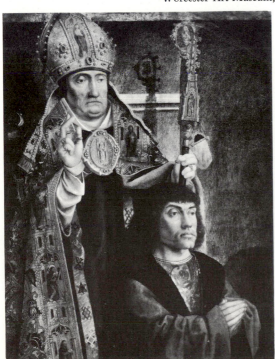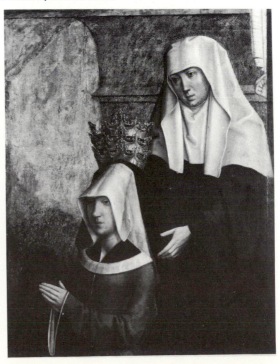

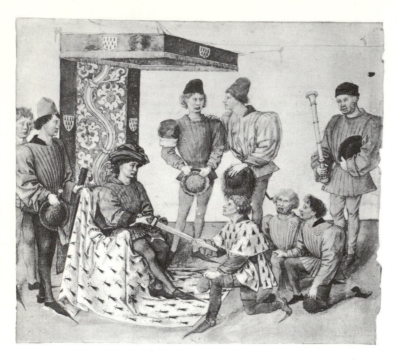

left: 279. MASTER OF RENÉ OF ANJOU. The Duke of Brittany giving a sword to the King of Arms, *Book of Tourneys*. c. 1460–65. Illumination, 15 1/8 × 11 5/8 (page). Bibliothèque Nationale, Paris (Ms. fr. 2695, fol. 3v).

THE MASTER OF RENÉ OF ANJOU

With the accession to power in 1454 of René, Duke of Anjou, King of Sicily and Jerusalem, ruler of Provence, littérateur and amateur painter, his court at Angers became artistically one of the most interesting in France for the next several decades. Two of his chief artists were Netherlanders, Barthélémy de Clerc and Coppin Delft, but the creator of the distinct style visible in works for Duke René is known only as the Master of René of Anjou. The style first appears in the *Book of Tourneys* of about 1460–65 (Paris, Ms. fr. 2695), a rule book for the staging of the cherished pageants of the nobility (Fig. 279). Tournaments were the last gasp of medieval chivalry, which had been shot out of its saddle both literally and figuratively by English longbowmen at the Battle of Agincourt in 1415.

The style of the book, so different from that of the Rohan Master, who had been patronized by René when he was a young man, is delicate and sketchy, heightened with water color, almost impressionistic in its feeling for light, fluid surfaces. There is no parallel to this in Flemish painting or illumination, for the aesthetic qualities visible in earlier works have

come to the fore again, and the viewer is much aware of them. A delicate modeling of the rather stockily proportioned forms and a fine sense of design in the artistic interplay of form on a manuscript page with figures that bulk a bit too large for the architecture attest to a distinct style, yet one that has affinities with that of Fouquet.

The consistency of style in this work, and in another treatise on the tourney for the monarch, of approximately the same date but by a different hand (Paris, Ms. fr. 2696), makes it extremely dubious that these works or others were painted by the monarch himself, as some have thought. We must doubt his production of these art works when we consider the idea against the backdrop of 15th-century artistic training and practice, the necessity for the artist whose livelihood depended upon it to complete illustrations in a manuscript. Sustained work of the type necessary for the illumination of manuscripts must be denied to René.

The most famous of his literary works is the *Livre du Cuer d'Amours Espris (Book of the Heart Seized with Love)*,[6] an allegorical romance he completed in 1457. The work, in Vienna (Ms. 2597), is mediocre as literature, but its illustration, executed by about 1465, is masterly. The justly famous night scene of Amour giving the king's heart to Désir (Pl. 19, after p. 308), often compared with Piero della Francesca's *Dream of Constantine*, presents a wonderful understanding of artificial light, exceptional for its period. Whereas Piero tended to generalize in terms of an ideal night scene, the René Master created his poetic night lighting by concentrating on the surface quality of objects revealed by light. The almost magical effect achieved by the artist is unusual; it is not comparable with the later work of Geertgen tot Sint Jans, whose mystic lighting is very different from this poetry of naturalism, also seen in the dawn scene of Cuer at the magic well (Fig. 280). The artist's great concern with soft lighting tends to obscure structure; in compensation the specificity of time gives evidence of keen vision and artistic sensitivity of exceptional magnitude. The

Master's basically sensory approach makes the embarkation of Cuer and Désir with two feminine companions for the island of the Ospital d'Amours a worthy ancestor of Watteau's famous painting the *Departure from Cythera*; the comparison is not unjust.

THE MASTER OF MOULINS

Before the close of the century central France produced one other truly extraordinary artist of the status of Fouquet. Named after his chief work, the triptych in Moulins Cathedral, the Master of Moulins [7] remains unknown, despite all attempts to identify him with the court artist Jean Perréal, Jean Hay of Brussels, or Jean Prévost of Lyon. The influence of Hugo van der Goes is the one certainty about him. A number of works related to the *Moulins Triptych* have been assembled on stylistic grounds to represent his *œuvre*. Possibly the earliest work of the group is the portrait in Munich of Cardinal Charles II of Bourbon, which may have been painted shortly after the sitter became a cardinal in 1476. It reveals the master's characteristic facial type: a long thin nose, a pointed face, and a rather small mouth. His female figures show a preference for slightly slanted eyes, particularly visible in the next attributed work, the *Nativity* of Cardinal Rolin, in Autun (Fig. 281). The types seen here are clearly related to Hugo van der Goes's *Portinari Altarpiece*

(Fig. 186), especially the left-hand shepherd. Hugo's closed space was emulated by the Master of Moulins, and the perspective organization is related to that of Hugo's *Monforte Altarpiece* (Fig. 184). The *Nativity* is quieter in design, cooler in color, than Hugo's work, and his intense emotional drama was rejected in favor of a grave elegance conveyed by greater regularity of clarified outline and avoidance of strong movement. The low wooden wall at the back of the foreground, separating the shepherds from the sacred space, provides a key to the total effect. On the basis of the age of the donor, Cardinal Jean Rolin (son of Philip the Good's chancellor), the work has been dated as about 1480, for Jean Rolin died in 1483 at the age of seventy-five.

above: 280. MASTER OF RENÉ OF ANJOU. Cuer reading the inscription on the magic well, *Livre de Cuer d'Amours Espris.* *c.* 1457–65. Illumination, 11 3/8 × 8 1/8" (painted surface, page). Österreichische Nationalbibliothek, Vienna (Ms. 2597, fol. 15).

left: 281. MASTER OF MOULINS. *Nativity. c.* 1480. Panel, 21 5/8 × 28". Musée Rolin, Autun.

282. MASTER OF MOULINS. *Moulins Triptych.* *c.* 1498. Panel, 4' 11 ½" × 9' 3 ³/₈". Cathedral, Moulins.

The master's major work, the *Moulins Triptych* (Fig. 282), dated as about 1498 on the basis of the probable age of seven or eight of young Suzanne of Bourbon, presents the Virgin and Child of the Apocalypse in glory, surrounded by angels in the central panel; Pierre II of Bourbon and his gigantic patron saint, Peter, on the left wing; and Anne of Beaujeu and her daughter Suzanne, both presented by a gigantic St. Anne, on the right wing. The giant saints are reminiscences of Hugo, as is the exterior Annunciation. The central panel again shows the master's compacting of space, a delicate plasticity, and an aristocratic elegance. A regular but not monotonous balancing of forms, a subordination of plasticity to the exigencies of a highly rational formal organization, and a normative French generalization of surfaces create a spirit that suggested to Sterling the qualities one associates with Ingres. Color is richer than in the earlier works, technique is finer, and the forms are more delicate and gracious, suggesting a stylistic parallel on French soil to the flattening tendencies already seen in late 15th-century Flemish painting.

right: 283. MASTER OF MOULINS. *Portrait of a Princess* [Suzanne of Bourbon(?)]. *c.* 1498. Panel, 13 ½ × 9 ½". The Lehman Collection, New York.

A comparison with the early works allows a dating of about 1498 for the portrait of a young princess (Lehman Collection, New York) who has been identified as Marguerite of Austria by Sterling and Suzanne of Bourbon by Hulin de Loo (Fig. 283). Set against a pier that divides the landscape into two parts, a device also used by the Flemish Master of the St. Ursula Legend,

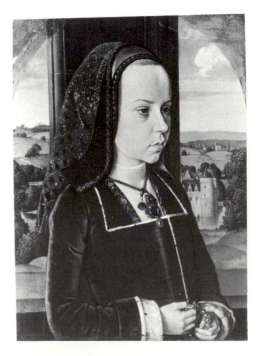

the young girl's piquant face is clearly presented and suggests an affinity with Hugo's portrait of Margarita Baroncelli in the *Portinari Altarpiece*. Of the same decade is the Louvre portrait of a feminine donor with Mary Magdalene whose features are the very epitome of the master's type.

Attempts have been made to relate a panel of Charlemagne combined with the meeting at the Golden Gate, in London, with the master's *Annunciation* (Fig. 284), in Chicago. However, the architectural styles of the backgrounds are not in accord, and Friedländer's dating of the London panel as about 1495 seems at variance with a presumed date of about 1510 for the Chicago panel, its conception being parallel to Gerard David's development of a more youthful Virgin. The almost petulant Virgin, who disregards the childlike angel announcing to the vaults, is clearly looking beyond to a scene now lost. Though the forms are still strongly silhouetted, the softer modeling points to a date later than the *Moulins Triptych*.

A stage of about ten years earlier is seen in the Brussels *Virgin and Child Adored by Angels*. The somewhat melancholy portraits of the Dauphin Charles-Orland, who died in 1495, and a praying child, both in the Louvre, seem to anticipate slightly the Brussels painting.

Possibly the latest work that can be attributed to the Master of Moulins is the *St. Maurice with a Donor* (Fig. 285), now in the Glasgow Art Gallery. Châtelet has presented evidence that the donor, identified from the Chateaubriant family coat of arms, is François Chateaubriant, abbot of Evron in 1491, and dean of St-Maurice, Angers, in 1516, of which he had been a canon before becoming dean.[8] François Chateaubriant died in 1535 at the age of ninety-one; thus if the identification is correct and if the work was painted in 1516, he appears as a very youthful seventy-two. The work has also been dated as about 1500, when other Chateaubriants were in their thirties, but this date seems too early. Doubt has also been raised as to whether the saint is Maurice or Victor. Like Fouquet, the Master of Moulins expressed in his art the rational organization generally visible in French painting. His clearly balanced form, more even lighting, and more delicate color set his painting apart from that of Flanders, even when indebted to it.

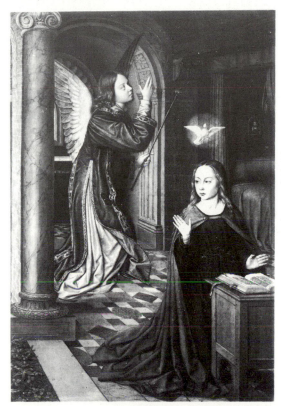

PROVENCE

In Provence, where artistic expression in the 14th century had been dominated by the papal court, the end of the "Babylonian captivity" brought about a slow decline that continued through the first third of the 15th century.[9]

Parisian influence is superimposed on an Italian base in two works of about 1390, a *Calvary*, in the Louvre, and the *Retable of Touzon*, also in the Louvre. Occasionally the decline was interrupted by the International Style Gothicisms of such artists as Jean Mirailhet, active at Nice and Marseilles and living until 1457, who about 1425 painted the retable of the *Virgin of Mercy*, now in the Musée Masséna, Nice; and Jacques Iverny of Avignon, who painted in the 1420s a Madonna and Child triptych, now in the Galleria Sabauda, Turin, that mixes Sienese style and International Style luminosity of drapery. Artistic development was also retarded by the unknown painter of the portrait (Fig. 286), in the Musée Calvet, Avignon, of the cardinal and saint, Pierre de Luxembourg, who died in 1387 at the age of eighteen, renowned for his sanctity and his filth, for he was never known to take a bath. The work is both *retardataire* and Italianate, despite the plastic naturalism of the cloak, which has led to a late dating, ranging from 1430 to 1450. There is a sense of volume in the generalized features and hands that belies the linearism of the eyes and detaches the figure from the gold-brocaded background.

The earliest masterpiece of painting in Provence, the *Annunciation* (Fig. 287), now in the church of the Magdalen at Aix, shows a later

above: 286. PROVENÇAL. *Pierre de Luxembourg.* 1430–50. Panel, 30 3/4 × 22 7/8". Musée Calvet, Avignon.

right: 287. MASTER OF THE AIX ANNUNCIATION. *Annunciation.* 1445. Panel, 61 × 69 1/4". Church of the Magdalen, Aix-en-Provence.

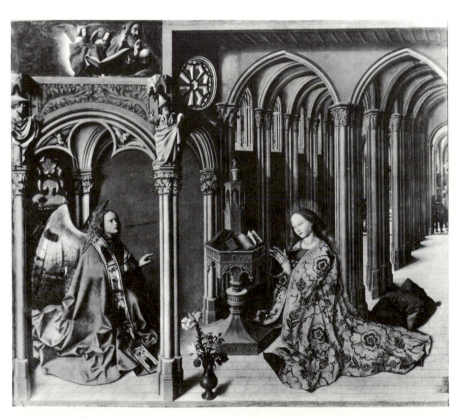

stage in the interest in volume. A documented work, it was commissioned in the will dictated in 1442 by the draper Pierre Corpici and was to decorate a tomb in Saint-Sauveur; it was completed by July, 1445. Originally it formed a triptych, the wings of which are in Brussels and Rotterdam; the still life that once topped the Rotterdam panel is in the museum in Amsterdam.

The unknown painter has been described as Flemish under the influence of Konrad Witz, Flemish under the influence of Sluter and Van Eyck, and Flemish under the influence of the Master of Flémalle; he has been identified with Antonello da Messina's teacher Colantonio, with Jean Chapus from Chambéry, with Barthélémy de Clerc, with an unknown painter from Dijon, and with a Frenchman working in the south of France. That he was a Frenchman from the Burgundian region seems the most likely possibility, since Grete Ring pointed out the reappearance of a lectern like that in the Limbourgs' St. Jerome drawing (Fig. 26). Also, the Virgin's mantle is a brocade of the type known as *brocart de Tours,* and the staging of the Annunciation is like that in Broederlam's altar wings in Dijon, except that the Virgin directly faces the angel, and the light rays issuing from God the Father are similar. Both icono-

graphically and in volumetric conception there is a relation to the Master of Flémalle; the Child sliding down the light rays is a motif seen in both Flemish and Burgundian masters. The reminiscences of Sluter in the bulky prophets on their consoles may be due to the general feeling for sculpturesque volume so widespread in Flanders and in all northern European art of the 1430s and 1440s. Though the architecture suggests a relationship to the Master of Flémalle, it is conceived differently, with the Annunciation and the little landscape behind the angel's wing balanced against the rendering of the church interior. A more concrete, domestic interior setting characterized the Flémalle *Mérode Altarpiece* (Pl. 7). Here Broederlam's conception of a vestibule before the sacred structure has been altered to become a stage on which the Annunciation appears as an anticipation of the development of Christianity, rather than a Flemish portrayal of a religious event in naturalistic guise; the symbolism is more overt than disguised. Furthermore, the Aix Master felt it necessary to show God the Father (whereas the Master of Flémalle felt that He could be understood without being portrayed), and he flattened the perspective of the rose window so that its symbolic content could be clearly read.

Cast shadow is visible, but it does not disturb the balance and pattern of forms, but spatial chiaroscuro is so little stressed that the warm plum color of the angel's robe and the red-yellow of the Virgin's garment stand out sharply against the cool blue-gray background, which is almost as readable as an architectural rendering. Striving for precision, and thus to be differentiated from the greater, more obdurate naturalism of the Master of Flémalle, the Aix Master is clearly not Flemish but is thoroughly French in his artistic expression, although it is quite possible that he was trained in Flanders.

On the right wing, in Brussels, Jeremiah stands on a plinth (Fig. 288) but is painted in full color like an actual figure, rather than a sculptural grisaille, with the appurtenances of a scholar seen above him on a shelf. (This distinct

left: 288. MASTER OF THE AIX ANNUNCIATION. Jeremiah, *Annunciation,* right wing (Fig. 287). 1445. Panel, 59 7/8 × 33 7/8". Musées Royaux des Beaux-Arts, Brussels.

still life has led to an interpretation of one of the elements as a host box, expressing a disguised symbolism.) The Flemish incorporation of naturalistic objects into a coherent spatial unity is replaced by a precise, balanced, less spatial conception that is only seemingly accidental. In contrast to the spatial chiaroscuro of the Eyckian *St. Jerome in His Study* (Fig. 121), a Flemish occupational portrait, this panel of the *Annunciation* continues the symbolic conceptions of the past, modernized by a naturalism presented with a clear, logical structural organization.

The figure of Isaiah, from the left wing, in Rotterdam, and its accompanying still life, in Amsterdam, repeat the idea; the figure of Isaiah is even more strongly reminiscent of the earlier sculpture of Sluter, for he is almost drowned by his voluminous garment. On the backs of the wings the "Noli me tangere" again shows Sluter-like drapery, though less carefully composed and treated, the background seeming almost oppressive in its heavy dark-red patterning. Though exterior panels were normally less carefully done, the design is certainly due to the Aix Master, to whom no other works can convincingly be attributed. No other artist so ably united Flemish mystic naturalism and French clarity.

Shortly after mid-century Provence attracted artists from many parts of France and from abroad. Yet it possessed a more unified style than can be found anywhere else in France. Who the creator of this unity may have been cannot be answered, but a partial explanation lies in Provence's independence. Ruled by René of Anjou, who kept it free of war, it finally became part of the French kingdom only in 1479, a year after his death. There is no doubt, however, that one of the finest 15th-century French works is the *Pietà* from Villeneuve-lès-Avignon, often dated about 1460 (Pl. 20, after p. 308), now in the Louvre. It presents the intensely lighted, mystic theme of the Virgin mourning over the body of the dead Christ, bent over her lap at an impossibly sharp angle, flanked by John and a donor at the left and the weeping Magdalen at the right. There is an intentional variety in their portrayal. The eye moves from the kneeling donor in white surplice, gazing out into the space of the spectator, to the more general and elegant figure of the youthful John. Then it moves to the Virgin, an old woman, certainly old enough to be the mother of the man on her knees, her head bent to one side in contemplation. Next it moves to the equally generalized figure of the Magdalen, the simplified planes of whose face lead the eye to the figure of Christ. This swarthy figure, emaciated, elongated, and angular, greenish in tone, and thrust to the right of center as a balance for the strong white garment of the donor, is the psychological focus of the devotional drama.

The painting is revelatory of the widespread change in the third quarter of the century to the "style of the long lines," first seen in Flanders in Rogier and again here in Avignon. The theme was conceived in Rogier's terms but with an underlying sharp sense of balance, with the Virgin as the stabilizing element of a surface design that suggests triangularity, horizontality, and verticality in masterful combination. A strongly decorative treatment reminiscent of medieval work is presented by the unmodulated ground plane and the tooled, flat, infinitely extensive gold background, against which is set, as though it were sky, a Moslem building suggestive of Egypt or Constantinople, which had apparently been seen by the artist. He set his basically iconic scene in illimitable space, yet he suggested a finite milieu in the background building and in the magnificent clarity of figure treatment. The cleanliness of line and essential airlessness are in the service of an extremely restrained plasticity. Using a subdued color scheme, which has suggested Iberian influence to some writers, the artist emphasized a sharp, flat light-and-dark pattern rather than a spatial chiaroscuro to create a modulation of almost papery surfaces with little extension into depth. The clarity, even elegance, of such restrained mystic and iconic pathos places its creator at the crossroads of north and south, of Flanders and Italy, the ideals of which he both honored and united.

Close in style is the *Altarpiece of Boulbon* (Fig. 289), in the Louvre, showing Christ standing in the tomb, the other members of the Trinity, the symbols of the Passion, and a donor presented by St. Agricola, patron saint of Avignon. It was probably painted shortly after 1457. The donor's head is modeled much like that of the Avignon *Pietà,* with which there are so many other points of contact that this may be a shop work.

Close affinities in style to these works are evident in the art of Enguerrand Quarton, called Charonton in Provence, who went from Laon to the south of France as early as 1444. (The *Pietà* has been attributed to him.[10]) At Aix, Arles, and Avignon in the years between 1444 and 1466, he was given contracts that still exist for two preserved works. The *Virgin of Mercy,* of 1452, now in the Musée Condé, Chantilly, was commissioned by Pierre Cadard as a family votive picture destined for the Celestine convent in Avignon (Fig. 290). The contract was to be executed by Charonton and Pierre Villate of Limoges. All humanity—popes, cardinals, kings, clerics, and others—is sheltered under the outspread cloak of the supernaturally large Virgin. Pierre Cadard's father, Jean Cadard of Picardy, physician to the children of Charles VI and professor of medicine at the University of Paris, kneels before a *prie-dieu* at the left, and his mother, Jeanne, kneels at the right. They are formally presented by gigantic figures of the two Sts. John, their size recalling Sluter's portal figures of the Chartreuse de Champmol, though there is nothing beyond this to suggest an influence. The figure style is, in general, close to that of the Avignon *Pietà,* and the concept of surfaces is related, though there is a more general modeling of the features and a less plastic treatment over-all.

Charonton's most famous work is the large *Coronation of the Virgin* (Fig. 291), in the Hospice, Villeneuve-lès-Avignon.[11] The contract, specifying the zones of Hell and Purgatory, the earth, the sky, and Paradise, and other details, was in many respects quite clearly and literally followed. Above in Heaven, indicated by the gold background, the Virgin is crowned by the Trinity, represented in a manner which expresses the *Filioque* doctrine of the double procession of the Holy Spirit. This had become dogma at the Council of Florence in 1439. On each side adoring angels, saints, and the ranks of the blessed are seen. Below is the blue sky, where

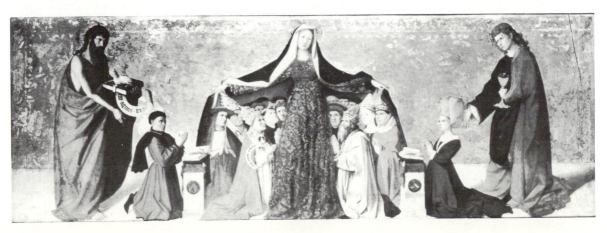

angels carry small souls toward Heaven, and then the earthly scene, with the commissioner of the work, Jean de Montagnac, kneeling at the foot of the cross against a Provençal landscape background. To the right is Jerusalem, to the left, Rome, beyond which appear the mass of St. Gregory in a church and Moses before the burning bush. Below are Hell and Purgatory.

Iconographically based on St. Augustine's *City of God,* the painting is conceived like a sculptured tympanum. We remark the importance of line, gentleness in outline, delicacy of shadow, balancing of tones, almost decorative patterning, elegance, and (most remarkable of the governing concepts in the art of this transplanted Picard) the classical feeling and the almost stereometric construction of the landscape. So clearly is this landscape presented that the mountain to the left of the Crucifix has been readily identified as Cézanne's most famous

motif, the Mont-Ste-Victoire. In the donor figure the simplification of the garments is combined with a clarity of silhouette consonant with the clear light of the pale green Provençal landscape.

The Virgin's face is more rounded than any in contemporary Flemish work but very different from the moon-faced Madonnas of the Master of Flémalle, being justly related to a 15th-century sculptured feminine head, from the Palais de Justice at Laon, which reveals the same linear tendencies and incisive sculptural feeling. Charonton, despite his northern origin, presents an essentially French Gothic, hieratic concept of iconic form. His elegant, almost courtly linearity—which suggests a contact with illumination—and what we think of as French sophistication are unparalleled in the Flemish-dominated art of his native soil.

A similar clarity appears in two almost identical Pietàs, one without the donor, in the private collection of Miss Helen Clay Frick, New York, and the other a softer copy with a donor, in the Frick Collection, New York. The *Pietà* without

below: 291. ENGUERRAND CHARONTON. *Coronation of the Virgin.* 1454. Panel, 72 × 86 ⅝″. Musée de l'Hospice, Villeneuve-lès-Avignon.

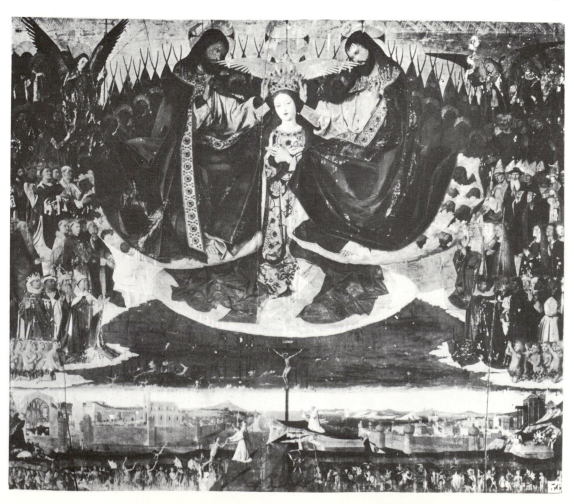

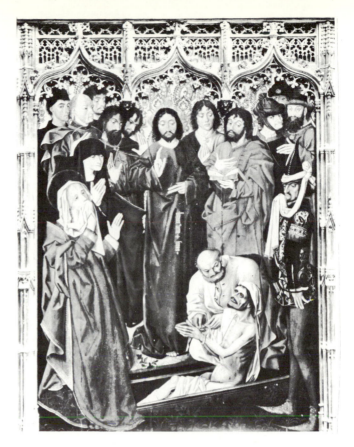

right: 292. NICOLAS FROMENT. *Raising of Lazarus,* center panel. 1461. Panel. 68 ⁷/₈ × 52 ³/₄". Uffizi. Florence.

the donor has been considered the original, dating about 1450, the copy dating about 1470. The name of Konrad Witz, the Swiss painter to be considered later, has been attached to the first work, without any agreement among historians. The Witz attribution is not supportable on the basis of color, and even the Provençal attribution of the copy is uncertain. Facial types are close to those of Witz, but all the other artistic elements—atmosphere, space, light, conception of form and structure—are different. The origin of the works is enigmatic and seems likely to remain so, though one is tempted to think of Jean Chapus from Chambéry or someone from a nearby region when one gives weight to the mixture of Gothic architecture, Alpine peaks, clear air, and a knowledge of plasticity that suggests contacts with Italy.

Other artists in southern France show Italian contacts, particularly Louis Bréa of Nice, whose *Pietà* of 1475, in the monastery church at Cimiez, a suburb of Nice, has even been denied by some French writers as being French. The composition is related to that from Villeneuve-lès-Avignon, and the wings present Sts. Martin and Catherine. Stylistically it is related to Italy, even though it repeats the Avignon *Pietà* composition in a somewhat different and less accomplished fashion.

Connections with Italy reach an astonishing point in the art of Nicolas Froment, born at Uzès in Languedoc and mentioned from 1450 to 1490. We first meet him in a triptych of the *Resurrection of Lazarus* (Fig. 292), now in the Uffizi, signed and dated 1461, and perhaps painted for the Convento del Bosco near Florence. The style is unusual for Tuscan painting, and the triptych may not have been made there. It shows the naturalism of the north in such an angular, hard, awkward way that Hulin de Loo said of it that even the landscape grimaced. Almost primitive in the movement of the figures, it is crowded, like German provincial painting, with a vertical perspective rather than a depth perspective, so that the figures press close to the picture plane. Their pointed faces, hard modeling, and heavy eyes suggest that the artist looked at the Master of Flémalle with the intent to sharpen every line he could find.

Such dramatic content as it possesses is largely due to the overemphatic treatment.

Certainly Flanders furnished models to Froment, for the figure at the right of the Resurrection scene, with his back to the spectator and his hand at his hip, appears in Bouts's later *Justice of the Emperor Otto;* one may conclude, therefore, that the figure must have been current in Flemish art to be adopted by two such disparate artists. The exterior Madonna is clearly based on the Master of Flémalle or the early work of Rogier and is more spaciously conceived than the interior. Froment's style thus differs greatly from that of other French painters in his wholesale adoption of Flemish forms, which he altered according to his limited vision.

This work does not prepare us for his masterpiece, the *Altarpiece of the Burning Bush* [12] in Saint-Sauveur at Aix (Fig. 293). Froment was in Avignon in the years 1468 to 1472 and may there have come to the attention of Duke René of Anjou. René paid him for this altarpiece in 1476 and is represented on the left wing with Sts. Mary Magdalene, Anthony, and Maurice behind him; his second wife, Jeanne de Laval, appears on the right wing with Sts. John the

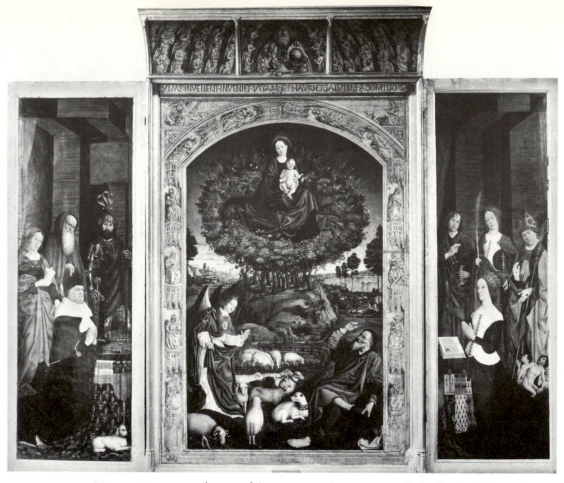

293. Nicolas Froment. *Altarpiece of the Burning Bush.* 1476. Panel, height 13′ 5 ½″ (including painted archivolt). Cathedral of Saint-Sauveur, Aix-en-Provence.

Evangelist, Catherine, and Nicolas behind her. The work was apparently donated by René of Anjou to the Carmelite church at Aix. Its recondite iconography (deciphered by E. Harris in 1938) does not follow the normal type, for the Virgin and Child take the place of God the Father, who appeared to Moses in the burning bush; however, God appears flanked by angels in the panel above.

The theme of the bush that burned but was not consumed was likened by the early Church Fathers to the Immaculate Conception, in which the Virgin conceived without being consumed by the flames of concupiscence. The theme appears early and late, in hymns from the 10th to the 16th century and in the two most popular late medieval books, the *Biblia Pauperum* and the *Speculum Humanae Salvationis.* In the former Moses's vision in the burning bush is a prophecy of the Nativity; in the latter, the burning bush is the prototype of the Annunciation. Thus the angel opposite Moses, a supernumerary in a

burning-bush scene, is in actuality the angel of the Annunciation, as is seen from the medallion on its breast, showing the figures of Adam and Eve, whose sin made Christ's birth and sacrifice a necessity. The inscription above the central scene is taken from Proverbs 8:35, which appears in the Roman Missal at the time of the Feast of the Nativity and at the Feast of the Immaculate Conception as part of the lesson from the *Liber Sapientiae;* the letters *SAP* end the inscription. In the Roman Breviary, the Feast of the Circumcision, referred to in the lower inscription, is immediately followed by a reference to the Tree of Jesse, which is depicted in the figures in niches painted on the gold frame on either side of the central panel. The virgin with the unicorn's head on her lap, in the upper right corner, is a prototype of the Annunciation, an idea repeated in Jeanne de Laval's prayer book, whose illuminated initial shows the Annunciation. The Annunciation theme also recurs on the exterior grisailles (Fig. 294).

In the central panel the mirror in the hand of the Child reflects the Mother and Child in accord with a very common reference to Mary's virginity. The bush is a rosebush. Mary in a rose bower is a theme found in numerous paintings, especially in Germany, and the idea of the Virgin in a tree has been discovered in Guillaume de Deguileville's very popular *Pèlerinage de l'Âme,* where the Virgin is placed in the mystic apple tree with Christ as the mystic apple. Disguised symbolism, as seen in preserved French work, seems not to have been very popular; thus its presence in this altarpiece was probably due to King René. Confirmation for this conclusion occurs in the record of payment, where the work is mentioned as a *rubum quem viderat Moyses,* the words that begin the lower inscription.

Stylistically Froment has changed markedly for the better since his Lazarus triptych and has refined his earlier drama. The central panel, with its angular Moses and plastically conceived forms, has behind it a landscape of Tuscan type with winding rivers and pleached trees stepping back into space in a manner analogous to similar scenes in the art of Piero della Francesca, the Pollaiuoli, and others. Very different from northern landscapes, it does, however, contain an element seen in the north, a symbolic rising sun at the left; its light has no effect upon the construction of the painting, which is lighted from the position of the spectator. Also Italian is the placing of the foreground animals, which are arranged either horizontal to the picture plane or at right angles to it. Italian landscape, northern iconography, and Flemish form are intermingled, the last being treated in a rather harsh, angular manner without any softening by atmosphere. Light both models and conceals Froment's forms, particularly on the exterior grisailles (Fig. 294), where the simulated statues of the Virgin and the angel seem almost intimidated by the huge, very plastic canopies over their heads, which are more firmly lighted than the comparatively flatter figures.

Froment thus shows a combination of styles, no one dominant. Flemish and Italian elements are in tension, so that, because of this contest, there is a partial loss of that clarity and precision previously visible in the art of Provence. The tilting and flattening of the bush and its size are responsible for the supernatural quality, while

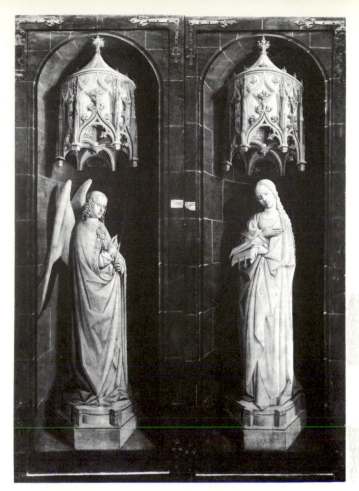

294. NICOLAS FROMENT. Exterior of the *Altarpiece of the Burning Bush* (Fig. 293).

the naturalism of treatment, balanced by the monumentality of the lower portion, reveals the grandeur of the design and its execution as existing midway between Italian and Flemish conceptions.

Related to Froment and probably from his shop is the *Matheron Diptych,* in the Louvre, with bust portraits of René and Jeanne de Laval seemingly modeled on the *Burning Bush* portraits but with slight changes of costume. Also reflecting his style is the *Legend of St. Mitre,* hung behind the high altar in Saint-Sauveur, Aix, probably painted about 1470 and showing a conscious concern for a balance of human and architectural forms. Froment's influence is also visible in the Pertussis retable from St-Suffrein, Avignon, now in the Musée Calvet.

Toward the end of the century there was a further influx into Provence from Flanders and from Italy that was more mannered in character. With the transfer of Provence from Angevin to French political control, a gradual decline began,

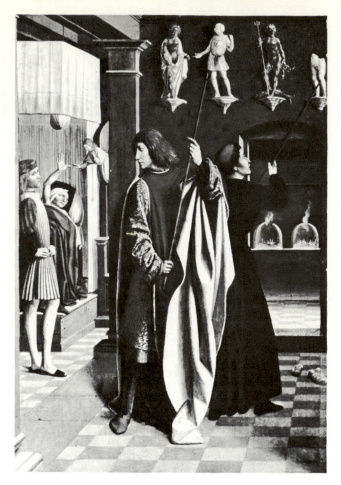

295. MASTER OF ST. SEBASTIAN (Josse Leiferinxe [?]) *St. Sebastian Destroying Idols.* *c.* 1499. Panel, 32 ½ × 21 ¾". John G. Johnson Collection, Philadelphia.

and art in Provence became provincial, but before that another master enriched the history of Provençal painting.

Toward the end of the century there appeared in the south of France an artist called the Master of St. Sebastian, sometimes identified with Josse Lieferinxe, from the region of Cambrai.[13] In Marseilles and Aix between 1493 and 1508, he was commissioned in Marseilles in 1497 to execute a *St. Sebastian Altarpiece,* with eight scenes, to be painted in collaboration with Bernardino Simondi from Piedmont. His collaborator died in the following year, and Liefer-

inxe contracted to complete the work alone by 1499. Scattered panels (four in Philadelphia, one in Baltimore, one in Leningrad, and one in the Galleria Nazionale in Rome) are believed by Sterling to be part of this altarpiece. All are seemingly related, six panels representing events from the saint's life, and the panel in Rome showing pilgrims worshiping the relics of a healing saint.

Other works have been attributed by Sterling to the master, six of these, including the *Marriage of the Virgin,* in Brussels, and a *Pietà,* in Antwerp, possibly from a Calvary altarpiece of about 1500–03. The Brussels painting seems more northern than the Philadelphia panels but, like the later works, shows the use of comparatively large areas of light and dark and sharp folds for dramatic effect. Sterling even conceived a distant relation to Geertgen.

Josse tended to generalize and smooth his surfaces with that sense of clarity and balance so characteristic of southern France, where, like the artists of this region so close to Italy, he created simplified forms that suggest spatial depth and movement but in actuality are extremely quiet. The reduction of movement to its least disturbing elements, the coolness of color, and the clarification of light create the feeling of a *tableau vivant,* whose figures are essentially foils for light. Such a scene as *St. Sebastian Destroying Idols* (Fig. 295), in Philadelphia, presents the essence of these qualities, sharp and clear. Visually acute in perceiving forms in space without attempting to create their atmospheric milieu, the Master of St. Sebastian created separate, distinct, and inherently logical elements. The checkerboard floor of *St. Sebastian Destroying Idols,* for example, is not an accident but an indication of the logic of construction and organization in French art. Such clarity and linear precision—intellectual, still, restrained, and rhythmically unified—have come to be thought of as typically French; they appear again in the work of such great French artists as Poussin, Jacques Louis David, and Ingres.

SPAIN AND HISPANO-FLEMISH PAINTING

FOURTEENTH-CENTURY SPAIN ARTISTICALLY WAS a Sienese colony, for the persuasive power of Duccio's followers swept away the Franco-Gothic style that had preceded it, as Siena won an artistic victory outside Italy in the early 14th century. In the more remote and provincial regions of Spain the older manner persisted almost to the end of that century. On the eastern coast, in Catalonia and Valencia, and in the Balearics, areas commercially and culturally long in contact with Italy and with the maritime centers on the Gulf of Lyon, the Sienese style appeared early and soon penetrated Aragon, which was artistically dependent on the coastal areas.

This interest in Italy was paralleled in political affairs. The kings of Aragon had long had their own *Drang nach Osten*, or drive to the east, beginning in the last quarter of the 13th century, when Peter III conquered Sicily. His third son, Frederick II, founded the line of Aragonese rulers of the island, who also became kings of Naples when Alfonso V, known as the Magnanimous (ruled 1416–58), prevailed over the Neapolitan claims of René of Anjou in 1443. Alfonso's nephew Ferdinand II of Aragon, who had united his kingdom with that of Castile by marrying Isabella of Castile in 1469, continued Aragonese control of Naples after 1502. When he died fourteen years later, the united kingdoms, Naples and Sicily, passed into the hands of his grandson, Charles of Hapsburg, who became Emperor Charles V in 1519, ruling over

Spain, the kingdom of Naples, Austria, the Netherlands, and the newly discovered lands of the Americas.

The "drive to the east" was paralleled in Castile and Aragon by a "drive to the north," for Los Reyes Católicos, Ferdinand and Isabella, had married their daughter Joanna the Mad to Philip, the only son of Emperor Maximilian of Austria and ruler of the Netherlands. The wave of Flemish influence in the arts, which had risen on the eastern coast of Spain in the 1440s, reached tidal proportions in the interior in the last quarter of the century, producing the Hispano-Flemish style. This, in turn, gave way to Renaissance forms from Italy, but not before it had produced an immense number of Spanish adaptations of Flemish naturalism, following at a distance the evolution of Flemish painting. Wholesale importations of Flemish works into Spain (the number of works still in Spain or known to have come from Spain is vast indeed), the travels of Spanish painters to the Netherlands, and the appearance in Spain of Flemish painters such as Miguel (or Michiel) Sithium and Juan de Flandes (John of Flanders) as court painters to Ferdinand and Isabella repeated what had occurred earlier in relation to Italy.

Both the International Style under northern influence and the Hispano-Flemish sequel adhered to attitudes which clearly distinguish the art of Spain from that of its northern contemporaries. The Spanish artist (and his patron)

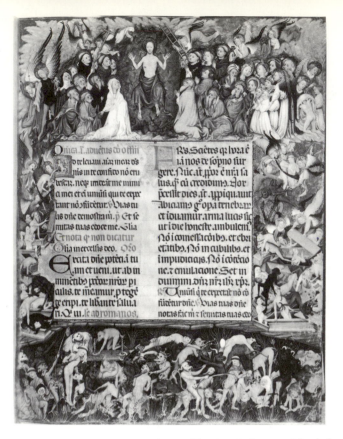

296. Rafael Destorrents(?). Last Judgment, *Missal of St. Eulalia.* 1403. Illumination, 10 ⅝ × 13 ⅝". Cathedral, Barcelona.

conceived of the religious experience in a more direct fashion, so that Spanish art of the period was almost totally lacking in disguised symbolism. Moral allegories and the symbolic nature of Flemish naturalism were disregarded; the narrative and the sensory immediacy of a saint's legend had greater meaning for the Spanish, and the artists seemingly viewed themselves as artisans, as careful creators of well-crafted images.

Stylistically the Spanish attitude produced works that are seldom confused with Flemish paintings. The chief difference in the Hispano-Flemish period—roughly the second half of the 15th century—was the frequent replacement of Flemish color, with its brilliance and variety, by more muted harmonies of brown and green. The Spanish painters, less interested in the illusion of spatial relations, either neglected this aspect, particularly in the representation of interiors, or ignored it, as in their extensive use of gold backgrounds, which constitute a basic denial of the landscape as a naturalistic setting for the religious scene. Thus landscape did not develop so strongly in Spain as in the Nether-

lands; when it was employed (and it became common later), it tended to be taken over bodily from Netherlandish paintings, with little transformation. Spanish artists tried to produce the effects of Flemish painting by broader brushwork instead of the precise, miniaturistic skill of the Flemings, which is seldom visible in the art of Spain. More concerned with an impressive formal totality, the Spanish painters strove for greater splendor and more vivid realism.

Castile was the most thoroughly Hispano-Flemish area of Spain in the 15th century. Although Catalonia produced the earliest example of the mingled traditions, the pictorial naturalism of Flanders, with its concern for the texture of varied surfaces, was not popular along the eastern coast, where Italian influence had been and was again to be strong.

No Sienese painters have been recorded in Spain, but the Florentines Gherardo Starnina, at the end of the 14th century, and Dello Delli, in the 15th century, each spent a number of years working for Spanish patrons. Furthermore, Avignon, during the "Babylonian captivity" of the papacy and afterward, was a nearer source for Italian influence.

Wall paintings in an oil technique dated 1346, in the convent of Pedralbes, Barcelona, present a fine early instance of the penetration of Sienese ideas. Somewhat harder and sharper than the art of Simone Martini, with which it is closely related, that of Ferrer Bassa, the creator of these works, is an outstanding example of the Italo-Gothic style. This style, continued in Catalonia and Aragon by artists such as Ramón Destorrents, like Ferrer Bassa a court painter, and by the Serra brothers, Jaime and Pedro, was transformed toward the end of the century into the International Style. The Italo-Gothic style is not our concern in this book, but it was widespread, and its course can be followed in C. R. Post's monumental history of painting in Spain and in the writings of such historians as José Gudiol, J. Ainaud, Saralegui, and others.[1]

THE INTERNATIONAL STYLE

France was once again to exert its artistic power; the International Style in Barcelona has such a French flavor that when we find it, for example, in the *Missal of St. Eulalia*, which is

now in the Cathedral of Barcelona, it seems as if its presumed creator, Rafael Destorrents, son of Ramón, had seen the art of Jacquemart before he painted this work, between March and September, 1403, for Bishop Don Juan Ermengol, who gave it to the cathedral. His understanding is so great that Rafael must have visited Paris and worked in its shops. His style is Parisian, and not the mixture of Catalan, French, and Bolognese that characterizes the unknown illuminator from the monastery of San Cugat del Valles, who was borrowed in 1403 by King Martin of Aragon to finish his breviary (Paris, Ms. Rothschild 2529), and who also knew Parisian manuscripts.[2] The latter artist adapted ideas for his calendar from the *Belleville Breviary* type, and other French aspects appear in his work, probably under the influence of models owned by the king. Destorrents's *Missal of St. Eulalia* is much purer in style and delightful and beautiful in color, with a poetic delicacy and variety. One feels an aesthetic emphasis in the page of the Last Judgment and in the Hell scene below (Fig. 296), with its delicately colored apple-green and pink devils. Qualitatively it shares the same degree of artistic achievement found in the French miniaturists by whom it was influenced.

The International Style also came to Spain in another way, as may be seen in another missal (Barcelona, Archives of the Crown of Aragon, Cod. 30), illuminated by Juan (or Jean) Melec in the first decade of the 15th century. Identified in the missal as a priest from Brittany, Jean Melec had apparently worked in Paris before coming to the monastery of San Cugat, for his style and iconography can be traced in the products of some of the leading shops in Paris, though in the less important gatherings of Parisian manuscripts. Possibly because he did not become a leading master in Paris or because of his religious affiliations, he went to Barcelona, where his work was, comparatively speaking, outstanding. A hard, sharp style and somewhat dirty, steel-gray faces are characteristic of his art. Parallels to these styles appear in panel painting of the school of Luis Borrassá, who is discussed below.

Despite wars and other disasters, natural and unnatural, the Iberian Peninsula has preserved large numbers of paintings and mountains of documents to aid in identifying their creators. Over two thousand retables, in whole or in part, have survived from the 14th and 15th centuries, the greater number coming from the latter century. Commissions arose from the need to fill the newer Gothic structures and their chapels with altarpieces, which were paid for by princes, nobles, prelates, guilds, and rich merchants. In Spain the altarpiece took a distinctive form, though its basis, as was the case with all art in Spain, had relationships to the rest of Europe. A mixture of influences was present and assimilated in Spain, but the characteristic retable form seems to have been strongly influenced in its formative stages by Italy. The typical Spanish retable is divided into vertical strips flanking a central scene, or scenes, or a sculptured image, usually not much wider than the side strips. These are normally divided into several panels, commonly showing scenes from the life of the saint represented in the center. A natural result was an emphasis on narrative. This is very strong in Spanish art, where standing saints occupying single panels are far less frequent than in Italy or Flanders. Spanish retables are also different in that they are fixed, without folding members, and protected by a slanted frame called the *guardapolvos* (dust guard), which is decorated with figures and separated from the other panels by slightly projecting Gothic frame members. Such members also serve as the internal divisions of the retable.

Luis Borrassá [3] was the most prominent and influential painter in Barcelona in this period; numerous contracts for retables refer to him as their painter. Eleven preserved retables painted between 1402 and 1426, when he died, are documented. On the basis of these, twenty more have been attributed to him. Born in Gerona about 1360, he was working as early as 1383 in the convent of San Damián in Barcelona, and shortly before 1390 he painted the *Retable of the Archangel Gabriel,* now in the Cathedral of Barcelona. His first preserved works are even earlier; these are predella panels now in the Musée des Arts Décoratifs in Paris. One, the *Beheading of John the Baptist,* reveals a strong decorative tendency in the treatment of draperies and a richness of setting; the figures themselves are rather Italianate. A characteristic work of his later years is the *Retable of St. Peter,* in Tarrasa, executed between 1411 and 1413. The narrative aspects of his early style have been enriched with a larger sense of drama, particularly visible in

the scene of the Calling of St. Peter (Fig. 297), which is also distinctive for showing the new stylistic interests in perspective and more naturalistic surfaces. Borrassá's color is stronger than that of Rafael Destorrents, but, despite the Italo-Gothic souvenirs of the greenish face tones, newer, pinker, bluer, and more lively color is used. In short a softer, more gaily colored veil has been thrown over the Italian types as the artist strove for a closer approximation of visual reality than he had inherited from the Serras. Their style was continued by the colorful but otherwise conservative works painted between 1402 and 1435 by Ramón de Mur.

An important and leading painter for over thirty years, Borrassá had numerous pupils and followers. Among them were Gerardo Gener, who at twenty-two entered Borrassá's shop as an apprentice in 1391; Juan Mates, a better artist than Gener, active in Barcelona between 1392 and 1431; and Jaime Cabrera, who was trained under Jaime Serra before coming under the influence of Borrassá and was active in Barcelona between 1394 and 1432. Four major unknowns worked under Borrassá's influence in Barcelona itself, and his influence spread into the surrounding areas of Tarragona and Lérida, dominating the art of Mateo Ortoneda in the first center and Jaime Ferrer the Elder in the second. The latter's most important work, a *Last Supper,* in Solsona, mixes Netherlandish and Italian types. A fifth major unknown, the Master of (and probably from) Roussillon, whose most important work is a *Retable of St. Andrew,* in New York, represents, in his greater naturalism of forms and movements, a steppingstone to the style of the second important artist of the International Style, Bernardo Martorell. [4]

Martorell, painter and miniaturist, now considered to be identical with the Master of St. George, was probably trained in the shop of Borrassá and is traceable in Barcelona between 1427 and 1452, becoming the leading artist in Catalonia in the second quarter of the century. In his earliest work, the *Retable of St. John* from Cabrera de Mataró, in the Diocesan Museum, Barcelona, he was influenced strongly by the older master, but his style gradually changed with the introduction of more varied color and more tonal effects than those of Borrassá and with his greater interest in the naturalism of setting and detail. Martorell's progress can be

followed through such works as the *Virgin between the Theological Virtues,* in Philadelphia, the *Retable of St. Vincent,* in Barcelona, Catalonian Museum, the *Retable of St. John the Baptist and St. Eulalia,* in Vich, to his best work in the United States, his panel of *St. George and the Dragon* (Fig. 298), in Chicago, painted before 1437. Its side panels are now in the Louvre.

Against a rocky background the elegant saint vigorously rides his beautiful white horse parallel to the picture plane to attack a batwinged, lizard-like dragon to the lower right, as the princess kneels on a rocky ledge above the horse's head praying for a favorable outcome. Rich yet delicate in color, with a fine sense of design and composition, the Chicago work is revelatory of the last stage of the International Style, when rhythmic elegance became intermixed with a strong naturalism and drama. The background, however, is still the conventional Sienese schematic setting of rocks and castle, the land forms being tilted toward the spectator, but a fine variation of light tones creates a patterned surface, and naturalistic details include even bits of blue sky. Also different from Italian models is the marked decorative quality created by the

297. LUIS BORRASSÁ. Calling of St. Peter, *Retable of St. Peter,* detail. 1411–13. Panel. Church of Sta. María, Tarrasa.

rich detail of the saint's splendid armor, the lilies of the crown of the princess, and her rich creamy white and pink costume. Above all, the artist was far more aware of light not merely as an abstract artistic element but as a natural one.

In 1437 Martorell contracted to paint the *Retable of St. Peter,* from Púbol, now in the Diocesan Museum, Gerona. Despite inconsistencies such as nonperspective grounds, it shows a further advance in naturalism, particularly in the donor portraits, and a growing feeling for simplification of forms.

Between 1445 and 1452, according to Gudiol, he painted the *Retable of the Transfiguration,* in the Cathedral of Barcelona. In those panels which are artistically the most important (for, as in his other works, the shop played a large part in the execution) a visible stylistic change has occurred; the early brownish chiaroscuro and delicate miniaturistic manner have been replaced by a broad, more monumental and incisive manner. A serious concern for perspective animates the predella panel showing Christ and the woman of Samaria (Fig. 299) and that of Christ and the woman of Canaan. The large, simplified, and tonally unified figures are set against architectural forms winding back into depth.

A fresh wave of Italian influence seems to have affected Martorell, and the comparisons made of his work with Florentine art of several decades earlier are not unjust. The trend toward monumentality seen in this late style was to affect his followers and dominate the second half of the century in Catalonia. His followers, including Jaime Ferrer the Younger of Lérida, the painters of Gerona, and Valentin Montoliu in Tarragona, were exceedingly numerous. The chief master to succeed him was Jaime Huguet, whose production rose over all others in the second half of the century.

In Valencia during this period the Italo-Gothic style was penetrated through and through by the International Style, as it had been in Barcelona, despite the presence in the city of the Florentine Starnina, recorded in Valencia in 1395 and 1399, and working in 1401 on the decoration of the city for the triumphant entry of Martin of Aragon, along with other artists. According to Vasari he returned to Florence in 1403. Valencia continued to be important politically as the center of the kingdom of Aragon and artistically as the center of an active school

above: 298. BERNARDO MARTORELL. *St. George and the Dragon.* Before 1437. Panel, 56 × 38″. The Art Institute of Chicago (Gift of Mrs. Richard E. Danielson and Mrs. Chauncey McCormick).

below: 299. BERNARDO MARTORELL. Christ and the woman of Samaria, *Retable of the Transfiguration,* detail of predella. *c.* 1445–52. Panel. Cathedral, Barcelona.

of painting with strong Italian contacts. After Alfonso the Magnanimous became king of Naples in 1443, the contacts became even stronger and continued into the Baroque period.

The strong Italian aspect of the International Style in Valencia is seen particularly in the *Retable of Bonifacio Ferrer* of about 1400, commissioned by the brother of St. Vincent Ferrer for the Cartuja, or Carthusian monastery, of Portaceli, and now in Valencia. Its types are thoroughly Italianate, but the softening tendencies in the treatment of forms and the greater fluidity of drapery curves and surfaces reveal the new style penetrating into the fabric of the older approach, and the decorative tendencies so characteristic of Spanish art aid in the transformation of the Italian style.

A real intruder upon the Valencian scene was the painter Andrés Marzal de Sax, active in Valencia between 1393 and 1410, when, sick and impoverished, he is last mentioned as receiving free lodging from the city in recognition of the

merit of his work and for his generosity in teaching the painters of Valencia. Early in his Valencian career this painter, probably from Saxony, as his name implies and as his art indicates, was working with the Valencian Pedro Nicolau, who may be the painter of the delicately colored and charming *Coronation of the Virgin* (Fig. 300), of about 1410, in the Cleveland Museum of Art (where it is attributed to the Master of Rubielos). Marzal de Sax's earliest work was done for the city in collaboration with Nicolau. Among other works, in 1399 they painted a retable for the chapel of the Confraternity of St. James. In 1400 they were still working together, painting a retable for the cathedral, but in the same year Marzal de Sax signed the final receipt for the *Retable of St. Thomas the Apostle,* in the cathedral. In 1404 however, he was working with Gonzalo Pérez, and in 1405 he contracted for another retable to be executed with Gerardo Gener of Barcelona. In 1407 he apprenticed his son Henry to the silversmith Berenguer Motes, and the last documented reference is that of 1410 noted above.

The *Doubting Thomas* (Fig. 301), in the Cathedral of Valencia, may have come from the retable of the saint that he completed in 1400. It combines northern and Italianate ideas but

below: 300. PEDRO NICOLAU(?) OR MASTER OF RUBIELOS(?). *Coronation of the Virgin.* c. 1410. Panel, 57 × 36″. The Cleveland Museum of Art (Gift of Hanna Fund).

301. MARZAL DE SAX. *Doubting Thomas.* 1400(?). Panel. Cathedral, Valencia.

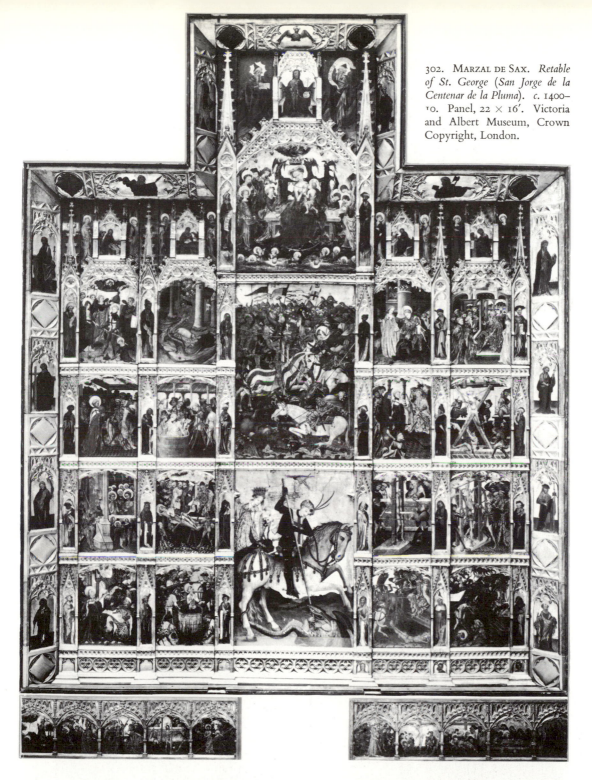

302. MARZAL DE SAX. *Retable of St. George (San Jorge de la Centenar de la Pluma).* c. 1400–10. Panel, 22 × 16′. Victoria and Albert Museum, Crown Copyright, London.

portrays rather dramatic local facial types in the figures at the upper right. While the St. Peter suggests Italian work, the figure of Christ calls to mind the approach of Master Bertram, though the draperies lack the luminous quality of the Hamburg painter. Sax's proportions are slightly more slender, his gestures more marked than those in German painting, and there is a tendency to accentuate faces and gestures.

The outstanding work attributed to him is the *Retable of St. George (San Jorge del Centenar de la Pluma),* in the Victoria and Albert Museum, London (Fig. 302). Three large scenes placed one above the other occupy the center: St. George,

wearing a fine plumed hat, gracefully fights the dragon below. Above this is a splendid battle scene, which has been interpreted as Jaime I defeating the Moors with the aid of the saint and as Pedro I victorious at the battle of Albocacer, though such an intended parallel is unusual in Spanish art. Above that is the enthroned Virgin nursing the Child. The retable is capped by a smaller panel of an enthroned Christ. In addition to the 16 narrative side panels, there are a predella with Passion scenes and framing scenes with figures of prophets, apostles, evangelists, and saints. The work is exceedingly rich in decorative detail and presents a strongly patterned style that seems to be a reduction of the stronger plasticity of northern Germany, the surfaces being treated as tonal patterns. The types are varied; gentle and brutal figures exist side by side. Marzal de Sax's art had a strong influence on the Valencian painters, who united his northern drama and rough types, his naturalism, and his detail with the basic linearity of Valencian style, so that the work of his followers is much less plastic than that of Marzal de Sax himself.

below: 303. GONZALO PÉREZ. *Retable of Sts. Ursula, Martin, and Anthony Abbot.* *c.* 1420. Panel. Museo de Bellas Artes, Valencia.

Gudiol attributed to Gonzalo Pérez a *Retable of Sts. Ursula, Martin, and Anthony Abbot* (Fig. 303), in Valencia, one of the finest products of 15th-century Valencian art. While it reveals an unprecedented sense of simplicity and subtle volume, it is Valencian in the strength of linear feeling, here in perfect union with subdued northern plasticity, and Valencian in its hints of decorative richness. Gonzalo Pérez had worked with Marzal de Sax and the Catalan Gerardo Gener in 1404 and with Gener in 1405 on a *Retable of St. Dominic* for the cathedral; he is referred to in contracts for four lost retables, and his will is recorded in 1451. If he was the painter of these panels of about 1420, which is not at all certain (Gudiol remarked that there were ten painters of this name in Valencia in the 15th century!), he must be considered the leading painter of the period before Jacomart.

The *Madonna and Child* (Fig. 304), in the Walters Art Gallery, Baltimore, a work possibly painted about 1430, is conservative in style, repeats a model of 1404 attributed to Pedro Nicolau (the retable at Sarrión), and shows Italianate greenish undertones in the faces. [5] (It has also been dated about 1400 and attributed to Lorenzo Zaragoza.) However, the artist was aware of the International Style. The delicate

coloration of the garments and the type of throne are close to Parisian miniatures of the last decades of the 14th century. International Style tendencies are far from emphatic, so that the work is rather flat and clearly decorative, and luminosity of surface is tentative at best. The painting reveals the underlying tendency in Valencia to continue the linear, decorative aspects of the temporarily supplanted Italo-Gothic spirit, which was to return in a newer form with the art of Jacomart in the second half of the century. This tendency helps to explain the appearance on Valencian soil of a number of works of much lower quality under the influence of the Catalonian Serras.

HISPANO-FLEMISH STYLE

The next stage of artistic development in Catalonia brings us to an entirely and drastically different conception of the pictorial image from that witnessed in Valencia, though its preparation has been clearly seen in Catalonia and dimly discerned in Valencia. The new manner is known as the Hispano-Flemish style. Its influence on Catalonia and Valencia was of relatively short duration, but in the interior of Spain it was the dominant movement in the second half of the century, particularly in Castile, the most ardent follower of Netherlandish conceptions. The mystic naturalism of the Netherlands appealed to the religious conservatism of Spain. In the second half of the century the Netherlandish point of view crowded out Italian concern with scientific perspective and the perfectibility of natural forms. Apart from the eastern coastal areas, eclectic Spain, forced to choose in the 15th century between a mystic concept of nature and an idealized concept of man, preferred to accentuate nature rather than to idealize man and, like the north, was, in time, to prefer Mannerism to the Renaissance. Its preference was fostered by the dynastic affiliations of Castile and Aragon with the Netherlands and Germany and further aided by the enthusiastic, indeed passionate, collector's instinct of Queen Isabella, who is known to have owned almost five hundred paintings. In the eastern coastal region of Spain and in Aragon, its chief dependency, Italian concepts of idealized form and monumentality made stronger inroads, as the late art of Martorell has demonstrated.

The Hispano-Flemish style was first presented in 1445 by Luis Dalmau in his *Virgin of the Councilors* (Fig. 305), painted for the chapel of the town hall in Barcelona. The style is a direct reflection of that of Jan van Eyck, who had visited the peninsula in 1427 and 1428, in the former year as a member of the embassy to Catalonia, in the latter as a member of the successful mission to Portugal which terminated in the marriage of Isabella of Portugal to Philip the Good. While waiting for Philip's decision, Jan traveled to Santiago de Compostela and to the court of Castile in 1429. He may have gone on to Barcelona and Valencia, but there is no evidence for this. In any case Dalmau's turning to the art of Flanders was not the result of Jan's visit but of the gradual victory everywhere outside Italy of Flemish art over the International

Style, which Flanders itself had fructified.
Though Dalmau had also been at the Castilian
court, it was a year before Jan's visit. His contact
with Van Eyck came in 1431, when the King sent
him and a tapestry weaver, Guillermo d'Uxelles
(who may have been a transplanted Fleming
from Ixelles, now a part of modern Brussels) to
Flanders to acquire knowledge of the technique
of Flemish tapestry so that it could be instituted
in Valencia. [6]

By 1436 Dalmau was back in Valencia, and
Gudiol may be right in ascribing to him at this
period the *Annunciation* in Valencia, the *St.
Ildefonso,* and the *Transfiguration* in the cathedral
in Valencia. These works are painted in oil and
show Valencian preferences in their gold back-
grounds, but they are different in their figure
types and certainly finer in quality than the more
slavish copying of Eyckian work in the Barce-
lona painting of 1445, nine years after Dalmau's
return to Spain and two years after he moved to
Barcelona. Opposed to this ascription is the
definite superiority, particularly in the drawing,
of the Valencian works over what is thus pre-
sumed to be later and therefore should be better
work by the same artist. Perhaps Post is correct
in attributing these works, as well as a *Crucifixion*
(Fig. 306), in the Bauzá Collection, Madrid, to
Louis Allyncbrood of Bruges. He is traceable in

Bruges in 1432 and 1436 and is next met in Valencia in 1439, where he died sometime before 1463. (His son Joris became a master at Bruges in 1460.) Van Eyck's work was known in Valencia, for it is recorded that Alfonso V acquired there in 1444 a *St. George* and an *Annunciation* by Jan, the first known examples of what became a host of Flemish models for Spanish painters.

Thus the *Virgin of the Councilors* of Luis Dalmau remains the earliest documented Hispano-Flemish work. Presenting unschematized architecture and a landscape instead of a gold ground, employing aerial perspective, painted in oils with graduated light and color and a marked naturalism, it is modeled after the *Ghent Altarpiece* and the *Van der Paele Madonna,* which Dalmau rendered in a wooden fashion. In place of the refinement and aesthetic character of the International Style there is a naturalism more intensely conceived and more dramatically rendered in Spain than in Flanders. Dalmau flattened Van Eyck's forms by a stronger linearity and less plasticity and stiffened them at the same time. Further, Dalmau was not so fine a draftsman, as is evident in the drawing of the hand around the body of the Child.

Dalmau's strong emulation of Flemish style was not highly successful in Catalonia. His artistic outlook was supplanted by that of Jaime Huguet, who continued Martorell's style and went on to develop a distinctive manner that had far fewer contacts with the Flemish outlook.[7] Born before 1414 at Valls, in the province of Tarragona, and raised by a painter uncle, who moved to Barcelona, close to the shop of Martorell, by 1434, Huguet did his early work mainly in Zaragoza and Tarragona, as pointed out by Gudiol, and not until 1448 did he return to Barcelona. In the years before his death in 1492 he became the city's leading painter.

Huguet's second style, in the late 1440s, shows a brief contact with Flemish style. After the middle 1450s he advanced in the direction of a more Italianate and tranquil linearism, which was firmly established by 1465 and governed the art of his later years. The masterpiece of the first style is the *St. George* in Barcelona (Post attributed this to an Aragonese follower, Martín de Soria), which goes beyond Martorell in the incisive draftsmanship and characterization of

307. JAIME HUGUET. Titular saints, *Retable of Sts. Abdón and Senén,* center. 1459–60. Panel, 47 ¼ × 63 ¾″. Church of Sta. María, Tarrasa.

the saint, and almost eliminates any fluid luminosity of surface. Its date must be very close to 1448.

The panels from the *Retable of St. Vincent,* of the later 1450s, from the suburban church of Sarriá, now in the Catalonian Museum, Barcelona, characterize the second style, which seems to combine an influence from the contemporary Flemish interest in elongated forms (the style of the long lines) with naturalistic detail, types that suggest Bouts, gentle angularity, and a crowding of the surface in the attempt to negate spatial depth. A minimum of perspective and of chiaroscuro is employed in this revolt against Flemish tactile space.

Along with a return to a limited chiaroscuro, elegant formal patterns in figures and color, with which he allied his highly sensitive and delicate draftsmanship, appear in the 1459–60 *Retable of Sts. Abdón and Senén* (Fig. 307), in Tarrasa. An Italianate quality seems to pervade these forms, with only a suggestion of northern expression. Subsequent works, such as the eight panels from the *Retable of St. Augustine,* in Barcelona, executed between 1465 and 1480,

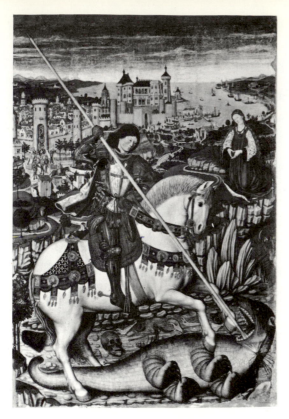

308. PEDRO NISART. *St. George.* 1468–after 1470. Panel. Museo Diocesano, Palma de Mallorca.

are further assertions of the same preference for surface richness, sumptuousness, and brilliant draftsmanship. Huguet's chief followers in Barcelona were the members of the Vergós family, who, like Pedro García, Martorell's chief follower in the second half of the century, mixed the styles of Huguet and Martorell but in inverse proportion. Huguet's influence was widespread; the towns of Lérida, Tarragona, Gerona, and even the province of Roussillon were dominated by his style, and another group under his influence is found in Aragon.

At Palma de Mallorca in the Balearics was painted one of the best-known Hispano-Flemish works (Fig. 308), the *St. George* of Pedro Nisart, who was probably from Nice. He began the work, now in the Diocesan Museum, Palma de Mallorca, in 1468. Though assisted by Rafael Moguer, he did not complete it until after 1470. It was formerly considered as possibly a copy of the Van Eyck *St. George* known to have been owned by Alfonso V, but Gudiol's argument for a French origin of the landscape background is convincing, though the theme itself is posed in the manner met frequently in the first half of the century (e.g.,

in the Martorell panel in Chicago and in shop works of the Master of Flémalle, among the many). Nisart formalized his model to make a tableau by turning the torso directly toward the spectator, and he reveals Franco-Italian training in the sharp separation of foreground action and background landscape.

A more Italianate style characterizes the dour-faced, large-figured *Martyrdom of St. Sebastian* of Alonso de Sedano of Burgos, also in Palma. The work takes a position midway between Flemish naturalism and Italian monumentality because of the determined elimination of atmospheric effects.

Another excellent master in the wake of Huguet was the Master of the Seo de Urgel, known from organ wings in the cathedral there and from a retable for Puigcerdá, now in the Catalonian Museum, Barcelona. His St. Jerome from the retable combines a French landscape, seen from a high point of view (and thus indicative of a very late date in the 15th century) and a slender figure type related to Huguet but more modeled and tonal, suggesting that its painter had been in the Netherlands.

In Valencia the acceptance of the Flemish style and its transformation into a truly Hispano-Flemish style were hindered by an artist who played the same part there that Huguet played in Barcelona. This was Jaime Baço Jacomart, who was born before 1413 and died in 1461. By 1440 he was so well known that Alfonso V called him to Italy and paid his way, but he did not go until 1443, though Alfonso had, nevertheless, made him a royal painter in the previous year. The retable for Burjasot, for which he had contracted in 1441, was completed for him by Juan Rexach, in the first collaboration of a long association. Jacomart returned briefly to Valencia before 1446, when he was recorded in Naples. In the following year he painted twenty banners for Alfonso and probably visited Rome to meet, or meet again, Cardinal Alfonso Borja (Italian: Borgia), later Pope Calixtus III (1455–58), who commissioned a retable for his chapel at Játiva. By 1451 at the latest Jacomart was back in Valencia, where it seems he spent the remaining ten years of his life, beginning a retable of St. Catherine for the palace chapel in 1458, the year in which Alfonso V died. His successor, Juan II, continued to patronize Jacomart, paying for the St. Catherine retable in 1460. In this year Jacomart contracted for a retable for the town

of Catí, his only preserved documented work—and most of it was painted by Juan Rexach! Rexach's style is known on the basis of the *Retable of St. Ursula* from Cubélls, in the Catalonian Museum, Barcelona, signed and dated 1468, and it becomes evident on comparison with the works attributed to Jacomart that Rexach presents a watered-down version of the greater master's work. In general, Jacomart was more monumental than his Catalan contemporaries.

The Játiva *Retable of Sts. Ildefonso and Augustine,* made for Cardinal Borja before 1455, shows the donor kneeling in slightly wooden fashion in cardinal's robes before St. Ildefonso. The saint calls to mind the model for enthroned saints established much earlier by Simone Martini's *St. Louis of Toulouse.* The shell niche behind the saint is a Rexach motif, but in the figures there is a lively quality and clarity of line and pattern. Though the line is somewhat tight, and particularly so in the panel of the Madonna and Child with St. Anne (a modernization of the Walters Gallery's 1430 *Madonna and Child*), there is in this retable a profuse scattering

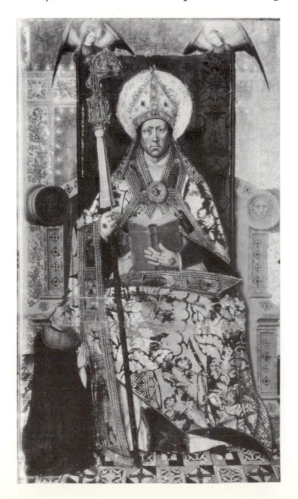

of Gothic detail about the background that, despite a certain nod to plasticity, results in a flattening of form. Jacomart's style mediates between Italian clarity and linearity and northern naturalism and atmosphere. He had a large influence on the lesser painters of Valencia in the succeeding years, notably on his collaborator, Juan Rexach, who was heard of as early as 1431 and was still working in 1482.

Perhaps Rexach's work, but more interesting than usual and sometimes attributed to Jacomart himself, is the *St. Martin Retable* in the Diocesan Museum at Segorbe. Gudiol created a "Segorbe Master" for this work of about mid-century, which he considered as intermediate between Jacomart and Rexach. Its modeling and naturalism have certain clear reminiscences of the delicacy and grace of International Style work. The scene of an elegant, fluffy-haired, youthful St. Martin dividing his cloak with a tattered beggar calls to mind similar conceptions in the art of the Limbourgs. A fine landscape behind the scene suggests the work of Provençal artists; thus the work shows both a reluctance to turn to Hispano-Flemish ideas and a desire to retain, even though it was no longer possible, some of the elegance of the earlier style. The central figure of St. Martin (Fig. 309) possesses intimations of monumentality and shows a great delight in textile patterns, but the surfaces are flat. There is much refined draftsmanship but little plasticity or atmosphere. Combined with this is an intensity of expression and a rigidity of feeling, the strongest modeling being devoted to the features, so that the spectator's eye tends to concentrate on them.

Elsewhere in Spain the change from an International Style to a Hispano-Flemish one met far less resistance. Aragon, however, so close to Catalonia and Valencia, modeled itself upon its eastern neighbors. Here the Italo-Gothic style was so strong that the International Style took an Italian form, despite the presence of northern artists, including a John and a Nicholas of Brussels documented in 1379 at the archiepiscopal court at Zaragoza. Not until the first decade of the 15th century did northern

left: 309. JAIME BAÇO JACOMART or JUAN REXACH(?). Titular saint, *St. Martin Retable,* center. *c.* mid-15th century. Panel. Museum, Segorbe.

influence penetrate Aragon in preserved work. The *Retable of Sts. Catherine, Lawrence, and Prudentius* in the Cathedral of Tarazona, by Juan de Leví (documented in Zaragoza between 1402 and 1407), reveals an elegant linearism of elongated decorative forms that suggest the influence of French miniatures of the same period. Far sharper in outline and linear decorativeness is the art of Nicolás Solana, who seems to unite the styles of Leví and Marzal de Sax. The latter's influence is particularly visible in Aragon in the works of the Retascón Master, though numerous Aragonese paintings as late as the 1430s show the influence of the more important coastal schools. What seems specifically Aragonese at this period is a harder line and a sharper expression, as in the Lanaja Master's *Virgin and Child* of 1439, in the Lázaro Galdiano Museum, Madrid, which repeats with greater surface accentuation the Valencian type seen in the Walters Gallery *Madonna and Child.*

Navarre, though more subject to influences from France, was strongly influenced by Aragon and its models, as is evident in the *St. Ursula* by Master Jacobo in the Barcelona Museum. However, the *Crucifixion Triptych* in the Valdés Collection, Bilbao, which Gudiol thought French, is surely German, for its iconography and style recall Master Francke. Elsewhere French influence appeared, but in the *Retable of St. Catherine* in the Cathedral of Tudela the stylistic influence of Juan de Leví is seen.

The presence of Starnina at Toledo, in Andalusia, in the 14th century and Dello Delli at Salamanca in the first half of the 15th century lent to these regions a distinct Florentine caste, and the transition from Italo-Gothic to International Style took place without the intrusion of French or Flemish elements. In León the painter Nicolás Francés appeared in the late 1420s or early 1430s, lending a northern color to painting in this region until his death in 1468. In the 1430s he was painting the chief retable of León's French-style cathedral. Stylistically the fragments show the phase of infusion of the soft style with greater volumetric concern, a phase visible in the early work of Lochner and elsewhere in Germany and characteristic of the interest in plasticity everywhere evident from the late 1420s to the 1440s, or even later, depending upon the region. The clear style of Francés, with its balance between narrative and formal variety, dominated in the León area for the rest of the century. Juan de Burgos, known from an *Annunciation* (Fig. 310) in the Fogg Art Museum, Cambridge, Massachusetts, was apparently working with Francés about mid-century. His style is close to Francés's in its strong outlines, determinedly modeled forms, and soft-surfaced but plastic draperies.

The earliest dated Hispano-Flemish painting in Castile is the *Retable of the Virgin* from Buitrago, of 1455, whose portraits of the donors kneeling at *prie-dieux*, in the Collection of the

310. JUAN DE BURGOS. *Annunciation. c.* 1450. Panel, *c.* 36 × 13 ¼" (each). Fogg Art Museum, Harvard University, Cambridge, Massachusetts (Gift of Meta and Paul J. Sachs).

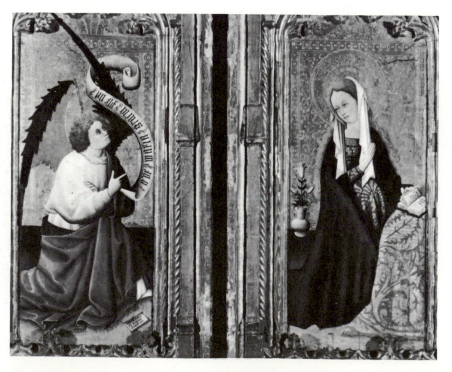

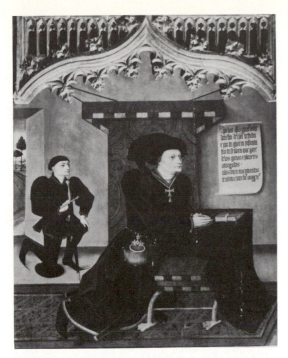

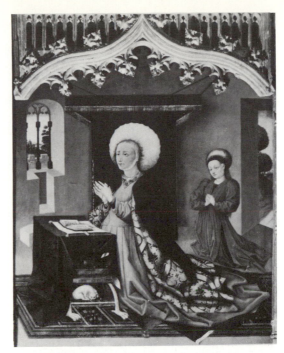

Duque del Infantado de Viñuelas (on loan to the Prado), were painted by Jorge Inglés (George the Englishman). All that is known of the painter is his name, but his training may have been in the Netherlands, for his style is vaguely like that of Rogier van der Weyden. Stylistically intermediate between the Master of Flémalle and Rogier, his work shows a gradual loss of Flemish purity in its translation into Spanish, that is, a growth of decorative ornamentation at the expense of naturalism of setting and an accentuated, almost exaggerated expression, gesture, and movement at the expense of lyrical balance. In his portraits of the donors, the Marquis de Santillana and his wife, he depends on silhouette and flat pattern, with little chiaroscuro in comparison with his Flemish models (Fig. 311). But in place of a Spanish decorative gold background there are a landscape vista and a suggestion of architecture that is more than just schematic. The *Retable of St. Jerome* from Mejorada, in Valladolid, may be attributed to him on the basis of style.

More accomplished are the four panels attributed to his successor, the Master of Sopetrán, now in the Prado, which originally came from the Hermitage of Sopetrán. The *Annunciation* is a copy of Rogier's Antwerp *Annunciation,* with some reversals, while the *Donor Portrait* (Fig. 312), which may or may not be a portrait of the son of the Marquis de Santillana, is also strongly influenced by Rogier.

above: 311. JORGE INGLES. Marquis of Santillana and his wife, *Retable of the Virgin,* donor portraits. 1455. Panel. Collection of the Duque del Infantado de Viñuelas, on loan to Prado, Madrid.

below: 312. MASTER OF SOPETRÁN. *Donor Portrait. c.* 1460–70. Panel, 40 $\frac{1}{2}$ × 23 $\frac{5}{8}$". Prado, Madrid.

Stylistically it is related to the Antwerp *Seven Sacraments Altarpiece*. Despite the excellent handling of details, the lack of proper spatial relationships, even though they were attempted, seems to point to the hand of a Spaniard who had received a course of training in Rogier's shop in the 1450s, but it is not possible to say that the work was painted then.

The first Castilian artist whose career can be documented, and whose style is recognizable whether the works are signed or not, created a large *œuvre* and an immense following in Castile, Salamanca, and Zamora provinces. He is Fernando Gallego, whose important output extended over the second half of the century. [8] Thought to have been born about 1440, he is traceable as early as 1466 and as late as 1506, working mainly in Salamanca, where the Spanish Vasari, Palomino, said he was born. Early in his career he may have visited the Netherlands and Louvain, for his style has affinities with that of Dirk Bouts; however,

313. FERNANDO GALLEGO. Investiture of St. Ildefonso, *Retable of St. Ildefonso,* center. *c.* 1475–80. Panel, 54 × 51 ⅛". Cathedral, Zamora.

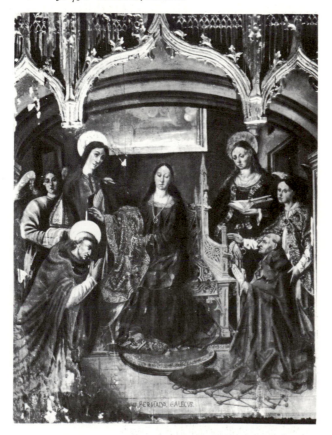

Bouts's works could have been seen in the peninsula, and a voyage to the north is not an absolute certainty as it seems to be with the Master of Sopetrán. Gallego was not a slavish copyist. His style is highly personal, Spanish, and expressive. In his sense of form and color, with a preference for more sober colors such as greens, grays, and soft blues, he was totally unlike Bouts; he was also a more primitive painter than his Flemish counterpart.

Two of his earliest works are a *Crucifixion* and a *Pietà,* in the Weibel Collection, Madrid. Strongly dramatic and expressive drawing is combined with an angularity of form, a primitivism asserted by the lack of atmosphere, a schematized landscape, and a sharp, flat delimiting of the contrasting lights and voluminously draped forms. St. John's sorrow becomes a grimace in the Crucifixion scene; yet Gallego's vitality is undeniable. His strong, contorted movements were more controlled in later works, but his underlying dramatic spirit is expressed here in the drapery surfaces, whose chiaroscuro is forceful and exciting. His earliest dated work is the *Retable of St. Ildefonso* (Fig. 313), in the Cathedral of Zamora. It honors Cardinal Mella, who died in 1467 and who had received his cardinal's hat in 1466, but, as Post pointed out, it was influenced by Schongauer prints that are not earlier than the late 1470s; thus the work must have been a posthumous commission. The handling shows greater mastery and monumentality, and the large figural movements are more fluid, though the features approach caricature.

In 1468 Gallego was recorded as working at the Cathedral of Plasencia, and in 1473 he was commissioned to paint no less than six retables for the Cathedral of Soria, all of them now lost. Signed but not dated is a triptych of the Virgin, St. Andrew, and St. Christopher. now in the New Cathedral, Salamanca. Gudiol thought it as early as 1470, which seems too early, for it shows a larger conception and greater mastery than the Zamora work. In 1473 Gallego completed in a mixed technique some astrological frescoes (now much repainted) on the vault of the library of the University of Salamanca. The last record is a request in 1507 for payment for a now lost work in the chapel of the University at Salamanca. Like each leading Spanish master presented in these pages, his influence was wide-

spread, in part because of the numerous collaborators who carried his style as far west as Portugal. One was Francisco Gallego, obviously related to the master, who was paid in 1500 for the *Retable of St. Catherine* in the Old Cathedral, Salamanca. A *Pietà* by Francisco inserted into Dello Delli's retable in the Old Cathedral, Salamanca, is based on Hugo van der Goes's Vienna *Lamentation* (Fig. 183), but everything has become more wooden, and the eyes have a particularly heavy, glazed stare.

A second group of Castilian Hispano-Flemish paintings, parallel in time to the productions of Gallego and his following, are grouped around another of the chief painters of 15th-century Spain, the Master of St. Ildefonso, who takes his name from a work in the Louvre, the *Investiture of St. Ildefonso* (Fig. 314). He is related to Gallego by a largeness of figural conception and a marked activity of drapery folds, but his figures grimace less. A more suave modeling, with less dependence on linear accentuation in the eyes and mouth, results in greater harmony and calmer assertion of the plastic quality, and there is a grandeur of conception that is not expressionistic. The style of the Master of Flémalle is discerned in the background of his art, but it probably reached him through German prints such as those of Master E.S., in one of the early instances of the power of that new medium (see Chap. 18). Between 1483 and 1485, with the co-operation of another master, the Master of Luna, he painted the *Retable of the Santiago Chapel* in the Cathedral of Toledo. The retable is documented as the work of Juan Rodríguez de Segovia and Sancho de Zamora, but which name belongs to the Master of Luna and which to the Ildefonso Master has been impossible to say.

Gudiol has arbitrarily called the better master Sancho de Zamora, and attributed to him the figures of St. Athanasius and St. Louis of Toulouse, from the monastery of La Merced near Valladolid, now in the museum there. These seem earlier than the *Retable of the Santiago Chapel*, in which the more atmospherically conceived figure of John the Evangelist (Fig. 315) shows a marked yet severe emulation of Hans Memlinc's types from the *Donne Triptych* (Fig. 207), and a fluid drapery has replaced the earlier harshly broken folds. His coworker, the Master of Luna, derives from the Sopetrán

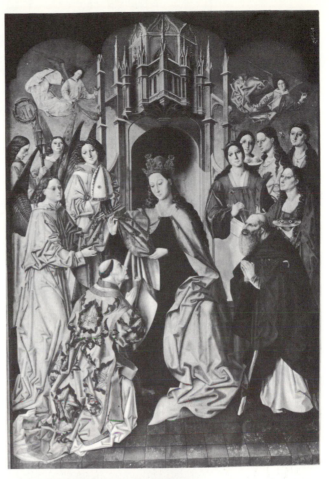

above: 314. MASTER OF ST. ILDEFONSO. *Investiture of St. Ildefonso. c.* 1475–80. Panel, 93 3/4 × 67″. Louvre, Paris.

left: 315. SANCHO DE ZAMORA(?). John the Evangelist, *Retable of the Santiago Chapel,* detail. 1483–85. Panel. Cathedral, Toledo.

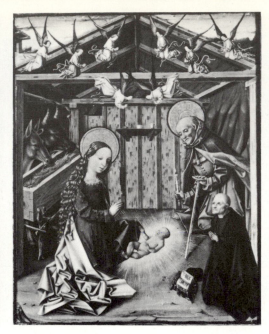

316. MASTER OF ÁVILA. *Nativity. c.*1470–80. Panel. Museo Lázaro Galdiano, Madrid.

Master and from early Rogier of the Duran Virgin type, which he reduced to banality.

The chief follower of the Ildefonso Master in Valladolid and Soria provinces was the Osma Master, who, toward the turn of the century, was working for more simple surfaces and quieter forms, as in his *St. Anne with the Virgin and Child and Donors,* in the Archeological Museum, Valladolid.

Van der Weyden's influence, perhaps conveyed by German prints, is also visible in the art of the third branch of Hispano-Flemish painting on northwestern Spain, which is grouped around the Master of Ávila, possibly García del Barco (active 1465 to 1476). His chief work is a triptych of the *Nativity* (Fig. 316), in the Lázaro Galdiano Museum, Madrid, with a grisaille Annunciation on the exterior. The work is a free version of Rogier's *Bladelin Triptych* (Fig. 141) but executed several decades later and not improved by its Hispanic translation. The types, however, are more serene than those the master normally derived from Gallego.

The chief painter in Navarre, Pedro Díaz of Oviedo, was under the influence of the Ávila Master; his most important work is the retable of 1487–94, in the Cathedral of Tudela, in which Castilian and Flemish influences mingle.

Far more interesting is Diego de la Cruz (the Master of Los Reyes Católicos),[9] author of a gigantic retable now dispersed among American collections and possibly painted at Valladolid. Active at the end of the century, he created this retable for the reigning monarchs about 1496–97, as can be told from the heraldic insignia, which probably refer to marriages uniting Spain, Burgundy, and Austria. He may have been trained in Cologne under the Holy Kinship Master (see Chap. 17). Be that as it may, he followed models stemming from Rogier, of a generation earlier, but he was head and shoulders above his compatriots in his understanding and handling of Netherlandish chiaroscuro, space, and architecture and in the rendering of surface textures. Typically Spanish are his intensity, his glum or glowering faces, and his somber color. Four of the panels are in the John N. Willys Collection, Palm Beach, Florida; the spatially interesting *Marriage at Cana* (Fig. 317) is in the National Gallery in Washington, D.C.; and the *Christ among the Doctors* is now in the Fogg Art Museum, Harvard University, Cambridge, Massachusetts.

The retable in the Diocesan Museum, Burgos, is closely related, its central scene of the Adoration of the Magi showing a further debt to the spatiality of late 15th-century Cologne, both in figure arrangement and landscape setting. High technical ability, amplitude of form, and gravity of conception are united in these works in a Hispano-Flemish parallel to the growing monumentality seen at the same time in Bruges in the work of Memlinc and then David. Other painters in Castile in the last years of the century selected another side of Flemish late 15th-century painting. Some paralleled the

turn toward gravity and quiet, while others adopted the sentiment of Memlinc and the softer chiaroscuro and much greater sentiment of Albrecht Bouts. An example of the latter direction is the Master of Sta. María del Campo's *Virgin of Mercy,* from Palencia, now in the Archeological Museum, Madrid.

However, in this region, as elsewhere in Spain late in the century, Italian art began to exert a greater attraction than before. As with the Flemish masters, its influence appeared first in ornament (Master of Los Balbases, *Retable of St. Stephen,* Los Balbases), then in concepts of form, probably derived at first from prints such as those attributed to Mantegna and finally as a result of trips to Italy.

South of Castile the Hispano-Flemish style gradually supplanted the strong Italian influence, in Seville beginning about mid-century. In the last quarter of the century Andalusian painting was dominated by members of the Sánchez family and is characterized by a softening of Castilian violence without a compensatory rise

in quality, except for one amazing, splendid work by an anonymous Sevillian painter of the fourth quarter of the century, the *St. Michael* (Fig. 318) from Zafra, now in the Prado. Minuscule serpents, dragons, and apelike demons almost surround the large, resplendently armored, youthful saint. Small angels carry on the combat behind and above him, while high above, like the host in a Last Judgment, vast multitudes crowd the remaining space in dense rows. Soft lighting on the armor and figures and clarity of silhouette are in union with the miniaturistic and the monumental, the patterned and the spacious.

Appearing late on the Hispano-Flemish scene, the Flemish court painters Miguel Sithium[10] and

left: 317. DIEGO DE LA CRUZ (MASTER OF LOS REYES CATÓLICOS). *Marriage at Cana.* c. 1496–97. Panel, 61 × 37″. National Gallery of Art, Washington, D.C.

below: 318. HISPANO-FLEMISH. *St. Michael.* c. 1475–90. Canvas mounted on wood, 95 1/4 × 60 1/4″. Prado, Madrid.

Juan de Flandes influenced their Spanish contemporaries for only a relatively short time. Sithium, or Michiel Sittow, born at Reval in 1469, was an apprentice in Bruges in 1484 and appeared in Spain in 1492 but returned to the Lowlands and the court at Malines with Philip the Handsome in 1502. After 1505 he pursued his career in his native city, where he died in 1525.

Juan de Flandes,[11] who may have been trained in Antwerp, spent the last three decades of his life in Spain, having been sent in 1495 by Maximilian of Austria to make portraits of the Spanish royal children. Entering Isabella's service in 1496, he received the title of court painter two years later, about which time he executed for her (with assistance) his renowned miniature altarpiece, now dismembered and much scattered. From it is the characteristic and thoroughly Flemish *Christ Crowned with Thorns*, in the Detroit Institute of Arts (Fig. 319), which reveals Juan's delicate and charming miniaturistic style with its superb luminosity and subtle color.

After the death of Isabella in 1504 he executed a retable for the chapel of the University of Salamanca, of which little is left, and about 1510 began in a more monumental style the high altar of the Cathedral of Palencia. A document of 1519 makes reference to his widow. It is known that he had a son, and works in a Renaissance manner close to that of Juan himself have been attributed to him.

Toward the end of the century the Hispano-Flemish style, under the aegis of artists whose works are generally of higher quality than that of the vast outpouring of the second half of the century, assimilated conceptions originating in Italy. The result was a transformation into a Renaissance style, which, as in northern Europe, almost immediately adopted a Manneristic outlook.

Again it was the eastern coast of Spain that led the way, if Bartolomé Bermejo may be identified with that area. This artist, who has been rightly called the greatest of the Spanish primitives, cannot be related to any of Spain's

above: 319. JUAN DE FLANDES. *Christ Crowned with Thorns.* c. 1498. Panel, 8 1/2 × 6 3/8". The Detroit Institute of Arts.

right: 320. BARTOLOMÉ BERMEJO. *St. Michael.* 1474–77. Panel. Wernher Collection, Luton Hoo.

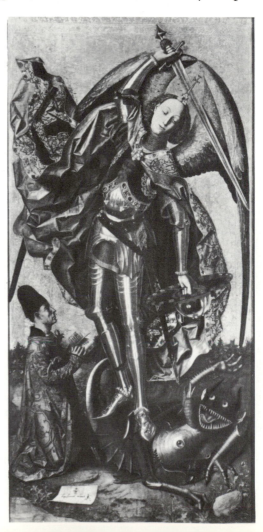

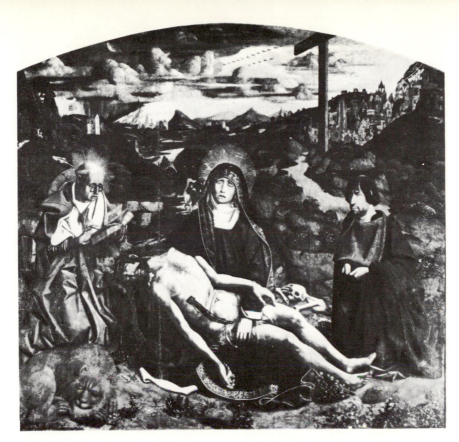

321. BARTOLOMÉ BERMEJO. *Pietà*. 1490. Panel, 74 ³/₈ × 68 ⁷/₈″ (including frame). Cathedral, Barcelona.

schools, though there is a suggestion of the Master of St. Ildefonso in his early style. In Aragon between 1474 and 1477, he influenced Aragonese painting, which had little force at this period. In 1486 he worked in Barcelona in collaboration with Jaime Huguet, making paintings for Sta. María del Mar. In 1490 he painted and signed his famous *Pietà* in Barcelona Cathedral, and documents of 1495 refer to designs for stained glass for the cathedral. One panel from his designs is preserved in the baptistry. According to Gudiol, the last document concerning Bermejo dates from 1498, when, it seems, he was in Vich.

From his Aragonese period comes the painting of *St. Michael* (Fig. 320), from Tous in the province of Valencia, now in the Wernher Collection, Luton Hoo. The signature "Bartolomeus Rubeus" is different from the name in the document of 1474, referring to a retable at Daroca dedicated to S. Domingo de Silos, in which he is called "Bartolomé de Cárdenas." (The figure of the titular saint from the Daroca retable, now in the Prado, is certainly earlier than the *St. Michael*.) The *St. Michael* suggests that Bermejo had traveled in Flanders, for it calls to mind similar St. Michaels by Christus and Memlinc. The drapery, hard and vigorously

crumpled like that of the Ildefonso Master, immediately catches the eye; the artist studied it with the intent to reproduce its naturalistic aspect. Yet this is subordinated to the very evident power of compositional organization, which immediately raises the work above the average Hispano-Flemish level. The design of the saint's movement is echoed and balanced by the donor on the lower left and by the sharp-toothed, triangular-mouthed demon at the lower right. Bermejo presents an impressive sense of form, despite angularities and the typical Aragonese gold background.

Apparently contemporaneous is the *S. Engracia* in the Isabella Stewart Gardner Museum in Boston. The figure type is Flemish, but the color is somber, showing the normal browns, tans, and generally cool tones so suited to the Spanish expression and so characteristic of it. A largeness and grandeur are discerned in the figure, despite a heavy overlay of naturalistic detail, which has happily been subordinated to a relatively simplified outline.

This development is carried to its culmination in the *Pietà* (Fig. 321), in Barcelona Cathedral, signed "Opus Bartolomeus Vermejo Cordubensis" and dated 1490. It was made for Canon Luis Desplá, seen kneeling at the right. Flemish

influence is strong, but the landscape setting, the dramatic lighting of the figures and of the background while the middle ground is subdued in tone, and especially the silhouetting of dark forms are unlike Flemish work and may be due to the influence of northern Italy. The right side of the donor's face, with its heavy stubble beard, emerges from a strong dark treatment of the head. This dramatic note is continued in the fully plastic treatment of the Virgin's expressive face and in St. Jerome's features, also revealed under Bermejo's strong light. The center of the drama is the face of the Virgin, rather than the almost puppet-like figure of Christ, whose eyes are slits in a dark face and whose blood streams down the body in a curve that is decoratively conceived. The Virgin's expression of grief and overwhelming suffering is so strong that the figure of Christ is almost a supernumerary, a

322. NUNO GONÇALVES. Archbishop panel, *Retable of St. Vincent.* *c.* 1460–70. Panel, 81 ³/₄ × 50 ⁵/₈″. Museu Nacional de Arte Antiga, Lisbon.

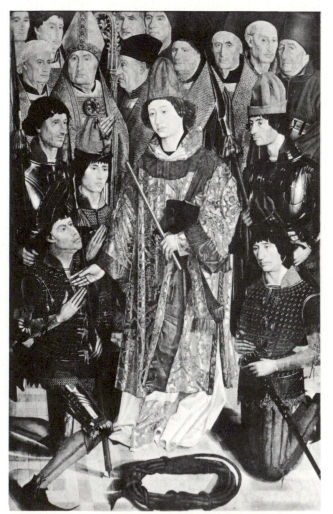

cause but not the center of grief. Bermejo designed his work as a drama of movement from head to head set out against a strongly dramatic landscape. A brewing storm is seen at the left, and above a jagged landscape heavy clouds move across the sky toward the town bathed in somber reddish light at the right.

Bermejo's power is evident, though its source cannot be discerned in Córdoba. The possibility of a Flemish training has already been suggested; some confirmation is offered by the attribution to him by Gudiol of a *St. George,* in Paris, Musée du Petit-Palais, which repeats exactly a figure found in Flemish miniatures of the 1480s and later. Also, the background wall and drapery repeat a like motif in Rogier's Philadelphia *Crucifixion* (Fig. 143). Further proof of Flemish influence can be seen in the nude figures in the panel of the *Descent into Limbo,* Barcelona, inspired by some such work as Memlinc's Danzig *Last Judgment.* The relationship provides a *terminus ante quem* for Bermejo's travels in the Netherlands.

Some have thought that Bermejo was trained in Portugal under Nuno Gonçalves,[12] the leading Portuguese painter of the 15th century, who is known for his *Retable of St. Vincent,* from the Lisbon convent of St. Vincent, a four-paneled polyptych painted for the monarch, Henry the Navigator, in the 1460s (Fig. 322). Gonçalves created an agglomeration of heads in his four narrow panels with little space. The figures are all organized in a vertical spatial relationship; yet the result is monumental, with a magnificent, almost relentless naturalism of detail. His sense of surfaces is skillfully subordinated to the importance of the over-all formal design, and thus the interplay of elements reaches a high artistic level unequaled by most of his peninsular contemporaries or by his followers. His weighty form and his color, however, carried on in Portugal into the 16th century.

In Valencia the transition was led by Rodrigo de Osona the Elder, first mentioned in 1464. His early work shows the influence of the style of Jacomart. But his signed *Crucifixion* (Fig. 323) of 1476, in the church of St. Nicholas, Valencia, is stylistically parallel to the work of Bermejo, though there are marked differences because of the souvenirs of the still-prevailing gentler Valencian manner, to which he added a landscape background of north Italian inspiration.

Osona, however, had the same element of human drama that informs the work of the more illustrious Bermejo. His son, of the same name, continued his style in a weaker and even more Italianate manner, without the larger grandeur of the father.

The *Martyrdom of St. Cucufas* (Fig. 324), in Barcelona, once thought to be a work of 1473 by Master Alfonso from Córdoba, has in recent years been recognized from documents as the creation, between 1504 and 1507, of a German artist called in Catalan Anye Brú but in German Hans (or Heinrich) Brun (or Brün). The largeness of figural conception, the naturalism of surface, and the monumentality of form of this work would be exceptional in Spanish art of the period to which it had been attributed, but the establishment of its German origin puts the picture of Spanish art in Catalonia at the turn of the century in its proper focus.

With Pedro Berruguete, traceable in 1477 and 1504, the year of his death, in Ávila, Spanish art was even more significantly oriented toward Italy. [13] Born in Paredes de Nava, he was probably trained in the Gallego manner, but his works after 1483 establish very clearly that he was the Pietro Spagnuolo who was in Urbino in 1477, working under Joos van Ghent on the decoration of the ducal chamber in the palace of Federigo da Montefeltro. When he returned to Spain, he had a far greater understanding than any of his contemporaries of Italian and Flemish art. Back in Spain, at Toledo, by 1483, he brought his knowledge to bear on a series of retables. His Urbino experiences are recognizable in the six predella paintings of kings and prophets of Israel from the *Retable of St. Eulalia* for Paredes de Nava (Fig. 325), and his command of architectural perspective is seen in the two altarpieces painted for the Dominican convent at Ávila. Unfortunately, the practice of the time, which saw much of the work turned over to assistants, has resulted in uneven quality, the mark of most Hispano-Flemish paintings created by masters other than the leaders in the adoption of the Hispano-Flemish style. Last of the great

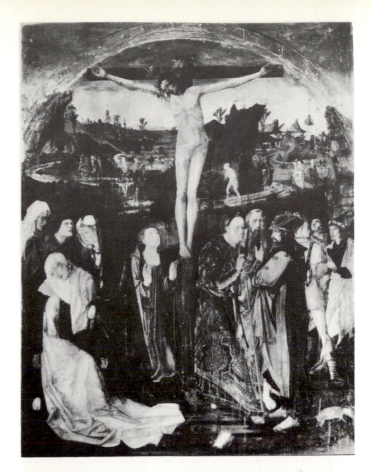

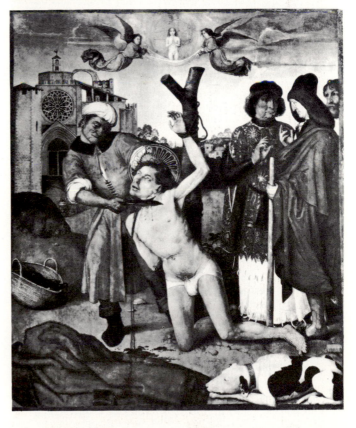

above: 323. RODRIGO DE OSONA THE ELDER. *Crucifixion.* 1476. Panel. Church of S. Nicolás, Valencia.

right: 324. ANYE BRÚ. *Martyrdom of St. Cucufas.* 1504-07. Panel. Museo de Arte de Cataluña, Barcelona.

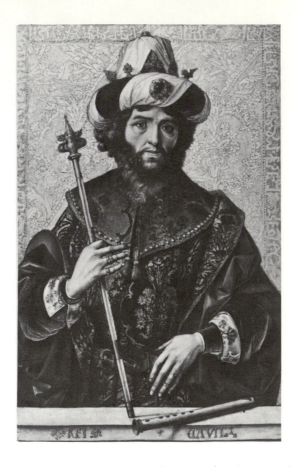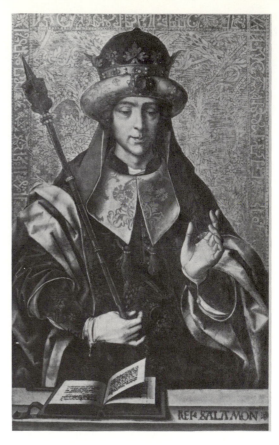

325. PEDRO BERRUGUETE. King David and King Solomon, *Retable of St. Eulalia,* predella panels, After 1483. Panel, 37 × 25 ⁵/₈" (each). Church of Sta. Eulalia, Paredes de Nava, Palencia.

primitives, Berruguete was qualitatively and chronologically the first of the Italianizing painters. Trained first in Tuscany, later in Rome, these painters had a new orientation, to which they were led by the developments in Flemish art itself and which brought an end to the Hispano-Flemish style in Spain.

The transformation of the Italo-Gothic manner into a northern-dominated International Style, through which Flanders was able to wrest Spanish art from Italian supremacy during the second half of the 15th century, and particularly in the interior of the peninsula, was achieved in spite of the country's normal orientation and position in the Mediterranean world. Hispano-Flemish art ran a course like that in Flanders—from International Style decorative naturalism to Eyckian realism to Rogierian linearism and the formalism of Bouts. It was, however, a laggard in time, so that the later phases of Netherlandish development had little influence. Even Bermejo, somewhat of a parallel in his

emotionalism to Van der Goes, apparently shifted his allegiance in his late *Pietà* to northern Italy, and Berruguete, after his return from Italy, hastened the demise of the Netherlands' hold on the Spanish temperament by works that were increasingly Italianate in composition, conception, and form.

Thus the Hispano-Flemish style is only an episode in the history of Netherlandish painting, though it lasted half a century. It achieved its finest moments in Catalonian painting, where it so transformed the normally Italian-oriented outlook as to produce a hybrid but splendid art. Such a union of the native and the foreign, found three centuries earlier in Catalonian Romanesque wall painting, is witness to the Spanish ability, in eastern Spain particularly, to assimilate the best of foreign expressions while retaining a constant formal drama and a concern for expressive means, commonly rendered with subdued color schemes in which values are frequently low and browns predominate.

16

PAINTING IN GERMANY AND AUSTRIA:
The First Half of the Century

THE LAST CENTURY OF THE GOTHIC SPIRIT IN Germany was one of the most productive periods in that country's history. It was the century of the invention of printing and the development of the graphic arts of woodcut and engraving. It also saw the creation of new styles much under Flemish influence in the fields of panel painting and sculpture, both being used, as in Spain, to embellish the numerous Gothic churches and cloisters. Free during the century from the scourge of warfare, German business prospered, and the wealthy merchants were in the forefront in commissioning works of art. The country was divided into small units, no one dominant. A central government, with a princely house setting tasks for the artists, was nonexistent to all intents and purposes, and the art reflects this lack of courtly models in a decentralization that saw the continuation in the 15th century of what had been observed in the period of the International Style—a series of regional styles perpetuated through the century by restrictive guild regulations. In compensation there was a tremendous productivity of an art as vital as that elsewhere but not so refined, and it rarely scaled the heights attempted in Italy and Flanders.[1]

The German artistic shops were essentially provincial, and the artists remained artisans without being uplifted by a courtly sophistication; their art was more naïve than that of their foreign contemporaries. Flemish artists took delight in the representation of nature, which, though subordinated to religious concerns, was conceived as constituted of subtle graduations of atmospheric tones, color, and form. Possessing a broader outlook than the German artist and being less introverted, the Flemish artist accepted a mysticism that existed outside the individual and thus was more strongly fixed on nature than in Germany. There medieval mysticism seems to have been expressed in a more personal and contemplative poetry, which was turned inward in disregard of the unifying forces of nature. Thereby controls were more internal, so that norms were more personal, more variable, and less fixed, since nature was far less of a norm. When new artistic conceptions were encountered, the reactions or the acceptances often tended to be violent. Instead of assimilation, acceptance often meant the abandonment of the old in favor of the new, since a restricted outlook cannot tolerate two value systems of equal strength. This may explain in part the strongly expressionistic character found not merely in German art of the 15th century but in provincial expressions generally. Of course, not all artists were so affected, nor is this the only possible reason for the development in Germany of the styles that preceded what has been called the "late Gothic baroque." This explanation may aid in understanding the appearance of that frenetic style toward the end of the century, after the Flemish outlook had penetrated German art.

The International Style has been seen in many places in Germany, among others, in the works of Master Francke in Hamburg, Konrad von Soest in Westphalia, and the Master of St. Veronica in Cologne, whose delightful insouciance and delicacy of light, pastel coloring were an expression of the translation into panel painting of the aesthetic attitudes of the miniaturist's art. The style had penetrated into the Upper Rhine in the early decades of the 15th century, and by the late 1420s, in such a work as an *Annunciation* in the Augustiner Museum in Freiburg (attributed to the shop of the Frankfurt Paradise Garden Master), there appeared new conceptions that seem to derive from Flanders and from Tournai. A gradual infusion of a new sense of plasticity filled out and gave greater weight to the still doll-like forms, even though the delicacy of coloring and the basic charm of the International Style were unchanged.

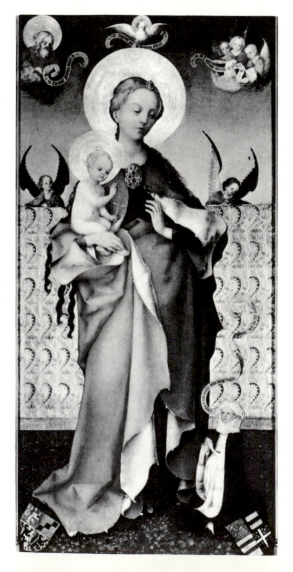

STEPHAN LOCHNER

This transition to a new, carefully modeled, smooth-surfaced plastic style appeared in many centers all over Germany and Austria. The most outstanding example, however, is to be found at Cologne in the early art of Stephan Lochner. [2] He went to Cologne from Meersburg, near Lake Constance, though the date is not known. In Cologne in 1442 he was paid for decorations related to the visit of Emperor Frederick III, and he apparently married and bought a house in that year. He was elected councilor of the painter's guild in 1447 and again in 1450 to serve from Christmas to Christmas of the next year. A letter of August 16, 1451, from the Cologne town council to the town council of Meersburg speaks of the death of Lochner's parents and of the painter's inability to travel to Meersburg. On September 22, 1451, permission was sought to make a new graveyard adjoining his house during an outbreak of the plague, but he himself died of it before his term as guild councilor had expired.

The *Crucifixion* in Nuremberg has been attributed to Lochner and cannot be much earlier than the 1430s, probably the earliest date that can be given for the start of the artist's career, considering the documentary evidence about the death of his parents in 1451. Cologne style is visible, though the background is brick-red rather than gold. The youthful aspect of St. John is in keeping with the art of Lochner's predecessor, the Veronica Master, as is the soft modeling of graceful forms. Lochner's work, however, is more plastic, though obviously still youthful, if it is compared with the clearly later and stylistically advanced *Madonna with the Violets* (Fig. 326), in the Diocesan Museum, Cologne. This has a curious unexplained relationship to Jan van Eyck's Antwerp *Virgin at the Fountain* of 1439 (Fig. 115). The poses are similar, with the relaxed leg in the same position, and both show two angels supporting a brocade behind the Virgin. The system of garment folds is not identical, and it may be, since the Child is different in both form and position and since there is no donor in Jan's work, that both derive

left: 326. STEPHAN LOCHNER. *Madonna with the Violets.* *c.* 1435. Panel, 83 $^1/_2$ × 40$^1/_8$″. Erzbischöfliches Diözesan-Museum, Cologne.

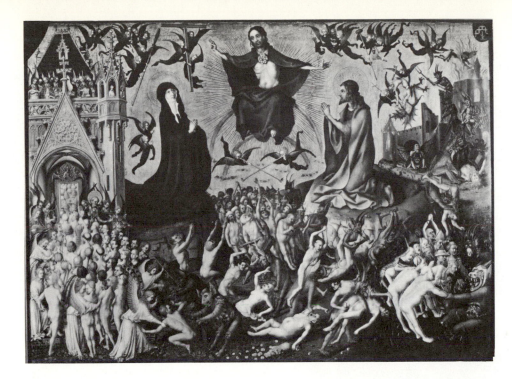

left: 327. STEPHAN LOCH-
NER. *Last Judgment Altarpiece,*
central panel. *c.* 1435-40.
Panel, 48 × 67 ³/₈″. Wallraf-
Richartz-Museum, Cologne.

below: 328. STEPHAN LOCH-
NER. Martyrdom of St.
Bartholomew, *Last Judgment
Altarpiece,* detail of wing.
c. 1435-40. Panel, 15 ³/₄ ×
15 ³/₄″. Städelsches Kunst-
institut, Frankfurt.

from an earlier model. Lochner's Madonna is
more monumental than his earlier *Crucifixion,*
despite its still gentle outlines and treatment. He
has modernized the gentle shading and delight-
ful modeling of the Veronica Master's style, but
the drapery is still paper-thin by comparison
with that of Jan and his forms are not so plastic.
Its date may be about the middle of the 1430s.

Following soon after is the *Last Judgment Altar-
piece,* originally in the church of St. Lawrence,
the central panel of which is now in the Wallraf-
Richartz-Museum in Cologne (Fig. 327). A
conservative, still medieval rendering of the
theme, it approaches the anecdotal in the great
emphasis placed on the action of the demons
and the reactions of the damned. A confusion
results because of the great crowds of figures and
the intent to specify in detail. The figures of the
Virgin and John, giants when compared with
the blessed and the damned, kneel on solid
ground, while Christ is seated in judgment on
a mandorla in the air above. The scale and size
of the three central figures counterbalance the
strong surface movement and anecdotal detail,
to which the large crowds of small angels also
contribute. The representation suggests earlier
illumination rather than the Flemish universality
that was to replace this essentially miniaturistic
and gentle approach. Yet the chief figures
dominate the composition, establish its stability,
and assert the religious message.

The wing panels representing the martyr-
doms of saints are in Frankfurt (inner panels) and
Munich (outer panels). Typical is the Martyrdom
of St. Bartholomew, in Frankfurt, set against a
gold background (Fig. 328). It is treated with
a great deal of naturalism, as in the motif of the
flayer, with his knife in his teeth, tugging at
the skin of the saint's arm, and in the play of
light forms against the darker forms behind the

above: 329. STEPHAN LOCHNER. *Madonna in the Rose Bower.* c. 1438–40. Panel, 19 ⁷/₈ × 15 ³/₄". Wallraf-Richartz-Museum, Cologne.

below: 330. STEPHAN LOCHNER. *Adoration of the Magi Altarpiece.* c. 1440. Panel, 7' 9 ³/₄" × 8' 7 ¹/₂" (center), 7' 8 ¹/₈" × 3' 10 ¹/₂" (each wing). Cathedral, Cologne.

table. A luminous quality of surface softens the horror of the scene, as does the generalization of the figures into types. The beautiful, grassy, floral ground seems anachronistic, in view of the nature of the event portrayed, and the garments are still close to those of the International Style. Therefore a date in the second half of the 1430s seems indicated.

The next stage in Lochner's development shows a further concern for rounded, volumetric forms; it is first seen in the slightly later *Madonna in the Rose Bower* (Fig. 329), in Cologne. Derivations from the Veronica Master may be seen in the generalized treatment of surfaces and in the types of music-making angels, who also recall the style of Tournai, but the forms, though still softly modeled, are less linear and more plastic, and a delicate interplay is devised between plastic forms and nonplastic elements such as the crown, the rose bower, and the gold background. A poetic sincerity emerges in the Madonna as young as the Veronica of the Veronica Master, if not younger. The light coloration and gentle religious spirit make the painting seem even more ethereal, despite its greater plasticity, than the works of Lochner's predecessors.

His most famous work, the *Adoration of the Magi Altarpiece* (Fig. 330), in the Cathedral of Cologne, painted about 1440, was early identified as Lochner's work by none other than Albrecht Dürer, who paid to have it shown to

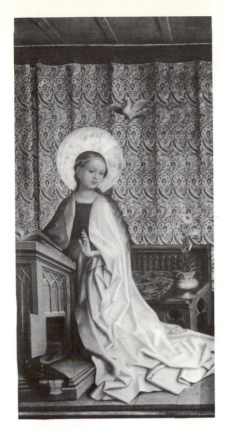
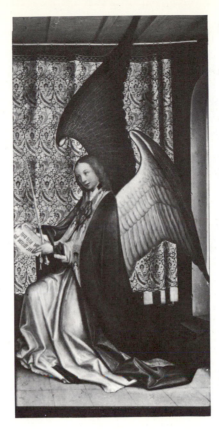

331. STEPHAN LOCHNER. *Adoration of the Magi Altarpiece,* exterior. (Fig. 330).

him in 1520, when he traveled down the Rhine to the Netherlands. Flanking the central Adoration are St. Ursula and her companions, on the left wing, and St. Gereon, the other patron saint of Cologne, and his companions, on the right. Plasticity of form has been augmented by deepening the shadows and the color, which seems an epitome of that of the International Style, here given a greater sonority with greens, browns, pinks, bluish whites, and brownish purples subtly intermixed and blended. These hues create an atmosphere that seems to cling to the surfaces and endows all with a velvety sumptuousness. Even the metal surfaces respond to this sensuous caress, which gently rounds the forms and sets them out against the dematerializing gold background.

The exterior Annunciation (Fig. 331), in full color, is presented as if in a large room, with a response to the new naturalistic ideas from Flanders. In place of a gold background a gold brocade is hung at the back. Lochner thereby achieved the solemnity of the older ecclesiastical interiors but surpassed them in suggesting the supernatural by means of the gold brocade. The Virgin turns from her *prie-dieu* with a modest maidenly gesture. Her drapery is more plastic than that of the interior and more naturalistic in the treatment of folds; it is also more Flemish. Though the tonality of the Annunciation is basically cooler in color than the interior scenes, and thereby approximates more closely the feeling of grisaille, the pearly flesh tones animate the features to suggest the breath of life itself.

A seemingly less carefully executed work is the *Presentation in the Temple,* in the Gulbenkian Collection, Lisbon, dated 1445 and once part of a portable altar. Despite its rougher execution, there is keen observation of natural effects, as in the light cast shadow of the baldachin. Unusual in conception is the interplay between Simeon and the Christ Child, who affectionately strokes Simeon's beard. The iconography is also unusual, for Joseph, instead of a female figure, carries the traditional basket of doves.

In the Altenberg *Nativity,* now in Munich, which may be a part of the same altar, Lochner succumbed to Flemish influences to the extent of eliminating the gold background, so that the eye moves past the shepherds with their flocks to the distant landscape with its buildings. The pointed architectural outlines and those of the wings of the angels form an effective contrast to the rounded forms of the youthful

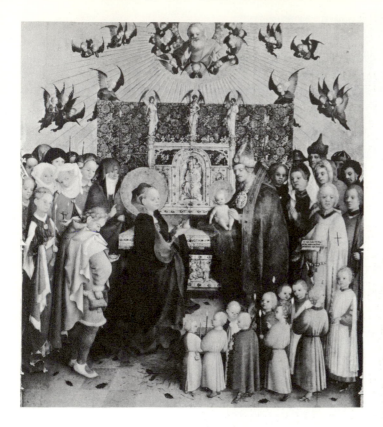

gradual and occasionally reluctant. In essence it was a modernization of the older style by the introduction of a more plastic expression, which, because it combined old and new, strongly influenced his contemporaries and followers.

The transformation of older modes was sometimes more rapid. In the region of the Middle Rhine the Master of the Darmstadt Passion, working between 1435 and 1450, was almost the only German artist to prefer the style of Jan van Eyck. He is known from the wing

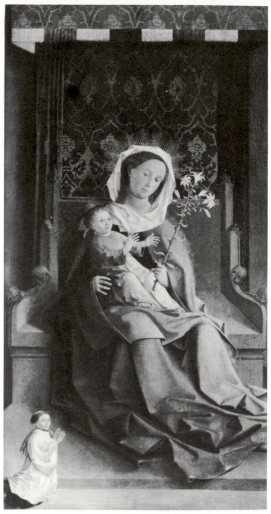

left: 332. STEPHAN LOCHNER. *Presentation in the Temple.* 1447. Panel, 54 3/4 × 49 5/8". Hessisches Landesmuseum, Darmstadt.

above: 333. MASTER OF THE DARMSTADT PASSION. *Madonna and Child Enthroned. c.* 1435–50. Panel, 79 1/2 × 42 1/2". Gemäldegalerie, Staatliche Museen, Berlin-Dahlem.

Virgin and the Child, before whom she kneels in the attitude of a Madonna of Humility.

In 1447 Lochner painted the theme of the Presentation again in a more elaborate work, now in the Landesmuseum in Darmstadt (Fig. 332). It is dated by the inscription on the letter held by the knight of the Teutonic Order. In this work Lochner gives way to Flemish influences more strongly than before; the drapery treatment is more angular, and the forms are less rounded. Older ideas, however, are still visible in the very small figures of the youthful choir, the gold background, and the varied groups of small angels, conventions that are part and parcel of Lochner's outlook. There remain the same delightful use of pastel colors, a sweetly sincere feeling, and a largeness in over-all conception. Though more naturalistic, the details never disturb the fairy-tale quality of the whole, which is augmented, and given devotional meaning, by the movement of the eye beyond the central figures to the golden altar, with its brocade background, and to the angel groups around God the Father—a movement from the charm of the natural to the mystery of the supernatural.

Lochner's transformation of his style under the influence of Flemish angular naturalism was

334. LUCAS MOSER. *Magdalen Altarpiece*. 1432. Panel, *c.* 10′ × 6′ 6″. Church, Tiefenbronn, near Pforzheim.

panels, now in Berlin, of Passion scenes for an altar from Bad Orb, now in Darmstadt. His style reflects Eyckian spatial conceptions, but, a man of his times, he combined them with figure types derived from Tournai. His richness of color, chiaroscuro lighting, and magnificence of surface texturing are all Eyckian, as may be seen in the Berlin *Madonna and Child Enthroned* (Fig. 333), with its minuscule donor of the altarpiece. Less Flemish is the tendency toward linearity, seen in the drawing of the features, and the hands are weak in contrast to the masterful handling of the setting. Other panels preserved in Berlin from the altarpiece are the Trinitarian Pietà, modeled on the Master of Flémalle; the Adoration of the Magi, its stable transformed into a ruined palace of David, with a wonderful variety and interplay of lights and darks; and a panel showing Constantine adoring the True Cross. Distinctive of this exceptional artist are a more velvety surface than in Eyckian work and a deeper color range than is customary among his German contemporaries.

LUCAS MOSER

A marked sculpturesque and less soft naturalism is found in the region of Baden in the sole surviving example of the work of an outstanding artist, Lucas Moser. In the church at Tiefenbronn, near Pforzheim, is his *Magdalen Altarpiece* (Fig. 334), signed and dated with an unusual inscription: "Schri kunst schri und klag dich ser din begert iecz niemen mer so o we 1432 lucas moser maler von wil maister dez werx bit got vir in" ("Cry art, cry, and mourn bitterly, no one wants you any more, so oh woe; 1432, Lucas Moser, painter from Weil, master of this work, pray to God for him"). Some have thought that the inscription refers to a lack of patronage following the Council of Constance (1414–18), but this had ended thirteen years previously. Thus the artist and the reason for the inscription are unknown. A glass painter called Moser worked in Ulm shortly after 1400, and documents there refer to a Master Lucas, but the relationship to Moser is uncertain.

The altarpiece presents events from the life of the Magdalen according to Burgundian and Provençal accounts. The feast in the house of Simon (Luke 7:36–50), combined with the feast in the house of Lazarus (John 12:1–8), is seen above, and in the predella below Christ is shown flanked by the wise and foolish virgins.

The left scene represents the miraculous voyage of the Magdalen to Marseilles, accompanied by Martha, Lazarus, Cedonius, and Maximin, with a seascape that seems to combine the feeling for distant land and water seen in the Flémalle Dijon *Nativity* (Fig. 90) with the older fish-scale treatment of water found in the John on Patmos miniature of the Limbourgs' *Très Riches Heures* (Fig. 35). A greater plasticity than in earlier miniatures is visible but it is not so advanced as contemporary Tournaisian work.

This more plastic expression is also evident in the unusual center panel (Fig. 335), which is hinged to cover a sculptured centerpiece. As her

335. Lucas Moser. *Magdalen Altarpiece,* center shutters. (Detail of Fig. 334). 58 ⅝ × 35 ⅜".

companions sleep, the Magdalen makes a miraculous appearance to the sleeping pagan prince and the wide-awake, adoring princess in the palace room above. There is a detailed naturalism almost painstakingly presented in the stones, roof shingles, and other natural forms in this foreign country, which is indicated as heathen by the crescent moon crowning the castle in the background. Chiaroscuro is masterfully employed and combined with heavy-lidded faces to give the effect of night and sleep. Moser was not fully in control of perspective, but neither were his Flemish contemporaries at this date.

The right panel represents the last Communion of the Magdalen, brought from the wilderness by angels and dressed only in her long hair. Bishop Lazarus is seen through the door of a Gothic church. The doorway is crowned by a crucifix and embellished at the left by a sculptural column with a monkey (symbol of the base passions) at the bottom, surmounted by a giant, holding heavy chains, who supports the Virgin and Child under a canopy at the top.

In the strong plasticity of his heavy-faced figures in space and in the naturalism of his details Moser reflects the emphasis on sculptural weight and density that characterized the first generation of Flemish painters and, in the 1430s, spread into Germany. If Moser's despair, as expressed in the inscription, was truly due to the loss of patronage following the Council of Constance, the "Burgundian" element in his art might be a by-product of the Council, which undoubtedly attracted artists from many centers to fill the needs of the prelates in attendance, and would have provided the contacts for Moser's acquaintance with the new style.

KONRAD WITZ

If Moser's artistic innovations in Germany can be related to the Council of Constance, then the Council of Basel, between 1431 and 1434, may help to explain the art of Konrad Witz[3] of Rottweil in Württemberg (Swabia), which bears a formal relationship to that of Moser. Witz entered the guild in Basel in 1434 and became a citizen in the following year, during which he married Ursula von Wangen of Basel; thus he may have been born about 1410. In 1441–42 he received payment for paintings made

for the city, and he must have prospered, for in 1443 he bought a house there. His career was short, however, for his wife was referred to as a widow in 1446, and she herself was dead by 1448, leaving a young son, later to be a painter, and a daughter Katharina who entered a Basel convent in 1454. Witz's brief span of activity nevertheless produced some remarkable works.

His training is unknown. Despite early attempts to identify his father, Hans, as a painter with court connections in Brittany and Burgundy, Hans's profession remains unknown, though he may have been a painter. One must turn to Konrad's paintings for information.

The earliest work that is generally agreed upon is the *Heilspiegel Altarpiece,* now dismembered: one of its panels (Augustus and the Tiburtine Sibyl on one side, St. Augustine on the other) is in Dijon; one (Solomon and the Queen of Sheba) is in Berlin; and the nine remaining scenes (from six panels) are in Basel. It was possibly the last donation of Canon Heinrich von Rumersheim, intended for the high altar of the seminary of St. Peter in Basel. The theme of the altarpiece is typological, based on the *Speculum Humanæ Salvationis,* or *Mirror of Human Salvation,* that ever popular treatise in which events from the Old Testament and Roman history prefigure man's salvation in Christianity. The centerpiece, now lost, was possibly a Nativity or an Adoration of the Magi, but five scenes from the exterior are extant: the angel of the Annunciation, the Church, the Synagogue, St. Augustine, and St. Bartholomew. From the interior, Antipater before Caesar, Esther before Ahasuerus, Abraham and Melchizedek, Abishai before David, Sabobai (Sibbecai?) and Benaiah (1 Chronicles 11), the Queen of Sheba before Solomon, and Emperor Augustus and the Tiburtine Sibyl still remain.

The figures from the exterior are all presented, in color, as standing in small rooms, often relieved by a door or window giving a view of blank blue sky beyond. Surprisingly, the rooms are presented without decoration, being simple spatial boxes of just enough depth to contain the figures. The figures are short in proportions, slightly awkward in movement, but solid and firmly rounded, with generalized surfaces and somewhat angular folds in the drapery. Despite the awkwardness, the inaccurate perspective, and the crowding of the figures, a feeling for forms

336. KONRAD WITZ. The Synagogue, *Heilspiegel Altarpiece.* c.1435. Canvas on wood, 33 7/8 × 31 7/8". Kunstmuseum, Basel.

in a simplified space is presented in the clearest possible fashion. The slight tendency to oversimplify may be due at this point to artistic youth.

Thoroughly characteristic is the figure of the Synagogue (Fig. 336). She wears a yellow dress with vermilion sleeves, and a bit of blue sky is seen through the doorway. Her broken staff echoes the lines of the room, a compositional device again echoed in the bending of her body. Her eyes are veiled by a thin gauze strip, and she holds tablets inscribed with imitations of Hebrew characters. A strong plastic emphasis is produced by the modeling light that picks out the garment folds and casts a shadow on the plain back wall.

Witz used strong value and simple color contrasts to create plasticity, rather than the unifying, space-creating chiaroscuro of the Master of the Darmstadt Passion, who was also a fine colorist. Thus Witz's forms occupy a region somewhere between atmospheric fluidity and nonatmospheric plasticity, but closer to the latter because of a strong outline and edges often sharpened by a reflected light.

The interior figures are set before brocaded backgrounds (regilded), each scene enlivened by rich naturalistic detail. The Roman ruler has a contemporary aspect, for his crown suggests a papal tiara, reminding one that the popes until modern times were both religious and secular

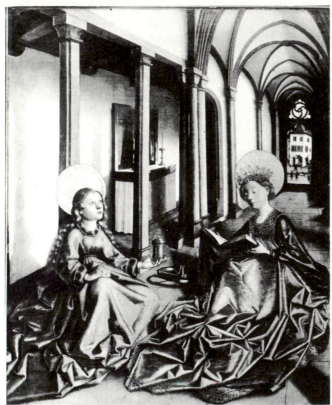

rulers. Esther and Ahasuerus (Fig. 337) are rendered with forceful color contrasts, the olive green of Esther's garment balancing the pinks of Ahasuerus's robes. Everywhere on the more carefully executed interior the intent of the involved drapery design and gold ornamented background (which replaces the naturalism of the exterior spatial boxes) is to heighten the religious character. Yet the artistic and human vitality of the scenes is always present; Ahasuerus grins at the sight of an Esther whose appearance and modesty obviously delight him, for Witz conceived of him as a young man who would naturally respond to feminine beauty. Solomon's garment pattern suggests a quality of magic (Solomon was often considered a good magician); Augustus, with a similar drapery pattern, seems an astrologer looking heavenward and the sibyl is a solid, robust, stocky *hausfrau.*

Witz took liberties with the proportions of his short, rounded, plastic forms, directing all his distortions toward a reasonably simplified outline. Also, light plays an important part in his work. He established in many of his figures a large frontal area to catch the light and lead the eye to the faces, and his color often tends toward strong green, red, and yellow; yet it is continuously modulated to remove any harsh notes. Witz's *Heilspiegel Altarpiece* has an interplay of rich jewelry, intricate drapery, and varied surfaces, all with tremendous life and plastic expression. By differentiating light and color he boldly monumentalized his forms and set hard against soft, fluid against still, warm against cool, bright against dull. In short, he produced a superb variety enhanced by a naïve charm.

Possibly from an altarpiece of the Virgin for the convent of the Dominican nuns in Basel are three panels of approximately the same size and technically identical. Probably dating between 1440 and 1443, the panels show the Annunciation (Nuremberg), St. Catherine and the Magdalen seated in a religious interior (Strasbourg), and the meeting of Joachim and Anna (Basel). The artist's style, within the short period separating this from the *Heilspiegel Altarpiece,* has evolved in terms of a firmer grasp of related forms in space and a determined awareness of problems of linear perspective. To accomplish his end the setting of the *Annunciation* was reduced to bare essentials, with light used to create its spatial ambient. A natural

chiaroscuro falls upon the forms, distinguishing wood from plaster, cloth from hair and flesh. Awareness of the structural limits of his space is also visible in the panel of *Sts. Catherine and Mary Magdalene* (Fig. 338), a truly architectonic construction. Its spirit is repeated in the *Meeting before the Golden Gate,* which is a sculptured niche translated into painterly illusion. Originally the inner panel from the altarpiece, as the golden background indicates, this scene reveals an even greater concentration upon mastering the actuality of natural forms, notably in the small stream bordered by grasses and edged with pebbles.

Witz's last known work is the signed and dated *Altarpiece of St. Peter,* completed in 1444 for Bishop François de Mies, which decorated the chapel of Notre-Dame des Maccabées in the Cathedral of St-Pierre at Geneva. The chapel was founded by the bishop's uncle, Cardinal de Brogny. The center is lost, but the wing panels, now in Geneva's Musée d'Art et d'Histoire, are preserved; on the left wing is the Adoration of the Magi, with the Miraculous Draft of Fishes on the back; on the right wing the kneeling donor is presented by St. Peter to the Virgin and Child, and on its back is the freeing of Peter from prison.

Witz's intense preoccupation with coherent religious narrative in union with visual reality reaches its peak in these panels. It appears in the lighting of the freeing of St. Peter (Fig. 339), with cast shadows intended to create a nocturnal effect in what is one of the earliest night scenes in northern art. The same preoccupation appears in the volume of the cubic buildings behind the freed saint; in the monumentalized stable of the Adoration panel (in actuality the ruined palace of David, who, in simulated sculpture above the entrance arch, holds his harp); and in surface variety such as peeling plaster and intricate drapery folds, particularly in the portrait of the donor, who lifts his head out of a triangular mass to look at a Madonna and Child reminiscent of the Master of Flémalle.

Most astounding of all the panels is the Miraculous Draft of Fishes. In the left foreground (Fig. 340) such a depth-defining *repoussoir* element as the small piece of land with plants

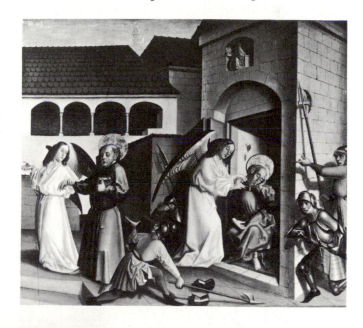

above: 339. KONRAD WITZ. Freeing of St. Peter, *Altarpiece of St. Peter,* reverse of right wing. 1444. Panel, 52 × 60 ⅝". Musée d'Art et d'Histoire, Geneva.

left: 340. KONRAD WITZ, *Miraculous Draft of Fishes, Altarpiece of St. Peter.* detail. Cf. Pl. 21.

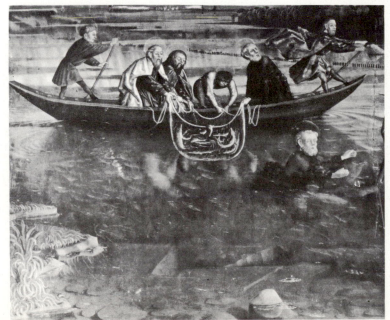

on it is relegated to one corner, and the eye is led into the scene by the portrayal of forms seen beneath the surface of the water. As evidence of his clarity of observation one discovers that Konrad Witz has recognized and portrayed the difference between reflected and refracted light in the boulder half in and half out of the water and in the rocky ledge that is visible below a surface flecked with gaseous bubbles released by decomposing organic matter. The illusion of a still pond is complete; not even Jan van Eyck saw so clearly.

Moving from this dark green foreground to the center of activity, where Peter floats in the lighter-colored water, the eye is attracted by the red of Christ's garments (Pl. 21, after p. 308). His vertical, scale-setting figure is an interesting contrast of plastic and simplified broad color areas, which are repeated in the strongly horizontal, lighter-red garments of the fisherman and their reflections in the water. The varied movements pull the eye upward to be caught by the evenly illuminated far side of the lake, an amphitheater for the main action. Aerial perspective is not seen, but by lightening the green and tan tonalities of the wide, distant view of the region about Geneva, a cool foil is created for the red-robed figure of Christ, who is so placed that the sense of suspension on the surface of the water is utterly convincing.

Again one sees how much Konrad Witz achieved with color forms that assert a balance

and rational order. Even though his types are naïve and generalized, his harmonious unification of man and nature is so unusual that something of the Renaissance spirit, one feels, had affected him, perhaps because of living so near Italy. This receptive artist combined a mystic conception of the unity of nature with a feeling for the weight, density, and actuality of all matter existent within it.

If against this development is set the *Holy Family* in Naples, attributed to Witz's youth, it is evident that, though the types are Eyckian in face and form, the Naples work is unlike Witz in the shaky architectural construction of the nave, with which the masterful treatment of light in the side aisles is in complete contrast. One must conclude that the influence but not the hand of the master is seen here.

A much closer work, also not by his hand, is the St. Christopher panel in Basel. It shows reflected and refracted light in the rippled water, but the highly schematic, flat, and artificial rock forms are not in balance with the other naturalistic elements. They are too divergent to be viewed as inconsistencies in the make-up of a young artist, and the *repoussoir* plants at the lower left are dissimilar in concept to Witz's certain production. Nor can the *Crucifixion* in Berlin be attributed to Witz. Despite the excellence of its figural organization and the crispness of forms, there are too many eye movements and an almost mannered falling out of the forms. The extremely skillful handling of the landscape, showing an aerial perspective of a later date, is revelatory of the abilities of an unknown developed master rather than those of a talented beginner.

Witz did have followers, [4] the chief of these being the creator of the Basel Madonna with the Child standing on her lap. Another close follower is responsible for the two panels of St. Martin and St. George, also in Basel, both coming from the parish church of St. Martin in Sierenz. The closest of all the works related to Witz and his following is the *Decision on the Redemption of Man* (Fig. 341), in Berlin, which has even been proposed as the missing centerpiece of the *Heilspiegel Altarpiece*. Stylistically, however, this is not justified. There is a similar crinkly quality in the draperies, and the proportions are similar, but the types are slightly different. To the right of the Trinity are seen

341. WITZ FOLLOWER. *Decision on the Redemption of Man. c.* 1440(?). Panel, 53 ³⁄₈ × 63″. Gemäldegalerie, Staatliche Museen, Berlin-Dahlem.

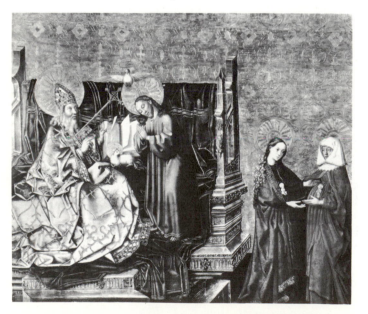

the Virgin and Elizabeth of the Visitation, with the infant John kneeling in the womb to adore the infant Christ. This is more advanced stylistically than the *Heilspiegel Altarpiece,* particularly in the facial modeling, and may be a shop work comparable to the production of the similar Nuremberg, Strasbourg, and Basel panels.

HANS MULTSCHER

Farther east, in the city of Ulm, the art of a third painter, Hans Multscher, [5] follows at a short distance the progressive steps of Moser and Witz. Not so close to the stimulating centers, which Constance and Basel seem to have been, Multscher used more conservative elements to show a comparable stylistic development. Born at Reichenhofen, near Leutkirch in the Allgäu, he became a citizen of Ulm in 1427. In 1431 appears the first reference in Ulm to his activities as an artist, and yet another is the inscription, "bitte gott fur hansen multscher von richenhofen, bürger zu ulm, hat das werk gemacht, da man zählt 1437" ("Pray to God for Hans Multscher of Reichenhofen, citizen of Ulm, who has made this work in 1437"), on the frame of the *Wurzach Altarpiece,* now in Berlin. In January, 1456, he signed at Innsbruck a contract for an altarpiece for the Frauenkirche at Sterzing (now Vipiteno, Italy) and between July, 1458, and January, 1459, was in Sterzing to install the completed altarpiece. No further mention precedes his death in Ulm in 1467.

Germany was particularly partial to the altarpiece adorned with a central gilded sculpture of large size and flanked by painted wings whose backgrounds echo the gilding of the central image. An early example with numerous small figures had appeared in the art of Master Bertram; with Multscher, Witz, and many other artists of this same generation, the sculptured altarpiece with painted wings and single central image becomes the preferred form. In Germany particularly the artist assumed a new role, that of master of the work, which meant either making or contracting for the frame, or having a frame maker in association with him. Occasionally he himself practiced more than one art. Hans Multscher was one such sculptor-painter, and his paintings express a basic interest in relief sculpture.

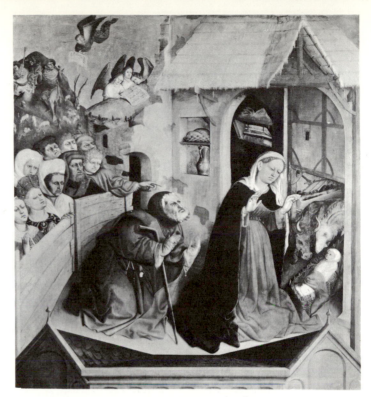

342. HANS MULTSCHER. Nativity, *Wurzach Altarpiece,* scene from left wing. 1437. Panel, 58 1/4 × 55 1/8". Gemäldegalerie, Staatliche Museen, Berlin-Dahlem.

The centerpiece of the *Wurzach Altarpiece* has been lost, but its wings still exist in Berlin. The interior scenes are taken from the life of the Virgin: on the left wing are painted the Nativity above the Adoration of the Magi; on the right wing, the Pentecost above the Death of the Virgin. On the exterior are Passion scenes of Christ in the Garden of Gethsemane, Christ before Pilate, the Carrying of the Cross, and the Resurrection.

Multscher crowded his scene with heavy, blocklike figures, compressed their space by introducing more actors than could ever possibly be accommodated on his stage, and treated them all as robust peasants with heavy faces and large jaws. Heads lift and turn; mouths gape, sneer, or turn down at the corners; eyes are emphatically modeled for expressive purposes, and their glances move in all directions in accordance with Multscher's desire to emphasize dramatic content. Even the Nativity (Fig. 342), crowded with crude onlookers on the far side of the board fence, becomes a drama charged with emotion, rather than an occasion for rejoicing. The mood is signalized by the books above the manger, as well as by the loaves of bread in a basket and

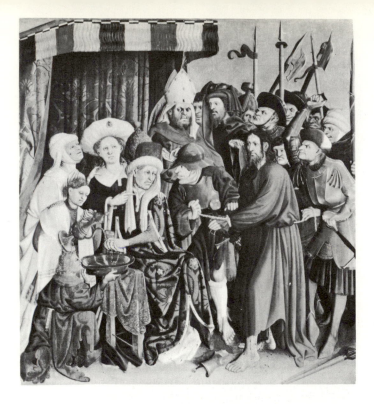

left: 343. Hans Multscher. Christ before Pilate, *Wurzach Altarpiece,* scene from exterior. 1437. Panel, 58 ¼ × 55 ⅛″. Gemäldegalerie, Staatliche Museen, Berlin-Dahlem.

344. Master of the Tucher Altarpiece. Crucifixion, *Tucher Altarpiece,* center. *c.* 1445. Panel, 69 ¾ × 42 ⅞″. Church of Our Lady, Nuremberg.

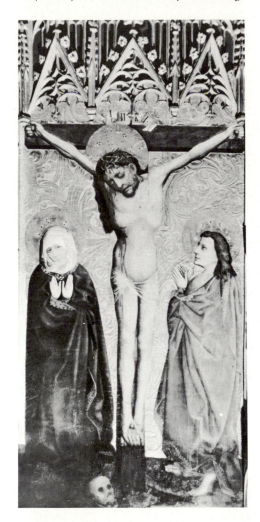

the pitcher, clearly Eucharistic symbols in disguise, that fill the niche in the exterior wall of the ruined stone structure behind the Virgin. She is posed much like a Madonna of Humility, while Joseph, behind her, lifts his head in effective awkwardness. Forcefully modeled, Multscher's figures were apparently inspired by the art of Tournai, though he was less interested than his contemporary, Moser, in naturalistic details. His concern was directed toward expressive plastic figures that cast emphatic shadows and are painted with comparatively strong, simple, local colors in a manner suggesting Konrad Witz.

Nowhere in Multscher is there that passion for discovering the variety of nature seen in Witz. His desire to instill the utmost of human drama into his plastic depictions almost leads to caricature in the scene of a terrified, open-eyed Christ before a Pilate and a High Priest and other spectators who curl their lips or bare their teeth to express Multscher's concept of the depravity of the coarse, brutish world that crowds thickly about (Fig. 343). Yet these violent contrasts are subordinated to a fine sense of design that superimposed a regularity and balance of accent upon Multscher's off-center compositions.

The settings are essentially archaic—as in the stylized trees, *millefleurs* tapestry grounds, and Sienese-style rock forms—and essentially foils for action. Even the naturalism in the body of the resurrected Christ, stepping from a tomb whose lid is still in place (to emphasize the miraculous character of the event), cannot disguise the fact that in the character of his setting Multscher is no more progressive than the Master of Wittingau. The unique quality of his expression lies not in perspective or in the concept of the setting but in endowing his weighty, almost cubic figures with an intense violence. This is epitomized in the scene of

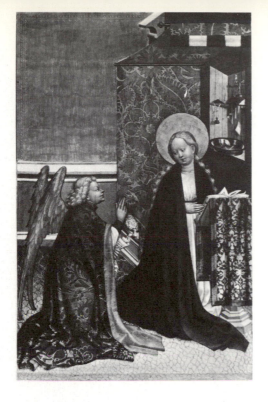

tion. Set against a stylized, floral-patterned gold ground, the work shows a modernization of earlier Nuremberg style in the combination of Bohemian-inspired chiaroscuro with figure types like those of the Master of Flémalle. The transformation of the older style is not complete, for the Virgin's features in the Crucifixion scene are related to the older mode.

In Austria the Albrecht Master (works in Vienna, Klosterneuburg, and Berlin) combined in the late 1430s mementos from the older style of Hans von Tübingen with a stronger plasticity and color conceived in terms of light, as did his contemporaries farther west. Suggestions of Tournai are visible in facial types and in naturalistic details in the now-destroyed *Annunciation* (Fig. 345), from Berlin, in which a niche behind the Virgin contains a brass basin and other objects rendered with an intense concentration on their actuality. In spirit, though not in detail, the Albrecht Master stands only partially immersed in the Flemish flood.

His slightly later contemporary, Konrad Laib of Salzburg, was an out-and-out follower of Netherlandish art. Laib was a citizen in Salzburg in 1448, coming from Eislingen, and he is now identified with the "d. Pfenning" of the 1449 *Crucifixion* in the Österreichische Galerie, Vienna (Fig. 346). He adopted Netherlandish compositions, as in his *Epiphany,* in Cleveland, and

Christ Carrying the Cross, which anticipates the late Gothic baroque.

In Nuremberg the chief artist of the second quarter of the century was the Master of the Tucher Altarpiece. His chief work, still in the Church of Our Lady, was painted about 1445. Its central Crucifixion scene (Fig. 344) is flanked by the Annunciation and the Resurrec-

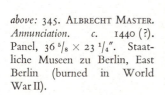

above: 345. ALBRECHT MASTER. *Annunciation.* *c.* 1440 (?). Panel, 36 $^5/_8$ × 23 $^1/_4$″. Staatliche Museen zu Berlin, East Berlin (burned in World War II).

right: 346. KONRAD LAIB. *Crucifixion.* 1449. Panel, 70 $^7/_8$ × 70 $^7/_8$″. Österreichische Galerie, Belvedere, Vienna.

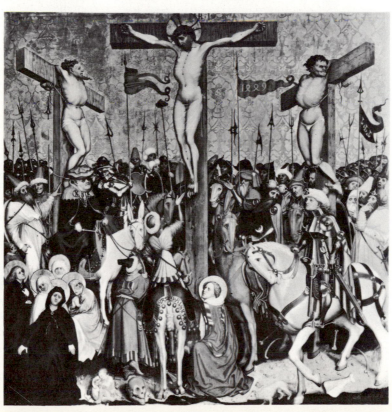

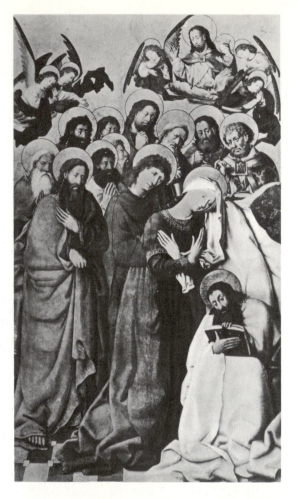

Netherlandish mottoes, for the Vienna *Crucifixion* is signed "Als ich chun," a German version of Jan van Eyck's famous inscription. Though some of his motifs are Eyckian, the style is strongly Tournaisian; conservative reminiscences in the occasionally softer modeling of the features alternate with more forceful types, as in his *Prophet Hermes,* in Salzburg (possibly a wing panel for the Vienna *Crucifixion*).

Also painting in Austria about mid-century was the Master of Schloss Lichtenstein. His *Death and Coronation of the Virgin,* in Lichtenstein Castle (Fig. 347), and the stylistically close *Meeting at the Golden Gate,* in Philadelphia, mix the influence of Tournai with the spirit of a contemplative Multscher. His elongated, quiet, yet plastic forms still retain a residue of earlier elegance. They also point forward to the second half of the century by their elongation.

Southern Germany and Austria at this period were more progressive and also more prosperous than the north, but the same spread of influence can be found. A single example will suffice: Johann Koerbecke, first recorded in 1446 in Münster, where he died in 1491, shows a style in Westphalia that, even as late as 1457, still owes a debt to Master Francke. In Koerbecke's Christ before Pilate (Fig. 348), Landesmuseum, Münster, the master's forms and composition, however, have been invested with a greater naturalism and solidity, the draperies have far greater weight and texture, and the vigorous movements and expressions have lost any suggestion of International Style fluidity.

In summary, the first half of the 15th century saw the gradual transformation of the International Style into a more angular and severe plastic expression, which spread across the German-speaking lands, in some cases enthusiastically espoused, as by Moser, Witz, and Multscher, in others reluctantly adapted, as by the Master of the Tucher Altarpiece. More sweeping developments were in store for the art of the following half-century.

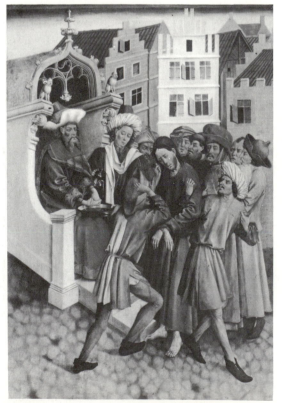

above: 347. MASTER OF SCHLOSS LICHTENSTEIN. *Death of the Virgin.* c. 1450. Panel, 8′ 4 1/2″ × 3′ 10 1/2″. Schloss Lichtenstein, Lichtenstein bei Reutlingen, Germany.

left: 348. JOHANN KOERBECKE, Christ before Pilate, *Marienfeld Altarpiece* (dismembered; from left side). 1457. Panel, 36 1/4 × 24 5/8″. Landesmuseum, Münster.

17

PAINTING IN GERMANY AND AUSTRIA:
The Second Half of the Century

SHORTLY AFTER THE MIDDLE OF THE 15TH CENTURY events of lasting significance in the history of Europe took place. Constantinople fell in 1453, the Hundred Years' War ended in the same year, and Gutenberg printed his Bible before three more years had passed. By the end of the century the groundwork had been laid for the criticism of existing beliefs, partly because of the wide diffusion of knowledge through the new "black art" of printing. The seeds of nationalism were sown with the rise of vernacular printed works, and the old ecclesiastical bonds had already been loosening under the force of new intellectual movements. An expanding commerce, which resulted in the discovery of America at the close of the century, and the strong rise of monarchical government in the second half of the century were factors contributing to the death of medieval Europe and the birth of a modern era.

A close correlation among political, social, and artistic movements is sometimes possible but just as often impossible. There was no artistic event comparable to the fall of Constantinople, for even the innovation of printing was dependent upon the already existing visual arts. Nevertheless, a significant change took place in German painting within a few years after the invention of printing.

We must beware of applying our modern concepts of national units to the 15th century, whose regions were more closely united in outlook than they are today. Painters such as Konrad Witz and Lucas Moser, though geographically distant from the Netherlands, were as close to it in spirit as Flanders' physical neighbors, for their artistic development was part of a still-international movement found on both sides of the Alps. The comparison often made between the sculpture of Sluter and Donatello has a greater validity than is always realized. The seeming intermixture of Italian conceptions of the density and monumentality of form in Witz's art is a logical concomitant of the common artistic goal in Italy and the north—the functioning of weighty forms in a more naturalistic space.

The "Rogierian revolt," if it may be so termed, that followed was a northern reaction to the overstrong pursuit of such goals. Rogier's style, which reasserted linear, rhythmic configurations, but within a spatial milieu, found ardent and closer followers than had the earlier styles. Not only his sense of linear rhythm but also his types, proportions, and elastic, fluid movements were copied and projected into and out of depth with greater or lesser success. Rogier's style, as well as Flemish iconography and whole compositions, invaded German lands, or more exactly, were carried home by the artists who must have flocked to the great shops in the Lowlands during their travels. Some, like Memlinc, never returned; those who did sharpened the Flemish imprint even further on the art of their generation.

277

COLOGNE, WESTPHALIA, NORTH GERMANY

Cologne, geographically most susceptible to Netherlandish influence,[1] presents the clearest evidence of the new style in the art of the Master of the Life of Mary. He takes his name from an altarpiece devoted to the life of the Virgin, which was donated by Dr. Johann Schwartz to St. Ursula's, Cologne, in 1463. Seven of its panels are now in Munich; the eighth is in London.

The influence of both Rogier and Bouts is visible in the art of this master, whose forms are thinner and more elongated than those of his Flemish counterparts. There is a cheery elegance in his forms, and such scenes as the Munich *Birth of the Virgin* (Fig. 349) show a softening of the greater drama in Flemish painting by a more fluid movement that pauses on genre details and

accessory actions. The scene is staged, rather than set in natural space, though the stage is deeper than in the art of Lochner or of such a transitional figure as the Master of the Glorification of the Virgin. A closer dependence on Flemish types and composition is manifest in the Munich *Visitation* (Fig. 350), which echoes Rogier's Leipzig *Visitation* (Fig. 126) but is expanded horizontally. Hillocks like those of Bouts are arranged in diagonals, but there is less naturalistic coloration, so that buildings and land forms are seen as color bands rather than as natural forms in space. The Lochner-like angels in the sky are another indication that the master was not a Fleming. However, he was well aware of spatial articulation, and the use of successive spatial zones that move the eye diagonally from background left to foreground right is a unique solution to the narrative demands of the Meeting at the Golden Gate. The *Crucifixion* in Cologne by the Life of Mary Master is closer to Bouts, yet different and inventive in the assymetrical placing of the Cross. Though dominated by Bouts, it is less anecdotal and more pensive, with gentler actions, and it continues the tradition of the Cologne school in the higher key of its tonalities.

Associated so closely with the Life of Mary Master that his work has been thought to represent the master's early style is the Master of the Lyversberg Passion, whose work is distinguishable in that it lacks the sense of space and balance of the Life of Mary Master. He crowds his forms to such an extent that the paintings, particularly the *Taking of Christ*, of 1464, in Cologne, seem a combination of quotations in form and color from Bouts, with a few individual additions.

It was the fate of Cologne's painters in the later years of the 15th century to become as anonymous as those who came after Lochner. Three masters stood out in the final decades: the Master of the Holy Kinship, active between 1480 and 1520; the Master of St. Severinus, active between 1485 and 1515; and the Master of the St. Bartholomew Altarpiece, active from 1470 to 1510. All three show strong connections with the art of the Netherlands. The Holy Kinship

above: 349. MASTER OF THE LIFE OF MARY. *Birth of the Virgin.* 1463. Panel, 33 ½ × 42 ⅞″. Alte Pinakothek, Munich.

left: 350. MASTER OF THE LIFE OF MARY. *Visitation.* 1463. Panel, 33 ½ × 42 ⅞″. Alte Pinakothek, Munich.

above: 351. MASTER OF THE HOLY KINSHIP. *Holy Kinship Altarpiece.* 1500. Panel,
55 1/2 × 73 1/4″ (center), 55 1/2 × 33 1/2″ (each wing). Wallraf-Richartz-Museum, Cologne.

below: 352. MASTER OF ST. SEVERINUS. *Dream of St. Ursula. c.* 1490–1510. Canvas,
48 3/8 × 44 7/8″. Wallraf-Richartz-Museum, Cologne.

Master takes his name from the *Holy Kinship Altarpiece* (Fig. 351), in Cologne, of about 1500. Preserving the delicate coloration of his Cologne predecessors, he continued their practice of direct borrowings from leading Flemish artists but modernized their style by crowding the composition with strongly decorated surfaces and colored shadows. The Master of St. Severinus is formally much related to the Holy Kinship Master, except that his figure types, as in his *Adoration of the Magi* in Cologne (of about 1512 according to Stange), suggest a Dutch origin, for the art of Van der Goes seems to have been filtered through Geertgen. The interest in light of the Master of St. Severinus also differentiates him from the Holy Kinship Master, and it is best seen in the *Dream of St. Ursula* (Fig. 352), in Cologne, one of the most charming German pictures of the 15th century. Since it comes from a cycle of 19 paintings on St. Ursula, now scattered, the artist has also been called the Master of the Ursula Legend. The Master of the St. Bartholomew Altarpiece, known from his "name work" in Munich and a *St. Thomas Altarpiece* (Fig. 353), in Cologne, of about 1499, is also related to Flanders. His figure types especially are traceable to Flemish contemporaries working in a modified Van der Weyden manner crossed with the style of the Virgo Master. His surfaces, like those of his Cologne contemporaries, are crowded with proliferating draperies; his color is enamel-like, and his outlook conservative.

In Westphalia a more archaic style, with a gentleness of spirit comparable to that of Lochner's followers, characterizes the art of the Master of Liesborn, who is responsible for the fragments in the Provincial Museum, Münster, and an *Annunciation* and a *Presentation* in London, all from the main altar of the abbey at Liesborn, made in 1465 for its abbot, Henry of Cleves. Eyckian echoes appear in the angels' features.

Documented in 1475 in Hamburg, Hinrik Funhof followed Bouts and emulated the spirit

above: 353. MASTER OF THE ST. BARTHOLOMEW ALTARPIECE. *Doubting Thomas*, *St. Thomas Altarpiece*, center. 1499. Panel, 56 1/4 × 56 3/4″. Wallraf-Richartz-Museum, Cologne.

below: 354. HERMEN RODE. The Virgin appears to St. Luke, *Altarpiece of the Guild of St. Luke*, exterior left wing. 1484. Panel, 29 1/8 × 17 1/2″ (complete wing 68 1/2 × 22 1/2″). Sankt-Annen-Museum, Lübeck.

of his late style (altarpiece of about 1482 in St. John's, Lüneburg). In the commercially important city of Lübeck Hermen Rode painted for the church of St. Catherine in 1484 the altarpiece that is now in the museum there. Its style reflects that of the Liesborn Master but is less precise in spatial organization and more awkward in arrangement, though there is a compensation in the greater feeling for spatial chiaroscuro and in the warmth of color. A naïve charm is seen in its often-reproduced panel of St. Luke, in an Eyckian interior, drawing the Virgin, who stands behind him (Fig. 354).

ISENMANN AND SCHONGAUER

Qualitatively far more interesting in the assimilation of Flemish ideas is Caspar Isenmann of Colmar along the Rhine. Traceable in Colmar as early as 1433, he became a citizen in 1436 and died in 1472. Four panels in the Unterlinden Museum there come from a *Passion Altarpiece* of 1462–65 for St. Martin's. These reveal that the artist's early style was close to Witz's but that he responded quickly to the mobility of the new Rogierian expression, for the Crowning with Thorns presents rounded, plastic figure types of short proportions, whereas the draperies of Christ are treated in the new manner. The Resurrection scene (Fig. 355) goes even further in adopting new ideas; the figure of Christ is derived from Rogier's background figure in the scene of Christ appearing to His Mother from the *Mary Altarpiece* (Fig. 130). The twist of Christ's body has been further accentuated and flattened. The flattening has also been extended to the uniformly toned, diagonally interlaced Flemish hillocks leading back to the church on the horizon. Less atmospheric than that of his Flemish prototypes, Isenmann's work combined the plastically rendered foreground guards with a more linear, Flemish-inspired Christ, angel, and the Three Marys, into a unified but varied whole against a gold ground.

A far more famous master in Colmar in the second half of the century is better known for his engravings than for his paintings. This is Martin Schongauer,[2] who was born about 1435 (?), probably in Augsburg, and went to Colmar when his goldsmith father, Caspar Schongauer, moved there from Augsburg about 1440, be-

coming a citizen in 1445. Martin, who never married, was apparently working near Ulm about 1462, painting saints in the Klarenkloster at Söflingen. A documentary notice that he matriculated three years later at the University of Leipzig, in the winter semester, has continued to plague art historians. Was he a student, or was he employed by the university in some artistic capacity that demanded his registration? It is known that his brother Paul, a goldsmith like his father, became a citizen of Leipzig in 1478. Whatever the answer, Martin was back in Colmar in 1469, and his only dated painting is the *Virgin of the Rose Bower* of 1473 in St. Martin's, Colmar. In 1477 he owned a house in Colmar, and after 1488 he was working on a Last Judgment fresco on the west wall of the church of Breisach, a town across the Rhine a few miles from Colmar where he died in 1491. On the basis of his 115 engravings and the 1473 painting, other paintings have been attributed to him.

The *Virgin of the Rose Bower* (Fig. 356) is the only certain work among the many products of Schongauer's active shop, which provided a number of altarpieces for the surrounding region. The painting displays a mastery of exe-

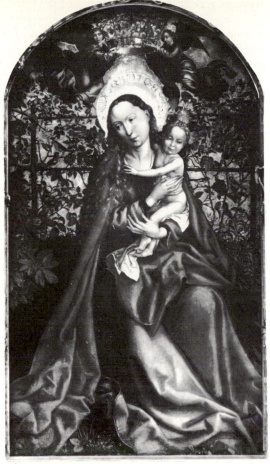

left: 355. CASPAR ISENMANN. Resurrection, *Passion Altarpiece,* wing. 1462–65. Panel, 42 $\frac{1}{2}$ × 28 $\frac{3}{4}$". Musée d'Unterlinden, Colmar.

above: 356. MARTIN SCHONGAUER. *Virgin of the Rose Bower.* 1473. Panel, 78 $\frac{3}{4}$ × 45 $\frac{1}{4}$". Church of St. Martin, Colmar.

cution and a monumentality of conception that raise it high above the general level. Unique in its conception of intimacy and variety, with the heads turning in opposite directions, the basic theme is not new, though its Flemish naturalism is. Based more on the art of Bouts than of Rogier, the figures have been broadened, made heavier, and treated with a distinct sharpness that is almost metallic. Outlines accented by sharp reflected lights and clear delineation of tonal areas betray the hand of an engraver, but one with a largeness of conception. The active drapery and the density of the background bower indicate, in comparison with the engravings, an early stage in Schongauer's career, though he was already an accomplished master.

The mastery is so evident that it is difficult to accept Buchner's attribution of two panels, one

with Christ and Apostles and Beheading of John the Baptist, in Munich, and the other, with St. George and the Dragon, in Colmar, as early works by Schongauer. Both show a modernization of the earlier plastic style by the addition of atmospheric qualities, even though the setting still retains highly stylized furrowed rocks and meticulously detailed grasses and tree forms in the manner of Multscher but more rounded. On these forms have been imposed a basically unpleasant chiaroscuro and a soft modeling, resulting in a soft pictorial relief.

Also considered by some as early work are a *Flagellation* and a *Noli me tangere* from the Dominican church in Colmar, showing very poor rendering of hands and an excessive emaciation of Rogier's figure types, plus the older detailed treatment of grasses; these stylistically could not possibly be early works if the Beheading and St. George panels are also early. It is thus unlikely that either can be attributed to Schongauer's own hand (Stange even attributed them to the Housebook Master).

More certainly by Schongauer is the Annunciation from the *Orliac Altarpiece* from Isenheim, now in Colmar. Painted on two narrow panels, it shows a control, a sense of structure, and a quality of conception and execution that can be readily accepted as Schongauer's work. Also closely related are a number of small panels of the Nativity: One in Munich shows a gulf between the foreground group and the shed behind that makes it a questionable attribution to Schongauer. The *Nativity and Adoration of the Shepherds* in Berlin, though sufficiently metallic to merit consideration as a work by Schongauer, introduces shepherds modeled with a heavy chiaroscuro that cannot be correlated with any engraved work. The Vienna *Nativity*, on the other hand, seems to reflect more closely and without inconsistencies the engraving style of the late 1470s and early 1480s, with a fine interrelationship of parts and a variety of form characteristic of this period in his engravings.

The closeness of these works to Schongauer is a measure of the force of his style and the spread of his influence. Of all the German artists of the 15th century Schongauer was the only one whose influence was to spread far beyond the narrow limits of the region in which he worked. His stylistic adaptations from Bouts and Rogier became a distinct personal vision that drew from Flanders but did not depend upon it. He was one of the few German artists to develop a style of clarity and balance that avoided the excesses in movement, space, and overly dramatic expression characteristic of many of his contemporaries.

THE HOUSEBOOK MASTER

Another master print maker was the Housebook Master,[3] named from an illustrated manuscript in Wolfegg Castle. He has also been known as the Master of the Amsterdam Cabinet, since 80 of his prints, 63 of which are unique, are in that collection. Of his 89 prints, 69 exist in only one copy. Like Schongauer, he too has had paintings attributed to him.

He was working in the Middle Rhine area in the fourth quarter of the century, and possibly came from Mainz. Bossert and Storck thought that he was born in Augsburg between 1447 and 1452, was at Heidelberg in 1480, and made a trip to the Netherlands in 1488. Solms-Laubach and Panofsky thought that he was Dutch in origin. Stange and Musper have reasserted a German origin for him. A date of about 1465 for the beginning of his career has been inferred from a dedication miniature in Heidelberg dated 1480 and a drawing in Berlin of Emperor Maximilian attending a peace mass in 1488. The Housebook, or book of drawings, that has given him his name probably dates from the second half of the 1470s.

As a print maker he was influenced in his early work by Master E.S. (see Chap. 18). His early work as a painter is seen in a *Passion Altarpiece* (panels in Freiburg and Berlin), originally from Speyer, the central panel of which, the Crucifixion, is now in the Augustinermuseum, Freiburg (Fig. 357). Considered by Stange to date from the middle 1470s, the work shows almost no influence of Rogier but is seemingly a modernization of ideas basically from Multscher in its dramatic expression. An emphatic naturalism is conveyed by figures of shorter proportions, expressive silhouettes, and compacted and crowded forms. Foreground space is created by the circular design of the group of soldiers gambling for Christ's garments. This is counterbalanced by the highly animated silhouettes of the flanking groups, whose constit-

uent figures are massed together with a vitality that prefigures the late Gothic baroque. Less intentionally dramatic, the Ecce Homo panel, also in Freiburg, and the Last Supper, in Berlin, which is superficially related to Bouts, are more representative of the artist's temperament as revealed in his prints. Even the scene of Christ before Caiaphas, in Freiburg, with its interesting, truly night-lighted vignette of Christ before the *praetorium* in the right background (probably inspired by a work such as the Lyversberg Passion Master's version rather than directly by Flemish work), shows the characteristically anecdotal, narrative bent of the Housebook Master.

The charming variety and vivacity of his style appear in the painting of the *Lovers*, of 1479, in Gotha. In a more linear, sharper, and more incisive style than that of the *Passion Altarpiece*, it also shows greater delicacy in light and modeling. The Housebook Master's work carried over into the 16th century, for an altarpiece from his shop with scenes from the life of the Virgin, now in Mainz, is dated 1505. The Netherlandish component of his art, visible in spacious settings and in a delicate atmosphere that adheres to his figures and plays around the mouths so that almost all faces seem to have a slight smile, is also seen in miniatures of the four Evangelists, of about 1500, in Cleveland. Distinctly individual, the Housebook Master was less dependent upon established Netherlandish models than his contemporaries.

THE STERZING MASTER

The growing linearity in German painting of the third quarter of the century was an accompaniment to the spread of Van der Weyden models. The Master of the Sterzing Altarpiece worked in Multscher's shop, but because of the stylistic differences between Multscher's *Wurzach Altarpiece* and the panels from Sterzing (now Vipiteno, Italy), the latter have been ascribed to the hand of a different painter, who, under Rogier's influence in style and composition, became the dominant master at Ulm. Accentuating and simplifying Rogier's contours, employing figures that are more elongated and elegant, he projected his forms into a deeper space. An early work, painted before this aim had been achieved but still under Rogierian influence, is the *Two Lovers* in Cleveland (Fig. 358). It is markedly linear in its elongations, which are presented with great delicacy. Carefully separated from the poised lovers is a dense fairy-tale wood of meticulously rendered trees, plants, and flowers, a setting for their symbolically oriented presentation in bright, light, warm colors against the darker green background.

below: 357. HOUSEBOOK MASTER. Crucifixion, *Passion Altarpiece*, center. *c.* 1475(?). Panel, 51 3/8 × 68 1/8″. Augsutinermuseum, Freiburg im Breisgau.

right: 358. MASTER OF THE STERZING ALTARPIECE(?). *Two Lovers*. *c.* 1460–70. Panel, 25 1/2 × 15 1/2″. The Cleveland Museum of Art, (Delia E. and L. E. Holden Funds).

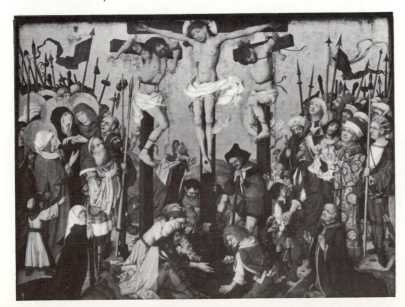

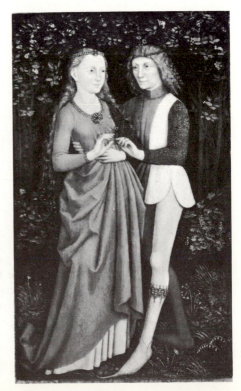

MICHAEL PACHER

On the southern slope of the Alps, in the Tyrol, one of Germany's most important 15th-century artists created a style that ignored the almost complete domination elsewhere of Rogier's outlook. Facing Italy and responsive to its art, Michael Pacher, sculptor as well as painter, was unique in assimilating the Italian manner while retaining his northern naturalism.[4] His forcefully naturalistic sculpture is related to the late Gothic baroque of Veit Stoss and Tilman Riemenschneider but differs from their work in a less expressionistic drapery and in comparatively calmer movement of forms in space. The same spirit characterizes his paintings, which take from Italy an interest in logical perspective and a clarified space, but within which his organically conceived figures move freely in a dramatic manner that is totally un-Italian and thoroughly northern.

Pacher, one of three artistic brothers, was probably born at Neustift near Brixen (Bressanone, Italy) in the Tyrol. As early as 1467 he was recorded as a citizen of Bruneck, where he had established a workshop and was making altarpieces. Thus his years of traveling probably came in the late 1450s or early 1460s. After 1467 he was painting frescoes of Church Fathers in the sacristy at Neustift, and on December 13, 1471, he signed a contract to make for Abbot Benedict Eck of Mondsee an *Altarpiece of St. Wolfgang* that was to be entirely by his own hand and for which he was to receive 1,200 Hungarian gulden. Pacher signed this immense work in 1479, on the back, and again in 1481 on the frame. In type it is a sculptured shrine closed by a double set of painted wings, capped by intricate Gothic pinnacles, and having a carved predella with painted wings.

When both pairs of wings are open, the central scene, carved in wood, painted, and gilded (Fig. 359), shows the Coronation of the Virgin flanked by large figures of St. Wolfgang holding a model of the church, at the left, and St. Benedict with a cup of poison, at the right. When the wings are closed, Sts. George and Florian, the warrior saints, dressed in contemporary armor, are seen to left and right of the sculptured center. High above, the Crucifixion is placed in the midst of intricately carved late Gothic architectural forms. The predella contains a sculptured Adoration of the Magi behind its own painted wing panels, which

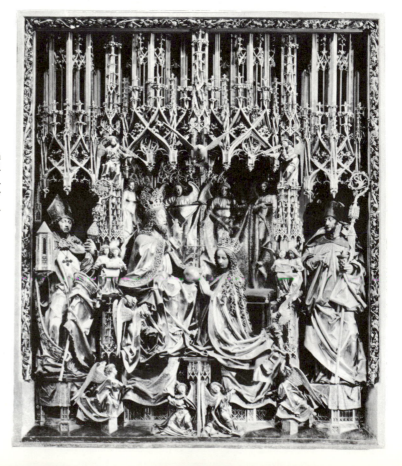

359. MICHAEL PACHER. Coronation of the Virgin, *Altarpiece of St. Wolfgang*, center. 1471–79. Carved, painted, and gilded wood, 12' 9 ½" × 10' 4 ½". Church, Sankt-Wolfgang, Austria.

show the Church Fathers on the outside and the Visitation and the Flight into Egypt on the inner faces.

The Coronation of the Virgin in the center, its figures painted to simulate lifelike forms, is one of the most incredibly intricate pieces of carving of the whole medieval period. Thoroughly illusionistic in intent, it is, however, different from the chiaroscuro naturalism of Nicolaus Gerhaert (the Leyden sculptor who in the 1460s had brought a new sculptural style to Germany), adhering instead to the spirit of Hans Multscher and the *Sterzing Altarpiece*. In its linear naturalism light is not an important artistic element, as it was with Gerhaert. Thus the intent was a striking spatial naturalism with accentuated detail, balanced figures, sweeping draperies, and the detachment of sculptural elements from any relief character.

All writers on Pacher have commented on his close connections with Andrea Mantegna, whose frescoes in the Eremitani Chapel of 1449–54 were completed before Pacher went to Padua and the Veneto. Like Mantegna, Pacher took great delight in architectural forms seen in perspective from a low viewpoint, and, like Mantegna, he set his principal actors close to the picture plane. He also employed a simplified outline though it is not so simplified as that of Mantegna. The result is a sharper dramatic content, accentuated by frequently placing principals on opposite sides of the view into deep space. His foreground figures occupy the close space almost like gigantic *repoussoirs*, with the effect of pushing the city or landscape into depth with far greater violence than in Mantegna. Also different is the concern for ambient light, which became almost a passion with Pacher for rendering interior architecture.

The exterior of the outer wings, possibly painted by Friedrich Pacher, shows four scenes from the life of St. Wolfgang, the most notable being the scene of the saint in full regalia building a chapel against a superb Alpine landscape.

When these wings are opened and the inner wings are left closed, eight scenes from the life of Christ are presented, four on the back of the outer wings, and four on the front of the inner wings. The scene of Christ driving the money-changers from the Temple (Fig. 360) is possibly the most baroque painting of the altarpiece. Christ's posture is thoroughly impossible, for

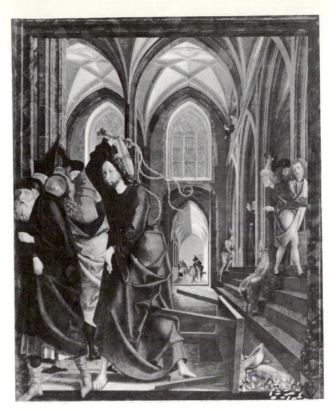

360. MICHAEL PACHER. Expulsion of the Money-changers from the Temple, *Altarpiece of St. Wolfgang.* 1471–81. Panel, $68\frac{7}{8} \times 55\frac{1}{8}''$. Church, Sankt-Wolfgang, Austria.

it is more than *contrapposto*; it anticipates the Manneristic *figura serpentinata*, winding itself about a central axis. The onlookers standing on the vaulted platform at the right contribute to the impression that this scene is an important anticipation of Tintoretto's painting of the theft of the body of St. Mark during a thunderstorm, but Pacher's typical central view into depth, with the fleeing, classically garbed figures in the brightly lighted cloister beyond, is a more dramatic assertion of deep space than is to be found in Tintoretto.

Pacher's drama also resides in the architecture as well as in the figures. Through the variety of lights and darks his spacious architectural constructions become emotive settings for the drama of the figures. In the Woman Taken in Adultery the strong recession of the paving tiles is echoed in the center line of the vaults above, which, as elsewhere in Pacher's interiors, are filled with a superbly varied flow of direct and reflected light delicately delineating the forms; the front surface of the composition is animated by countermovements of figural action, striking

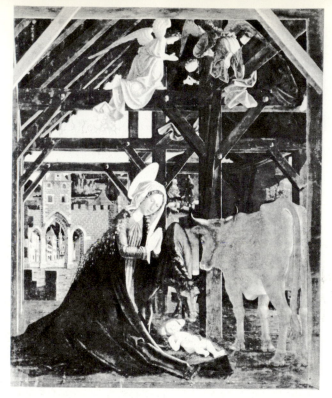

361. MICHAEL PACHER. Nativity, *Altarpiece of St. Wolfgang*. 1471–81. Panel, 68⅞ × 55⅛". Church, Sankt-Wolfgang, Austria.

profiles, and reflected lights. Despite their sharply characterized naturalistic detail, Pacher's figures are touched by a classicizing ideal conveyed with an interplay of soft reflections and clear line.

The inner wings, when opened to reveal the sculptured centerpiece, show, on the inside, four scenes devoted to the infancy of Christ. The justly famous Nativity (Fig. 361) is another anticipation of Tintoretto. A Madonna of Humility, the Virgin, seen from below, adores the Child, who is placed at eye level. The scene within the stable is illuminated by a supernatural light seemingly emanating from the Child. It casts a glow on the monumental cow and lights the adoring angels in the rafters overhead, creating a more concrete interplay of lights and darks than is found in Van der Goes's *Portinari Altarpiece* of about the same time, which treats light in similar fashion. Van der Goes's relationship to a late Gothic dramatic expression is readily discerned from such a comparison.

Pacher's northern spirit is thus made clear, as it is in the symbolic overtones of Christ's sacrifice given to the scene of the Circumcision, revealed by the second opening, which takes place

in the apse of a church at the emplacement of the altar. What is also clear is that Pacher was far in advance of his German contemporaries in the rationale of forms in space.

His *Altarpiece of the Church Fathers* (Pl. 22, after p. 308), in Munich, of about 1483, was made for the collegiate church at Neustift under Dean Leonard Pacher. It continues, particularly in lighting, the spirit of the *St. Wolfgang Altarpiece*, though the architectural frames are painted instead of carved. Immediately behind the saints are rich simulated marble panels and gold brocades. Monumentalized forms characterize the four Fathers, Jerome, Augustine, Gregory, and Ambrose. In front of each is a symbol or reference to the saint: Jerome preparing to remove the thorn from the lion's foot, Gregory lifting the Emperor Trajan from Purgatory, Ambrose with the cradle, and Augustine pointing to a child with a spoon. This last motif refers to the story that Augustine, walking along the shore and pondering the mystery of the Trinity, met a child spooning the sea out of a hole in the sand; when he told the child that what he was doing was impossible, the child replied that Augustine's attempt to understand the Trinity was equally impossible. The figures dominate their intricate architectural settings through action, strong light and dark, and monumentalized form. The outer figures, Jerome and Ambrose, turn in toward the center, and the forms before them play a similar part in the compositional organization.

On the exterior are scenes from the life of St. Wolfgang. The scene of St. Wolfgang healing a sick man shows a magnificent nude, inspired by Pacher's understanding and feeling for ideal form but again suggestive of Mantegna's art, which here has been thoroughly assimilated to produce a sharp-edged, detailed, and somewhat attenuated figure. The face looking up at the saint is a superb example, among the many in Pacher's art, of the control of perspective. This is also visible in the room interior, finely lighted from two directions with one light stronger than the other. The result is, as in the *St. Wolfgang Altarpiece*, a superb articulation of space conceived architectonically.

In two later works, the *Flagellation* and the *Betrothal of the Virgin* (Fig. 362), both in Vienna, Österreichische Galerie, from the high altar of the Franciscan Church in Salzburg, where

Pacher was working in 1484, a distinct change can be discerned. Though the figures are close to the picture plane and present dramatic silhouettes, a shortening of space and a compactness make the scenes more dramatic. This is particularly visible in the *Betrothal of the Virgin*, where Pacher concentrated on the figures almost in Italian Renaissance fashion, giving less importance to spatial depth. There is also a change to a horizontal composition of the heads that is not accidental, for the concept of the microcosm as expressive of the macrocosm is here in germ and thus marks a departure from the earlier sense of verticality and ascension. Human drama is now important and the background is reduced almost to an allusive element.

The direction taken by Pacher's art toward dominance of the individual over the setting is in advance of developments in general in the 15th century, when his contemporaries still turned in the direction of Flanders. Only Marx Reichlich followed Pacher's example. He appeared as a citizen of Salzburg in 1494 and must have been associated with Pacher until the older master died there in 1498, for his works repeat the ideas of Pacher but with a softening of his spatial and formal drama. Other artists in Salzburg show no knowledge whatsoever of Pacher's art.

In Austria the younger Master of the Vienna Schottenaltar (Scotti Altarpiece) was another follower of Rogier. His *Adoration of the Magi*, Vienna, Österreichische Galerie, of about 1475, is comprised of forms and colors from Rogier's repertory, possibly conveyed by way of the northern Netherlands. In the *Adoration* his figures suggest Virgo Master types, while in other works they are derived from Pleydenwurff in Nuremberg. All are comparatively flat and even in their lighting. The Dutch influence probably came from a Virgo Master triptych of the *Adoration of the Magi*, now in Salzburg, and thus is an interesting example of direct influence.

In Salzburg and Passau, Rueland Frueauf the Elder was the leading master from 1470. Born near Passau, probably between 1440 and 1450, often working in Salzburg, he finally settled in Passau, where he died in 1507. His artistic career after 1470 was spent in both cities. After many years of working in a Rogierian manner, his style began to change in the 1490s to a calmer mode that has been called a classicizing trend in late Gothic art. It appears in the *Annunciation* (Fig. 363), from an altarpiece of the life of the Virgin, in the Österreichische Galerie in

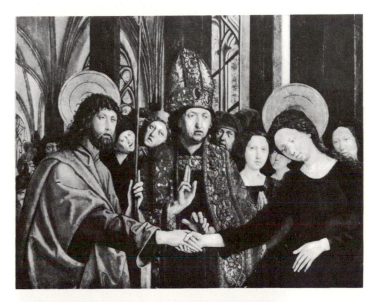

above: 362. MICHAEL PACHER. *Betrothal of the Virgin,* fragment. 1486–98. Panel, 44 ¹/₂ × 54 ³/₄″. Österreichische Galerie, Belvedere, Vienna.

right: 363. RUELAND FRUEAUF THE ELDER. *Annunciation. c.* 1490. Panel, 82 ¹/₄ × 52 ³/₄″. Österreichische Galerie, Belvedere, Vienna.

287

Vienna. A work of about 1490, it shows the monumentalization of formal movement noted in Michael Pacher grafted onto a Flemish-inspired base to create a clear style with even lighting. Surface movements in ample curves, simplified folds replacing the intricate, crumpled Netherlandish folds, and a large, simplified space with relatively unadorned and undifferentiated surfaces are the marks of this new manner, which places flattened rhythmic forms in freer space. The *Annunciation*, dated 1490, is one of four panels from Grossgmain. Formerly attributed to a "Master of Grossgmain," they are now given to Rueland Frueauf.

To his son of the same name have been attributed some light-colored, harmoniously conceived, and delicately executed panels from a dismembered altarpiece of 1505 in the monastery collection at Klosterneuburg (Fig. 364). A fanciful conception of protoromantic landscape of an almost Oriental delicacy provides the setting for both religious and nonreligious scenes that seem derived from International Style manuscripts. With high rocks and small figures, genre scenes and anecdotal narrative, his panels are distinctly light-hearted in feeling.

Of about 1490 is a man's portrait, in Vienna, signed at the top "R.F." This has been attributed to the father, because it presents the clarity of line distinctly seen in the Grossgmain painting and the tendency toward simplification of surface observable in Rueland Frueauf the Elder's work. The quieter drama of his work is a countermovement to the dramatic outpourings found elsewhere in Germany in the last several decades of the century, reaching particularly vehement expression in sculpture.

FRIEDRICH HERLIN

The principal follower of Netherlandish ideas in Nördlingen was Friedrich Herlin, first traceable there in 1459. He was probably the son of the painter Hans Hörlin, recorded between 1442 and 1476. Friedrich Herlin's name is found on the tax rolls every year from 1459 to 1499, except for 1467, when he was in Rothenburg painting the altarpiece for the high altar of the church of St. James. His earliest work, the altar-

right: 364. RUELAND FRUEAUF THE YOUNGER. *Boar Hunt.* 1505. Panel, 30 × 15 ⅜". Stiftsmuseum, Klosterneuburg.

piece for the Herrgottskirche in Nördlingen, is dated December 8, 1459. Closely dependent on Flanders and the Rogier shop, he modeled the figure of John the Baptist, for example, after the John of the *Von Werl Altarpiece* (Fig. 97).

In 1462 he began the painting for the high altar dedicated to St. George in the city church in Nördlingen, which he probably completed by 1465. (The sculptured Crucifixion was added in 1477–78 by Simon Lainberger of Nuremberg.) This work, too, shows a marked dependence on the Netherlands; the Annunciation, on the inside of the left wing, copies Rogier's *St. Columba Altarpiece* (Pl. 10), which Herlin probably saw in Cologne, and the St. George slaying the dragon (Fig. 365) repeats a type common in the Netherlands, adopted here in Germany as it was in Spain. Sharper modeling, extremely hard lighting on the armor, and a lessening of atmospheric quality give to Herlin's emulation of Flemish style a feeling of flattened space and an aura of provincialism. These characteristics may be observed in his work generally, for though his types come from Flanders, they have stiffened in transit, losing much of the fluidity of light and the gentle gradation of tones they possessed in their homeland.

A provincial charm is inherent in the portraits of the family of Jakob Fuchshart, donor of the

St. George Altarpiece (Fig. 365), who are represented on two wing panels. The males all kneel in the same way, their heads all turned at exactly the same angle; the female members, all in pews, wear large white headdresses that are similarly oriented. Wooden in effect because of the lack of movement within the design, they still result in a naïve unity.

A naïve charm is also found in the background representation of the town of Santiago de Compostela in the *St. James Altarpiece* of 1467, in Rothenburg, for, despite the scale discrepancies in the figures on its streets, the artist has faithfully rendered his home town of Nördlingen.

In 1472 Herlin, obviously with much shop participation, completed the *St. Blasius Altarpiece* for the church at Bopfingen. The Nativity scene from this altarpiece, which, if not executed by Herlin, was at least designed by him, is clearly dependent on Rogier's *Bladelin Triptych* (Fig. 141), though Herlin accepted reluctantly or failed to understand Rogier's progressive elements. By making the three principal figures about the same height, he made his composition too regularized, and the lighting shows that Herlin did not understand Rogier's symbolic treatment of light, for he replaced Pierre Bladelin with a midwife holding a lantern to illuminate the scene. This alteration makes Joseph's gesture of shielding the natural light of his candle—as opposed to the divine radiance of the Child—utterly meaningless.

Most mature of all Herlin's works is the so-called *Family Altarpiece* (Fig. 366), of 1488, in the town hall in Nördlingen. At the left St. Luke presents the kneeling donor and the four male children; St. Margaret presents the donor's wife and four daughters at the right of the enthroned, heavy-faced Virgin, who holds the Child in a pose derived from Memlinc. A greater unity of form and spatial arrangement is visible in the composition, and the forms have a greater monumentality than heretofore.

Dependent upon Rogier for iconography, compositions, and motifs, but stylistically removed from Flanders in the accentuation of flatter surfaces, is the work of Hans Schüchlin, whose early altarpiece for Tiefenbronn (Fig. 367) was executed in 1469. Because of the surface flatness, his backgrounds lack modulation in the same way, though less strongly, as Herlin and the Nuremberg painters, with whom he can be most closely associated; but his figures and scenes are less crowded, his movement is softer, and he has a greater delicacy.

Schüchlin's son-in-law, Bartholomäus Zeitblom, came from Nördlingen before 1482 and died in Ulm between 1518 and 1522. Stylis-

365. FRIEDRICH HERLIN. *St. George Altarpiece*, exterior. *c.* 1462–65. Panel, 7′ 5 3/8″ × 8′ 8 3/8″. Städtisches Museum, Nördlingen.

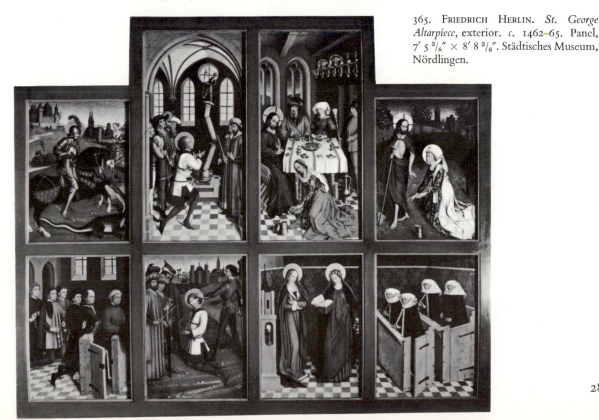

right: 366. FRIEDRICH HERLIN. *Family Altarpiece*. 1488. Panel, 57 $^7/_8$ × 74 $^3/_8$″. Städtisches Museum, Nördlingen.

below: 367. HANS SCHÜCHLIN. Resurrection, *Altarpiece*. 1469. Panel, 67 $^3/_8$ × 50 $^3/_4$″. Church, Tiefenbronn, near Pforzheim.

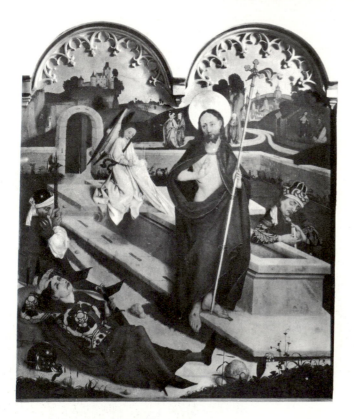

NUREMBERG PAINTING

Nuremberg was the chief center of Franconia; the historical accident of Dürer was to make it the major artistic center of southern Germany in the early 16th century. During the third quarter of the century its chief artist was Hans Pleydenwurff, who came from the Bamberg region to appear in Nuremberg about 1451 and, in 1457, received permission to live in the inner city. He continued to live in Nuremberg until his death in 1472.

His developed style is seen in the dismembered diptych of the *Man of Sorrows* (Fig. 368) of the late 1450s. The Man of Sorrows appears in the left panel, now in Basel. It was commissioned by Count Georg von Löwenstein, who is portrayed on the right panel, now in Nuremberg. The work is a modernized treatment of the theme seen earlier in Master Francke, but the earlier pathos has been replaced by a more naturalistic and dramatic expressiveness conveyed by the dark face of Christ, by His strong gaze back over His shoulder to the Count on the next panel, and by the forceful light and dark patterning of the evenly illuminated forms. The less modeled style of the portrait is achieved by silhouetting the white-haired figure of the Count (died 1464) against the dark background and by painting sufficient detail into his light-toned face and hair and the darker supporting garments to animate the surfaces, while the darks in the tilted face are

tically unrelated to Schüchlin, he was trained under Herlin and was strongly influenced by Herlin's late style. He developed a calm, dispassionate corporeality and avoided excessive movements, while stressing falling lines. This calm outlook gives his elongated figures a still, occasionally too quiet, monumentality.

restricted to the eyes and mouth. Clarity and linearity are the effective results.

From the now-dismembered *Breslau Altarpiece* of 1462, the panel of the Descent from the Cross (Fig. 369), in Nuremberg, shows Pleydenwurff's allegiance to the art of the Netherlands. Probably he made a trip to that region in the early 1450s. More vertical in accentuation than Rogier's figures and thus more suggestive of those of Bouts, Pleydenwurff's forms are arranged in a descending vertical chain to create dramatic expression. Lacking a transition between foreground action and background landscape, the flattened composition is further emphasized by rendering the sky as a patterned gold brocade. (Only in this element does Pleydenwurff show a connection with the previous Nuremberg style of the Tucher Master.) As a thorough-going Rogier follower, Pleydenwurff presents in his late *Crucifixion*, in Munich, probably close to 1472, Flemish types that he has conceived more solidly and crowded more actively in compact groups on either side of the Cross. Above the foreground is seen a landscape, in which, following Flemish models established a generation earlier, he has depicted a city. The effect is more spacious than one would expect from the compression of the foreground action.

Pleydenwurff's strongly Flemish but flattened style of active surface movements was continued by Michael Wolgemut, his successor as the leader of Nuremberg painting. Best known as the teacher of Albrecht Dürer, Wolgemut was born in Nuremberg in 1434 and lived there until he died at a ripe age in 1519. He was taught by his father Valentin and worked in Munich with the painter Gabriel Mäleskircher. In his youthful travels he probably visited the Netherlands and then returned to work in the Pleydenwurff shop on the 1465 *Hofer Altarpiece*, now in Munich. The scene of the Descent from the Cross from this altarpiece is clearly related to Pleyendwurff's version in Nuremberg (Fig. 369), but varies from it by the manner in which forms are conceived *in vacuo* with little cast shadow and set against a background uniformly treated as a single tone in color and value, to effect a more abstract and unmodulated patterned space. Thus in Nuremberg (and elsewhere in Germany) there was a strong trend to abstract and stress linear elements at the cost of unity of form and light, and to use color in patches rather than as a balancing element.

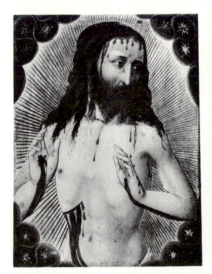

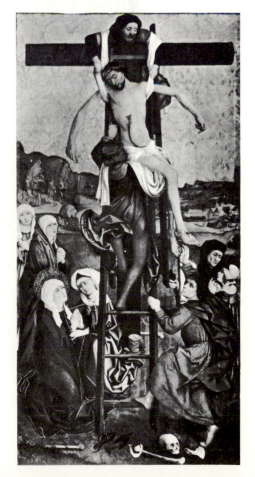

above: 368. HANS PLEYDENWURFF. *Man of Sorrows* adored by *Graf Georg von Löwenstein*, divided diptych. *c.* 1455–60. Panel, 12 1/4 × 9″ (each). Kunstmuseum, Basel (left); Germanisches Nationalmuseum, Nuremberg (right).

right: 369. HANS PLEYDENWURFF. Descent from the Cross, *Breslau Altarpiece*, wing. 1462. Panel, 9′ 4 5/8″ × 4′ 7 7/8″. Germanisches Nationalmuseum, Nuremberg.

below: 370. MICHAEL WOLGEMUT. Nativity, *Zwickau Altarpiece*, left wing. 1479. Panel, *c.* 98 ½ × 69″. Church of the Virgin, Zwickau.

bottom: 371. JAN POLACK. *Fall of Simon Magus.* 1492. Panel, 68 ⅞ × 73 ⅜″. Bayerisches Nationalmuseum, Munich.

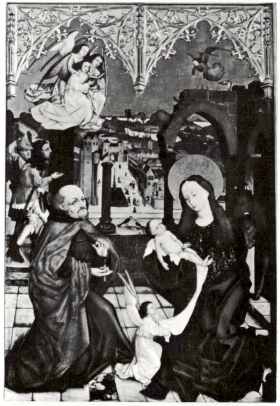

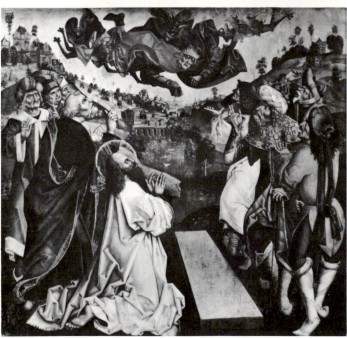

Wolgemut married Pleydenwurff's widow in 1472 inheriting the shop in accord with the common practice. His hand is visible in the *Zwickau Altarpiece* (Fig. 370), of 1479, in the Marienkirche there, for which he received 1,400 gulden. This work reveals the evolution in Nuremberg painting toward the late Gothic baroque style, which implies stilted agitation, brusque, precipitous movement, accentuated facial expressions, violent swinging draperies, and figural movements in all directions. Combined with these characteristics is a greater interest in spatial chiaroscuro, which only makes the confusion greater.

Wolgemut's personal style is increasingly difficult to identify in the further course of Nuremberg painting, when more masters were active in his shop. In the last decade of the century there was such a unity of style that the preserved works may be considered as variations on a stylistic theme. Among these can be mentioned the airier shop panel of St. Luke, with a fine feeling for volumes in space, from the altarpiece for the Augustinian monastery, now in the museum in Nuremberg, and the *Carrying of the Cross* by the Master of the Strache Altarpiece, also in Nuremberg, both dating from the 1490s. Wolgemut the painter became submerged in Wolgemut the entrepreneur, even branching out into the field of book illustration and book production.

In Munich Jan Polack created an indigenous but related violent style, best seen in the *Fall of Simon Magus* (Fig. 371) of 1492. Now in the Bavarian National Museum in Munich, it is one of six dated panels from the high altar of St. Peter's in Munich.

German painting in the third quarter of the 15th century succumbed everywhere except on the southern slope of the Alps to the greater and more fluid pictorialism of Flemish art, and sculpture surrendered in its turn to a pictorial naturalism imported from the Netherlands. Both arts shared the enthusiasm, vitality, and excitement of the increasingly larger production that sets the second half-century apart from the much quieter first part. An increased emotive force accompanied the change to more pictorial ideas that was inevitable once a decisive turn was made toward less static concepts of artistic form. German art became more moving emotionally as the limits between the two arts dissolved in the common aim of pictorialism.

IN THE SECOND HALF OF THE 15TH CENTURY THE tempo of German art was increased, and that of life in general was heightened. Business improved and became more active, towns grew richer and commanded more works from the artists, roads were widened from bridle paths, light carts were introduced to transport goods more rapidly, and communication was swifter and broader. The new prosperity and the new conditions of life in all its phases undoubtedly provided the stimulus for the invention and spread of book printing, which came into life around mid-century to become the revolutionary force in the rise of the modern world. The creation of many copies of a text, each alike and unmarred by a copyist's errors, encouraged exact thought and precise knowledge. Preparing the groundwork for the Reformation, Germany was emerging from its medieval state, as Renaissance ideas penetrated there and in the Netherlands. Interestingly enough, along with the dissemination of knowledge through the printed book, superstitious belief also grew tremendously in Germany, augmented by the printing and distribution of such matter as astrological prognostications and fantastic travel literature. In addition, printing techniques fostered the development of the arts of woodcut and engraving, whereby book illustrations and individual prints could be produced in multiple copies.[1]

THE INVENTION AND SPREAD OF PRINTING

It is generally conceded that, for all practical purposes, the printing of books with a press and movable type began in western Europe with Johann Gutenberg, but its antecedents can be traced to the Orient as early as the 2nd century of our era. Before it could develop there had to be an adequate supply of paper.

Paper is an ancient invention, but knowledge of it came to Europe from the East at a relatively late date. The earliest specimen of pure rag paper is Chinese and dates from A.D. 150. Not until about 751 did papermaking reach the Western world, through the conquest by the Moslems of Samarkand, with its Chinese craftsmen, in 704. About 1050 paper with a gelatin size was introduced into Europe through Spain and Sicily by the Moslems. In 1102 Roger I of Sicily drew up a deed on paper, and there is another sheet, in the archives at Palermo, of about 1109 issued by his wife Adelaide. A stamping mill for making paper was set up in 1151 at Jativa in Spain, and in 1157 Jean Montgolfier set up a paper mill at Vidalon in France. The famous paper mill at Fabriano in Italy dates from 1276, and its earliest watermarks date from 1293 and 1294.

Various other devices for printing books also go back to China at an early period. In A.D. 175 Confucian classics were cut in stone, and exact

372. FRENCH. *Bois Protat.*
c. 1380–1400. Wood block,
c. 23 1/2 × 9″. Collection of
Emile Protat, Mâcon, France.

copies were made in the form of rubbings on paper. A printing ink for wood block was developed there from lampblack in 400. The oldest known wood block is a portion of the *Diamond Sutra* (a Buddhist discourse on the nonexistence of things) of 868, which was printed by Wang Chieh from blocks on unsized mulberry-bark paper and pasted into a roll. In 883 there is a mention of block-printed books in Szechuan province by Liu Pin-sen. Block printing became quite common; a more infrequent system was printing from separate earthenware characters in an iron form, used in China as early as 1041–49. In 1314 Wang Cheng in his *Book of Agriculture* presented the earliest account of movable wooden type (sawn from engraved blocks), the first use of modern principles. This was done, however, without a press. In 1403 a type foundry with block types, probably of Chinese origin, cast in bronze, was set up by the king of Korea, and there is a Korean book of 1377 that says it was printed by means of cast letters.

In Europe the printing of textiles from blocks is as old as the 6th century, and other forms of printing were practiced long before Gutenberg. The earliest preserved wood block in the West-

ern world, presumably intended for producing a single print on paper is probably the *Bois Protat* (Fig. 372), a fragmentary block from which a print can still be made. On one side it bears a portion of a Crucifixion and on the other a partial figure of the angel of an Annunciation. From the costumes it can be dated between 1380 and 1400, and it is related to manuscript illumination of that period in the elegance of costume and form (the soldier at the extreme right of the Crucifixion wears a helmet of a type seen in the Limbourgs' illuminations).

A number of references to printing in Europe prior to Gutenberg have been much argued. Procopius Waldfoghel in Avignon in 1444 was doing something related to printing, but what is not certain. In 1445 Jean le Robert, abbot of St-Aubert, Cambrai, sent to Bruges for two copies of a doctrinal *jettez en molle* ("cast in a mold"), and in 1451 he sent to Arras for another doctrinal, also *jettez en molle*. There is a reference of 1452 that Jean van den Berghe at Louvain had to join the carpenters' guild, along with other printers of letters and pictures. His argument to the court against joining the guild was that his art concerned the clergy, but it was not upheld. He may have been making block books in which picture and text were cut together. The members of the religious order of the Brethren of the Common Life were also active in this craft. Despite certain documentary material about Lorens Coster of Haarlem, the evidence for Coster as the inventor of book printing is not so clear as that related to Gutenberg, who is described in a Parisian document of 1470 as the inventor of printing.

Johann Gutenberg, born about 1398, was a native of Mainz, though he conducted his experimental work on printing in Strasbourg. From the testimony of witnesses in a lawsuit there in 1439 it is known that Gutenberg produced a secret something that was marketable, for later a Mainz banker, Johann Fust, provided 800 gulden for wages, paper, and other things required to produce copies of a large Bible. It was completed at Mainz before August 16, 1456, for on that date the vicar of a nearby church wrote a note at the end of one of these books that he had finished rubricating and binding it. This was the *Gutenberg* (or *Mazarin*, or *Forty-two-Line*) Bible, the first printed book. (The number of lines is the usual manner of identifying early books

without name or place or date of publication.) The *Gutenberg Bible* consists of 641 leaves, 16½ by 12½ inches, bound in two volumes. Over forty copies still exist. Apparently it was produced with six presses, several being in constant use in the period of 1450–56, with a crew of two or three workmen for each press, as well as a compositor. On November 6, 1455, Fust established by legal proceedings that he had lent money to Gutenberg five years earlier, and thus we have a *terminus post quem* for the printing of the *Gutenberg Bible*. Two years later the type was in Fust's possession and he had copies for sales; at the same time Gutenberg was entered in the record for nonpayment of debts of long standing. In 1465 Gutenberg was pensioned by the archbishop of Mainz for the services he had rendered, and when he died at the beginning of 1468, a Dr. Homery laid claim to the type and other apparatus he had been using.

Only one other book can be connected with Gutenberg, the *Catholicon*, an encyclopedic dictionary first compiled in the 13th century by Johannes Balbus. This has 373 leaves and is as large as the *Bible*; its colophon, or maker's statement at the end, states that it was made in Mainz in 1460. The type for the *Catholicon* is smaller than that for the *Gutenberg Bible*, and the same type had been used in 1454 and 1455 for printing indulgences for those who gave money to help in the war against the Turks.

As a result of the lawsuit with Gutenberg, the materials went to Fust, who with Peter Schöffer, later his son-in-law, took over the type and the apparatus to begin printing as the firm of Fust and Schöffer. Their first effort was a Psalter of 175 leaves of the size of the *Gutenberg Bible*, with a colophon stating that it was produced by "an ingenious invention of printing or stamping without any driving of the pen, and to the worship of God has been brought to completion by Johann Fust, a citizen of Mainz, and Peter Schöffer of Gernsheim in the year of the Lord 1457 on the vigil of the feast of the Assumption" (Aug. 14). They printed the Bible again in smaller type in 1462 and below the colophon added a cut of their own coat of arms, the original use of a printer's mark.

Their first rivals were Johann Mentelin of Strasbourg and Adolf Rusch. Printing thus rapidly passed out of the hands of Gutenberg and his immediate successors. An early type was that of a 36-line Bible of about 1460 by an unidentified printer, and this same type was used in 1461 and 1462 by Albrecht Pfister of Bamberg to publish the *Edelstein*, a book of fables in German rhyme, with 85 woodcuts, the first illustrated book.

Printing then spread extremely rapidly, aided by the sack of Mainz in 1462. Two Germans, Conrad Sweynheym and Arnold Pannartz, were at Subiaco in Italy sometime before 1465 and by 1467 had published a *De Oratore* of Cicero and Augustine's *De Civitate Dei*, under the patronage of Cardinal Torquemada, abbot of Subiaco. Torquemada's own *Meditationes*, however, were published in Rome in 1467 by Ulrich Han. Sweynheym and Pannartz themselves moved to Rome in 1470. Printing in the north of Italy had begun as early as 1469, when Johann of Speyer and his brother Wendelin began printing in Venice, under a five-year monopoly. Their first published work was a Cicero *Epistolae ad Familiares*, followed by Pliny's *Historia Naturalis* and then Augustine's *De Civitate Dei*. Johann of Speyer died of the plague, but his brother Wendelin finished the Augustine in 1470 and applied for an extension of the monopoly, which the Venetian government wisely refused him.

Now others, such as Nicolas Jenson, who according to a legend had been sent to Mainz by the king of France to learn this new art, began printing; the invention of lower case is due to Jenson. In Venice after 1495 Aldus Manutius was at work; he invented Italic lower case, to which he later added Italic capitals. As early as 1470 there was printing in Paris, by 1471 it had begun in Utrecht, and in 1473 Ketelaere and Gherart Leeuw were working in Holland. In 1475 it is found in Valencia, where Lambert Palmaert was followed by the Crombergers in the early 16th century. Printing came to England by way of William Caxton, governor in Bruges of the English Nation (a trading company). In 1476 he moved to Westminster, after having learned printing from Colard Mansion in Bruges. At his death in 1491 his press was taken over by Wynkyn de Worde, his Flemish helper.

In Cologne printing began early; its appearance in Augsburg came in 1468, at Nuremberg and Beromünster in 1470, Speyer in 1471, Esslingen in 1472, Ulm, Lauingen, Meersburg, and Budapest in 1473, Lübeck in 1474, and so on. By the end of the century printing had spread

373. GERMAN. *Buxheim St. Christopher.* 1423. Woodcut 11 3/8 × 8 1/8″. The John Rylands Library, Manchester.

widely over Germany and other parts of Europe. In many cases the monasteries patronized the craftsmen, who in the early years of the art often printed only a single book, for the difficulties in obtaining paper were great. Paper was extremely expensive, being a factor of over 50 per cent in the cost of a book; type, on the other hand, was easy to make, and a screw for the press could be obtained from any wine press.

At Augsburg the engravers were extremely powerful and allowed Günther Zainer to set up a press only on condition that he employ engravers for his work; as a result Augsburg continued for a long while to be a center for vernacular printing and illustrated Latin works. In 1471 the first illustrated translation of the medieval perennial favorite, the *Vitae Patrum*, was published by Zainer in two-column format with woodcuts at the beginning of the life of each saint; the double column, a manner inherited from manuscripts, made the work easier to read.

Gradually entrepreneurs arose in the field of printing; Anton Koberger in Nuremberg was one of these, and later Michael Wolgemut hired Koberger to work for him. Koberger earlier had entered into an exchange agreement, employing Rusch of Strasbourg to print or have printed a portion of a monumental Bible with a commentary by Nicolaus de Lyra.

Though Italian printing is different from northern work, the incisive quality of printing craftsmanship is seen in both; however, Italian type is more classical in character than the Gothic of the north. The early types have in certain cases been imitated by more recent type designers.

EARLY PRINTS
AND ILLUSTRATED BOOKS

Printing was, of course, going on in the medium of the single sheet, as was seen in the *Bois Protat* wood block. An early Flemish print in Brussels of the *Virgin and Child and Saints* is dated 1418. Another early dated work is the *Buxheim St. Christopher*, dated 1423 on the inscription below it (Fig. 373). Possibly from the Upper Rhine, in style it is somewhat like the

two earlier works, but it is somewhat hardened and angular in character, with embryonic shading lines, normally characteristic of later works. These early prints were usually hand-colored and sold to the public and thus were a form of popular art; the cult of the saints as intercessors was very strong at the end of the Middle Ages, and most of the 15th-century prints are of saints. The greater number, of course, have disappeared, and it is almost entirely by accident that these works have survived, some pasted into books, others pasted into the lids of small chests, and the like.

The earliest prints have what has been called a "loop" or "hairpin" style, which is close to the style of manuscript illumination of the years around 1400, the folds of drapery having a soft, fluid fall. An early print of the Death of the Virgin also shows this style and, like most early prints, has no shading lines, coloring being added later by water-color washes. In early Crucifixion prints the blood flowing from the side, feet, and hands was normally added in color after the print was made. Some of the prints were not colored, and these particularly reveal the strength of line of the early print makers. The lines are essentially unmodulated; as a result they give the same feeling of incisiveness and cleanness found in the early printed books.

All are relief prints and not intaglio prints. In relief printing the ground is cut away, leaving the lines at the original surface level, which is then inked and, in early examples, printed by applying a dauber, a pad, or a rubber to the back of the paper to make it pick up the ink. Such lines cannot be cut too thin or they will break off under pressure. Thus in early prints shading devices and the resultant spatial connotations were disregarded, and naturalistic settings were frequently omitted, so that an over-all sense of pattern is strong.

This can be observed in a print of about 1420, a *St. Dorothy* (Fig. 374) in the Munich Collection. The very popular story related to this saint of Cappadocia, a young lady of incomparable beauty and grace, concerns the taunts she suffered on the way to her martyrdom. One Theophilus threw back at her the words she had used to describe her vision of paradise, but just before her death, which took place in the dead of winter, a fair, barefooted child appeared, clothed in purple and bearing a golden basket filled with roses and apples. St. Dorothy sent this messenger to Theophilus to demonstrate the truth of her vision. The popularity of the saint produced a play of about 1340, the manuscript of which is still preserved in the Kremsmünster monastery, in Austria, and two printed versions

374. GERMAN. *St. Dorothy* (S. 1395) *c.* 1420. Woodcut, $10^5/_8 \times 7^1/_2''$.

375. NETHERLANDISH. *Virgin and Child* (S. 1108). *c.* 1430–40. Woodcut, $13^3/_4 \times 10^1/_8''$.

of her story appeared later, one by Ulrich Zel at Cologne, the other by Simon Koch at Magdeburg, each of these little leaflets having a printed woodcut frontispiece of the saint. The woodcut reinforces the story, with decorative, stylized trees in bloom behind the saint, whose heavier form shows an early change, within the still fluid, hairpin-loop drapery style, in the direction of the more sculpturesque style of the second quarter of the century.

The use of parallel lines to indicate shading was a comparatively late device and does not seem to appear much before the 1430s; this is seen in a *Virgin and Child* (Fig. 375), in Berlin, the standing Virgin shown in glory and surrounded by angels. The work comes from the Netherlands, as the lettering on the angular scrolls held by the surrounding angels testifies. The more elongated character of the Virgin and the angels reveals the general transformation that took place under the influence of Rogier van der Weyden, an influence of the greater artist upon the lesser.(It must be remembered that woodcuts were produced by relatively simple

craftsmen for a populace unable to afford painting.) Flemish style is seen here; the more delicate line is less thick than in the German woodcuts, giving evidence of higher skill in execution rather than a later date. The line, however, is unmodulated, and the draperies are indicated by what has been called the "pothook" style that had appeared in the 1418 Brussels *Virgin*. The style parallels the angular drapery in Flemish painting.

This early period also saw the development of the picture-book type known as the block book. Text and illustrations were cut from the same block, and printing was effected by means of rubbings taken from the surface of the block. One of the most popular was the *Biblia Pauperum*, the first block book edition of which was printed in Flanders about 1465. In it surrounded by inscriptions, New Testament scenes appear in the middle of an architectural frame, flanked by their Old Testament prefigurations and by explanatory texts. The work went through 11 editions in the 15th century, for it was very popular with the less literate clergy. An early German edition is known in which the text was filled in afterward, the original cutter of the block possibly fearing that he might make a slip in cutting the text, which, of course, would have ruined the complete block. This practice also characterized a number of other block books and is probably the basis of the replacement of the block text about 1480 with hand-set type, as in other books.

Most of the early block books are believed to have been of Netherlandish origin, as seems to be the case with the *Ars Moriendi*, which directly reflects Flemish style. This block book had its text on separate pages, and the illustrations appeared in both woodcut and engraved form, the engraved version being in the manner of Master E.S., though not by his hand. It is possible that the unknown woodcutter was the original designer of this work of about 1466. It was intended for spiritual edification, particularly for the dying, who in their last hour were enjoined to repent their sins and save their immortal souls from damnation by affirming their Christian faith, so that they would "die well." Eleven woodcuts present the dying man on his bed, surrounded by Christ (standing or on the Cross), saints, angels, the sins, and devils, the last holding inscriptions which tell of their defeat (Fig. 376).

376. NETHERLANDISH. Page from the block book *Ars Moriendi. c.* 1466. Woodcut, $8\frac{1}{2} \times 6\frac{1}{8}''$.

Other block books, such as the *Canticum Canticorum* (the Song of Songs, which was to the medieval era a parable of the Virgin that had provided painting the motif of the enclosed garden), first printed in 1466, were also very popular. The Apocalypse was another medieval favorite to appear (1430–40) in block-book form, as did the *Speculum Humanae Salvationis* (first edition about 1465), it too being religious in nature. The series of the Seven Planets is one of the few nonreligious block books. In Germany many of these were published by Albrecht Pfister at Bamberg; two editions in German and one in Latin of the *Biblia Pauperum* were issued by him.

Before the end of the century a variety of works had come from the European presses, including old religious favorites, the newer moralizing treatises, such as Sebastian Brant's *Narrenschiff (Ship of Fools)* of 1494, and Latin editions of the classics, such as the comedies of Terence. Other works were astrological prognostications, almanacs, fables, books on travel and husbandry—in short, books of all kinds.

Other types of single prints were produced, one of the most interesting being the dotted print (the term given to what is in reality a wood engraving), so-called because of the use of punches to create a pattern.

The print also had other uses, such as the "Neujahrswünsch," or New Year's card, which often had an inscription on a banner expressing New Year's wishes; one of the most charming of these bears the representation of the naked Christ Child playing with a bird; an open chest with slips of paper in it is seen on the ground. The theme exists today except that the child has lost its religious meanings, the classical figure of Father Time having driven out the Christian spirit.

In time the woodcut line was refined, as hand coloring became less frequent and shading lines were introduced. Perspective, which had been seen in the block books, appeared widely, and the woodcut gradually became a self-sufficient picture with settings, variations in tone, and variations in coloristic as well as textural effects. All this demanded greater skill on the part of the *Formschneider*, or woodcutter, who did the actual cutting, though an artist furnished the drawing. Toward the end of the century artists of greater ability than those of the early period were enlisted as designers for woodcuts, the most renowned being Albrecht Dürer, who occupies a special place in the history of the medium.

The iconography of these works produced during the 15th century was normally related to what was being done in miniature painting, rather than in panel painting. The iconographic model was commonly another book, a logical outgrowth from the earlier art of the handwritten book. This is particularly evident in such works as the *Legenda Aurea* and the *Vitae Patrum*. Single cuts, however, tended to follow the lead of the panel painters.

Occasionally artists can be connected with early works. One of the most interesting is the illustrator of Bishop Bernhard von Breydenbach's *Peregrinationes in Terram Sanctam*, published at Mainz in 1486 with woodcuts by the Utrecht artist Erhard Reuwich. Views of harbors seen by the artist, figures of "Saracens" in their native costume, Turks on horseback accompanying Genoese, and animals all appear in Breydenbach's book of his travels to the Holy Land. The most interesting revelation of the mind of artists of the era is seen in a page of animal illustrations (Fig. 377), where on the same page with animals Reuwick had seen appear animals, such as the unicorn from the bestiaries, that Reuwich believed in even though he had not seen them.

EARLY ENGRAVING

In contrast to the relief print produced by woodcuts, engraving developed the intaglio print, which is made from a metal plate on which the design is gouged out with a tool, the burin. The related dry point is drawn with a needle directly on the lead (later, copper) plate. In both processes the ink is held in the grooves of the plate. After all surface ink has been wiped from the plate, the dampened paper is forced down into the incised lines to pick up the ink. Dry point gives a less precise line, because the metal is not removed from the groove, as in engraving, but only displaced, forming a burr on the line edge, which also holds ink. Thus the dry-point line normally has one side sharp and the other irregular; soft, atmospheric effects are the result. Fewer prints can be made from dry-point plates, since the burr wears down very rapidly from the pressure of the press.

Another intaglio method is etching, in which the lines are scratched through a wax or enamel-like coat, called a ground, applied to the surface of the plate. When the plate prepared by this method is immersed in acid, the exposed metal is decomposed by chemical action. The depth of

377. ERHARD REUWICH. Animal page, from Bernhard von Breydenbach, *Peregrinationes in Terram Sanctam*, Mainz, 1486. Woodcut, $9^7/_8 \times 7^1/_2$" (page).

the line in the plate is determined by the length of time the plate is immersed in the acid. Deep etching produces strong, dark lines in the final print. Etching first appeared in the early 16th century and did not become a common medium for a century. Dry point was never widespread.

One is immediately struck by the essential difference between engraving and woodcut. The former requires that the spectator become aware of the actual execution. Engraving is an art form whose skill of execution and variety of lines and tones must be seen close up, unlike the woodcut, which depends for its basic visual effect upon viewing from a distance. The engraving, then, must be read in two ways, as an over-all design pattern, succession of forms, or ideas, and as a variegated, essentially scintillating surface of an aesthetic nature.

The origins of the intaglio print are even more difficult to trace than those of the woodcut. It was, of course, a logical outgrowth of two art forms, the engraved work of goldsmiths and other smiths on plates, armor, and enameled plaques, and the engraved brasses of tomb monuments and slabs, both of which have a long history prior to the 15th century. From the very beginning, because of its precision, the engraved print required more careful workmanship than the woodcut, for both its materials and its labor were more demanding and more expensive. Early engravings were generally not colored, though painted highlights are found in prints by Mair von Landshut; the practice may have led to the invention of the chiaroscuro woodcut.

Early engravings in many cases were in competition with manuscript illumination; they have been found pasted into books in the places normally reserved for illuminations. The small format of the early engravings may have been governed by their early use in manuscripts and for playing cards. The technology of the time could have produced large plates for the engraver, for it did so when maps and metal tomb slabs were made.

Though the earliest preserved wood block, the *Bois Protat*, is probably French, the earliest engravings seem to be German in origin, with Italian engravings slightly later and Netherlandish engravings appearing as late as about 1450. The engravers followed the same path of stylistic development as the painters. The earliest date for a German engraving is 1446, but the work of the Master of the Playing Cards is considered to be at least a decade earlier, as is proved by the style of his works.

First identified by Passavant, the Playing Card Master apparently worked in Switzerland or southern Germany, because he reproduced in one of his works the Alpine violet, a plant found only in the higher Alpine regions and unknown to other early engravers. (Recently an attempt has been made to link him with Gutenberg and Mainz.[2]) Max Lehrs attributed 106 engravings to him on the basis of his distinctive style, which uses shallow, irregular, oblique lines to create shading. A delicate, almost black snow effect is obtained by his use of the burin, probably a straight tool as opposed to the curved burin, later used everywhere in the north.

His earliest works are the playing cards that give him his name. They show a sensitive portrayal of nature, notwithstanding highly stylized backgrounds and plant forms. Skilled in the use of his medium, he rendered surfaces to produce a feeling of textural variety and a sense of light within the form and over the surface. The short, repeated line of the Master of the Playing Cards was used with great imagination, for example, in the *King of Wild Men* (Fig. 378). By variation

right: 378. MASTER OF THE PLAYING CARDS. *King of Wild Men* (L. 108). *c.* 1435–40. Engraving, $5\frac{1}{4} \times 3\frac{1}{2}''$.

300 THE FIFTEENTH CENTURY

in direction and spacing, the same short line renders the textures of the hat, the sleeves, the skin, the grass, and the rocks or mounds the figures stand on. The master was active from about 1435 to the late 1460s, as is evident from the Flémalle types that he employed for his figures and his somewhat plastic handling of formal elements.

Chronologically he was succeeded by the elder Israhel van Meckenem, also known as the Master of the Berlin Passion, whose art reveals a more ornamental character, possibly due to training as a goldsmith, a training attributed to many of the early engravers. It is known that he moved to Bocholt in the lower Rhine region from the village of Meckenheim, near Bonn, and worked between 1450 and 1465 in the lower Rhine region. Lehrs, in 1900, sorted out 115 engravings that seemed to be by a single hand, and Max Geisberg,[3] in 1903, published a revised list of Lehrs's catalogue, excluding only 16 from the list, 14 of which he attributed to the master's engraver-son, Israhel van Meckenem the Younger. The elder artist's method of working is close to that of the Master of the Playing Cards, though his forms are different. Since prints traveled readily from place to place, it may be that the similar technique of working the plate was acquired from the prints themselves.

MASTER E.S.

Another identifiable artist is known only by his initials, E.S. He was active in the upper Rhine between 1450 and the late 1460s, possibly even into the 1470s, and is best known for the engravings of the *Einsiedeln Madonna*,[4] on which his initials appear and which bear the date of 1466. Undoubtedly the work was commissioned in 1466 for the fifth centenary celebration of the miraculous dedication to the Virgin of the chapel built by St. Meinrad, patron and martyred saint of the famous Benedictine monastery of Einsiedeln in Switzerland, which was founded about 934. The engraving is an outstanding example of his mature style.

The large *Einsiedeln Madonna* (there are two smaller plates) shows the Virgin in her chapel (Fig. 379) flanked by angels and St. Benedict(?). Above, the Trinity is seen on a balcony, where God the Son sprinkles holy water in a

379. MASTER E.S. *Einsiedeln Madonna* (L. 81). 1466. Engraving, $8\frac{1}{4} \times 4\frac{7}{8}$".

consecratory act. An inscription on the arch of the chapel refers to the miraculous dedication, "Dis ist die engelwichi zu unser Lieben Frau zu den Einsiedeln, Ave gratia plena" ("This is the consecration of the angels to our Blessed Lady of Einsiedeln, Hail [Mary] full of grace"). The date and the initials of the artist flank the portal, and the papal arms are seen above, probably in reference to a papal indulgence of 1464 to pilgrims to the abbey.

The earlier style of Master E.S., seen in such a work as *Luxuria and the Fool* (Fig. 380), shows a close relation to the Playing Card style but is more precise and less pictorial. Master E.S. added variety to the earlier manner and a greater subtlety to his surfaces by a greater use of separate and distinct strokes, though some areas are in the Playing Card manner.

The *Madonna on the Crescent*, one of the 316 works attributed to him, shows a figure type

and concept of form still related to the Master of Flémalle. The possibility of a trip to the Netherlands is not to be ruled out, as can be seen from his engraving of the *Martyrdom of St. Erasmus*. A strong relationship exists between this and Bouts's works. Possibly there was an intermediary, for this is not a one-to-one relationship, the German engraving showing a more dramatic and active figure treatment.

Master E.S.'s *St. Christopher* is not radically changed in style from his early work, but he did introduce burin lines across the sky, which, with the strong use of line and greater shading, enhance pictorial effect. Iconographically the figures of sea nymphs or sirens that he included show a relationship to the early 15th-century work seen in the *St. Christopher* (Fig. 21) by the Broederlam "school." Master E.S. was conservative in his adoption of Flemish types, being interested in forms that by the 1460s were no longer fashionable in Flanders; thus, like German painters generally, he was several decades behind the times. However, the interest in natural form, architectural form, and textured surfaces became characteristic of the art of engraving, even though Master E.S. looked both backward and forward in his view of nature.

His *St. John the Baptist* (Fig. 381), in a desert setting, is placed at the center of a circular engraving surrounded by the four Evangelists, alternating with the four Fathers of the Church (Jerome, Augustine, Ambrose, and Gregory). The work may have been made as a paten design for a goldsmith, though there is no motif that refers to Communion. John the Baptist holds a book in one hand and points to the lamb with the other, in reference to the passage from John 1: 29. This engraving was popular, and details were copied from it by other engravers later. Another typical example of the engraver's trade is a sheet of scenes of the Passion in roundels, plus various saints. It was probably designed to be cut apart and pasted into a Book of Hours or a comparable service book for the laity.

The master's closeness to tradition is seen in his *Fantastic Alphabet*. Though the set is not the earliest of such forms, it is one of the finest. A grotesque combination of forms, it had its natural antecedents in the marginal penworks and drolleries of numerous earlier manuscripts, but his model was either the fantastic alphabet in Bergamo attributed to Giovannino de' Grassi or a closely related South German model. Israhel van Meckenem is known to have copied Master E.S. in his grotesque alphabet. The letters by Master E.S. adhere to the model and are chiefly secular, though some have a religious subject, such as the letter *D*, where a donor presented by an angel adores John the Baptist holding the lamb; the connecting elements that

below : 380. MASTER E.S. *Luxuria and the Fool* (L. 213). *c.* 1450–60. Engraving, $5^3/_4 \times 4^1/_2''$.

right : 381. MASTER E.S. *St. John the Baptist* (L. 149). *c.* 1460(?). Engraving, diameter $7^1/_8''$.

right: 382. MASTER E.S. Letter *G*, from the *Fantastic Alphabet* (L. 289). *c.* 1464. Engraving, 5 3/4 × 3 3/4".

below: 383. MARTIN SCHONGAUER. *Virgin and Child with a Parrot* (B. 29). *c.* 1465–70. Engraving (first state), 6 1/4 × 4 1/4".

fill in the outline of the letter have a wonderful fantasy.

In the fantastic letter *G* a not particularly veiled commentary deals with the licentious life of monks and nuns, with further allusions to their animality in the monkeys and dog on the left-hand stem of the letter (Fig. 382). The letter *N* carries this biting satire even further, for the monks wear fools' costumes. Not all the letters carry such comments; the letter *P*, which presents fighting men, is filled out at the angles with the wings of the birds hovering overhead, and the letter *T* combines animals and reptiles. The letter *X*, a combination of four musicians, is seemingly a criticism of the itinerant musician, who was generally regarded as a low, dissolute type.

Master E.S., who worked at least as late as 1467, had numerous imitators and copiers. Though it is doubtful that he had a school in the exact sense, it is very clear that he had a school in the general sense, for he was copied by many engravers.

MARTIN SCHONGAUER

Martin Schongauer forms a link between the early engravers, as represented by Master E.S., and the Renaissance ideals to be strikingly expressed by Albrecht Dürer. He had a tremendous influence on the artists of his day, in both engraving and painting, for he participated in the past and communicated to the future.

Schongauer's art as a painter has already been seen, the only certified work from his hand being the *Virgin of the Rose Bower* of 1473. All of Schongauer's 115 engravings are signed with his initials separated by a cross and crescent, which may have been designed from the family armorial device, according to some. Of course, not all works so signed are by Schongauer, who was much imitated. The form the device takes aids in dating Schongauer's engravings as early or late; the characteristic of the early works is an *M* with vertical lines, whereas the later

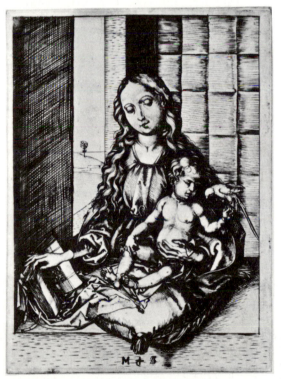

engravings show slanting lines in the letter. None of his engraved work is dated, and thus the time sequence is based on stylistic grounds.

Certainly Schongauer had traveled, the trip to Leipzig being known on documentary evidence and a trip to the Netherlands being assumed on iconographic and stylistic grounds.

In such a Bouts-like early work as the *Virgin and Child with a Parrot* (Fig. 383), possibly of 1465–70, it is evident that Schongauer was think-

ing in the painterly terms in which he had been trained. (This was not the case much later, when he so developed the medium that he shed the earlier and obvious dependence on painting.) Far more than Master E.S. his concepts were governed by painterly ideas, for he essayed textural variety more directly and consciously than the earlier master. He seemingly narrowed the window opening of his model, apparently feeling unprepared at this juncture to handle a full landscape. The use of the burin is already competent and is a forecast of his later complete mastery. In the art of his predecessors lines were both curved and straight, but Schongauer, more truly than any previous artist, used the burin strokes as modeling lines that follow the forms and reveal their shapes. Reflected lights are carefully and effectively used. In the *Virgin and Child with a Parrot* his general concept was ahead of his technique, for the burin work in the treatment of the background drapery is summarily presented. Schongauer had yet to realize that the engraving technique demands that areas be read aesthetically even when they are not strong factors in the over-all treatment. At this stage he treated the less important areas as merely filler, without interest except as over-all pattern. This was soon corrected in subsequent works, where the filling areas developed a refined life of their own, though of necessity a subordinate one.

Such a development can be seen in his early *Nativity* (Fig. 384), dependent upon a model by Rogier, which shows a background that is subordinate, yet full of exciting and varied passages to delight the eye without detracting from the main action. Organic relations are examined more perceptively. Perspective, as in the placing of the stones at the left of the Nativity, is an element of which the artist has become strongly aware. Textures are more masterfully presented than before, the artist even making distinctions between the coarse hair of the ox and the finer hair of the nearby Child, with refinement of technique and dexterity of handling. Clearly, he realized that the intaglio print is to be seen both close up and as a more distant whole; he also realized the aesthetic quality demanded by the medium in treating surfaces.

Also of the early period is the famous *Temptation of St. Anthony* (Fig. 385). Possibly suggested by the animal forms employed for the letter *T* from the *Fantastic Alphabet* by Master E.S.,

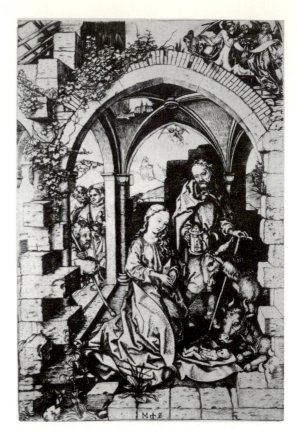

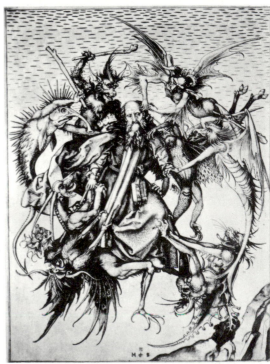

top: 384. MARTIN SCHONGAUER. *Nativity* (B. 4). *c.* 1470. Engraving, 10 1/8 × 6 3/4″.

above: 385. MARTIN SCHONGAUER. *Temptation of St. Anthony* (B. 47). *c.* 1470–75. Engraving, 12 1/4 × 9″.

the demons are presented as zoomorphic forms performing the acts of human beings, in contrast to the Gothic concept, seen so frequently on cathedral portals and in manuscripts, of the demon as a low, unruly human type equipped with claw feet, a tail, and occasionally bat wings. Even Schongauer's conception of the elevation of the saint was unusual, though sources for the motif can be found in the literature of the saint. In this work Schongauer approached a late Gothic baroque feeling. Here is the temptation as a *tentatio*, or trial in the physical sense. In a basically flat, circular composition animal and insect forms in fantastic combination surround the unperturbed saint. Scales, claws, rubbery snouts, spiny and hairy members make up these fantastic demons. They claw the saint, pull his scarf, elevate him into the air, yet have no effect upon St. Anthony, whose quiet figure, by its very quiet, enhances the violence of the encircling forms. These are superbly rendered by the artist, his technical facility achieving an unprecedented height. A wonderful variety characterizes these figures, with their thin, knobby arms, thick faces, thin, streaming or thick, bunchy hair in an incredible display of forms "spawned by the brain, not by the sea."

The *Flight into Egypt* (Fig. 386), of this period, was emulated later by Albrecht Dürer. The interesting tree form at the left and the palm bending down with angelic assistance to provide food for the Child and the weary family have been thought to be evidence for a southern trip by Schongauer; however, no motifs of a like nature can be found in other works to substantiate such a belief, nor is their naturalism outstanding. The tree at the left appears later in Bosch's art, undoubtedly taken from this engraving; Schongauer's own model could have been the staff of the *Buxheim St. Christopher* of 1423.

The *Death of the Virgin* (Fig. 387), with its interestingly detailed candelabra (a model for goldsmiths' work), presents a strong and dramatic perspective rendering of the scene, which has a parallel in design and emotion in Hugo van der Goes's treatment of the same theme of about 1480 (Fig. 194). There is another connection with Van der Goes in the figure at the extreme left, who gazes pensively off into space and forms a strong contrast to the other figures, almost all concerned with the Virgin. It is pos-

below: 386. MARTIN SCHONGAUER. *Flight into Egypt* (B. 7). *c.* 1470–75. Engraving, 10 × 7 ⁵/₈".

bottom: 387. MARTIN SCHONGAUER. *Death of the Virgin* (B. 33). *c.* 1470–75. Engraving (first state), 10 × 7 ⁵/₈".

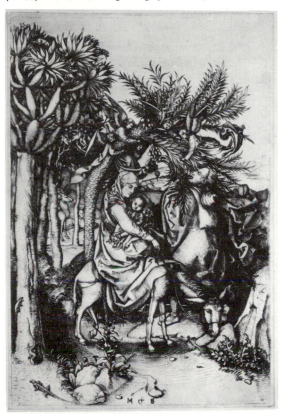

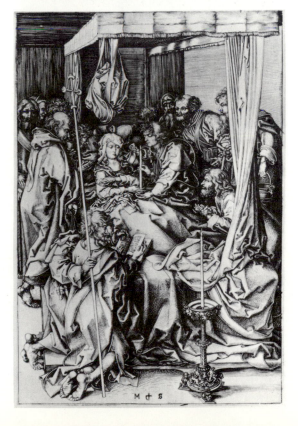

sible that Van der Goes took this idea from Schongauer, or both the painting and the engraving may have been derived from a common model; but there is a connection. Hugo too used the perspective placement of the Virgin but flattened it far more strongly than Schongauer; he also introduced the figure of Christ, a more medieval conception in this respect than Schongauer's, which omitted Christ.

A later stylistic phase is met in the large *Road to Calvary* (Fig. 388). Christ's figure is almost lost in the center, as the figures move parallel to the picture plane from the right, then turn into depth to move back toward the hill of Calvary in the left background. This larger figured composition, with a greater variety of types than before (not all handled successfully), is based on a model, a painting by Jan van Eyck known from a copy in Budapest. Here Schongauer attempted more and achieved more. The drama is augmented by a darkened sky over Golgotha on the left side, rendered with parallel lines, and by a completely blank sky on the right. The strong treatment of the hilly landscape on the left is counterbalanced by the lightly indicated hill forms on the right, with a delicacy and suggestive power that was not to meet its equal until the time of Rembrandt's *Hunter with Dogs*. Different types, different actions, different formal elements, and technical variety make this an outstanding work, whose quality was well recognized in its own time and later.

This later style, with its greater pictorialism and more dramatic content, appears in other works of this second mature phase. The *Archangel Gabriel* (Fig. 389), from a pair of engravings of the Annunciation, may or may not have had a Nativity as a centerpiece, but the two works can well stand alone. The magnificent fluidity and movement of drapery are carried further than in Schongauer's earlier treatment of the Annunciation on a single sheet. The angel holds a staff with a blank scroll about it, though normally one would find the "Ave [Maria] gratia plena" upon it. The movement of the scroll about the staff is echoed in the swirling of the garments about the gently curved, slightly genuflecting angel. The standing Virgin's pose and attitude are majestic, in keeping with Schongauer's new conception of the grandeur and dignity of the theme.

A clear, steady progress in the mastery of his medium and in the expression of a human concern and a constant increase in grandeur characterize Schongauer's work, so that in his delicate late style the tones are more even and the constrasts between "color" and form become less arbitrary. This creates the feeling of a soft tonal veil falling lightly over the whole scene, without turning the human drama of his scene into mere prettiness or sentiment. A stage on the way to the ultimate style is seen in a *St. Christopher*, engraved with the saint in three-quarter view and the Child frontally placed to look out at the spectator, thus regularizing the composition (Fig. 390). A beautifully rendered symbolic iris at the right establishes the *repoussoir* land form, and the eye is caught by the growing

388. MARTIN SCHONGAUER. *Road to Calvary* (B. 21). *c.* 1475. Engraving, 11 1/4 × 16 7/8".

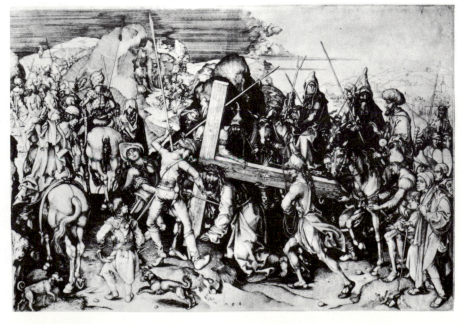

simplification yet increased subtlety and beauty of the detail. Water curls about the knobby legs of the saint as he moves, while the water between the spectator and the figure is slightly disturbed, as shown in varied light patterns created by horizontal strokes of the burin. Schongauer's equally unsentimental nude figure of St. Sebastian is treated not with the feeling of slight self-consciousness often seen in other northern treatments but like a personal and pensive Gothic lyric.

Even late in his career Schongauer was transforming works by his predecessors; his *St. John on Patmos* is a parallel to Master E.S.'s version, with a greater naturalism and an increased refinement in the handling of materials, textures, space, and atmosphere.

Twelve plates of the Passion were issued in a series by Schongauer. In the Christ before Pilate he transformed the violent action of a typically German conception of the previous generation, as in Multscher, into a quieter and more introspective drama. The same quality is also observable in the *Ecce Homo*, in which the ugly man on the stair is really allied to the figure of Christ by his movement rather than opposed to Him. Before the stairs a dog acts as a scale-setting device, and the background is flattened to emphasize the contrast between the shouting and the quiet figure. The *Crucifixion* from the Passion series, though restrained, suggests emotion in such subtle details as the rough wood of the cross arm and upright. The *Entombment* seems to have been inspired by the art of Bouts, though it is not an exact copy of Bouts's London En-

left: 389. MARTIN SCHONGAUER. *Archangel Gabriel,* left plate of an Annunciation (B. 1). *c.* 1480. Engraving, 6⅝ × 4⅝″.

center: 390. MARTIN SCHONGAUER. *St. Christopher* (B. 48). *c.* 1480. Engraving, 6¼ × 4⅜″.

right: 391. MARTIN SCHONGAUER. *St. Michael* (B. 58). *c.* 1480–91. Engraving, 6⅜ × 4½″.

tombment (Fig. 164), for Schongauer was never a slavish copyist. Unusual, however, for Schongauer is the strongly assymetrical Boutsian composition, in which figures are crowded and the horizontals and verticals are more emphatic.

The late style became more ethereal, the forms more elongated, more graceful, more beautiful, and more delicate. This is evident in the *St. Michael,* which shows the saint triumphing over a curling, contorted, lobster-clawed demon, who is a squirming mass of tentacles and tails (Fig. 391). A simplification is seen here despite the activity. The *Virgin and Child in a Courtyard* is another triumph of simplification, in which the white spaces seem to create an effect of inner reflection, meditation, and repose.

An ultimate refinement characterizes this last style. Delicacy of line effects an over-all tone in which neither the lights nor the darks are too strong. They create a predominance of a middle tone which seems coloristically richer than anything seen before in engraving. The *Noli me tangere,* the *Coronation of the Virgin,* and others have a unity that is reinforced and augmented by the delicacy of their execution and the profundity of their conception. Such consummate

below: 392. MARTIN SCHONGAUER. *Nativity* (B. 5).
c. 1480–91. Engraving, 6 1/4 × 6 1/8".

bottom: 393. MARTIN SCHONGAUER. *Censer* (B. 107).
c. 1480–91. Engraving, 11 3/8 × 8 3/8".

mastery had been forecast in the representation of the Foolish Virgin, which follows a series of the Five Wise and Five Foolish Virgins.

An epitome of the late style, very close to his last years, is the *Nativity* (Fig. 392), in a broader format than the early work. Less related to Rogier, more simplified, more delicate in its burin work, it has none of the variegated natural forms and the marked perspective of architectural forms. The youthful vigor of the earlier and painterly work influenced by Bouts has been supplanted by this ultimate refinement and sheer beauty of surface. The simplification of its organization, with diagonals to tie everything together, conveys in a much quieter and more delicate fashion a wonderfully controlled exuberance. Such fluidity of form and tone, nobility of feeling, and grandeur of spirit equal in engraving the late style of Rogier van der Weyden.

As the *Nativity* seems an epitome of Schongauer's religious works, so the *Censer* (Fig. 393) sums up his inventive craftsmanship. A work of unbelievable richness, subtlety, and complexity, it is for those very qualities also one of his most famous. Probably designed as a model for goldsmiths, its execution in metal obviously demanded a master in the craft with an astounding capability and broad vision. As complex and baroque on the printed paper as the sculptured pinnacles of the altarpieces of Pacher, Stoss, and Riemenschneider, it is, however, different. Despite its dynamism, it seems to assimilate the delicacy and profundity of Rogier's late style, to which Schongauer united a subtle refinement.

Schongauer's increasing mastery had been paralleled by a progress from a strongly painterly style, which in the *Temptation of St. Anthony* and stylistically related works bore the imprint of late Gothic emotionalism, to an expression less closely tied to atmospheric illusion, less violent in feeling, and more expressive of the inherent possibilities of his medium. His development led him to a profundity of human insight and a metallic brilliance of increasing refinement and subtle tone expressive of the distinct nature of engraving that can only be called classic.

NETHERLANDISH ENGRAVING

There were also Flemish artists in the engraving field, though curiously there seem to have

Plate 17. HIERONYMUS BOSCH. *Christ Carrying the Cross.* c. 1515. Panel. $30\frac{1}{4}'' \times 32\frac{7}{8}''$. Musée des Beaux-Arts, Ghent. (See p. 210.)

Plate 18. JEAN FOUQUET. Fall of Jericho, from Josephus, *Antiquités Judaïques*. *c.* 1470–75.
Illumination, 16 $\frac{7}{8}$ × 11 $\frac{13}{16}$″ (page). Bibliothèque Nationale, Paris (Ms. fr. 247, fol. 89). (See p. 220.)

Plate 19. MASTER OF RENÉ OF ANJOU. Amour gives the king's heart to Désir, *Livre du Cuer d'Amours Espris*.
c. 1457–65. Illumination, 11 ³/₈ × 8 ¹/₈″ (page).
Österreichische Nationalbibliothek, Vienna (Ms. 2597, fol. 2). (See p. 224 and Fig. 280.)

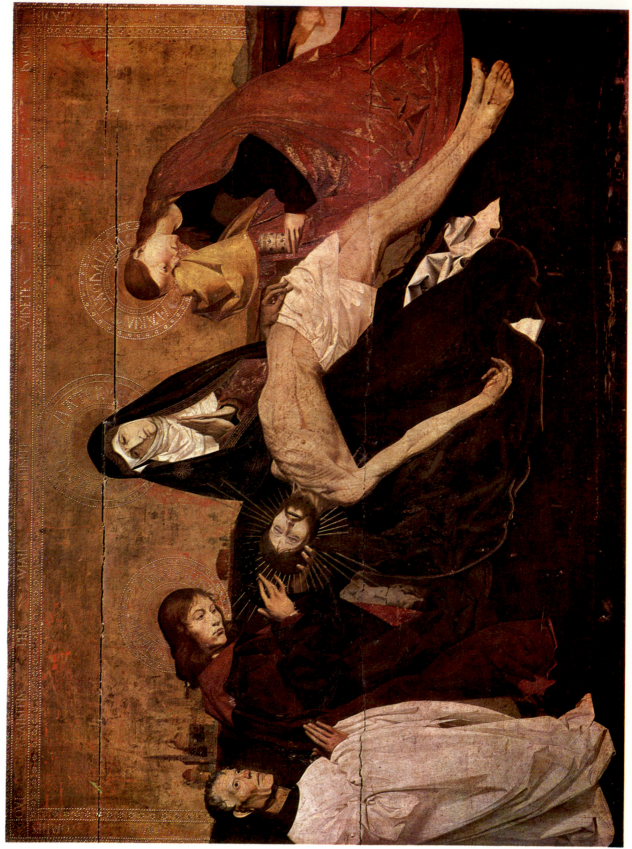

Plate 20. *Pietà* from Villeneuve-lès-Avignon. *c.* 1460. Panel, 63 ³/₄ × 85 ⁷/₈ . Louvre, Paris. (See p. 230.)

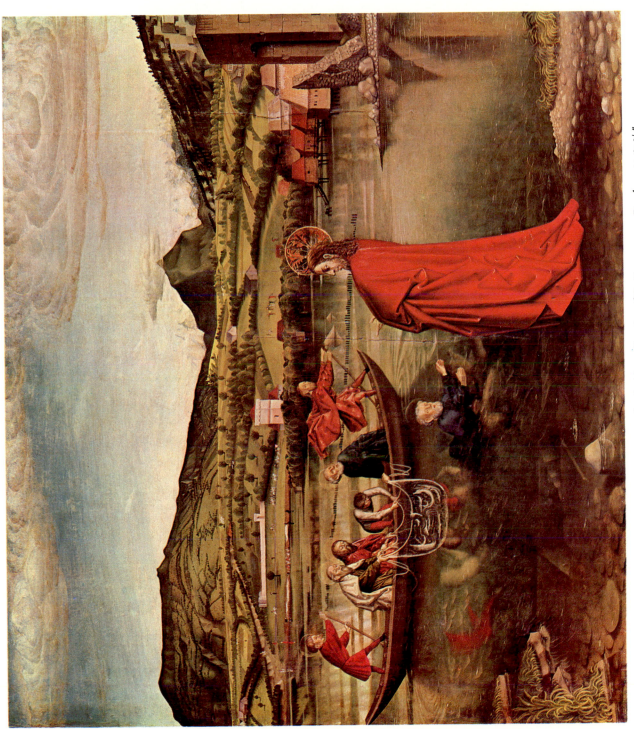

Plate 21. KONRAD WITZ. Miraculous Draft of Fishes, *Altarpiece of St. Peter.* 1444. Panel, 52 × 60 5/8″. Musée d'Art et d'Histoire, Geneva. (See p. 271 and Fig. 340.)

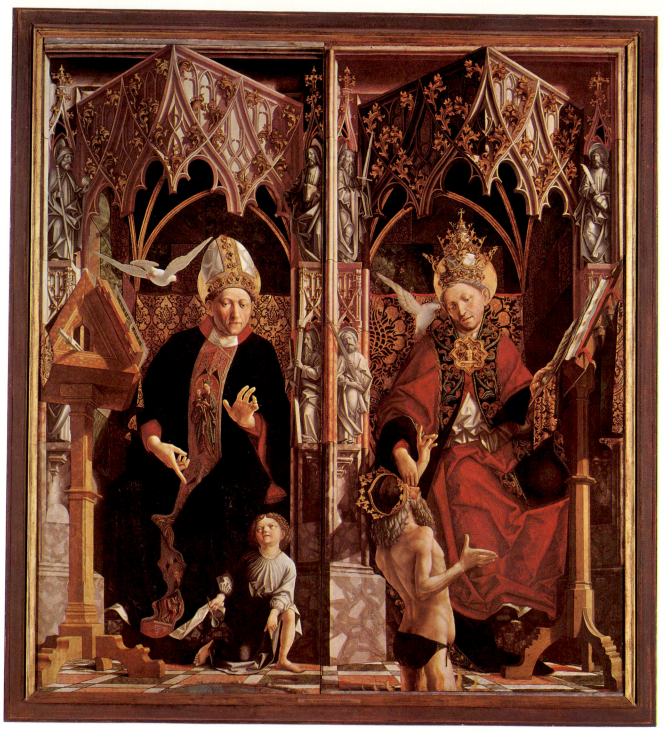

Plate 22. MICHAEL PACHER. *Altarpiece of the Church Fathers.* c. 1483.
Panel, c. 85 × 77 $^1/_8$″ (center), 81 $^1/_8$ × 36 $^5/_8$″ (each wing).
Alte Pinakothek, Munich. (See p. 286.)

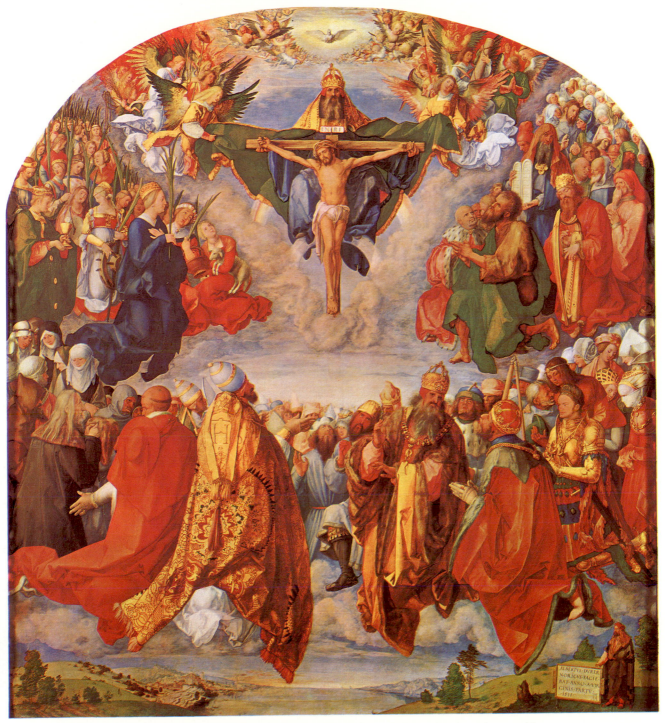

Plate 23. ALBRECHT DÜRER. *Adoration of the Trinity.* 1508–11. Panel, 53 ¹/₈ × 48 ⁵/₈″.
Kunsthistorisches Museum, Vienna. (See p. 346 and Fig. 450.)

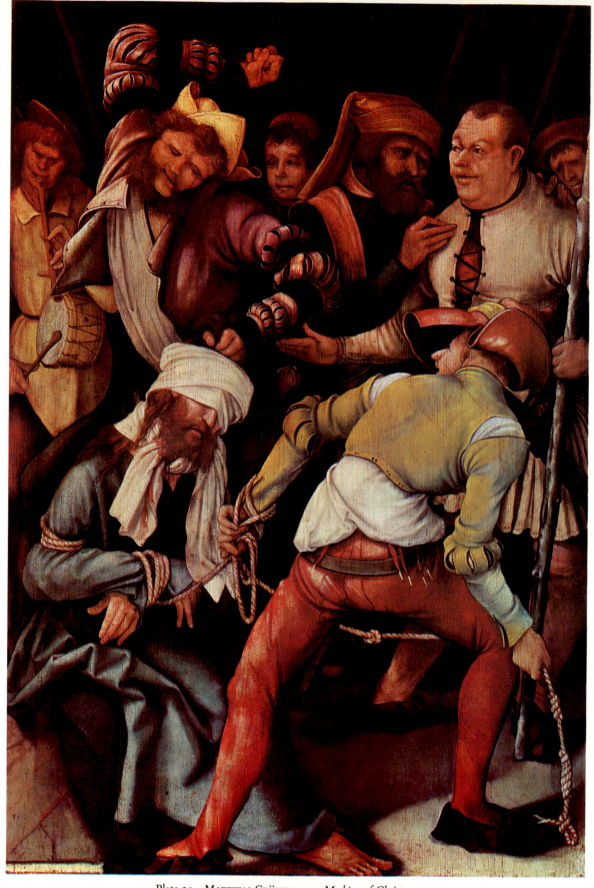

Plate 24. MATTHIAS GRÜNEWALD. *Mocking of Christ.* 1503.
Panel, *c.* 42 $\frac{7}{8}$ × 28 $\frac{7}{8}$″. Alte Pinakothek, Munich. (See p. 359.)

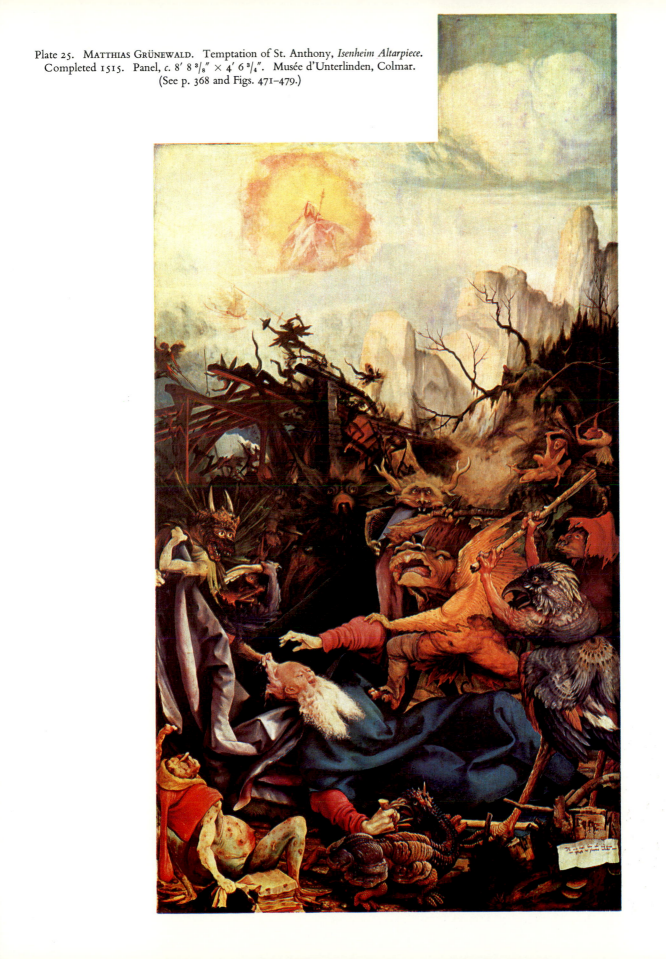

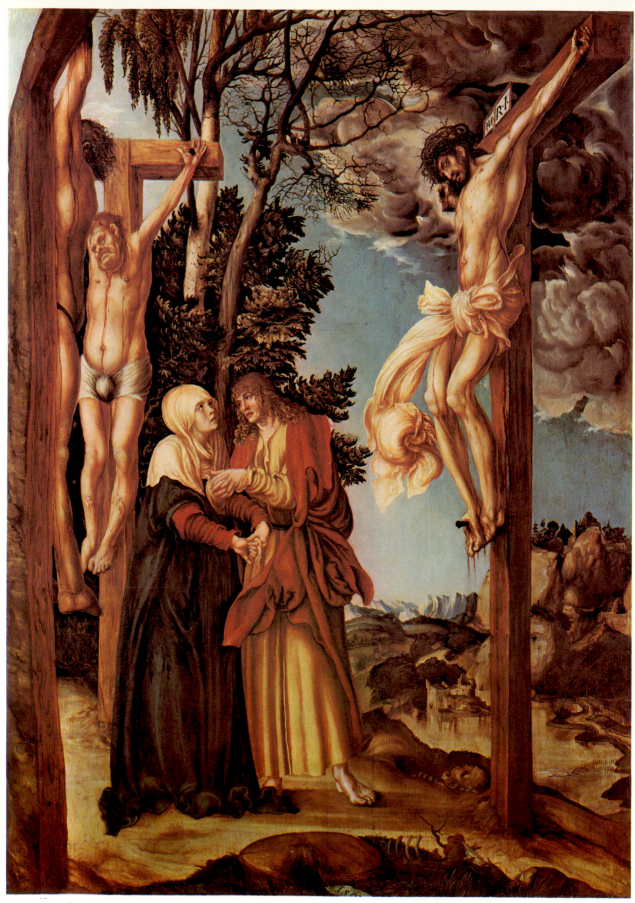

Plate 26. Lucas Cranach the Elder. *Crucifixion.* 1503. Panel, *c.* 54 ³/₈ × 42 ⁷/₈″.
Alte Pinakothek, Munich. (See p. 372.)

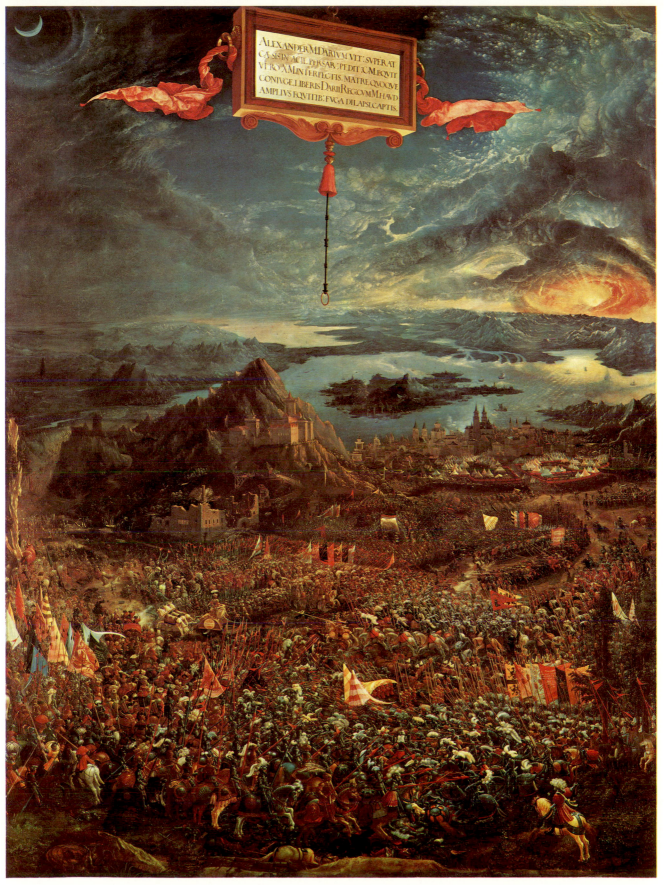

ALEXANDER·M·DARIVM·VLT:·SVPERAT
CÆSIS·IN·ACIE·PERSAR:·PEDIT:·C·M·EQVIT
VERO·X·M·INTERFECTIS·MATRE·QVOQVE
CONIVGE·LIBERIS·DARII·REGVM·M·HAVD
AMPLIVS·EQVITIB:·FVGA·DILAPSI·CAPTIS.

Plate 27. ALBRECHT ALTDORFER. *Battle of Alexander.* 1529. Panel, *c.* 52 $\frac{1}{4}$ × 47 $\frac{1}{4}$".
Alte Pinakothek, Munich. (See p. 386.)

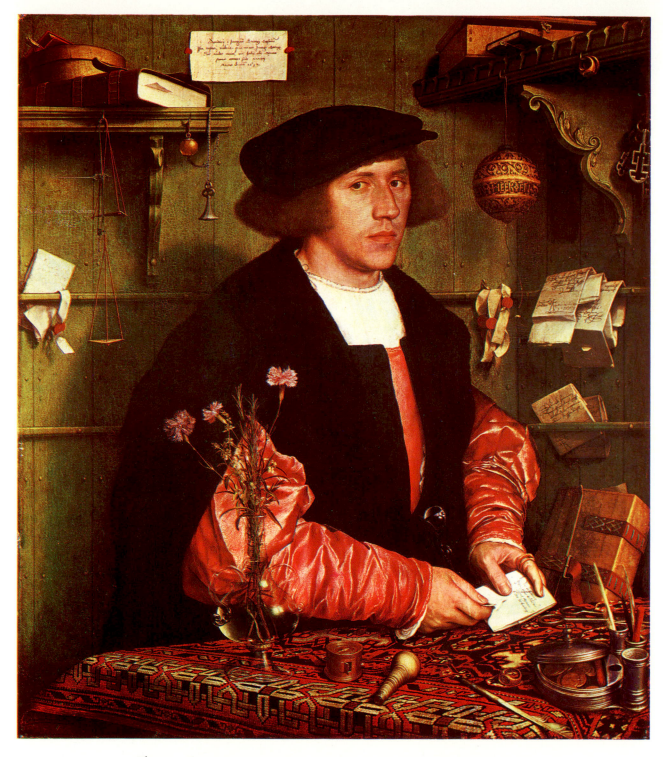

Plate 28. HANS HOLBEIN THE YOUNGER. *Georg Giesze.* 1532. Panel, 37 ³/₄ × 33″.
Gemäldegalerie, Staatliche Museen, Berlin-Dahlem. (See p. 413.)

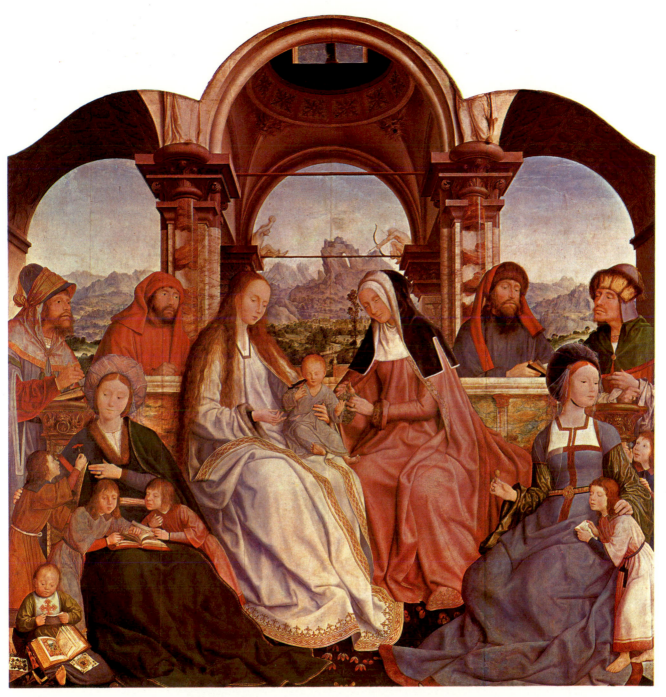

Plate 29. QUINTEN METSYS. *St. Anne Altarpiece.* 1507–09.
Panel, *c.* 88 $^3/_8$ × 86 $^1/_4''$ (center), 88 $^3/_8$ × 36 $^1/_4''$ (each wing).
Musées Royaux des Beaux-Arts, Brussels. (See p. 419 and Fig. 561.)

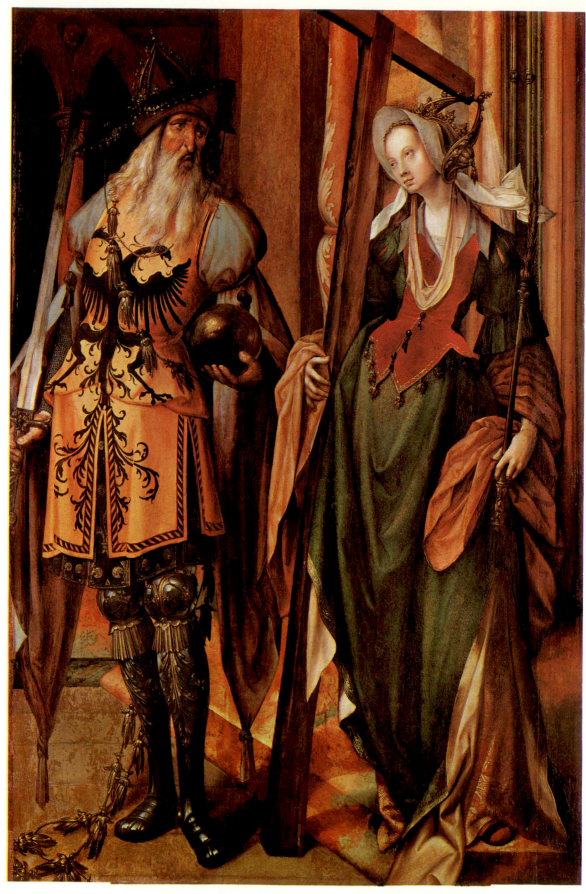

Plate 30. CORNELIS ENGELBRECHTSZ. *Constantine and St. Helena.* c. 1510–20.
Panel, 34 1/2 × 22 1/4″. Alte Pinakothek, Munich. (See p. 440.)

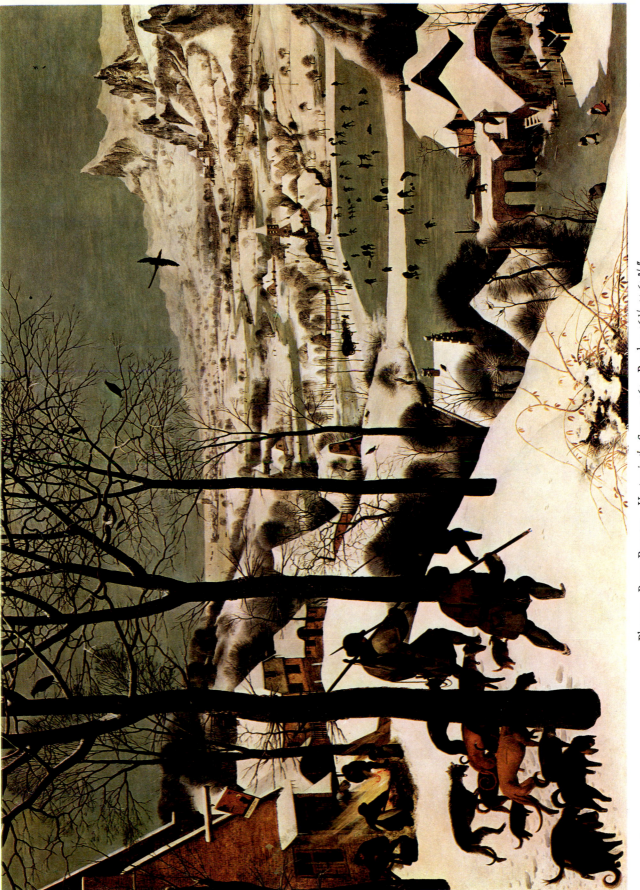

Plate 31. PIETER BRUEGEL. *Hunters in the Snow.* 1565. Panel, c. 46 1/8 × 63 3/4".
Kunsthistorisches Museum, Vienna. (See p. 480.)

Plate 32. PIETER BRUEGEL. *Magpie on the Gallows.* 1568.
Panel, c. 18 × 20". Hessisches Landesmuseum, Darmstadt. (See p. 484.)

right: 394. MASTER OF THE LOVE GARDEN. *The Love Garden* (L. 324). *c.* 1460–70(?). Engraving 8 ⅝ × 11 ″.

below: 395. MASTER W WITH THE KEY. *Tree of Jesse* (L. 1). *c.* 1475(?). Engraving, 16 ³⁄₈ × 11 ⅞″.

been no French engravers at this period. One of many followers of Master E.S. is the Netherlandish Master of the Love Garden, who takes his name from a work of that title (Fig. 394). The form of the garden was probably derived from representations of the Madonna in the Paradise Garden, which, with this, probably contributed to the theme of the Fountain of Youth so popular in the next century. The garden itself, despite its Biblical antecedent in the Song of Songs, may have been taken over from Arabic tales. Somewhat analogous are the bath scenes found in Flemish manuscripts of the third quarter of the century. The master's work is extremely complex visually, though the complexity is due more to inability than to artistic profundity. When he portrayed the love garden, with its young men and women in amorous dalliance, he essayed naturalistic representation under the influence of Master E.S., whose plant forms are strewn about the ground and whose trees have been multiplied in rather monotonous fashion. Not so able as his predecessor in the handling of figures, the Master of the Love Garden had difficulty in standing his young men on their feet.

Also attributed to him is a *Christ before Pilate*, in an interior setting. Derived from a Dutch miniature, which it copies closely, it demonstrates the frequent dependence of the print maker upon the miniaturist. The replacement of Pilate's wife looking in the window with a landscape outside the window and the omission of the sword of one of Jesus's guards are typical copyist's transformations. Such copying helps to explain the radical changes that occur from time to time in early engravings, such as the rather sudden acquisition of a well-thought-out perspective by lesser artists.

Master W with the Key, active between 1465 and 1485, is best known for his engraving of the *Tree of Jesse* (Fig. 395), which was copied by Gerard David in his Lyons painting. The date of the print corresponds to the period of Schongauer, as the modeling indicates. Movement is more fluid than in Schongauer's early style and

is more sophisticated in conception, though not so simplified nor so clarified as in Schongauer's later work. More painterly in its individual elements, the style is in keeping with Flemish developments of the period of the 1460s and is characteristic of the more painterly nature of Flemish engraving. Master FvB, possibly Frans van Brugge, working in the last quarter of the cen-

tury, shows, in such a work as his *Two Fighting Peasants*, an equally pictorial style, but it is harder and cruder than that of Master W with the Key. A greater angularity in gesture and in movement and drawing that is far less accomplished than the previous master's characterize his work. He was, nevertheless, a fine technician, with a strong interest in realistic aspects and a concept of perspective that he shared with his Flemish contemporaries. Fifty-nine engravings have been attributed to him.

Dutch engraving is best represented by Master I A M of Zwolle,[5] whose work also dates from the last quarter of the century. He has been identified with Jan van Mijnnesten, who became a citizen of Zwolle in 1462, was active about 1475 in Gouda and Delft, and died in Zwolle in 1504. Only 26 engravings have been attributed to him, many of which carry the name of "Zwoll," probably referring to the town of Zwolle, as the "Bosch" in the prints of Alart du Hameel probably refers to the town of 'sHertogenbosch (and not to the source of his engravings in the paintings of Hieronymus Bosch). Less painterly than Flemish engravers, Master I A M shows greater delicacy than his German contemporaries, and though his angularities and simple realism recall the art of Geertgen, his work has suggested the underlying hand of a sculptor, for there is a fine precision in the cleanness of his burin work (Fig. 396). As with so many of his peers, the strong influence of Flanders is visible in his draperies and compositional models. What is distinctly his own in his developed style is a feeling for tonalities in modeling and treatment of the setting; these are generally high in key and reminiscent of the soft atmosphere of the Dutch landscape.

LATER GERMAN ENGRAVING

One of the most prolific of all engravers of this period was Israhel van Meckenem the Younger,[6] born about 1450 in Bocholt. The eldest of three children, as is known from documents in the Bocholt archives of 1490 and 1494, he was a pupil of his father, from whom he learned the crafts of the goldsmith and the engraver. Sixteen of his early prints are copies of his father's engravings. After serving his apprenticeship with his father he may have entered

the shop of Master E.S., for he copied a large number of Master E.S.'s works and owned a number of his plates. He was in Cleves in 1465 and in Bamberg in 1470; in 1480 he returned to Bocholt, where he bought a house. In 1482 guild records mention him as a master, and, according to the records, between 1482 and 1489 he continued to practice as a goldsmith. In 1489 he was elected to the town council. He died November 10, 1503.

His production was the largest of any 15th-century engraver; no less than 624 individual plates came from his hand; some of these were copies of Master E.S., Schongauer, Master P.W., Master W.A., Master B x G, the Housebook Master, Wenzel von Olmütz, Dürer, and Holbein the Elder.

His style is clearly seen in the double portrait of himself and his wife Ida, of about 1490 (Fig. 397). That he was a master engraver rather than an artist in the modern sense of the term seems to be implied in his portrait; his trademark was his initials I V M, found in the strip left for inscription at the bottom, preceded by "figuracio facierum Israhelis et Ide eius uxoris" ("A picture of the countenances of Israhel and his wife Ida"). He seems a practical individual and rather shrewd (as does his wife), a master craftsman who did not hesitate to issue as many prints of a single plate as he felt could be sold,

396. MASTER I A M. *Last Supper* (L. 2; B. 2). *c.* 1480–90(?) Engraving, 13 5/8 × 10 1/2″.

for in certain cases over a hundred prints of single plates have been preserved. The double portrait is an interesting form in the north, with a possible borrowing of the idea from head-and-shoulders representations seen several generations earlier in paintings of Christ and the Virgin from the circle of the Master of Flémalle. The type is also found at this late date in South German double portraits.

Stylistically a sharpness of line and edge is characteristic of Israhel van Meckenem, who had a tendency toward sharp contrasts of light and dark, with little atmosphere, as a result of the almost steely character of his burin work. An excellent depiction of texture, however, and an awareness of light effects, as seen in the cast shadows, show a naturalistic approach executed with a high degree of competency. There is a strong interest in genre in his work, treated with a lively spirit, as is seen in the *Wife Beating Her Husband*, one of a series of scenes of daily life (!). The wife is urged on by a vociferous, curly-tailed demon, the whole characterizing Ira (Anger) and pointing the moral that such action is not *comme il faut*, obviously a warning to wives. Technically this too is highly proficient, but variety in lighting and form is rather restricted.

An interest in the dance for itself underlies Israhel van Meckenem's *Dance of Herodias*. The orchestra is shown in the center on a stand above the heads of the dancers, and the beheading of St. John and the feast of Herod, far in the background to left and right, are much subordinated to the theme of the dance. Space, perspective, and composition are well handled by the artist. Obviously the work was designed to appeal more for its representation of the pageantry of court life than for its religious message.

The theme of the dance was also treated by Master MZ (Mattäus Zasinger? Martin Zink?) in a *Dance at the Court of the Duke of Bavaria* (Fig. 398), of 1500. Though working into the 16th century and influenced by Dürer, his conceptions were closer to those of the 15th. Furthermore, he was less able than Van Meckenem in organizing space and form; his windows into space cut small, deep holes into the background. To organize the scene he tilted it, but its perspective articulation is as awkward as the inserted figures. This too is evidence of a change

top: 397. Israhel van Meckenem the Younger. *Portrait of the Artist and His Wife Ida* (B. 1). *c.* 1490. Engraving, $4\frac{7}{8} \times 6\frac{3}{4}''$.

above: 398. Master MZ. *Dance at the Court of the Duke of Bavaria.* 1500. Engraving, $8\frac{2}{3} \times 12\frac{1}{5}''$.

toward secularization, to which the engravers were quickly responsive.

Wenzel von Olmütz, active between 1481 and 1500 in Olmütz on the eastern border of Bohemia, where he was born, has had 91 plates attributed to him. Most of these are copies after other engravings and paintings; occasionally he introduced ornamental elements into his copies. Many of his works are dated, and some record now lost works by others. Where he copied Schongauer, the drapery lacks the incisive organization and presentation of crisp folds seen in the art of the master from Colmar, and his feeling for texture and form is much more limited than in other artists of this era.

THE HOUSEBOOK MASTER

The Housebook Master,[7] discussed previously as a painter, is far better known for the unusual character of his prints, many of which are dry points on lead, a medium that permitted the artist different linear and textural possibilities. He has also been called the Master of the Amsterdam Cabinet, because a large number of his unique prints are located in the print collection of the Rijksmuseum there. The "housebook" of about 1475 in the Waldburg-Wolfegg Collection is a book of 68 leaves from an original 98. It contains colored pen drawings of the planets, representations of everyday life, recipes, tables, implements, battle scenes, coats of arms, and

pieces of artillery. That the master himself was responsible for all the illustrations in this work is open to question, stylistic differences being evident (page 35a, for example, is markedly different from his panel pictures).

Courtly life in ideal form is seen on a number of the pages. The bathhouse occurs in several scenes in which youthful figures of both sexes are scattered about in pairs, charmingly presented with such pleasant enlivening notes as romping dogs and a richly dressed young minstrel sitting on a window sill strumming what can only be a love song on his lute (Fig. 399). Hunting scenes also appear, again peopled by youthful types, the young ladies following behind the gentlemen as they go out to the hunt on charmingly wooden horses who all lift their forelegs in much the same fashion. An atmospheric quality in these colored pen drawings is suggested by the artist's use of a line of variable stress. The individual forms are modeled essentially by the outline, with only a slight indication of tonal areas by washes or restricted crosshatching.

The planet pictures belong to a type of representation found earlier in manuscript illumination and in prints both north and south of the Alps. The personified figure of the planet is shown on horseback in the sky, flanked by the signs of the zodiac that the planet controls, while the varied activities of the planet's children appear below. Venus's children (Fig. 400) dis-

above: 399. HOUSEBOOK MASTER. Bathhouse scene, *Housebook*, pp. 18b, 19a. *c.* 1475. Colored pen drawing, 10 $\frac{7}{8}$ × 14 $\frac{3}{4}$″. Graf von Waldburg-Wolfegg Collection, Schloss Wolfegg, Germany.

left: 400. HOUSEBOOK MASTER. The planet Venus, *Housebook*, p. 15a. *c.* 1475. Colored pen drawing, 9 $\frac{1}{8}$ × 5 $\frac{5}{8}$″. Graf von Waldburg-Wolfegg Collection, Schloss Wolfegg, Germany.

right: 401. HOUSEBOOK MASTER. The planet Mercury, *Housebook*, p. 16a. *c.* 1475. Colored pen drawing, 9 $\frac{1}{4}$ × 5 $\frac{5}{8}$″. Graf von Waldburg-Wolfegg Collection, Schloss Wolfegg, Germany.

port themselves in a delightful manner. At the lower left a naked youth welcomes a pretty girl into his bathtub set in a leafy bower; in the background another boy tumbles a girl in the bushes; and to the right of the bathing scene young couples tread a stately round to a musical accompaniment played for all these twelve-year-olds by children half their age. Acrobats practice their skills in the background to the accompaniment of pipe and tabor.

Under the planet Mercury (Fig. 401) are found the arts. A sculptor in the foreground reaches over his work to accept a drink from a young lady as reward for his efforts. In the center the organ maker assembles an instrument. To his right a painter practices his trade, with a young feminine companion looking over his shoulder at the triptych of the Madonna on his easel. The schoolmaster, at center left, is also a child of Mercury and metes out punishment on the bare bottom of a culpable pupil, while other more industrious children pursue their studies. The zodiacal signs of Gemini and Virgo flank the personification of Mercury in the sky above. In the *Housebook* a detailed explanation of each planet and its powers appears on the facing page. (In Italian engravings the text was engraved below the scene.)

Coloristically employed, the line has weight and modulation—now light, now heavy, now continuous, now broken, it is full of exciting, surprising pictorial variety and accent at the service of a humorous conception. This humor of the master's drawings is met again in his prints, where dry point is frequently used. This medium is rare; Dürer employed it three times. After the Housebook Master it did not come into its own until Rembrandt. An airy, atmospheric, painterly feeling and humor characterize the master's output, much of which is secular in nature. As his work increased in sophistication, the use of light and dark was more adroit.

An early print in his career is the *Aristotle and Phyllis* (Fig. 402), in which the philosopher is ridden like a horse by his mistress. In the privacy of his garden they are discovered by two figures who look over the wall like a pair of elders from a typical scene of Susannah in her bath.[8] Such a secular work must have been produced for a small circle of sophisticated patrons; obviously it was not intended for sale to a widespread public, which would not have understood the

above: 402. HOUSEBOOK MASTER. *Aristotle and Phyllis* (L. 54). *c.* 1475–80. Dry point, diameter 6 1/8″. Rijksmuseum, Amsterdam.

below: 403. HOUSEBOOK MASTER. *Road to Calvary* (L. 13). *c.* 1480–90. Dry point. 5 1/16 × 7 1/8″. Rijksmuseum, Amsterdam.

"classical" story (which is actually medieval). The romping nude babies in the Housebook Master's work are also new subjects in northern art. His handling became more sure and sophisticated as time progressed.

Not all his works were secular. A scene of Christ collapsed under the weight of the Cross (Fig. 403) adds an enigmatic element to his art, for Christ looks toward a strange little hillock that is apparently intended to be a human head looking back at Christ (Golgotha?). The crowded composition of the middle ground contrasts with the more open space of the foreground to accentuate this interchange of glance. The moralizing theme of the young man and death, a thoroughly medieval conception that recurs in the master's middle style, reveals his frequent artistic device of contrast and confrontation.

This device underlies his dry point of the *Three Living and Three Dead Kings*. With characteristic dramatic movement he epitomized the idea of violent and sudden death. Here is an instance of that heightened spirit of the late 15th century which took such a strong and dramatic turn in painting and sculpture.

Living had become more intense and dramatic; it was expressed in art and life by change, volatility, and a heightening of emotions in the tenor of daily life. Punctuated by recurrences of the plague, the period of tension, contrast, and conflict affected the regions both north and south of the Alps. Savonarola, in Florence, and the bonfires of the vanities were southern parallels to the fervent spirit of the north.

The Housebook Master's late *Stag Hunt* presents figures involved with nature and participating in it, though his pictorialism continued to be expressed in line. Shading in large areas is not characteristic of his prints; he chose to shade only small areas and those always in relation to a form. In the *Stag Hunt* small stones are introduced into the landscape to provide shaded elements that animate a specific area. The master preferred this method to shading his areas with tonal washes.

below: 404. HOUSEBOOK MASTER. *Crucifixion* (L. 15). *c.* 1490. Dry point, 6 × 5 ¼″. Rijksmuseum Amsterdam.

right: 405. HOUSEBOOK MASTER. *Holy Family* (L. 28). *c.* 1490-92. Dry point, 5 ⅛ × 4 ½″. Rijksmuseum, Amsterdam.

One of his most impressive works is the late *Crucifixion* (Fig. 404). An extremely large figure of Christ hangs heavily on a cross made from rough-hewn tree trunks. A less strongly accentuated rough cross had been presented by Schongauer, but the motif itself is at least as early as the 10th century. A marked pictorialism is found in the head of Christ, and the dramatic tension of the hands and the stress on the arms at the joints has suggested to some that the Housebook Master was the young Grünewald. This is most unlikely, if not impossible, given the date of the master's earliest work and the character of his late paintings.

Another late work, seemingly the last of all, is the *Holy Family*, which shows Joseph playfully rolling apples toward the Child (Fig. 405). The figure types are different here, the Child in body form and pose seemingly suggested by classical art, Joseph almost a dwarf, and the Virgin a majestic figure. The earlier anecdotal quality is retained only in the treatment of Joseph. The apple, of course, symbolizes the instrument of Adam's fall and Christ's sacrifice. Despite the playfulness, there are overtones of a gravity little evident in the master's earlier work, and this is paralleled by a stylistic change toward a greater simplification, with shading used more pictorially than ever before, though it still clings to the edges of the forms.

In quality and originality and in variety and richness of tonal effect the Housebook Master's

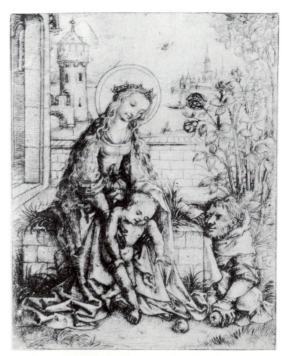

works stand out in the history of early prints. His coloristic quality, his basically painterly approach, and his humor set him apart as one of the leading creative spirits of the period.

MASTER L CZ, MAIR OF LANDSHUT, THE NUREMBERG CHRONICLE

The pictorialism of the Housebook Master, who seems to have had no close followers in the print field, is met in the works of other print makers of the end of the 15th century. Master L CZ, active in the 1490s, is now thought to have worked in and around Nuremberg.[9] Only 12 engravings have been attributed to him. In pictorial character his work approaches that of the Housebook Master, though it is evident that Master L CZ came to pictorialism via engraving rather than via painting. (An attempt to identify him with the Master of the Strache Altarpiece is not convincing.)

His *Temptation of Christ* (Fig. 406) is his best-known work. Presenting a monumentalized Christ, it has a simplicity and over-all grandeur that dominate the detailed rendering of drapery and hair as well as the grotesque complexity and wild confusion of the ugly form of the Devil. The highly developed landscape, naturalistically rendered and more forceful than in the work of Schongauer, from whom it seems to have derived some inspiration, exhibits massed trees, rocks, and other natural elements in a calculated relationship to the surroundings. This ability to relate his figures to nature has led some writers to postulate a Flemish origin for the master. The motif of the goat silhouetted against the sky, high on the cliff at the right, appealed to his younger contemporary Albrecht Dürer, who borrowed it for his *Fall of Man* engraving of 1504 (Fig. 441). He was probably drawn to Master L CZ by the forceful and direct burin work, the interest in light, and the rich tonality.

Nicolaus Mair of Landshut, in Bavaria, was also active at the end of the century, a number of his works bearing the date of 1499. His early prints are quite crude technically, though his later work is more proficient. Twenty-two engravings and three woodcuts have been attributed to him. His output is interesting because of his practice of printing on colored paper and of heightening some of the lines and highlights

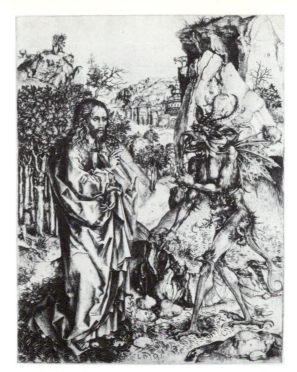

406. MASTER L CZ. *Temptation of Christ* (B. 1). c. 1490–1500. Engraving, $8\,^3/_4 \times 6\,^5/_8''$.

in color afterward. His *Samson and Delilah*, for example, shows his interest in perspective and in a general pictorialism. To create the latter he emphasized crosshatching, but his concomitant tendency to overemphasize line often flattened his forms. A *Nativity* (Fig. 407) expresses the same quality, its general pictorialism leading to a chiaroscuro effect. This effect was developed later in woodcuts with separate blocks for each color and one for the highlights. True chiaroscuro woodcuts, possibly the invention of Lucas Cranach the Elder, appeared before 1510. Mair's mixed technique was not carried further in engraving by other artists.

In book illustration the most remarkable enterprise was that of Wolgemut, who, with his stepson Wilhelm Pleydenwurff, interested himself in printing, undertook the production of two illustrated works, hired Anton Koberger to do the printing, made the woodcuts in his own shop, and thus became a leading entrepreneur. These two works are Stefan Fridolin's *Schatzbehalter*, a religious "treasury," and Hartmann Schedel's *Nuremberg Chronicle*, the former appearing in 1491, the latter in 1493. Work on the two publications probably began in the late 1480s, and Wolgemut had financial backing for them in a contract of December 29, 1491.

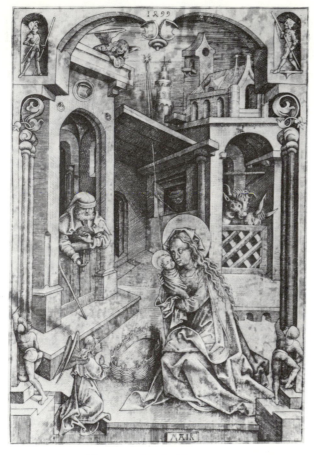

above: 407. MAIR VON LANDSHUT. *Nativity* (L. 5) 1499. Engraving 7 7/8 × 5 3/8".

below: 408. WOLGEMUT SHOP. Portugalia, *Nuremberg Chronicle*, p. 290. 1493. Woodcut, 9 1/8 × 9".

The *Nuremberg Chronicle*, a historical record of the world up to the time of publication, is one of the outstanding works of the 15th century, with 645 woodcuts used for a total of 1,809 impressions. Forty-four different woodcuts represented 270 kings, 28 papal portraits were used for 326 different individuals, important cities were represented on one or sometimes on two pages, lesser towns to a total of 69 were represented by 22 woodcuts, and three woodcuts of monasteries were used to illustrate 20 more. The *Schatzbehalter* generally shows a largeness of conception that differs from the anecdotal naturalism of earlier illustration. The *Nuremberg Chronicle*, published in German and Latin, is the outstanding work of 15th-century Nuremberg printing. The Portugalia scene (Fig. 408), from the *Chronicle*, reveals a new spirit in its landscape, a grasp of natural configuration, and a continuity of space which have caused some writers to consider this to be the work of the young Albrecht Dürer, previous to setting out on his travels at Eastertime, 1490. The scene is conceived as if the spectator were on an eminence looking down across a valley to hills rising up behind. Shading is used for pictorial effect—never easy in the woodcut medium—and there is an unprecedented modernity and mastery of conceptual unity. Its effect is certainly to be seen in the work of Nuremberg's greatest genius, Albrecht Dürer.

Thus, at the close of the 15th century an artistically awakened Germany, impelled by the new arts of printing and engraving, was preparing for the great, though short, period of high artistic genius to follow. The meeting of the two great 15th-century movements, from Flanders on the north and west and from Italy on the south, had already produced a violent reaction in German painting. Though the reaction was part of a widespread trans-European movement, provincial Germany had felt its force most of all, for the local basis was least firm. Transforming Rogier's subtle Gothic rhythms into violently plastic movements, German painting was ready at the end of the century for the leadership of a Joshua and a Moses rolled into one. And as the times produced the man in the sphere of religion, so they did in art, but they were profligate, for both a Moses and a Joshua appeared, in the persons of Albrecht Dürer and Grünewald, whose art, so different one from the other, lighted the way at the beginning of the 16th century.

THE SIXTEENTH CENTURY:
Confrontation and Conflict

In all the spheres of human activity the 16th century was very different from its predecessors. The tides of nationalism produced separate powerful states that were internally dissimilar. The greatest in extent, the supranational Hapsburg empire, had achieved its position through fortunate marriages but was to maintain it only with difficulty, for the empire was too much for one individual to rule effectively. France had reabsorbed the provinces that feudal politics had allowed to become independent, and though it continued to interfere in Italy, still a congeries of city and papal states, France was on the road to a political entity with a distinct national image. A standing army had been voted as early as 1439, and the French bureaucracy established was so efficient that the monarch could meddle in Italian politics after 1494. The wars of the first quarter of the century in Italy led in time to the principle of the balance of power in Europe, in which the independence and security of a state within the system depended on common action against any state that tended to become too powerful.

With the decline of the international authority of the Church, the European states made agreements among themselves regarding territorial expansion. Corresponding to the growth of the national states was the increasing decentralization of ecclesiastical organization. A prime example is the Concordat of Bologna (1516) between Francis I of France and Pope Leo X, by which the monarch received the right to nominate his candidates to the highest French ecclesiastical positions. Nomination in effect meant election and thereby ensured monarchical control of the Church on French soil; this concordat was possibly the prime reason that France did not become Protestant. Spain was already in complete control of its ecclesiastical structure. In Italy, on one hand, and in Germany, on the other, papal power was strong, for the prince-bishops in the latter country had a long history of ecclesiastical control of government. The outbreak of the Reformation in Germany, after 1517, thus took place where papal power—and papal exactions—were strongest. The break came, it seems, not because of the indulgence controversy but because the strains on European religious belief were greater than any cohesiveness that remained in the declining and still medieval Church. Ruptures had appeared earlier, as in Bohemia fifty years before. The Reformation was another such; it became permanent partly because of the transformation of the papacy under Julius II into a strong temporal power that, in effect, had become the Italian national state.

The change occasioned by the Reformation reflected not merely resistance to ecclesiastical abuses but also the conflicts in life and thought that arose when increasingly compartmentalized areas of knowledge and creative activity encountered the concept of universality. An ultimate harmony of all knowledge and the unity of truth were still concepts of importance, for in this age of transition order and disorder went hand in hand. The possibility of the reconciliation of opposites was recognized and desired. Individualism had allowed men a glimpse of the possibilities of control of their social, intellectual, and physical environment. The dynamic society and thought of the period had either to go forward or fall back into a medieval pessimism. Inasmuch as the Humanists firmly believed in the power of knowledge to increase virtue, and thereby enhance one's piety, pessimism was contrary to their intellectual atmosphere.

The individualism of the age produced a growing consciousness of the importance of the ruler. It resulted in moral exhortations to him, such as that in the younger Holbein's portrait in Washington of *Edward VI as a Child* (see Chap. 25). Similar exhortations appear in the writings of Philippe de Commines, Erasmus, Thomas More, and especially Machiavelli. The last turned from the Humanistic Erasmian hope for the power of a properly educated, right-thinking, ethical, idealistic, virtuous Christian prince to a more realistic concept of political morality, which he identified with those actions taken in the interests of a particular state—in his case, Florence. Machiavelli and More both recognized the possibility of the arbitrary use of power unchecked by any Christian tradition and sought their answer in the concept of the ancient city-state.

Neither realist nor idealist was to discern the path of the future. Although the Italian and Netherlandish towns continued to be centers of commerce and culture and the Hanseatic League lived on, the governmental framework was not to take the form of the city-state either singly or in leagues. Instead, the future was to reinforce the position of the ruler and culminate in the concept of absolute monarchy, with one marked exception, the Netherlands.

The Netherlands became increasingly discontented with monarchical economic policies, and there was a gradual shift of economic power to the northern Netherlands during the 16th century. Economic disruptions led to revolts in the towns. Another factor was the Reformation, which, in time supported by the nobility, spread in reaction to the ultra-Catholic policies of Philip II, who came to the throne when his father, Charles V, abdicated in 1555. The nobles became increasingly powerful after Philip moved to Spain in 1558. A decade later popular and aristocratic opposition united against Philip's harsh measures; two decades later the revolt had become an irreparable breach that led by the next century to the establishment of Holland as an independent state. Nowhere else in Europe was the course of monarchy so strongly opposed.

During the 16th century commerce continued to expand, aided by the voyages of discovery and by gold from the New World, for Europe's

gold supply, despite renewed mining activity, was being drained off by the luxury trade with the East. Prices rose faster than wages in the 16th century, and capital accumulated in the hands of the great banking families, so much so that the election in 1530 of Charles V as Holy Roman Emperor was accomplished by bribing the German electors with vast sums of money advanced by the Fugger banking family. Economic power was still subject to political power, but during the century the royal houses of Spain and Portugal enriched themselves by retaining a portion of the lucrative overseas trade. Bruges had rivaled Venice in the 15th century, but Antwerp surpassed it in the 16th century. Everywhere the scope of commercial activity enlarged with the new possibilities of trade.

The activities of men were becoming important subjects in themselves, and were reflected in art in the development of the genres, of which landscape painting was one. Thus Herri met de Bles could paint a landscape in which the various aspects of mining were represented, and Pieter Bruegel could make the activities of building and shipping a subordinate but exciting aspect of his painting of the Tower of Babel.

Humanism as a movement had begun to penetrate the north in the late 15th century. By the 16th century it was fully established in the schools, publishing houses, and courts. The Humanistic goal of reconstructing the present to revitalize Christianity by uniting it with the virtues of antiquity appeared as a potent force with the writings of Erasmus. The 16th century re-emphasized the microcosm as a reflection of the macrocosm, the single element as a reflection of the whole of divine order.

The artistic heritage of the previous century was replaced for some by a new sense of a cultural community in which the artist, in his investigation of the antique, also became a scholar, an intellectual seeker after truth—and didactic. Artists may have been inspired by the methods of Humanistic scholarship, which seemed to convey to its adherents a new vividness and a heightened reality.

The categorizing of life and thought reinforced modal concepts under the impetus of a new movement that exerted equal force on both sides of the Alps. This was Mannerism, another international style, which in the course of the century became identified with the cultivated elegance of the courts. The movement furthered the spread of the conception of the artist as intellectual, scholar, and creator, an individual whose spiritual qualities had been elevated by Neoplatonic belief to the highest human plane. The native expressions of Mannerism began to appear in the Netherlands as early as the first decade and in Germany by the middle of the second decade.

In Germany the first third of the 16th century produced some of the greatest artists in its history—Dürer, Grünewald, Cranach, Altdorfer, Hans Holbein the Younger—and a whole host of artists of second rank. German painting and sculpture of the 15th century had absorbed Flemish realism and, to a lesser degree, Italian Humanism. Fed by the dynamic emotionalism of its late Gothic style, German art of the 16th century rapidly developed two main streams: an idealizing art oriented toward Italy and the classic, led by Dürer, whose artistic hand fell on almost every shoulder; and a native continuation epitomized by the art of Grünewald, which only superficially accepted Renaissance innovations. Grünewald in his late work transformed them into emotively charged, superhuman Christian ideals. Both streams in time led to Mannerism. Before that, however, they expressed a spiritual movement whose parallel in fervor is the Reformation. What unleashed this force can only be guessed at; what its results were clear to see: a vital, emotive, expansive artistic expression that had a quick flowering, a manneristic sequel, and extinction. With the Peasants' Revolt in the middle 1520s and the subsequent internal wars, art in Germany, to all intents and purposes, ended.

Even during its period of richest outpourings, the first three decades of the century, German art was still regional, its greatest regional expression being the landscape manner of the Danube School. The chief centers of artistic endeavor were the prosperous South German city republics, such as Nuremberg and Augsburg. Other centers, such as Ulm, Regensburg, Wittenburg, and Freiburg, welcomed painters, who were hired by the bishops or by enlightened courts. German unity is thus to be found chiefly in the dynamic impulses, intense convictions, and creative zeal of its artists. This spirit informed the art of Germany and gave it a separate and distinct identity.

In the Netherlands the crisis that had been anticipated by Van der Goes broke about the head of the traditional Netherlandish artist, whose ways of thought were still strongly allied to the past of pictorial naturalism. Then appeared a late Gothic flamboyant style, mingled with Renaissance ornament. Its center was Antwerp, where the artists searched their past to rediscover a monumental ideal in the art of Jan van Eyck, and turned as well to the ideals of Italy and antiquity. The concept of the past as having a separate history led to Romanism in art, that is, a direct contact with Italian art and its heritage. The cult of the personality rose higher; first Raphael, then Michelangelo became the model, as in Italy. Not all artists followed this course, for the northern spirit was still strong; but those who did not adapted themselves by developing the new manners of the fantastic, genre, the portrait, and landscape, in a new empiricism which was occasionally penetrated by the monumentalized ideal and Manneristic aspects. Painting on canvas became more frequent during the century for traditional themes as well as the newer genres. The variety of the age reached its highest expression in the reassertion of the old constants of Netherlandish art by Pieter Bruegel. His concept of man and of pantheistic nature was a summation of the past and prepared the way for the recrudescence of the northern spirit in the period to follow.

ALBRECHT DÜRER

ALBRECHT DÜRER, PAINTER, PRINT MAKER, AND theoretician, was the first self-conscious northern artist to leave clear records of his conception of art as more than craft, and the first to conceive of himself as innovator and reformer. Awareness of his artistic mission united to artistic genius made him the first great personality of German art in the 16th century.[1] Born in Nuremberg on May 21, 1471, he was the second son of Albrecht Dürer the Elder, a goldsmith from Hungary who had come by way of the Netherlands to Nuremberg in 1455.[2] There he married and raised his family, training his son Albrecht until he was old enough to be apprenticed in 1486 to Michael Wolgemut. Even before his apprenticeship young Dürer had an awareness that is visible in his *Self-portrait* (Fig. 409), made at the age of thirteen, now in the Albertina Collection in Vienna. With all the character of a late Gothic drawing and with a fine handling of texture and materials, its clarity and objectivity of vision make it an astonishing performance, despite the woodenness of the eyes, which were drawn in afterward, with a sideward gaze instead of the frontal aspect that would have resulted from using a mirror. Truly this is the work of a child prodigy. There are few in the history of art, for artistic mastery has to await the growth of artistic vision, which seldom comes early. A sense of maturity is already apparent, though the wiry sharpness of the silverpoint line inevitably reflects the style learned from his father.

Dürer recorded that he learned much in Wolgemut's shop, though his fellow apprentices were hard on him. At Eastertime, 1490, he began his wander years. Where he went before he returned to Nuremberg four years later is known only partially. He was in Basel in 1492 and early in 1493, but he must have been in the Netherlands earlier. He had intended to work under Schongauer, but when he came down the

409. ALBRECHT DÜRER. *Self-portrait.* 1484. Silverpoint, 10 ⁷/₈ × 7 ³/₄″. Albertina, Vienna.

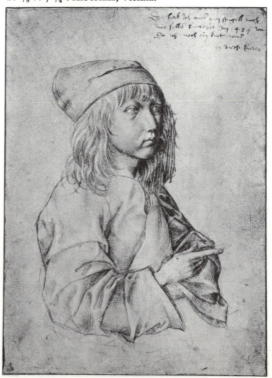

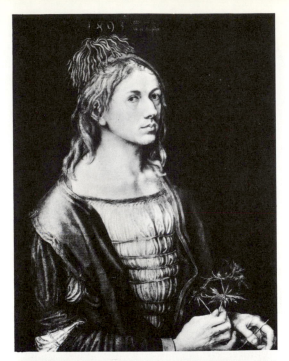

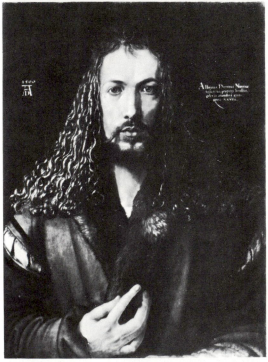

left: 410. ALBRECHT DÜRER. *Self-portrait*. 1493. Parchment on linen, 22 ¼ × 17 ½″. Louvre, Paris.

below: 411. ALBRECHT DÜRER. *Self-portrait*. 1500. Panel, 25 ⅝ × 18 ⅞″. Alte Pinakothek, Munich.

hand with elongated Gothic fingers laid against the side of his head. Not so linear as the earlier drawing, more pictorial in using shading by means of hatching and in the simple indication of mere outline for the cap, shoulders, and sleeve, it is a fragment from a pictorial whole, with the emphasis placed on what the artist considered essential: the facial expression, the problem stated in the eyes of a reflective individual who examines himself, the character of his art and his world. The same spirit is seen in a work of a year later, again a self-portrait, in the Lehman Collection, New York, part of a sheet of studies that includes a hand and a pillow in addition to the frank and still questioning gaze. Learning, investigating, thinking—these are the bases for this still sharp, still clear, but now more incisive portrayal.

Of the same year is his painted *Self-portrait* in Paris (Fig. 410), again looking at the spectator and again with a questioning in the eyes. He holds a flower in his hand, an indication of his coming wedding, for his father had called him back to Nuremberg to an arranged wedding. The form is presented with an increased monumentality, looming toward the spectator with a greater sense of sculpturesque bulk than before. The insistence on direct contact between figure and spectator is made more direct by such naturalistic detail as the hands holding the eryngium flower.

In the Prado *Self-portrait* of 1498 several influences appear, the view out of the window behind the figure suggesting the Flemish corner portrait, but the closeness to the picture plane and the parapet on which the arm creates a horizontal note are suggestive of Italy. Horizontals and verticals are stressed to assert a quiet, rational control over the interesting details of costume and figure. Here Dürer has monumentalized the portrait; Flemish light, color, and detail are united to Italian solidity of form.

A culminating point in this early development is seen in the Munich *Self-portrait* of 1500 (Fig. 411), hieratical and rigidly frontal according to a *theoretical* schema, with a solemnity of portrayal that is astounding. In its hieratical

Rhine to Colmar early in 1492, Schongauer had been dead almost a year, and his brothers sent the young artist on to another brother in Basel.

The introspection implied in the youthful silverpoint appears again in a drawing of about 1492 that must have been made in Basel, now in the Erlangen University Library. It shows the young Dürer looking out at the spectator, his

quality it is medieval, but it is also modern, for no other artist had presented himself in this manner, which, as Panofsky has suggested, is like a portrayal of Christ, the hand lacking only an orb. Like a Salvator Mundi, Dürer viewed art as a matter of genius, as something from the hand of a creator. To medieval man the artist merely revealed what God had created, but the modern Italian conception of art elevated, as in Leonardo's writings, the artist to this exalted position held previously only by God. Thus the artist now had a mystical identification and quasi equality with God, in whose form he had been created. To a northerner like Dürer a religious significance was allied to the concept of genius. No longer simply the honest craftsman holding an example of his work nor disguised as St. Luke painting the Virgin, the artist has assumed the semblance of the Creator whose hand gives life to previously nonexisting form, and so Dürer gave prominence to the curled hand. With such a characterization of the artist the medieval world has been left behind, and the new Humanistic world of the Renaissance has appeared north of the Alps.

This emphasis upon the creative individual is responsible for the great number of drawings, letters, and other writings by Dürer. Dürer had

412. ALBRECHT DÜRER. *Holy Family in a Landscape. c.* 1491–92. Pen drawing, 11 3/8 × 8 3/8″. Kupferstichkabinett, Staatliche Museen, Berlin-Dahlem.

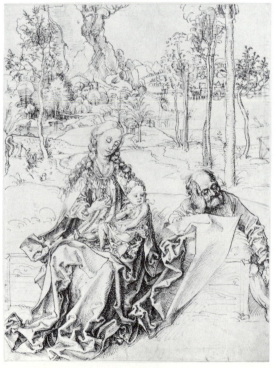

a concept of posterity and of the position of the artist who leaves behind the record of his creative acts; thus he later signed and dated his earlier drawings. This awareness of the artist's place, his mission, and his responsibility is visible in the art of Albrecht Dürer. The way was now open to new and different conceptions of art, to new aesthetic elements, and to the establishment of rule and order in art as there is rule and order in creation itself. Even supreme knowledge is open to the human creator and, indeed, becomes necessary to him, for the artist has to become aware of everything, has to study and learn not merely the external appearance of things but their internal order and structure.

With the 1500 *Self-portrait* the artist as the subject of the painting ceased in Dürer's art; though he represented himself in drawings and paintings later, he never again presented himself in this manner. His theoretical basis having been resolved, it no longer needed assertion, and he turned again to the basic elements of his art, which had been an early concern. His drawing of a hunt of 1489, in the Kunsthalle, Bremen, signed and dated, is reminiscent of the work of the Housebook Master, as seen in the action of the horses, in the rendering of figures in space, and in the pictorial movement. A strong influence of the Housebook Master also appears in the drawing of a *Young Couple Taking a Walk*, in the Hamburg Kunsthalle, though Schongauer's influence as well is evident in the drapery movements.

Dürer's pictorialism was different from that of Wolgemut's shop, where Flemish style was converted into patterned, silhouetted, and flattened compositions. Dürer thought in terms of rounder forms, as in his drawing in Berlin of the *Holy Family in a Landscape* (Fig. 412), where a relationship to the Housebook Master's Joseph rolling apples is seen in the sleeping Joseph. However, the Madonna and Child are Netherlandish in style and far more monumentalized, and the drapery is extremely rich in variety. Furthermore, the trees stepping back into space to the massed trees at the back of the middle ground demonstrate a close parallel to Geertgen tot Sint Jan's background in the Berlin *St. John the Baptist* (Pl. 14, facing p. 165). Even the pond and the tree forms are derived from either this work or one extremely close to it; though

Dürer added a low wall at the left, the derivation is still clear. Thus there is artistic evidence for a trip to the Netherlands during the four years that he was away from Nuremberg.

Two years may have been spent in the Netherlands before he went to Colmar in 1492. Sent on to Basel, he soon found work, it is evident, for he made the woodcut frontispiece of St. Jerome and his lion for the *Epistolae Beati Hieronymi*, published by Nicolaus Kesler on August 8, 1492. The actual cutting was done by a *Formschneider* whose hand was not excessively delicate. The design, however, was by Dürer, and it reveals a clear Flemish influence, distantly recalling such works as the Eyckian Detroit *St. Jerome* (Fig. 121). The forms tend to go up as well as back, but a skeletalized semblance of the grandeur of the original design is still visible.

In 1493 in Basel he made some of the illustrations for Marquart von Steyn's *Ritter vom Turn* (from the French original by La Tour Landry), a moralizing instruction book for daughters, one of the many moral treatises of the time. In 1492–93 he made illustrations for an unpublished edition of the comedies of Terence; though the attribution is doubted by some scholars, the drawing still visible on the whitened surface of the uncut blocks shows a style impossible to find in other works published in Basel at the time. The pictorial conception is probably the result of his Netherlands experience united to his own sense of pictorial vision, which he had nurtured by emulation of the Housebook Master. To this he added in the treatment of the draperies the crispness of Schongauer's style. The youthful, laurel-crowned Terence writing his plays and the castle with the drawbridge in

413. ALBRECHT DÜRER. *Terence Writing.* 1492–93. Pen drawing on wood block, 3 1/2 × 5 5/8″. Kupferstichkabinett, Basel.

the distance at the left create a balancing of forms in space (Fig. 413). A feeling for depth, distance, and landscape organization is presented with an airiness and a sensitivity to the sheer beauty of natural forms. Though Panofsky attributed the crispness and economy of line to the "epigrammatic" qualities of the Ulm School of woodcutting, where thin line and large white spaces predominated, the development observable here seems equally understandable from Dürer's previous experiences.

Dürer also contributed illustrations to one of the most famous books of the period, Sebastian Brant's *Narrenschiff*, published in Basel by Bergmann von Olpe in 1494. The book was immediately successful, was translated into many languages, and went through numerous editions, six in Brant's own lifetime. A moralizing treatise, its didactic qualities are presented with both gravity and ribald humor in 112 chapters attacking vicious or criminal offenses, insolence, riotousness, sloth, presumptuousness, and various other perversities. The initial chapter deals with the scholar who says:

> Of splendid books I own no end,
> But few that I can comprehend;
> I cherish books of various ages
> And keep the flies from off the pages.... [3]

The book's success was undoubtedly due to illustration and text in combination, the former pointing up the latter. The idea of a gathering of fools in a ship bound for "Narragonia" (*Narr* being German for fool) was common to several literary traditions (in Flanders it was known in the form of the Blue Ship). Such fools as those who make noise in church, who say one thing and do another, who make noise in the streets when good people are sleeping, who waste their time, who superstitiously believe in astrology, who boast, squander, or refrain from good works, and the like are the subjects illustrated by the five or six artists who worked for the publisher. Opinion has been divided as to Dürer's actual participation. His influence is strong in many cuts where it is evident that he did not make the original design, and his figure types and landscape conceptions are seen in many places. He probably did about a third of the woodcuts. They have a lively quality that can only be due to this young artist who could ably handle form and who could create action and

pictorial effects by means of line with limited shading.

In 1494 Dürer returned to Nuremberg to marry Agnes Frey. The marriage, arranged by his father, produced no children; it was not a truly happy marriage but one common at a time when women were uneducated and were confined to the performance of household duties. We know that Agnes sold Dürer's prints for him at the fairs and managed the household, sometimes and later in his life in a nagging fashion. This is known from a letter written after Dürer's death by his friend, Nuremberg's leading Humanist, Willibald Pirckheimer, whom he had known since his earliest days. (Albrecht Dürer the Elder had moved his family into a house behind that belonging to the Pirckheimer family, where they lived until Albrecht was five.) Through Pirckheimer, Dürer met and became familiar with the leading Humanists of the city. As numerous letters attest, he became known and respected for his knowledge and mental abilities, as well as for his artistic abilities, by the leading German Humanists and scientists of the day.

Back in Nuremberg, his interests having been broadened by his work in illustration, Dürer continued to draw and to study and at the same time prepared to settle down as a master with his own shop. Living in his father's house until the latter's death in 1502, he turned to print making and undoubtedly made paintings as well; Winkler attributed several specific works to this period, which, however, are difficult to accept.

In 1494, to perfect himself further in the art of engraving, he made drawings from mythological engravings by Mantegna, tracing the contours but replacing Mantegna's parallel diagonal lines of shading with modeling lines that follow the form and create a more dramatic effect. Mantegna's even and unified surface treatment, produced by variation of burin pressure and depth of cut in the diagonal-line shading, is markedly different from Dürer's accentuation of and concentration upon the figures. Dürer's method in these drawings expresses a northern concern for the particular. His copies show a greater sense of immediacy in the treatment of shapes and elements; at the same time some of the abstract design and idealization of Mantegna's austere style escaped the northerner's grasp. The *Battle of the Sea Gods*, the *Drunken Silenus*, and the *Death of Orpheus* (Fig. 414) in Ham-

414. ALBRECHT DÜRER. *Death of Orpheus*. 1494. Pen drawing, 11 ³/₈ × 8 ⁷/₈″. Kunsthalle, Hamburg.

burg, after a lost Mantegna engraving, are examples of works of this nature. Dürer's more dramatic interplay of lights and darks transformed the Italian style into a northerner's view of antiquity: the gods battle more furiously, Silenus seems more grossly drunk, and the maenads attack an Orpheus whose face is rippled by his emotions.

As Panofsky has pointed out, Dürer never copied the antique directly; the Italians were his models and his intermediaries. His interest in Italy and things Italian led him, late in 1494, to leave Nuremberg and go to Venice. This has been concluded from his drawings of a woman in Venetian costume dated 1495 (in Vienna), a lobster (Berlin), a lion (Hamburg), and others, and from a comment in a letter of 1506, written from Venice, that what had pleased him eleven years ago no longer pleased him. Unfortunately his correspondence of later years and his diary, written later, make no other mention of this first trip. A sheet of drawings in Vienna with a copy of a painting of the Rape of Europa, an antique archer, an astrologer, and a sculptured lion may also be taken as evidence for this Italian trip.

left: 415. ALBRECHT DÜRER. *View of Arco.* 1495. Water color, 8 ³/₄ × 8 ³/₄″. Louvre, Paris.

below: 416. ALBRECHT DÜRER. *Men's Bathhouse* (B. 128). *c.* 1496–97. Woodcut, 15 ³/₈ × 11″.

employs elements seen earlier, the Joseph recalling certain drawings (Fig. 412), the details suggesting his Flemish experiences; but the Virgin is more clearly monumentalized, and the landscape is more varied, yet unified with richer tonalities and richer surfaces.

The engraving of *St. Jerome*, with the saint in the desert kneeling before a crucifix, utilizes the lion drawn in Venice and shows that Dürer's drawings were made as aids and studies for later work. Jerome, with an old man's shaggy, bearded head, possesses a powerful idealized body. The counterbalancing landscape background recalls the Housebook Master's methods.

Of 1496 is the drawing of a *Women's Bathhouse* in Bremen, in which a hitherto exceptional element in northern art, the nude, was combined with a search for perspective unity. Though his figures were based on posed models, one looking directly at the spectator, Dürer tried to arrange them in a natural way so as to retain an organic unity, in which the semiclassical pose of the center figure is employed as a stabilizing form. Spatial intervals between forms were also his concern, as in the *Men's Bathhouse*, a woodcut of about a year later (Fig. 416). Here the problem

A number of landscape drawings in water color were made on the way to Italy and on the return trip. The courtyard of the castle at Innsbruck, in the Albertina, Vienna, seems to have been made on the way, for the forms are carefully studied and conjunctive elements are analyzed in detail; on the other hand, the nontopographical view of the castle at Trent, in the British Museum, and the *View of Arco*, on Lake Garda (Fig. 415), in Paris, must have been done on the return, for they show a coordination of elements, a unity of forms, and a coherent expression missing from the Innsbruck scene, thus indicating Dürer's assimilation of Italian modes during his stay.

His new synthesis of Italian breadth and northern love of detail appears in works created between the return to Nuremberg and the year 1500, a synthesis already seen in the 1500 *Self-portrait*. Forms became rounder and more solid; space became deeper and was organically related in the works produced after the Venetian trip. As his engraving tone became deeper and richer, Dürer transferred to his woodcuts the precision and incisive cutting of his engraving style, thereby elevating the woodcut to an unprecedented height before the eyes of his contemporaries. Even his signature changed, the lower-case *d* becoming a capital *D*.

The engraved *Virgin and Child with the Dragonfly*, a work of about 1495 or early 1496, again

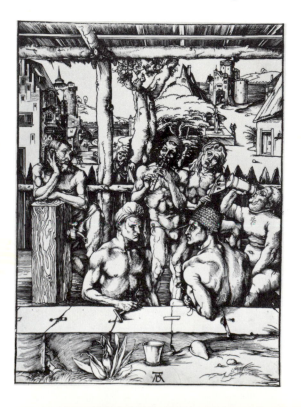

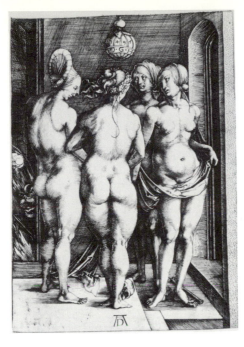

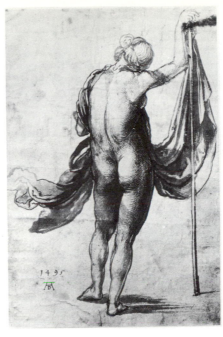

was treated compositionally in a more Italianate fashion; the two figures in the foreground are placed to show front and back views; a fat figure at the right, turned inward, is counterbalanced by the man leaning on a post, from which a spigot projects in an obvious reference to his sex; and the central stabilizing element of the group is the flutist. A classicizing foreground is balanced by a northern background, full of variety and interesting detail, very much a parallel to the Prado *Self-portrait* of 1498. The concern for proportions of human figure types mostly idealized in varied actions, rendered with northern detail, is striking witness to Dürer's synthesizing spirit and his desire to transform his northern inheritance.

His first dated engraving is the *Four Witches* of 1497 (Fig. 417), based on the classical Three Graces, to which he added a fourth figure.[4] All are rather Gothicized, and again he attempted to deal directly with the idealized nude female. The bulky bodies are made even more bulky by being crowded together, and the contemporary headdresses contribute an incongruous note.

Possibly this engraving was put aside for a while, for if we compare the Louvre drawing (1495) of an idealized nude seen from the back (Fig. 418), it would appear that Dürer handled the nude female form far more effectively two years before he did the *Four Witches*. It is possible, however, that the Louvre drawing is a

copy of a painted Italian form. (His drawing of the same year, done freehand after Pollaiuolo's *Rape of the Sabine Women*, shows a highly Gothicized elongation of both male and female figures, both lacking a clear articulation of their members.) Yet the direction Dürer was taking is evident when the Louvre nude is compared with an earlier realistic drawing in Bayonne (1493), portraying an unidealized smiling model dressed only in head covering and slippers (Fig. 419).

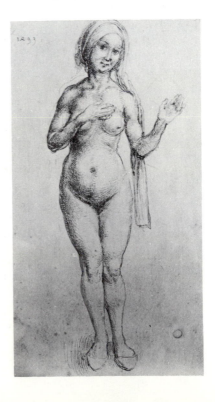

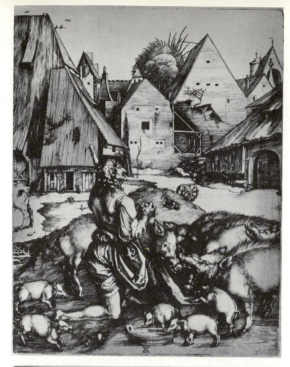

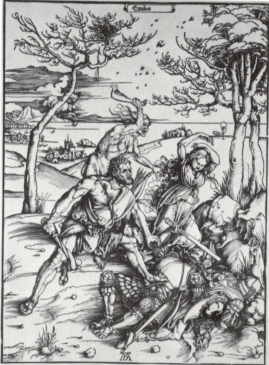

left : 420. ALBRECHT DÜRER. *Prodigal Son* (B. 28). 1497 (?). Engraving, 9 3/4 × 7 1/2″.

below : 421. ALBRECHT DÜRER. *Hercules and Cacus* (B. 127). c. 1497. Woodcut, c. 15 1/4 × 11 1/4″.

what obvious in using the pyramid and triangular roof forms to establish the basic X of the composition, into which the Prodigal Son has been fitted as the peak of the bottom triangle, the surfaces are rendered with a magnificent feeling for their actuality. They bear witness to the artist's search for significantly organized and stabilized forms. The force and power of Dürer's synthesizing approach is as evident to us today as it was to his contemporaries.

Dürer turned to classical themes as well as naturalistic genre and religious subjects, and the weight of his experience was brought to bear in the execution of woodcuts such as *Hercules and Cacus* (Fig. 421). The activity takes place against a spacious landscape background, in which the extremely fine-line cutting of the clouds at left and the white cloudless sky at right are reminiscent of Schongauer's engraving of the *Road to Calvary* (Fig. 388), whereas the clumps of trees and buildings in the distance may be traced back to such works as the Portugalia of the *Nuremberg Chronicle* (Fig. 408), but these details are all handled with a sensitivity of line previously seen only in engraving. Hercules and the Eumenides, of which one is definitely borrowed from Mantegna, seem almost accessory to this powerful sweep of landscape, and the whole, in compositional method, is a modernization of such works as the Terence figure of 1492–93. Also from the second half of the decade, and close to 1498, is the engraving of *Hercules at the Crossroads,* with the hero between Virtue and Vice (Fig. 422), an independently composed work with recognizable elements from Mantegna in the figure of Virtue, the small child running away at the right, and the central tree—all derived from the lost engraving of the death of Orpheus, copied earlier. The figures of Vice and her satyr companion seem to have been derived from another Italian work, the Hercules being possibly an original creation by Dürer. Certainly the landscape background, as well as the organization of the whole, is Dürer's invention. By thematically interrelating figures and landscape he took a very large step toward his goal of artistic synthesis. Here the ascending road is clearly the rough path of

It would appear, therefore, that the dramatic lights and darks and moving drapery of the 1495 drawing are elements derived from a painting rather than from an observed form.

Possibly of 1497 is an engraving of the *Prodigal Son,* shown kneeling in the farmyard amidst the swine (Fig. 420), for which a preliminary drawing exists in London. Though the work is some-

virtue, from which the descending landscape, with its softer forms, leads off to the right. However, the landscape, though thematically related, is still stylistically different from the Italianate foreground.

Dürer's interest in all aspects of nature can account for his engraving at this time of a biological freak, the *Monstrous Sow of Landser*, an interest that was undoubtedly shared by his contemporaries who bought it.

During this period Dürer was also painting portraits in oils, as in the Gothicized portrait of his father (1490) in the Uffizi. Though it is in the Wolgemut manner, as is to be expected, with sharpness of outline and silhouette it has a sense of a far greater monumentality in the hands and a more plastic feeling in the face than any work from the Wolgemut shop. The shading of the rounder forms indicates a feeling for a greater pictorialism than can be found in Wolgemut.

Of 1496 is the portrait in Berlin of *Frederick the Wise*, Elector of Saxony and one of Dürer's early patrons. The early sharpness of outline is augmented by sharp value contrasts and an almost wild glance in the eyes that brings to mind the expressive spirit of the late Gothic style. Yet the calm pose and the quiet hands on the balustrade show again the classicizing elements in Dürer's art.

About the same time he also created for Frederick the Wise the sharply delineated, large Madonna in Dresden (Fig. 423). She adores the

below: 422. ALBRECHT DÜRER. *Hercules at the Crossroads* (B. 73). *c.* 1497–98. Engraving, 12 1/2 × 8 3/4".

bottom: 423. ALBRECHT DÜRER. *Dresden Altarpiece. c.* 1496 (center), *c.* 1503 (wings). Linen. 42 1/8 × 38" (center), 44 7/8 × 17 3/4" (each wing). Gemäldegalerie Alte Meister, Staatliche Kunstsammlungen, Dresden.

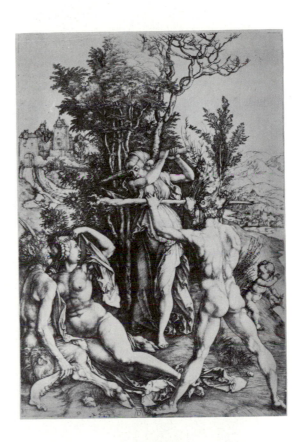

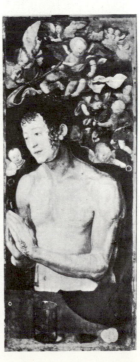

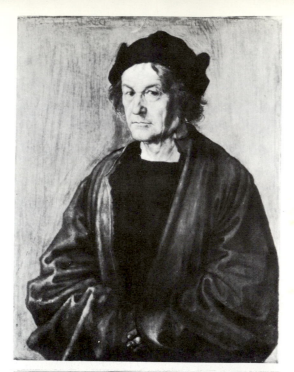

Madonna panels, Sts. Anthony and Sebastian occupy the wings. Behind the figure of an unconcerned Anthony, on the left wing, is seen an epitome of the ideals Dürer was trying to reconcile: Italianate angels fighting zoomorphic demons of northern inspiration. Behind the half-naked Sebastian angels appear with the saint's crown of martyrdom. These depictions occurred again later in altered form, for Dürer's two saints influenced Grünewald's *Isenheim Altarpiece*.

In 1497 he again portrayed his father (replica in London) in a manner very different from that of 1490 (Fig. 424). In those seven years Dürer had not lost the concentration and intensity of the early work. The conception of the totality of human form and a majestic and intense expression are allied to a monumentality enhanced by a pattern of light that circles the form and leads to the head, which is tremendously dramatic yet faithfully portrayed, with a strong glance directed out at the viewer. The strength of psychological drama, far more successful and penetrating than in the portrait of Frederick the Wise, is achieved without the hardness and linearity of the earlier work, which it surpasses also in its unity of pictorial elements. The artist saw his father clearly, and his respect and love for him, known from his letters, informs every nuance of the gnarled surface of the face.

In the few years just before 1500 Dürer created some engravings of unprecedented quality outstanding examples of a complete maturity. The *Sea Monster* (Fig. 425), also called the "Triton and Amymone," of about 1498, has never been satisfactorily explained, though Panofsky concluded that it probably represents one of the perennial abduction stories of fanciful type. Pictorially it seems to have been inspired by the theme of the Rape of Europa; the nude female bathers at the left and the man in Turkish costume rushing down to the shore with upstretched arms, all set against a fine, naturalistic landscape background, also argue for an ultimately classical or classicizing source. With this union of Flemish realism in the background and classical idealism in the foreground figures, Dürer

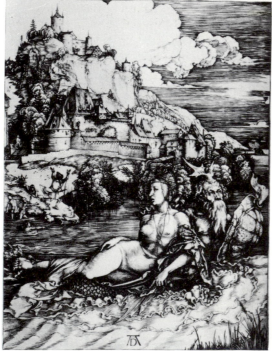

sleeping Christ Child, surrounded by minuscule angels swimming in the almost too spacious interior, while in the back room Joseph practices his trade as a carpenter. The wings of the *Dresden Altarpiece* are obviously in a different style, and were added by Dürer to the impressive center panel about seven or eight years later. More unified and without the scale disparities of the

demonstrates complete control of his medium, now technically highly proficient and rich and delicate in tone. Reminiscences of his previous compositional methods are visible in the use of diagonal interest and the balancing of the design, in which the *repoussoir* grasses in the lower right-hand corner play a part.

From this same period, about 1498, must come the *Madonna and Child with a Monkey* (Fig. 426), an engraving which again shows the influence of the Housebook Master. The monkey, as usual, symbolizes man's base passions overcome by Christ's sacrifice. Pyramidal construction, increased refinement of technique, as in the beautifully rendered velvet sleeve of the Madonna, and the just relationship of parts make an impressive achievement. The house by the water in the background is taken from Dürer's water color (1497–98) of a *House by a Pond* (Fig. 427), in the British Museum. A greater unity of form in the landscape is evident when the *House by a Pond* is compared with an earlier water color, the *Wire-drawing Mill* (c. 1494), in Berlin (Fig. 428). The movement into space and the concentration of light in the later water color clearly surpass

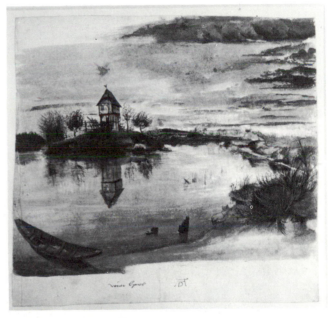

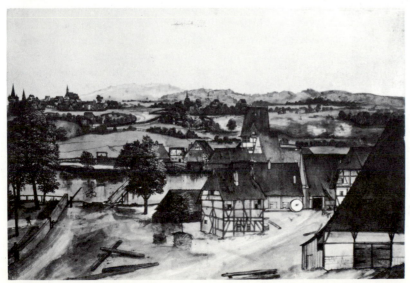

above left: 426. ALBRECHT DÜRER. *Madonna and Child with a Monkey* (B. 42). *c.* 1498. Engraving, 7 1/2 × 4 7/8".

above: 427. ALBRECHT DÜRER. *House by a Pond. c.* 1497–98. Water color, *c.* 8 1/4 × 8 3/4". British Museum, London.

left: 428. ALBRECHT DÜRER. *Wire-drawing Mill. c.* 1494. Water color, 11 1/4 × 16 3/4". Kupferstichkabinett, Staatliche Museen, Berlin-Dahlem.

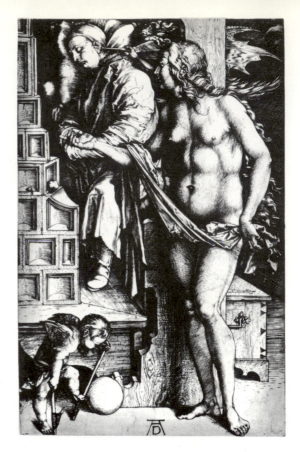

the more linear and essentially topographical conception of the earlier one. Additive units with a generalized light are seen in the earlier work, but the later landscape anticipates in breadth of understanding and feeling for nature those to come much later in the Romantic period. Dürer, now recognizing the oneness of nature, tried to encompass all aspects of his world, to let nothing escape him, moving, it seems, in all directions to take in everything with a youthful enthusiasm, verve, and artistic curiosity.

The *Dream of the Doctor* (Fig. 429) of about 1498–99 shows a doctor of theology leaning his head against a pillow, a sign of slothfulness, before a Nuremberg stove that keeps him warm as he sleeps. Since he is clearly not working—praying or pondering religious matters—he is giving way to the vice of sloth. The presence of the feminine nude is explained by the fact that sloth begets lewdness and causes the idler to succumb to the temptations of luxury, according to the medieval moralizing treatise *La Somme le Roi.* As used by Dürer, the subject also became an exercise in the ideal proportion of figures, the subtlety of lights, direct and reflected, and the textural variety of natural objects: the flesh of the nude, the clothes of the doctor, the wood of the chest and bench, the tiles of the stove, and the wings of the demon who blows lewd thoughts into the ear of the sleeping idler with a bellows. Majestically presented, it is a work of great beauty.

The woodcuts of this period show a comparable mastery. The *Great Passion,* great in size and majestic in conception, comprised 12 woodcuts, of which 7 appeared between approximately 1497 and 1499 though the series was not completed until 1510. During his lifetime Dürer made six versions of the Passion, the last being incomplete at his death in 1528. The earliest in the *Great Passion* series were probably the Flagellation, the Mount of Olives, the Entombment, and the Lamentation. The Ecce Homo was intermediate in time of execution, and the Bearing of the Cross and the Crucifixion were later, about 1498–99.

The Bearing of the Cross (Fig. 430) was compositionally derived from the Housebook Mas-

ter (Fig. 403), as is seen in the figure at the right holding the rope and in the backward glance of Christ, who looks at Veronica here instead of at a stone. This is more complex than the earlier work, however, with a greater sense of drama and crowding of forms, and the setting follows a more traditional type by adding a city gate as background at the left. Dürer has balanced his almost baroque quality of strong activity by the large size of the foreground figures and the comparative simplicity of the city gate. The Flagellation is also strongly active, with a spotting of motifs such as the crown of thorns placed at the lower right to balance the architectural form at the upper left. The Ecce Homo was probably derived from Schongauer but is quite different, in that Christ is separated from the crowd, rather than united in active contact with it by a man on the staircase. Dürer's Christ is still a figure of devotional piety, but it is also a monumentalized, majestic form.

The greatest work of this period is the *Apocalypse* series, issued in book form in German in 1498. Designed and published by Dürer, 15 woodcuts of the Revelation of St. John were used to illustrate the text printed on the back of

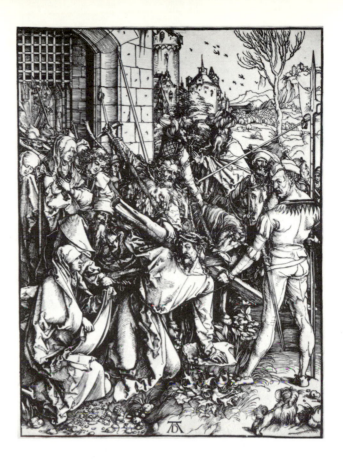

the cuts. A Latin edition was issued in the same year. The text was derived from Anton Koberger's German Bible, published in Nuremberg in 1493, which itself was based on the Cologne Bible of 1480. Dürer took over the scheme and many iconographical details but transformed them by the force of his conception into an artistic form that overwhelmed his contemporaries and later generations. The strength of Dürer's statement discouraged further attempts at the theme for several centuries. There are two main divisions: the early works, possibly dating from an assumed start about 1496, are the Adoration of the Lamb and the Hymn of the Chosen, the Whore of Babylon, the Seven Trumpets Given to the Angels, the Sea Monster, and the Beast with Lamb's Horns; the late prints are St. John's Vision of Christ and the Seven Candlesticks, the Four Horsemen of the Apocalypse, St. John Devouring the Book, and St. Michael Fighting the Dragon. The remainder of the 15 cuts were executed at intervening dates. In 1511 the series was reissued in Latin with an added woodcut on the title page.

The *Apocalypse* woodcuts have a new fineness of cutting and intensity of conception, visible, for example, in the Whore of Babylon, which also has a greater complexity of surface movement and more dramatic treatment of the lights and darks. (Again Dürer used his earlier drawings, for the woman's costume is related to the 1495 drawing of a woman in Venetian costume.) Though somewhat unclear and confused, this and the Opening of the Seventh Seal have an extreme richness and variety; Dürer crowded everything into the scene in his desire to express the character of the work. Gradually this crowding came under control. The early works show an overwhelming of the artist by the inner meaning and expressive power of the evangelistic account, but in time his compositions advanced in restraint, monumentality, and simplicity; the earlier minute arrangements of light and dark were replaced with more coherent effects of mass and form.

A largeness of conception appears in the cut of the Angel locking up the Devil for seven years. Stemming, it seems, from Master L CZ's

Temptation of Christ (Fig. 406), though not a copy, its forms are built in a similar fashion. Foreground forms are balanced by the distant landscape, in an opposition seen previously but here more complex and with figures added at the upper right. However, the whole is still conceived as a composition of oppositions, space pitted against volume, with a diagonal balancing in depth; large, monumental forms in the foreground; and small, intricately detailed forms in the distance.

A late work in the series, the theme of St. John devouring the book, though it can be conveyed without awkwardness in literature, is difficult to represent in art. Dürer handled it convincingly by subordinating the motif to the central miraculous appearance, to which the eye is led by the light rays and the leglike columns (Fig. 431). The scene is enriched by the close landscape at right and a strong diagonal movement. The act of swallowing the book is rendered with remarkable success, as though it were a natural food; this is achieved by subordinating the idea of eating to the idea of receiving the book; but it is done at the expense of fineness of detail.

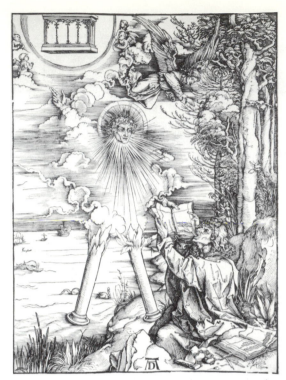

above: 431. ALBRECHT DÜRER. St. John Devouring the Book, from the *Apocalypse* series (B. 70). *c.* 1498–99. Woodcut, 15 3/8 × 11 1/8".

below: 432. ALBRECHT DÜRER. The Four Horsemen, from the *Apocalypse* series (B. 64). *c.* 1497–98. Woodcut, 15 1/2 × 11".

bottom: 433. ALBRECHT DÜRER. St. Michael Fighting the Dragon, from the *Apocalypse* series (B. 72). *c.* 1497–98. Woodcut, 15 1/2 × 11 1/8".

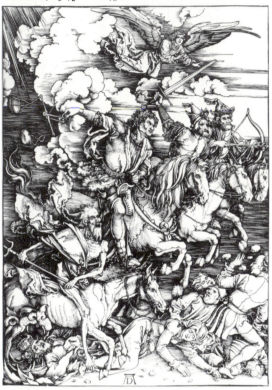

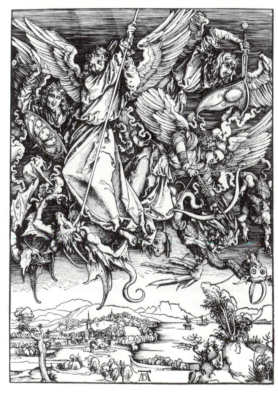

Most famous of the woodcuts is the scene of the Four Horsemen, with Death, War, Pestilence, and Famine shown riding over the world in a tremendous rhythmic movement that over-whelms all before them (Fig. 432). Again the visionary quality is achieved in part by the con-trast in forms; the figure with the scales is the most heroic and monumental, while those to the right and Death below are smaller in size and less important in position. Riding the air, they sweep over the world, only Death, whom man knows and knows well, touching the world.

Equally impressive is St. Michael Fighting the Dragon (Fig. 433). It was surely suggested by the demon in Schongauer's *St. Michael* (Fig. 391); otherwise, Dürer's demons can be found earlier only in Schongauer's famous *Temptation of St. Anthony* (Fig. 385). The elevation of the scene into the air undoubtedly comes from the same source. The complexity is another point of simi-larity to Schongauer, but the whole is more intense because of the wall of figures presented close to the picture plane without space on either side or above. Only below is there relief from the strong action, provided by a superb land-scape without shading except at the water's edge, the land forms being shown chiefly in outline.

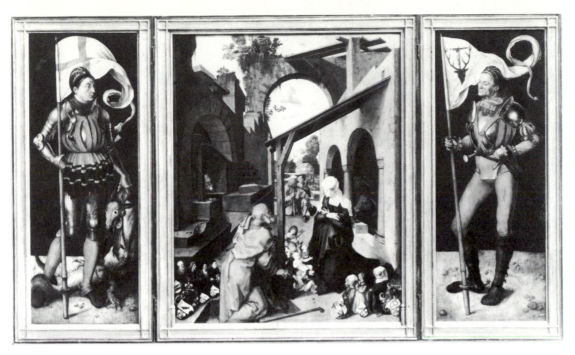

434. ALBRECHT DÜRER. *Paumgärtner Altarpiece*. 1503–04. Panel, 61 × 49⁵/₈″ (center),
61³/₄ × 24 (each wing). Alte Pinakothek, Munich.

Because of the dramatic shading above, the landscape becomes the less naturalistic area and thus is merely allusive.

The *Apocalypse* woodcuts spread Dürer's fame and influence even more than before. The richness and variety derived from Schongauer and the past were given a new plastic force, to which was added a dramatic chiaroscuro in woodcut, engraving, and painting. Dürer took from copper engraving the richness of tone and the possibility for variety in detail and used them in his woodcuts so dynamically, so coherently, boldly, and monumentally, that his contemporaries could not even distantly approach him. Nor could they approach his technical virtuosity.

After 1500 this spirit continued, though in a more restrained and searching art. Dürer attempted to rationalize more distinctly his investigations of the theoretical aspects of perspective and proportion by the minute analysis of natural forms. These elements were a consideration in works of the last five years of the century, but their study was intensified in the following five. Dürer's studies of nature appear in the Munich *Lamentation* of about 1500, in which the background recalls both Flemish landscape and the background of the *Sea Monster* engraving but

turned into painted form with, unfortunately, rather hard color and sharp lights. The foreground scene seems dependent upon Hugo van der Goes for its underlying conception. The minute size of the kneeling donors in the corners is utterly incongruous.

The Munich *Paumgärtner Altarpiece* (Fig. 434), of 1503–04, is a triptych, the Nativity in the center, Sts. George and Eustace on the wings. The donor family is represented in minuscule form in the center panel, but the two saints are thought to bear the likenesses of Stephan and Lukas Paumgärtner, the former a very good friend of Dürer. Van der Goes's influence may again be seen in the shepherds in the background of the Nativity, though the composition is different in almost all other respects. Dürer set the scene on a platform and built a series of arched and other architectural forms that show his concern for perspective according to rule, rather than empirically arrived at as in earlier work. In the wing panels he set the portrait heads of the Paumgärtner brothers on monumentalized, idealized, and logically constructed bodies in rather easy poses, with concentration on costume detail, thus again merging northern and Italian elements, all strongly silhouetted.

The resultant beauty is not yet a true synthesis of the two approaches, for the northern is clearly dominant on the wings, in contrast to the center panel, where the organization suggests solidity and mass in more concrete space.

The developments at this stage came rapidly. The *Adoration of the Magi* in the Uffizi (Fig. 435), painted for Frederick the Wise in 1504, suggests that Dürer had become acquainted with Leonardo's designs, the architecture and the rearing horseman in the background being strongly suggestive of Leonardo's famous treatment of the same subject. With a new concept of space Dürer went beyond the Paumgärtner Nativity; he was now able to give the foreground greater amplitude by extending it in depth. He constructed a truly Renaissance stage, upon which he arranged his solidly built figures close to the picture plane. But the achievement under Leonardo's inspiration in this, one of the most beautiful of Dürer's works, did not last in this form; Dürer had yet to assimilate the early Renaissance completely, and the High Renaissance, which Leonardo represented, was still far beyond his comprehension.

Basically intermediate is such a work as the *Jabach Altarpiece* wings, in Cologne, which show a monumentally presented Job being doused by his wife with a bucket in one scene and in the other being soothed by musicians (one of whom is Dürer himself). Playing of music to soothe is related to contemporary concepts of treatment for insanity. The Renaissance is evident not merely in Job himself but also in the musicians' poses, one turning his back on the spectator, the other facing him; but the accumulation of detail and the twisting of the figures show Dürer's inability at this point to achieve completely the Renaissance goal for which he was obviously striving.

The engravings of this period increased in richness. The *St. Eustace* (Fig. 436) contains earlier elements, being a combination of studies: the horse had appeared in a 1495 drawing of a mounted *Landsknecht*, or foot soldier; the greyhound lifting his head is seen in a drawing in Windsor Castle; and the citadel in the background is transmitted from a drawing in Paris, probably dating from the early years of the century. St. Eustace has dismounted to worship the stag with the crucifix between his antlers. In the foreground, dogs are arranged parallel to the picture plane and at 90 degrees to it, all carefully studied. The tendency to regularize is exceedingly strong, almost too much so, but the work is saved by the variety of detail, eye-catching complexity, and richness of setting and execution.

The *Nemesis* (*Das Grosse Glück*), for which Dürer employed the proportions of Vitruvius for the figure on the globe (Fig. 437), is a monumental Germanic feminine nude above an almost cartographic aerial view of a mountain landscape, which may have been suggested by a woodcut with an aerial view of Venice by

435. ALBRECHT DÜRER. *Adoration of the Magi*. 1504. Panel, $37\frac{5}{8} \times 44\frac{7}{8}''$. Uffizi, Florence.

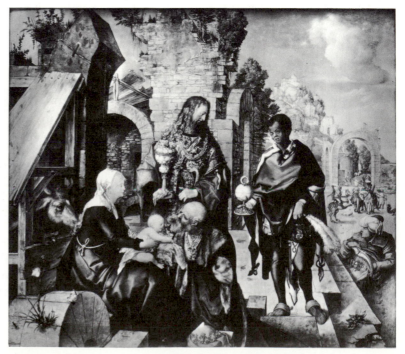

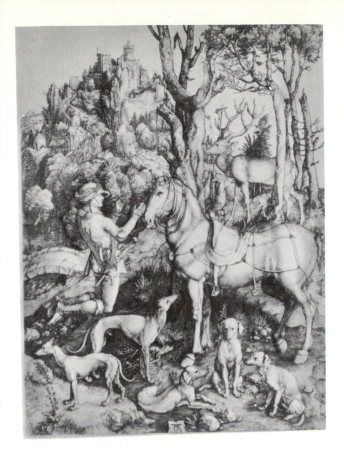

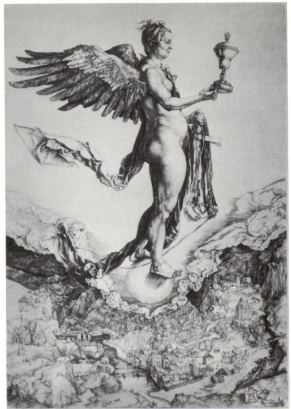

Jacopo de' Barbari. Dürer's studies of human proportion were partially influenced by this artist, a Venetian engraver and painter, known in the north as Jakob Walsch, who went to Germany in 1500, was in Wittenberg until 1506, and later became court painter to Margaret of Austria. A new device appears in the *Nemesis*, the tablet on which is engraved the artist's familiar monogram.

In turning to Renaissance art to learn its theory, Dürer came to conclude that everything was governed by rule, though not to the extent of being dominated by it. Dürer, after all, was no fool; he knew that artistic sensitivity and judgment enter into every work; he felt that there was a secret and that a sensitive artist who could obtain that secret would find all things open to him. This conception lies behind the theoretical works that he published at the end of his life. Dürer was well known to his contemporaries for his keen mind and wealth of knowledge; contemporary letters attest to this over and over. He was at home among the Humanists, the poets, the mathematicians, and the religious leaders of his day, and his greatest friend was Willibald Pirckheimer, the leading Humanist of Nuremberg. Thus Dürer was not merely

a craftsman (he even tried his hand at poetry, which Pirckheimer promptly ridiculed) but also an analytical seeker, investigating science, as it was known to the Renaissance, in his search for rule and order.

The analytical approach is also found in some magnificent water colors of the period. The *Rabbit* (Fig. 438), of 1502, in the Albertina, Vienna, shows the same unity seen in the portrayal of human and landscape forms; there are other works of similarly incredible exactitude, such as the *Great Piece of Turf*, the *Stag Beetle* of 1505, the *Whitsuntide Rose*, muzzles of animals, and a head of a stag. In the engraved *Nativity* of 1504, a restatement of the architectural problems of the Paumgärtner Nativity, forms in space organized by means of perspective are the dominant interest. Dürer constructed them with dramatic spatial intervals and imparted to the architectural construction something of the dynamic quality found earlier in the *Apocalypse* woodcuts; the work also shares their fantastic spirit. Composi-

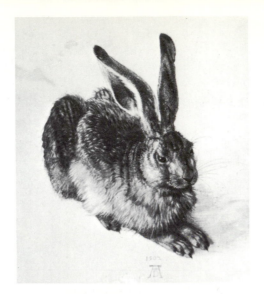

right: 438. ALBRECHT DÜRER. *Rabbit*. 1502. Water color, 9⁷/₈ × 8⁷/₈″. Albertina, Vienna.

right: 439. ALBRECHT DÜRER. *Flight into Egypt* (B. 89). *c.* 1504. Woodcut, 11³/₄ × 8¹/₄″.

far right: 440. ALBRECHT DÜRER. *Christ with the Victory Standard*. 1504-05. Drawing, 18¹/₂ × 5³/₄″. Städelsches Kunstinstitut, Frankfurt.

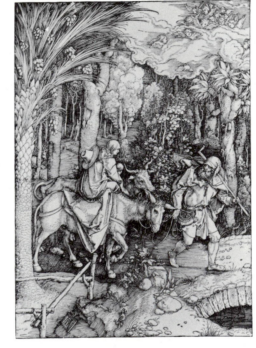

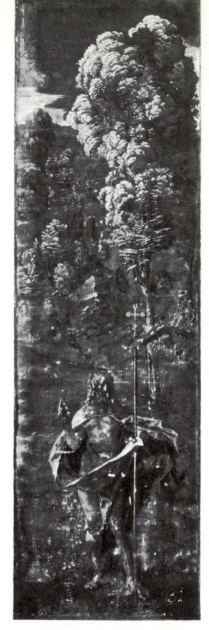

tionally this engraving has returned to an organization along a diagonal with rich details, a restrained, yet magnificent sense of light, and eye-catching dramatic effects such as the placement of his monogram high in the ruined architecture.

In this first five years of the century he issued, though not all at one time, woodcuts of the life of the Virgin. Seventeen cuts in all were made in these years. Early, about 1503, is the *Birth of the Virgin*, with some of the spirit of the Apocalypse series in its organization and spatial conception. The upper portion is presented supernaturally and the lower, naturally: a figure drinks out of

a tankard below, as an angel swings a censer above. It may be that this woodcut was planned earlier and temporarily put aside, for the *Joachim and the Angel* scene suggests such works of the late 1490s as the woodcut *Martyrdom of the Ten Thousand*. The *Flight into Egypt* (Fig. 439) borrows its close space and its forms close to the picture plane from Schongauer's engraving of the same subject (Fig. 386), and the impenetrable background, also from Schongauer, is almost more Rogierian than Rogier himself. But Dürer transformed his borrowed motifs by organizing them in a continuous space to suggest the depth and dark places of a German forest, a proliferating

nature watched over by the angelic heads floating in the light sky above. This work is very different from the *Joachim and the Angel*, showing that Dürer did not advance equally on all fronts at the same time.

Decorative aspects also occur in Dürer, though normally one does not think of him as a decorative artist. In the woodcut of the *Betrothal of the Virgin*, of 1504 or 1505, the gateway behind the scene is a flattened, decorative screen, in front of which monumental figures act out the story.

In 1504 Dürer created the so-called Green Passion, drawings on green paper heightened with white; it may have been a private commission, or it may have been a model for paintings. Based on previous versions but varying from them, as in the *Carrying of the Cross*, which stretches out across the scene with forms more markedly parallel to the picture plane than before, these drawings demonstrate Dürer's inexhaustible wealth of inventive power. The interest in light they reveal is also seen in the *Christ with the Victory Standard* (Fig. 440), in Frankfurt, in which the upper portion of the drawing is a landscape with a dynamic rendering of detail in the trees. Here is an emotionalism normally associated with his great contemporary, Grünewald, and the artists of the Danube school of landscape painting, such as Cranach and Altdorfer. Dürer's concept of landscape in this drawing is diametrically opposed to the earlier landscape water colors and even to the more recent background of the *St. Eustace* engraving. Instead of the earlier naturalism there is a proliferation of a few elements that foam up before our eyes, containing within the single form of the tree an unreal activity of highly expressive and emotive power. This aspect was not followed much further by Dürer but was taken up by others in the development of a distinctive school of landscape painting.

Dürer continued to study the art of Jacopo de' Barbari, whose almond-shaped figures in his *Victory and Glory* apparently had a strong relationship to the northerner's work shortly before 1500. Dürer changed Jacopo's elegant, proto-Manneristic forms into heavier, more muscular, bulky, and more heroic figures. Dürer tended to overstate, as Jacopo de' Barbari understated. Studying human proportions in a more theoretical fashion than before (the unlovely *Nemesis* is one of the early statements), he made a series

of drawings of the ideal male nude. One example is his *Apollo* drawing, in London, with "Apolo" spelled backward. Partially under the influence of Jacopo de' Barbari and the added influence of an Italian copy of the antique *Apollo Belvedere*, he refined Apollo's proportions and made his figure more slender. The penultimate stage in this study is represented by the pen drawing of *Adam and Eve* in the Morgan Library, New York, which uses the *Apollo Belvedere* type for the figure of Adam.

The *Fall of Man* engraving of 1504 (Fig. 441) shows that Dürer's studies of ideal human proportions had reached a summation. Its background is replete with iconographic significance, though one element is "noniconographic," the goat on a high hill being adopted from the *Temptation of Christ* (Fig. 406) by Master L CZ. In the foreground Adam, whose vigorous movement contrasts with the quieter movement of Eve, holds a tree branch with a parrot and a cartouche, on which Dürer inscribed his name and the date and to which he added an inscription for the first time.

As Panofsky pointed out, the mountain ash held by Adam signifies the tree of life, while the

441. ALBRECHT DÜRER. *Fall of Man* (B. 1). 1504. Engraving, $9^{7}/_{8} \times 7^{5}/_{8}''$.

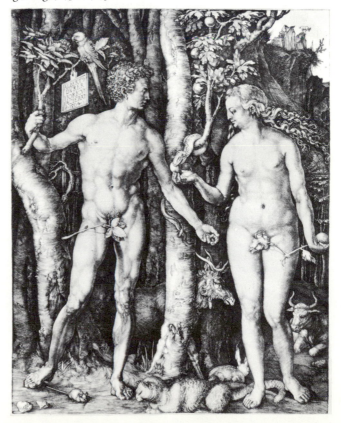

fig tree around which the snake is coiled represents its opposite. There are other contrasts, the mouse and the cat, the parrot and the serpent, and the elk and the ox, all of which had significant meaning for the erudite of the period. The four temperaments, the sins, and their related diseases are characterized here: the elk symbolized the melancholic, susceptible to the vice of despair, the sin of avarice, and the disease of black gall; the ox represented phlegmatic sluggishness, subject to the sins of gluttony and sloth; the cat was representative of choleric cruelty, subject to pride and wrath; and the "concupiscent" rabbit's sanguine sensuality symbolized lechery and blood diseases—all as a result of Adam and Eve's having eaten of the tree of knowledge, which contaminated their originally pure blood. The concept of the four temperaments has a long history traceable to Hellenistic concepts of the four ages of man.

Dürer set his ideally proportioned forms as a plastic relief against the almost impenetrable, Pollaiuolo-inspired, dense forest background. With the utmost delicacy Dürer achieved a new height in the handling of his burin, dissolving the earlier long lines into a series of short lines that are almost dots, increasing the tonal richness and subtle modeling without loss of the sense of form. Jacopo de' Barbari's influence on Dürer both in handling and conception of these harmoniously balanced forms has here been thoroughly assimilated.

The augmented tonal quality had been achieved the year before, when Dürer took up charcoal drawing to make a profile portrait of Willibald Pirckheimer, whose massive head is magnificently accentuated. The sense of his personality is undisguised, even though Dürer minimized the fleshy details of his good friend. These richer tonalities are equally evident in the 1503 *Head of Christ*, a magnificent study in perspective, whose emotive force is accentuated by the eyes, open mouth, and upturned nostrils. The eye line itself recalls the similarly expressive eyes of German Romanesque Crucifixions. This freer style of drawing achieved the dramatic spirit of the

Christ with the Victory Standard. In both works there was a loosening of the bonds of his self-imposed classicizing style; it must be remembered that Albrecht Dürer's outlook grew out of a Gothic spirit and that he superimposed Italian ideas upon a basically northern character. The expression of the northern outlook seen in the *Apocalypse* woodcuts recurred in slightly different form in the charcoal drawings and in other works of these years.

A balancing of these two forces is seen in the *Crucified Christ* drawing of 1505[5] (Fig. 442), the

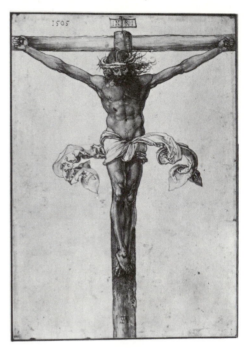

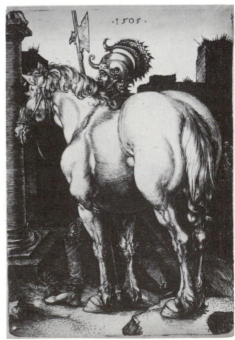

above: 442. ALBRECHT DÜRER (disputed as Hans Baldung). *Crucified Christ*. 1505. Pen and wash, 12³/₈ × 8¹/₂″. Albertina, Vienna.

right: 443. ALBRECHT DÜRER. *Great Horse* (B. 97). 1505. Engraving, 6¹/₂ × 4¹/₂″.

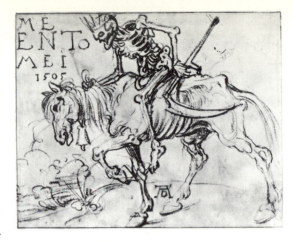

right: 444. ALBRECHT DÜRER. *Memento Mei.* 1505. Charcoal, 8 1/2 × 10 1/2". British Museum, London.

floating loincloth recalling Flemish ideas, the arms pulling from their sockets and the rough wood of the cross suggesting the Housebook Master. But the calm, bending position of the head and the body proportions suggest Italy.

Such alternation between overt drama and quiet balance, between emotional outpouring and classical idealism extends even to the two famous engravings of 1505, the *Great Horse* (Fig. 443) and the *Little Horse.* The tremendous mass of the great horse placed in perspective depth, its surface rendered as beautifully as the skin of the 1504 Eve, has a grandeur that impressed later generations. Caravaggio, for example, used the artistic idea for his *Conversion of Saul.* The *Little Horse,* so called because of its relation to the space, for both works are about the same size, shows a much more classicizing portrayal, probably inspired by Leonardo's drawings, with the horse parallel to the picture plane. A further Renaissance element is seen in the flaming brazier above, which Panofsky thought formed a contrast to the horse, the latter representing the animal passions, the flame the passions of the spirit. But again the contrast is seen between dramatic, naturalistic northern elements and the Italianate ideal.

A restatement of the 1504 concept of ideal proportions is seen in the *Satyr Family,* of 1505. However, the more animalistic character of the satyr in Dürer's mind called for a change in external aspects, so that the mother has over-large breasts and a slouching attitude, and the father, though heroic, is heavily muscled and almost gross in contrast to the *Apollo Belvedere* type of the 1504 Adam.

With an economy of line the 1505 Louvre drawing of a nude seen from the back shows a superb use of outline and delicate shading, its definite use of light and cast shadow producing the feeling of a back wall close to the figure. Here is a heightened awareness of light, which seems to have developed from the charcoal drawings and such works as the *Christ with the Victory Standard.* Earlier, light had been merely a tool to illuminate form or a compositional element, as in the 1497 portrait of Dürer's father. Here there is an awareness of light as a thing in itself, which reached a culminating stage when Dürer went to Venice.

An interest in light plays a part in the *Memento Mei* (Fig. 444), of 1505, in the British Museum. Here is Death on a gaunt horse with a bell around its neck, an exaggeration of the head in the *Little Horse.* The horse moves differently, with a roughness, freedom, and high dramatic content. This charcoal drawing may possibly relate to the reappearance of the plague in Nuremberg, but in it can again be observed the contrast of northern and southern viewpoints; the balance was never static and it shifted constantly.

In the summer or fall of 1505 Albrecht Dürer left Nuremberg for Venice, not to return until early in 1507. Almost on his arrival he received a commission for an altarpiece for the church of S. Bartolommeo from the Fondaco dei Tedeschi, the association of German merchants in Venice. This work, now badly damaged and much repainted, the *Feast of the Rose Garlands,* or *Rosenkranz Madonna,* was completed in 1506 and is now in Prague (Fig. 445). It relates to the rite of the rosary, according to tradition the invention of St. Dominic, who kneels prominently at the left. Equally prominent at the right is the Emperor Maximilian. A host of other figures surrounds the Madonna and Child, some of them portraits of Germans of Venice, among whom can be found Dürer himself. The painting illustrates the idea of a universal brotherhood of Christianity through the distribution of garlands of white roses (symbolizing the Hail Marys of the rosary and the joyful mysteries of the Passion) and red roses (symbolizing the Our Fathers and the sorrowful mysteries of the Passion) to laymen and clergy, to men and women, to rich and poor alike.

In the new kind of monumentality and new conception of space and form is seen the very clear influence of contemporary Venetian art.

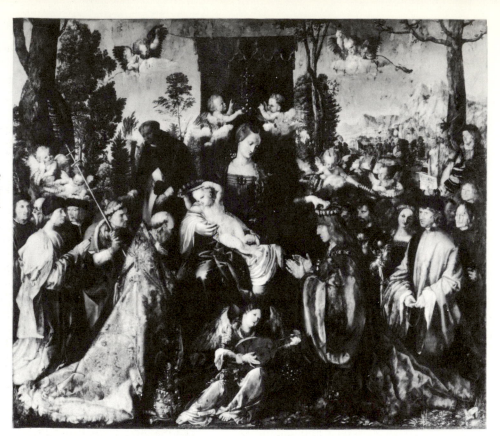

445. ALBRECHT DÜRER. *Feast of the Rose Garlands.* 1505–06. Panel, 63 5/8 × 75 5/8". National Gallery, Prague.

The solemnity of organization is very different from the proportions studies and the Nativities of the immediately preceding years. In conception as well as unity of spatial movement there is far more High Renaissance grandeur than in the earlier analytical exercises. The work was much admired and Dürer was very pleased. As a result of this and other works the Venetian Senate offered him an appointment as a city artist at 200 ducats a year, which he refused.

His letters from Venice to Willibald Pirckheimer are very revealing of his delight, his excitement, and his growth in knowledge of art and of his place in it. Pirckheimer had lent him money for the trip and burdened him with commissions to buy pearls, precious stones, finger rings, Greek books, and other things. Dürer executed these commissions and in his replies revealed that he was well received by Giovanni Bellini, who, he said, was "very old but still the best painter of them all." All men, he said, except the painters wished him well, and he must have been busy, because he wrote to Pirckheimer to ask Dürer's mother to put his younger brother Hans to work with Wolgemut if possible, saying, "I would gladly have brought him along with me to Venice and that would have been useful to me

and him, and he would have learned the language, but my mother was afraid that the sky would fall on him." In a later letter he told Pirckheimer to throw away the rings that he had sent if they did not please him and added, "What do you mean by setting me such dirty work? I have become a *gentleman* at Venice." The position of the artist in Venice was very different from his position in the north, which, of course, Pirckheimer knew, and Dürer's underlining of the word gentleman shows *his* full realization. Nevertheless, Dürer did return to Nuremberg, for basically he was northern at heart. Though he recounted that the Doge and the Patriarch came to see his painting—and he enjoyed himself to the hilt—he did return.

In one of the letters before his return he mentioned having made a picture of a type he had never made before. This may be the 1506 painting of the twelve-year-old Christ in the temple arguing with the doctors (Fig. 446), now in Lugano-Castagnola. A study exists for the head of the youthful Christ, made in a refined linear manner not seen heretofore, a manner also seen in a study of the hands in the lower left-hand corner. Such drawings make one feel more strongly than before that Dürer was basically

an engraver. The painting, executed in Rome,[6] is unusual in the presentation of figures in half length, crowded around the central figure in a strong surface design that is found in the north at this time only in the art of Bosch, though no influence from that master is implied. Instead there are suggestions of the caricatures of Leonardo and the solid, square Roman heads of Mantegna combined with long-bearded, bald-headed northern types, such as the prominent figure to the lower right, which suggests the art of Grünewald (and which it may have influenced). In the midst of this curious agglomeration of figures, the youthful Christ seems to be midway between the north and Italy. He is placed slightly above the center, which is occupied by hands shown in the classical gesture of dispute.

This work is very different from the ones Dürer had done in Italy eleven years before. What he saw then were individual details, single elements; now he saw more comprehensively, more plastically, and in a more unified fashion. Though the space is not deep and the drama of the heads is almost cacophonous, for they are shown as both flat-toned and sharply modeled by light, the effect upon the observer is that of a forcefully plastic, yet highly active, kaleidoscopic surface drama.

The Berlin *Virgin with the Siskin*, based on a Bellini formula of a frontal Virgin with a drapery hanging close behind, allowing views of a landscape on either side, was also painted in Venice; in the addition of the Infant John the Baptist it presents a specifically Tuscan motif. There is a mixture of elements, the left-hand landscape being Leonardesque and the right-hand view being far more like Venetian work. Despite this combination, it is clear that Dürer was still not an Italian; the overly plastic, shiny-surfaced angel heads above the Virgin leave no doubt of his basic affiliations. (The curious character of the Virgin herself may partially be due to repainting.) However, the work does give witness to richer, warmer concepts of color and Venetian concepts of light, which soften to some extent his almost too monumental style.

Certainly the most unusual of the works done in Venice is the Berlin *Portrait of a Young Woman* (Fig. 447). Essentially constructed out of tone and color and not out of line and hard shading, this work, with its blank background in two shades of blue to suggest sea and sky, reveals

a true sense of air and atmosphere. It is an uncharacteristic work for Dürer, for here the concept of light as an element in itself reached a culmination in Dürer's painting; its fluidity was never equaled later.

The results of the year and a half in Venice were not merely this concept (which had been

below: 446. ALBRECHT DÜRER. *Christ among the Doctors*. 1506. Panel, $25^{5}/_{8} \times 31^{1}/_{2}''$. Thyssen-Bornemisza Collection, Lugano-Castagnola.

bottom: 447. ALBRECHT DÜRER. *Portrait of a Young Woman*. 1506. Panel, $11^{1}/_{4} \times 8^{1}/_{2}''$. Gemäldegalerie, Staatliche Museen, Berlin-Dahlem.

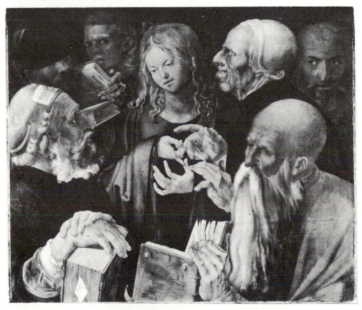

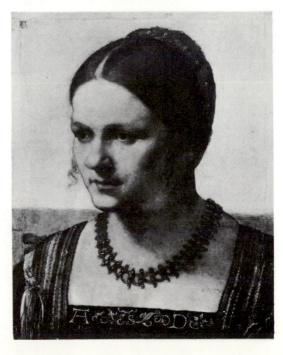

recognized earlier) and the strengthening of coloristic, luministic tendencies, but also a strengthening of Dürer's knowledge of classical conceptions and Renaissance theory. Now acquainted with the thinking of Italy in both artistic and intellectual matters (as can be concluded from his copy of *Euclid*, now in the library at Wolfenbüttel, inscribed with the information that it was bought in Venice in 1507, and from accounts of his trip to Ferrara and Bologna to see a man whom he could talk to about perspective), he returned home in 1507.

In good condition financially, for he had earned enough to pay debts and establish himself firmly as a result of this Venetian sojourn, Dürer showed new qualities in his art of the succeeding years. A change is seen in his concepts of proportion, as in the painted *Adam and Eve* in the Prado of 1507. Adam is more slender, smoother in surface treatment, and seemingly almost floats above the ground, an effect produced by the lighting around the relaxed foot. An air of swaying, Gothic delicacy is imparted to the forms, with a proto-Mannerism discernible in the willowy figures with their fluid outlines. Their proportions have been altered, and they are now nine heads tall instead of eight, as in the 1504 engraving. The rocky ground upon which they are placed is probably a device to suggest the world into which they are thrust, a device that was to be taken over by Cranach.

In 1508 Dürer painted for Frederick the Wise a small *Martyrdom of the Ten Thousand* (Fig. 448), now in Vienna, which he based on his woodcut of the same subject of about ten years earlier, and to which he added certain elements of Crucifixion iconography. The results are, for Dürer, unfortunate. Dürer and Pirckheimer are seen in the center. The artist holds a flag on which he identified himself as "aleman," that is, as German, rather than as a citizen of Nuremberg. The proportions of the forms as they recede in space have been carefully worked out, and so has the modeling of each and every form. Though rhythmically united, it is overly plasticized and represents the worst error of artistic judgment that Dürer ever made. There is just too much going on; nowhere did he subordinate sufficiently. His color is again rather hard, for the richness of Venetian color was essentially foreign to him. In a way Dürer's very evident struggles with color are amusing, for he was never truly a colorist in paint. His graphic works, however, profited immensely after his return. Thus only in paint was Venetian influence short-lived.

In 1507 he had received an order for an altarpiece to be placed in the Dominican church in Frankfurt. It was given by Jakob Heller, a mer-

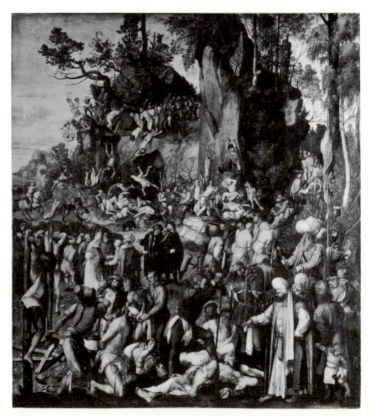

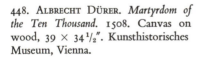

448. ALBRECHT DÜRER. *Martyrdom of the Ten Thousand*. 1508. Canvas on wood, 39 × 34¹/₂″. Kunsthistorisches Museum, Vienna.

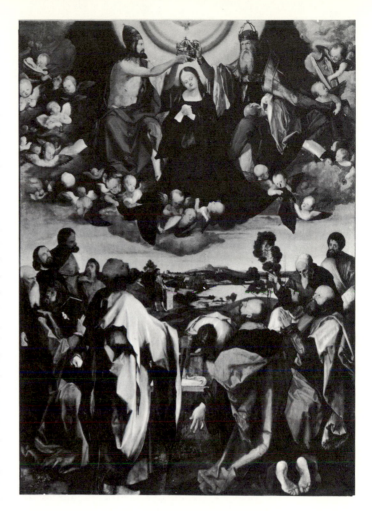

right: 449. COPY BY JOBST HARRICH AFTER DÜRER. Central panel of the *Heller Altarpiece*. Copy 1614, original 1508–09 (destroyed by fire). Panel, 74 3/8 × 54 3/8″. Historisches Museum, Frankfurt.

chant of that city whom he had met in his cousin's house. The work, executed in 1508 and 1509, was unfortunately destroyed by fire in 1729, but a copy of the central panel had been made in 1614 by Jobst Harrich. Side panels were made by Dürer's shop and by Grünewald later.

Dürer's letters to Heller have been preserved and make amusing reading,[7] for he made Heller a good price and then, after putting far more work into the painting than he apparently intended originally, asked for and got more money. Though Heller was apparently a very shrewd merchant, he more than met his match in Dürer, as the letters clearly show. Dürer assured Heller that he would touch no other painting while working on the panel, which meant, however, not that he would do nothing else during this time but that the daylight hours would be spent in painting, the nights being reserved for drawing and print making. When Heller, whose letters to Dürer are unfortunately lost, apparently insisted on the greatest care in executing the work, he received a reply that is an insight into contemporary practice. Dürer immediately denied that he had said he would paint it with the greatest possible care:

> If I did, I was out of my senses, for in my whole lifetime I should scarcely finish it. With such extraordinary care I can hardly finish a face in half a year; now your picture contains nearly 100 faces, not reckoning the drapery and landscape and other things in it. Besides, who ever heard of doing such work for an altarpiece? No one could see it.

He assured Heller that he was using the finest colors and that the central panel would take him about thirteen months to execute, and in a later letter told Heller that he should have painted it in the way Heller had bargained for, because then he would have finished it in half a year. But Dürer did expend great pains on the work, for we read:

> I have painted it with great care, as you will see, using none but the best colors I could get. It is painted with good ultramarine under, and over, and over that again, some five or six times; and then

after it was finished I painted it again twice over so that it may last a long time. If it is kept clean I know it will remain bright and fresh 500 years, for it is not done as men are wont to paint. So have it kept clean and don't let it be touched or sprinkled with holy water.

Dürer also instructed Heller on how to install the painting:

> Let it hang forward two or three finger breadths, for then the light is good to see it by. And when I come over to you, say in one, two, or three years' time, if the picture is properly dry, it must be taken down and I will varnish it over anew with some excellent varnish which no one else can make; it will then last 100 years longer than it would have before. But don't let anybody else varnish it, for all other varnishes are yellow, and the picture would be ruined for you. And if a thing on which I have spent more than a year's work were ruined, it would be a grief to me.

The copy (Fig. 449) shows that the theme was a combination of the Ascension of the Vir-

gin and her Coronation, with the apostles grouped around her empty tomb in the center. In the sky above angels supported the kneeling Virgin as she was about to be crowned by Christ in a papal tiara and God the Father in a crown much like the iron crown in Monza. A similar composition, the *Coronation of the Virgin*, in the Vatican, without the figure of God the Father, was painted by Raphael in 1503. Whereas Raphael arranged his figures in a horizontal composition with two zones, Dürer curved his surface design to provide a greater sense of contact between earthly and heavenly zones. The compositional unity is greater than anything he had achieved in Venice, and it anticipates Titian's equally High Renaissance *Assunta* in Sta. Maria dei Frari. Though in facial detail the figures are often northern, and some show northern iconography, there is an over-all subordination of detail to the whole that is unprecedented in Dürer's art. Its destruction was a calamity.

Numerous drawings exist for this work, the *Praying Hands* being the most famous of Dürer's studies. As his best-known work to the lay public, it has become ubiquitous in modern advertising of religious items and events and—cast in plaster—a common piece of religious goods; therefore it is hard for us to slough the effect of rank commercialism and to see the hands clearly as a work of art. However, Dürer captured, through the delicate poise of their position, a sense of religiousness comparable to that of the hands of Donatello's *Magdalen* in the Baptistry in Florence. The drawing for the protruding feet of the kneeling saint slightly to the right of center is equally fine, and it shows a slightly different aspect of Dürer's drawing style. In these works, as in the head of the old apostle to the right with a pointed beard and in the drapery study for the figure of God the Son, among the many studies for the *Heller Altarpiece*, there is a greater luminosity than before; Dürer has realized the potentialities of a dominant middle tone. He moves up to lights and down to darks, so that a new, highly painterly quality results. There is no longer the feeling of combining northern and Renaissance ideas; this is a true assimilation, in which Dürer composed like a High Renaissance Italian, thinking in terms of monumentality and unity of form, shape, space, and light.

Equally advanced is his *Adoration of the Trinity* (Pl. 23, after p. 308), in Vienna, of 1508-11.

Though he had vowed to Heller to stick to engraving, since "very careful nicety does not pay," he painted this work for Matthew Landauer, who with Erasmus Schiltkrot had founded an almshouse in Nuremberg in 1501 and added a chapel to it in 1508-09. The painting was originally the chapel altarpiece. Executed as carefully as Heller's altarpiece must have been, this is the last of Dürer's great pictures of this period.

Iconographically it is an Adoration of the Trinity combined with the *City of God* of St. Augustine, with all the people and classes of society joining in the adoration. Originally it possessed a sculptured frame, designed by Dürer, showing the Last Judgment. Landauer's portrait in the work was painted from a magnificent preserved sketch in Frankfurt that reveals a devoutness of quiet intensity. He, along with kings, popes and cardinals, bishops and commoners, a multitude often being represented by a single figure, adore the figure of Christ on the Cross upheld by God the Father, as the Dove hovers above.

The perspective of forms in space is handled as ably as in the *Martyrdom of the Ten Thousand*, but the forms here are unified into a coherent whole in this similar artistic problem by subordinating the vast multitude to the large movement of which they are a part. The perspective is aided by the direction of the glances of the figures, predominantly toward the Crucified Christ, though variations were introduced to avoid monotony. The result is the realization of the sublimity of Dürer's vision, which elevated the figures into a natural space in midair above the world below. In this respect it is reminiscent of the superb accomplishment in St. John's Vision of Christ and the Seven Candlesticks, from the woodcut series of the *Apocalypse*. The design has often been related to Raphael's *Sistine Madonna*, but its perspective movement carries the eye deeper into space both above and below to reinforce the supernatural drama of the Adoration. Below, the world landscape differs from that in the St. Michael and the Dragon from the *Apocalypse*, for instead of being a section of the natural world framed by the picture border, it conveys a sense of the world's extension beyond the empty bay reaching to the horizon. At the lower right Albrecht Dürer himself stands beside a table next to the inscription

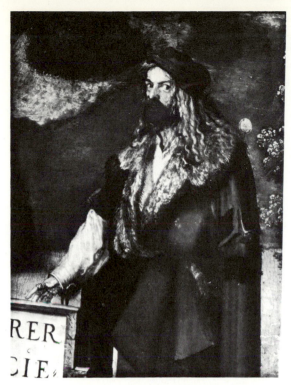

450. ALBRECHT DÜRER. *Adoration of the Trinity*, detail with self-portrait. 1508–11. Panel, 53 1/8 × 48 5/8″. Kunsthistorisches Museum, Vienna.

with his name and the date of completion (Fig. 450). Despite the amplitude of the earthly landscape, with its finite sweep of clouds across the background, this zone, with its proud painter, is dwarfed and insignificant in relation to the heavenly world above.

Withal there is a hardness and sharpness of outline, and color is still hard, though it is softer than in the previous works. That Dürer overworked his paintings is also seen in the Berlin *Praying Madonna* of 1511. The hand of the engraver is strongly visible, for Dürer never truly developed his painting style.

After 1511 Dürer almost abandoned painting, turning again to engraving to emphasize and further develop its pictorial potentialities. In 1511 he published what he called his "three great books": the *Apocalypse*, in its third edition but including an added title page with a woodcut of the Virgin appearing to John; the complete *Great Passion*, with five added woodcuts dated 1510, and the complete *Life of the Virgin*, with two added woodcuts and a title page showing the Virgin on a crescent moon. He also issued in this year his *Small Passion*, a series of 37 smaller woodcuts which, like the *Great Passion*, was accompanied by Latin poems written by Chel-

donius, a Benedictine of Nuremberg. All the books bear the Nuremberg imprint of "Albrecht Dürer the Painter," and show Dürer as printer, publisher, and bookseller.

The woodcut *Small Passion*, two cuts as early as 1509, shows enriched tone and greater complexity, a result of his continuous concern for painterly qualities after his return from Venice. There is a new magnitude of conception in the cuts for this series and in the additions to the *Great Passion*.

The cuts added to the series of the *Life of the Virgin* are the Dormition of the Virgin and the Presentation in the Temple. In terms of drama and conception they parallel the *Adoration of the Trinity*. The Dormition differs strongly from Schongauer's *Death of the Virgin* (Fig. 387), with its prominent candlestick in the foreground. Dürer varied the foreground to assert an architectonic spirit, created depth by the sculpturesque organization of form and space, and added tonalities of surface and feeling. The Presentation in the Temple is set in a large hall, the figures so placed as to harmonize with its spatial grandeur. The setting is vitalized by such notes as the arm of the man around the foremost post. A *repoussoir* element, it creates in the architectural interior something of the same effect of diagonal movement that he achieved in his earlier landscapes by balancing a close form on one side against a deep space on the other. In this scene, however, there are also height variations, which add to the impression of spatial articulation.

The woodcuts added to the *Great Passion* were conceived in what Panofsky has called a "visionized, subjective" manner. In the Resurrection (Fig. 451), of 1510, diagonal lines are used to create an effect of weightlessness, and the figure of Christ is separated from the soldiers by cloud forms. Dürer also separated the natural from the supernatural by means of light, differentiating the paler form of the risen Christ from the darker forms of the guards. In form the figure of Christ is related to his representations of Adam in 1507 and 1504, the latter predominating in proportion, the former in elegance.

In grandeur of conception the *Great Passion* additions were equaled, or outstripped, by the *Trinitarian Pietà* of the following year (Fig. 452), a work that influenced such southern painters as Cigoli, Tintoretto, and even El Greco, whose treatment of the theme combined Dürer and

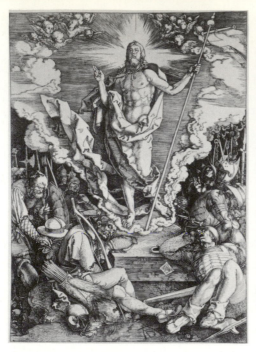

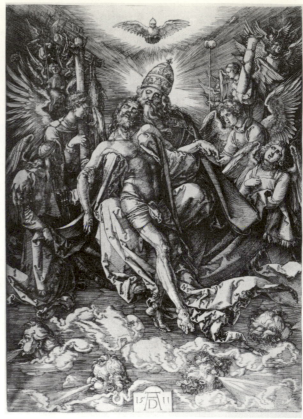

above: 451. ALBRECHT DÜRER. Resurrection, from the *Great Passion* series (B. 122). 1510. Woodcut, *c.* 15 1/2 × 11″.

right: 452. ALBRECHT DÜRER. *Trinitarian Pietà* (B. 15). 1511. Woodcut, 15 1/2 × 11 1/4″.

Michelangelo. As usual, Dürer built upon his earlier ideas, carrying forward in this instance the spirit of St. John's Vision of Christ and the Seven Candlesticks from the *Apocalypse*. Here, however, the raw emotionalism of the *Apocalypse* woodcuts has been refined to a greater subtlety and control, and the over-all design, though seemingly more complex because of the tonal quality and the variety of subordinated detail, has been simplified. The effective coloristic device seen in the Resurrection reappears in the differentiation of lighter and darker forms, and there is a similar use of diagonal lines.

After these works a change took place; Dürer attempted to reduce his crowded detail and overemphatic modeling so as to create a more fluid style. In his search for a tonal subtlety that would achieve in his graphic art the softer pictorial quality he was losing so rapidly in painting, he took up dry point, which first appears in his *St. Jerome by a Pollard Willow*, of 1512. By experimenting with dry point and later with etching, he strove to free his style from an inherent drift toward hardness. When he found that the dry-point plates wore too rapidly, he turned to etching on iron. He also abandoned this as a medium in favor of a light etch as a timesaver

on his engravings, going over the etch with the burin. (The first instance of this process is the *St. Jerome in His Study*, of 1514.)

The dry-point *St. Jerome* that he did in 1512 is a monumental figure with a majesty created by the closeness of view and idealization of the figure. Wonderful tonal variety characterizes this work, but Dürer returned to engraving in the two following years to produce his great trio: *Knight, Death, and the Devil*, of 1513 (Fig. 453); *St. Jerome in His Study*, of 1514 (Fig. 454); and *Melencolia I* (Fig. 455). Dürer conceived of them as a unit with a meaning that Panofsky and Saxl have magnificently elucidated. The *Knight, Death, and the Devil* was intended to typify the life of the Christian in the practical world of decision and action, that is, the *vita activa*; *St. Jerome in His Study* symbolized the life of the saint in the spiritual world of sacred contemplation, that is, the *vita contemplativa*; and the *Melencolia I* was meant to represent the life of the secular genius in the rational and imaginative world of science and art.

The *Knight, Death, and the Devil*, reminiscent compositionally and spatially of the 1504 *Fall of Man*, combines Germanic and Italian Renaissance motifs. The knight had appeared in a

drawing of a mounted *Landsknecht* of 1498, and the horse was a "souvenir" of his Venetian trip, with some decorative motifs derived from Verrocchio but with the added influence of Leonardo, whose horse sketches show a lifted hind leg. This specific detail is not to be found in Verrocchio's or Donatello's equestrian statues, both of which Dürer knew. The combination results in a more dynamic form than the *Small Horse*, of 1505. The knight, personification of Christian faith, is accompanied by a dog symbolizing the virtues of untiring zeal, learning, and truthful reasoning. Little heed, then, is paid to Death or the Devil, who are markedly subordinated to the steadfastness of the knight.

The engraving of *St. Jerome in His Study* shows the scholar in his sunlit room, with gentle light streaming through bottle-glass windows that cast their shadows upon the wall, softly illuminating a space into which the spectator seems to be admitted. The even tonality of the scene, more pictorial in character than the more strongly contrasted ambiance of the knight, and the perspective vanishing point placed above the eye level of the spectator at the right-hand side, rather than in or close to the center, aid the sense of intimacy. Elements in the room are orthogonally placed to further the perspective design. The sleepy lion and the dog also contribute to the peace and quiet of a setting so ex-

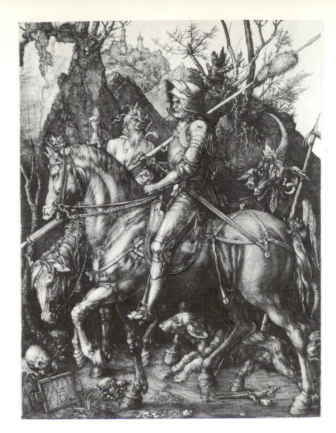

above: 453. ALBRECHT DÜRER. *Knight, Death, and the Devil* (B. 98). 1513. Engraving, *c.* $9^{3}/_{4} \times 7^{1}/_{2}''$.

below left: 454. ALBRECHT DÜRER. *St. Jerome in His Study* (B. 60). 1514. Engraving, $9^{3}/_{4} \times 7^{3}/_{8}''$.

below: 455. ALBRECHT DÜRER. *Melencolia I* (B. 71). 1514. Engraving (first state), $9^{3}/_{8} \times 6^{5}/_{8}''$.

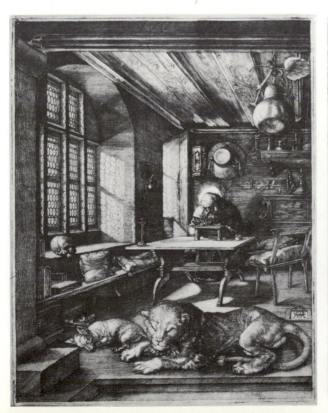

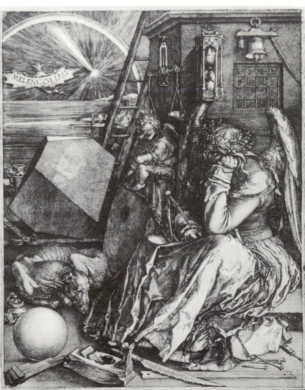

pressive of the contemplative spirit symbolized by the saint.

Of the three works the most involved iconographically is the *Melencolia I*, of 1514, symbolic of one of the four humors, or temperaments. The melancholic humor, according to late-medieval thought was sluggish, lazy, surly, mournful, absent-minded, clumsy, stingy, greedy, malicious, cowardly, unfaithful, irreverent, and sleepy; the melancholy man shunned his fellows, despised the opposite sex, which was inimical to him, and was inclined to study. As a result he was the most likely prey of insanity. Previous illustrations of the humors had often presented each as a single figure; such representations had appeared in medieval cathedrals as Vices. There was also a scenic type, found in incunabula, in which the humor was represented by couples.

Under the influence of the Florentine Neoplatonists the melancholic type was elevated to a much higher position in the 16th century than it had occupied previously. Marsilio Ficino, head of the Neoplatonic Academy, himself a Saturnine melancholic (Saturn, most distant and slowest of the planets to make its revolution about the earth, was closely linked with the melancholic in medieval thought), considered the melancholic's *furor melancholicus* and the *furor divinus*, or divine frenzy, as related if not identical. By twisting the tenet that all great men were melancholics to say that all melancholics were great men, the door was opened to an elevation of the type. Thus Saturn, highest of the planets, and Melancholy were associated with high thought. Dürer's *Melencolia* corresponds

to this transformation, for he presented the melancholic as a representative, in Neoplatonic terms, of an art, that of geometry, but also as a *melancholia artificialis*, or artist's melancholy. Thus Melancholy sits in perplexed reflection upon geometrical matters but is unable to act, while the child on the millstone, symbolic of practical skill which acts unthinkingly, is happily busy. Artistic mastery thus must come from a union of unthinking, freely acting, practical skill with the learned, inert Melancholy, symbolic of theoretical insight. When theory and practice are not united, the result is an earthbound impotence and dejection, the first stage of melancholy, that is, Melencolia I.

The scattered forms and objects are related to this basic conflict; the comet, the dog, the bat, the dark face of the main figure—all relate to Saturn and to Melancholy. Saturn's deleterious effects could be counteracted by the appeal to Jupiter, symbolized in the magic square or 16-sided *mensula jovis* on the wall, for Jupiter symbolized the soul as Saturn symbolized the mind. Dürer clearly had this in view, for in a sketch he noted that the key signified power and the purse denoted wealth. His interest in theoretical matters, seen again and again, appears once more in a most recondite manner; and Dürer was not alone in this interest. As Panofsky has shown,[8] the Neoplatonism expressed here is also found in Michelangelo's sculpture of Lorenzo de' Medici in the Medici Chapel, in Florence.

The implied relationship to Michelangelo takes another form in Dürer's 1513 engraving of the *Angels Holding the Sudarium* (Fig. 456), in which the head of Christ is a consummation of the spirit of the Passion series. Copied without the angels by his pupil, Hans Sebald Beham, it was widely circulated. It reflects an earlier 15th-century type, the forms being crowded into a space so narrow as to be almost insufficient for their existence and seemingly pressed in by the frame. The effect is that of tremendously powerful angelic forms, an effect also to be found in the later panels of the Sistine ceiling by Michelangelo. Whether this is a purely fortuitous relationship is hard to say, but there is an attributed work that also suggests a relationship to Michelangelo. This is an engraving, apparently of a few years later, with four figures symbolic of the four temperaments, to which is added a copy of Michelangelo's portrait. Not

456. ALBRECHT DÜRER. *Angels Holding the Sudarium* (B. 25). 1513. Engraving, 4 × 5½″.

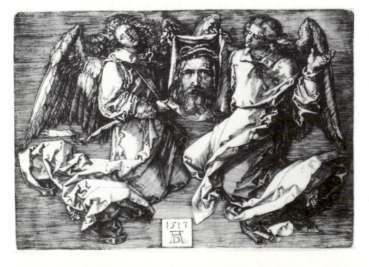

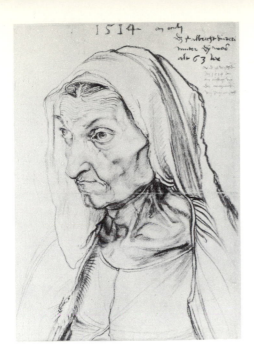

left: 457. ALBRECHT DÜRER. *Mother of the Artist.* 1514. Drawing, $16^1/_2 \times 11^7/_8$″. Kupferstichkabinett, Staatliche Museen, Berlin-Dahlem.

the best of the works ascribed to Dürer, it is, nevertheless, an interesting enigma of Italian relationships.

A largeness of dramatic conception is also found in the Berlin drawing of 1514 of his mother (Fig. 457). In this year his mother died, as is clear from the inscription: "That is Albrecht Dürer's mother; she was 63 years old. She died in the year 1514 on the Tuesday before Rogation week about two hours before night." There is an account in Dürer's writings of her death, from which his reverence and respect for her clearly rise to the surface; in the charcoal drawing, with the emotionalism he commonly reserved for this medium, he presents Barbara Dürer in a strange contrast. Were is not for the left eye, almost out of its socket, one would imagine this to be the portrait of a woman who drove a hard bargain and who gave little affection or love. The left side, however, transforms this into a face whose spiritual power and inner intensity were clearly seen by the artist.

A like drama is observable in Dürer's 1516 portrait, in Nuremberg, of his old teacher, Michael Wolgemut. The head of the determined old man emerges from the dark background to meet the strong light which reveals by the pictorialism of its conception and execution an immense inner force.

At this period Dürer continued to experiment to increase the tonal richness of his graphic style. He etched several works on iron, among them the *Agony in the Garden*, of 1515, with a rich but

somewhat labored surface, and an *Angel with the Symbols of the Passion*, of 1516, equally active in "color" and form. The most famous is the last, the *Great Cannon*, of 1518, in which Dürer represented himself in the second figure. This is less obviously pictorial than his earlier works, and the marking out of the town background is used as a foil for the foreground activity in a composition that is a much more subtle variation on the older manner of diagonal oppositions.

During the period of his experiments with new possibilities in the graphic processes, Dürer was also working for Emperor Maximilian I. Their first contact, which possibly came in the course of the monarch's visit to Nuremberg in February of 1512, eventuated in Dürer's appointment in 1515 as a court painter with an annual salary of 100 florins. From a modern standpoint the most curious of the works that Dürer designed and supervised for Maximilian was the *Triumphal Arch* (Fig. 458), an immense print made from 192 wood blocks and measuring $11^1/_2 \times 9^3/_4$ feet. Johannes Stabius, astronomer, poet, and historiographer, was responsible for the program; the design of the architectural framework was the work of Jorg Kölderer, architect of Innsbruck, while Dürer was chief designer, with Pirckheimer serving as the chief aid in working out the iconography. The design was done by July, 1515, and the cutting by 1517. Its conception was apparently due to the Emperor, who had the arch filled with a variety of events related to himself and his genealogy. The doorways (Portal of Fame, Portal of Honor and Power, Portal of Nobility) to the arch are almost lost in the vast surface array of scenes, in which the Emperor is presented in an aedicula in front of the cupola, within which is the mystery of the Egyptian hieroglyphs. Supposedly resembling a monument of antiquity, the whole fabulous effect is not merely unclear but mannered in its wayward northern Humanism, which has suggested a relationship to South German and Swiss decorated house fronts. Extremely complex, too large to apprehend, and too detailed to comprehend, it is a megalomaniac work which has its only parallel in the *Triumphal Procession*. Worked out from the Emperor's pro-

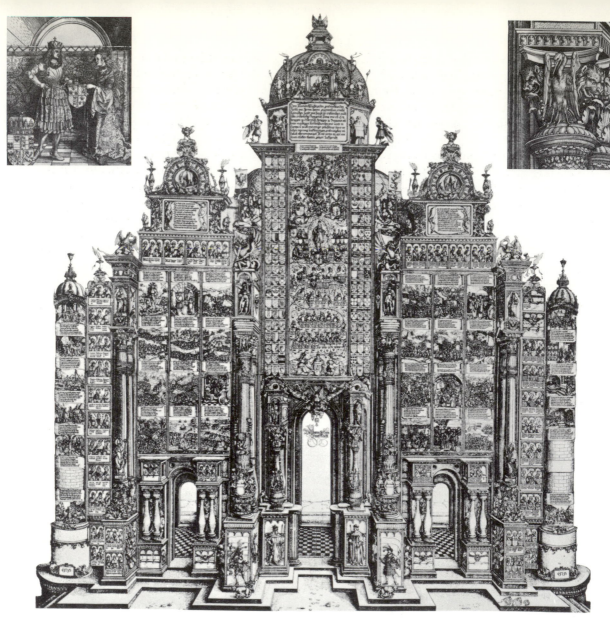

458. ALBRECHT DÜRER (AND OTHERS). *Triumphal Arch* (B. 138), with two details. 1515–17.
Woodcut (192 blocks), *c.* 10′ × 9′4″ (without inscription).

gram in 1512, the *Procession* was executed later, with woodcuts by a number of artists: Beck, Altdorfer, Huber, Schäufflein, Springinklee, and Dürer, whose portion was done between 1516 and 1518. It was brought to an end by the death of Maximilian in 1519, and what was completed was published in 1526 as a sheet 60 yards long. The triumphal procession, an idea dear to the Renaissance, is here seen in its northern expression, created with the aid of the recondite Humanists at the Emperor's court.

The Emperor also commissioned a *Prayer Book*, which was printed by Hans Schönsperger of Augsburg. He completed the printing of ten copies by the end of 1513; each of the existing five is different, so that it has been concluded that this was a proof printing. Between 1513 and 1515 Dürer decorated 45 leaves, beginning with red pen lines, later adding other colors, the intent apparently being to print the work in its final form with colored woodcuts, a comparatively rare practice at this period. Wonderfully alive, occasionally fantastic, Dürer's variety of marginal illustrations are a delight to the eye for their artistic quality and their mannered expression. The last work for Maximilian was a woodcut portrait of 1518 which reflects a Flemish scheme.

Other works were produced during this period, when his style has been described as decorative. The term is not quite exact, for only the works for Maximilian are decorative, as was essentially their intent. Somewhat related is the *Rhinoceros* print, of 1515, made after a description. Possibly a drawing had reached Dürer in Nuremberg after the landing of one such beast in Lisbon. Dürer had much earlier shown an interest in comparable ideas in his *Monstrous Sow of Landser* of the 1490s.

During this period Dürer was making engravings, doing a few paintings, and working on his books on theory. His shop was now very well developed, and he was successfully selling his "books"; in short, his position was well established. One of his finest engraving of this period is his 1519 *St. Anthony before a City* (Fig. 459). The pyramidally shaped saint is seated in the right foreground, the town behind repeating his monumental form. A magnificent tonality pervades the whole atmosphere, in keeping with the reflective spirit of the hooded saint, clearly identified by his T-staff and bell. Technically of the utmost richness, yet not labored, the work combines delicacy and fineness of detail in a new union with monumentally conceived form.

A new spirit seems to pervade the work, perhaps in response to the Lutheran movement, for there are no devils present to tempt the saint. If this be a temptation of St. Anthony, a theme then at the height of its popularity, it is a temptation in a new, Humanistic, Renaissance sense; his eyes hidden, as he sits with his book in his hand, St. Anthony reflects and struggles inwardly against sin. In the medieval mind sin was visited upon man by the Devil with God's permission; man could but resist and try to achieve grace by belief in Christ. Thus evil was something external, and man was a mere instrument, upon whom the Devil could play as he wished. This passive role is here exchanged in Dürer's conception for an active role of resistance to temptations that are internal and individual; Anthony struggles against human forces of temptation that arise within himself. This must be the only reason for the scene, for Dürer's works always have meaning; his subjects are never purely formal essays. The individualism of Lutheran belief, the stress upon the individual's relationship to God, to which we know Dürer was sympathetic, seems to have found expression here. It is significant that other artists of about this period revived not the figure of the Devil but the theme of the Dance of Death. The earlier connection of Sin and Death now seems compartmentalized; Death acquired an active role in the artistic thought of this era, as Sin receded in artistic prominence.

Between July, 1520, and the same month in the year following, Dürer took his fourth important journey, another trip to the Lowlands. Fortunately he kept a diary, which has been preserved, of this trip made ostensibly to attend the coronation of Charles V at Aachen and to petition for the renewal of his pension, which had been cut off by the death of Maximilian. He took his wife and her maid with him, though he recorded that his wife often ate alone. In exchange for paintings and engravings he received a pass from the bishop of Bamberg, which enabled him to go down the Rhine toll-free as far as Cologne. So down the Rhine he traveled, keeping a record of all his expenditures, large and small, recording the receptions in his honor at the centers along his route where he stopped. At Cologne he visited with his cousin Niklas, to whom he presented a gift, and was well received by the painters. From there he went to Antwerp, where he was received as an honored guest.

Well impressed by the prosperity and industry of the Netherlands, he met such leading painters as Quinten Metsys and Joachim Patinir and attended the wedding of the latter. He recorded his impression of the decorations being readied for the triumphal entry of Charles V into Antwerp and noted their cost as 4,000 florins, 1,000 times the price he had charged for the

459. ALBRECHT DÜRER. *St. Anthony before a City* (B. 58). 1519. Engraving, 3 7/8 × 5 5/8".

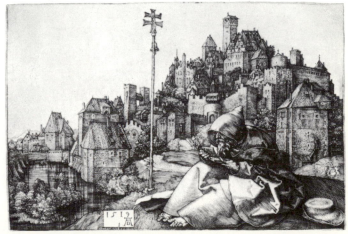

Heller Altarpiece. In Brussels he saw Rogier van der Weyden's *Justice* paintings, the palace, and the zoo behind it. Selling his prints or exchanging them, making portraits in charcoal and in pen as he went from place to place, he bought curios to send back to Nuremberg and saw the sights, recording, for example, his deep impression of the gold, silver, ornaments, and articles of daily life imported from the newly conquered land of Mexico. Bernard van Orley invited him to a costly dinner, and he met Erasmus, whose portrait he also "took." Bernard van Orley and Lucas van Leyden (with whom he traded engravings) are two of the artists of the period of whom he made portrait drawings that have fortunately been preserved. He made drawings of a lion in the zoo and later went to Zeeland to see a gigantic whale that had been washed up on the shore. On October 23 he was at Aachen for the coronation, and there he recorded that he had given Mathis 2 florins worth of art wares. This last note probably refers to Grünewald, for 2 florins worth of his wares was a large amount. From there he went to Cologne, where he paid to see Stephan Lochner's altarpiece and to have his pension renewed by the new emperor.

After the coronation and the trip to Cologne he returned to Antwerp, where earlier he had given a number of prints to Thomas of Bologna to be sent to Rome and traded for "Raphael's work," that is, prints after Raphael by Marcantonio Raimondi. Like a modern tourist he climbed

to the top of the tower of Antwerp Cathedral to enjoy the view. When the winter was over, he took a trip to Bruges and to Ghent, in the former seeing works by Jan van Eyck, Rogier and Hugo, as well as Michelangelo's *Madonna*. At Ghent he set down his impression of the *Ghent Altarpiece*, "a most precious painting, full of thought...." Returning to Antwerp in time to attend the wedding of Patinir, he then went to Malines to see Margaret of Austria, the former and future regent, to whom he made costly presents; but, as he recorded, his request for Jacopo de' Barbari's sketchbook was rejected and he received nothing in return. In June he had reckoned up his bill and was ready to leave when the King of Denmark gave a banquet, to which he invited Dürer. After this he returned home.

The trip, though he noted that he had lost money on it, was thoroughly successful and thoroughly enjoyed. He had met many people, had painted, drawn in charcoal and "metalpoint," had traded for all manner of things, some of which he baled up and shipped back to Nuremberg, and had been artistically stimulated, for his subsequent works show a reinforced feeling for tonalities.

Even the works executed in the Netherlands and immediately after the return show this, for example, the *Portrait of a Man* (Bernhard von Resten[?]), in Dresden, of 1521 (Fig. 460), with its Flemish portrait scheme of a large hat as a device to frame the face in three-quarter view

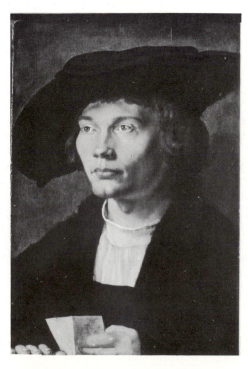

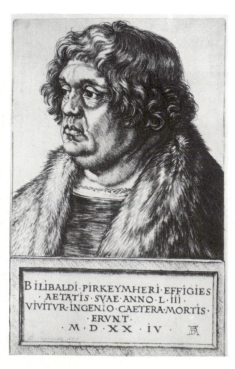

left: 460. ALBRECHT DÜRER. *Portrait of a Man* (Bernhard von Resten [?]). 1521. Panel, 17 $^7/_8$ × 14 $^3/_4$". Gemäldegalerie Alte Meister, Staatliche Kunstsammlungen, Dresden.

right: 461. ALBRECHT DÜRER. *Willibald Pirckheimer* (B. 106). 1524. Engraving, 7 $^1/_8$ × 4 $^1/_2$".

and the bust-length figure with the hands showing on the edge of the frame. Less dramatically treated than in the Wolgemut portrait, the face is more evenly lighted, to create a sense of inner poise and composure. The 1521 painting in Lisbon of the *memento mori* theme of St. Jerome reflecting over a skull, for which there exists a preparatory drawing of an old, bearded man with his hand to his head, was probably executed in the Netherlands, for it was much copied by Flemish artists. The softer pictorialism in both drawing and painting, with a dominance of middle tones, is indicative of the effect that the Netherlands had upon the master engraver of Nuremberg. White plays an important part in heightening the lights in the drawing.

In the years after the Netherlands trip there was a new understanding and artistic comprehension built upon all that had gone before. Reinforced by coloristic ideas that had been impressed on him in the Netherlands, as they had been earlier in Venice, Dürer's feeling for greater tonality was achieved without the labored surface quality of the post-Venetian works. He enlarged his concept of atmosphere and color, which had been brought into balance in his engravings and woodcuts in the years before 1520. An example is the woodcut portrait of Ulrich Varnbühler of 1522. As in the Von Resten portrait of the previous year, the hat is employed as a framing and silhouetting device in a bust portrait, but the more archaic motif of the hands

on the sill is omitted. The result is an impressive accentuation of the individual. Superb variety in the details heightens the coloristic feeling imparted by this life-size woodcut.

A refinement of textural variety without loss of monumentality is also met in the 1524 engraved portrait of *Willibald Pirckheimer* (Fig. 461); in place of the hat used in the Varnbühler portrait a blank background silhouettes the figure. The result is a more formal portrait, in which any sense of atmosphere around the figure is completely eliminated in favor of atmospheric conviction within. Dürer's heavy-jawed, corpulent friend appears wonderfully sympathetic, alive yet full of dignity.

The 1523 woodcut of the *Last Supper* was, according to Panofsky, intended to relate to Lutheran thought, for the table is bare except for the chalice, and the paschal lamb is conspicuously absent from the plate prominently placed in the foreground. Somewhat related to Leonardo's conception of the theme is the grouping in three's at the ends of the table, and the low perspective viewpoint emphasizes the symbolic import of the representation.

A monumentalized simplicity, in which grandeur is united with a reinforced pictorialism, characterizes the portraits of the late years before Dürer's death in 1528, the *Four Apostles*, in Munich, and the 1523 drawing of *St. Philip*, now in the Albertina in Vienna. This last was the foundation for the great engraving of the saint, made three years later, and for the St. Paul of the *Four Apostles*.

During this last period Dürer was drawing and painting less and writing more, as he was occupied with his books on measurement and proportion. In 1526 he engraved his portrait of *Erasmus* (Fig. 462), for which he had made a sketch in the Netherlands. Possibly the organization was influenced by a Quinten Metsys portrait medallion sent by Erasmus to Pirckheimer. In this portrait he used light in an unusual new way; the inscription, in Latin and Greek, is placed on the back wall in what seems to be a picture frame beside the scholar at his writing desk, but the framed area also seems to be a window that lights the scene in opposition to another light from the front. The idea of the

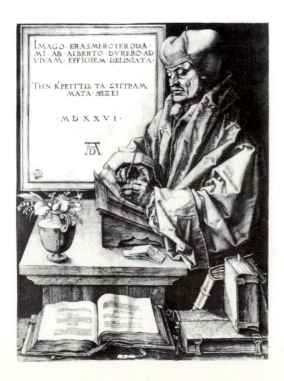

left: 462. ALBRECHT DÜRER. *Erasmus* (B. 107). 1526. Engraving, $9^{3}/_{4} \times 7^{5}/_{8}''$.

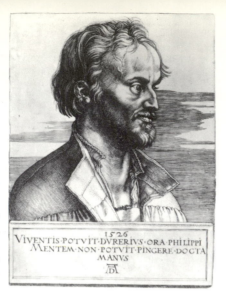

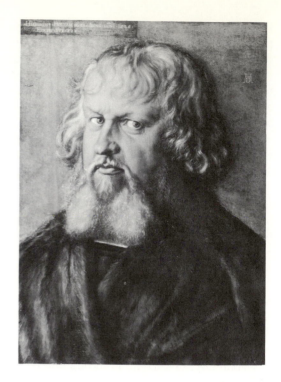

left: 463. ALBRECHT DÜRER. *Melanchthon* (B. 105). 1526. Engraving, 6⁷⁄₈ × 5″.

right: 464. ALBRECHT DÜRER. *Hieronymus Holzschuher.* 1526. Panel, 18⁷⁄₈ × 14¹⁄₈″. Gemälde-galerie, Staatliche Museen, Berlin-Dahlem.

frame-window seems an almost intentionally confusing device that suggests Manneristic practices. The common consideration of Italian Mannerism as an emphasis on skill, grace, and intuitive judgment supplanting order and logic is not applicable here, but this is ingenious; it is more intuitively conceived than before, and, though Dürer did not abandon all concepts of order and rule, his enigmatic use of light produces a very different effect from that of the preceding, clearly comprehensible portraits.

This new animation of the internal and constituent elements appears also in the *Melanchthon* portrait engraving of the same year (Fig. 463). Melanchthon, one of the leading Protestant intellectuals, had been summoned to Nuremberg to reorganize its schools and its religious instruction. As in the Pirckheimer portrait, there is an inscription with identification and date, but here it serves as a balustrade at the bottom, and instead of the blank background behind the subject's head, there are linear clouds that set the form against a vast space, recalling the similar conception of background in the 1506 portrait of a Venetian girl. In contrast to the close space of the Varnbühler and Erasmus portraits and the virtual denial of external space of the Pirckheimer portrait, this deep space behind the head suggests a dramatic accentuation of the individual's place in the thinking of the times. (Melanchthon was an outstanding representative of the new religion Dürer supported.) Monumentality is enhanced by the perspective of the head and by the subtle silhouette of the large brow set against the higher space of the sky to imply high thought and great mental ability.

This is also the period of the 1526 Berlin portrait of *Hieronymus Holzschuher* (Fig. 464), in which the sitter looks at the spectator out of the corner of his eyes below an almost fiercely knitted brow. Again an inner drama is expressed in this stern father type, which has appealed much to Germans, for reproductions of this work have been found in many a German home. Augmented in tonality by the slight, soft cast shadow on the varitoned back wall, the figure emerges from the pictorial space without the wire-hardness of Dürer's earlier paintings.

Finally free from the constraint of the engraver's burin, overcoming the lifelong impediment to a completely unified style, Dürer made his last great painting in 1526, the *Four Apostles,* now in Munich (Fig. 465). Not as once thought the wings of a triptych that was never executed, the two panels were offered to the town council of Nuremberg and accepted. Dürer received in return 100 florins, with an additional 10 for his wife and 2 for his apprentice. The panels have texts beneath them which are translations by Luther of quotations from the writings of the four apostles. These apostles also symbolize the four temperaments, and this was undoubtedly in Dürer's mind, for the temperaments were associated with the four forms of religious experience Dürer was presenting. St. John, fore-

most at the left, who represents the sanguine temperament, was favored by Luther over St. Peter, just behind, the symbol of Rome, who represents the phlegmatic; Paul on the right panel illustrates the melancholic, and Mark, turning his head to the right, symbolizes the choleric temperament. The disciples were so identified with the humors by Johann Neudörffer, who worked for Dürer as his professional calligrapher.

What is visible in the panels had been forecast, at least in the case of St. Paul, for his garment is derived from the St. Philip engraving of 1526. The grandeur of conception, enhanced by the monumental, austerely overwhelming forms, represents Dürer's final statement of Renaissance monumentality, unity of detail, and form. He died two years later in April, 1528.

In the last years of his life much of his effort had been directed toward the completion of his writings. In 1525 he had published in German his volume, *The Teaching of Measurements with Rule and Compass*; in 1527 he had issued a long essay, *The Art of Fortification*, and he was at work on his *Four Books on Human Proportions*, one already completed and the remaining three parts awaiting final revision when he died. The book on measurements was reprinted with some corrections and added woodcuts in 1538 (a Latin translation had appeared in Paris six years earlier). It was printed in Latin in Nuremberg in the same year as the reprinted first edition, and both the Latin and German editions were printed in Holland in the early 17th century. The *Four Books on Human Proportions* were published with Pirckheimer's assistance in October of 1528, the cost being borne by Dürer's wife. These too were reprinted and translated into Latin; eight editions appeared in different languages in the 16th century and four in the 17th. It is interesting to note that Dürer's type of normal man, eight heads tall, like the Resurrection woodcut of 1510, returns to the system developed in the 1504 *Fall of Man*. Numerous preparatory drawings exist for the books on human proportions. Tall, slender figures, short, stumpy figures, lean and fat, young and old, and normal figures of both sexes were illustrated by Dürer. He was not trying so much to produce an academy as he was to show shortcuts to an intellectual understanding of form in art. The intellectual pursuits that occupied his later years were of great inter-est to his contemporaries, and the success of his books shows that what he had to say to them was important. The translations into Italian, French, Spanish, and Dutch are sufficient witness to this.

It was not merely in the medium of the printed word that Albrecht Dürer was important as a teacher but also in the character of his woodcuts, engravings, and paintings. His genius brought the Renaissance to the north to transform the older style. Uniting the theory of Italy with the practice and religiousness of the north to create in the body of his work a "Melencolia II," he became a strong influence upon all Germany, upon that Flanders which had received him so splendidly in 1520, and upon France, Spain, and Italy as well. Dürer's ideas spread both north and south, and those great artists who followed closely upon him, such as Altdorfer (see Chap. 22), also influenced Italy. This reciprocal influence made a visible mark in subsequent art of the 16th century.

465. ALBRECHT DÜRER. *Four Apostles*. 1526. Panel, c. 84½ × 30″ (each). Alte Pinakothek, Munich.

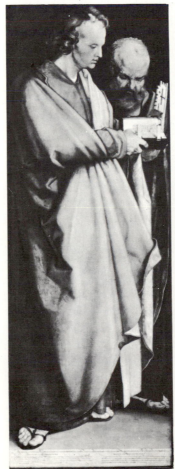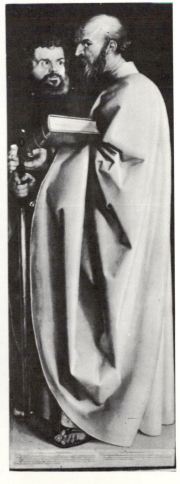

THE SECOND GREAT GENIUS OF THE RENAISSANCE in Germany, Matthias Grünewald [1] (whose name was not Grünewald at all, but Mathis Gothart Neithart), was born about 1470–75 in Würzburg and died in Halle a few months after Dürer in 1528. Early knowledge of Grünewald arose from the effort of the 17th-century German artist and historian Joachim Sandrart to collect material for his book on German artists, the *Teutsche Akademie*. Sandrart had a great deal of difficulty in finding information and, though not the first to confuse Grünewald with Hans Baldung Grien, popularized the name he is widely known by today. Sandrart said that Grünewald was unhappily married and very lonely and that he died about 1510. Actually he never married and died eighteen years later. Only in this century has material been found relating to him, much of it in recent years. In the early years of this century when another expressionist, El Greco, was also being brought to light, Heinrich Schmidt was the first modern scholar to uncover the facts. Not until the 1920s was Grünewald's real name discovered, and the basic modern book on him, by Zülch, was not published until 1938.

Now we know that he was a court painter for the archbishop of Mainz, Uriel von Gemmingen (1508–14), and for his successor, Albrecht von Brandenburg, archbishop from 1514 to 1545 and cardinal from 1518. The first document about Grünewald comes from the Mainz Domkapitellprotokoll and refers to Master Mathis der Maler in 1510 as "Wasserkunstmacher," or designer of waterworks. In 1511 he was supervisor of the archbishop's building activities in Aschaffenburg Castle. In 1517 he improved upon another master's fountain in front of the collegiate church at Aschaffenburg, and there are documents related to an altarpiece for Heinrich Reitzmann, canon at Aschaffenburg, in the same year. Other documents exist; the artist received payment for three altarpieces in Mainz in 1524 and 1525, which Sandrart described and which the Swedes, after their conquests in Germany, lost when the vessel that was carrying them to Sweden was destroyed in a storm.

In 1525 he left the cardinal's service because of his sympathies in the Peasants' War; though acquitted by Albrecht von Brandenburg, he did not return to his service, apparently being a Lutheran at heart, for the books he left at Frankfurt when he departed for Halle in 1528 included a New Testament, 27 sermons and other pamphlets by Luther, as well as the *Twelve Theses of the Christian Faith*. In 1526 he had apprenticed his adopted son, Andreas Neithart, to Arnold Rücker, organ builder, sculptor, and table maker of Seligenstadt. We know that in 1527 the Council at Frankfurt asked him for a drawing of a water mill to be built on the bridge over the Mainz River, but the drawing was not made, for he was called upon

by the city of Halle for another fountain. He died in Halle at the end of August, 1528.

Though it had been thought that he had his shop in Seligenstadt, it has recently been concluded that the references on the Seligenstadt tax rolls to Master Mathis, a common name in the Mainz area at this time, in actuality refer to a sculptor by this name and not to Master Mathis Gothart Neithart. References to this other Master Mathis appear as early as 1490 (when he is called a master) and after Grünewald's death in 1528. That the two are not identical is also seen from the two works of 1503 by Grünewald, which are definitely early works and not those of a man who has been a master for thirteen years. It may be that Grünewald, now forever tagged with Sandrart's erroneous name, may have received his training in Nuremberg and was probably there in the first decade of the new century. When he went to Mainz to become official painter to the archbishop is not certain, but it may have been in the years shortly before 1510.

The earliest works attributable to Grünewald are the painted panels for the *Lindenhardt Altarpiece*, a carved triptych originally made for Bindlach, dated 1503. On the outside of the wings (Fig. 466) are represented the fourteen auxiliary saints: eight on the left, led by St. George; and six on the right, led by St. Denis. Behind St. George are Sts. Margaret, Barbara, Catherine of Alexandria, Blaise, Pantaleon, Christopher (in normal rather than the traditional gigantic size), and Eustace. Sts. Denis, Erasmus, Giles, Cyriacus, Acacius, and Vitus appear on the right wing.

The style is radically different from that of Albrecht Dürer. The panels show a curious and fascinating combination of sharp, linear elements; strong light and dark; greater naturalism in the portrayal of local types without the tendency to idealize, though monumentality of form is not foreign to him, as witness the large simplifications in St. Denis's garments; and an effective use of silhouette. A variety of ideas is present, no one completely dominant, though pictorialism has the greatest weight. This is clearly a youthful work, in which the possibilities of artistic construction are still battling for prominence. Plastic form, silhouetted form, and lighted form are all effectively mixed and dramatically crowded together at this stage. The fig-

ure of Christ on the back of the carved central panel is difficult to accept as the work of Grünewald; if it is, one must admit that Grünewald was certainly a youthful painter seeking his way.

The *Mocking of Christ*, in Munich (Pl. 24, after p. 308), was dated 1503 on the epitaph, which has now disappeared as the result of a cleaning. From the Convent Church at Aschaffenburg, it was acquired by the museum in 1803 by way of the Carmelite Convent in Munich. It is Grünewald's earliest work of certain date. Pictorialism is here more emphatically dominant over the linear silhouette. There is a relation to Dürer's *Jabach Altarpiece* in the figure at the left rear playing on a pipe and beating a tabor; a drawing formerly in Haarlem, Koenigs Collection, of a figure blowing on a trumpet may have been Grünewald's first response to Dürer's figure. From the outset Grünewald used his drawings in a very different way from Albrecht Dürer, as coloristic differences in drawing reveal. For the latter the preparatory drawings were completed entities to be taken over bodily, for his sense of organization was so clear and sharp that he put things together in his mind and thus used his drawings as building blocks from which his

466. MATTHIAS GRÜNEWALD. Fourteen auxiliary saints, *Lindenhardt Altarpiece*, exterior of wings. 1503. Panel, 62 5/8 × 27″. Church, Lindenhardt.

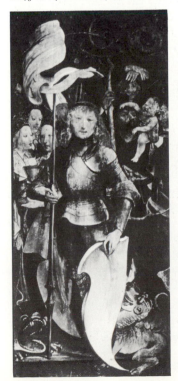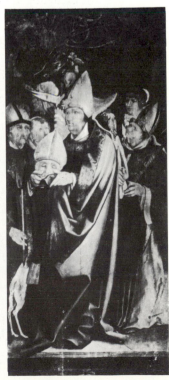

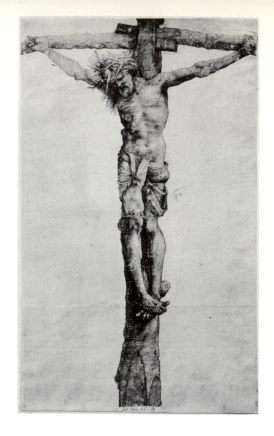

works were constructed. Grünewald, however, worked in a more painterly, fluid fashion and changed his compositions as he developed his paintings; his drawings were only first stages of his ideas.

In the Munich *Mocking of Christ* the elements seen in the *Lindenhardt Altarpiece* wings reappear; silhouette, light over the surface, dark shading and lower light in immediately adjoining areas, and, especially, color of a type never achieved by Dürer. The ability to build with varied colors and the awareness of color warmth set Grünewald apart from the more cosmetic conceptions of Dürer. Though the setting of the dark background is nowhere really defined, the theme is given veracity and poignancy through its naturalism and dramatic action. In place of the logically constructed, organic building of Dürer's forms are fluid movements by which Grünewald sought to capture the emotional content implicit in the action, even to the neglect, if necessary, of the exactitude of organic connections among body parts, as in the flowing, curved movement of the man with upraised fist over Christ. Crowding of forms, occult balance of the composition, and momentary feeling create an emotional impact that suggests the reawakening of a Gothic world in modern dress.

Grünewald's drawing of *Christ on the Cross* (Fig. 467), of approximately 1505 in Karlsruhe, may be compared with Dürer's like figure of 1505 (Fig. 442). Both used a rough cross form, but that of Grünewald is rougher; both used light, but Dürer's figure suggests a gleam of light over the surface of an ideal body, whereas Grünewald's form is large, heroic, and less idealized, to express the agony of the sacrifice. The feet are crossed and the head is weighted down by the crown of thorns. The dramatic suffering conveyed in the drawing is also met in the painted *Crucifixion*, of about the same year, in Basel. Christ's figure is even more expressive, the hands magnified in a manner recalling a like emotional use in Ottonian manuscript illumination. The bowing of the legs and the tattered cloth around the loins accentuate the helplessness of a powerful figure. Light—strong upon

the figure of Christ, weaker upon the figures below—follows an emotional and painterly rather than a natural order, as it flares and diminishes over the swelling and contracting surfaces below. Adding to the emotional impact by covering the lighted body with wounds and emphasizing the pull of the body on the joints, in this work Grünewald made his first finished statement of the theme of the Crucifixion. Essentially complete and little altered, the same statement was to appear again and again in his few preserved works.

In 1508, it may be remembered, Dürer had completed his now-lost center panel for the *Heller Altarpiece*, for which his shop made the wings. Heller ordered additional wing panels in grisaille from Grünewald. Four saints were painted on these wings, which were fixed: St. Lawrence above St. Elizabeth on one, St. Cyriacus above St. Lucy (?) on the other. The figures of the male saints (Fig. 468) are now in Frankfurt; the female saints, discovered in recent years, are in Donaueschingen (Fig. 469).

St. Lawrence is a boyish, chubby saint revealed by light. The large, forceful drapery movements seem to have a volition and mobility of their own, flowing over the symbol of the saint's martyrdom, the grid. Again Grünewald sil-

houetted his forms, making the head lighter than the dark surrounding background, animating the cowl by interpenetrating lights and darks, and delicately modeling the fleshy face by lighting and accentuating the eyes and the undersides of the nose and mouth. The inclined head completes a movement through the drapery that suggests a curving form like that in the sculptures of the *Schönen Madonnen* of a century earlier.

A sense of immediacy and individuality characterizes the face of St. Cyriacus, who, one feels, could be met walking down the street today. Much smaller than the saint, the Princess Artemia is portrayed as possessed by a demon in the rolling of her eyes toward the outer corners and by her splayed fingers. To effect his cure the saint uses her neckcloth as leverage to force open her mouth with a tremendous thumb. Indicative of Grünewald's mastery of telling detail are the curling edges of the book in the saint's left hand and the pages revealed by subtle lighting, direct and reflected.

St. Elizabeth is crisply lighted, as are the pleats in her dress. Repeated lines and narrow areas of shadow create a dynamic upward surge to carry the eye to her beautifully lighted head finely modeled in soft, reflected light.

The saint tentatively identified as Lucy, unveiled and holding the palm of her martyrdom, seems to be conceived by the painter as a Christian witch, her hair blown by an unknown wind. The narrow eyes are set in a full, fleshy face, a type that recalls the Master of Flémalle and his stylistic parallels in Germany.

The spirit of the north emerges in these works: light, air, forms in space, the appearance of things as they exist in nature (as opposed to Dürer's imposition of an order upon nature) but mystically lighted and mystically revealed, for nowhere is physical nature truly defined. A medieval infinity of space is implied in the edge lighting of the arches above the female saints' heads, thereby suggesting spatial continuity beyond the finite niches in which the figures are placed.

Another painting of the *Crucifixion* (Fig. 470), now in Washington, is dated in the second half of the first decade, possibly about the middle. Again we see the tattered loincloth, the dark background, the strong effect of the cross arms, here heavily bowed. The right foot is sharply

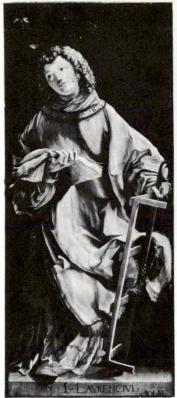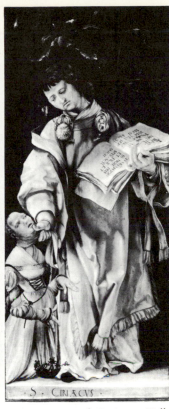

above: 468. MATTHIAS GRÜNEWALD. Sts. Lawrence and Cyriacus, *Heller Altarpiece*, upper panels from fixed wings. *c.* 1508–10. Panel, *c.* 39 × 17″ (each). Städelsches Kunstinstitut, Frankfurt.

below: 469. MATTHIAS GRÜNEWALD. Sts. Elizabeth and Lucy(?), *Heller Altarpiece*, lower panels from fixed wings. *c.* 1508–10. Panel, 37³/₄ × 16⁷/₈ (left), 39⁷/₈ × 17¹/₄ (right). Fürstliche Fürstenbergische Sammlungen, Donaueschingen.

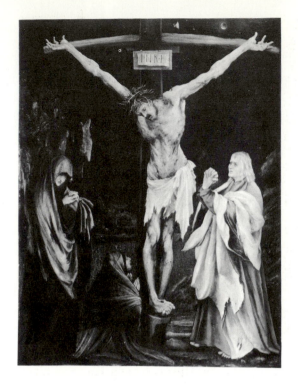

above: 470. MATTHIAS GRÜNEWALD. *Crucifixion*. *c.* 1508–10. Panel, 24 1/4 × 18 1/8″. National Gallery of Art, Washington, D.C. (Samuel H. Kress Collection).

below: 471. MATTHIAS GRÜNEWALD. *Isenheim Altarpiece*, exterior. Completed 1515. Panel (with framing), *c.* 9′ 9 1/2″ × 10′ 9″ (center), 8′ 2 1/2″ × 3′ 1/2″ (fixed wings, each), 2′ 5 1/2″ × 11′ 2″ (predella). Musée d'Unterlinden, Colmar.

turned from the vertical line of the body, and the chest protrudes to emphasize the sucking in of the stomach, all according to the *Revelations* of St. Birgitta, whose visions were widely known in the 15th century and an edition of which was published in Nuremberg in 1501–02. Again the light swells and dies, the drapery rises and falls in an artistic expression of the pathos of the Crucifixion revealed through color. Grünewald's use of color produced effects of both richness and somberness. He subtilized and disguised a dynamic contrast of primary hues by setting his brilliant tones against dark backgrounds, out of which they emerge like softly glowing gems with the most subtle gradations.

Possibly in 1509, when it is presumed that he made the wings for Heller's altarpiece, or at the latest in the following year, he was at Isenheim working for the Antonite commandery on the great *Isenheim Altarpiece*, now in Colmar. This, his best-known work, was completed in 1515, the date painted on the ointment jar of the kneeling Magdalen of the Crucifixion.

In its original arrangement, as it was installed in the chapel of the Antonite commandery, the altarpiece, when closed (Fig. 471), showed the Crucifixion flanked by the figures of Sts. Anthony and Sebastian at left and right respectively on the fixed wings. In the first open position (Fig. 472) the fixed wings were covered, and the Annunciation, the Angel Concert and Nativity,

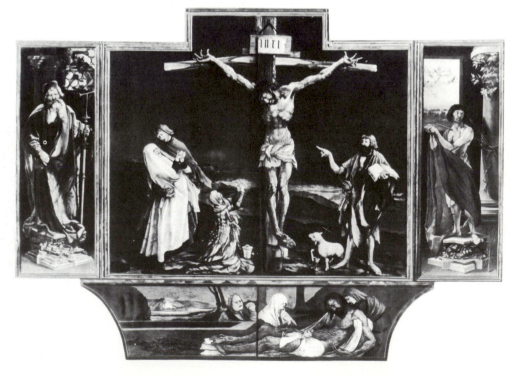

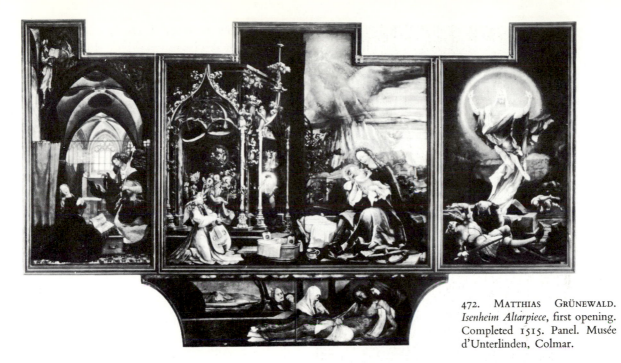

472. MATTHIAS GRÜNEWALD. *Isenheim Altarpiece*, first opening. Completed 1515. Panel. Musée d'Unterlinden, Colmar.

and the Resurrection were visible. Opened once more (Fig. 473), the second set of wings showed the meeting of Sts. Paul and Anthony on the left and the Temptation of St. Anthony on the right, the center being occupied by the sculptured figures of St. Athanasius, biographer of St. Anthony, who is seen enthroned in the center, and St. Jerome, author of the *Life of St. Paul* and source for the scene of the meeting of the two saints. Below, the predella, an Italian fea-

ture of transition between altar table and altarpiece, was normally covered with a painting of the Entombment; when this panel was opened the sculptured figures of Christ and the apostles were revealed. These were the work of the same artist who carved the figures above, Nicholas von Hagenau, who executed them about 1503

below: 473. MATTHIAS GRÜNEWALD. *Isenheim Altarpiece*, second opening. Panel, with sculptured center by Von Hagenau. Completed 1515. Musée d'Unterlinden, Colmar.

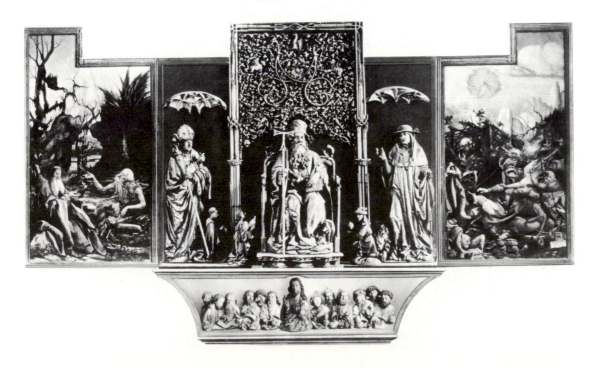

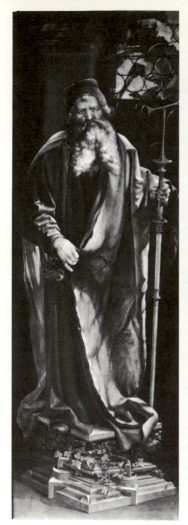
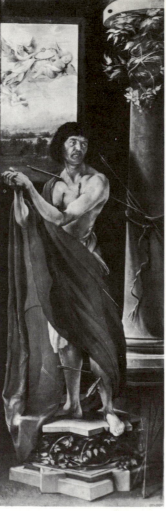

474 and 475. MATTHIAS GRÜNEWALD. Sts. Anthony and Sebastian, *Isenheim Altarpiece*, fixed wings (Fig. 471).

for the then preceptor of the commandery of the Hospital Order of St. Anthony, Jean d'Orliac, a Savoyard.

The painted altarpiece, however, was commissioned from Grünewald by that preceptor's successor, the Italian Guido Guersi, who held the office from 1508 to 1516. Originally placed in the chapel of the commandery, the work was seen daily by the sufferers from the various diseases treated by the Hospital Order, one of which was the new social disease of syphilis, early known in Germany as the French disease and in France as the German disease. Sts. Anthony and Sebastian on the fixed wings are two of the three plague saints so popular at the time; the third, St. Roch, is not present here.

Anthony (Fig. 474) is shown on a pedestal (in itself a curious device); above his head a demon breaks through a bottle-glass window, an action

the saint ignores, as in the Schongauer *Temptation of St. Anthony* (Fig. 385), which is also recalled in the conception of the demon. The placing of the saint, a seemingly living individual, on a pedestal creates in the mind of the viewer a confusion of the limits between reality and symbolic form. This illusionistic naturalism is characteristic of the spirit of the late Gothic style, which had appeared in the painted and sculptured altarpieces of the second half of the 15th century.

St. Sebastian (Fig. 475), who looks away from the center panel (as does the St. Lucy figure for the *Heller Altarpiece*), is also standing on a pedestal with blood running down his body. Though shot full of arrows that have poisoned his legs so that the flesh is a gangrenous green, the saint pays no attention to his wounds, thereby creating a forceful demonstration of the difference between the natural and the real. The placement of Sebastian and the column at his back derives in part from Albrecht Dürer's Man of Sorrows, of 1509, from the small engraved *Passion*. The head of the saint seems a portrait, though who is portrayed is not known. Seen through the window at the back, a calm Rhenish landscape contrasts with the energetic action of two pudgy Germanic angels flying to the saint with his crown of martyrdom, though in actuality he met his martyrdom later.

Grünewald's conception was influenced by Dürer's wings for the *Dresden Altarpiece* (Fig. 423), with Anthony on the left and Sebastian on the right.[2] But though Grünewald followed Dürer in the placing of the two saints and took from him the angelic forms behind Sebastian and the demonic form behind Anthony, he modified his own original conception, which showed the head of Sebastian turned toward the central panel, as Schonberger has shown in his study of Grünewald's drawings, to create a greater drama and greater mystery, more effective finally than if the head had not been turned away.

The wings were conceived as leading to the central Crucifixion panel, in which the movements of the two saints are repeated. Anthony's swaying movement is echoed in the apostle John and the fainting Mary, and Sebastian's pointing action is taken up and reinforced by John the Baptist, who points to the sacrificial body of Christ on the Cross. Behind the Baptist (whose curving finger was elongated in the process of painting, as X-rays have shown) is an

below: 476. MATTHIAS GRÜNEWALD. Detail of Christ, *Isenheim Altarpiece* (Fig. 471).

bottom: 477. MATTHIAS GRÜNEWALD. Detail with the Magdalen, *Isenheim Altarpiece* (Fig. 471).

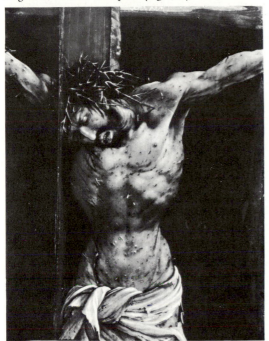

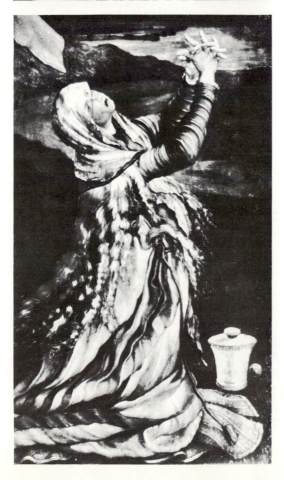

inscription from the Gospel of St. John 13:30, "He must increase, but I must decrease"; however, the motif is taken from the *Revelations* of St. Birgitta, as are other elements in the work. John the Baptist, it will be remembered, was dead at the time of the Crucifixion, having been decapitated on Salome's request at the time of Herod's feast. Next to the spread feet of John is seen the charming lamb with cocked head, looking out of the corner of its eyes at the spectator as it bleeds into a chalice on the ground, another motif from St. Birgitta, as is the marked difference in figure scale, Christ being largest of all.

The calm pose and gaze of John the Baptist—with which the almost electric quality of the hair, pointing finger, tattered book and drapery, and extended leg with its knobby knee so strongly contrast—is a counterbalance for the agony conveyed by the tortured body of Christ (Fig. 476). In surety of draftsmanship and over-all conception Grünewald has surpassed his earlier renderings of the theme. The open mouth of Christ showing the teeth, the body stuck with thorns, the formal unity of the truly heroic body proportions, the design of the fingers spread in radiating points for an internal energy and pathos, the dislocation of the joints by the pull of the body—all contribute to an artistic restatement that has augmented tenfold the grandeur of the figure and the actuality of the sacrifice.

John in red and Mary in white are placed in a new relationship that unites them in grief, a far superior expression of the drama to earlier versions. In the earlier paintings Grünewald was following a more traditional statement, in which Mary and John were witnesses rather than participants in the emotion of the theme, as they now are. Yet the drama is restrained, only the hands revealing the overwhelming quality of Mary's grief. Outpouring of emotion is confined to the smaller figure of the Magdalen (Fig. 477), who lifts her agonized, grief-torn face to peer through her veil at the figure of Christ towering above her as she wrings hands so charged with electric energy that they parallel those of Christ above. This high emotional quality is reinforced by the dramatic repetition of the wrinkles on her sleeves and by the dynamic flow of her hair from under its covering. Grünewald achieved such emotional effects stylistically by accentuation of the outlines, as in the fingers, by the richness and strength of

value and color contrasts, by the opposition of swelling lights against turbulent darks, by contrasts of softness and hardness, and by silhouettes and softly molded forms, all more subtly handled than before.

When the first set of wings is opened, the Annunciation is seen on the left wing. The scene takes place in a chapel, where the Virgin, like a simple girl, kneels before a chest on which her book rests (Fig. 478). Bent backward in reaction to the onrushing angel, she lifts clasped hands like those of the fainting Mary of the Crucifixion and looks out of the corners of her eyes at the angel. The dove, symbol of the Holy Ghost, hovers close to her head in a glory. The pointing fingers of the angel recall those of John the Baptist, in an intended prefiguration that unites the Annunciation with the Crucifixion. The Annunciation in a religious interior is an archaism, but the red curtain and the books in the background transform the interior into a place of study and retirement. Symbolically enhancing the sacred character of the event is the elongated figure of Isaiah standing in the spandrel above and holding his prophecy that a virgin shall conceive. Though he has no visible support, he seems to stand there naturally in his ragged garments, wearing a forked beard and a turban that add to his exotic character. The subdued tones of the vigorous plant growth behind

478. MATTHIAS GRÜNEWALD. Detail of the Annunciation, *Isenheim Altarpiece* (Fig. 472).

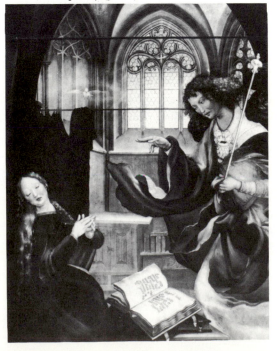

him recall the vegetation in the St. Dorothy and St. Lucy panels from the *Heller Altarpiece*.

Even more illusionistic than in the art of Pacher, light softly fills the upper areas of the vaults and creates a mystical, ethereal atmosphere consonant with the sanctity of the event. The cool light balances the sharper contrasts of color and formal action. Below, the illumination has been reduced to a tonal patterning, so that modeling in relation to a definite light source is hardly looked for. Pattern is also emphasized by the archaizing use of gold leaf in the angel's staff and breast medallion. The gold often jumps out of a picture when handled by a lesser master, but here it is subtly integrated with the warm colors of the angel's garments, which, with the other warm foreground colors, are in contrast to the background blues, grays, and browns.

Two preparatory drawings for the pose of the Virgin exist, both in Berlin. In the painting Grünewald refined the movement, modified the drapery to suggest a *contrapposto*, and changed the direction of the Virgin's glance from down and away to sidewise. He also changed the hands. The drapery in the painting is subdued to effect a concentration upon the psychological response, which has become more important than mere artistic display of drapery movement.

The Angel Concert and Nativity, in the central panel, are divided into equal areas of light and dark. In an elaborate chapel at the left, surrounded by angels and a supernatural light, the Virgin kneels in adoration of herself with the Child at the right, a visionary theme stemming from the *Revelations* of St. Birgitta. Hosts of angels small and large pour out of the dark interior of the chapel to add their adoration to that of the Virgin and to serenade the Mother and Child with viols. Their leader, a blond, pugnosed angel, in delicate colors, kneels in a reduced mirror image, so to speak, of the Virgin and Child of the Nativity.

A rich variety is seen in the angelic forms. The bronze-colored angel of leaves and feathers at the extreme left contrasts with the pug-nosed angel and with the large, full-jawed angel on the steps of the chapel. The vermilion garments of this last angel change from red to blue on the shadow side at the edges and are more strongly varied in color than those of the foremost angel. Above, the angelic heads are wonderfully individualized; toward the center of the

chapel, for example, is a child with closely cropped black hair surrounded by a halo studded with precious stones that make a realistic note in contrast with the surrounding glory. Disregarding conventional types, Grünewald created a whole new set of angelic forms to enlarge his concept of the visionary as a transformation of the realistic into the supernatural by means of unrealistic terminations and lights. Forms are revealed and obscured by light, and the halos both emanate and reflect light.

The architecture has an almost independent life, with scrolls rolling up the flat surfaces of the curves like leaves in the wind and figures of seemingly ancient character standing on top of and between the gold columns.

A homely realistic link is provided between the visionary chapel and the Nativity scene by the tub and the beautifully painted symbolic glass carafe on the steps. The Virgin, dressed in a beautiful crimson robe with almost flamelike lights, affectionately cradles her child on a cloth that is as tattered as the loincloth of the Crucified Christ, as the Child, with head back, looks up at his mother in a way that shows an awareness of the future, even more pointedly referred to by the play with the rosary, symbol of the Seven Joys and the Seven Sorrows of the Virgin. The movement of the pudgy fingers illustrates the drama recounted in St. Birgitta's *Revelations*.

Behind the Virgin, roses are seen, symbolic of her virginity, as is the low garden wall over which is seen a church in the distant valley. Above it the Annunciation to gigantic shepherds takes place in rays of light pouring from the almost Teutonic, bearded figure of God the Father in the sky overhead. Angels swim in the upper air, materializing out of light. Line is completely absent here, but in the foreground a delicate line is combined with subtle modeling, as in the definition of the arms and fingers of the Child. Seen against the light, Grünewald's angels and God the Father are achieved without modeling by a play on light values alone. To the right, and distinct from this heavenly emanation, a late-afternoon sun lights distant chalk cliffs, reinforcing by contrast the supernatural character of the angelic host.

Grünewald's profound understanding of varieties of light reached an equally high peak in the panel of the Resurrection (Fig. 479). An ascending Christ floats upward against the dark

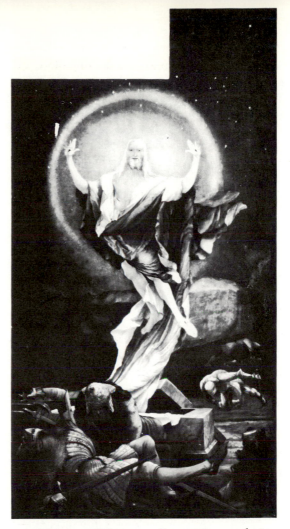

479. MATTHIAS GRÜNEWALD. Resurrection panel, *Isenheim Altarpiece* (Fig. 472).

night from his tomb, trailing a white cloth that changes as it rises from cool to warm and provides a supporting element to relate the visionary to the real. This relationship is further accentuated by the awkward, falling, angular soldiers, blinded by the blaze of supernatural light from Christ. He is surrounded by an aureole that changes from red to yellow at the center, out of which emerge the almost unrecognizable lineaments of His face.

As ethereal as the figure of God the Father in the sky of the Nativity, He shows the wounds on hands and feet, but His white skin is washed clean of all sores, in a significant contrast to the agonized, crucified Christ of the Crucifixion scene. Like Him, the sufferers at the hospital could also be freed of their taints, sins, and diseases. Grünewald, following Birgitta's text, expressed in painted form the belief in the difference between the human and divine natures of Jesus.

On feast days the panels were opened to the innermost scenes to present the Meeting of Sts. Paul and Anthony, according to Jerome's *Life of St. Paul*, and the Temptation of St. Anthony, according to Athanasius's *Life* of the patron saint of the Hospital Order. In the meeting scene Paul, at the right, is an aged transformation of a portrait, now in the Erlangen Library, which Sandrart considered to be a likeness of Grünewald. Paul points toward St. Anthony, whose features are those of Guido Guersi, identified not only by a drawing of the preceptor of the Order from Grünewald's hand but also by the coat of arms against the rock beside him; and other preparatory drawings exist. The event illustrated has a long iconographic history. Anthony, thinking to himself that he had succeeded in his eremitical life, was told by a voice to visit Paul and learn humility. Journeying to find Paul, he discovered a man older than himself who was favored by God each day with a visit from a raven bringing a loaf of bread to sustain him. On the day of Anthony's visit the raven brought a double loaf, which the saints broke between them. This Eucharistic reference appears as early as the 7th century on the Ruthwell cross, in Dumfriesshire, Scotland. It is to this miracle that the gaze of St. Paul is directed.

The "desert" landscape, with a palm tree probably derived from an engraving, is a silhouetted, moss-covered, barren, eerie country. Strange shapes and great cliffs rise in the far distance to terminate the space. Figures and landscape are complementary. The hand of Paul seemingly repeats the gesture of John the Baptist in the Crucifixion scene, as he points to St. Anthony, who, in the symbolic thinking of the time, had been elevated as a result of his thaumaturgy to a position almost comparable to that of Christ. Such exaltation of the saints became so strong that the Council of Trent, 1545–63, recognized the danger and moved to diminish their importance in the popular mind.

The Temptation of St. Anthony (Pl. 25, after p. 308), a truly thundering climax to the emotionality of the *Isenheim Altarpiece*, shows the recumbent saint raising a hand to protect himself from the onslaught of the encircling zoomorphic demons, one of whom pulls the saint's hair as another, in hawklike form with its sharp beak wide open, raises a club to beat him, and a third, characterized as a reptile, bites the fingers in which he clutches his rosary. Eleven fantastic animal forms baring their fangs prepare, it seems, virtually to devour the saint. According to the account of his life by St. Athanasius, Anthony was brought back to his tomb from the village where he had been carried after having been beaten senseless by the demons. Then he defied the encircling demons once more to do their worst and uttered the cry: "Where were you, good Jesus, where were you? Why didn't you help me and heal my wounds?" (inscribed on the scrap of paper at the right). Christ then intervened to disperse his tormentors and heal his wounds. In the background above a ruined hut (which stands for Anthony's tomb) angels in the sky, seen against the light streaming from a Christ resembling God the Father, are locked in combat with demons in reptilian and other animal forms. The hut, the conflict (seen earlier in Dürer), and Christ as God the Father probably came from mystery plays of the Temptation of St. Anthony.

The compositional arrangement was derived from several sources, northern and Italian, no doubt by way of miniatures in the possession of Guido Guersi. To such miniatures the diagonal arrangement may be attributed. The encircling of the saint, however, is much like Schongauer's famous Temptation engraving (Fig. 385), but there is a more concrete influence from Lucas Cranach's 1506 woodcut of this theme. The beautifully painted, misshapen figure in the left-hand corner, red-cowled, barebodied, and toad-footed, whose running and spurting sores cover his swollen belly, is an adaptation of a Dürer-attributed woodcut of a syphilitic of 1496. This diseased demon has taken the saint's girdle book while the others rush over his body in their eagerness to destroy him. The position of this demon figure apes and mocks that of St. Anthony. The toad, suggested by the feet, has a long history of association with evil and with St. Anthony's trials.

The dramatic conflict and emotional intensity of the panel are further heightened by contrasts in color, value, and lighting, the background and foreground lights falling from opposite angles.

What Grünewald presented in this altarpiece is an assimilation and a transformation of his borrowings, a transformation that can be likened to the change between his preparatory drawings and his paintings. His style served a religious

ideal that found its summation in the theme of St. Anthony's temptation, a temptation far greater than that borne by ordinary mortals but resisted by the saint more strongly than he was tempted. Anthony's life was a perfect exemplar of the way to salvation. By resisting the Devil and believing in Christ, he achieved salvation; the sufferers at the hospital, by a comparable belief and adherence to his example, could also achieve this goal. Nowhere is Grünewald's late medievalism more intensely portrayed.

After the completion of the *Isenheim Altarpiece* Grünewald painted for Heinrich Reitzmann, canon of the collegiate church at Aschaffenburg, a panel for a Mary of the Snow altarpiece. From Reitzmann's will of 1517, it is known that the Chapel of the Virgin of the Snow was consecrated in 1516, and in the following year the panel was already prepared for painting by Master Mathis. On the original frame the work was dated 1519, the year of its completion.

One panel is certain as having been made for the altarpiece; this is the representation of the *Miracle of the Snow*, in Freiburg (Fig. 480). It depicts the legendary foundation of Sta. Maria Maggiore in Rome in August, 352. Pope Liberius and the patrician John both dreamed of a fall of snow that would mark the site of a new church and awoke in the morning to find it. The Pope, with cardinals holding his rich, red cloak, is shown marking the outlines of the future church as John and his wife kneel nearby. Above, the couple looks up at the vision of the Virgin in the sky, as the Pope dreams in his curtained bed. From the view of Rome it is evident that Grünewald constructed his background from works of other artists.

The presentation of the space in the scene is very different from that in previous works by Grünewald because of the stress upon the middle ground and the background. The work, however, is as dramatic as any seen before, as is evident in the emphatic naturalism of the Pope's features and those of the aged couple. Yet a dreamlike quality pervades the whole, made real by the sumptuousness of the deep-red garments, the incisive characterization, and the absorption of the Pope in the miracle as he traces the outlines of the foundation. Drama of line and form is again augmented by a drama of color; the rich foreground reds are opposed by the verdant grass surrounding the patch of snow, the blue-green sky above, and the yellow aura of light around the Virgin.

A restatement of the Nativity composition of the *Isenheim Altarpiece* appears in the Virgin and Child panel known as the *Stuppach Madonna* (Fig. 481), in the church at Stuppach. This has been thought to be the central panel of Reitzmann's altarpiece. Here, however, the Child

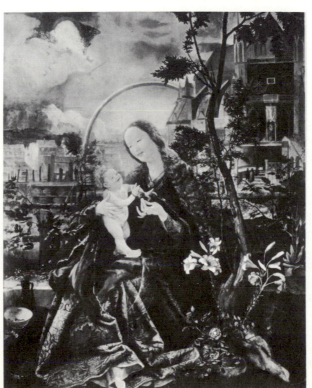

left: 480. MATTHIAS GRÜNEWALD. *Miracle of the Snow*. 1519. Panel, partly covered with canvas, 70 1/2 × 36". Augustinermuseum, Freiburg im Breisgau.

right: 481. MATTHIAS GRÜNEWALD. *Stuppach Madonna*. *c.* 1518–20. Canvas (transferred to panel), 72 7/8 × 59". Church, Stuppach.

482. MATTHIAS GRÜNEWALD. *Crying Angel. c.* 1516–18. Black chalk heightened with white, $9^5/_8 \times 7^7/_8$″. Kupferstichkabinett, Staatliche Museen, Berlin-Dahlem.

An increase in artistic profundity and internal drama is found in Grünewald's subsequent work. The Munich *Meeting of Sts. Erasmus and Maurice* (Fig. 483), mentioned in the 1525 inventory of the collegiate church at Halle, was removed for protection in 1540 to Aschaffenburg by its donor, Cardinal Albrecht of Brandenberg, who is represented as St. Erasmus. The work was probably painted in the early 1520s, shortly after the *Stuppach Madonna.* In its off-center composition it suggests the 1503 *Mocking of Christ,* but it is more spacious, more painterly, and its decoration is richer. A greater simplification, a less agitated outline, and a less overt drama is visible here and in later works.

This change is visible in Grünewald's last version of the *Crucifixion* (Fig. 484), which came from Tauberbischofsheim and is now in the museum at Karlsruhe, along with the back of the panel showing Christ carrying the Cross (the panel was sawed apart in 1883). The Crucified Christ is even larger and more monumental than in the earlier works, evoking the spirit of a deësis. A greater naturalism and a more Renaissance spirit seem apparent, for the head of Christ is less bent, the agony of the Virgin is more contained, and there is almost—for Grünewald—an idealization in the form of Christ. In its new proportions Christ's body is even more heroic than in earlier versions of the theme, and there is almost a palpably constructed space out of which the chest and head surge toward the spectator. The figure of John (for which a preparatory drawing exists) is equally transformed toward the heroic, and even the Virgin assumes a new monumentality of form.

By contrast with what has gone before, this work is High Renaissance, though one hastens to add that it is Grünewald's own High Renaissance, in which the conception is more austere and the drama is more contained in less active forms. At the same time Grünewald was even less interested in physical beauty than in the *Isenheim Altarpiece,* where, underneath the great emotive intensity of expression and richness of color and form, one can detect at least a partial identification with those northern painters whose interest in nature had become all-absorbing;

stands on his mother's knees to look up into her face. Dressed in a richly brocaded dress, the Virgin is more monumentally conceived and less humanly presented than before. A reserve has necessarily come over the features, one feels, to counteract the enormous activity of the floral forms in the foreground, including the common symbol of the lilies, and the great variety of symbolic elements beyond the garden background. Among them are beehives and fences, buildings in wood and stone, a church which may be Strasbourg Cathedral at this time, a rainbow, and unevenly lighted clouds in which God the Father and angels appear in yelloworange tones against patches of intense blue sky.

A stylistic change may be seen here and in subsequent works. Distinct use of sharp lines to bound the lighter forms and give them shape is not so evident as heretofore. The pictorialism is greater and more than ever subservient to the emotional content of the theme. To Grünewald settings were not reproductions of natural terrain to portray nature convincingly. He merely alluded to natural settings, for the plausibility of a natural setting was desired only as a vehicle for the spiritual content. What is conveyed suggests a medieval spirit making use of Renaissance artistic elements: perspective, clarity of form, and the dominance of human form. To these was allied a mystic, profoundly evocative use of light and a color as sumptuous as that of any Venetian painter, but the result is a thoroughly northern transcendentalism. This spirit governs the preparatory drawing in Berlin for the *Stuppach Madonna.* It is also seen in the Berlin *Crying Angel* (Fig. 482), a figure which may antedate the *Stuppach Madonna.*

nothing else can explain the great beauty of light that animates such a scene as the Annunciation or even the Resurrection there.

At this stage it seems as if Grünewald was reacting against High Renaissance works by asserting his expressionism as the means to monumental plasticity and heroic proportion and as a suitable vehicle for the conveyance of his artistic and spiritual meanings. He recognized the grandeur and monumentality inherent in the High Renaissance outlook but emptied the form of its Humanistic content to replace it with Christian austerity and emotive drama. The Humanistic hero has become a Christian hero in High Renaissance form.

The meaning is conveyed through line, light, and plastic form united in an expressive and expressionistic style, as is also visible on the back panel, where Christ shows an agonized yet ecstatic grimace as He carries the Cross. The last expression of this spirit is the Aschaffenberg predella panel with the Deposition, in which the body of Christ is as heroic as that in the Karlsruhe *Crucifixion*.

Grünewald, then, was at opposite poles from Albrecht Dürer, though, as in the late art of Dürer, his own late works show a monumentality and drama of form which in part supplant the spiritual drama seen in the *Isenheim Altarpiece*. The *Isenheim Altarpiece* is thus a comparatively calm middle point in Grünewald's expressionistic development, the later works presenting almost inflated forms that seem to swell and expand from within. The painter exaggerated their proportions, their size, and their movements to express a disturbing, dramatic and dynamic content and a profound sense of conflict between elements that Dürer saw as reconcilable. In this expression and conflict Grünewald reasserted more strongly than in his early works the contrast between northern transcendentalism and the Humanistic spirit of the Renaissance. Though in the later works the Renaissance elements were strongly presented and even overexaggerated, as in the large head of Christ and the contrastingly small head of John in the Karlsruhe *Crucifixion*, they arouse the feeling that the painter was unsatisfied with these means, that the forms were inadequate to contain his intensely religious and emotional message.[3]

left: 483. MATTHIAS GRÜNEWALD. *Meeting of Sts. Erasmus and Maurice. c.* 1520–22. Panel, 89 × 69¼″. Alte Pinakothek, Munich.

right: 484. MATTHIAS GRÜNEWALD. *Crucifixion. c.* 1525. Panel, 77 × 56⅛″. Staatliche Kunsthalle, Karlsruhe.

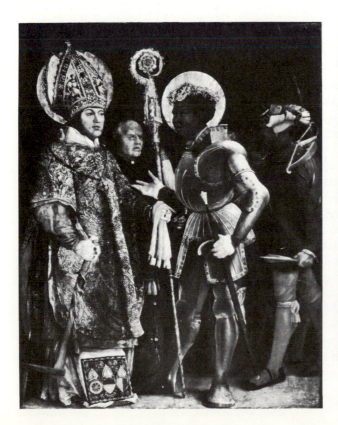

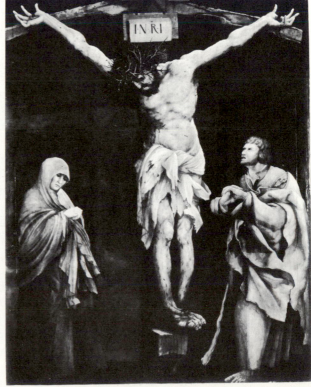

LUCAS CRANACH THE ELDER

TAKING A DIFFERENT ROAD FROM DÜRER, YET influenced by him, was a painter whose earliest works made him an outstanding member of the Danube school,[1] but whose later art espoused a charmingly insouciant, courtly, mannered sophistication little related to the idealizing aims of Dürer. Lucas Cranach the Elder,[2] born in Kronach in the diocese of Bamberg in 1472, whose family name was either Sünder or Müller, was apparently trained by his painter father Hans. About 1498 he probably started on his travels.

About 1500 he was in Vienna, where some two years later he painted the seated, half-length portraits of *Dr. Johannes Cuspinian* (Fig. 485) and of his wife Anna, in the Oskar Reinhart Collection, Winterthur. Setting the naturalistically presented figures close to the picture plane with a dramatic landscape background as a foil, the artist combined a typically northern emphasis upon atmosphere and variety of texture with rich, warm color. To the strongly pictorial figure of Anna Cuspinian he added decorative elements. The hilly landscape reveals a Düreresque influence in the evocative twisting bare branches contrasted with fully foliated tree forms. A similar richness and northern portrait style are seen in the figures of Dr. Stephan Reuss and his wife, of the following year, 1503, in Nuremberg.

Dated by style in the year 1502 is a *Penitent St. Jerome* in Vienna, which sets the form more deeply into the same type of landscape. Its coloristic, dramatic foreground action and prolifera-

tion of landscape elements create a warm emotionality, a drama of subject and setting, that is the hallmark of what has been called the Danube school. The richly colored 1503 *Crucifixion*, in Munich (Pl. 26, after p. 308), set in a forest with the crucified figures placed high above the eye level of the spectator, forcefully contrasting the idealized body of Christ with the coarser thieves,

485. LUCAS CRANACH THE ELDER. *Dr. Johannes Cuspinian.* c. 1502. Panel, 23 1/4 × 17 3/4". Oskar Reinhart Collection, Winterthur.

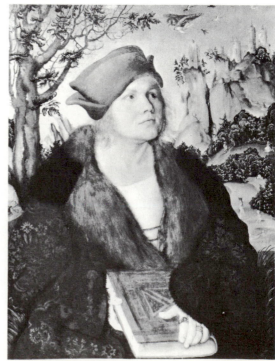

is an equally dramatic expression of the Danube style. Through strong coloration, value contrast, and plasticity of form the figures of Mary and John express an emotionalism epitomized in the flying garment of the figure of Christ.

Indirectly it recalls the art of Pacher and his chief follower, Marx Reichlich, whose art was probably seen by Cranach, if not in Vienna, at Sankt-Wolfgang on the way to Vienna, but the work also indicates a possibility of acquaintance with Venetian art. The rich verdure is highly suggestive of such an influence, and Cranach could have made the trip to Italy during his wander years. The full color may also have been inspired by Venice. However, the use of the crucified thief along the left margin as a *repoussoir* element to lead across a diagonal to the figure of Christ seems to have come from the art of Pacher, and the landscape elements can all be found in the woodcuts and engravings of Dürer. The strength of emotional drama and the power in execution of the religious theme are Cranach's contributions to a spirit shared by many in Germany in the early years of the new century.

A modification of this spirit, and an indication of Cranach's natural bent, appeared very rapidly. His *Rest on the Flight into Egypt* (Fig. 486), of 1504, in Berlin, is more lyrical and more decorative. Playful winged putti scramble about the foreground, mingling with richly robed angels, as Mary, in a rich red robe, and Joseph look out toward the spectator. The landscape is here an adjunct, a marked change from the earlier works.

In this same year of 1504, it seems that Lucas Cranach went to Wittenberg, on the Elbe north of Dresden, where in 1505 he became court painter to Frederick the Wise of Saxony, succeeding Jacopo de' Barbari. (By this time he had married Barbara Brengbier of Gotha, who died in 1541 after giving him two sons and three daughters.) The *Rest on the Flight* may have been painted after he arrived in Wittenberg, for the putti suggest those in Dürer's Dresden Madonna and Child (Fig. 423), which was also made for Frederick the Wise. Less plastic in expression than Cranach's earlier works, the *Rest on the Flight*, with its deep space as a counterfoil to the foreground activity, shows the change toward the more decorative style that gradually came over his art as he settled down in Wittenberg.

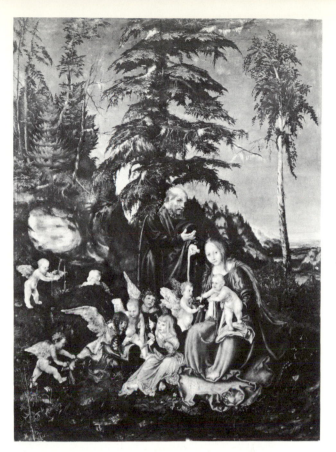

486. LUCAS CRANACH THE ELDER. *Rest on the Flight into Egypt.* 1504. Panel, 27 1/8 × 20 1/8″. Gemäldegalerie, Staatliche Museen, Berlin-Dahlem.

This style is manifest in the *St. Catherine Altarpiece*, of 1506, in Dresden, a rather confused work of somewhat dubious compositional unity. It is too strongly decorative, as in the flat patterning of the hose of the executioner and his "assistant." From the standpoint of color and of the various portraits, the work is, nevertheless, well executed, and the mannered confusion of its center panel is relieved by the excellence of the wings with standing saints, for example, Sts. Barbara, Ursula, and Margaret on the left wing. Delicate treatment of the feminine figures and accentuated surface ornamentation replace the earlier plastic, modeled style. Patterns of light and dark are rendered with warm color, reds, yellows, and golds being dominant.

This patterning had been forecast by the ornamentation of the foliage seen in earlier work, and by drawings of a few years earlier. In his 1504 drawing of *St. Martin Dividing His Cloak* (Fig. 487), in Munich, the subject is created in black and white on a blue background with an extensive use of white. The surface-filling short

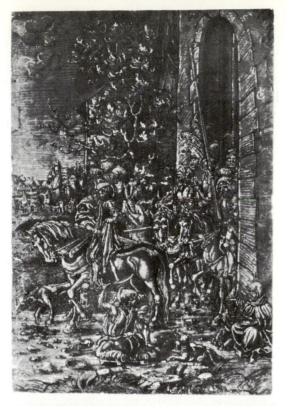

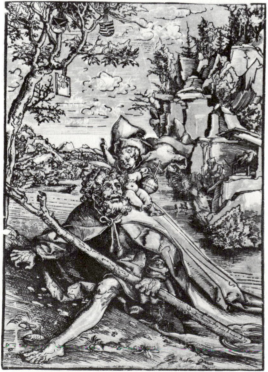

top: 487. Lucas Cranach the Elder. *St. Martin Dividing His Cloak*. 1504. Pen and ink heightened with white on blue-green ground, 7³/₈ × 5″. Staatliche Graphische Sammlung, Munich.

above: 488. Lucas Cranach the Elder. *St. Christopher* (B. 58). 1509. Chiaroscuro woodcut, 11 × 7⁵/₈″.

white lines create a decorative, though agitated, whirlwind-flecked surface that almost obscures the action and parallels in its abstract drama Dürer's *Christ with the Victory Standard* (Fig. 440).

During this period Cranach was also making woodcuts. Such works as his *St. Michael and the Dragon* and his *Temptation of St. Anthony*, of 1506, used by Grünewald, were influenced by Dürer's work of the latter half of the 1490s. Cranach made a less exacting demand upon the *Formschneider* for perfection in translating the drawing into woodcut form. The fine lines and precise cutting of a Dürer woodcut are not present, the execution being much less precise and, by comparison, almost sloppy. Possibly this is responsible for Cranach's innovation, the chiaroscuro woodcut, which appeared before 1509. Through the use of a second block in color the desire for a greater pictorialism was satisfied; at the same time, by introducing color the costly labor necessary for fine cutting was avoided, since chiaroscuro woodcuts depend on coloristic variety for a rich effect rather than upon fine line cutting. Thus by his invention Cranach moved away from the close alliance between engraving and woodcut that had been established by Dürer.

An example of this new type is the *St. Christopher* of 1509 (Fig. 488), in which a tablet hanging on the tree shows a winged serpent, Cranach's device, which became his coat of arms when he received letters patent allowing him to display them in 1508. He may have reused or recut an old block of 1506 for this purpose.

In 1509 Cranach took a trip to the Netherlands and there made a portrait (now lost) of Maximilian's grandson, the young prince who later became the Emperor Charles V. Given the greater pictorialism widespread in the Netherlands, it is possible that the trip suggested the idea of the chiaroscuro woodcut to him. Certainly such a painting as his 1509 *Holy Kinship Altarpiece* (Fig. 489), in Frankfurt, presents artistic conceptions and modes of dress directly related to Flemish work of this date. The floor patterning, the classicizing architecture, and the composition, with its accent on a logically constructed foreground, are presented with an emphatic disregard for spatial continuity into the background, which had marked his earlier works. Under Flemish influence he created large,

organic, plastic foreground units, but with connectives in the form of children running about so freely that they disrupt and destroy his attempt to create grandeur and monumentality. This phase did not last long in Cranach's art, for it was foreign to his basic outlook. There are certain overly plastic accentuations in such a work as his Leningrad *Venus and Cupid*, of 1509, in which he depended upon Jacopo de' Barbari and Dürer's *Eve* of 1504 (Fig. 441). He transformed the Venus figure by the emphasis upon the breasts, by the alluring look toward the spectator, and by the decreasing plasticity in the limbs toward the extremities. Underlying was his intent to create a sensuous figure, an intent at opposite poles from Dürer's aim to create an ideal and "right" form.

In the middle of the second decade Cranach's figural constructions continued to show Flemish influence. The *Massacre of the Innocents*, in Dresden, shows a high point of view directing the eye down upon a squirming mass of children somewhat subordinated to an over-all spatial construction; this, however, is not entirely successful, for Cranach's ornamental tendencies were becoming increasingly strong. More effective is the 1516 woodcut of *St. John Preaching in the Wilderness*, in which he did not attempt

such a high point of view or the incorporation of so many figures into the scene. Seemingly he had looked again at Dürer's work, and with greater understanding, though the depths of the forest are spatially restricted and the decorative qualities are easily seen. The subject is one that rose in importance in this period, being popular in the Netherlands as well as in Germany, and it probably reflects the new religious movement that came to its first open declaration through Luther's action in Wittenberg in the following year.

The evolution of Cranach's underlying decorative tendencies was rapid in his portraits. The full-length figure *Henry the Pious*, of 1514, in Dresden (Fig. 490), is activated by setting the Duke against a dark background, with his hand on his sword almost as though to draw it. The whole possesses a strange new drama of angular movements and color contrasts, red in the stockings and slashed inner garments, green and yellow in the cloak. The angularity and sharp contrasts show that Cranach was not interested in plasticity but in a dramatic decorative quality. Even naturalistic space was not important; the forms exist on a highly active surface plane toward which everything is pressed. Cranach has subdued his earlier plastic use of light in favor

489. Lucas Cranach the Elder. *Holy Kinship Altarpiece.* 1509. Panel, 47¼ × 39″ (center), 47¼ × 17⅛″ (each wing). Städelsches Kunstinstitut, Frankfurt.

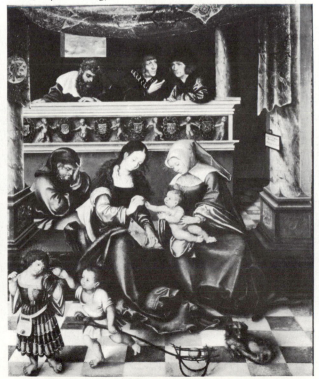

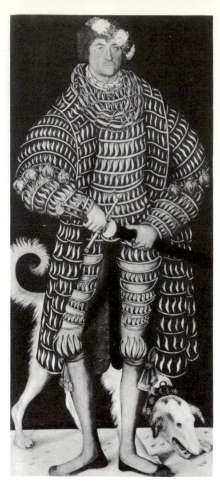

right: 490. LUCAS CRANACH THE ELDER. *Henry the Pious.* 1514. Canvas mounted on wood, 72½ × 32½". Gemäldegalerie Alte Meister, Staatliche Kunstsammlungen, Dresden.

below: 491. LUCAS CRANACH THE ELDER. *John Frederick the Magnanimous.* 1529. Panel, 25 × 16". Formerly, Gutman Collection, Haarlem.

ness in the reproduction of his models, for it is often impossible to distinguish the master from the shop. It must also be said that Cranach developed a type of formula painting that, under his close supervision, was readily reproducible. He himself is also recorded to have worked with tremendous energy, so that he undoubtedly did much on each work turned out. Evidence of the extensive activity of the shop is offered by the more than sixty copies of portraits of the Electors ordered from Cranach by John Frederick the Magnanimous when he came to the electorship of Saxony.

In such portraits as the 1526 three-quarter-view bust portraits of Luther and his wife in Darmstadt, the tendency toward diminished plasticity is emphasized by the silhouette, but a subtle projection of the shapes is achieved by a delicate modeling. A stronger drama of the interior forms appears in Cranach's 1527 portraits of Luther's parents, in Wartburg.

Possibly the most striking of Cranach's portraits is that of *John Frederick the Magnanimous,* of 1529, formerly in Haarlem, Gutman Collection (Fig. 491). The costume is like that of Henry the Pious, but the garment is even more markedly flattened, and the head, by its greater plasticity, dominates the superficially bulky body. Almond-shaped eyes look both at and beyond you. The quizzical aloofness, achieved in part by the linearity of the eyelids, is a sophistication

of evenly illuminated forms, which reinforce planarity. Even more startling, however, is the new concept of the portrait. Not only is it a full-length figure, but there is a new, essentially unnaturalistic heightening of the subject distinctly different from the early portraits.

Well acquainted with Martin Luther, who stood godfather for one of Cranach's children, Cranach, aided by his shop, portrayed him many times at various periods of his life. One of the earliest works is a woodcut of 1521–22 showing Luther as Junker Jörg, the disguise he assumed after defending his theses at the Diet of Worms. The disguise was a subterfuge known to many, for it must be remembered that Luther was under the protection of the Elector of Saxony.

Both of Cranach's sons, Lucas the Younger and Hans, worked under him, along with other artists, at one time as many as 16 being in Cranach's shop. Thus it cannot be doubted that many of the works, including the portraits of Luther, have a great deal of shop participation. However, Cranach obviously held his shop to a very high degree of craftsmanship and faithful-

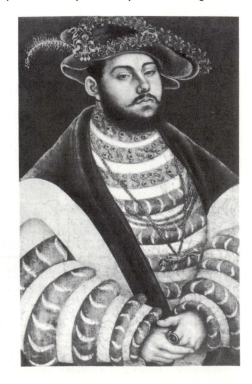

of portrayal that appears again in Cranach's mythological subjects and in those drawn from Greek and Roman antiquity.

A high point in his portrait production is the naturalistic portrayal of *Dr. Johannes Scheüring*, of 1529, in Brussels (Fig. 492), which is suggestive of Dürer's Holzschuher portrait. However, Cranach rejected Dürer's overwhelming drama and incisive linearism, achieving effect more by silhouette and surface ornamentation than by emphatic plasticity. A significant variation is encountered in the unmodulated background, treated as a completely blank area against which the wayward curls of hair are silhouetted. Not so ferocious a figure as Holzschuher, it shows—in the tilting of the eyes, as in the John Frederick portrait, in the quieter aspect of the hands, and in the marked patterning of the drapery, outlined at almost every fold—gravity without excessive severity.

This work, like the Luther portrait previously discussed and the portraits of Luther's wife and parents, demonstrates that Cranach had one style, essentially naturalistic, for certain figures, and another, essentially based on sophisticated pattern, for princely portraits. Such an expression of a concept of modes was probably derived from Renaissance theories of decorum, like that expounded by Castiglione, whose famous *Courtier* was written about 1507 but not printed until 1528.

A clarity of form that is neither entirely plastic nor pictorial is seen in both portrait styles, as well as in other works with similar stylistic ideas; an example is *Judith with the Head of Holofernes* (Fig. 493), in New York, of about 1530, one of a number of representations of the same type and pose.

The sophisticated use of pattern, flattened light, and subtle tonal gradations over a form silhouetted against a dark background (which adds to the decorative effect) conditions a great number of Cranach's works on various types of subject matter. One can almost select at random. Such is the character portrayed in the *Venus* (Fig. 494), in Frankfurt, and in paintings of Lucretia, Adam and Eve, or the Three Graces. The search for the ideal human proportion that had governed Dürer's treatment of the nude was of no concern to Cranach. His figures are willowy, sensuous, graceful, and mannered. An extremely youthful long-legged feminine type is often represented. The *Judgment of Paris* (Fig. 495), for example, presents the three beautiful, naked con-

left: 492. LUCAS CRANACH THE ELDER. *Dr. Johannes Scheüring.* 1529. Panel, 20 1/4 × 13 3/4″. Musées Royaux des Beaux-Arts, Brussels.

right: 493. LUCAS CRANACH THE ELDER. *Judith with the Head of Holofernes. c.* 1530. Panel, 35 1/4 × 24 3/8″. The Metropolitan Museum of Art, New York (Rogers Fund).

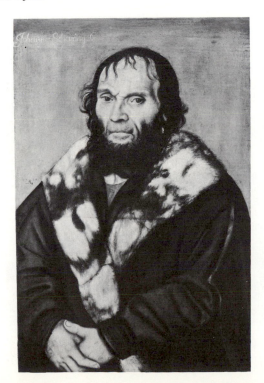

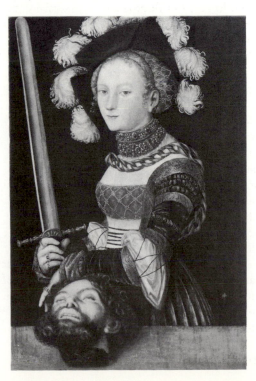

tenders in this way, but there is no self-consciousness as they stand around in delightfully awkward poses, demurely lascivious, the central beauty gazing out at the spectator with unabashed almond-shaped eyes. Wearing filmy, revealing veils and richly adorned from the neck up with ropes or chains of jewelry, they forcibly remind one of the hedonistic aspect of 18th-century art.

Such sophisticated sensuality and delightful fantasy was new in German art of this time. The gravity of the classical theme, so much the concern of Albrecht Dürer, is nowhere present; Cranach and his patrons preferred the pleasurable side of the classical heritage. That this is a reflection of the Wittenberg court cannot be doubted, for this court and others like it were his patrons.

Occasionally there is a thematic type that had interested Dürer, such as a portrayal of Melancholy, but such themes are in the minority, and Cranach is to be compared to Dürer in this regard as Titian may be to Giovanni Bellini. For both later artists the interest in form and color was visually the stronger element. This more hedonistic aspect, presented at the same time that Cranach was painting for Catholic clients a great number of similar Madonna and Child paintings, is responsible for a theme that would be expected from a court artist, a hunting scene.

There are several of these by Cranach. One (Fig. 496), in the Prado, of 1545, in which the scene unrolls before the spectator, is governed by a panoramic conception of space that had become popular in Flanders by about 1515. The various activities of the hunt, in almost miniaturistic detail, are presented from a high viewpoint as the landscape retreats and rises away from the picture plane. An even lighting is employed over formal variations that are marked out in color by value and line.

A comparable expression controls Cranach's *Fountain of Youth* (Fig. 497), of 1546, in Berlin. The theme was a popular one, as demonstrated by Ponce de Leon's search for the true fountain. Again Cranach employed the high horizon and the panoramic landscape, in front of which figures, all old women, approach a square pool from the left, become rejuvenated when they reach the middle, as can be seen from their lively action, and emerge at the right to indulge in the pleasures of youth. The result, however, is very different from his early landscapes, with their dramatic content and emotional drama. A decorative insouciance is seen in the light, delicate, spacious, and less plastic manner.

A trace of this quality appears in his late *Self-portrait* (Fig. 498), of 1550, in Florence, though here he modeled more strongly and filled the

left: 494. LUCAS CRANACH THE ELDER. *Venus*. 1532. Panel, 14 1/2 × 9 7/8″. Städelsches Kunstinstitut, Frankfurt.

right: 495. LUCAS CRANACH THE ELDER. *Judgment of Paris*. 1530. Panel, 13 3/4 × 9 1/2″. Staatliche Kunsthalle, Karlsruhe.

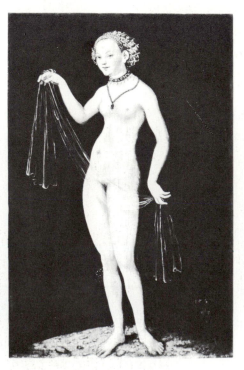

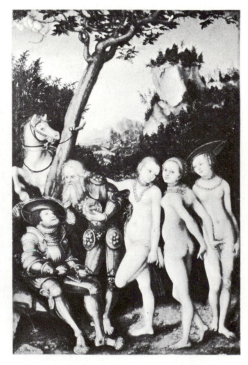

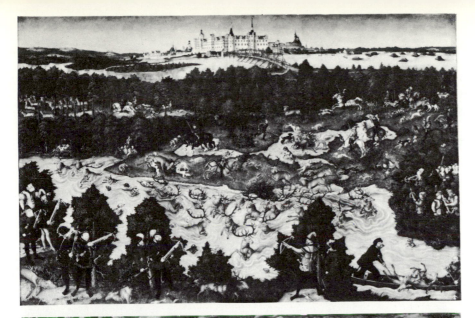

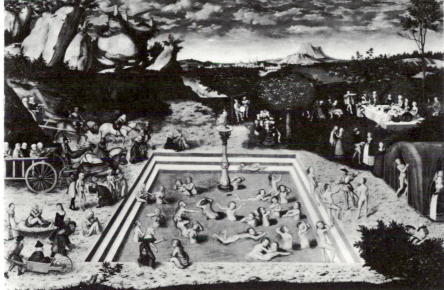

above: 496. LUCAS CRANACH THE
ELDER. *Hunting Scene.* 1545. Panel,
$46^{1}/_{2} \times 69^{3}/_{4}$". Prado, Madrid.

left: 497. LUCAS CRANACH THE
ELDER. *Fountain of Youth.* 1546.
Panel, $47^{5}/_{8} \times 72^{7}/_{8}$". Gemälde-
galerie, Staatliche Museen, Berlin-
Dahlem.

below: 498. LUCAS CRANACH THE
ELDER. *Self-portrait.* 1550. Panel,
$26^{3}/_{8} \times 19^{1}/_{4}$". Uffizi, Florence.

space so that the top of the head almost pushes
against the upper edge of the frame, implying a
greater mass and plasticity than is actually pres-
ented. Cranach portrayed himself much as he
had portrayed other leading men of his era, and,
indeed, his position was equally eminent. He,
too, had worked for Emperor Maximilian on
the *Prayer Book;* he, too, had occupied civic
positions of importance, having been a member
of the Wittenberg city council in 1519 and every
other year thereafter, becoming Burgomaster
of Wittenberg in 1537, a position he held for
three years.

Having become prosperous, he had bought
an apothecary shop near the marketplace in 1520
and had also become a bookseller and printer.

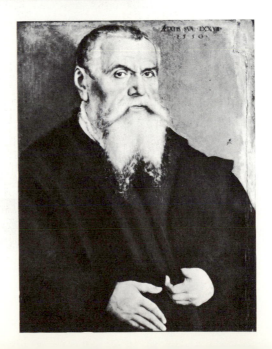

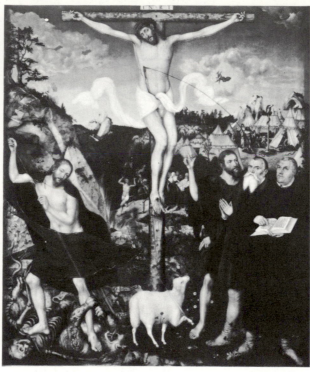

499. LUCAS CRANACH THE ELDER AND THE YOUNGER. *Allegory of Redemption.*
1553–55. Panel, 11′ 9³/₄″ × 10′ 2″. Church, Weimar.

In 1550 he eventually moved to Augsburg, where he had been summoned three years earlier by John Frederick, who had been taken prisoner. When his prince moved to Weimar two years later, Cranach accompanied him. The artist died there in the following year, still painting, as is attested by the *Allegory of Redemption* (Fig. 499), in the Weimar Stadtkirche, which was finished by his son Lucas the Younger. (His other son, Hans, had died in Italy in 1537.) In the center panel, to the right of Christ on the Cross, are John the Baptist, Cranach, and Martin Luther, who points to the passage in his translation of the Bible concerning the blood of Jesus, "which frees us all from sin." The blood arcs out in a stream from the side of Christ to fall directly upon Cranach's head, a clear demonstration that no priestly intercessor is needed. (The motif was anticipated in Dürer's 1509 *Man of Sorrows* engraving.) The direct access of the individual to salvation was, of course, a basic tenet of Luther's doctrine. The lamb, at the base of the Cross, to which John points with his left hand, may have been suggested by the work of Grünewald. At the left Christ conquers evil in the form of a demon grasping His lance of light, like one of Schongauer's demons overcome by St. Michael. In the background, deep to the left of the Cross, Adam is driven out of Paradise after the Fall, which is to be redeemed by Christ's sacrifice. To the right in the background are seen the adoration of the brazen serpent by the Hebrews in the wilderness and the annunciation to the shepherds of the birth of Jesus, which complete the allegory of sin and redemption. Much of the work must have been done by Lucas the Younger, whose style followed that of his father, but the son subsequently carried elegant decorativeness a step too far toward a decidedly mannered system.

Cranach, despite his Danube-style beginnings, did not take up the challenge laid down to northern art by Dürer; instead, he went his own very personal, sophisticated way to create a thoroughly insouciant, delightfully fantastic art without parallel in the north.

ALBRECHT ALTDORFER

ALBRECHT ALTDORFER, LANDSCAPE PAINTER PAR excellence of the Danube school, presents certain similarities in his early work to the early works of Cranach, but his later art is a logical continuation of his early style and not, as in the case of Cranach, a departure from it. Much of his life was spent in Regensburg, of which he became a citizen in 1505. The son of the engraver Ulrich Altdorfer, who left Regensburg about 1491, he was probably born there about 1480. In 1505 he was recorded as coming from Amberg, near Regensburg, but this was apparently a temporary location, for there is no record of him at Amberg. The records show that he remained in Regensburg, though it is possible that in 1511 he went to Vienna, where he definitely was in 1535 on official business. However, his earliest years before 1505 are not traceable.

It must be remembered that these were not peaceful years. In 1529 the Turks, who had been advancing westward, made their famous attack on Vienna, which was beaten off. (This represents their farthest westward penetration.)

Altdorfer was already married when he bought a house in Regensburg in 1513. He must have done well in Regensburg, for he bought another house in 1517 and sold it in 1522; in 1530 he owned a vineyard, and in 1532, the year in which his wife died, he bought another house with a large garden. His possessions were so numerous that his will of 1538, the year of his death, consisted of ten pages written on both sides. The will mentions that he had at this time a pupil by the name of Hans Muelich. In 1519 he had been a member of the junior council of Regensburg; in 1526 he was a member of the senior council and was made city architect. In that capacity he built the city wine cellars and slaughterhouse in 1527. The following year he turned down an invitation to become mayor of the city. Clearly important in city affairs, he was a member of the council which, in 1533, decided to adopt Lutheranism in Regensburg.

Altdorfer's early preserved works are chiefly prints and drawings, but his first signed painting is the *Satyr Family* (Fig. 500), in Berlin, of 1507, which shows his concept of landscape as clearly more poetical in spirit than that of Cranach at a comparable date, though their works have similar roots. The landscape appears as a screen, with less penetration into depth, less dramatic movement, and far more of a sense of the poetry and mystery of nature than in Cranach. Though the satyr's wife is seen from the back, like an Italian nude, and is in classical fashion (light-skinned, instead of ruddy like her mate), the family almost merges with the landscape.

This fusion is perfectly achieved in the *St. George in a Wood*, of 1510, in Munich (Fig. 501). St. George is almost indistinguishable from the trees, his elaborate plumed helmet having the same character and coloration, while the horse and, in part, the dragon are, on first glance, the most easily recognizable forms. Man and nature are

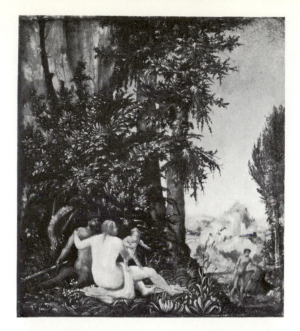

the *Dead Foot-Soldier in the Forest*, a drawing in Berlin, shows the return of life to the earth from which it had come. Though nature is wild and somewhat forbidding, it is the grandeur and drama which are important; that the man is dead is not, for he has succumbed to nature's movements, his presence merely an articulating, scale-setting device. Thus Altdorfer's concept of man and nature was dissimilar from that of Cranach, in whose work nature often echoed the mood of man. For Altdorfer it was the opposite; man echoes nature's mood and becomes a part of natural rhythms.

His painting of the *Rest on the Flight into Egypt by a Fountain*, of 1510, in Berlin, indicates that a part of this interest in nature stemmed from the art of Michael Pacher. His own interests lay in the variety of nature and its poetic and magical aspects, as may be seen in such drawings as the *Pine Tree*, in Berlin, in which a few figures and houses appear, but only as witnesses to Altdorfer's exaltation of nature and its forms. A tree form by itself could express for him the whole drama and variety of nature, a microcosm reflecting the macrocosm.

In the Berlin *Holy Night* (Fig. 502), of 1512, the Nativity is almost lost in the movement of light over the bricks of the ruined stable. The light from the large, round moon in the upper left-hand corner draws the eye, for it is the chief actor in the scene, picking out the rejoicing angels who hover over the ruins and accentuating the mortar joints. The beauty and poetry of the night landscape has its own existence, into which even the religious drama is made to fit, for the supernatural light from the Child is no stronger than the lunar light filling most of the scene.

By 1515 a new style, more vivid in color, more heroic, and more monumental had developed in his art. It is from this period that his independent landscape drawings date, as well as his work on the *Prayer Book* of Maximilian, 109 parchment leaves in the Besançon example being decorated by him.

About 1518 he was working at the monastery of Sankt-Florian in Austria, for which he painted

here united in Altdorfer's conception of the grandeur and mystic unity of nature. Very different from the ideas of any previous German artist, this work partakes of Venetian feeling and suggests the art of Giorgione, though the form is more dramatic, in the northern trend. No direct influence is suggested, though it is, of course, possible that Altdorfer could have gone to Italy during his early travels. But nature itself took the lead in his art, and in a number of works of this period around 1510 it became dominant;

a series of Passion scenes and scenes from the life of St. Sebastian. An intensified drama, with strong movements in light and dark and color, characterizes these works in the new style. However, the same dominance of natural forms is visible. Dramatic lighting prevails, and the color of the costumes creates strong notes by sharp contrasts of value and tonal purity. To this, nature adds its color in the *Christ on the Mount of Olives* (Fig. 503). An angry red sky behind the scene forecasts the events to come, indicated by the torches and the obscure figure of Judas in the darker area at the left. Altdorfer stretched the visual limits of his scene by setting his figures deeper into space to vie with the moody color of the landscape. In the Passion scenes a quality of awkwardness is used effectively in the lesser figures, though the figure of Christ is far from idealized. Architecture, when present, is often classicizing and cleanly marked out, with sharp value contrasts between wall surfaces and moldings. There is a frequent use of strong red-green and blue-yellow contrasts in the garments of the surrounding figures, who are often organized both two- and three-dimensionally in a circular movement about the slightly bulbous-nosed, watery-eyed, awkward, unheroic figure of Christ. Seemingly a simple carpenter, Christ is an ordinary man subject to the evil tormentors of this world. Occasionally the influence of Dürer can be seen, as in the scene of Christ carrying the Cross, an adaptation of Dürer's woodcut from the Passion series (Fig. 430).

Though the color contrasts, with their strong red and blue notes, as in the Crucifixion, suggest an influence of Venetian art, the differences are stronger than the similarities. Venetian art tended to emphasize tones of red, ultramarine, warm brown, and yellow that express a human delight in nature; these colors also appear in Altdorfer's work, but he emphatically added greens and blue-greens in large quantities of purer, less muted color, effectively offsetting the warm, sensuous effect of Venetian painting. In addition, Altdorfer now and then turned the circular

below: 502. ALBRECHT ALTDORFER. *Holy Night*. 1512. Panel, 14 1/8 × 10″. Gemäldegalerie, Staatliche Museen, Berlin-Dahlem.

right: 503. ALBRECHT ALTDORFER. *Christ on the Mount of Olives*. c. 1518. Panel, 50 5/8 × 37″. Monastery of Sankt-Florian, near Linz.

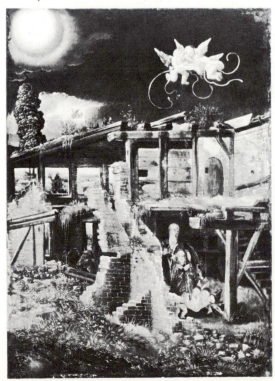

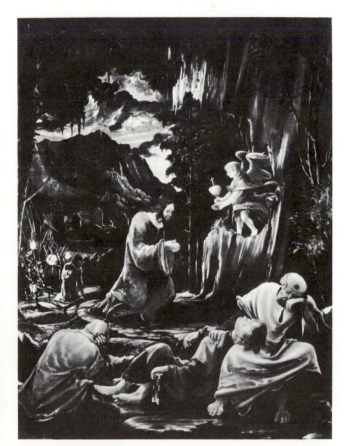

movements just described into space and elongated them into an ellipse to create diagonal movements, to which he allied a coloristic movement achieved by spotting warm colors that change in intensity, purity, and size as they move into and out of depth.

In the *Beating of St. Sebastian*, at Sankt-Florian (Fig. 504), Grünewald's influence appears, for the unusual projection forward of the recumbent white body and hanging head of Sebastian, with crimson used to model the form, suggests the effects Grünewald achieved (but with a warmer feeling) in the risen Christ of the *Isenheim Altarpiece*. The fantastic antique costume of the figure about to beat the saint with a club may, however, derive from Italian engravings; certainly the architectural elements in the Sankt-Florian paintings are based on Bramante engravings. However, Altdorfer calculated his disjunctions of form and exaggerations of movement into space to achieve the maximum in expressive effect, which indicates that he was acquainted with Grünewald's art.

Certainly the color effects in the Sankt-Florian paintings are at variance with Altdorfer's earlier works, for they follow Grünewald's lead, though they lack both the subtlety and more sensuous effects of the master of the *Isenheim Altarpiece*. Altdorfer was not basically sensuous, as one might say Cranach was; instead of Cranach's gentle sophistication, Altdorfer conveys an earnestness and directness, as well as an accentuated realism, nowhere present in Cranach or Dürer but visible in Grünewald.

About 1520 another change appeared in Altdorfer's style. Though not radical, it is discernible as a "High Renaissance" clarification and simplification, with a compacting of forms, as in the scenes of the legend of St. Florian, from a dismembered altarpiece, of which two panels are in the Uffizi, three more are in Nuremberg, and two others are in private hands. More architectonically constructed than his earlier works, they reveal less of the violent color contrasts used only a few years before. In the scene of the *Finding of the Body of St. Florian* (Fig. 505), in Nuremberg, fewer figures are employed, and though the number of figures was possibly dictated by the event represented, their movements are quieter, showing a more thoughtful assimilation of what was evidently Grünewald's influence. One also feels that some knowledge of the art of Leonardo must have come to Altdorfer

in his representation of mountainous backgrounds as devoid of vegetation, with ridges and peaks that are close in manner to the Italian master.

The further development of this style reaches a peak in the *Birth of the Virgin* (Fig. 506), in Munich, dated between 1521 and 1525 but probably close to the former year. The scene takes place in a church (again recalling Grünewald, who employed a related device in his Annunciation) at the emplacement of the side-aisle altar, where an angel overhead censes and a ring of smaller angels joyfully sails through the air above out into the nave and back around again, a centrifugal movement of tremendous energy suggested by the rapid diminution in size of the angelic forms as they fly. Their movement is augmented by repeated color, particularly red, that increases in intensity as the figures grow large and diminishes as they grow smaller.

This use of color intensity as a space-creating device is also seen in the red-garbed figure of Joachim, closest to the picture plane, and a lesser intensity of red in the feminine figure next to him in spatial depth; the color play also aids in uniting the upper and lower parts of the painting. In addition space is created by variations between the light and dark parts of the church, the nave and farther side aisle being both lighter in value and cooler in hue. These technical aspects connote to the eye of the spectator both the grandeur of the setting, with all its solemn overtones, and a naturalistic glorification of the event.

In the first half of the 1520s the conceptions of Altdorfer are overcome by a sense of quiet that is epitomized in the *Danube Landscape near Regensburg* (Fig. 507), in Munich. Here is a landscape painted for itself, without a single human figure, though a castle is seen at the back of the middle ground, providing a slight human indication, as does the road winding into the distance. It is organized along diagonal movements running across the painting from the *repoussoir* tree at the left to the tree at the right, then diagonally again, following the road into the distance in a further diagonal direction. This is not an objective portrayal of the landscape (which seems more like the wooded landscapes south of Innsbruck than a scene along the Danube) but its pantheistic expression in a poetic, nonscientific, and dreamlike manner.

top: 506. ALBRECHT ALTDORFER. *Birth of the Virgin. c.* 1521. Panel, 54 3/4 × 51 1/4″. Alte Pinakothek, Munich.

above: 507. ALBRECHT ALTDORFER. *Danube Landscape near Regensburg. c.* 1522–25. Panel, 11 × 8 5/8″. Alte Pinakothek, Munich.

At the opposite pole from the analytical, or topographical, landscape, it affirms the movement, vastness, and sense of life within nature. The lyrical feeling imparted by this landscape, heightened by the clouds above, sailing into the clear area of the sky, is very different from the effect of the early *Satyr Family* of 1507, with its

strongly decorated surface treatment and minimal spatial depth; this is a truly mystic exaltation of natural forces, of an ideal of natural beauty, of the movement of light, and of the growth and quiet strength of natural forms in which man finds peace. Such a concept of the soul of the landscape was to find an echo in the landscapes of the German Romantic painters of the 19th century, whose aims approached, albeit more consciously, those of Altdorfer.

An interest in architectural construction governed his painting of 1526 of *Susanna at the Bath* (Fig. 508), also in Munich, for which a preparatory drawing of the palace structure exists in Düsseldorf. Barely visible under the trees at the left are the elders, who peer out from the bowery cover as Susanna, fully clothed, is having her feet washed. The setting is an idyllic flowering lawn adjoining a huge marble palace filled with people. The stoning of the elders is visible on the terrace to the right. A fanciful construction built up out of Italian architectural elements reminiscent of the work of Bramante's Milanese period, the whole is put together with almost miniaturistic delight in detail, presented under a soft, even illumination, against which the palace structure stands out sharply. On the left is a view into a romantic, hilly landscape, in its way as fanciful as the architecture.

The miniaturistic tendencies visible here are also in Altdorfer's great *Battle of Alexander* (Pl. 27, after p. 308) of 1529, in Munich, depicting Alexander's victory over Darius at Arbela on

above: 508. ALBRECHT ALTDORFER. *Susanna at the Bath.* 1526. Panel, 29½ × 24″. Alte Pinakothek, Munich.

right: 509. ALBRECHT ALTDORFER. *Allegory of Poverty and Riches.* 1531. Panel, 11 × 15¾″. Gemäldegalerie, Staatliche Museen, Berlin-Dahlem.

510. ALBRECHT ALTDORFER. *Lot and His Daughters*. 1537. Panel, $42^{1}/_{8} \times 74^{3}/_{8}$". Kunsthistorisches Museum, Vienna.

the Issus River in 333 B.C. The painting was commissioned by Duke William IV of Bavaria. Here the miniaturistic elements have been subordinated to a pantheistic cosmological conception, in which the setting sun reflected on the water and the rising moon take part, as in a Crucifixion scene. Below, vast hordes of armies are seen in action, banners flying and lances atilt. In the center Darius in his chariot flees the battle and Alexander on horseback pursues him. The armies clash, mingle, and recede along diagonal lines to the tents and castle in the background, beyond which the sea is shown with ships on its surface meeting a cold, blue, mountainous sublunar landscape bare of all vegetation. Seen from some high vantage point, the panorama of the landscape is given scale by the tablet, with its inscription recording the action, hanging in the air above our eyes. With crimson draperies flying out on either side to aid the illusion of floating in air, and stabilized by the cord hanging from its center to lead the eye to Alexander below, the tablet fixes the whole swirling, spatial conception. Swarms of figures are organized in a serpentine movement into space and engaged in all the varied activity of battle, suggesting the futility of human endeavor. (In spite of this suggestion, the painting was a favorite of Napoleon when it was taken to France in 1800.)

Two years later Altdorfer painted his *Allegory of Poverty and Riches* (Fig. 509), in Berlin, with beggars riding upon the train of Pride. A new unity of figure, architecture, and landscape, which had been forecast in the *Battle of Alexander*, ties the elements together into a progressive movement from foreground to background. Unlike the *Battle of Alexander*, where the foreground was only implied by the tablet hanging in midair, the foreground here is the starting point for a progressive movement into depth that carries the eye back to the horizon, above which rises a sky almost like the type of northern Baroque sky that Ruysdael was to paint arching over the head of the spectator a century later. In formal organization the painting corresponds to the northern landscapes of the 1570s and 1580s.

Of 1537 is the Vienna *Lot and His Daughters* (Fig. 510), in which the previous style seems to have been exchanged for an interest in volume and facial expression, as though a Giorgione Venus had been seen through northern eyes. The change is radical and, indeed, seemingly so retrograde that its attribution to Altdorfer has been questioned. Architectonic construction is present, but idealized form is little realized; Italian Renaissance conceptions were basically foreign to Altdorfer except in his revelation of the microcosm as mirror of the macrocosm.

Despite his architectural constructions, particularly evident in his drawings of the years just before and after 1520, Altdorfer did not approach his world scientifically, creating instead a formal, compositional, and coloristic drama of an intuitive identification with nature that anticipated not only the Baroque to follow but also the Romantic identification of man and nature of the early 19th century.

HANS BALDUNG, CALLED GRIEN, ATTEMPTED TO carry on the line established by Dürer, in whose shop he received his formative training, but neither Baldung nor other followers of Dürer had the great unifying vision of their master or, what was much more important, his breadth of artistic imagination and synthesis. Dürer had had his influence upon Altdorfer and his other great contemporaries, but that influence, after the *Apocalypse* woodcuts, was more often one of incidentals than of basic outlook. Cranach had turned aside from the problem of uniting Renaissance theory and northern practice, Grünewald had paid no attention to it, and Altdorfer had metamorphosed the poetic landscape of the Venetians into a northern mystical and magic poetry oblivious to any Venetian suggestions attendant upon its birth.

Baldung, born of an academic family at Schwäbisch-Gmünd in 1484–85, was working about 1500 in a shop in Strasbourg, and about 1503 he went to Nuremberg to enter Dürer's shop. In 1505 he made drawings for book illustration (more than 250 drawings of all kinds have been preserved), but when Dürer left for Venice in the latter part of the year, Hans Baldung disappeared from view. He is traceable in 1507 in Halle, where he completed two altarpieces for the cathedral. In 1509 he became a citizen of Strasbourg and was married. The next few years he spent there as a painter, designer of stained glass, and book illustrator, but in 1512

he moved to Freiburg, where his brother Caspar was teaching at the university. He remained in Freiburg for his five most creative years, until early in 1517, when he returned to Strasbourg to renew his citizenship and spend the remainder of his life. He died there in 1545, an honored citizen.

The 1507 *Adoration of the Magi Altarpiece* (Fig. 511), in Berlin, from Halle, represents, on extremely narrow wings, the figures of Sts. George and Maurice on the interior, and Sts. Catherine and Agnes on the exterior. The types are clearly inspired by Dürer, St. George, for example, recalling the *Paumgärtner Altarpiece* (Fig. 434). But Baldung's style is hard, and the forms are sharp in contrast and crowded. The saving grace of the whole composition is a rich sense of color more fluid and warmer than that of his master. An able, intellectual young artist, Baldung was a bit awkward and less plastic than Dürer; in comparison, his color in this instance plays almost too strong a part.

His growth, however, was rapid. Far more accomplished is his *Three Ages of Woman* (Fig. 512), in Vienna, painted between 1509 and 1511, which may have been a part of a Dance of Death series. It may also be considered as a Vanitas allegory. The playful action of the child below, pulling the veil over itself, reminds us of Cranach's Venus and Cupid scenes and reiterates the medieval concept of veiled Cupid as a symbol of lust. Death catches the other end of the

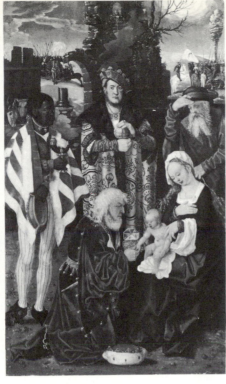
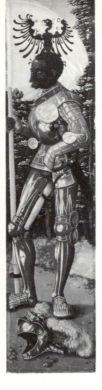

veil and holds up an hourglass behind the woman
as an older woman enters into the scene at left
to stay Death's hand. The proportions of the
young woman, like those of Baldung's Eve
drawing of 1510, in Hamburg, were derived
from Dürer's 1504 engraving of Adam and Eve
but made more lithe and elegant. The appear-
ance of the figure of Death suggests a leaning
toward the outlook of Grünewald, for there
is in Baldung's art a sense of fantasy and northern
mysticism that Dürer normally excluded.

Of all German painters of this period Baldung
was the most involved with the supernatural.
This interest manifests itself frequently, appear-
ing again in the chiaroscuro woodcut of the
Witches (Fig. 513), of 1510, possibly based on a
1506 drawing in Paris by Altdorfer. The chia-
roscuro woodcut is a medium with which Bal-
dung was in sympathy, given his coloristic
inclinations, and which he handled very well.
Though the forms are Düreresque in propor-
tion, their movements are more dramatic and
the whole is a fluid, integrated expression of
the artist's fascination with a fantastic reality.
About 1510–11 may be dated a *St. Christopher*
woodcut, which shows Dürer's influence in
general handling. Cutting is fine and precise,
though a little dry and too regular, especially in
the outlining of the figure; yet there is a

lyrical feeling that separates it from the more
austere drama of Albrecht Dürer. Hans Baldung's
conceptions in treating religious themes were not
so dramatic as those of Dürer except when he
adopted Dürer's compositions, as in the chia-
roscuro woodcut of the *Crucifixion* of 1512–14,
based on Dürer's engraved *Passion.*

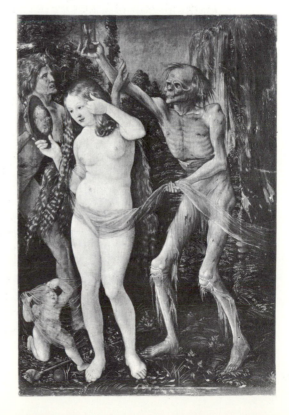

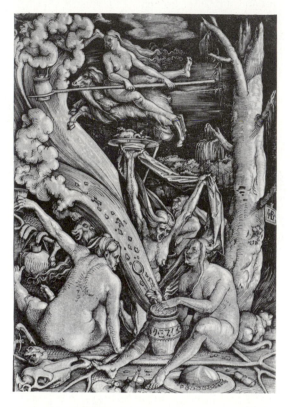

The influence of the Danube style appears in his Vienna Academy *Rest on the Flight into Egypt* (Fig. 514), of about 1513. The dripping trees and the mountains behind, so characteristic of the works of Cranach and Altdorfer in this style, are present; however, the treatment is sharper and clearer than in Altdorfer's comparable work. Withal Baldung shared the feeling for the drama of figure and landscape seen in Cranach and Altdorfer; he also shared their compositional organization.

Despite his training under Dürer, he was basically sympathetic to an emotive expression. This conditions his *Holy Family*, of about 1513, in Innsbruck, whose large plastic figures are set into a vaulted room screened by curtains on rods reminiscent of Grünewald's setting of the Annunciation, while the putti and also Joseph recall Dürer. Thus Baldung shows a tendency to combine the extremes represented by the two greatest German artists of the era. This amalgamating spirit is seen in several versions in painting (Berlin) and woodcut of the *Lamentation over the Body of Christ*, of the period of 1513–15, in which the closeness of plastic form to the picture plane imparts a stronger emotionalism of movement and color than is to be found in Dürer alone.

During these years Hans Baldung was working on the *Prayer Book* of Maximilian, as well as the high altar for Freiburg's Münster. Its central panel of the *Coronation of the Virgin* (Fig. 515) repeats the theme of Dürer's now lost center panel of the *Heller Altarpiece*, with music-making angels inspired by Grünewald; however, the setting is not elevated, and the gestures are more awkward. The Annunciation panel is an adaptation of Grünewald's panel now at Colmar. Baldung's angel was inspired by the *Isenheim Altarpiece*, and the variegated character of the outline of the Virgin's drapery also reveals its influence. Yet the Visitation panel on the opposite wing is almost Rogierian in its composition though Düreresque in formal treatment. Nevertheless, the influences have been assimilated, for Hans Baldung was not a slavish copyist. The ultimate source for the composition of the *Flight into Egypt* is Schongauer's engraving, brought up to date formally and plastically and set out against a black background to emphasize the rhythmic qualities of the design. The Nativity is treated as a night scene, a conception that became very

popular in Germany and the Netherlands in the second half of the decade 1510–20, since it allowed artists to experiment with dramatic natural light and contrast it with the supernatural light from the Child.

Baldung's linearity, which occasionally makes his works seem somewhat dry, has its compensations in more stained-glass designs and in a series of portraits painted during this period in Freiburg. The portrait of *Ludwig, Graf von Löwenstein*, of 1513, in Berlin, is not overly plastic, for a simplified line was used as a contrast to the more active details of costume in an effective bust that fills the frame. Its mood and expression are repeated in the portrait of *Christoph, Markgraf von Baden* (Fig. 516), of 1515, in Munich. The linearity of the form is even more marked and is used consciously and expressively in the portrayal of an obviously thinner-faced subject than Graf von Löwenstein, line again vying with the delicate modeling of this long-nosed, thin-lipped personage with his jeweled hat cocked to one side. These linear determinants control flatter volumes within a limited space arrested by a blank background and are thus compositional elements leading to the features of the individual portrayed. A further example is the Munich portrait of the Count Palatine, *Philip the Warlike* (Fig. 517), painted as a student at the age of fourteen in 1517. He looks out of the corners of his large eyes at the spectator. The effect is very appealing, as is the delicate linearity of the features and the equally delicate modeling. The lighter face dominates and contrasts with the

darker, more plastic body, for the light on the face is even, while that on the body is graduated in effect.

From this period is Baldung's impressive woodcut of the *Ascension*, of 1515–17 (Fig. 518). Influenced by the "visionary" style of Dürer's *Resurrection* in its tonal quality, it is far less fine in its cutting; in conception, however, the limp, pathetic body of Christ being raised to heaven

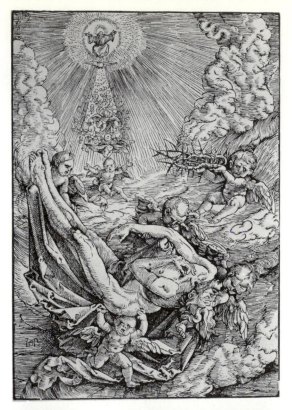

by mourning putti is one of Baldung's finest expressions. The idea of such a figure probably stemmed from a work by Dürer, which probably also influenced Altdorfer's Sankt-Florian painting of Sebastian succored by the Roman women and the finding of the body of St. Florian; but, as in Altdorfer, it is imbued with a far stronger pathos. The heightened emotionalism in the representation of bodies without volition, either dead or unconscious, appealed strongly to German artists of this era of the Reformation.

In 1517 Luther nailed his 95 theses on the Wittenberg church door, and about this same year Baldung painted his *Death and the Woman* (Fig. 519), now in Basel. The white-skinned, full-formed woman and dark Death are dramatically set against a darker background. Her reaction as characterized by Baldung is far more than dismay when she turns to discover the source of the unexpected kiss; here Baldung presents a moralizing statement about the outcome that will be reached unwittingly by sensuality. Something of the same spirit animates his 1519 woodcut of *Adam and Eve*.

His interest in value contrasts to heighten emotional drama had appeared before and recurs in his night *Nativity*, in Munich, of 1520. As in Altdorfer, eerie light cast by the moon in the upper left-hand corner on the ruined architectural setting evokes the transcendental spirit of the event, which vies with and is intensified by the contrasting emphatic naturalism of detail. As one would expect, the sense of fantasy was not carried so far as in the art of Altdorfer (one is also reminded of Witz's Geneva altarpiece).

In 1521 Baldung created his famous woodcut of *Luther as a Monk* (Fig. 520), bathed in the light of the Holy Ghost hovering over the tonsured head. It was made for Johann Schott's edition of the *Acta et Res Gestae* of Luther. Cranach portrayed Luther as a sophisticated individual, well aware of his world; but Baldung, in keeping with his basic tendencies, presented him as a naïve monk, touched by divine revelation, a transformation of Luther into a saintly hero, as indeed he appeared to many at this time.

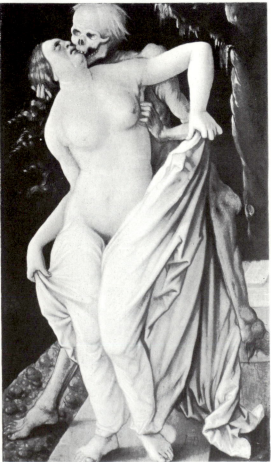

above: 518. HANS BALDUNG GRIEN. *Ascension* (B. 43). 1515–17. Woodcut, 8 3/4 × 6".

left: 519. HANS BALDUNG GRIEN. *Death and the Woman.* c. 1517. Panel, 11 5/8 × 6 7/8". Kunstmuseum, Basel.

(This is the same year in which Cranach issued his woodcut of Luther as Junker Jörg.) Baldung effectively combined sharp line, tone, and deep shadow to "visionize" the Protestant hero.

About 1523 Baldung's style began to change toward a harder outlined, more sharply silhouetted, and simplified manner, within the limits of which the modeling from light to dark is high in key and distinct in its transitions; one might almost say that Baldung modeled on a value scale from light to gray, often setting his forms against a dark background. The result of this more even illumination is a limited and sharply flattened volume, as the figures became more idealized, more heroic in size, somewhat elongated in proportion, colder in feeling, and Manneristic in effect. This style characterizes, for example, his *Adam and Eve* (Fig. 521), of about 1525, in Budapest; several allegorical feminine figures of 1529; and some classical themes of about 1530–31. He painted the themes of Mucius Scaevola, Hercules and Antaeus, and Pyramis and Thisbe, among others, in this intellectually classicizing approach to Mannerism.

The style was also employed in three woodcuts of 1534 to express what are well-nigh romantic conceptions of wild horses in the forest. Herds of wild horses were known to exist in the hills and woods of Alsace even later than the date of Baldung's prints; their presentation in these woodcuts in varied attitudes, kicking, neighing, grazing, reclining, or fighting, seems to symbolize an outburst of unrestrained passion that found its outlet in the wild animal. Though the woodcuts have been interpreted as related to an exposition of the mating habits and emotional life of animals, in one of them (Fig. 522) a monkey sits next to the tablet with Baldung's signature and the date upon it. Now the monkey was a common symbol for the base passions of man, and it is significant that this is the only woodcut of the three in which a human figure is present, observed peering out from behind a tree at the upper left. That Baldung had a purely scientific approach in mind, as is implied by the "sociological" interpretation, is at variance with the presence of the monkey and the man and particularly with the lack of accurate observation. A subjective, emotional, dramatic, and essentially mystical presentation, it was meant by Baldung to relate to man and his base passions. (It is no accident that Fuseli, in the late 18th

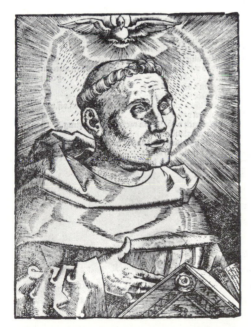

above: 520. HANS BALDUNG GRIEN. *Luther as a Monk* (B. 39). 1521. Woodcut, 6 × 4 1/2".

right: 521. HANS BALDUNG GRIEN. *Adam and Eve. c.* 1525. Panel, 79 7/8 × 32 7/8" (each). Museum of Fine Arts, Budapest.

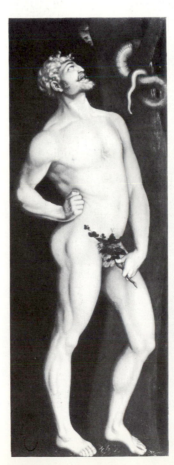
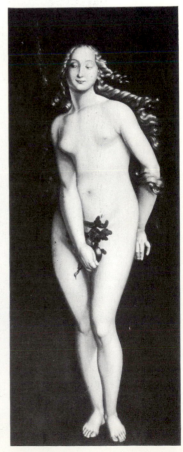

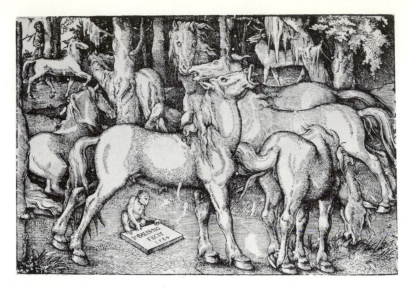

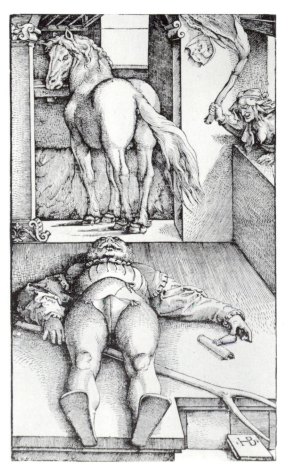

right: 522. HANS BALDUNG GRIEN. *Wild Horses* (B. 57). 1534. Woodcut, 8⅞ × 13″.

below: 523. HANS BALDUNG GRIEN. *The Bewitched Groom* (G. 122). 1544. Woodcut, 13½ × 7⅞″.

century, borrowed the center horse's head, which stares with wild eyes at the spectator, for a horse with an even wilder expression in his famous versions of the *Nightmare*.) Baldung again employed his hard, sharp outline and fluid, generalized line to express the power and movement of the horses.

Several late paintings, such as the *Three Ages of Man* (and woman), of 1539, in the Prado,

interrupted the vast number of book illustrations that occupied his later years, for with the entry of Protestantism into Strasbourg there were fewer jobs for the painters. His late style was a continuation of the previous classicizing manner, except that the figures became more elongated and mannered, suggesting a renewed influence of the art of Cranach, though this was possibly an independent development. In spirit, however, there is an underlying disquiet.

In 1544, the year before his death, Baldung produced one of his most famous woodcuts, the *Bewitched Groom* (Fig. 523), dated on the basis of a related drawing of that year. The work, possibly an allegory of anger, was more carefully executed than the wild-horse woodcuts, but it shows a strong interest in the same type of expression. The horse (inspired by Dürer's *Great Horse* of 1505) participates in the fantastic aspect of the scene as it turns to glare balefully at the spectator, while a witch leans into the scene through the window, her torch held high, giving a partial explanation for the strange rendering, with its forceful perspective used to augment the drama. Here are a fantasy and a spirit reflective of the times, which were becoming increasingly troubled. It is fitting that Hans Baldung, who in his early work had followed the lead of Dürer, with strong influences from the transcendental spirit of Grünewald, and whose mannered, classicizing style after 1523 was essentially in the service of that same radically different spirit, should be revealed in his latest work as an artist whose development constantly belied the viewpoint of his early master. Of all Dürer's followers he was the most outstanding and influential.

THE DÜRER SCHOOL, DANUBE-STYLE FOLLOWERS, AND SWISS PAINTING

THE DÜRER SCHOOL

A host of extant paintings testifies to the large number of artists who sprang up in southern Germany in response to the challenge of the times and demonstrates one of those inexplicable explosions that happen from time to time following the appearance of truly great innovators. Dürer's influence was such that he may be considered the determinant of German art; almost no one escaped the impact of his works of the 1490s. But his later conceptions were too majestic and, in part, too austere to be thoroughly understood. Thus the fantastic elements that were part and parcel of the German outlook, which Dürer synthesized in his *Apocalypse* woodcuts but subdued in his later works, are more strongly evident in the lesser masters.[1] These elements, coming from the late Gothic baroque, which some have said should instead be called a late-Gothic "mannerism," led the artists to that northern Mannerism already seen in Baldung. With few exceptions it made headway even in Dürer's shop, given authority by the master himself, who approached it closely in works made shortly before he died.

Second in importance after Hans Baldung was Hans Süss, called Hans von Kulmbach, who was born about 1480 and died at Nuremberg in 1522. According to Sandrart, he was born in Kulmbach. Probably active in Dürer's shop about

1500, at the earliest, he became a citizen of Nuremberg in 1511 and between that date and 1514–16 was working for Krakow, where he may have journeyed during these years. His Berlin *Adoration of the Magi*, initialed and dated 1511, was probably made for Krakow. Influenced in its architecture by the central panel of Dürer's *Paumgärtner Altarpiece* and the Uffizi *Adoration of the Magi*, it also shows the influence of the *Jabach Altarpiece* wings in the Joseph figure.

Hans's *Tucher Altarpiece* (Fig. 524), of 1513, in the church of St. Sebald, Nuremberg, is a *sacra conversazione*, the most Italianate in form and color of his works of this period. The monumental figures are set against a low wall that separates them from a magnificent distant view; Dürer's models are very closely followed in type and pose throughout.

Less hard in color than Dürer, Hans von Kulmbach had a great delicacy of feeling for both color and form. His portrait of an unknown man, in Nuremberg, painted shortly after 1520, shows this in a very effective color contrast of blue eyes against reddish-orange skin tones, and the black line of the garment edge is used tellingly to give form to the body. The calm spirit of his painting is characteristic of this able master, whose name, Süss, means "sweet," an apt term for his art. Like so many of his contemporaries, he was also a designer for woodcuts and stained glass.

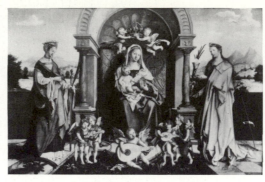
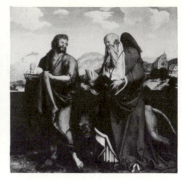

524. HANS VON KULMBACH. *Tucher Altarpiece*. 1513. Panel, 59 1/2 × 90″ (center),
59 1/2 × 59″ (each wing). Church of St. Sebald, Nuremberg.

Also strongly influenced by Dürer was Hans Schäufelein, born in Nuremberg about 1480–85, who was working in Dürer's shop about 1503–04, to judge from woodcuts by him printed in Nuremberg. He has been connected with the Dürer shop's *Ober St. Veit Altarpiece* in the Diocesan Museum, Vienna, which was completed in 1507. Apparently he painted the wings of an altar in Niederlana, near Mersan in the Tyrol, about 1509–10. Between 1510 and 1515 he was in Augsburg, where he came under the influence of the elder Holbein while working for Emperor Maximilian. In 1515 he moved to Nördlingen, became a citizen and its city painter, and died there between 1538 and 1540. Responsible for a large quantity of woodcuts, he used Dürer's stylistic models as his artistic stock in trade.

Both the Beham brothers, Hans Sebald and Barthel, received their training under Dürer. Sebald Beham, two years older than his brother, was born in Nuremberg in 1500. Both he and his brother were expelled from the city in 1525 for anarchistic and atheistic views. Given permission to return in the same year, Sebald had another brush with the authorities in 1528, for he apparently published, as his own, work taken from Dürer's books on proportions. In 1529 he returned to Nuremberg and in 1530 or 1531 was in either Mainz or Aschaffenburg, working for Cardinal Albrecht of Brandenburg. Relinquishing his Nuremberg citizenship in 1535, he moved to Frankfurt, where he lived until his death in 1550. Miniature painter, etcher, engraver, and designer for woodcuts and stained glass, Sebald Beham followed Dürer closely, almost too closely, for his most famous work is the woodcut of the frontal head of Christ extracted from the

1513 Dürer engraving of the angels with the veil of Veronica. He was also a portraitist.

Barthel Beham was also a painter, engraver, and designer for woodcuts. He was in Munich after 1527 and worked for the Duke of Bavaria after 1530; according to Dürer's calligrapher, Johannes Neudörffer, he died on a trip to Italy in 1540. His woodcuts are strongly influenced by Dürer, but his portrait of *Ludwig X of Bavaria* (Fig. 525), of 1537 or 1538, now in the Liechtenstein Collection, Vaduz, shows the development of that aristocratic mannered style characteristic of northern and Italian painting of the second quarter of the 16th century, an international portrait style recognizable in such diversified hands

525. BARTHEL BEHAM. *Ludwig X of Bavaria*. 1537–38. Panel, 27 1/8 × 22 7/8″. Sammlungen des Regierenden Fürsten von Liechtenstein, Schloss Vaduz, Liechtenstein.

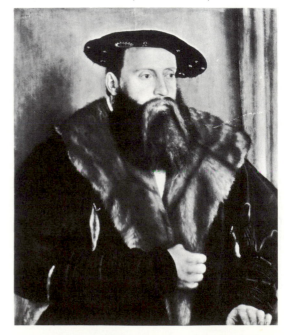

as those of Bronzino, Holbein the Younger, Christoph Amberger, Antonio Moro, and a host of lesser artists.

The style normally employed a generalized facial treatment, rather evenly lighted, with a strong sense of silhouette, and the figure was normally posed against a limited, darker, slightly modulated background space, which contrasted with the detailed naturalism of the garments. (Fur collars are almost emblematic of the style.) The social status of the sitter, his economic prosperity, and his aristocratic bearing are the chief elements in these decorous portraits, character portrayal having been neither an interest of the painter nor a requirement of the sitter.

Georg Pencz was equally associated with Dürer, having been in his shop in the early 1520s. Like the Behams he was born about 1500, and like them he was banished from Nuremberg in 1525. A designer of woodcuts and stained glass, he was a prolific engraver of works of fine quality, some of them of very small size. He, too, was a portraitist, an example being the Kassel portrait of *Hans Siegmund von Baldinger*, of about 1540. A city painter of Nuremberg in 1532, he was made court painter to Duke Albrecht of Prussia in 1550 and died in Leipzig on the way to take up his new position. The Baldinger portrait confirms Sandrart's assertion that Pencz made a trip to Italy, for the organization and placement of the figure recalls Bronzino's Ugolino Martelli portrait. Recent scholarly opinion has given to Georg Pencz the series of woodcuts of the *Planets*, once attributed to Sebald Beham and, as late as 1954, to Barthel Beham. Though created about 1530, iconographically they follow the Italian engravings of about 1460, which are the earliest preserved version in print form. Stylistically here as elsewhere Dürer's influence can be seen, particularly in the character and structure of the landscape background and in the foliate frame ornamentation.

Many other artists came under Dürer's influence, among them Erhard Schön, who showed it as early as 1517, when he provided illustrations to Koberger's *Hortulus Animae*, of 1517–19. In the course of his career he made over 1,200 book illustrations, among them those for a Bible published at Lyons in 1519–21 and another Bible published in 1524 by Peyrus at Nuremberg, where Schön was working with Hans Springinklee, another follower of Dürer; a

526. ERHARD SCHÖN. *Four Rulers. c.* 1534. Anamorphic woodcut.

Bible published at Prague in 1529 had a frontispiece by him. He died in 1542. In the modern era his best-known work is a curious perspective woodcut made about 1534(?) of four portraits of celebrated rulers, shown one above the other (Fig. 526). The anamorphic images of Charles V, Pope Paul III, Ferdinand I, and Francis I are elongated horizontally on the paper and are visible in proper proportion only when the woodcut is viewed from the extreme side or through a thick glass tube; thus perspective is made a plaything, in keeping with the Manneristic sense of fantasy so widespread at the time. What to Dürer had been a serious pursuit, engaged in because of its meaning in an ordered, ideal scheme, became for Schön a playful device, an arcane conception that has certain parallels to Hans Baldung's woodcuts of wild horses of the same year.

Schön was not a member of Dürer's shop, but there were others, such as Hans Leu, Hans Dürer, Nicholas Glockenden, Hans Plattner, Hans Springinklee, Wolf Traut, and several unknown artists identifiable only by their style, who came directly under Dürer's influence and spread his style abroad in their paintings and particularly in their vast quantities of book illustrations.

DANUBE-STYLE FOLLOWERS

The Bavarian and Austrian roots of the Danube style are to be found in the late Gothic baroque of Jan Polack in Munich, in Mair of Landshut, in Pacher and his follower Marx Reichlich, with external influences from North Italian and Venetian painting and from the

woodcuts and engravings of Dürer of the 1490s. The style was epitomized in the epic grandeur and lyrical expression of Altdorfer's painting. [2] Though Jörg Breu the Elder from Augsburg had created in his *Zwettl Altarpiece* of 1500 the first example of the style, his painting came under the influence of Burgkmair and Holbein the Elder when he returned to Augsburg. Lucas Cranach abandoned the style when he went to Wittenberg to work for Frederick the Wise. Only Altdorfer explored and developed its potentialities of forms immersed in space, even inundated by the vastness of nature. His example was followed by numerous painters of lesser talent. Three of these are his brother Erhard Altdorfer, the Master of Pulkau, and the greatest of all his followers, Wolf Huber.

Erhard Altdorfer, pupil of his brother, worked in Austria at Lambach and Klosterneuberg, then in 1512 became court painter and architect to the Duke of Mechlinberg at Schwerin, where he is traceable until 1561. He was more detailed and pedantic than his brother. The Master of Pulkau, whose *Nativity*, of the second decade, can be seen in the Chicago Art Institute, was a more volatile painter than Erhard but with less control of his streaks of light than his master. In his sketchy style and in Erhard's more labored paintings the lyrical quality of Altdorfer's conceptions is lacking.

Wolf Huber, [3] on the other hand, approached Altdorfer's lyricism in his works about 1510. Probably born at Feldkirch in Austria about 1490, he was influenced in his early work by Cranach before coming under Altdorfer's influence about 1510. After 1515 he was in Passau as court painter to the bishop; he died here in 1553.

527. WOLF HUBER. *Mondsee*. 1510. Drawing, $5 \times 8\,1/8''$. Germanisches Nationalmuseum, Nuremberg.

His drawings of the *Mondsee*, of 1510 (Fig. 527), in Nuremberg, and a *Bridge over a River*, dated 1515, in Munich, though not so strong as Altdorfer's drawings, show a delicacy and tonal quality revelatory of a poetic response to the intimacy of nature. His *View of Feldkirch*, of 1527, in two examples, one in Munich, the other in the British Museum, shows less of Altdorfer's mystical quality, in part because of less attention to tonal quality but also because he was basically more dependent on nature than was Altdorfer. His woodcuts are stylistically close to his drawings, the 15 attributed to him showing fine technical ability in their cutting.

His paintings share in the dramatic qualities of the era. The *Raising of the Cross* (Fig. 528), of 1522–25, in Vienna, in its sculpturesque conception of form, with its dramatic light and color accentuating the raising of the Cross *toward* the spectator (an anticipation of Tintoretto's similar treatment), is a northern equivalent of Italian High Renaissance conceptions of the unity of artistic elements. By 1530, in his painting of *Christ on the Mount of Olives* (Fig. 529), in Munich, the balance of eight years earlier has been tipped in the direction of a greater intensity of expressive form, sharply delimited spatial intervals, sharply lighted opposed masses, and strong perspective movements and color. However, his *Allegory of the Crucifixion* of 1540, in Vienna, shows numerous small figures dotting the landscape as animating elements in a manner paralleled at this date in the work of Netherlandish landscapists.

The greater drama of the works of Altdorfer and Huber was avoided by the succeeding generation of landscapists. Augustin Hirschvogel (1503–53) expressed a different outlook, related more to the early style of Huber. Possessing a fine sensitivity for natural forms, in his landscape etchings he transformed the Danube-style landscapes of Altdorfer into gentler expressions. He was interested in the panorama of nature, rather than its drama, its power, and its turbulent aspects. Thus his landscapes are expressions that exist midway between the topographical and the intimate view of nature.

Another artist of the following generation was Hans Sebald Lautensack (1524–66). Also influenced by Altdorfer, his landscapes are more tonal than the comparatively linear but suggestively atmospheric expressions of Hirschvogel.

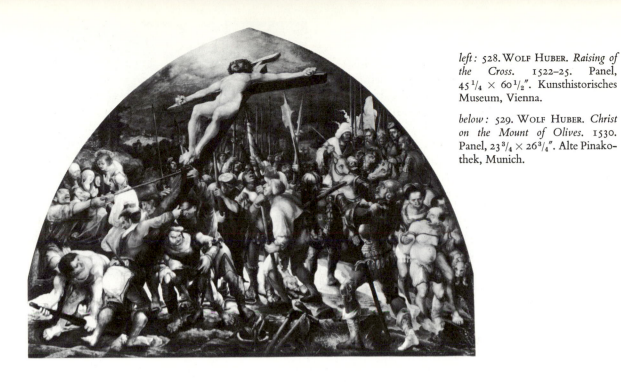

left: 528. WOLF HUBER. *Raising of the Cross*. 1522–25. Panel, $45\frac{1}{4} \times 60\frac{1}{2}''$. Kunsthistorisches Museum, Vienna.

below: 529. WOLF HUBER. *Christ on the Mount of Olives*. 1530. Panel, $23\frac{3}{4} \times 26\frac{3}{4}''$. Alte Pinakothek, Munich.

SWISS PAINTING

Switzerland produced three painters worthy of mention in the general scheme of northern art: Urs Graf, Niklaus Manuel Deutsch, and Hans Leu the Younger (already cited as a Dürer pupil, working in his shop about 1510).

Urs Graf was the son of a goldsmith of Solothurn, where he was born about 1485. He is best known for his energetic engravings, which respond to the general Dürer influence that fell upon most engravers at this period. His figure of 1523 (Fig. 530), which may be a Lucretia, is thoroughly representative of his vigorous but conservative style, its elements recalling works of about twenty years earlier in the art of Dürer. Setting a form against a landscape with an abundance of white space is characteristic of his work, but he did not achieve the interrelationship of the two apparent in the art of such an artist as Altdorfer, whose drama is more profound. Occasionally coarse, many of Graf's works deal with the contemporary genre of soldiers and their feminine camp followers and reflect the turbulent character of the times. He probably died in Basel in 1527 or 1528.

Niklaus Manuel Deutsch, painter, mercenary in Italy, poet, and bailiff, apparently practiced painting only in the ten years between 1514 and 1524. Because of his activity in the religious affairs of his native city, Bern, his relation to the Reformation is clearer than that of most painters of his day. Several satirical writings still exist in which he excoriated the pope and equated him with Antichrist, a popular pastime of the day in the north. Though far from the greatest works of literature, his verses are valuable documents by one responsive to the revolutionary character of the times. Verses also exist for a now lost *Dance of Death*, painted between 1514 and 1522 on the walls of the Dominican cloister at Bern, in which the religious of monastic affiliation are roughly and coarsely treated.

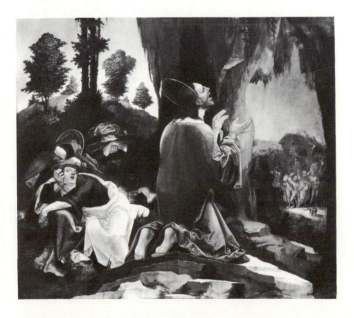

An able painter, close in spirit to Hans Baldung, he was much influenced by the German painters. Four panels in the Bern Kunstmuseum, from an altarpiece probably painted for the Antonite church in Bern, deal with events from the life of St. Anthony. Two are signed and dated 1520. The demonic *Temptation of St. Anthony* (Fig. 531) combines the saint's horizontal position and the overstressed pulling of his beard from Cranach's 1506 woodcut with Grünewald's manner of treating the luxuriant foreground foliage, which is also seen in Deutsch's *Meeting of Paul and Anthony.* Grünewald also influenced the dominantly zoomorphic forms, though the forms themselves are not copied. Niklaus Manuel's figures are more obviously grotesque and are presented against a painterly landscape in greater turmoil. Too strong an interest in the particular and in the overinflated demonic forms robs his work of the conviction and artistic plausibility of Grünewald's. This carries over into the feminine *Temptation of St. Anthony,* a work influenced by Altdorfer's engraving of the theme made in 1506. The strength of outline and the characteristic linear sharpness are indicative of a certain lack of sensitivity in comparison with the work of outstanding German painters. About 1524 he painted a *Judgment of Paris* (Fig. 532), now in Basel, which may be based on Cranach. But in contrast to Cranach's works, the figures are heavy and overly decorative, with value contrasts and naturalistic details that are overemphatically hardened. Underlying Niklaus Manuel's art is a curious note, that basically he was a draftsman, and the feeling arises that painting was to him a tool for expression. His work does not communicate a love for paint, which may explain his abandonment of the field after 1524, after creating interesting paintings and pleasing drawings.

532. NIKLAUS MANUEL DEUTSCH. *Judgment of Paris. c.* 1524. Canvas, 87 ³/₄ × 63″. Kunstmuseum, Basel.

PAINTING IN AUGSBURG:
Hans Holbein the Elder, Hans Burgkmair, and Hans Holbein the Younger

RICH, INDEPENDENT, AND COSMOPOLITAN, THE city-republic of Augsburg outshone its sister re-public of Nuremberg in many things. As the preferred city of the Emperor Maximilian and the home of the greatest merchants and bankers of the era (the Fuggers, Weslers, Peutingers) and other patricians, its outlook was broader than Nuremberg's and its contacts more wide-spread. Artistic activity was intense, and the Hol-bein family, the two Jörg Breus, Ulrich Apt and his sons, Thoman and Hans Burgkmair, Leon-hard Beck, Hans Weiditz (the Petrarch Master), and later the fine portraitist Christoph Amberger were the city's leading painters. Even more than that of Nuremberg, Augsburg painting was in-fused with Italian Renaissance ideas, for which it acted as a dissemination point. In intellectual matters, however, Nuremberg was the leader.

HANS HOLBEIN THE ELDER

Hans Holbein the Elder, traceable in Augsburg from 1493, father of a son far greater than him-self, was an important artist in his own right.[1] His artistic maturity corresponds in time, but not in outlook, to that of Albrecht Dürer. Pos-sibly born about twelve years earlier than Dürer, he was the son of a leather dresser from Schöne-

feld, who died about 1484; his painter brother Sigmund was born after 1477. The elder Hans's earliest work may go back to 1490, but his first dated paintings are the altar wings of 1493 in the cathedral in Augsburg, coming from Wein-garten Abbey. These and the *Death of the Virgin* (Fig. 533), of about 1490–95, in Basel, which was an inner wing of the St. Afra altarpiece

right: 533. HANS HOLBEIN THE ELDER. *Death of the Virgin* c. 1490–95. Panel, 54 × 28″. Kunstmuseum, Basel.

from the Kaiserheimerhofes in Augsburg, show such strong Flemish influence that a trip to the Netherlands before he settled down in Augsburg has been conjectured.

Stylistically Holbein the Elder took a step sideways, for his outlook recalls the art of Wolgemut and Pleydenwurff. An extreme conservatism governs his restatement of Rogier's types, but his Neo-Gothic interpretation is seen in a very different conception of light and shade. Rogier would never have allowed a soft naturalistic atmosphere to interfere with and dominate the rhythmical composition, as Holbein did. The softness of atmosphere is so pervasive that the faces cast soft shadows against their halos, thus serving to silhouette the features. Instead of symbols of sanctity the halos seem like a new kind of headgear attached to their wearers.

In 1499 Holbein was working at the Convent of St. Catherine in Augsburg. The nuns had received a special papal dispensation which allowed them and others to make the pilgrimage to the chief Roman basilicas by praying before paintings of the churches. Holbein completed his painting of the *Basilica of Sta. Maria Maggiore* in 1499 and the *Basilica of St. Paul* in 1504; others were made by Hans Burgkmair. Neither artist had seen the monuments which form the background for scenes related to the patron saint of each church.

In 1500 and 1501 Holbein was in Ulm, and in the latter year he went to Frankfurt to paint seven of eight scenes of the Passion and two large panels of the genealogy of Christ and of the Dominicans. The works, now in the museum at Frankfurt, present an extreme elongation in figure style and a stronger linearity, in part because the figures are set against dark backgrounds. The abstraction from a normal setting brings out the subtle coloration of the forms, giving the surfaces a soft gleam, in which the changing color effects—for example, crimson shadows on light-blue garments—do not hinder the development toward a greater clarity and precision. This is next seen in another treatment of the theme of the *Death of the Virgin*, also in Basel, painted in 1501, yet still Neo-Gothic.

Holbein returned to Augsburg in 1502 to paint an altarpiece for the monastery of Kaisheim at Donauwörth (its 16 panels now in Munich). In these the soft style, with fluid color and elongated Flemish figure types, reveals a new ele-

ment, particularly visible in the Adoration of the Magi scene (Fig. 534); the rhythmical surface movement of Flemish inspiration has been replaced by a spacing of the figures in depth that strongly suggests Italian influence, possibly conveyed by Hans Burgkmair, although not necessarily.

Though Hans Holbein's shop was busy, his brother and his two sons working for him, he gradually ran into debt, so that he became the defendant in five lawsuits between 1503 and 1521. In 1516 he moved to Isenheim to paint an altarpiece for the commandery of the Antonite Order, and about this time painted his *Altarpiece of St. Sebastian*, now in Munich (Fig. 535). It is possible that he painted it at Isenheim, for a touch of Grünewald's influence is suggested by the angel of the exterior Annunciation scene. The Martyrdom of St. Sebastian, in the central panel, is a rather inept attempt to assimilate Italian conceptions and is greatly lacking in dramatic impact. Attempting to emulate Italian Renaissance ideas in the archers, Holbein failed to establish a cleanly organized composition; the kneeling archer in blue and white is not

534. HANS HOLBEIN THE ELDER. Adoration of the Magi, *Kaisheim Altarpiece*. 1502. Panel, 55 1/2 × 33 1/2". Alte Pinakothek, Munich.

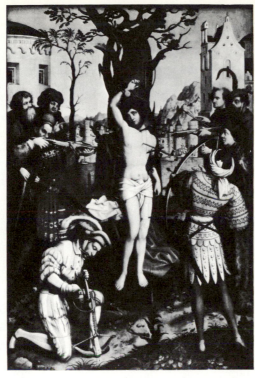

535. HANS HOLBEIN THE ELDER. *Altarpiece of St. Sebastian.* 1515–17. Panel, 60 1/4 × 42 1/8" (center), 59 × 18 1/2" (each wing). Alte Pinakothek, Munich.

well integrated with the rest of the action, while the archer in the golden garment, with his back to the spectator, is too linear and detailed to be read as a stage in movement toward the saint. Sebastian is treated in such soft chiaroscuro that his gaze verges on the sentimental, while his pose is as soft as the modeling. Holbein the Elder was more interested in spatial organization than in asserting the plasticity of form, though the spatial movement is far from being inexorable. In sum, this is a *tableau vivant* instead of a martyrdom.

In contrast the wing panels, with Sts. Elizabeth and Barbara, have a largeness and monumentality of form strongly lacking in the central panel. The treatment of soft light has been reduced to concentrate upon the form, and the result is entirely successful in form and color. Apparently the single figure was within Holbein's grasp; a many-figured Renaissance composition was beyond his comprehension. To reinforce his presentation he added Renaissance decorative elements of grotesques, garlands, and architectural framing members in a classicizing style, showing thereby an understanding of detail but only a tenuous grasp of the compositional essentials of the new style.

The hovering angel of the Annunciation, on the exterior, has a pose related to the art of Gerard David, though its drapery movement and its somewhat ugly face may derive from Grünewald. It is clear, however, that Holbein the Elder was not able to assimilate the grandeur of the transcendental drama of Grünewald's conception, for his Virgin, like the angel, derives from David, and the architectural background behind her also suggests Flemish models.

A comparably tenuous grasp of classicizing ideals is seen in his *Fountain of Life*, Lisbon, of 1519. This, too, is a modernization of David's ideas, deriving from the popular theme of the Virgin among virgins, with an added and relatively insignificant fountain in the foreground. Renaissance details appear in the architecture, but the whole composition is less clear and less rigorous in construction of spatial intervals than it was intended to be, and the work falls between the two stools of Renaissance logic of plastic construction and northern naturalism of surface detail.

The numerous fine drawings from the hand of Hans Holbein the Elder reveal the strong feeling for line that is so evident in his painting. His Berlin portrait of *Jakob Fugger* shows his ability to seize character and present it subtly without exaggerating the visual aspects of the sitter. Touched with washes to vary the surface feeling, Holbein's delicate line was created by the brush. The same delicate yet incisive delineation of form is seen in his Berlin portrait, *The Artist's*

Sons Ambrosius and Hans (Fig. 536), of 1511, in silverpoint. Contrasts of light and dark within the forms animate the generalized surfaces.

Holbein the Elder is lost sight of after his move to Isenheim; in 1524 the Augsburg painter's guild records speak of him as deceased. He tried to transform German art from a late-medieval, Neo-Gothic form into a Renaissance one by adopting details of architecture and ornament and by attempting Renaissance spatial ideas. However, this became mixed up with his basic northern ideas—to result in an ambiguity thoroughly characteristic of many contemporary artists who were still governed ideologically by the northern transcendental spirit. Yet his delicacy of line and ability to seize the visual characteristics of form, as well as to present it with sensitivity, did not die with him. They had already been passed on to Hans the Younger.

HANS BURGKMAIR

Holbein the Elder has been likened to a Moses who saw the promised land but could not enter. His younger contemporary and fellow basilica painter for the nuns of the St. Catherine Convent, Hans Burgkmair,[2] crossed into the Holy Land of Italian Renaissance ideas with a sprightly step. Burgkmair occupied in Augsburg the position occupied in Nuremberg by Dürer, and like him spread the new conceptions through his paintings, woodcuts, and engravings. Born in Augsburg in 1473, the son of the prominent Augsburg painter Thoman Burgkmair, he may have been in Colmar in 1490, working under Schongauer, whose portrait was possibly painted by him. In 1498 he was back in Augsburg, becoming a master and marrying the sister of Holbein the Elder in this year. Probably he had

already been to Venice and Milan, and though he kept his shop in Augsburg until he died in 1531, he may have made other trips away from Augsburg. A recent study of his drawings indicates that he traveled to the Netherlands shortly before 1510; he may have made other trips before this.

His earliest work is related to that of the elder Holbein. These paintings (now in the Augsburg Gemäldegalerie) show Roman basilicas: *St. Peter's*, of 1501; *St. John Lateran*, of 1502; and *Sta. Croce*, of 1504. The first shows St. Peter before the basilica, which was known to the artist only through engravings or drawings rather than from first-hand acquaintance. However, in the upper zone, showing Christ on the Mount of Olives, Italian conceptions appear in the rocky outcrops surrounding Christ (much like similar shapes in contemporary Venetian woodcuts of the lives of the saints) and in a greater feeling for a logical spacing of forms. The theme is repeated in much the same fashion in a fragment in Hamburg, of 1505 (Fig. 537). Dark, warm color, dramatic light effects, and landscape details worked in the more plastic Venetian manner characterize the style, and Christ, long-haired, with a narrow forehead and pointed beard, is given an expressive character by the fixity of his gaze. The sentiment conveyed seems slightly excessive, possibly because Burgkmair's style was so closely emulated in 19th-century Sunday-school textbook illustration.

It is possible that Burgkmair made another trip to Italy, and certainly one to Bruges, before the end of the first decade, for two paintings of the Madonna and Child, both in Nuremberg and dated 1509 and 1510, show a close influence of the school of Leonardo and of Michelangelo, which they reveal in monumental figures types and placement close to the picture plane. (The 1509 work repeats the pose of Michelangelo's *Madonna and Child* in Bruges.) Increasingly involved with designs for woodcuts, in 1510 he made 92 designs for genealogical woodcuts for Emperor Maximilian.

In the following years he was responsible for woodcuts for the *Weisskunig*, a long eulogy of the same monarch, and much work on the *Triumphal Arch* and the *Triumphal Procession*. During the same period he came into contact with Dürer, who made a portrait drawing of him.

An increase in tonal richness and feeling for form and a greater artistic sensitivity are evident

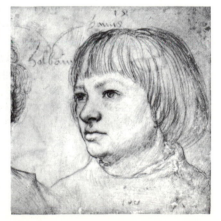

536. HANS HOLBEIN THE ELDER. *The Artist's Sons Ambrosius and Hans*, detail (Hans). 1511. Silverpoint, 4 × 6⅛". Kupferstichkabinett, Staatliche Museen, Berlin-Dahlem.

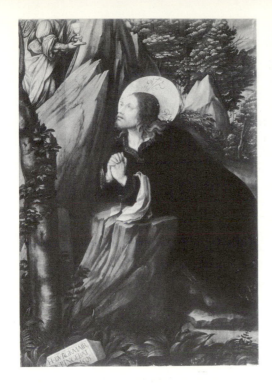

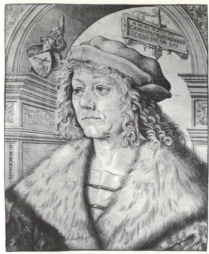

left: 537. HANS BURGKMAIR. *Christ on the Mount of Olives*, fragment. 1505. Panel, 36¼ × 24¾". Kunsthalle, Hamburg.

right: 538. HANS BURGKMAIR. *Johann Paumgärtner* (B. 34). 1512. Chiaroscuro woodcut, 11¾ × 9½".

below: 539. HANS BURGKMAIR. *St. John Altarpiece*, center. 1518. Panel, 60¼ × 49⅛" (center). Alte Pinakothek, Munich.

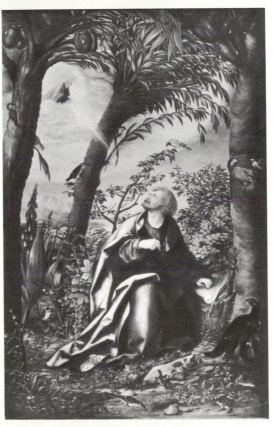

in such works as his *Vanitas*, a chiaroscuro woodcut of 1510, and his chiaroscuro woodcut portrait of *Johann Paumgärtner* of 1512 (Fig. 538). In the latter the Renaissance architectural forms and identifying tablet behind the figure, motifs used as early as 1505, were to appear later in the work of a much younger painter of Augsburg, his nephew Hans Holbein the Younger. The use of architectural elements has the strong decorative aspect that previously had been introduced into his woodcut style, with an early peak in the chiaroscuro woodcut of Maximilian on horseback, of 1508. Dürer's *Small Horse* engraving has seemingly influenced the Augsburg work, but the ornamental treatment is different from Nuremberg work, having that heaviness of line which occasionally appears in Burgkmair's works.

In 1518 Burgkmair painted the strongly Italianate *St. John Altarpiece* in Munich (Fig. 539). John, on a luxuriant, tropical Patmos, occupies the center panel, and large, monumental figures of Sts. Erasmus and Nicholas almost completely fill the space of the narrow wings. The type of figure seen in the 1505 Christ is re-employed for the figure of John; a reddish blond, with mustache, slight beard, and open mouth, he looks up and over his shoulder at the vision of the Virgin in the sky. The heavy vegetation of palm trees contributes to the general massiveness of effect. The Venetian manner was Burgkmair's model for his rather heavy color—the outer garment

crimson, the inner garment vermilion, the figure set against green, brown, and greenish tan foreground foliage, with greenish-blue hills in the background.

This weighty, dense color and chiaroscuro, which carry the emotional drama, are also visible in the *Crucifixion Triptych*, of 1519, in Munich, made for the Peutinger family, whose arms appear at the lower left. In this the figure of John is almost Raphaelesque, and a similar classicizing spirit is evident in the long lines of the

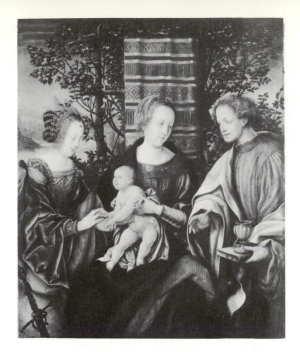

Magdalen, but her action in embracing the foot of the Cross is a northern note, as is the meticulous detail. The quiet treatment, so different from northern examples of the theme, the soft chiaroscuro, and the facial types of Sts. Lazarus and Martha on the wings all show the generalization of form and largeness of conception peculiar to Burgkmair's transplant of Italian art.

Though an assimilator of Italian ideas, Burgkmair was also influenced by Flanders, as may be seen in the type of detail and even in figure types and costume, mingled with Italian elements, in the *Mystic Marriage of St. Catherine* (Fig. 540), of 1520, in Hannover, and in his Berlin *Holy Family*. These suggest that Burgkmair may also have gone down the Rhine to attend the coronation of Charles V and may have visited

the Netherlands before returning home. Italian ideas, however, are unquestionable in his *Esther before Ahasuerus*, of 1528, in Munich, which, in its highly decorative and fanciful Manneristic architectural detail, combines suggestions of Carpaccio and an updated Michael Pacher. It was painted for Duke William IV of Bavaria, and in the following year he painted, for the Duke, a *Battle of Cannae*, also in Munich, one of the series of ancient battle paintings, of which Altdorfer's is most outstanding.

A portrait of *Hans Burgkmair and His Wife* (Fig. 541), of 1529, in Vienna, was once ascribed to Burgkmair himself but is now generally thought to be the work of his pupil Lukas Furtenagel; it shows Burgkmair's wife holding a mirror which reflects two skulls. The inscription of this *memento mori* may be translated: "Such was our shape in life; in the mirror nothing remains but this." The style approaches that international Manneristic portrait style discussed earlier, which affected Burgkmair as well, pointing again to his position as Augsburg's chief intermediary between Italy and the north.

In the field of the portrait, which became increasingly important, a leading member of the Augsburg school was the painter from Ulm Hans Maler zu Schwaz, who, with Bernhard Strigel from Memmingen (both probably pupils of Zeitblom), was active in Augsburg in the 1520s. Their successor was a Burgkmair pupil, Christoph Amberger, of the next generation (master in 1530, died in 1561), who was even more eminent. Rendered in clear, light, delicate tones, the features in his portraits are almost pearly in their coloration. The forms, easy in

above: 540. HANS BURGK-MAIR. *Mystic Marriage of St. Catherine.* 1520. Panel, 24 × 20 1/2". Niedersächsische Landesgalerie, Hannover.

left: 541. LUKAS FURTENAGEL. *Hans Burgkmair and His Wife.* 1529. Panel, 23 5/8 × 20 1/2". Kunsthistorisches Museum, Vienna.

right: 542. CHRISTOPH AMBERGER. *Christoph Fugger.* 1541. Panel, 38 3/8 × 31 1/2". Alte Pinakothek, Munich.

pose, embody a grace that prompted Glaser[4] to call him a German Veronese. One might remark that his edges are sharper and his conceptions more Manneristic than those of the Venetian master, particularly in his Munich portrait of *Christoph Fugger*, of 1541 (Fig. 542).

HANS HOLBEIN THE YOUNGER

With Hans Holbein the Younger, German 16th-century painting produced its last great master. Directly affected by the Reformation, which was responsible for the demise of altarpiece painting, he turned his talents to the portrait, becoming one of the finest portraitists the history of art has known. For the full development of his art, however, he had to abandon his adopted city of Basel, which, as Erasmus wrote to Sir Thomas More, had turned out the arts by its Protestant attitude, and by its excesses in their destruction.

Though born in Augsburg in 1497–98 and trained by his father, he was closely linked to Switzerland and to Basel. In 1514 or 1515 he and his brother Ambrosius went to Basel and entered the shop of Hans Herbster, probably in the capacity of journeymen. Hans the Younger soon gained fame as a book illustrator; an early work, of 1515–16, is the series of marginal illustrations he and Ambrosius added to a copy of Erasmus's *In Praise of Folly*, published at Basel in 1515. In them are the coloristic quality and fine drawing style learned from his father, which brought him to the attention of the publisher Froben, one of whose designers he became in 1516.

His first dated work is a panel of 1515, in Karlsruhe, showing Christ carrying the Cross, which repeats a composition of his father's in Donaueschingen and which is close to another version, of approximately the same date, in Chicago, by Hans Maler zu Schwaz. The younger Hans monumentalized the composition, whereas Hans Maler's work repeats what had been presented in Hans Multscher much earlier, even to the use of a gold ground. Hans Holbein the Younger, however, eliminated the figures making faces and sticking out their tongues. He placed St. Veronica in one corner and another figure in the opposite corner to serve as enclosing, stabilizing forms. He counterbalanced architectural form on one side with a mounted horseman on the other and used both as recessive elements to relieve any tendency toward a too strongly crowded foreground. Balance and rational order govern his conception and forecast future developments.

The mode in which he was to excel soon claimed him, and in 1516 he painted the diptych portrait, now in Basel, of the first bourgeois mayor of Basel, *Jakob Meyer and His Wife Dorothea Kannengiesser* (Fig. 543). Preparatory drawings exist in Basel, made in a combination of silverpoint and red chalk. The portraits were, it seems, executed in tempera and oil on lindenwood, a technique Holbein preferred for his portraits and other panels because of its possibilities for precision. The conception of the figure set against an architectural background probably derives from such a work as Burgkmair's *Paumgärtner* chiaroscuro woodcut of 1512, though Holbein's clarity and patterning

543. HANS HOLBEIN THE YOUNGER. *Jakob Meyer and His Wife Dorothea Kannengiesser*, diptych. 1516. Panel, 15 1/8 × 12 1/4" (each). Kunstmuseum, Basel.

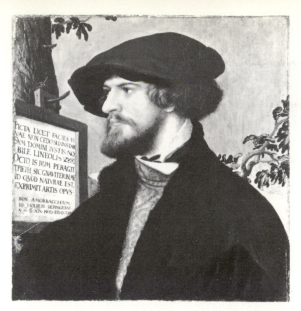

544. HANS HOLBEIN THE YOUNGER. *Bonifacius Amerbach*. 1519. Panel, $11\frac{1}{4} \times 10\frac{7}{8}$". Kunstmuseum, Basel.

of form differ from Burgkmair's tonal conception. A delicate modeling is confined to the features, the remainder of the forms being intentionally flattened, with color selectively employed to animate the areas of cap and garment. The precision and sensitivity of line have been built upon the models established by his father, but the son has already surpassed him in control and in the exercise of restraint.

Even his 1517 *Adam and Eve*, in Basel, though based on Dürer, seems governed by a portrait conception, for the subjects are presented as bust portraits. This magnifies their forms and suggests a monumentality partially denied by the loose color washes over the surface and the lack of idealization in the faces.

It was apparently in this year that Holbein went to Lucerne and then crossed the Alps to travel in northern Italy, returning to Basel in 1519, and becoming a master in the guild on September 25. In this year he painted *Bonifacius Amerbach* (Fig. 544), son of the Basel printer and publisher Johannes Amerbach and later professor of law at the University of Basel. The portrait, now in Basel, is a variation on the Jakob Meyer scheme. Holbein substituted a tree for the architectural background and pegged the identifying inscription to it. Probably Holbein's most dramatic portrait, it shows, in the balancing of his artistic elements—stronger chiaroscuro, flatter body forms, keen glance and sharp silhouette, strong value and color contrasts—that Holbein was the complete master of an independent portrait style. Later portraits were less intense and more evenly lighted, with less contrasting shapes and silhouettes.

In 1520 he married the widow of a tanner, Elsbeth Schmid, by whom he had four children; in the same year he became a citizen of Basel and set up his shop, painting religious works, portraits, making designs for woodcut and stained glass, and painting murals, both interior and exterior. Probably in 1520–22 he painted murals for the goldsmith Balthasar Angelroth for the façade of his House of the Dance. The designs, still extant in Basel, were probably derived in conception from Italy (Vasari mentions a work of like nature by Bramantino in the Sforza Castle in Milan), being revivals of antique wall decorations known at that time from Roman remains. Architectural perspectives, figures looking over balustrades, and illusionistic figures interspersed with classicizing rinceaux and scrolls were popular, and Holbein designed several such works for houses in Basel and Lucerne.

The effect of the Italian journey appears in his *Last Supper*, in Basel, dating between 1520 and 1525 but probably closer to the earlier year. The type of Christ is derived from Leonardo, as is the dramatic moment, for, like Leonardo, Holbein chose to represent Christ foretelling His betrayal. In contrast to Leonardo, Holbein isolated the betrayer on the spectator's side of the table and almost caricatured Judas's features. Holbein's attempt to assimilate his Italian model led him to create almost puppet-like types with large heads on small bodies. In rendering Christ's halo as a golden circlet in perspective, it led him to an imitation of Italian devices rather than to a true comprehension of the spirit.

Possibly related to the *Last Supper*, which has been thought to be an altar centerpiece, are four narrow, curved-top wing panels of *Scenes from the Passion* (Fig. 545). The eight scenes show an interest in dramatic night lighting like that seen in Germany and Flanders at this time, but the figure types, of strongly generalized aspect, are more Italian than northern. The panels may be related to the *Last Supper*, but they do not accentuate the softness of features found there. Under Italian influence Holbein adopted the composition of Raphael's *Entombment*, of 1507, for his version of the scene in the lower right-hand panel, yet his Entombment scene is still

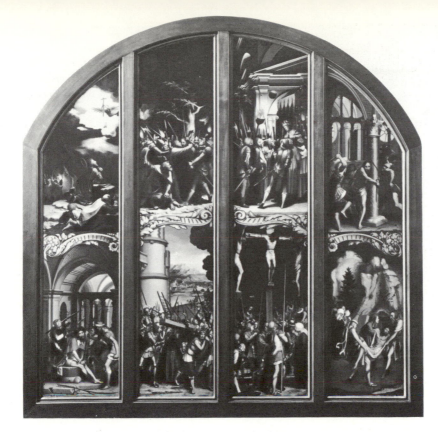

left: 545. HANS HOLBEIN THE YOUNGER. *Scenes from the Passion.* c. 1520–23(?). Panel, 58$^{7}/_{8}$ × 48$^{3}/_{4}$″. Kunstmuseum, Basel.

below: 546. HANS HOLBEIN THE YOUNGER. *Dead Christ.* 1521. Panel, 12 × 73$^{3}/_{4}$″. Kunstmuseum, Basel.

northern in its dramatic lighting, swerving movement, and expressive crowding. This spirit is more amply presented in the *Oberreid Altarpiece,* in the cathedral in Freiburg, and in the *Solothurn Madonna* of close date.

A reassertion of his basic objectivity was the starting point for the Basel *Dead Christ,* of 1521 (Fig. 546). Shown on a long, narrow panel, the figure of Christ, outstretched on a white cloth in a narrow slot, is a cadaver. Its naturalism is very different from that of its inspiration, Grünewald's heroic figure of Christ being lowered by John into the sarcophagus (set against a landscape background on the predella of the *Isenheim Altarpiece*). Holbein has concentrated his light upon the center of the body to emphasize the gangrenous hand and wound, leaving the open mouth and the staring eyes in shadow. The lighting is selectively used for dramatic effect, as in the contrasting light and dark on the feet. This parallels the night effects in the Passion panels.

That Holbein could achieve such drama within the confines of his objective approach is entire-ly unexpected. Though the style of the *Dead Christ* approaches the clarity and sharpness of the portraits, the details have been strongly accentuated by a seemingly naturalistic light to create an expressive effect. It reveals that Holbein also conceived in terms of modes.

There are few religious works from his output of the early 1520s. In 1522 he painted a mural with classical examples of civic heroism for the Great Council Room of the Basel Town Hall; of this fragments and preparatory drawings exist. Of necessity, however, the portrait came to occupy him more and more.

In 1523–24 he painted several portraits of Erasmus, who had come to Basel in 1521 to live with his publisher, Johannes Froben. The most famous is the Louvre version (Fig. 547), showing the Humanist Erasmus in profile, looking down at his writing desk and set close against a decorative cloth of dominantly dark green with red motifs. The portrait was undoubtedly influenced by Metsys's 1519 medallion of Erasmus. Holbein's calm, evenly lighted portrayal,

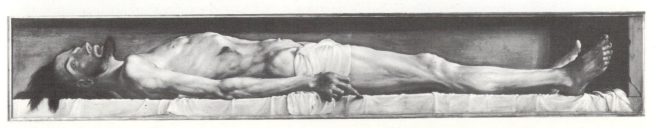

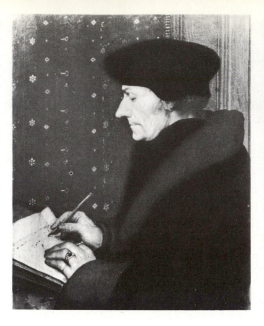

left: 547. HANS HOLBEIN THE YOUNGER. *Erasmus. c.* 1523. Panel, 16½ × 12⅝". Louvre, Paris.

right: 548. HANS HOLBEIN THE YOUNGER. *Laïs of Corinth.* 1526. Panel, 13⅝ × 10⅝". Kunstmuseum, Basel.

below: 549. HANS HOLBEIN THE YOUNGER. *The Family of Sir Thomas More.* 1526. Pen drawing, 15¼ × 20⅛". Kupferstichkabinett, Basel.

with beautifully balanced light and dark areas, is justly famous, for it is superior to his other versions (such as that in Basel, of 1523, which repeats the pose and lighting but treats the background as a blank light green area). A sense of quiet and inner reflection animates this work so delicate in plasticity and so restrained in spirit. A surviving drawing for the hands shows Holbein's careful preparation. What is again evident is the existence of two distinct modes, one for religious painting, and one for the portrait, the latter less dramatic and more international.

About 1524 Holbein left Basel to travel to France, as is known from the drawings in Basel made from the sculptured portraits of John, Duke of Berry, and his wife, which he had seen in the cathedral at Bourges. Back in Basel again, in 1526 he painted two works, both in Basel, with Magdalena Offenburg as his model, one portraying her as Venus with Cupid, the other

as the famous hetaera of Greek antiquity, *Laïs of Corinth* (Fig. 548). Magdalena (who was appropriately named) was the widow of a merchant; she and her two daughters lived what has been described as a dissolute life, and she may have been Holbein's mistress, but the interest in the works lies in the Leonardesque character of the facial treatment and the gesture of the hand, as well as in the general Italian character of the design, which, except for the spatial compression, is close to the High Renaissance.

In 1526, armed with letters from his Basel friends, Holbein left for a trip to the Netherlands, as conditions for painters were worsening in Basel because of the Reformation. Stopping first in Antwerp, he went on to England, where he presented his letters from Erasmus to Sir Thomas More, whom he painted in the midst of his family. The painting is known from the drawing in Basel that he sent back to Erasmus (Fig. 549) and from an old copy, for the original has been lost. The original painting was the first informal family group portrait *per se*, showing the members of More's family posed in their living room for the painter. No religious motif forms an excuse for the group portrait, nor are the figures engaged in any group activity. It was a family portrait pure and simple, the ancestor of 17th-century Dutch group portraits as well as the modern formal family photographs.

From this group portrait Holbein extracted several portraits of the family members to portray on individual panels, such as the 1527 portrait of *Sir Thomas More,* in the Frick Collection,

FAMILIA THOMÆ MORI ANGL: CANCELL:

New York (Fig. 550). A half-length portrait in the northern manner, it has, however, several elements that vary from the traditional three-quarter pose. The background drapery is like that in the Magdalena Offenburg portrayals, but the light is harder and the surface flatter. There is a linearity of form, with very little localized modeling in the face; space is restricted, and detail is overaccentuated, particularly in the golden chain with its Tudor rose pendant, which, rich and luxurious, indicate the sitter's high position. A similar Manneristic device had appeared in embryo in the Jakob Meyer portrait, in which the flanking columns were covered with gold leaf, but here the rendering has the ambiguity of an unnatural naturalism, a quality repeated in the flamelike lighting of the velvet sleeves.

On this first trip to England Holbein made other portraits, such as that of *William Warham, Archbishop of Canterbury* (London, Lambeth Palace; another version in the Louvre), for which there exists a preparatory sketch in colored chalks. The chalk-sketch manner was apparently learned by Holbein on his French trip. The Archbishop, rendered with a superb sensitivity to line and delicate modeling is, like Erasmus at his writing desk, shown in a close space surrounded by the "symbols of his profession." In 1528 the Louvre portrait of *Nicholas Kratzer*, the King's astronomer and a friend of Dürer, was painted showing the subject surrounded by his astronomical instruments. Portraits of several members of Sir Thomas More's family were made without such occupational accessories. This is essentially the nature of the Dresden portrait of *Sir Thomas Godsalve and His Son John* (the father a notary and court registrar helpful on Holbein's behalf), for the writing motif is strongly subordinated, being a mere allusion.

The 1528 portrait of *Sir Brian Tuke* (Fig. 551), in Washington, presents a Manneristic device in the arrangement of the identifying inscription and the sitter's motto within the background space rather than as letters naturally attached to a back wall or tablet. The letters are independent, invading the natural milieu of the portrait, yet they also augment the formal, over-all surface design. Here is a northern variation of a device that was also used, though later, in Italian Manneristic portraits; the source may lie in Italian medals. Holbein's abilities were never more brilliantly employed than in this objective portrait, in which the varied light on the face and the animation in the eyes are led up to by the more strongly lighted hands. One arm is placed horizontally on the parapet; the other moves back into space for a short distance until it is swallowed by the dark garment. Thus real spatial depth is only implied in this modernization of the traditional northern portrait style. The interplay of sharply characterized detail and large, simple, dark areas has by now been firmly established as the basis for Holbein's male portraits, and most of his later works are merely refined variations on the perfection here.

The trip to England was so financially successful that Holbein bought two houses after his

return to Basel. Again he set up his shop and returned to portraiture, and again he painted Jakob Meyer. In the *Madonna of Burgomaster Meyer* (Fig. 552) Meyer kneels with his family before the Virgin, whose features resemble those of Magdalena Offenburg. The work, now in Darmstadt, completed in 1528, is interesting for its deliberate scale discrepancies intended to monumentalize the composition. Meyer forms the apex of a subsidiary, reinforcing triangle, of which the forward corner is his nude youngest son, shown like a classicized baby Christ. On the opposite side his first wife, his second wife, and his married daughter kneel in profile. The daughter is small in size, for the figure is intended to lead the eye beyond and up toward the Virgin and Child, who are northern types with a strong naturalism of detail. Stylistically this is reminiscent of Holbein's older manner, but the forms are set within a limited space that is ambiguously compacted. Holbein monumentalized the whole by methods that are neither logical nor clear; the Italian Renaissance rationale of construction has been superseded by a pseudo-rationale.

The *Artist's Family* (Fig. 553), his portrait of 1528–29 of his wife and two of his children, Philip and Catherine, in Basel, is objective, yet also monumentally constructed. The lowered eyelids of his wife give her an unusual expression, which has produced reams of explanations and expressions of pity for her abandonment for two years and subsequently for another eleven. The explanation for the glance may be an eye disease; instead of varying the eyes as Holbein did so often to animate that portion of the face, here he varied the eyebrows to achieve the same effect. If the *Solothurn Madonna* of 1522 had Elsbeth Holbein as its model, as Ganz [5] thought, the heavy eyes there may be due to an early stage of the disease. Such a prosaic explanation is in keeping with Holbein's basically nonpsychological approach. His dispassionate and fundamental objectivity is evident in the homeliness of his daughter on her mother's lap.

The portrait in Hannover, of about 1529 or 1530, of *Melanchthon* is equally dispassionate, its calm objectivity at the opposite pole from Dürer's subtle glorification in his 1526 engraving of this high-browed, sharp-eyed thinker. Instead of idealizing a hero of the Reformation, Holbein showed how he looked. Apparently Holbein was far more sympathetic to the personality of Erasmus, for his small circular portrait of 1532, in Basel, conveys by its animated expression the sitter's inner vitality. In this three-quarter-view, head-and-shoulders portrait, the

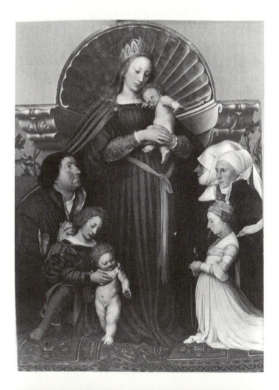

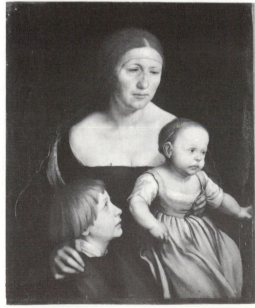

above: 552. HANS HOLBEIN THE YOUNGER. *Madonna of Burgomaster Meyer*. Completed 1528. Panel, $56^3/_4 \times 39^3/_4$". Hessisches Landesmuseum, Darmstadt.

right: 553. HANS HOLBEIN THE YOUNGER. *The Artist's Family*. 1528–29. Tempera on paper, later cut down and mounted on wood, $30^1/_4 \times 25^1/_4$". Kunstmuseum, Basel.

412 THE SIXTEENTH CENTURY

artist captured the personality by showing the slight ironic smile and by emphasizing the widespread brows above vital, peering, narrowed eyes.

Despite the efforts of the Town Council to keep him in Basel, Holbein left his family behind and returned to London in 1532, where there was more opportunity than a painter could find in troubled Basel. His work in England this time probably began with the 1532 portrait in Berlin of *Georg Giesze* (Pl. 28, after p. 308), a member of the Steelyard, that is, a merchant of the Hanseatic League established in London. Holbein used devices and a setting that make the portrait an exception to his normal manner, for it is intentionally Eyckian. Whether the carnation in the glass vase has its earlier symbolic meaning is difficult to say. Georg Giesze does not hold it but busies himself with the "tools" of his trade; bills of lading, monies, and the like are scattered about to indicate his merchant status. Jan van Eyck's spatial chiaroscuro is only hinted at by the even illumination, Holbein's painting being sharper and clearer, though as expertly detailed as any Eyckian work. Like Dürer's *Heller Altarpiece*, this work was probably painted to advertise the artist's virtuosity. Without doubt such a tour de force immediately brought its painter to the attention of the rich merchants and officials who would normally commission portraits.

In 1533 Holbein completed the London double portrait of the *Ambassadors*, the Frenchmen Jean de Dinteville and Georges de Selve, Bishop of Lavour (Fig. 554). The only parallel in Holbein's *œuvre* to the Giesze portrait, it shows numerous instruments on the table to indicate that the two ambassadors are intellectuals. An unusual element is the radically elongated skull stretched diagonally across the lower center. This anamorphic image [6] (possibly referring to the personal device of Jean de Dinteville, whose cap medallion bears a skull) breaks with the otherwise consistent spatial naturalism. It is as Manneristic as the lettering seen in the Tuke portrait and parallels the Erhard Schön portraits (Fig. 526). Another hidden but still undecipherable meaning may relate to the placement of Jean de Dinteville's foot at the center of a motif in the floor design. The visual complexity of still life possibly symbolizing Vanitas—the books and instruments seem to suggest a warning against pride in learning—agrees with the new Manneristic spirit.

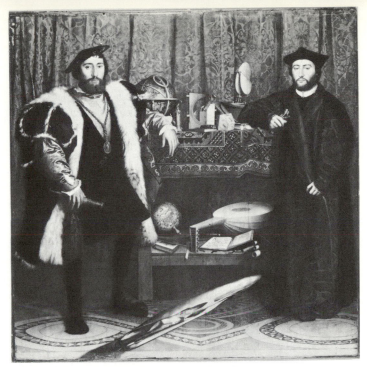

554. HANS HOLBEIN THE YOUNGER. *The Ambassadors*. 1533. Panel, 81 1/8 × 82 1/4". National Gallery, London.

These two portraits of Holbein's "Eyckian revival" had no counterparts among the ninety known portraits painted in England before his death of the plague in 1543, perhaps because the time needed to paint them made such works too costly. Subsequent likenesses were of the simplified manner employed in the Brian Tuke portrait. An early instance is the 1533 Berlin portrait of Hermann Wedigh, of Cologne. The frontal pose solemnizes the figure set against a blue background, which Holbein frequently employed to accentuate and give a vital warmth to the face. Careful preparation is a constant in these later portraits, and the majority contain an identifying inscription of the type used in the Tuke and Wedigh portraits. The type was employed for portraits of members of the court, such as that of Robert Cheseman of Dormanswell (now in the Mauritshuis), painted in 1533 as holding a falcon, and animated by the glance to the side; or members of Parliament, such as Sir Richard Southwell, seen almost in profile in his Uffizi portrait of 1533. Works such as these conform to a general formula, in which the half-length figure fills the frame and dominates the pictorial space. Occasionally varied, as in the 1535 frontal presentation of Charles de Solier, Sieur de Morette, in Dresden, they accentuate the dignity of the individual. Yet they

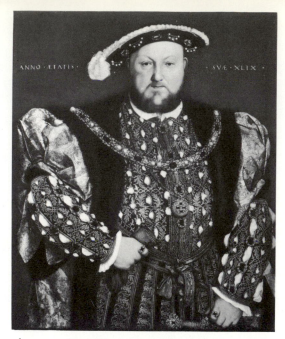

above: 555. HANS HOLBEIN THE YOUNGER. *Henry VIII in Wedding Dress* (replica?). 1539–40. Panel, $34^7/_8 \times 29^1/_4''$. Galleria Nazionale d'Arte Antica, Rome.

below: 556. HANS HOLBEIN THE YOUNGER. *Christina of Denmark, Duchess of Milan.* 1538. Panel, $69^3/_4 \times 31^7/_8''$. National Gallery, London.

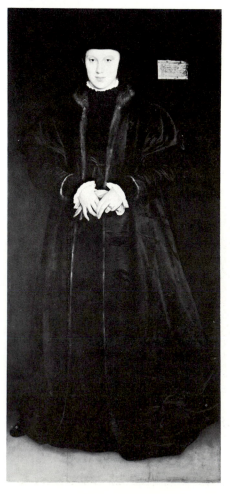

personalize the portrayal by a slight emphasis upon the facial modeling and suggest sumptuousness and social position by the subdued play of light over rich materials.

In 1536 Holbein became Henry VIII's court painter and was much occupied in a variety of works for the monarch. These ranged from murals, now destroyed but known from copies and engravings, to miniatures; from jewelry to costumes; and from hangings to settings for court masques. During this period his version of the *Dance of Death*, though designed earlier (1523–26), was published at Lyons in 1538. The series is outstanding not so much for the quality of cutting, which is much like that of the Dürer school, as for the lively drawing, variety of action, and over-all conception. The outlook of the artist was ironic rather than grim or frightening; one feels that Holbein had been touched by Erasmus and his circle.

The chief duty of a court painter, however, is the portrayal of the king, and Holbein made numerous paintings of Henry VIII and his family. The 1536 portrait of Henry, in Lugano-Castagnola, to which the Vienna portrait of Jane Seymour (another version is in The Hague) is a pendant, shows, in the rich costuming, the pose, and the flat patterns of linear, decoratively ornamented surfaces, a Manneristic spirit and an international type close to the portraits of Francis I by the Clouets (Fig. 642). Holbein's contribution is his perfection of stylistic means. Numerous replicas exist of the monarch. Some of them are full-length portraits, with Henry standing spread-legged in a rich setting; some are three-quarter-length portraits, with Henry resting his fist on his belt and his figure turned directly to the spectator, as in the *Henry VIII in Wedding Dress*, of 1539–40, in the Galleria Nazionale, Rome (Fig. 555).

Another duty of the royal portrait painter was the painting of prospective brides, the *raison d'être* of the 1538 portrait, in London, of *Christina of Denmark* (Fig. 556), sister of Charles V and widow of Francesco Sforza, Duke of Milan. Holbein accompanied the negotiating embassy to Brussels to paint the Duchess, for Henry was considering her for his fourth wife. The portrait is full length and superb in drapery design, with a fur edging leading to the face; the Duchess is slightly turned, looking down and out at the spectator as she holds her gloves before her in

both hands. Variety is created in this duly famous work by the inscription to the right of her head and by the subdued color and gentle surface sheen of her dark garment. Against blacks and dark blues Holbein set the light, delicate facial tones and masterfully executed hands.

The negotiations for Christina's hand fell through, but Holbein did paint Henry's fourth queen, *Anne of Cleves*, in a half-length, frontally posed portrait of 1539 (Fig. 557), now in the Louvre. Vermilions, yellows, and browns dominate here. Again formal and hieratic, the approach to the sitter is dispassionate, and her physical character is generalized. However, the formal beauty of the portrait did not accord with Henry's reception of its subject; he referred to her as the "Flanders mare," found her physically repugnant, and divorced her.

One of the earliest portraits of Henry's son Edward is the painting of about 1538, in Washington, *Edward VI as a Child* (Fig. 558). At first glance it is a very endearing portrayal. The little Prince of Wales holds a miniature scepter and, with a hand raised in greeting, is portrayed in a regal act. Actually the child is portrayed objectively, for the face with downward glance is quite impassive. Into the artistic activity in costume and accessories has been set the visual reality of a child. The inscription below exhorts him to live like his father and to be worthy of him.

This portrait, and those of later date before Holbein's death in 1543, as well as the early portrait style that began with Jakob Meyer, can be seen as one continuous progression of sensitive observation and clarity of rendering, without comment on the inner personality but with subtle indications of social status. By that time the bourgeois existed in the same milieu, almost indistinguishable in painted form from persons of noble birth and courtly function. The continued refinement of Holbein's method gives to these works great artistic value at the same time that they reveal, like the works of his contemporaries, the new position of the individual. Since a religious excuse was no longer needed, the number of portraits increased by leaps and bounds in the 16th century, particularly in northern lands, whose artists' traditional abilities in the depiction of nature made them the preferred portraitists of the era—and Holbein was the finest of them all. No one surpassed him in perfection of presentation, subtlety of refinement, or aesthetic sensitivity.

With the death of Holbein, art as a vital expression of the German spirit came to an end. No effort by Dürer or by any other painter could stem Protestant iconoclasm. When German artistic expression revived over a century later, it took form in music, which was acceptable to Protestantism as the old modes of painting were not. Painting had to change its modes —genre, still life, landscape, portraits—to conform to the changed religious outlook, which was hostile to the iconic potentiality of pictorial art. Religious art disappeared in Germany, and the other modes were developed elsewhere.

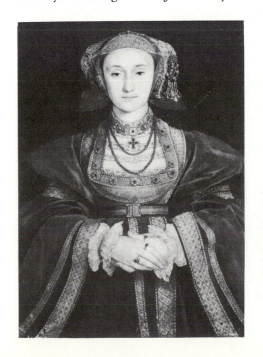

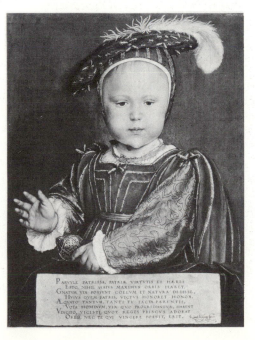

left: 557. HANS HOLBEIN THE YOUNGER. *Anne of Cleves.* 1539. Parchment mounted on canvas, 25 5/8 × 18 7/8". Louvre, Paris.

right: 558. HANS HOLBEIN THE YOUNGER. *Edward VI as a Child.* c. 1538. Panel, 22 3/8 × 17 3/8". National Gallery of Art, Washington, D.C. (Andrew Mellon Collection).

415

THE NETHERLANDS:
Metsys and Patinir

THE 16TH CENTURY IN THE NETHERLANDS created a different art, but only after the currents already seen in the late 15th century had run their course.[1] Italian ideas continued to infiltrate the Netherlands, gradually winning out after Flanders had developed its own expression of a late Gothic decorative style as tradition weakened under the forces for change in the painting of Metsys and Gossart, Dürer's prints, and the arrival of Raphael's tapestry cartoons in Brussels in 1517. Then the culmination of Antwerp Mannerism occurred.

This phase was short-lived, however, and passed rapidly into the full Romanist movement, which saw artists bypassing Dürer and German intermediaries to go directly to the antique (though they were never so single of purpose that they saw only the antique). Romanism had been prepared by Dutch painters and by Flemish enthusiasm for things Italian. The second wave of Romanists in many respects merely changed their models; in place of Dürer and Leonardo they took Raphael and Michelangelo as their schoolmasters. The Romanist victory coincided with the death of Quinten Metsys, Antwerp's chief painter and teacher. It dominated in Flanders and Holland from 1530 until supplanted in its turn by the later Mannerism that was to reign after the death of Bruegel. Though related to the community of European Manneristic thought, Romanism in the Netherlands retained a distinctive northern character. Early

it existed side by side with the traditional forms that perpetuated traditional northern concerns for light, color, and naturalistic detail. Sharing the stylistic means of the past, 16th-century Netherlandish painting united Italian Humanism and northern spatial mysticism. It set the stage for the Baroque, and the way was clearly pointed out by Pieter Bruegel in his last work.

The analytical spirit which engendered the autonomy of portraiture, landscape, genre, and mythological and religious painting, and even produced specialists in their production, may also be considered a factor in the evolution of a Dutch art that was distinct from the Flemish. This division closely paralleled the political separation of the southern and the northern Netherlands by the end of the century.

No longer dominant except in the field of the portrait, Flemish painting, overly tense and fluctuating in its allegiances, followed a turbulent course in many ways parallel to that of Italy. At the beginning of the century its approach to the ideal was empirical. Before it apprehended an intellectual basis for the production of art, its fluctuations were wide and free. The Italian Renaissance was in many respects as inimical to Flanders as the Gothic had been to Italy. A new cultural environment arose to nurture the new spirit. Its center in Flanders was Antwerp.

This city, as international as the artistic outlook came to be, grew by giant leaps in the 16th century. A deep-water port capacious

enough to accommodate the larger ships of the 16th century, it was aided in its expansion by an enlightened, liberal economic policy by the Hapsburg rulers of the Netherlands, beginning with Philip the Handsome, son of Maximilian and Mary of Burgundy.

Philip's early death in 1506 left his infant son, the future Charles V, born in Ghent in 1500, under the care and the regency of his aunt, Margaret of Austria, for Charles's mother, Joanna of Aragon, called the Mad, was incapable of ruling. Margaret was Regent of the Netherlands until Charles was fifteen and continued to rule there until her death in 1530, for Charles had succeeded to the crowns of Castile and Aragon in 1516, had been elected emperor to succeed his grandfather after Maximilian died in 1519, and thus was frequently absent from the Netherlands. Margaret filled the position ably, keeping court at Malines, where she employed Jacopo de' Barbari as her court artist and appointed Bernard van Orley of Brussels to succeed him after he died in 1516.

On Margaret's death in 1530 Charles's sister, Mary of Hungary, with her court at Brussels, acted as ruler until Charles V abdicated in 1555. Then his son Philip II, reared in Spain, came to the throne. He had lived very little in the Netherlands and understood its inhabitants not at all. When he left for Spain in 1559, he never returned. Charles's policy had been one of moderation, though taxation to finance his wars and measures against heresy had been increased in the 1530s. Philip further increased both, for the Reformation had made widespread gains, and he needed money as much as his father had. The succeeding years were the most difficult and the most bloody in Netherlandish history, even before the iconoclastic riots in 1566 and the arrival of foreign troops under the Duke of Alba in 1567. After the most incredible acts of cruelty and savage warfare, including the "Spanish fury" which fell on Antwerp in 1576 (when the mercenaries burned more than 800 houses and slaughtered more than 6,000 inhabitants), the decisive split between the southern and northern Netherlands took place with the Union of Utrecht in January, 1579. However, warfare continued for many years more.

The first half of the century was relatively peaceful and favorable to artistic production. The second half was its very opposite. Even artistic technique responded to the changing character of the times, so that the careful execution of the 15th century was gradually abandoned for a looser manner according with Manneristic conceptions. Increasingly the artists created for an independent market, rather than on contract, as in the 15th century. Art was becoming a commodity like the goods traded on the Antwerp exchange, a secularization that in the following century took the form of auctions for the disposal of artistic goods. Early steps on this road had been taken in Bruges in the 15th century and in Antwerp in the early 16th century, when painting and sculpture developed an export market. In Bruges, where Jan Provost led the field with a hybrid Mannerism, Adrian Isenbrant and the transplanted Lombard Ambrosius Benson put Gerard David's style and forms on a production line, increasing the amount of sentiment noted in David's latest work.

Nor was Antwerp far behind. The silting-up of Bruges's estuary led to a move of the foreign traders to Antwerp. By the end of the first decade the majority of foreign merchants had already transferred their businesses; by midcentury Antwerp had an estimated population of 200,000. The Venetian envoy, Contarini, recorded that over 1,000 foreign merchants were established there and conceded that more business was transacted in Antwerp in a few weeks than in a year in Venice, that as many as 500 ships had passed through the port in one day and that 2,000 carts entered the city every week. Antwerp sheltered large trading groups from the Hansa, from Germany, England, Portugal, Spain, and Italy. The volume of Flemish paintings that are still in the Iberian Peninsula, or have come from there to stock so many museums today, was the result of the enthusiastic collecting and purchasing of art by Spanish and Portuguese merchants established first in Bruges and then in Antwerp.

QUINTEN METSYS

In the 15th century Antwerp had been little heard from; its artistic level was so low that as late as 1493 the Antwerp painters' guild, to decorate its chapel with frescoes, imported Colijn de Coter of Brussels, Rogier's follower, who was far from the most glorious of painters.

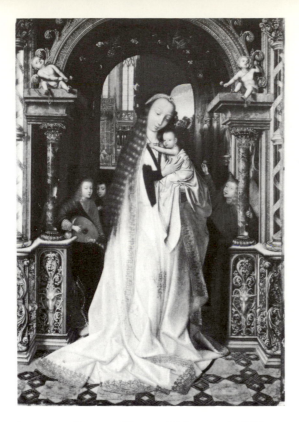

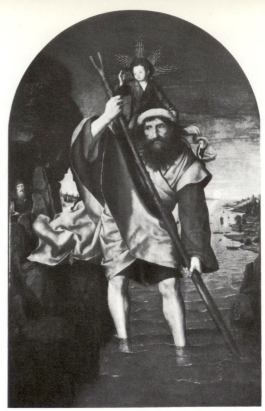

above: 559. QUINTEN METSYS. *Madonna and Child. c.* 1495-1505. Panel, 21 × 14 3/8″. Musée des Beaux-Arts, Lyons.

right: 560. QUINTEN METSYS. *St. Christopher. c.* 1500–05. Panel, 41 3/4 × 28 3/8″. Musée Royal des Beaux-Arts, Antwerp.

The leader who was to effect the transition in Antwerp from 15th-century to 16th-century art had become a master there only two years before. Quinten Metsys [2] (also, Quentin Massys or Matsys), born in Louvain about 1465 or 1466, became Antwerp's leading master by 1510. Of Gerard David's generation, Metsys too built upon the past and looked to the future, but Metsys's art and outlook were more acutely tuned to his era. He was also more innovative and a more complex artistic personality than David, as is shown in his variety. Interested in personality and expression, he explored the varieties of modes and types. Early drawn to Memlinc, to the Van Eycks, the Master of Flémalle, Rogier, and Van der Goes, then to Dürer and to Leonardo, he viewed the past and the present as an eclectic, selecting according to his personal values rather than according to traditional beliefs. Like Bosch he was drawn to the grotesque and like Bosch gave it a personal morality, equating ugliness with evil and the beautiful with the good. A new world of sentiment per-

vades his panels, different from that of the predecessors whose techniques he employed.

Though he was born in Louvain, there is little in his art to suggest that he received his training there under the direction of the inheritors of Bouts's shop. Van Mander implied that Metsys was self-taught, and there may be an element of truth in the two tales he related: that the artist learned painting by coloring prints while convalescing from a serious illness, and that he abandoned his trade of blacksmith because he loved a girl who loved him but not his trade. According to this second tale, Metsys learned the trade of his rival, a painter, to win the girl. Metsys's father was a blacksmith of Louvain, and the son's name does not appear on the Louvain guild lists. He entered the Antwerp guild as a master in 1491, having been married five years earlier to Alyt Tuylt, daughter of a prosperous landowner. When she died in 1507, leaving two children, he married again. From this marriage, to Catharina Heyns in 1508, came ten children.

Rapidly assuming the lead in Antwerp, Metsys was acquainted with Erasmus and his Antwerp friend and fellow Humanist, Petrus Aegidius (Pieter Gilles). He painted their portraits for Sir Thomas More in 1517, and More extolled him as the reviver of ancient art. When Dürer visited Antwerp, he recorded that he was shown

Metsys's house, which was apparently a show place with a fine collection of paintings. Metsys bought another house in 1521. He died in 1530, leaving two sons, Jan and Cornelis, who became masters in the following year.

Metsys's early work is problematical, the earliest certain work being the *St. Anne Altarpiece* of 1507–09, in Brussels, painted when he had already been a master for two decades. Earlier works have been attributed to him. Characteristic of the style of these works is the standing *Madonna and Child* (Fig. 559), of which there are several versions, that in Lyons being qualitatively finest. Though the composition goes back to the Master of Flémalle's lost Virgin and Child in an Apse, accompanied by music-making angels, the manner of their treatment, the inclusion of putti, and the exceedingly sumptuous— and somewhat cluttered—architectural setting are indications that the type was transmitted to Metsys by Memlinc, with whom he shared a feeling for delicacy and charm. Subsequent work in the presumed early style, such as the *Enthroned Madonna and Child*, formerly in the Dyson-Perrins Collection in London, and two more enthroned Madonna and Child paintings in Brussels (one bearing the coat of arms of Louvain), are more monumentally conceived and show an increase in tonal chiaroscuro. This is also visible in the fine *St. Christopher* (Fig. 560) in Antwerp, which repeats the composition of the Bouts shop *Pearl of Brabant Altarpiece* wing (Fig. 175). But Metsys monumentalized drapery and form and subordinated the landscape to effect a close view and a distant view, almost eliminating the middle ground. Despite the detailed treatment, the whole is more strongly atmospheric and closely approximates Leonardo's *sfumato* chiaroscuro. This work is generally dated before the *St. Anne Altarpiece*, yet without any doubt Italy influenced his works of the first decade, possibly as a result of a trip to northern Italy. The chiaroscuro, monumentality, and method of construction are all so different from northern adaptations of those elements that one feels a first-hand contact must have taken place.

That the Italian impression was assimilated, rather than swallowed whole, was due to the strength of Metsys's expression and genius, which are clearly visible as distinctly northern in the *St. Anne Altarpiece* (Pl. 29, after p. 308), made between 1507 and 1509 for the Louvain Brother-hood of St. Anne for their chapel in St-Pierre, Louvain. The theme is related to the Holy Kinship, and the regularized composition of softly draped figures, whose heads are grouped in three inverted triangles, is set close to the picture plane before a triple-vaulted, open-air loggia. The architecture, complete with tie rods and a central dome, was surely inspired by northern Italy, even though the shiny marble columns attached to the piers suggest the art of Memlinc. Though the work is given the formality of a Coronation of the Virgin, the projecting faces and the light coloration of the forms weave a tapestry of broken-color movements across the surface. Changing color, appearing for the first time since Joos van Ghent's *Crucifixion Triptych* (Fig. 181), animates the generally high-keyed surfaces. The most remarkable example is visible in the greens turning to crimson in the shadows of the garments of the angel announcing to Joachim on the left wing (Fig. 561). The compressed effect was probably inspired by Van der Goes's

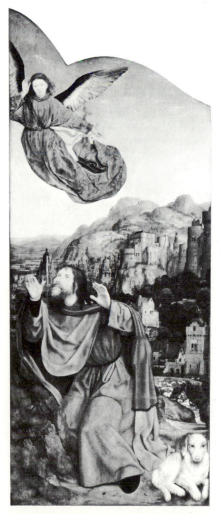

561. QUINTEN METSYS. Annunciation to Joachim, *St. Anne Altarpiece*, left wing. 1507–09. Panel, 86³/₈ × 36″. Musées Royaux des Beaux-Arts, Brussels.

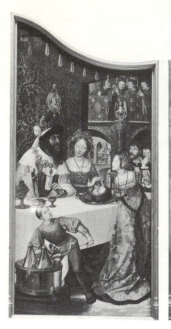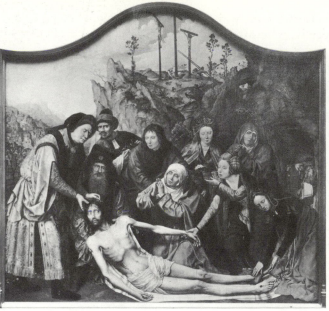

562. QUINTEN METSYS. *Deposition Altarpiece.* 1508–11. Panel, 8′ 6³/₈ × 8′ 11¹/₂″ (center),
8′ 6³/₈″ × 3′ 11¹/₄″ (each wing). Musée Royal des Beaux-Arts, Antwerp.

Death of the Virgin (Fig. 194). Idealizing the softly rendered faces, Metsys set his forms against the landscape and completely eliminated the middle ground. The background is bathed in the same soft light as the foreground. It creates an almost visionary effect with subtly graduated values. The dramatic projections of the wild, mountainous landscape against the sky are rendered with an aerial perspective. Unlike earlier northern landscapes, this suggests the panorama of a dramatized nature. The death of St. Anne on the right wing, also inspired by Van der Goes's *Death of the Virgin*, is bathed in a harmonious warm color and light, and the largeness of conception is united with monumental figures surprised in personal reactions to the event. The quality of personal sentiment is equally visible in the exterior scene of the rejection of Joachim's sacrifice, which includes a portrait, possibly that of the artist. Close spatial intervals augment the monumentality of the forms. These dominate the rich setting by color, value, and variety of human gesture. The left wing, showing the offer of a third of Joachim's fortune to the Temple, presents an interesting, high-keyed, almost exotic city view through the round-arched openings.

This new style of soft illusionism laid over monumental form met with success, for in 1508 Metsys was commissioned to paint the

Deposition Altarpiece (Fig. 562) for the Chapel of the Carpenters' Guild in Antwerp Cathedral. Now in the Antwerp museum, it was completed in 1511. Rather than borrow the central theme entirely from Rogier's great altarpiece, then still in Louvain, he turned to Petrus Christus, preferring to replace the arabesques of Rogier's emotional rhythms with life-size figures of monumental stature, immobilized in their realism and emotionally restrained. The Virgin worships, rather than swoons, and the figure of Christ is a pitiful dead human being, rather than a symbolic sacrifice. The figures form a screen across the foreground, which is conceived as an extremely narrow stage, with only a slight penetration in depth visible in the candle-lit cave being prepared as the last resting place. The landscape behind, with the three crosses seen high on the distant hill, is so patently separated from the foreground by the lack of a middle ground that it has become an evocative rather than a narrative element. In combination with the mountainous landscape seen in aerial perspective at the left, it reinforces the contained emotionalism.

The guild's patron saints are honored on the wings, the left wing showing the presentation of the head of John the Baptist to Herod by Salome; the right wing, John the Evangelist in the boiling caldron. The contracted space of the

central panel reappears in the Herod scene, with a fine contrast of implied depth and crowded, rich, realistic detail, even including a Roman medallion on the wall over the swarthy head of Herod. Elaborate costuming, varied gestures, and complex value relationships tie the two wings together in an over-all, flickering surface movement. Elegant beauty is accentuated and contrasted with coarse ugliness, notably in the executioners on the right wing, straining their muscles and grimacing with the effort of stoking the fire, while above them in the caldron John the Evangelist lifts his hands and face in a softly angular movement to the heavens, with a piously sweet expression. The textures of his curly beard and soft flesh are delicately rendered with almost a miniaturist's precision. At least one face in the crowd was derived from a caricature by Leonardo, and the composition recalls the same scene in Dürer's *Apocalypse*.

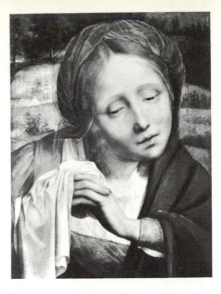

563. QUINTEN METSYS. *Weeping Magdalen*, fragment. c. 1513. Panel, 13 × 9 1/2″. Gemäldegalerie, Staatliche Museen, Berlin-Dahlem.

The inherent softness of surfaces is perhaps epitomized in a fragment of the *Weeping Magdalen*, in Berlin, of about 1513 (Fig. 563). Broken color is used in the service of a delicate chiaroscuro, and the generalized features, rendered with the utmost refinement, reveal an approximation of the aims of Leonardo and probably his influence. This influence is certain in several works, one being the *Madonna and Child with the Lamb*, in Poznán, which is derived from Leonardo's Louvre *Madonna and Child with St. Anne*. The landscape was probably painted by Patinir. Thus the work was created between 1515 and 1524. Leonardo's influence seems to have been strongest just before the middle of the second decade.

Metsys's development is not at all certain. What is proposed here is a change of style presumed to have occurred about 1515, so that the later development is considered as a movement away from the idealizing monumentality of the decade 1505–15 toward an increase in dramatic and genre elements, at the expense of an earlier, more formal exactitude. On the other hand, repetitions of earlier compositional ideas by the master and his shop serve to confuse the stylistic picture, for Leonardesque forms and motifs appear as late as the 1529 kissing *Madonna and Child* in the Louvre, a motif that first appeared, it seems, about 1512–14 in versions of this sentimental theme in Berlin and Brussels.

The intrinsic variety of Metsys's art is nowhere more evident than in his portraits. The Chicago portrait of a *Man with a Flower* (though often called a pink, the flower is blue, and unidentifiable beyond belonging to the broad family of Compositae) is loosely painted, yet sharply delineated, with little texture. Archaic in organization, the portrait may date in the early years of the first decade. By contrast the 1509 portrait of a *Man with a Letter* in Winterthur is shown in a cubicle hewed out just sufficiently to contain the figure (Fig. 564). Strongly lighted from the left, tilting his head to look at the spectator, and markedly unidealized, the subject, by the strength of the glance, is involved with the spectator in a direct, personal sense. Metsys achieved this by the extreme closeness of the naturalistic, powerfully plastic figure to the picture plane, as well as by the sidelong glance, and by the action of the figure, which suggests that the

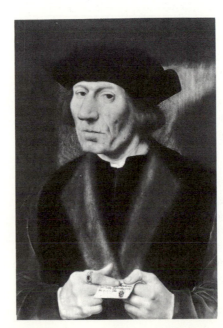

564. QUINTEN METSYS. *Man with a Letter*. 1509. Panel. 18 1/8 × 13″. Oskar Reinhart Collection, Winterthur.

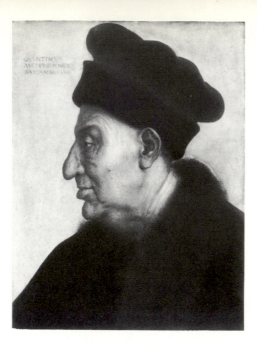

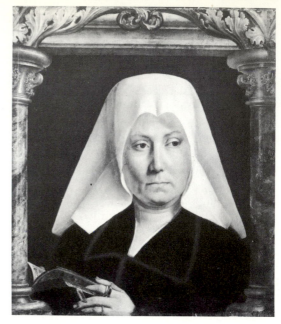

above: 565. QUINTEN METSYS. *Portrait of an Old Man.* 1513. Parchment transferred to canvas, 18⁷/₈ × 14¹/₂″. Musée Jacquemart-André, Paris.

right: 566. QUINTEN METSYS. *Portrait of a Lady.* c. 1510–15. Panel, 19 × 17″. The Metropolitan Museum of Art, New York (The Michael Friedsam Collection).

presence of the spectator has interrupted him.

Entirely different is the tellingly individualized profile *Portrait of an Old Man* (Fig. 565), in the Jacquemart-André Museum in Paris,[3] signed in Latin and dated 1513. It is based on Italian art in that it revives the profile type, which had been dormant since the Louis of Anjou portrait (Fig. 42) a hundred years before. Although possibly derived from a Leonardo cartoon, this has all the northern details and none of the generalization characteristic of Italian work. The 17th-century German engraver Hollar reproduced this old man and the "Ugly Duchess" (so-called because Tenniel used her for the Duchess in *Alice in Wonderland*) under the title of the *King and Queen of Tunis*; he attributed their invention to Leonardo.

In 1517 Metsys painted for Sir Thomas More the portrait of Erasmus, in the Galleria Nazionale in Rome, and the companion portrait of Petrus Aegidius (Gilles), Lord Radnor Collection, Longford Castle, which return to the 15th-century occupational portrait type, with a new human and Humanistic concern in the reference to and delight in books so characteristic of the new age. The sense of the real and the

actual enlivened by art is to be found in all Metsys's portraits, and even the caricatures of Leonardo were made real.

The *Portrait of a Canon* in the Liechtenstein Collection, Vaduz, may be close in date to the Metsys Erasmus portrait, though conflicting elements appear; the treatment of features recalls earlier work, but the broad and even handling of the landscape is calmer and more serene than the dated works with landscape backgrounds. The organization seems to repeat a Memlinc formula, but it is endowed with greater breadth and individuality.

Individuality is supremely achieved in the New York *Portrait of a Lady* (Fig. 566), which has been dated as early as 1510 and as late as after 1520; its devices are closely related to the 1509 *Man with a Letter*, with the addition of framing architecture used more knowingly as a compositional, formalizing element that echoes the strict frontality of the head. This formalism has been disguised by the sidelong glance, the turning of the body, and the sense of a specific moment created by the play of light and the device of the fingers inserted in the lady's Book of Hours.

The interest in variety which had led Metsys to translate Leonardo into Flemish terms also led him into the exploration of the past, which in turn led him to an investigation of genre. Elements of these possibilities for artistic expression *per se* have already been seen here and there in Metsys's art. They appealed to the Portuguese,

one of whom, Eduardo,[4] became Metsys's pupil in 1504 and a master in the Antwerp guild in 1508. A year later Metsys received the commission for a large altarpiece for a cloister in Lisbon. This was probably the dismembered work of which some panels are in Lisbon and the scene of the Rest on the Flight into Egypt is in Worcester, Massachusetts. The wings of another altarpiece, made for King Manoel between 1513 and 1517, are probably the panels now in the Coimbra museum. The emphatic expressions on the features are in a direct line from the *Deposition Altarpiece*.

The exploration of the past in Metsys's art appealed to Rubens, who owned the famous *Banker and His Wife*, of 1514 (Fig. 567), now in the Louvre. A recreative expression of the past, it has moral and symbolic overtones implied by the objects on the shelves and in the contrast between the money in the scales held by the husband and the pages of the Book of Hours turned by the wife in Eyckian costume. The original inscription on the frame read: "Let the scales be true and the weights equal." Suggested either by Petrus Christus's *St. Eligius* (Fig. 155) or by an original close to Van Eyck (for the reflecting mirror appears again), the *vanitas*-genre scene has been changed in construction. Metsys regularized it and clarified the interior space by accentuating the horizontal lines of shelving that are parallel to the picture plane. The composition, measured by spatial intervals, is closely allied to that of the *Deposition Altarpiece*, for the painter once again introduced a small movement into depth at the right, by way of a narrow view into the space beyond.

Metsys's mixture of morality and genre is best seen in the *Unequal Pair* (Fig. 568), National Gallery of Art, Washington, which illustrates the moral that a fool and his money are soon parted, for the purse of the ugly old fondled fondler is being handed to the girl's accomplice. The morality of this was exceedingly popular, not merely in the writings of Erasmus, to which many have related the work, but also in those of Sebastian Brant, which the long ears on the accomplice's hat suggest. Such satirical genre, also seen in the *Usurers* (perhaps a copy), in the Doria Gallery in Rome, was eagerly taken up and pursued by his followers of the next generation, above all in the frenetic works of Marinus van Reymerswaele.

Metsys also united caricature and genre with the religious theme. This combination is seen in two works very close in spirit: the small *Ecce Homo*, in the Prado (Fig. 569); and the *Adoration of the Magi*, in New York. The number "26" on a pilaster on the latter has been interpreted as 1526. Both works include grotesque types suggesting that Metsys was influenced by the works of Bosch, which he united with the caricatures of Leonardo. In both Metsys's genius produced an assimilation that makes the works highly personal expressions of his own vision.

The variety of his inventiveness was an inspiration to many of his contemporaries and to such artists as the Master of the Mansi Magdalen, named for a work in Berlin; the Master of the

below: 567. QUINTEN METSYS. *Banker and His Wife.* 1514. Panel, 28 × 26 3/4". Louvre, Paris.

bottom: 568. QUINTEN METSYS. *Unequal Pair. c.* 1515–20(?). Panel, 16 1/2 × 24 3/8". National Gallery of Art, Washington, D.C.

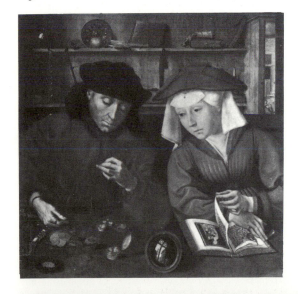

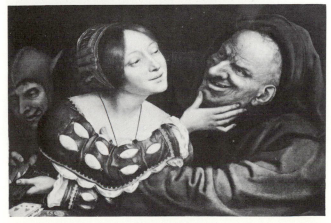

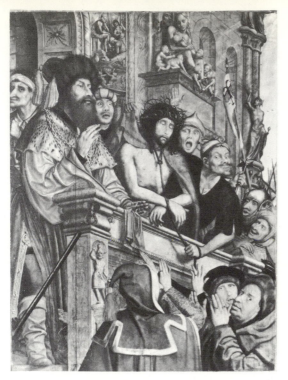

569. QUINTEN METSYS. *Ecce Homo*. c. 1520(?). Panel, 63 × 47 1/4″. Prado, Madrid.

Morrison Triptych, whose name work is now in Toledo, Ohio; the Master of the Holy Blood; and Joos van Cleve. The satirical genre painters such as Van Reymerswaele and Van Hemessen are also outstanding followers of Metsys, whose emphasis on psychological immediacy naturalistically presented forged the connecting link between the 15th and 16th centuries.

JOACHIM PATINIR

The exploration of the world following Columbus's discoveries and a parallel artistic analysis of its organic structure appear strongly in the art of landscape painting. Even Bosch had revealed this in his works. But the landscape painter who best expressed a new conception of the world that was to influence his contemporaries and successors for several generations was Joachim Patinir. Coming from Bouvignes or Dinant in the Meuse River valley, he was a free master in the Antwerp guild in 1515. Where he was before this is not known, though it has been suggested that he was in Bruges and acquainted with the art of Gerard David. Training under Bosch is also a possibility. Three signed works (in Vienna, Antwerp, and Karlsruhe)

have similar inscriptions, and these works have been the basis of other attributions.[5] According to Van Mander, Patinir executed a landscape for a painting by Joos van Cleve, and apparently he furnished landscape backgrounds for other contemporaries. The first known landscape specialist, he was mentioned in the diary of Dürer, who painted a portrait of him, now lost, made a drawing for him with four St. Christophers and attended his second wedding. Patinir died in 1524, undoubtedly at an early age, and his birth date has thus been conjectured to have been between 1475 and 1480. Metsys, his close friend and collaborator, became the guardian for two of his three daughters.

The single work that has been documented as a collaboration is the *Temptation of St. Anthony* in the Prado (Fig. 570), which was executed, according to old records, by Patinir and Master Coyntyn, that is, Metsys. The landscape is the real subject of the picture, and the theme is handled very differently from Bosch's treatment, for Anthony is a prosperous gentleman whose coattail is pulled by a monkey (a souvenir of the scarf-pulling devil from Schongauer's engraving). This is a minor element, however; the principal action is a transformed Judgment of Paris, complete with apple held out by one of the feminine temptresses. The inclusion, even transformed, of a classical subject in a northern religious painting shows a new era at hand.

The concept of a landscape that recedes unbroken to a distant high horizon, a panorama of a world grand and vast, surveyed from a high viewpoint, had appeared earlier, in the art of Hans Memlinc. Thus this "new" vision of mountain, river, sea, and clouds united was anticipated in artistic thought before the voyages of discovery.

The idea was taken up so avidly and widely at the time that attributions to Patinir constitute a dumping ground for a host of works that never came out of his shop. Though not the inventor of the panoramic form, he was such an outstanding performer in landscape painting that his work established the genre in Flemish painting. His fundamentally noncalligraphic use of the system of brown foreground, green middle ground, and blue background, with fine nuances of transitional tones and generalized lighting, was widely copied. Within the zones there is a sharp, accurate characterization of natural forms.

The signed *Baptism of Christ* (Fig. 571), in Vienna, with a subordinate theme of John preaching in the wilderness in the left middle ground, presents close to the picture plane the figures of Christ and John, whose types and gestures, though seemingly based on Schongauer's engraving, are reminiscent of the Bouts tradition. John's brown garments unite with the foreground color to subordinate him to the hieratic figure of Christ. God the Father appears in a Bouts-like window in the clouds above, and the hovering dove completes the Trinity. Rock forms, clearly, have been painted from stones taken into the studio, an old device. Thus the

mountain that balances the foreground action presents a certain sense of fantasy, for this is a constructed landscape of excerpted details and not a topographical one. The over-all conception is neither an objective Eyckian vision nor a German lyrical expression of the mystery of nature. Patinir was still tied to the conception of the grandeur of Creation; thus the overtones are dominantly religious and directly in the midstream of Flemish art.

The painting of the *Passage to the Infernal Regions* (Fig. 572), in the Prado, generally considered a late work, presents an unusual combination of motifs: angels escort souls to the bank

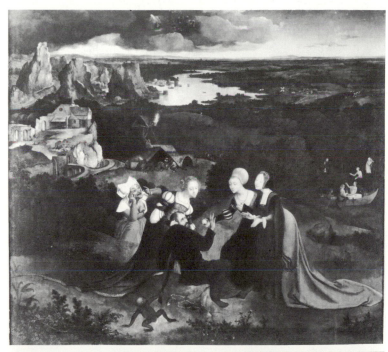

570. JOACHIM PATINIR AND QUINTEN METSYS. *Temptation of St. Anthony. c.* 1520–24. Panel, 61 × 68 1/8". Prado, Madrid.

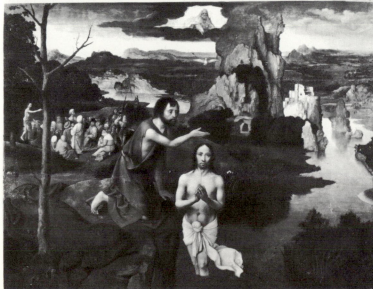

571. JOACHIM PATINIR. *Baptism of Christ. c.* 1515–20. Panel, 23 3/8 × 30 1/4". Kunsthistorisches Museum, Vienna.

425

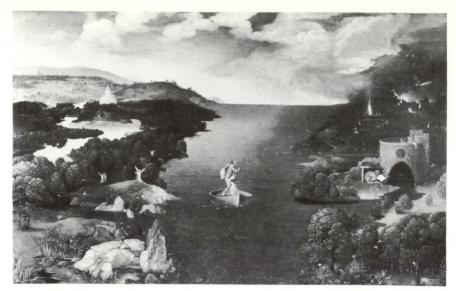

right: 572. JOACHIM PATINIR. *Passage to the Infernal Regions. c.* 1520–24. Panel, 25 ¼ × 40 ½″. Prado, Madrid.

below: 573. JOACHIM PATINIR. *Flight into Egypt. c.* 1515–20. Panel, 6 ¾ × 8 ¼″. Musée Royal des Beaux-Arts, Antwerp.

of a wide river, on which a classically attired Charon, as large as a St. Christopher, ferries another soul, seated on the thwarts before him, over to a Bosch type of Hell guarded by Cerberus on the other side. It is a curious union of Christian and classical iconography. The landscape background is different only in motif from the *Baptism of Christ,* for the layered recession of landscape elements rising to a high horizon is again visible. This is still the basic northern, naturalistic outlook, not yet truly Renaissance in feeling, since it merely introduces classicizing elements into a vast world panorama.

The insertion of little village scenes into the far middle ground of these landscapes is seen in the signed *Flight into Egypt* (Fig. 573), in Antwerp; another, in Berlin, is also attributed to

Patinir. Horizontals appear in perspective and verticals from a normal view, a perspective dualism that became a convention. Such scenes, occasionally with ruined buildings, became a common motif in the works of Patinir's followers, who peppered their middle grounds with like buildings and genre motifs. The device of the central motif with two spatial avenues into depth is also found in Patinir, who often divided the landscape along a diagonal with a space side and a volume side that interpenetrate, using such devices as light areas against dark or roads winding into depth to vary the otherwise obvious layering of the tonal zones.

The theme of St. Jerome in the wilderness was also popular among landscape painters, since it, like scenes of St. Anthony's life in the wilderness, or the Flight into Egypt, furnished excuses for the rendering of dramatic panoramic landscapes. The Louvre *St. Jerome* attributed to Patinir combines the central motif and silhouetted mass with a diagonal arrangement running from lower left to upper right. (The goat on a crag shows knowledge of Bosch's *Hermits Triptych* in Venice; as a result, awareness of Bosch's iconography means awareness of his style.)

What distinguishes Patinir generally from his followers is a concern for the epic grandeur and sweep of natural forms, rather than a concern for man's actions and interrelationship with natural forms. Chief among his followers was Herri met de Bles (Henricus Blessius), the creator of more grandiose and more atmospheric panoramas, but no succeeding Flemish landscapist was untouched by his art.

FLEMISH MANNERISTS AND EARLY ROMANISTS: Jan Gossart, Joos van Cleve, and Bernard van Orley

JAN GOSSART

Of tremendous importance in the penetration of new ideas into the north was the first "Romanist," Jan Gossart, also called Mabuse, who came from Maubeuge in Hainaut.[1] The most accomplished artist of his generation and an innovating pioneer, he taught either directly or by example many of the following generation. He was born about 1478 and was probably trained in Bruges, but he is first heard of in 1503, when he became a master in Antwerp, registering as Gennyn van Hennegouwe. (In his earlier period he signed his work—in itself indicative of the change in outlook—Jeannine Gossart; after 1516 he changed to the Latin form, Joannes Malbodius.) He took pupils in Antwerp in 1505 and 1507 and then entered the service of Philip of Burgundy, spending about ten years at Philip's castle of Suytborg, near Middleburg in Walcheren. When Philip went to Utrecht as its bishop in 1517, Gossart followed. In 1508, when Philip went on a mission to the Vatican, Gossart accompanied him, making drawings of the monuments for his patron. He must have been back by 1509, for in that year he became a member of a religious brotherhood in Middleburg. On Philip's death in 1524 he worked for Adolf of Burgundy and others of the Burgundian house, then returned to set up shop in Middleburg, where he died in September or October, 1532.

Gossart's early work was based on the late 15th-century painting of Flanders, but the trip to Rome was seemingly the first trip by a Flemish artist under his patron's guidance with the intent to record the art of the antique. It had as much importance for Flanders as Dürer's trips to Venice had for German artistic developments, because in time Flemish art lost prestige, and Italian art gained as the greater, more important Humanistic art. Consequently, the previous naturalistic basis of Flemish art came to be replaced by one founded on ideal classical sculpture, anatomical studies, and rational perspective.

Interest in ancient Rome and the Renaissance had been prepared by northern artists' gradual adoption of a historical viewpoint. The past was seen as something separate, no longer a continuum with the present but an ideal golden age that had once existed and was to be emulated. Thus the artist would follow those artists and works he thought best exemplified his ideal, and so Gossart was inspired not only by classical art but by such intermediaries as Marcantonio Raimondi, Jacopo de' Barbari, and Dürer. The first artist to think in these terms, he was the first Romanist, as that term came to be applied to like-thinking painters of the north. In the long run his effect was greater than Metsys's.

The signed *Adoration of the Magi* (the *Carlisle Epiphany*), in London (Fig. 574), is the outstanding pre-Romanist work of his early period,

574. JAN GOSSART. *Adoration of the Magi. c.* 1507–08(?). Panel, 70 × 63 3/4". National Gallery, London.

which extends from 1503 to 1515. The painting combines elements derived from his predecessors, but in a way that in no wise diminishes the grandeur of his result. The high architecture and the elongated forms of the angels show a very clear influence of Hugo van der Goes's *Monforte Altarpiece* (Fig. 184), while the Madonna is midway between the types of Van der Goes and Gerard David. The seated dog in the lower right-hand corner aids in dating the work as after 1502–03, for this motif is derived from Dürer's *St. Eustace* engraving (Fig. 436). Gossart's understanding of the monumentality and grandeur of Van der Goes reveals his own bent, as he sought in northern art those elements which he later went to Italy to discover directly.

A more dramatic expression under Dürer's influence appears in the grisailles of *St. Jerome in Penitence*, in Washington, possibly painted immediately after the Italian journey. The plastic foreground elements are sharply lighted and set against the grayed tone of the background, except for the small pond in the distance, which acts as a unifying element for the two panels and also serves to integrate foreground and background. The saint, in contrast to the contemporary northern concept of Jerome as an emaciated form, is a heroically constructed athletic figure of great physical power.

The grisailles apparently covered the Berlin *Agony in the Garden*, shown as a night scene. The forms are regularized and the composition carefully balanced, the sleeping apostles so arranged that they form a curve, out of the center of which arises vertically the figure of a very young Christ. The strong sense of triangularity gives a clear, restrained balance to any tendencies to create an overly dramatic, emotive, nocturnal scene such as those in German and later Flemish night scenes. Because of the lighting the forms are sharper in sculpturesque feeling.

After the return from Italy Gossart painted, about 1510–11, the *Malvagna Triptych*, now in Palermo (Fig. 575). The extremely complex painted architectural setting hangs like lace from the frame. Below it are the Madonna and Child and music-making angels, in the central panel, and Sts. Catherine and Dorothy, on the wings. On the exterior is represented the Fall of Man. The active architecture is a Flemish manifestation of the spirit of the late Gothic baroque, for its elements are essentially northern, not Italian, and the general figure type of the Madonna is derived from Gerard David, whereas the angels are Italianate. The background landscape seen through or below the architecture is equally active and thus reinforced the intense surface drama.

The lower terminus of the date is given by the figures of Adam and Eve on the exterior, since their design is borrowed from Dürer's Fall of Man woodcut from the *Small Passion* of 1509–11. In contrast to Dürer, Gossart presented his Adam and Eve against a deep landscape background, verdantly adorned and treated in a soft manner that suggests a knowledge of the art of Leonardo. But to Gossart, Dürer represented a more understandable classicizing point of view, just as the Venetians represented that viewpoint to Dürer, and Leonardo's influence was short-lived with him.

Apparently Gossart furnished architectural settings for some of the miniatures of the *Grimani Breviary*, now in Venice (one is signed "Cosart"), made about 1510 under the leading miniaturist of the day, Simon Bening. Participating in the Eyckian revival in his diptych of 1513–14 for Antonio Siciliano (owner of the *Grimani Breviary*), now in the Palazzo

575. JAN GOSSART. *Malvagna Triptych.* 1510–11. Panel, 17⁷/₈ × 13³/₄″ (center),
17⁷/₈ × 6⁷/₈″ (each wing). Galleria Nazionale della Sicilia, Palermo.

Doria in Rome (Fig. 576), Gossart turned back to Jan's *Madonna in a Church* (Fig. 100) for his figure of the Virgin, copying that painting but reducing the Virgin's elongation and thereby stressing Jan van Eyck's inherent monumentality. His emulation of Van Eyck's infinite variety of natural form took the direction of imposing a regularizing order upon his model. The donor panel shows St. Anthony presenting Antonio Siciliano (painted with shop assistance) before a landscape with a marked atmospheric perspective that goes beyond Patinir's. In place of Patinir's generalized lighting there is a more specific light play, and the play of space is more fluid. The soft-edged transitions are less visible than in Patinir's landscapes and are made doubly fluid by the strength of the foreground forms. His later landscapes are harder and sharper.

At the turning point in his stylistic development is his *St. Luke Painting the Virgin* (Fig. 577), originally hung in the church of St-Rombout at Malines and now in Prague, which has been traditionally dated about 1515. The forms are both more sculpturesque and more archaic than in his previous work. The Virgin recalls the round-faced figures of the Master of Flémalle, and the arrangement of the drapery in both

figures is archaic; the Child, however, has become a youthful Hercules. Reflected lights are now stronger, and a generally harder, more sculpturesque feeling is created by light and dark contrasts that tend to force the whole value system into a more rigorous mold than before, a stylistic change that was to characterize later works. The background combines Gothic and

576. JAN GOSSART. *Madonna and Child with the Donor Antonio Siciliano,* diptych. 1513–14. Panel, 16¹/₈ × 9¹/₂″ (each wing). Galleria Doria Pamphilj, Rome.

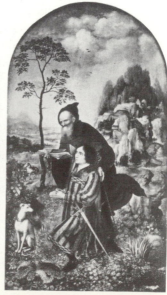

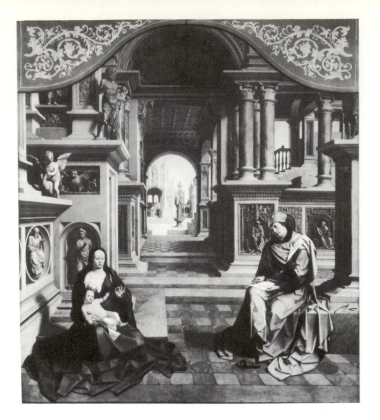

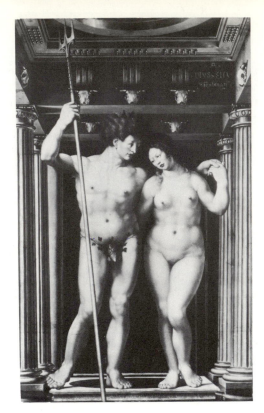

above: 577. JAN GOSSART. *St. Luke Painting the Virgin.* c. 1515. Panel, 90½ × 80¾". National Gallery, Prague.

right: 578. JAN GOSSART. *Neptune and Amphitrite.* 1516. Panel, 74 × 48¾". Staatliche Museen zu Berlin, East Berlin.

below: 579. JAN GOSSART. *Venus and Cupid.* 1521. Panel, 16⅜ × 12⅛". Musées Royaux des Beaux-Arts, Brussels.

Renaissance elements almost indiscriminately into a fantasy of architectural form.

Late in 1515 Gossart, in company with Jacopo de' Barbari, had begun a series of mythological paintings for Philip at the castle of Suytborg. Jacopo died the following year, and Gossart completed the work. Either from that series or related to it is the *Neptune and Amphitrite* (Fig. 578) of 1516, in Berlin. Seemingly an adaptation of the types of Jacopo de' Barbari as if seen through the eyes of Dürer, and close to the art of Philip's sculptor, Conrat Meit, the figures, the first idealized, classicizing nudes in Flemish painting, are set against a classical architectural background. Large, full forms of clear outline and fleshy weightiness are united with delicate surface modeling and strong curves.

Large form and greater movement are also evident in his *Vanitas,* in Rovigo, painted somewhat before 1520, if not later, as well as the

Adam and Eve in Berlin, of the early 1520s. Almost lumbering, these tremendously heavy figures are more sensuous than those of Albrecht Dürer. There is also a strong interest in surface for its atmospheric effect. A low eye level reinforces this overwhelming monumentality, so that the idealized figures seem to loom over our heads. This spatial drama is almost proto-Baroque.

A change is visible in his small *Venus and Cupid* (Fig. 579) of 1521 in Brussels, where again the ample, sensuous body form is employed. Delicately reflected lights animate the surface.

A feeling of movement over the surface is reinforced by the design of the composition, the figure having an imbalance that is righted only by its relationship to the little Cupid at the right. When a vertical line is drawn through the standing foot, it is seen that the head is on that axis but the neck and the body are all to the left; thus the figure of Cupid functions as an absolute necessity in stabilizing the whole design. Dramatized internally by the twisting of the torso and by the anomaly of the leg which seemingly is the supporting leg but in actuality is not, the work thus presents an ambiguity that is highly Manneristic in its over-all effect.

The next stage appears in the Vienna *St. Luke Painting the Virgin* (Fig. 580). Gossart returned to this theme in a work which may have been executed about the middle of the 1520s and which is radically different in conception from the earlier Prague painting. St. Luke kneels to sketch the Virgin, who has appeared in a cloud before him with angels surrounding her, while another angel, acting like a classical genius, guides the hand of the artist. Light emanates from the Virgin and Child to illuminate architecture covered with classical decoration, in the midst of which a sculptured Moses in a niche holds the tablets of the Law. The inspiration of the artist is basically the theme, an idea to be taken up in the Baroque period, with which the visionary spirit is very much in keeping. An adroit use of perspective (we look up into the architecture) augments the feeling that the scene is taking place within a space not of this earth, though related to it. The conception is very different from the normative, naturalistic spirit of earlier Flemish art, for it is proto-Baroque.

This visionary spirit, which marks such a strong break with the past, is characteristic of the art of the third decade in Flanders, the way having been paved by the cosmic visions of Bosch, the panoramic conceptions of Patinir, the psychological investigation of Metsys, and the "visionized" woodcuts of Dürer.

The Madonna and Child theme appears frequently in Gossart's art after the middle of the second decade. Developing from a modernization of Rogier's mode, the Virgin and Child become increasingly plastic and monumental; the Child is herculean and the Virgin large and rounded, with very curly hair as strongly lighted as the agitated folds of her drapery. The moving light over the forms is accompanied by a growing movement of the forms themselves, as in the Munich *Madonna and Child in a Niche*, of 1527, in which the Child reaches out toward the spectator and the mother reaches for the Child. Despite an overbearing sense of weight, the accentuation of detail and dynamic play of light and dark give a superb animation to the rich forms.

Richest of all is his *Danaë* (Fig. 581), of the same year in the same museum. Dressed in the deep-blue robe that normally clothes the Virgin, this young, beautiful, partially nude girl sits in an open, semicircular loggia, beyond which is a lightly painted fantasy of architectural forms, and looks up to the shower of gold falling from the vault. Rich, red-brown marble columns line the loggia and heighten the over-all feeling of warmth. Animated by the blue-red-gold contrast, the conception is truly hedonistic, though the blue robe seems to suggest that Gossart in designing this was, like a Neoplatonist, still sufficiently allied to the past to evoke the St. Barbara-Virgin correlation mentioned earlier in the discussion of the exterior of the *Ghent Altarpiece* and the Master of Flémalle's *Mérode Altarpiece*.

Gossart's abilities made him a superb portraitist. The earliest dated portrait, *Jan Carondelet* (Fig. 582), in the Louvre, of 1517, has a magnifi-

580. JAN GOSSART. *St. Luke Painting the Virgin. c.* 1525(?). Panel, 43 1/8 × 32 1/4″. Kunsthistorisches Museum, Vienna.

left: 581. JAN GOSSART. *Danaë.* 1527. Panel, 44 1/2 × 37 3/8″. Alte Pinakothek, Munich.

above: 582. JAN GOSSART. *Jan Carondelet Adoring the Virgin and Child.* 1517. Panel, 16 7/8 × 10 5/8″ (each). Louvre, Paris.

cent sense of underlying solidity and structure, which is revealed by a soft network of shade that gently modulates the illuminated details of the face and leaves it glowing with a silvery light, making the viewer aware of the personality of this reverent cleric. On the back of the right panel, the Virgin and Child, is a Vanitas still life of a skull in a niche.

Possibly in the mid-1520s Gossart painted the Berlin portrait called *Baudouin de Bourgogne* (Fig. 583). Its turbulent surfaces that catch the light are very different in manner from the smooth, relatively impassive surfaces of the international Manneristic portrait style. It does, however, possess a comparable clarity, and Gossart's stylistic approach allowed him to achieve the same sense of elegance by means of rich surfaces. He augmented the calmer manner of German and Italian practitioners of the style by a restrained excitement in the costume, over which the more simply and plastically rendered features were made to dominate. His later portraits became calmly monumental.

In the portrait, as in all that he touched, Gossart left a legacy that was large and influential.

above left: 583. JAN GOSSART. *Baudouin de Bourgogne(?).* c. 1525(?). Panel, 22 × 16 3/4″. Gemäldegalerie, Staatliche Museen, Berlin-Dahlem.

left: 584. JAN GOSSART. *Elderly Couple.* c. 1520–25. Parchment (or paper) on panel, 17 7/8 × 26 3/8″. National Gallery, London.

One of his finest is the *Elderly Couple* (Fig. 584), in London, probably dating in the early 1520s, a horizontal double portrait that presents both subjects revealed by light, yet subtly differentiated in surface quality. The old man is more dramatically rendered, but his wife is made equally important by the superb setting of her firm features against the white headdress. A monumentalization of the particular, with light and shade as the motive agent, the portrait recreates the active man and the passive woman, he looking up, she looking down. Value contrasts are strong in the man, weaker in the woman. The subtle differentiation of the individuals is the result of a long tradition, through which Flemish portraiture of the 16th century made its greatest artistic triumphs, building on the past by often uniting Flemish observation with monumentality and frequently with psychological penetration. In this, as well as other fields, Gossart was a leader of enormous stature.

JOOS VAN CLEVE

A large number of artists were working in Antwerp in the early decades of the 16th century, for art flourished there to a far greater extent than before. Evidence survives not only in guild records but also in the vast number of works preserved despite the wholesale destruction during the iconoclastic riots of 1566. Numerous minor masters are known, such as Colijn de Coter, already mentioned as an archaizing Rogier follower, of which movement he is the most notable. There was a Rogierian survival as well as an Eyckian revival.

An artist of higher quality was Joos van Cleve (or Van Cleef), really Joos van der Beke, from Cleves in the lower Rhine region.[2] Formerly known as the Master of the Death of Mary, from two paintings of this subject of 1515 in Cologne (Fig. 585) and Munich, he was one of the most productive masters, and probably the most eclectic, of his period. His works show almost every trend of the epoch, and his paintings have often been attributed to many of the major masters. Active in Antwerp by 1511, he was dean of the guild in 1515 and 1525 and died there between 1540 and 1541.

One of the painters trained in the older manner of Flemish art, like Metsys, whose manner also influenced him, Joos aided its transformation into a modern style. He is thought to have received his training under Jan Joest of Calcar (who also influenced the Master of Frankfurt and Barthel Bruyn of Cologne, and who died in Haarlem in 1519), with whom he may have worked between 1505 and 1508 on the altar for St. Nicholas, in Calcar. Dürer also inspired Joos's work, and the Vienna *Holy Family* shows that he stood to Dürer in Antwerp as Hans von Kulmbach did in Nuremberg.

According to Van Mander, Joos van Cleve collaborated with Patinir, and a possible result of that collaboration is the Brussels *Rest on the Flight into Egypt* (Fig. 586), once attributed to Patinir. It is notable for the central composition and the wicker picnic basket left of center in the foreground, both taken from Gerard David.

Guicciardini recorded that Francis I invited Joos to paint portraits of the monarch at the French court, where he worked after 1530 and where he assimilated some Leonardesque aspects. A typical example of his excellent portraiture is the Hampton Court *Eleanor of France* (replica in Vienna).

A *Madonna and Child* in Kansas City reflects the influence of Gossart in its curly-haired Virgin

585. JOOS VAN CLEVE. *Death of Mary*. 1515. Panel, 25 5/8 × 49 5/8". Wallraf - Richartz - Museum, Cologne.

433

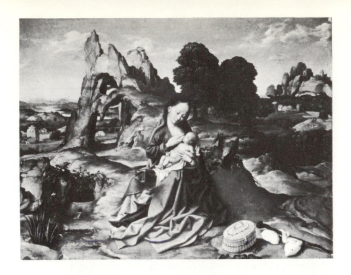

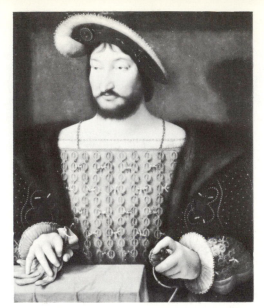

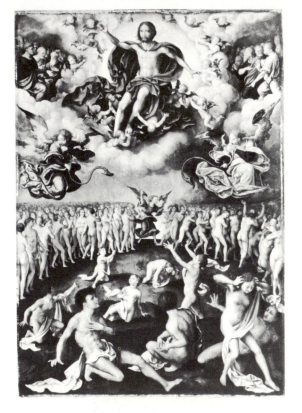

and heroic nude Child. Joos's variety of styles is a symptom of the search for the new way that was sought by many in the early years of the new century. A *Lucretia* in Vienna shows a manner influenced by Metsys in basic conception and in detail, as may be seen in the atmospheric effect around the eyes, in the floating diaphanous veil, and in the broken color of the sleeves. His detailed rendering of garment minutiae, combined with the large and generalized conception of the figure, relates to the contemporary portrait mode; here, too, detail—as in the fur and

cloth—was contrasted with delicate modeling and strong linearity of the body form.

Another aspect of his art appears in the New York *Last Judgment* (Fig. 587), of the 1520s, in which the theme has undergone a classicizing influence apparent in the *putti,* in the figure types, and in the figure of Christ, whose Raphaelesque pose brings to mind the arrival of Raphael's cartoons in 1517 in Brussels.

In portraiture Joos's ability is further demonstrated by the excellence in design, color, and characterization of his *Young Man in a Red Hat* (Philadelphia), against a blue-green background, painted in the early 1520s. A Berlin portrait of a young aristocrat adheres to the mode of the international Manneristic portrait style in its dark background and in its sharp treatment of lights and darks on the crisp surfaces of the crimson sleeves. As in other Flemish portraits, the face is atmospherically presented, rather than flattened under a general light. A soft, almost Leonardesque chiaroscuro dominates his portrait of *Francis I* (Fig. 588), in Philadelphia, painted after 1530. Joos's softer and more decorative adaptation of the newer ideas was well received; his

shop was large and its production extremely numerous.

Achieving their peak about 1520 was a group of artists, first distinguished by Friedländer, known as the Antwerp Mannerists, who were exponents of a style that was highly decorative in feeling as well as arbitrary in the combination of architectural motifs of Gothic and Renaissance type, usually depicted as ruins with inexplicable elongation of form and overornamentation of the surface. A whole group of works by unknown artists not confined to Antwerp adheres to these stylistic means of overexuberance and lack of restraint, with a tendency toward affectation and exaggeration. The style appeared as early as 1507. Friedländer divided the Antwerp Mannerists into groups according to their styles, the chief ones being the Pseudo-Blesius group (so-called from works once attributed to Herri met de Bles on the basis of a false signature), the group of Jan de Beer (master in Antwerp in 1504; died about 1535), that of the Master of the Von Groote Adoration, and that of the Master of 1518 (Jan van Dornicke). Elongation of form, modernization of older types in terms of the fantastic, exaggeration of manner, and especially the concentration on fanciful costumes with glittering appurtenances are characteristic stylistic features. The Adoration of the Magi and the Nativity at night were subjects with which the Antwerp Mannerists were particularly in sympathy and to which they added affected gestures and proportions that were often abnormal (Fig. 589).

The leading painter of Brussels, Bernard (Bernaert, Barend) van Orley, was influenced by the Mannerist spirit and by Gossart in his mature style. Born in Brussels in 1491–92, he was the son of Valentin van Orley, also a painter.[3] The family originally came from Luxembourg. Trained by his father (who moved to Antwerp in 1512), Bernard was associated with the court and was commissioned in 1515 to paint portraits of the six children of Philip the Handsome to be presented to the King of Denmark. This resulted in an appointment as court painter to the Regent Margaret in 1518. Two years after her death in 1530 he became court painter to her successor, Mary of Hungary.

Younger than Gossart, Van Orley paralleled in Brussels the adoption of Renaissance ideas in Gossart's work, though less effectively, for Bernard was basically an exuberant decorator. His art shows an enthusiastic adaptation of an Italy he apparently never visited, for his knowledge seems derived from engravings and from the Raphael cartoons he saw from 1517 on as supervisor of the tapestries made from them. His *Sts. Thomas and Matthew Altarpiece* of about 1512, in Vienna, shows a vigorous transformation of northern style under Italian influence, with a strong dependence at this time upon the tonality of Metsys. However, there is a greater sharpness in the delineation of form and a desire to create measured spatial intervals, even though they are not clearly realized.

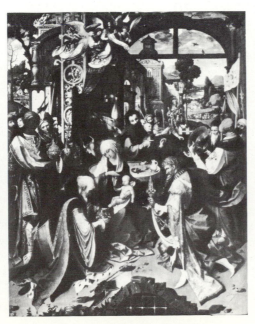

589. JAN DE BEER. *Adoration of the Magi Altarpiece. c.* 1520(?). Panel, 60 1/4 × 47 1/4" (center), 60 1/4 × 21 1/4 (each wing). Pinacoteca di Brera, Milan.

About 1516 he painted *Charles V* (in Budapest) in which the character of the Hapsburg jaw is emphasized (Fig. 590). The whole concept is stated in terms of late 15th-century portrayals, with an added tendency toward flatness of form. Seemingly Van Orley was not yet fully aware of the elegant fluid spirit of the international portrait style, though he was inclined to abstract, clarify, and reduce the spatial ambient by sharpening the contrast and the silhouette.

By the time of the *Virtue of Patience*, or *Job Altarpiece* (Fig. 591), of 1521, in Brussels, painted for Margaret of Austria, Manneristic overelaboration had appeared in his art. In attempting to create a flow of unified drama having the grandeur of Italian art, with perspective as an important element in the unification, he was hampered by his overconcentration upon the naturalistic details. As a result, in painting the dramatic moment of the central panel's theme, the Destruction of the Children of Job, he gave all the actions equal importance. Even the architectural decoration vies with the figural action, and too much goes on at once without subordination. The right wing, showing Job greeting his friends, and the landscape construction on the left wing, which shows the removal of Job's flock, are under Metsys's influence and are comparatively calm. Though the over-all conception lacks clarity, detail is well handled. The same is true of the outer wings, with the Parable of the Rich Man. The Raphaelesque nude rich man

served snakes in Hell by a pig-snouted demon inspired by Bosch, and the very naturalistic angular movement of the beggar Lazarus constitute an unconscious contrast of the two concepts that Van Orley attempted to reconcile.

His portrait of *Dr. Zelle* (Fig. 592), in Brussels, signed and dated 1519, shows Van Orley's great ability when he stayed within his tradition and capabilities. The large, fleshy face dominates its setting by the clarity of its forms and the concentration of the viewer's eye upon the lighter facial area at the apex of the body triangle, set parallel to the picture plane. The form in repose is monumentalized, but the book before the sitter and the shelf behind are set diagonally to vary the movement. Like Holbein's Giesze portrait (Pl. 28), the figure recalls Eyckian work, but the stability of form is greater than in the diagonally placed Holbein portrait.

The *Hanneton Triptych* of 1522, in Brussels, representing the Pietà (Fig. 593) in the central panel and the Hannetons, with their 12 children on the wings, males on the left wing and females on the right, seems to reflect Van Orley's contact with Albrecht Dürer, as well as the continuing influence of Raphael. Diagonal movement is employed to create emotive effects, as is the change in scale of the heads in the central panel, moving from a large John on the left to the two small heads in the upper right-hand corner. The gold background and the general organization reveal that Van Orley was intentionally paint-

left: 590. BERNARD VAN ORLEY. *Charles V. c.* 1516. Panel, 28 1/8 × 20 1/4″. Museum of Fine Arts, Budapest.

right: 591. BERNARD VAN ORLEY. Destruction of the Children of Job, *Job Altarpiece,* center. 1521. Panel, 69 1/4 × 72 1/2″. Musées Royaux des Beaux-Arts, Brussels.

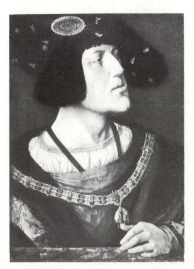

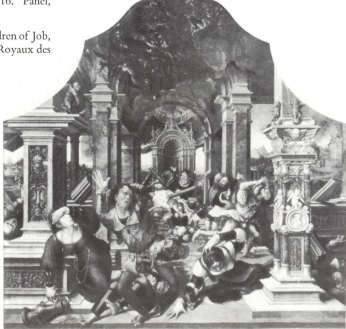

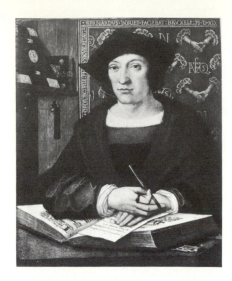

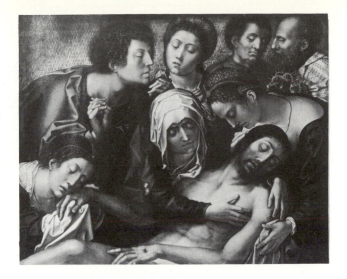

left: 592. BERNARD VAN ORLEY. *Dr. Zelle.* 1519. Panel, 15 3/8 × 12 5/8″. Musées Royaux des Beaux-Arts, Brussels.

right: 593. BERNARD VAN ORLEY. Pietà, *Hanneton Triptych,* center. 1522. Panel, 34 1/4 × 42 3/4″. Musées Royaux des Beaux-Arts, Brussels.

ing a modern version of Rogier's great work, the Escorial *Deposition* (Fig. 128). But Van Orley's work became overly plastic, *mouvementé,* and dramatic, lacking the highest integration.

His *Last Judgment Altarpiece* (Fig. 594), completed in 1525, in Antwerp, repeats the popular compositional type used by Joos van Cleve, Jan Provost, and others. The foreground is filled with male and female nudes intended to be heroic and idealized but in actuality mannered and verging on overexpressive sentimentality, and

the violently moving angels in the sky are witness to Van Orley's inherent tendency to overdramatize his scenes, also visible in the opposition of the serried ranks of nudes on the left to the Bosch-like Hell scene on the right. On the wings are representations in a finely painted and markedly naturalistic fashion of the Seven Works of Mercy, with forms tending toward the heroic. This desire to monumentalize the naturalistic leads to monumental genre painting in succeeding artists such as Van Hemessen.

Van Orley's late work was much in the field of tapestry and stained glass, including a series of tapestries of the *Hunts of Maximilian,* with fine landscapes, and stained-glass designs for Ste-Gudule, Brussels. His motto, "Elx syne tyt" ("One must be of one's time"), is unerringly apt.

594. BERNARD VAN ORLEY. *Last Judgment Altarpiece.* 1525. Panel, 8′ 1 5/8″ × 7′ 1 7/8″ (center), 8′ 1 5/8″ × 3′ 1″ (each wing). Musée Royal des Beaux-Arts, Antwerp (Property of the city hospitals).

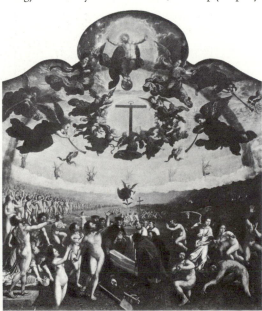
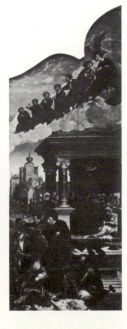

DUTCH MANNERISTS AND EARLY ROMANISTS:
Mostaert, Van Oostsanen, Engelbrechtsz., Lucas van Leyden, and Jan van Scorel

MOSTAERT, VAN OOSTSANEN, AND ENGELBRECHTSZ.

Dutch painters, always more distant from the Flemish tradition than their contemporaries to the south, developed their own provincial Mannerism and strongly advanced the trend of Romanism. The growing separation between Flemish and Dutch painting was partially due to the analytical spirit that fostered specialization in genre painting, landscape, and portraiture, but historical events also contributed toward the establishment of a Dutch entity. These events culminated in a declaration of national independence in 1581, though it was not until 1648 that recognition of that independence from Spanish domination became final. In the early 16th century, however, Flemish sway remained strong.

Jan Mostaert, like so many of his contemporaries, was a portraitist of ability, but he is also significant for his introduction into Haarlem of the sophisticated courtly style of the southern Netherlands.[1] Born in Haarlem about 1472 and traceable there as early as 1498, he was trained by Jacob Janszen, a contemporary of Geertgen. His contact with the courts came before 1519, when he was working for the Regent Margaret, in whose service he continued until at least 1521, for a Jehan Masturd appears in the court records for that year. However, his service must have been intermittent, because he served as dean of the Haarlem painters' guild in 1507, 1543, and

1544. In 1549 he left Haarlem for over a year to paint the high altar at Hoorn; he was last heard of in 1554.

Geertgen's manner dominated Mostaert's early period, which lasted until approximately 1515. Two early works are particularly close to Geertgen: one, the *Jesse Tree*, in Amsterdam, which has even been attributed recently to Geertgen himself; the second, a *Passion Triptych* in Brussels, whose central Deposition panel (Fig. 595) follows Rogier's famous work (Fig. 128), though the figures follow Geertgen. An *Adoration of the Magi* of 1515–20 in Amsterdam typifies his conservative bent; it is a modernized version of Geertgen's picture, but the figures are closer and more obviously parallel to the picture plane, and architectural details have been "Renaissanced."

His portraits include a dyspeptic male with a red beret, now in Berlin, painted before 1515 in a comparatively sharp linear style, with the figure set against a dark background; and a more ample, spacious *Portrait of a Man* (Fig. 596) of about 1515–20, in Brussels, which is more conservative than, for example, the works of Gossart. In the latter the figure is again set close to the picture plane, and the background (which contains the theme of Augustus and the Tiburtine sibyl) is divided into a space side and a volume side. This seems to have been one of his common devices, for a *Portrait of a Young Man* in Liverpool (with the theme of St. Hubert in the background) poses the figure in exactly the same

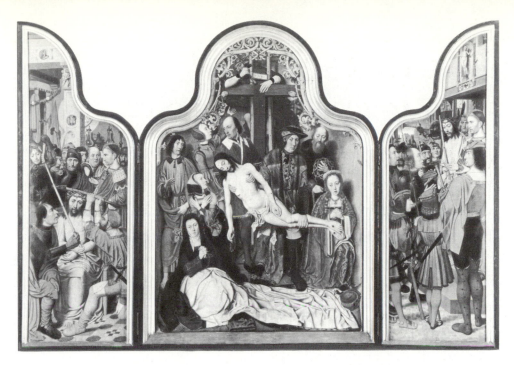

manner. In date it must be very close to the Brussels portrait. In both these portraits and the *Portrait of a Lady*, in Amsterdam, of 1525–30, a simple dignity is united with an effective, quiet organization of evenly lighted forms. In the feminine portrait St. Hubert's conversion is again seen in the background. The landscape is a large, rocky hill, which approximates the shape of the woman's beautiful white coif and seems an adaptation of a Patinir motif for portrait purposes; the lighter and warmer color of finely

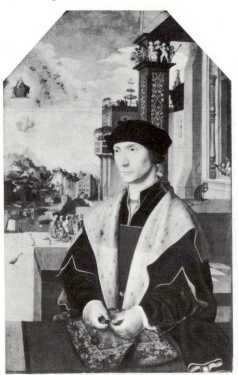

rendered face and coif are brought forward to dominate the expansive greenish prospect behind it. Essentially calm and conservative in outlook, Mostaert refined the older manner and conceded to the new principally in his backgrounds.

A number of artists in Holland exemplify the provincial Mannerism that developed locally, with occasional fresh infusions of the more sophisticated art from the southern Netherlands. Jacob Cornelisz. van Oostsanen was one of these. Born at Oostsan in 1470, he died in Amsterdam in 1533. A portraitist and designer for woodcuts, he was the first important artist of Amsterdam. In 1500 he is recorded as owning a house there; between 1507 and 1523 he was regularly employed in woodcutting; he also illustrated books published in Amsterdam by Daen Pietersz. In 1518 he made a painting for the church of St. Lawrence in Alkmaar, in 1522 another in the church at Hoorn, and in 1527 another for the abbey church at Egmont. Though strongly influenced by Dürer in his many woodcut designs, his later work shows Renaissance influences.

Van Oostsanen's *Crucifixion*, Amsterdam, is in the Geertgen tradition. The whole conception

439

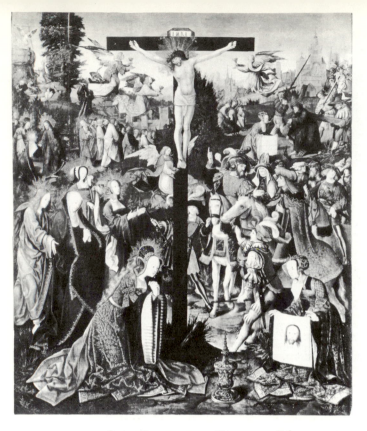

597. JACOB CORNELISZ. VAN OOSTSANEN. *Calvary. c.* 1510. Panel, 41 × 34⁵/₈″. Rijksmuseum, Amsterdam.

is a pastiche of older tradition, in which he denied deep space, as in much late 15th-century Dutch painting, by bringing his figures close to the foreground to fill it and prevent the eye from moving into the background, simultaneously dramatizing the light and dark contrasts over the surface. The strong actions of the

598. CORNELIS ENGELBRECHTSZ. *Crucifixion. c.* 1520–25. Panel, 24¹/₄ × 35¹/₄″. The Metropolitan Museum of Art, New York (Gift of Coudert Brothers).

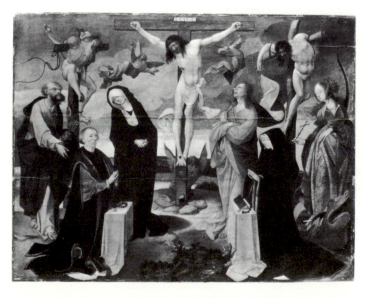

figures contribute to the sense of an active, crowded surface with types comparable to those in Geertgen's *Man of Sorrows* (Fig. 204).

Also in Amsterdam, his *Calvary* (Fig. 597) of about 1510, immerses the figures in space and multiplies them so extensively (in a way reminiscent of Dürer's *Martyrdom of the Ten Thousand,* Fig. 448) that the whole is lost in the manifold forms. A fantastic character intrudes in the costuming of his overly elegant, overly soft-featured figures, whose heads are reduced versions of Geertgen's larger spheroid forms. The insertion of other scenes from the Passion into a flattened background only serve to heighten surface movement. In detail the painting is highly successful, with a rich, fluid, colored chiaroscuro and rich draperies. The over-all effect, however, is close to that Manneristic spirit seen elsewhere, and the artist's fascination with the bonnets of the women is almost a mania.

Another Dutch painter of the late-Gothic Manneristic bent was Cornelis Engelbrechtsz. According to Van Mander he was born in 1468 and died at Leyden in 1533. Recent research has suggested that he was trained under that late Rogier follower of Brussels, Colijn de Coter. Cornelis was active in Leyden, according to the guild lists, from 1499 to 1522. He trained three sons to be painters, Pieter Cornelisz. (Kunst), Cornelis Cornelisz., and Lucas Cornelisz., and two other pupils are known, Aertgen van Leyden and, the most famous of all, Lucas van Leyden, who seemingly influenced his master.

Cornelis Engelbrechtsz.'s style parallels that seen in Jacob Cornelisz. van Oostsanen, with a comparable ornateness, complexity, and crowding of composition, handled with liveliness and skill in representing detail. This agitated spirit and richness of surface ornamentation appears in his Leyden *Crucifixion,* in which the dramatic gestures, the gaze, and the open mouths are used to heighten the emotional effect. Influence from Metsys is also evident. The *Feeding of the Ten Thousand,* in Berlin, is a fit subject for the concepts of the period, allowing the artist to show vast crowds in movement in the pictorial space.

His *Constantine and St. Helen* (Pl. 30, after p. 308), Munich, in which Helen looks much younger than her son, is almost an epitome of the mannered style, with a sense of continuous movement and elegant figure proportions. The bonneted figure of St. Helen, with long arms, long body,

narrow shoulders, slender legs, and a swelling stomach, presents the thoroughly mannered figure type also evident in Italy, but the reedy aspect is richly colored by the northern painter in the broken color mode first introduced by Metsys. Logical space is denied and flattened by the surface accentuation, and dramatic content is imposed upon the forms without regard to the theme or the action of the figures.

Occasionally, however, the drama is related to the theme, as in the *Crucifixion* (Fig. 598), in New York. A sustained agitation affects this work of the early 1520s. St. Peter is at the left, St. Margaret at the right, and the Virgin and John stand beneath the Cross, but the donors seem very much out of place as they calmly kneel in front of the strong action behind them. The very plain, almost ugly figure of John, gazing with well-drawn face upturned to the figure of Christ, contrasts strongly with the elegant garb and curving movement of St. Margaret to the right. Drama is further heightened by the contorted movements of the thieves; even the figure of Christ is not calm, the torso being strongly curved to the right, but this is again a surface agitation, for the forms do not move in space. In contrast to Grünewald's movement in the round, these figures move in a re-

stricted planar area that is cut off from the background. Like Van Oostsanen, Engelbrechtsz. reveals the attraction of emotive, mannered expression for artists of the northern Netherlands.

LUCAS VAN LEYDEN

Lucas van Leyden,[2] according to Vasari, was an even better artist than Albrecht Dürer, an opinion that Van Mander was pleased to add to his life of Lucas. Born in Leyden possibly in 1489 (Van Mander gives the date of 1494), Lucas died there in 1533. He studied first with his father, Hugo Jacobsz., who apparently also died early, and then entered the shop of Cornelis Engelbrechtsz.

A youthful prodigy, he was soon working independently; his earliest dated work is an engraving of *Mohammed and the Monk Sergius* (Fig. 599), of 1508. The inspiration of Dürer is obvious, but it is also evident that Lucas van Leyden was an extremely able engraver. The work was much admired, and Marcantonio Raimondi used the setting for a background to his engraving of Michelangelo's soldiers from the cartoon of the Battle of Cascina. Lucas created in a more atmospheric fashion than Dürer, with larger amounts of gray tonalities, and his line is less sharp and wiry. His basic conception was more painterly, in that he used softer tones, shadows that merge with one another, and a rich, carefully restricted tonality to give his works vitality. He achieved a full and masterful handling of the medium at an early age, with a fine sense of perspective and a balancing of forms by tonal oppositions.

His engraving of 1510 of *Adam and Eve* (Fig. 600), with Eve carrying Cain in her arms, was influenced by Dürer and Jacopo de' Barbari in its types, but Lucas created a fine contrast between the graceful Eve moving to the right in flowing garments and the skin-clad Adam with outthrust beard, shambling behind. Lucas's engraving method mixed northern and Italian techniques. The surface, particularly that of Adam's garment, is created out of a series of parallel diagonal lines in groups, with an occasional deepening of tones by other parallel line groups to create crosshatching. In other areas, especially in the tree, the engraved lines follow the contours in northern fashion. Thus his burin line sometimes defines the form and elsewhere

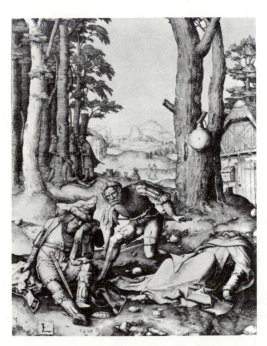

599. LUCAS VAN LEYDEN. *Mohammed and the Monk Sergius* (B. 126). 1508. Engraving, 11 3/8 × 8 1/2".

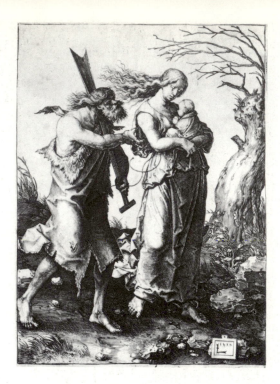

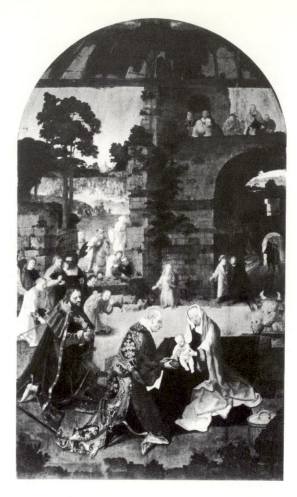

creates tonalities, performing two functions that were conceived as independent of one other.

Lucas's early work as a painter shows the attraction for him of Renaissance spatial amplitude and logic. His *Adoration of the Magi* (Fig. 601) in the Barnes Collection, Merion, Pennsylvania, is a very early work, whose basic organization reflects the Geertgen tradition but differs in its large and very deep stage space, in which comparatively small figures almost swim as they come to adore the Child. The interest in emphatic surface ornamentation that had governed his master was still strong enough to force its way through the counter spirit of the younger painter. Though restricted spatially because of this conflict of means, the work has a largeness and grandeur surpassing the art of his teacher.

Lucas's large engraved *Ecce Homo* of 1510 (Fig. 602), unites Dürer's art with an overlay of Italian construction, notably in the perspective of the buildings. The older type of Ecce Homo composition, in which the figure of Christ was placed at the left above the crowd before the platform, has been turned 90 degrees in space to occupy the focus of a large setting that incorporates some of the breadth and vastness of na-

above left: 600. LUCAS VAN LEYDEN. *Adam and Eve* (B. 11). 1510. Engraving, $6^3/_8 \times 4^3/_4''$.

above right: 601. LUCAS VAN LEYDEN. *Adoration of the Magi,* center. c. 1500–10. Panel, $30^1/_8 \times 17^3/_4''$. The Barnes Collection, Merion Station, Pa. (Copyright 1968 by The Barnes Foundation).

right: 602. LUCAS VAN LEYDEN. *Ecce Homo* (B. 71). 1510. Engraving, $11^1/_4 \times 17^3/_4''$.

right: 603. LUCAS VAN LEYDEN. *Lot and His Daughters. c.* 1509. Panel, 22⅞ × 13⅜″. Louvre, Paris.

ture. This recalls Schongauer's *Road to Calvary* (Fig. 388), whose background clouds seem to have reappeared here, for the same delicacy of tone characterizes the clouds and the background architecture, now contrasted with the accentuated values of the crowd before the platform. The superb unity Lucas achieved was to inspire Rembrandt's version of the theme.

A stronger drama soon appeared, as in the disputed *Adoration of the Magi,* in Chicago, in which the figures are arranged close to the picture plane. A low wall separates them from the traditional procession seen in the background as though through a large picture window. Gerard David is suggested in the softness of the second Magus, but the procession unites Renaissance splendor with the strange and foreign.

In pursuit of this enlarged dramatic content Lucas turned toward the fantastic, for *Lot and His Daughters* (Fig. 603), in the Louvre (of about 1509, if Friedländer is correct in his dating), seems to have grown out of Bosch's cosmic conceptions. Fire and brimstone fall on the unfortunate city of Sodom as it is engulfed by flood and earthquake. The space is deep, and the eye is carried into it by value and color contrasts and by the diagonal opposition of the foreground action at the left to the cataclysm at the right. Some survivors crossing the high wooden bridge in the middle ground serve to set the scale and magnify the terrible events in the background. The group seems almost Venetian in its poetic treatment, which is greatly at odds with the rest of the action. Lucas's magnificent, dramatic night lighting is a decade in advance of similar ideas in Germany. Such lighting and similar ideas from Bosch also appear in his signed and dated *Temptation of St. Anthony,* in Brussels, of 1511. Less interested in moralizing exegeses, he monumentalized Bosch's types, using his fluid *alla prima* technique and making the saint a lonely worshiper. A greater plasticity and stronger light reduce the horror of the demons.

What has been considered a new spirit is seen in the *Chess Players,* in Berlin, thought to date about 1510. Here is seemingly the self-sufficient genre scene, which, like the portrait, was becoming free from religious connections, as daily life now began to attain importance corresponding to the increasing independence of the individual. The theme, here presented with somewhat overly monumentalized half-length figures, appears in a similar work of possibly about 1514, in Wilton House, Salisbury, England, in which the chess players have been turned into gamblers; the forms are lighter in tone and are treated with greater emphasis upon the edge and strong light and dark patterning (Fig. 604). Another gambling scene, in Washington, was painted about 1520; its more plastic rendering, somewhat hard but with interesting reflected lights, accords with later developments in Lucas van Leyden's style. Still, these are not completely independent genre scenes, for in the mind of the times such themes carried moral overtones, as made explicit in Brant's *Narrenschiff,* Chapter 77, which was illustrated with a gambling scene of men and women together, as in Lucas's painting. What he has presented is a new version of disguised symbolism, which appears in the work of another Dutch painter of genre, Pieter Aertsen (or Aertszen).

becoming stronger in the use of line, silhouette, and flat plane than in structural color. His semi-idealized types are chunky, the foreground lute-playing angel possibly having been suggested by Venetian painting. The spatial conception has a new character: space for angels has been added before the traditional balustrade on which the Child is placed, and the upper limits of the scene seem to be spatially related to the garlands above the head of the Madonna, though they do not come out to the picture plane. The angel head to the left of the lute-playing angel occupies no clearly defined space and is comparable to like devices and figures in contemporary Manneristic painting. Such ambiguity may be a direct Italian influence, for it is paralleled in Antwerp painting. The use of black as a modeling element, particularly evident in the shading of the face of the lute-playing angel, may derive from Italian chiaroscuro methods, since it is at variance with the normal northern modeling in deeper tones of the same color.

This more violent manner is also seen in the *Annunciation* (Fig. 607) from the back of a Madonna and Child with Mary Magdalene and

above: 604. LUCAS VAN LEYDEN. *The Card Players.* c. 1514. Panel, 14 × 18″. Wilton House Collection, Salisbury, England (By permission of the Earl of Pembroke).

right: 605. LUCAS VAN LEYDEN. *Self-portrait.* c. 1525(?). Panel, 11 3/8 × 8 5/8″. Herzog Anton Ulrich-Museum, Brunswick.

below right: 606. LUCAS VAN LEYDEN. *Madonna and Child with Angels.* c. 1518. Panel, 29 1/8 × 17 3/8″. Gemäldegalerie, StaatlicheMuseen, Berlin-Dahlem.

The small *Self-portrait* in Brunswick has been variously dated[3]; when compared with the drawing of Lucas van Leyden, in Lille, that Dürer made in 1521, it shows an older man (Fig. 605); thus the date must be later in time. The tone is warm, with the face painted in tans and browns and topped by a black beret set against a red background. Lucas has accentuated the eye closest to the spectator and enlarged the other facial features nearest to view to create a sense of plasticity but not so strongly that the form loses its richness of painterly surface. Psychological aspects dominate as the painter seems to turn quizzically toward the viewer, looming out toward the pictorial surface.

The *Madonna and Child with Angels* (Fig. 606), in Berlin, of about 1518, appears to reflect Dürer's influence, but it is nevertheless the product of Lucas's own fully formed style, which was

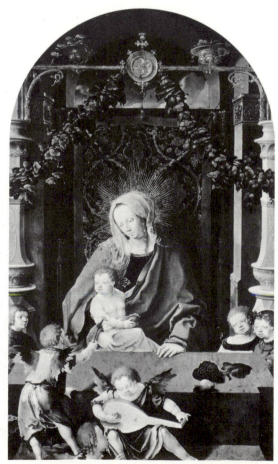

a donor, of 1522, in Munich. The angel clasps its hand to its throat to retain a garment seemingly being torn away by the little *putto* above, who vigorously tugs at the end of it. In the foreground scattered grape leaves have just been blown in by the same wind that has lifted the end of the garment into the *putto's* grasp. At any moment they will be blown away. With strong lights and darks and violent movement well expressed by the twisting, almost serpentine, scroll, the work is obviously not the quintessence of classical ideas. Forceful plasticity and ambiguity of setting characterize this Dutch expression of early Mannerism.

There is little stylistic change in the Amsterdam *Worship of the Golden Calf* (Fig. 608), of about 1525, but the subject is unusual for a triptych. Groups of roisterers in solid triangular construction fill the foreground, the foremost group showing inebriation and gluttony, while the theme that gives the work its title is relegated to the left middle ground. Farther back, Moses with the tablets of the Law descends from the mountain at the left. An unsystematic exposition of sin, the underlying conception seems to have

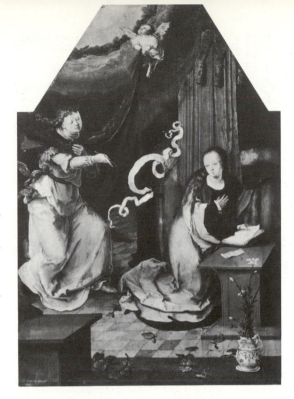

above: 607. LUCAS VAN LEYDEN. *Annunciation*. 1522. Panel, 16⅝ × 11½". Alte Pinakothek, Munich.

below: 608. LUCAS VAN LEYDEN. *Worship of the Golden Calf*. c. 1525. Panel, 36⅝ × 26⅜" (center), 35⅞ × 11¾" (each wing). Rijksmuseum, Amsterdam.

been inspired by the art of Bosch. The earlier gambling and card-playing scenes have been transformed into monumental genre scenes with specific and strongly moral overtones, Luxuria, for example, being clearly visible on the right wing. Thematically a moralizing drama dealing with the heresy of the worship of false gods, artistically the work is a drama of depth. Moving forms into space to create a dramatic situation,

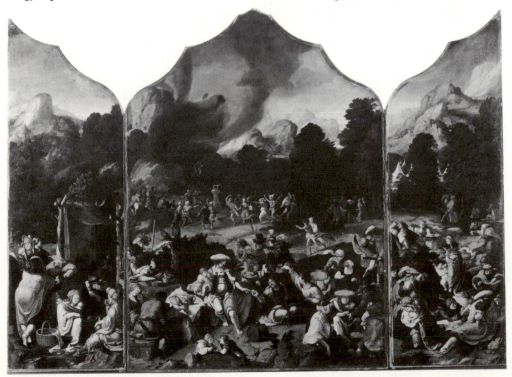

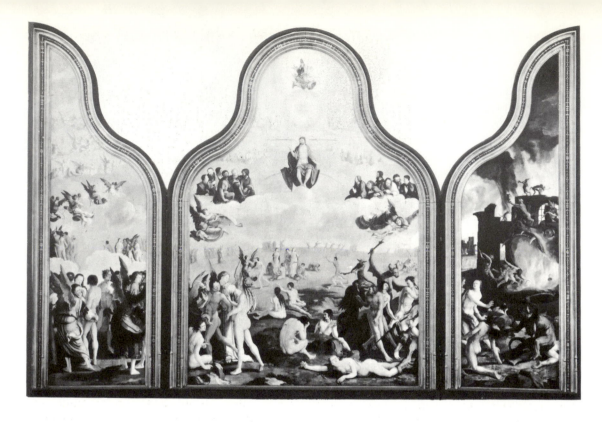

above: 609. LUCAS VAN LEYDEN. *Last Judgment.* 1526–27. Panel, 9′ 2 ³/₄″ × 6′ ⁷/₈″ (center), 9 ′2 ³/₄″ × 2′ 5 ⁷/₈″ (each wing). Stedelijk Museum "De Lakenhal," Leyden.

below: 610. LUCAS VAN LEYDEN. Sts. Peter and Paul, *Last Judgment,* detail of exterior.

Lucas carries the eye back to a landscape whose horizon is lower than any seen before and is a clear predecessor of the Baroque style.

In 1526–27 he painted his *Last Judgment* (Fig. 609), in Leyden, which is related to works such as those by Joos van Cleve and Bernard van Orley. Made for the church of St. Peter in Leyden, it shows the patron saint and St. Paul on the exterior of the wings. The work was painted as a memorial panel, rather than an altarpiece. Northern and Italian ideas are combined. The instinctive measuring of space by balancing forms to left and right suggests Italian art, while northern concepts appear in the Hell scene on the right, inspired by Bosch. Though the contrast between the classicizing nudes and the northern naturalistic devils is strong, both have a sense of weight and massive actuality. The facial types are further developed toward an acorn shape, with pointed chins and flattened heads, a type also seen in the patriarchs and apostles seated behind low clouds above and even in the central figure of Christ, recessed in space high in the sky. While strongly suggestive of the art of Signorelli at Orvieto of 1499–1504, Lucas's figures are more elongated than those of his Italian model or models. Perhaps, as in the case of Van Orley, the inspiration was Roman rather than Umbrian.

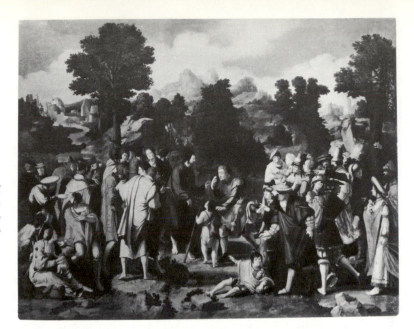

611. LUCAS VAN LEYDEN. *Healing of the Blind Man of Jericho*, center. 1531. Panel, transferred to canvas, 45 1/2 × 59 1/4". The Hermitage, Leningrad.

The sense of deep space recurs in the wing panels (Fig. 610). Sts. Peter and Paul are seated before distant landscapes organized on a modified brown-green-blue system different from that of Flanders. There is a warm foreground, and the brown-green middle ground is succeeded by a blue-green background broadly painted without vegetation but employing unified light and aerial perspective. Broader brushwork in the background contrasts with the more meticulously treated foreground lights and darks and costume details. The movement of the blowing hair of St. Peter is repeated in the leafless tree set deeper in space at his right. Dramatic content is further accentuated by the sinking ship shown behind St. Paul and the generally forbidding, rocky, distant landscape.

Lucas van Leyden's style developed in the direction of less careful over-all rendering of detail, as he sought larger and more dramatic effects with simpler planes of light and color. He was more and more interested in the subject of man in nature, an attitude shared with the other painters of his day, who, like himself, but less ably, depicted with increased frequency scenes of St. John preaching in the wilderness, St. John on Patmos, St. Jerome in the wilderness, or, in the early years of the century, St. Christopher. The quantity of such scenes still preserved is evidence of the change in the conception of man, who was inserted into nature in religious themes appropriate to such treatment. A continued development of spatial ideas is implied, because once the artist began to deal with man

in nature, he had to concern himself with nature not only as a backdrop but in relation to the whole expanse of natural form. This trend had taken a decisive turn in the art of Patinir, the outstanding practitioner in this development (though Bosch's role must not be minimized), who informed the landscape art of the northern painters with a greater spatial interest and sense of natural involvement. Lucas was the next genius of landscape art.

Van Mander relates that Lucas made a journey through the Netherlands when he was thirty-five, traveling in his own boat and giving banquets for Gossart and others of his colleagues in Middleburg, as well as in Ghent, Malines, and Antwerp, and that Gossart accompanied him after his visit to Middleburg. After the trip Lucas was in ill health, imagined that he had been poisoned, and took to his bed. Van Mander says that he lived six years more, most of them spent in bed, though he continued to work, making paintings, engravings, and probably also designs for stained glass. A number of such works are attributed to him by Van Mander.

In 1527 he took up landscape again in his painting of *Moses Striking the Rock*, in Boston. In 1531 he painted the *Healing of the Blind Man of Jericho*, now in Leningrad (Fig. 611), a work full of lively movement and certainly the finest of his landscapes. The freer construction developed in the previous decade is united with a greater spatial integration evolved from the interest in forms in space; the resultant composition is proto-Baroque. The figures are close to

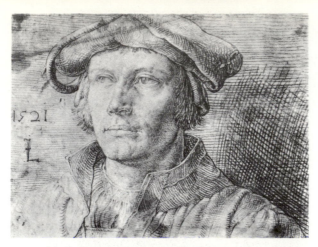

612. LUCAS VAN LEYDEN. *Head of a Man.* 1521. Drawing, 10 1/4 × 13 3/4″. Stedelijk Museum "De Lakenhal," Leyden.

the picture plane, and the semipyramidal shapes are made up of strongly lighted figures in idealized and contemporary costume arranged in parallel planes. The eye moves into depth down avenues opening into space, which are brought to our attention by light patches almost as intense as those on the foreground groups.

Most significant of all is the change from the high point of view with a high horizon to the lowered horizon line. It had been used earlier in the *Last Judgment,* but Lucas there had not fully realized its possibilities. Now a sense of continuity from foreground to background has been implied, for the perspective of human forms and landscape shapes conforms to the same eye point. Lucas's progress toward Baroque landscape construction, however, is still an intermediate step; it is as yet an implication, for the silhouetted tree masses are still treated in layers, which interrupt any continuous recession by being interposed as screens. We glance beyond them but are not visually transported behind them. Also, the middle ground is not yet a thoroughly integrated unit, despite the few figures inserted there to aid recession. However, by 1531 Lucas had gone far beyond Patinir and such Manneristic works as Jacob van Oostsanen's *Crucifixion* and his *Calvary,* in which the background scenes and figures are so strongly accentuated that the surface is a highly moving pictorial screen. Seemingly Lucas combined the northern intimate vignette with Raphaelesque conceptions to achieve an over-all grandeur. Continuous recession from foreground plane into a far-distant background, however, was not achieved for several generations, awaiting the flowering

of fully Baroque conceptions. Lucas van Leyden anticipated the heroic landscape of the later era, but his lead was not taken up by the northern landscape painters, who developed the intimate landscape, also leading to the Baroque.

Lucas van Leyden's abilities as a draftsman have been seen in his engravings, but portrait drawings have also been preserved. Such a drawing as the Leyden *Head of a Man* (Fig. 612), dated 1521, is more generalized than the traditional Flemish portrait. A simplification of the lights and a delicate tonality enhance the monumentality of the form, and the lighter tone of the face is ringed by the darker cap and clothing. The same fine quality is evident in the *Woman's Head,* in pen and ink, in the Louvre.

Like Dürer, Lucas van Leyden was an important creator, who, influenced in his beginnings by Dürer, the Italians, and Gossart, in return exerted an influence, particularly on Italy, through his 172 engravings. Interested in space and the drama of forms in space, he reached an outstanding position in the art of the Netherlands of the 16th century.

JAN VAN SCOREL

The most Romanist of all his generation was Jan van Scorel, who was born near Alkmaar on August 1, 1495, and died in Utrecht December 6 1562. Son of a priest (he was legitimized by Charles V in 1541), he took his name from the village of Schoorl, in which he was born.[4] About 1510 he was attending Latin school in Alkmaar, where Jan van Egmond, later burgomaster of Alkmaar, took an interest in him and sent him to study with Cornelis Buys, the brother, according to Van Mander, of Jacob van Oostsanen.

Cornelis Buys has been equated with the Master of Alkmaar, whose *Seven Acts of Mercy,* dated 1504, is now in the Rijksmuseum in Amsterdam (Fig. 613). Its direct style, with sharp characterization of natural forms and definite, yet soft cast shadow, is a typical late 15th-century, northern Netherlandish manner; distinct detailing and sharpness, a homely clarity and simplicity are revealed by a bright, even, over-all light that is in the Bouts tradition as transmitted by the Master of the Tiburtine Sibyl. Intimate scenes of daily life are created by individualizing objects sharply outlined against a

light background. The theme of the Seven Acts is developed by the appearance of Christ as both witness and inconspicuous member of the groups receiving the benefits of the works of mercy and charity.

Between 1516 and 1519 Cornelis Buys was recorded as a painter in Alkmaar, where he died before 1524. Van Buchel, a 17th-century chronicler, mentioned him as the teacher of Jan van Scorel, further stating that a votive panel for Jan van Egmond was begun by Buys and completed by Van Scorel. However, since there is no work that is indisputably by Buys, the identification of Buys and the Master of Alkmaar is still an assumption, and Van Scorel's connection is much too general for analysis.

Van Scorel may have gone to study about 1512 with Jacob van Oostsanen in Amsterdam, and possibly he went to Utrecht about 1517–18 to meet Gossart. In either 1518 or the following year he went to Venice by way of Basel and, undoubtedly, Nuremberg, where he may have worked in Dürer's shop. By the spring of 1520 he was in Venice, having left a work along the way, the *Holy Kinship Altarpiece* (Fig. 614) in the church at Obervellach in Austria. Something of both Buys and Jacob Cornelisz. seems evident in the rather wooden foreground groupings and in the costume of the figure at the extreme left. Though Van Scorel's work is more plastic and organic in its figural groupings, the background combines artistic ideas that are in part Germanic, as in the dramatically silhouetted Düreresque house behind the center, and in part Dutch, as in the softer atmospheric effect. A different lighting for the background creates the effect of intimacy associated with a small village and takes us back to the works attributed to Buys. Though technically different, the effect is similar. The wings show the influence of Metsys. Thus the result depicts that combination of influences sometimes found in a young artist.

Late in 1520 Van Scorel left Venice with a group of pilgrims for the Holy Land, where he stayed in the Franciscan monastery of Sion in

Jerusalem. He probably returned to Venice in 1521 to study its art, as the slightly later Amsterdam *Death of Cleopatra* (Fig. 615) clearly shows in its Giorgionesque treatment of figure and landscape (which also echoes Michelangelo).

In 1522 he went to Rome, where he was put in charge of the antique collections in the Bel-

above: 613. MASTER OF ALKMAAR. Feeding the hungry, *Seven Acts of Mercy.* 1504. Panel, 39³/₄ × 21¹/₄″. Rijksmuseum, Amsterdam.

right: 614. JAN VAN SCOREL. *Holy Kinship Altarpiece,* center. 1520. Panel, 44¹/₂ × 55¹/₂″. Church, Obervellach, Austria.

Having been made a canon of the church at Utrecht, Van Scorel returned to the Netherlands, going first to Alkmaar. Between 1527 and 1530 he was working for the city of Haarlem, making pictures. In 1528 he settled in Utrecht, where the next year he took Agatha van Schoonhoven, sister of a canon, as his mistress. They had six children. By 1550 he was famous enough to have been asked to go to Ghent with Lancelot Blondeel to restore the *Ghent Altarpiece*, and by 1551 he was prosperous enough to own three houses in Utrecht. He died in 1562. Two important pupils were trained under him, Antonio Moro and Maerten van Heemskerck (see Chap. 29), the latter during his Haarlem period.

Though Van Scorel was interested in the figure, he was a northerner and, as such, a painter of landscape. He, too, made important advances in the art. His 1527 *Entry of Christ into Jerusalem* (Fig. 616), in Utrecht, the central panel of a triptych for Herman van Lochorst, is divided by a diagonal moving from upper left to lower right. The movement forward into space is counterbalanced by the figures mounting the hill toward Christ, derived from Michelangelo's fresco of the Deluge, in the Sistine Chapel. In the distance an atmospheric, though somewhat topographical, landscape of Jerusalem attracts the eye by its linear design and lighter values. Unusual and unequaled in northern landscape painting, the *repoussoir* effect of the group around Christ is given scale by being silhouetted against the bird's-eye view beyond.

Van Scorel's *Baptism of Christ* (Fig. 617) in Haarlem, painted about 1528, surpasses Lucas

vedere, being appointed by the last non-Italian pope, the Hollander who came to the papacy on January 9, 1522, taking the name of Adrian VI. A simple, pious Dutch monk, who was no match for the worldly Italian court, Adrian VI appointed a number of his fellow countrymen to important positions, and Jan van Scorel was one of his appointees. When the Pope died on September 14, 1523, Giulio de' Medici became the next pope, Clement VII, and the Dutch appointees lost their positions.

top: 615. JAN VAN SCOREL. *Death of Cleopatra. c.* 1522. Panel, 14 1/8 × 24″. Rijksmuseum, Amsterdam.

above: 616. JAN VAN SCOREL. *Entry of Christ into Jerusalem.* 1527. Panel, 31 1/8 × 57 7/8″. Centraal Museum, Utrecht.

right: 617. JAN VAN SCOREL. *Baptism of Christ. c.* 1528. Panel, 47 1/2 × 61 5/8″. Frans Halsmuseum, Haarlem.

van Leyden in the creation of a proto-Baroque landscape, for its diagonal movements effect the gradual penetration into depth. The turning points are marked out by classicizing figures, which show careful study of Raphael, his illustrious predecessor in his Vatican post. As a source of motifs, however, Raphael shares with the antique. Individual figures, such as the man pulling his clothes over his head, are magnificently drawn and take their place in the masterful construction of forms in space. This conception shows that northern artists instinctively reached for a baroque expression and an integration of forms in nature. Compositionally it recalls such a work as Bouts's Gathering of the Manna scene (Fig. 169). Here the foreground and middle-ground lights are closely related, while beyond is seen a fine aerial perspective. *St. John the Baptist Preaching in the Wilderness*, in the Thurkow Collection, The Hague, of about the same date, is similar, though the sense of movement into depth is not so penetrating, for Van Scorel has screened off the background. Diagonal movement is again employed, the group at the right leading us deeper into space toward the figure of John the Baptist, thus creating a balance of close and distant forms.

At the same time Van Scorel was painting portraits with a high degree of artistic mastery that sets his work both in the Flemish tradition, yet distinct because of that mastery. The *Pilgrims to Jerusalem*, in Haarlem, of 1527–30, one of five similar paintings, shows the individuals lined up in a long row across the narrow, horizontal panel, each figure carrying a palm branch and each identified by his coat of arms. A group portrait, this is a descendant of Geertgen's portrayal of the knights of the Commandery of St. John and a predecessor of the secular guild portraits of Rembrandt, Hals, and other 17th-century painters. As a portrait group without a central motif, this work has little interest except in the heads, whose position has been varied to avoid monotony.

However, in making his portraits Van Scorel united northern light and color with his acquired feeling for the simplicity of Roman plasticity. An example from his Haarlem period is his *Portrait of a Man* (Fig. 618), in Amsterdam, which is stronger in value contrasts and silhouette than Gossart's Carondelet portrait, yet has not lost the sense of the individual. Though

left: 618. JAN VAN SCOREL. *Portrait of a Man. c.* 1527–29. Panel, 18 1/2 × 13 3/8″. Rijksmuseum, Amsterdam.

below: 619. JAN VAN SCOREL. *Mary Magdalene. c.* 1529. Panel, 26 3/8 × 30 1/8″. Rijksmuseum, Amsterdam.

the spatial chiaroscuro has been restricted to the figure, Van Scorel's greater plasticity of generalized surfaces, clarity, precision, and, above all, his psychological penetration have lent a new spirit to portraiture.

The greater psychological drama of the portrait style is found also in his religious painting. The *Mary Magdalene*, of about 1529, in Amsterdam (Fig. 619), sets the figure before a landscape in a manner that combines northern rock forms and reminiscences of Venetian organization with atmospheric lighting and proportions that are broader than high. This change of format allowed the painter to set his forms in a more ample space. The tree at the right and the rocks in the middle distance at the left are integrated with the figure as balancing elements in the design and serve to define space by their measured position and value. The richly dressed figure is

left: 620. JAN VAN SCOREL. *Rest on the Flight into Egypt.* c. 1530–32. Panel, 22 ³/₄ × 29 ¹/₂″. National Gallery of Art, Washington, D.C. (Samuel H. Kress Collection).

below: 621. JAN VAN SCOREL. *Presentation of Christ in the Temple.* c. 1530–35. Panel, 44 ⁷/₈ × 33 ¹/₂″. Kunsthistorisches Museum, Vienna.

evenly lighted and, as in a portrait, looks sidelong at the spectator.

Recession is achieved by opposing the generally warm tone of the figure to the landscape and the warm-colored tree to the cool, greenish distant rock form. The vitality of the glance and the sense of psychological awareness create a drama, aided by the moving, wayward locks of hair. This manner of treating hair was widely used by many northern painters pursuing dramatic motifs to animate their figures.

Of about 1530–32 is the *Rest on the Flight into Egypt* (Fig. 620), in Washington, a type thoroughly characteristic of Van Scorel's conceptions. Splendor of color and largeness of form characterize the foreground figures, the Child ex-

emplifying a type that Van Scorel developed from a Raphaelesque model. As in the *Mary Magdalene*, the figures are set before a landscape, here seen at the right as from a height and animated in the middle distance by a figure in wind-blown garments derived from Raphael's *Incendio del Borgo*. Other motifs are borrowed from antique Roman painting. The large size of the softly illuminated Madonna and Child, placed slightly above eye level, and the extreme smallness of the figure in the middle ground reveal an underlying sympathy with Manneristic expression. The forcing of the scale change recalls a similar device in the contemporaneous *Madonna dal Collo Lungo* by Parmigianino, and the elongated body of Van Scorel's Child emphasizes the difference in spatial position.

About 1530–35 he painted the *Presentation of Christ in the Temple* (Fig. 621), in Vienna. Its Roman architecture in the style of Bramante, crowded closely about the figures, makes one feel that this is a northernized Raphael. It is softly sculpturesque, less wiry than Italian work, and more fluid in light, color, and form. The un-Italian emphasis on architecture and space is the mark of Jan van Scorel's basic northern temperament and characteristic of his unique blend of the two streams of European art.

Jan van Scorel's Romanism was different from that of Gossart, whose art was close to the frenetic drama of the Antwerp Mannerists. Gossart's almost tortured style contrasts with Van Scorel's more complete assimilation of the rational clarity and humanizing balance of the Venetian and Roman High Renaissance. Though there also are evident Manneristic elements in Van Scorel, his Mannerism built strongly on Raphael, whereas Gossart's Mannerism was far more northern in its basis. Thus Van Scorel brought the northern Netherlands to the fore in the creation of new stylistic influences. Built upon the conceptions of Italy, the graceful, balanced Van Scorel style subdued the overvirile agitations of the native Manneristic movement.

THE NEXT GENERATION OF ROMANISTS FOLLOWED Van Scorel in their preference for a more balanced, less violent style. They fructified their art by extended journeys to Italy. Even more Roman than Van Scorel, Maerten van Heemskerck,[1] whose early work is characteristic of the general style of the early 1520s, was born at Heemskerck in 1498 but came under Van Scorel's influence in Haarlem. Like his master he also went to Rome for several years to absorb the spirit of the Renaissance at its source.

First a pupil of Cornelis Willemsz. in Haarlem, then of Jan Lucasz. in Delft, he worked under Van Scorel in Haarlem and Utrecht between 1527 and 1529. Afterward he opened his shop in Haarlem; then, in 1532, he set out for Italy.

His works before his Italian trip reveal the strength of Van Scorel's influence, as in the *Anne Codde* portrait in Amsterdam, of 1529, sometimes attributed to Van Scorel himself. Its clarity and simplicity show a breadth of artistic understanding that does honor to both master and pupil. Heemskerck's *Family Portrait* (Fig. 622), of about 1530, in Kassel, was also formerly attributed to Van Scorel, particularly because of the nude child in its mother's arms, which is close to Van Scorel's child in the *Madonna with Wild Roses*, Dr. Ernest Schwarz Collection, New York. This heroic, Italianate Raphaelesque type had appeared frequently in Van Scorel's work, but it seems out of place in this vigorously natural portrait group, with the other two playful and fully clothed children

and the variety of objects on the well-set, cloth-covered table.

These objects constitute a symbolic still life of Eucharistic significance, and their portrayal anticipates a comparable development to take place later in Italy. Though highly suggestive of the later still-life painting of Caravaggio, this manifestation has a purely northern stylistic source. It grew out of a style like that of the Master of Alkmaar, for the still life, though different in subject matter, presents the same limpidity and clarity of bright light, the same localized, soft cast shadow, and the same careful delineation of detail. Here is further evidence of the

622. MAERTEN VAN HEEMSKERCK. *Family Portrait. c.* 1530. Panel, $46^1/_2 \times 55^1/_8''$. Staatliche Kunstsammlungen, Kassel.

continuity within the northern development of the natural object as expressive of the inner spiritual state. And it is this which makes explicable and explicit the resemblance of the child in its mother's arms to the type employed for the Christ Child. The concealment of the symbolic import is characteristically Manneristic.[2]

Before Heemskerck left for Rome in 1532 he made the impressive *Portrait of His Father*, now in New York. Superficially recalling Metsys, but also Van Scorel in the generalized surfaces, it goes beyond them in filling the space with the large head and hat. The limits of the picture frame are almost disregarded, for the emphatically plastic head well-nigh transcends them. Also, strong shading and the emphasis on the large eyes show a psychological accentuation.

In this same year Maerten van Heemskerck completed his *St. Luke Painting the Virgin* (Fig. 623), in the Frans Halsmuseum in Haarlem, in which similar ideas of lighting are employed but with a greater drama provided by the use of eerie torchlight.[3] The saint is seated on what might be an antique sarcophagus. This, with other classical elements—the mask above the easel and the Bacchic figure looking in admiration over his shoulder—probably symbolize the antique world which had prepared the way for the New Dispensation. The relief of the saint on the end of the sarcophagus, seated on his bull symbol like Europa in a Rape of Europa, is probably an intentionally veiled, inverted reference to the virginity of Mary. On the left, the Virgin and Child, illuminated by a torch-bearing, classicizing angel symbolic of the New Light, are seated on a dais. Like the saint, the sacred figures are placed above eye level, and we look up to them. Set against an indeterminate background, the classicizing drapery and types, the sarcophagus, the mask, and the glasses on the saint's nose are sharply painted with typical northern mastery. The program endows the scene with a disguised symbolism under the influence of Manneristic ideas.

Heemskerck stayed in Rome for four years, drawing the local scene (his sketches have been invaluable for architectural history and the history of the rebuilding of St. Peter's), and deriving inspiration from the remains of the past.

He returned home in 1536 and between 1538 and 1543 is recorded as making an altarpiece for the church of St. Lawrence in Alkmaar, now at Linköping, Sweden. In 1540 he became dean of the guild in Haarlem and married for the first time. In 1546, his first wife having died, he married again. In that year he also contracted to paint the wings of an altarpiece for St. Bavo in Haarlem, with an Adoration of the Magi and an Adoration of the Shepherds, both now in The Hague. Made church architect of St. Bavo

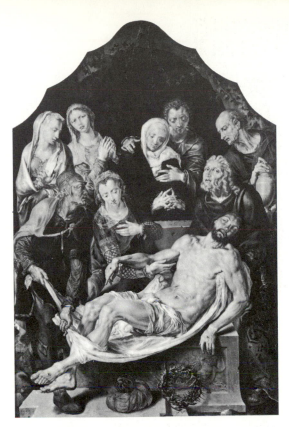

625. MAERTEN VAN HEEMSKERCK. *Entombment Triptych*, center. 1559–60. Panel, 86⅝ × 58⅝" (center). Musées Royaux des Beaux-Arts, Brussels.

in 1553, he continued to practice his craft in that city and bought a house in 1555. When the Spanish laid siege to Haarlem in 1572, he went to Amsterdam, returning to Haarlem the following year. He died in 1574.

He was one of the first Netherlanders to paint chiefly on canvas, and many of his works were engraved. His 1553 *Self-portrait* in the Fitzwilliam Museum, Cambridge, England, is a Manneristic half-length portrait, with the figure close to the picture plane, like a close-up photograph, almost filling the left side; to the right is a view into the Colosseum (Fig. 624). The whole is strongly theatrical in character, with different lightings for the figure and the background. His *Entombment Triptych* (Fig. 625), of 1559–60, in Brussels, with large figures of Isaiah and Jeremiah on the wings with the donors, carries this theatricality a step further, anticipating Baroque developments in the dramatic lighting and forceful contrasts, as well as in the tendency toward violent emotional reactions. An insistent plasticity, with compacted forms surging about the strongly illuminated body of Christ, creates a new feeling, which was to be fully developed

in the art of Rubens and other Baroque painters —pathos. The greater body of his work, however, is strongly Romanist in character, following Van Scorel's lead but colder in color.

Pieter Coecke van Aelst (born at Alost in 1502), like Heemskerck a second-generation Romanist but of conservative bent as compared with his Dutch contemporaries, was a pupil of Van Orley, probably after 1517.[4] After his training he made a trip to Italy. He was back in the Netherlands before 1527, when, according to the records of the painter's guild, he settled in Antwerp. In 1533 he went to Constantinople on an unsuccessful mission to obtain a commission for a Brussels tapestry works. In the following year he wrote a book on the Turks that appeared in French and English editions. In 1535 he may have taken part in the conquest of Tunis by Charles V, whose court painter he had become about 1534. On his return he took up his various activities of painter, sculptor, architect, decorator, and designer of tapestry and stained glass. Also about this time he married Maeyken Verhulst of Malines (his first wife had died in 1527), who bore him the daughter who became the wife of Coecke's most famous pupil, Pieter Bruegel. In 1541 he received a pension from the city of Antwerp for his tapestry work. He may have moved to Brussels in 1544; he died there six years later, in 1550. His interests were Humanistic, as demonstrated by the fact that from 1539 he translated and published in Flemish, French, and German the works of Serlio and Vitruvius (condensed), books which strongly affected Netherlandish architecture.

Though he probably began his career in the shop of his father-in-law, Jan van Dornicke, the Antwerp Mannerist master, Coecke was a typical Romanist of the second wave, revealing numerous Italianizing elements in the details of his paintings and in his desire to construct rational space. Nevertheless, indigenous qualities appear in his dramatic movement, which suggests a chastened Van Orley, and in his attempt to create space by silhouetted layers.

His *Last Supper* (with over forty versions: Belvoir Castle, 1527; Liège, 1530; Brussels, 1531, Fig. 626; etc.), while renewing Eucharistic symbolism, follows older conceptions by placing Judas on the spectator's side of the table. However, the influence of Leonardo's famous model of the same scene can also be seen, seem-

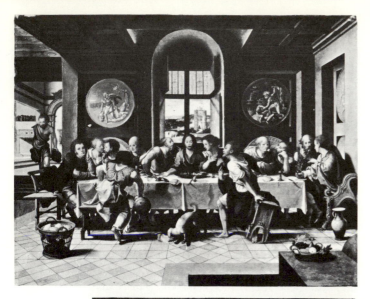

top: 626. PIETER COECKE. *Last Supper.* 1531. Panel, 25 × 32¼″. Musées Royaux des Beaux-Arts, Brussels.

above: 627. PIETER COECKE. Detail from the series, *The Manners and Customs of the Turks (Mœurs et fachons de faire de Turcz).* Published 1553. Woodcut, 1′ 5⅜″ × 15′.

ingly combined with Joos van Cleve's Paris version of about 1524. In the manifold activities of Coecke's apostles Leonardo's version is somewhat disturbed. To compensate Coecke placed another figure on Judas's side of the table, creating a spatial triangle leading to Christ. He also classicized the architectural setting. But the landscape view outside the window claims too much attention, and the vault above Christ's head is too high to suggest a halo; Van Orleyan violence is not entirely eliminated.

The highly dramatized conceptions so widespread in northern Europe late in the second and early in the third decade of the 16th century began to subside in intensity, particularly in the Neth-

erlands, when direct contact with Rome and the Renaissance outlook came about. Coecke's journey to Rome, with its relation to the High Renaissance of Raphael, resulted in a calmer assimilation of southern art.

The journey to Constantinople resulted in a printed roll made from ten woodcuts divided into seven compartments, dealing with the life of the Turks, published by his widow in 1553. One of these (Fig. 627), a view of Turks on a hill at the feast of the new moon, presents a vast background landscape influenced in method by Dürer; the pyramid of land occupied by the Turks in the center of the foreground is an element derived from northern landscapes. The type leads from Patinir to the "two-hole" landscape, strongly favored later, in which eye movements into depth are permitted on either side of a central mass. The combination of Netherlandish and Düreresque forms produced a spatial breadth that surely appealed to Coecke's contemporaries as much as the Turkish costumes and manners he portrayed.

In Liège, Lambert Lombard (1506–66) was the leading Romanist. Close in character to Coecke, he was both a painter and an architect.[5] From Liège, where he was a pupil of Jean Demeuse, he went to study under Arnold de Beer in Antwerp and later with Gossart at Middleburg. He was a protegé of Bishop Evrard de la Marck. He, too, made the journey to Rome, leaving in 1537 and returning to Liège the following year. His chief work is the altarpiece for the high altar of St-Denis, Liège, of about 1540, now dismembered (two panels in Liège, one in St-Denis itself, and one in Brussels), which shows a strong influence of Italian art and the Raphael school, indicating that he must have spent much of his stay in Rome studying in the Raphael *stanze* in the Vatican, particularly in the Sala di Costantino. In the scenes of the life of St. Denis there is an ardent repetition of the architectural settings and costuming of the Raphael school, which were not too well assimilated. Actions are awkward and architecture is too studied.

Far finer is his *Self-portrait* (Fig. 628), of about 1566, in Liège, looking rather fiercely at the spectator, with the bulky figure silhouetted against a light, indeterminate background. Recently this has been thought not to be a self-portrait but a work by a pupil, possibly Frans Floris. Bulk is actually suggested by outline

628. LAMBERT LOMBARD(?). *Self-portrait*(?). *c.* 1566. Panel, 30 1/4 × 25 1/4″. Musée de l'Art Wallon, Liège.

rather than by modeling, and space is suggested adroitly by the perspective of the hand at the right side of the composition. Though works by Lambert Lombard were engraved by Hieronymus Cock between 1554 and 1568, his greatest importance lies in the pupils he trained, three being illustrious: Frans Floris, Willem Key, and Hubert Goltzius.

THE FANTASTIC, GENRE, AND LANDSCAPE

Romanism, without doubt the dominant expression of 16th-century Flanders, by no means swept the field, for two movements continued to challenge its supremacy. Like Romanism, they had made their appearance early in the century. One of these was the fantastic genre strain, which had two parts. The first part, in terms of the period of its origins, was the following of Bosch; the second was the continuation of Metsys's version of genre motifs.[6] The second movement was concerned with landscape, in which Patinir's mode was followed by almost all.[7]

The earliest Bosch follower was the documented but artistically shadowy Jan Wellens de Cock (in 1503 master in Antwerp, dean of the guild in 1520, died in 1526), whose sons Hieronymus (*c.* 1507–70) and Matthys (*c.* 1509–48) are also important, particularly the former. Hie-

ronymus Cock established an engraving shop in Antwerp "At the Sign of the Four Winds," which after 1546 until about 1570 was the leading such shop in the Netherlands; for it Pieter Bruegel created many of his finest engravings.

There are no preserved paintings by Hieronymus Cock, but numerous works have been accredited to Pieter Huys (Antwerp, 1519–84), who became a master in 1545 and entered Cock's shop in the same year. His earliest dated work, a *Temptation of St. Anthony* (Fig. 629), now in the Louvre, is of 1547. Building motif by motif on the art of Bosch, Huys may justly be called a "faiseur de diableries," for his combinations of fantastic motifs were put together solely for their evocative effect. In time his early heavy-handedness was replaced by a more fluid organization and style.

Jan Mandyn from Haarlem (1502–c. 1560), who was in Antwerp by 1530, at which time he had two pupils, Gillis Mostaert and Bartholomew Spranger, was a more fluid painter than Huys but also a follower of Bosch. An initialed work, a *Temptation of St. Anthony* (Fig. 630), in the Halsmuseum in Haarlem, forms the basis for other attributions to him. Mandyn was less fantastic and more decorative in his combinations, which he rendered with typical warm-brown tones relieved by cool blues and blue-greens.

The second branch of fantastic genre, stemming from Metsys, was headed by Marinus van Reymerswaele, or Roymerswael (also Marinus Claeszoon), from Romerswaele on the island of Walcheren, where he was born about 1497. He was recorded in Antwerp in 1509 as the pupil of a glass painter; his dated works cover the

629. PIETER HUYS. *Temptation of St. Anthony.* 1547. Panel, 28 × 13″. Louvre, Paris.

above: 630. JAN MANDYN. *Temptation of St. Anthony*. 1547. Panel, 24 1/4 × 32 7/8". Frans Halsmuseum, Haarlem.

above: 631. MARINUS VAN REYMERSWAELE. *St. Jerome*. 1521. Panel, 29 1/2 × 39 3/4". Prado, Madrid.

below: 632. JAN VAN HEMESSEN. *Prodigal Son*. 1536. Panel, 55 1/8 × 78". Musées Royaux des Beaux-Arts, Brussels.

years between 1521 and 1542. In 1567 he was condemned at Middleburg to walk in a penitential procession and was then banished from the city for six years because of his participation in the destruction of a church the previous August. Where and when he died is unknown.

A ferocious intensity characterizes his repeated versions of a few close-to-life-size, half-length compositions, some probably derived from Metsys: the *Money Changer and His Wife* (four versions); the *Calling of Matthew* (two versions); *Two Misers*, in the Prado; the *Tax Collectors* (best variant in London); and the *Madonna and Nursing Child* (versions in the Prado and in Munich). Undoubtedly inspired by Dürer was the *St. Jerome*, of which the earliest dated version of 1521 is in the Prado (Fig. 631), of a preserved total of about eleven. The *Tax Collectors* may be a copy after Jan van Eyck transmitted by Metsys.

In all Reymerswaele's works there is a sharp and wayward quality of line that can only be characterized as aggressive. Verging on caricature, the figures grimace, turn their heads violently, thrust out expressive hands, with well-spread, sharply pointed fingers. Giving large, plastic forms soft surfaces, Marinus was close to Gossart in stylistic means, but to Metsys in figure types.

A second adherent to this mode, Jan Sanders van Hemessen, who came from a town near Antwerp, was enrolled as an apprentice in 1519 and became a master in 1524 and dean of the guild in 1548. In 1551 he sold his possessions and moved to Haarlem, where he died about 1563–64. Van Hemessen particularly was attracted to genre subjects, representing religious scenes acted out by large, astonishingly monumental, often half-length figures seen in detail under strong light and close to the picture plane. Typical themes were the *Prodigal Son* (Brussels, signed and dated 1536, Fig. 632), *St. Jerome* (numerous versions), and the *Calling of Matthew* (Munich example dated 1536, two later versions in Vienna). A variety of religious painting by Van Hemessen has been preserved. The works show an Italianizing contact in some of his figure types intermingled with his heroic peasants.

A variant outlook within the genre movement is found in the brilliant still-life painting of Pieter Aertsen,[8] who was born in Amsterdam in 1508 and died there in 1575. A pupil of Allart Claesz., he became a member of the Antwerp guild in 1535 and held an official position in it in 1542,

right: 633. PIETER AERTSEN. *Still Life (The Butcher's Shop).* 1551. Panel, 48⅜ × 65¾". Uppsala University Collection.

the year he married Kathelijn Beuckelaer, the aunt of his pupil Joachim Beuckelaer. He finally left Antwerp and in 1563 was listed as a citizen of Amsterdam, where he spent the remainder of his life. His earliest dated work is an *Old Peasant Woman*, of 1543, in Lille. An altarpiece in Antwerp is dated 1546, but most of his religious paintings were destroyed by the iconoclasts, as Van Mander related.

In 1551 he painted a *Still Life* known as *The Butcher's Shop* (Fig. 633), now in the Uppsala University Collection. The subject is actually the Flight into Egypt, but that scene has been relegated to a small area seen through the framework of a well-stocked butcher's shop. What is seemingly a still life of monumentalized meats close to the viewer— bright in color and handled with great painterly verve as well as excellent drawing—is in fact a Manneristic inversion of a religious scene. Objects of no intrinsic importance from the religious standpoint have become artistically the most important.

At the same time it may be noted that the items on the counter imply a symbol of Christ in the motif of the fish on a platter, with the two fish forming a cross, and that this motif is suggestively placed in relation to the religious theme of the Flight into Egypt. The meaning becomes even more clear as one proceeds to the distant scene at the right, which is seemingly an allusion to the Crucifixion, with an animal carcass suspended as if from the cross in the presence of two male and two female witnesses. The Flight, which was a flight from massacre, and the Crucifixion were thus set against the powerful realistic impact of the butchered animals.

Still life as an art form has been found in the disguised symbolism of objects in Netherlandish painting of the early 15th century, for example in the art of the Master of Flémalle and Jan van Eyck. In the later 15th and the early 16th century still life was augmented by the Vanitas theme, frequently with a skull, as on the back of Gossart's Carondelet diptych of 1517. In Van Reymerswaele's paintings a revived disguised symbolism appears, though he also painted scenes with nonreligious genre motifs, as had David earlier. Heemskerck's Kassel *Family Portrait* re-

below: 634. PIETER AERTSEN. *Peasant Interior.* 1556. Panel, 56 × 78". Musée Mayer van den Bergh, Antwerp.

veals a disguised symbolism, and the same thing appeared in Italy, where it became an intellectual exercise with Humanistic subject matter. Pieter Aertsen, like Heemskerck, transformed the naturalistic, nonreligious Netherlandish genre motif into a scene of disguised symbolism, but with Manneristic intent he emphasized the disguise. As a result of his inverted accentuation a large step in the development of the still life as a self-sufficient art form was made.

The Uppsala painting is a "two-hole" composition, with the abundance of nature agglomeratively presented. Aertsen painted other examples of this type, all of them with a high horizon, which allowed him to spread out the varied products that cram their surfaces. The *Peasant Interior* (Fig. 634) of 1556, in the Musée Mayer van den Bergh, Antwerp, presents a vari-

ant idea: A drunken figure looks with befuddled expectancy into the mouth of an open, empty jug; he is depicted with a fine observation of inebriation in the slightly closed eyes and raised brow. Mussel shells are scattered about the floor like rose petals. It may be that Aertsen conceived the painting as a pictorial treatise against gluttony (the boy at the left wears a Carnival crown), with overtones of the theme of the Prodigal Son. There is a moral, but now it must be sought for, like the arcane subject matter of some Italian Manneristic paintings.

The *Egg Dance* (Fig. 635), in Amsterdam, of 1557, shows a floor strewn with eggs, leeks, a snail, and other objects, over which a man is dancing; beyond him, in the upper right-hand corner, a young boy is entering the scene, his mother leaning over him and his father behind her. On discovering the idealized character of these three figures—in contrast to the naturalistic peasant types in the main action—one realizes that this is by implication the Holy Family. Again there is a veiled allusion, but the gaunt "type" with the bagpipes, the instrument often played by demons in 15th-century manuscripts, seems to characterize the scene as possessing an underlying evil symbolic of the world the youthful Christ Child is to enter.

A specifically religious scene without inversion is the *Christ in the House of Mary and Martha* in Brussels, of 1559, where the still-life objects are, like the figures, crowded about the picture plane. Still life and genre without inversion also appear in *The Cook* (Fig. 636), of 1559 in Brussels. This monumental cook before a classically ornamented fireplace is the least descriptive of Aertsen's portrayals, so that one suspects an underlying sardonic note concerning modality.

His pupil Joachim Beuckelaer (1530–35 to 1575–78) continued Aertsen's style but was more linear, as in his *Egg Woman* in Antwerp, of 1565, which lacks the monumentality of his master. This is also evident in his *Christ in the House of Mary and Martha* in Brussels, also of 1565.

In landscape painting the influence of Patinir fell on all the Flemish painters in this genre, such as Herri met de Bles, Cornelis Metsys, the Master of the Female Half-lengths, Lucas Gassel, and others. Their work acted as a bridge between the landscape art of the early years of the century and the landscapes of Bruegel. Chief of these was Herri met de Bles, apparently the nephew of Patinir, born at Bouvignes about 1510. He has been considered to be the Herry Patenir who became a master in Antwerp in 1535 and traveled in Italy, where he was known as Herri of Dinant (Bouvignes is close to Dinant) and nick-

named *Civetta* (little owl) because of the small owl that Van Mander tells us he used to hide in his paintings. His best-known picture is *The Copper Mine* (Fig. 637), in the Uffizi, where it has been exhibited ever since 1603. A row of trees divides the foreground activity from a background more grandiose, more complex, and more numerous in details than is visible in the art of Patinir. It is also more atmospheric in its rendering of the overly fantastic distant view. The greater multiplicity, however, is well suited to the various mining activities in the foreground. The mines are visible at the right, the flotation of the mineral is seen in the center, and the forge is being worked at the left. Such manifold action can be found in other landscapists of the second quarter of the century in Flanders who, like Bles, reduce the human scale to exaggerate the immensity of the visual world. Parallels to this tendency can be seen in the paintings of the Brunswick Monogrammist, who may be Jan van Amstel, and in Germany it has been remarked in the late work of Wolf Huber. This suggests that it is another aspect of the proto-Baroque spirit seen before in Dutch landscape painting.

THE PORTRAIT

The various genres of painting were so well defined in the north that Anthonis Mor van Dashorst, more familiar under his Spanish name, Antonio Moro, is known today chiefly for portraiture. There were other Flemish portraitists, including Pieter Pourbus, Willem Key, pupil of Lombard, and the unknown Master of the Forties, but Moro is most outstanding. He created images attuned to his times by combining the psychological drama of a Metsys, Romanist monumentality, and northern detail. More than all his contemporaries he achieved a cultivated formalism, dignity, and seriousness of outlook.

Born in Utrecht about 1517, he was trained by Van Scorel, as is clearly shown in his earliest work, a 1544 portrait of two pilgrims, Cornelis Horn and Antonis Taets, now in Amsterdam. Moro organized it into a profile and a three-quarter view and added a greater bulk and an increased softness to his master's model. Moving to Antwerp about 1545, he became a master in the guild in 1547, and two years later was painting in Brussels.

Among other works executed there, he did the 1549 Vienna portrait of *Antoine Perrenot de Granvelle* (Fig. 638), then bishop of Arras but later a cardinal and important in Netherlands political life. Moro was already a fully formed portraitist and already influenced by Titian (whose portraits of Charles V and Granvelle's father were then visible in Brussels). Since Moro did not go to Italy until the following year, 1550, there can be little question that Granvelle held up the Italian master as a model to be emulated in his own portrait. The elongated elegance of the darkly dressed figure, rather calmly lighted and set against a plain background, is furthered by a reserve in expression and in tonality, the latter particularly affected by Titian's style.

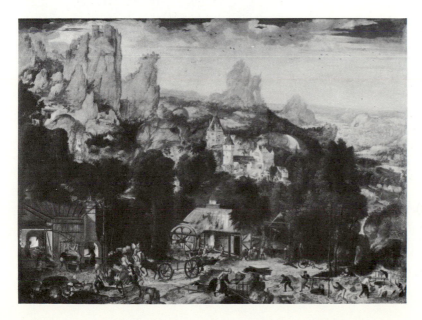

637. HERRI MET DE BLES. *The Copper Mine.* Panel, $32\,^5/_8 \times 44\,^7/_8''$. Uffizi, Florence.

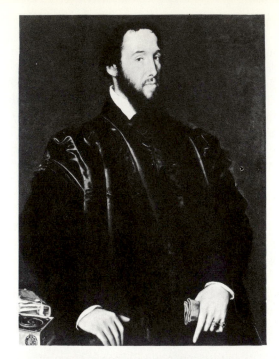

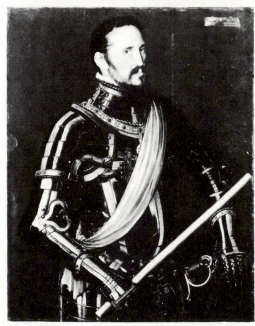

right: 638. ANTHONIS MOR. *Antoine Perrenot de Granvelle, Bishop of Arras*. 1549. Panel, 42 1/8 × 32 1/4". Kunsthistorisches Museum, Vienna.

below: 639. ANTHONIS MOR. *Fernando Alvarez de Toledo, Third Duke of Alba*. 1549. Panel, 42 1/2 × 32 7/8". The Hispanic Society of America, New York.

What distinguishes Moro's style is the accentuation of drapery detail and other surfaces in keeping with northern tradition. Even the simplified lighting and impassivity of the features are not due to Titian's influence; in the monumental isolation of the figure there is visible a formalism that has been partially seen in Holbein's portraits of a decade earlier and a reserve expressive of the age.

This quality is stronger in the portrait of *Fernando Alvarez de Toledo, Third Duke of Alba* (Fig. 639), in the Hispanic Society, New York, also painted in 1549. Equally simplified in light, color, and background (like that of the Granvelle portrait the background is bare of accessories), the portrait is again presented in a three-quarter pose. However, the comparative geniality of the Granvelle portrait has been replaced by a psychological drama. Its basis lies in the contrast between the almost gauche angularity of pose—as though the armor controls the man—and the impassivity of the face, out of which the eye in light, almost in the center of the head, stares fixedly at the spectator to create a drama of the spirit. Drama is furthered by an almost Eyckian rendering of the armor. Restraint has become constraint, and reserve has become isolation in a Manneristic outcome of the union of northern naturalism and Italian generalization.

The Alba portrait and others like it by Moro differ from earlier northern portraits; they seem perfect expressions of the rigid formality of etiquette and ritual inherited from the Burgundian court in which Charles V had been raised. Passed on to his son, Philip II, the court tradition was to become both more austere and more grandiose. Since Moro's style was so suited to the courtly attitude, it is no wonder that Mary of Hungary called him to Lisbon in 1551 to paint members of the royal family there. Thus he had only a year in Rome.

In 1552 he was summoned to Madrid to paint more princely portraits, and late in 1553 or early in 1554 he was sent to England to paint his famous portrait of Philip II's betrothed, Mary Tudor, then in her forties.

Like that of the Duke of Alba, this portrait of *Mary Tudor* (Fig. 640), now in the Prado, creates its drama by contrasts. Less somber than the Alba portrait, it is comparable in its solemnity and surpasses it in its sense of psychological drama. Mary Tudor looks directly at the spectator, her severe face evenly lighted. Holding the carnation of betrothal in one hand and gloves in the other, she sits bolt upright in a richly or-

namented dress that suggests an intentional variation of style on the part of Moro to accord with the prevailing English portrait mode established by Holbein. The vigorous treatment of detail and hands, though avoiding Holbein's linearism, and the sketching-in of a setting for the figure are only slightly at variance with Moro's previous portrayals. His basic combination of northern detail in costume, generalization of features of the immobile figure, and restraint in tonalities is still present.

Less formal is his *Self-portrait* (Fig. 641), of 1558, in the Uffizi, probably painted in Brussels, where Moro had returned after his journey to England. (Except for a brief trip to Spain with Philip II in 1559, he preferred to remain in the Netherlands, though he moved from Utrecht to Antwerp eight years before his death in 1576.) The effect of his own portrait is softer; the lighted eye is again in the center of the head, but the painter used the light area of his painted canvas to ameliorate any harshness. One may conclude that Moro approached each subject freshly. The sense of the sitter's position in life is never in doubt, and the sense of his distinct individuality never questioned.

In the hands of Moro the essentially Manneristic Netherlandish portrait manner probed the limits established by the new codes of decorum governing the court of his patron, Philip II; in the hands of such a painter as Pieter Pourbus, working in Bruges, it became cold and frigid; in the hands of Jean Clouet, in France, the style was transformed to comply with French preferences for elegance, airlessness, and patterned sophistication.

Jean, or Janet, Clouet was active in France before 1516. He may have been the son of a Michel Clouet, Simon Marmion's nephew, known to have been working in Valenciennes, or the son of a Brussels painter, Jan Clouet. There is no question, however, that his style was formed in Flanders, for the Flemish manner dominates his famous portrayal of *Francis I* (Fig. 642), in the Louvre, painted about 1525. The work is close to Gossart, though quieter,

like Joos van Cleve, in the treatment of body and garment, but from the neck up there is a concession to the French portrait style. This style is visible in the single certified painting by Clouet's predecessor as chief court painter, Jean Perréal. Perréal's portrait of *Louis XII* (Fig. 643), in Windsor Castle, painted about a decade earlier, is a disappointing work, considering his contemporary fame. It lacks the sensitivity of such a painter as the Master of Moulins, being much in the tradition of Fouquet's linearism. To

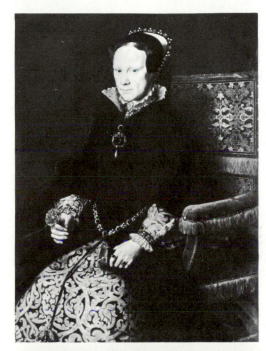

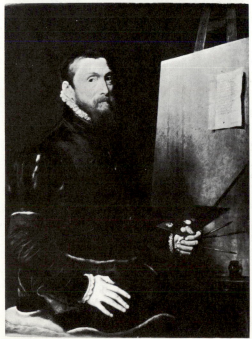

above: 640. ANTHONIS MOR. *Mary Tudor, Queen of England.* 1554. Panel, 42 $^7/_8$ × 33″. Prado, Madrid.

right: 641. ANTHONIS MOR. *Self-portrait.* 1558. Panel, 44 $^1/_2$ × 34 $^1/_4$″. Uffizi, Florence.

below: 642. JEAN CLOUET. *Francis I of France. c.* 1525. Panel, 37³/₄ × 29¹/₈". Louvre, Paris.

right: 643. JEAN PERRÉAL. *Louis XII of France. c.* 1515. Panel, 12 × 9". Copyright H. M. the Queen, Windsor Castle, England.

below right: 644. JEAN CLOUET. *Admiral Bonnivet.* 1516. Drawing, 9⁷/₈ × 7⁵/₈". Musée Condé, Chantilly.

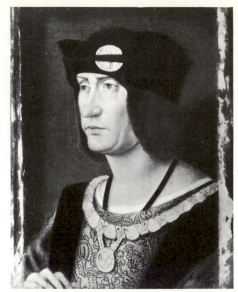

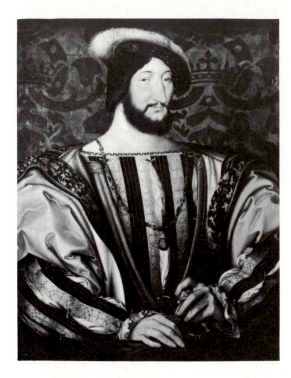

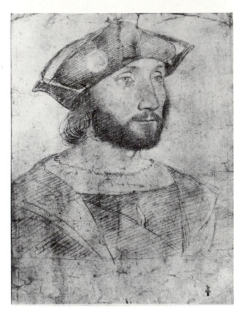

this tradition Clouet bowed in treating the head of Francis I. The close-patterned background and the linear rendering of the features contrast with the far more luxuriant character of the supporting garment. One feels in the head a strong concession to the manner of colored chalk (or crayon) drawing in red, white, and black so popular then and later in France.

In time the portrait drawing in chalk became recognized as a medium in its own right, and about one hundred thirty examples are attributed to Jean Clouet, most of them in Chantilly (Fig. 644). Though Clouet is recorded as having painted altarpieces at Tours, these have disappeared. In addition to the rather patterned chalk drawings, with their delicate, Italianate diagonal shading (possibly learned from Leonardo), at most eight oil portraits and nine miniatures are certainly from his hand.

That his art was transformed to accord with French style is again evident in his New York portrait of the French Humanist *Guillaume Budé* (Fig. 645), of about 1535. Cool, thin, and restrained, close to monochrome, it reflects the drawings so closely that volume is almost absent in the stress on patterned silhouette. An earlier phase of this development away from the robust, more colorful Netherlandish portrait style is visible in an attributed equestrian portrait of *Francis I* (Fig. 646) in the Uffizi, in which horse and rider are equally calm and restrained.

Jean Clouet was made a court painter in 1516, the year of Francis I's accession, and, though never naturalized, he became the chief court

painter in 1523, a position he held until his death in 1540 or 1541.

During this period more and more Italian artists were brought to France. Charles VIII, after his expedition to Naples in 1496, had brought home 22 Italian artists, and Francis I imported others. His greatest success was in attracting Leonardo, who died at Amboise in 1519. Though Francis could not entice Andrea del Sarto to stay longer than a year, about 1530 he commissioned Rosso Fiorentino and then Primaticcio to decorate his enlarged palace at Fontainebleau with mythological scenes.

On the other hand, the monarch's love for Italian art, which created the Fontainebleau school, did not blind him to the abilities of Jean Clouet, whose eventual position as chief court painter is witness to the supremacy of the northern portrait style. When we recall that shortly after 1530 Joos van Cleve was called to France to paint portraits, it is clear that in France, as well as south of the Alps, modal conceptions were operative.

François Clouet, also called Janet, born at Tours and active by 1536, succeeded his father as chief court painter and maintained that position under Henry II, Francis II, and Charles IX until his death in 1572. His tenure is again ample witness to modal thinking, for he continued his father's style and enriched it with a stronger chiaroscuro than is visible in the Budé portrait.

Two signed paintings from his hand show that François Clouet adopted the conventions of the international portrait style as it may be seen in the work of the Behams in Germany and Bronzino in Italy. One of these two works (Fig. 647) is a portrait of the apothecary *Pierre Quthe*, or Cutte, of 1562, in the Louvre. Slightly sharper than the German and Italian portraits and more resilient in line, Clouet's work shows a distinct silhouetting of flattened form against a slightly warm background. The whole is quiet, impassive, and restrained but animated by the

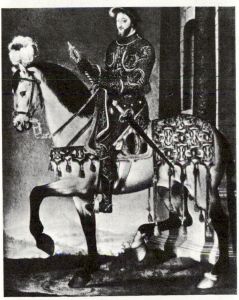

top: 645. JEAN CLOUET. *Guillaume Budé. c.* 1535. Panel, 15 5/8 × 13 1/2″. The Metropolitan Museum of Art, New York (Maria Dewitt Jessup Fund).

center: 646. JEAN CLOUET(?). *Francis I on Horseback. c.* 1525–30. Panel, 10 7/8 × 8 7/8″. Uffizi, Florence.

bottom: 647. FRANÇOIS CLOUET. *Pierre Quthe.* 1562. Panel, 35 7/8 × 27 1/2″. Louvre, Paris.

648. FRANÇOIS CLOUET. *Lady in Her Bath* ("Diane de Poitiers"). *c.* 1550. Panel, 36¼ × 32″. National Gallery of Art, Washington, D.C. (Samuel H. Kress Collection).

play of values in hand and herbal. The other signed work is the *Lady in Her Bath* ("Diane de Poitiers") in Washington (Fig. 648), possibly painted about 1550. The lady whose name is dubiously attached to the portrait was the mistress of Henry II; she has also been connected with the Fontainebleau-school painting of *Diana the Huntress*, in the Louvre. (The latter, however, is thoroughly Italianate in conception and form, with no northern characteristics.)

Clouet's painting shows an interesting combination: except for the nude body (derived from the now lost undraped version of Leonardo's *Mona Lisa*), the elements suggest Flemish connections—the child beside her, reaching for the fruit, recalls Heemskerck's Kassel *Family Portrait*; the nursemaid, the room interior beyond, and the background scene suggest contemporary Flemish interiors as depicted by Pieter Aertsen and others. What is distinctly different, however, is the almost Gothic linearity that accentuates the long nose and the face, in a further reflection of the French chalk style of drawing. Like many another Manneristic work, the scene is as obscure in meaning as the character of the setting, with its close, curtained space and the contrasting hole into depth.

François Clouet's skill, praised by contemporary poets in typical Renaissance fashion, was

also directed to the crayon portrait, in continuation of the direction established by his father.

This direction was also taken by another Netherlander, Corneille de Lyon, who established himself in France and who also conformed to the French mode of the portrait, though he made a distinctive contribution of his own. Coming from The Hague sometime before 1534, when he is traceable in Lyon, he had by 1541 become court painter to the Dauphin, later Henry II, but he was not naturalized until 1547. He remained in Lyon until his death about 1574. Corneille introduced a new mode of portraiture which was much imitated, so much so that authentication of his work is extremely difficult. He created small, bust-length figures almost like enlarged miniatures. Thinly painted with transparent colors, the courtly figures are usually set against a light-green background shaded to simulate a frame. His work is undated, but his early portraits show a distinct Netherlandish aspect close to the work of painters such as Joos van Cleve. His figures, with emphasis on the head, are softly treated, fluid and serene in feeling, according well with contemporary French taste for the refined, elegant, and delicate, as in his *Clément Marot* (Fig. 649), in the Louvre.

Thus the native and the transplanted Netherlanders demonstrate the force of the Flemish naturalistic tradition, even when the outlook and taste of the times demanded modifications. The changes visible in the work of the portraitists are essentially variations upon the basic theme of pictorial naturalism, manifesting a conformity equally applicable in the other genres.

649. CORNEILLE DE LYON. *Clément Marot*. Panel, 4¾ × 4″. Louvre, Paris.

TRANSPLANTED MANNERISM

The other side of the 16th-century coin was Romanism, with its exaltation of the monumentalized ideal. The undisputed leader of later Romanism was Frans Floris, who was born in Antwerp in 1516 and died there in 1570. Immediately after Lombard's return to Liège Floris, in his turn, went to Rome, where he remained for two years. During that period he must have copied Michelangelo's *Last Judgment*, whose types appear in his paintings, for he exchanged the Raphaelesque models of his teacher for the more dramatic models of Tintoretto and Michelangelo, whom he undoubtedly met. In 1540 he became a guild member in Antwerp, but not until seven years later is there a dated work from his hands. He was married in this same year of 1547. He counted William of Orange among his many patrons and made numerous decorations for the entry of Philip II into Antwerp in 1549 and again in 1556. In 1563 he bought a sumptuous house, whose façade he frescoed. In his later years he had numerous pupils, for his forceful Roman style was much admired by his contemporaries, and his was the leading shop.

His most famous work, the *Fall of the Rebel Angels* (Fig. 650), in Antwerp, of 1554, clearly reveals the influence of Michelangelo, with strongly Manneristic overtones in the crowded forms. Active, violent, and dramatic movement is evident, with only a slight suggestion in the angels of Raphael's *St. Michael and the Dragon*. The demonic figures, however, follow Michelangelo's model, except that their extremities are animal. Highly plasticized, the figures crowd close to the picture plane in a tempestuous and impressive display of magnificent body structure. Unfortunately, the rich, sumptuous color of his Flemish predecessors has been superseded, not only in Floris but in many other painters of his generation, by a restrained and less sensuous color. In many respects, but not all, Floris was an Italian working in the north, so purely had Italian elements been transmitted to the northern milieu. This is particularly visible in the *Fall of the Rebel Angels* and in the *Feast of the Sea Gods*, in Stockholm, of 1561. The latter does not differ much from what was going on in Italy at the time, except for certain elements of naturalistic detail which intrude into the idealized setting and the idealized forms. In Floris's Vienna

top: 650. FRANS FLORIS. *Fall of the Rebel Angels.* 1554. Panel, 10′ 1 1/4″ × 7′ 2 5/8″. Musée Royal des Beaux-Arts, Antwerp.

above: 651. FRANS FLORIS. *Last Judgment.* 1565. Canvas, 64 1/2 × 87 1/8″. Kunsthistorisches Museum, Vienna.

Last Judgment (Fig. 651), of 1565, southern Manneristic elements are so strong that the half-figure in undefined space at the lower left immediately suggests the art of Tintoretto and others. The huge demonic figure forcing a large and powerful man down into Hell before our eyes is another Manneristic device, for the bottom of the

left: 652. FRANS FLORIS. *Falconer's Wife.* 1558. Panel, 42 1/8 × 32 5/8". Musée des Beaux-Arts, Caen.

the face, to which the eye is led by the design of the portrait.

Other painters became equally Italianate and Michelangelesque Mannerism, as established by Floris, ruled the day. Such an artist as Martin de Vos of Antwerp (1531–1603), whose works were much engraved, shows a close adherence to Italian art forms and ideas (he spent ten years in Italy), following the sentimental spirit that came to rule the Italians. A true dichotomy began to exist between the religious subject treated in the imported manner and the portrait continuing in the native tradition.

Landscape also underwent a change, and the panoramic landscape of the early years, as seen in Patinir, as well as the protoheroic landscape of the second quarter of the century, visible in Lucas and Van Scorel, was replaced by a new type—the intimate, shadowed view of the forest interior, often in the "two-hole" composition, with an avenue into the wood on one side and on the other a view that was still rather panoramic and still seen from a high elevation. Figures, when present, were usually made small to magnify the feeling of an all-embracing nature.

One of the leading artists to establish this new development was Gillis van Coninxloo (1544–1606). His *Elijah Fed by the Ravens* (Fig. 653), in Brussels, shows the method described, but complexity is added to the rendering by the creation of a space side and a volume side with interesting penetrations along a diagonal from lower left to upper right. The resultant sense of intimacy has a parallel in the attention to the details of nature to be found in the other two markedly Flemish genres, the portrait and the still life. The Coninxloo landscape style, as later modified by Paul Bril when he went to Rome, was united with the Venetian landscape manner to affect the development of the Roman landscape style of the Caracci.

Though stylistically different from the art of Pieter Bruegel, the intimate landscape bears a spiritual relationship to it, for the close contact implied between man and nature in the Coninxloo style was to be expressed with equal strength but different means and meaning and higher quality in Pieter Bruegel's work.

picture frame is clearly conceived as the entrance to a bottomless pit; Hell opens up before us, and we subjectively teeter on its edge. Far in the distance Christ on the clouds makes an exaggerated spatial contrast. Again magnificent detail reveals the Flemish hand.

Like so many of the Flemish painters, Floris was a great portraitist, as may be seen in the *Falconer*, in Brunswick, and the presumed *Falconer's Wife* (Fig. 652), of 1558, in Caen. Clarity, sharpness, and rich but subdued naturalistic detail are used to reveal psychological penetration and understanding of the monumentalized individual. The falconer's wife may be somewhat gross, but the vitality of her personality is well presented by the animation of

below: 653. GILLIS III VAN CONINXLOO. *Elijah Fed by the Ravens. c.* 1585–90. Canvas, 45 1/4 × 70". Musées Royaux des Beaux-Arts, Brussels.

PIETER BRUEGEL
THE ELDER

THE ART OF PIETER BRUEGEL THE ELDER, FOUNDER of an artistic dynasty, is a fitting conclusion to the developments of the period. His art was at once both old and new: It was new in rejecting the Romanism of his contemporaries, new in conceiving the individual as a type (there are no known portraits by Bruegel), new in almost completely eliminating religious elements from his genre paintings, and new in unifying landscape and genre. Yet it was old in style, in artistic vocabulary, in the fantastic arsenal of types and witty forms that crowd the surfaces of his popular engravings and his painted encyclopedias. In the arbitrariness of strongly patterned construction tinged by Mannerism, it was modern.

Pieter Bruegel's birthplace is unknown, for there are several towns of the same name, and even his birth date is unknown, though it is generally considered to be about 1525. He died comparatively young in 1569, leaving two young sons, both of whom became outstanding painters. According to Van Mander, he was born in the village of Brueghel near Breda, studied under Pieter Coecke (whose daughter he later married) in Brussels, and then went to work in Hieronymus Cock's Antwerp engraving shop. Bruegel apparently worked for Pieter Balten at Malines [1] and then for Cock. After Pieter Coecke died in 1550, Bruegel went to Italy, probably in 1552–53, by way of France. That he had contact in Rome in 1553 with Giulio Clovio the miniaturist, patron of El Greco, is known, for Clovio owned three now-lost works by him. Van Mander said that Bruegel returned to Antwerp by 1551, when he entered the painters' guild; the Italian journey was, however, made after this date. Apparently he moved to Brussels about 1563, after his marriage, and spent the remaining years of his life there. We know that he was familiar with the city's leading Humanists of the day, such as the geographer Abraham Ortelius and others. Van Mander's account stressed the droll element in his art, and this point of view characterizes much of the commentary on his painting until our own century. But other elements, pointed out by Van Mander, have formed the basis for modern interpretations of an art that is in style exceptionally different from that of his contemporaries.[2]

His earliest work is known from drawings,[3] for example the *Ship in a Harbor* of about 1550. Comparatively crude in character, it gives an extensive view of the water, anticipating what was to develop later in Holland in the work of the seascape painters, who developed this into another artistic genre. A drawing from his trip to Italy shows a view of the Ripa Grande, Rome, and is signed "a rypa" with his name. Small forms are set in large space rendered by a delicate, distinctive technique with which he stressed clarity of outline, yet suggested the atmospheric position of the object. Whether he made drawings of Rome's monuments of architecture and painting is uncertain. In any case, none now exist.

His mountain landscapes made on the way to or from Italy and after his return (Fig. 654) are almost impressionistic, with short, small strokes establishing a delicate tonality of atmospheric effect, the forms being neither strongly outlined nor strongly contrasted in light and dark. He depicted the vast extent and the fluid and atmospheric quality of nature; yet the delicate strokes moving over the paper suggest a feeling for the variegated surfaces of natural forms. Both an intimacy and a sense of the monumentality of nature are united into one living and, one feels,

almost breathing whole. Clouds sweep across the mountains of his Alpine landscapes, and the mountains themselves move and turn with a tremendous life and energy to reveal a sense of the source and scope of nature. The high point of view from which we look down, out across the valley, and up the slopes of the mountains beyond, often presents a surprising but fortuitous parallel to the Chinese landscapes of the Sung period. To Bruegel nature had tremendous vitality. The basic things of life seem to come from his portrayal of the natural landscape, and this provides a key to his future art.

On his return to Antwerp to work for Hieronymus Cock he took up ideas like those of Bosch, which proved to be very popular. His pen drawing *The Big Fish Eat the Little Fish* (Fig. 655), in the Albertina, of which an engraving was published in 1557, is a fantasy of such ideas, finely done with a freshness and vitality that demonstrate the painter's proliferating inventiveness. In 1556 he made drawings for engravings of the Seven Deadly Sins and three years later a series of the Seven Virtues. In these, as in his other engraved works, the earlier meanings of old iconographic ideas are almost lost in the welter of fantastic additions. Motifs profuse in number and array are, so to speak, thrown in to give variety and intriguing, evocating animation to his subject, almost without regard for the moral they had pointed in Bosch's work. For the most part these are fascinating drolleries, despite the declared subject.

One of the earliest of Bruegel's paintings is the *Battle in the Bay of Naples* (Fig. 656), in the Galleria Doria in Rome, which carries further the ideas seen in the early *Ship in a Harbor* drawing, except that the viewpoint is high and the whole panorama is spread out before us. His *Temptation of St. Anthony*, in Washington, of the first half of the 1550s, is very much like the landscapes painted by the close followers of Patinir, except for the introduction of scattered fantastic elements. The work is diagonally organized in a manner seen frequently before, but in color it is fresher, more naturalistic than the

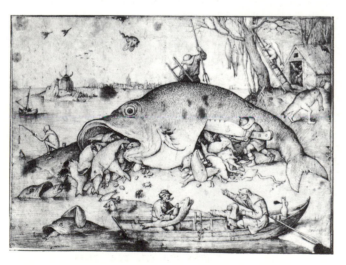

above: 654. PIETER BRUEGEL. *Mountain Landscape (Waltersburg)*. 1552–55. Sepia ink drawing, 12 ⅝ × 10 ⅝". Bowdoin College Museum of Art, Brunswick, Maine.

left: 655. PIETER BRUEGEL. *The Big Fish Eat the Little Fish*. 1556. Pen and gray ink, 8 ½ × 11 ⅞". Albertina, Vienna.

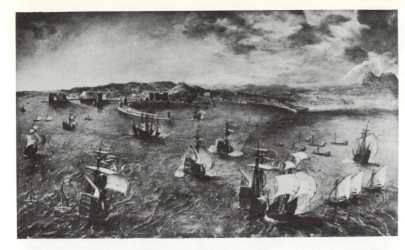

656. PIETER BRUEGEL. *Battle in the Bay of Naples. c.* 1552–54(?). Panel, 16 ⅛ × 27 ½″. Galleria Doria Pamphili, Rome.

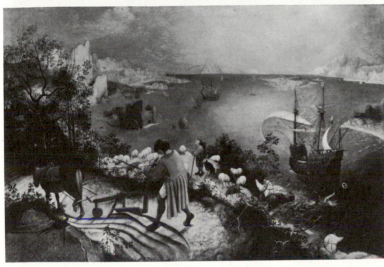

657. PIETER BRUEGEL. *Fall of Icarus. c.* 1555(?). Panel transferred to canvas, 29 × 44 ⅛″. Musées Royaux des Beaux-Arts, Brussels.

Patinir manner, and softer in atmospheric treatment; it is also intentionally archaic in style.

Earlier artists, when they turned to Italy, did not consciously reject their past so much as they tried to transform their present by incorporating the old with the new. As the Humanistic ideal became stronger, the naturalistic attitude dominated by spiritual considerations was felt to be inimical to the new approach and was gradually relegated to the nonreligious genre, thereby separating art more firmly into categories.

In returning to the first generation of the century, Bruegel consciously rejected the art of his own day, the Romanist concept of an ideal golden age *and its style*, and *chose* the style in which he would paint. The implication is clear: Style is a vehicle and not an organic manifestation in Bruegel's thinking. Yet in a sense this is a typical Mannerist inversion!

The *Fall of Icarus* (Fig. 657), in Brussels, probably of the mid-1550s, has been much discussed

as to its authenticity and its position stylistically (early or late) in Bruegel's *œuvre*. (The theme exists in two versions, both of which have been questioned.) It shows a man (in archaic costume) plowing regular furrows before a vast landscape, a shepherd looking up into the trees, and a fisherman busily engaged in his activity, as Icarus, son of Daedalus, the first inventor and designer of the Cretan labyrinth, plunges into the sea near the merchant ship sailing by. According to the ancient legend, Daedalus, to escape the tyranny of the Cretan monarch, invented wings made of feathers attached to a framework with wax for himself and his son. After a warning to his son not to fly too high, they started out on their flight to the mainland and to freedom. Icarus, breaking his father's injunction, flew too high, the sun melted the wax on his wings, and he plummeted into the sea and was drowned. His father sadly continued his flight to the mainland. This classic

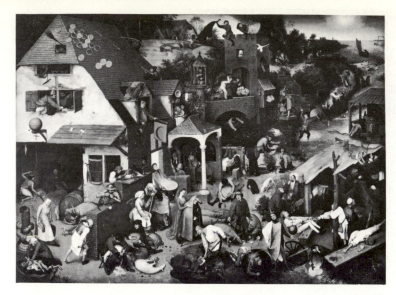

658. Pieter Bruegel. *Netherlandish Proverbs*. 1559. Panel, 46 × 64 1/8". Gemäldegalerie, Staatliche Museen, Berlin-Dahlem.

example of *hubris* (tragic insolence) is here treated by Bruegel as merely the excuse, as Tolnay pointed out, for the illustration of a Flemish proverb: "Not a plow stands still when a man dies." Thus no one pays attention to Icarus, who drowns as life goes on. Within the vast panorama of nature one man's death does not change or deflect its course; the sun in the background changes its course no more than that of the merchant ship. Certainly this is far different from the concept of man as dominant over nature.

This painting marks a stylistic advance beyond the *Temptation of St. Anthony*, for the conception of the landscape is related to the landscape drawings made on his Italian journey. We look out, down, and across to the city in the far distance as Bruegel explores the possibilities of the dramatic silhouette. This is seen in the plowman, and it is given an airy quality in the trees toward which the shepherd is looking. Color too has a new role to play, the red and blue-gray garment of the plowman coming out toward the spectator as the cooler landscape recedes, in a realization (eventually to be developed into a theory by the Impressionists) that warm colors advance and cool colors recede. Sculpturesque modeling of idealized figures, that basis upon which the Romanists built their formal structures, was of little interest to Bruegel; naturalism, with light effects and the old Flemish color united with delicate line and telling surface design, was a far more important artistic goal.

In 1559 Bruegel, building on his engravings, began to paint encyclopedic works with new stylistic means to express a sardonic viewpoint. Using a high horizon and a high point of view,

he spread the forms out before the eye, but, as in the work of Patinir, he employed a normal perspective in portraying human beings. In the *Netherlandish Proverbs* (Fig. 658), of 1559, in Berlin, the folly of mankind is expressed through illustrations of peasant sayings, set in a landscape organized along diagonals with a high horizon. Some of the proverbs are well known in various languages, though others are more local. Futile effort is illustrated in a number of cases, as by the man on the roof shooting one arrow after another, or the man butting his head against a stone wall, or the man bringing a bucket of coals into the daylight, the English of which is "bringing coals to Newcastle." The pies on the roof have a parallel in the post-World-War-I "Wobbly" refrain, "There'll be pie in the sky when you die." In the right foreground the richly dressed young man has the globe on his thumb, the equivalent of "having the world in the palm of your hand," while in the far left over the door the globe again appears, but inverted, a reference to the topsy-turvy world. The folly of men who cry over spilt milk and cannot really live a rational life is the basis of this ironic commentary, inspired by over 92 peasant proverbs.

In the *Combat between Carnival and Lent* (Fig. 659), in Vienna, of the same year, the high-horizoned landscape is again used as the background for an encyclopedic portrayal. In the foreground the emaciated, stupid priest holds as his "lance" a baker's shovel with two fish on it, while his gross, rotund opponent carries a spit heavily laden with non-Lenten meats as he rides his barrel "steed." Though attempts have been made to read a commentary on Lutheranism

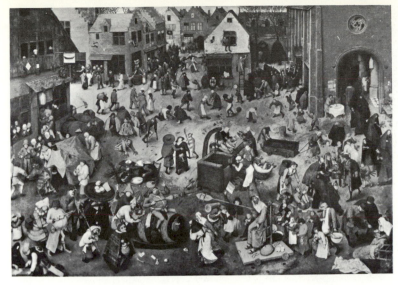

and Catholicism into this work, the explanation does not hold up when the work is considered detail by detail. The activity here, very different from comparable scenes in the art of Bosch, does not culminate in a grand religious statement fervently asserted.

Stylistically these works of 1559 are also different from Bosch. Bruegel has favored a circular, as opposed to the diagonally axial, organization for the *Proverbs*, and in the encyclopedic paintings he has used universal rather than naturalistic lighting with a chiaroscuro based on nature. Through the use of unmixed hues of color scattered in varied arrangements across the surface and through strong accentuation of outline the works have been given a magnificent sense of patterned surface ornamentation. Depth is suggested by the construction of a tilted base plane upon which all is presented and upon which the distant forms are made to diminish in proportion, color intensity, and size of the color patches. Bruegel was again being archaistic as he turned away from the subdued color schemes introduced by the Romanists to take up those of the Eyckian tradition. His richness and brilliance of color, conditioned by the *alla prima* painting of Bosch and partly the result of the color-patch method, is distinct from the more mystic expression of the 15th century. Movement achieved by silhouette and limited, localized modeling is also a part of his artistic means. The use of a high horizon is certainly archaizing, but it was the only manner in which the manifold activities could be presented without losing control of the design (as happened to some Mannerists who plasticized forms too strongly).

The same spirit animates stylistically the equally encyclopedic Vienna *Children's Games* (Fig. 660), of 1560. Bruegel again dealt with those who are close to nature, as in the previous

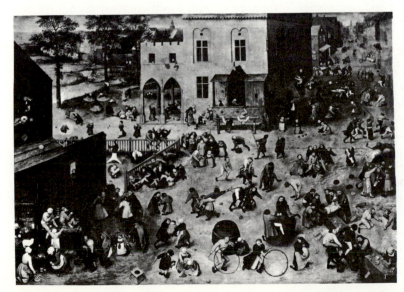

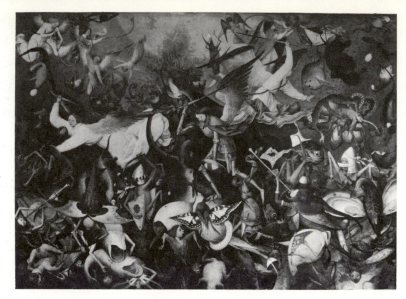

works that depicted peasants and the people of small towns, the unsophisticated, who express what seems to be an animistic view, in the sense that nature has produced these conscious beings who act in relation to their natural character, and the child is the most natural of all. (The painting may have been the first of a series on the ages of man.) Again there is a panorama with a high horizon, upon which Bruegel has spread out the encyclopedic range of the activities of the child at play. We can recognize almost every game that we ourselves have played as children and more besides. All are, here, delightfully colored and delightfully drawn.

The *Fall of the Rebel Angels* (Fig. 661), of 1562, in Brussels, is related conceptually to the encyclopedic works. A phantasmagoria of forms, it does not follow earlier or contemporaneous conceptions of the theme; the angels are elongated into a super-Gothicized slenderness that verges on caricature; and the demons, borrowed in

spirit, and occasionally in detail, from the art of Bosch, are fanciful and without the specific meaning found in the art of his predecessor.

This difference is quite evident in the animal form in the lower right-hand corner, which opens up its belly to reveal eggs inside. Such a figure is not fighting expulsion from Heaven. Also, the fighting actions of the unrebellious angels are directed against no antagonist. Traditional motifs are used for their evocative qualities, rather than for religious meaning, which has fallen by the wayside, again in contrast to the moralizing of Bosch, who conceived of evil as having a virile existence that had to be combatted. At best Bruegel's forms have only symbolic import as witnesses to the existence of evil forces, rather than meanings which transcend their use as interesting motifs. Thus the work becomes a mannered fantasy, a drollery, as was recognized by his contemporaries. It may also have been a satire on Floris's version of the theme.

The spirit expressed here undoubtedly grew out of the engravings of this period, in which Bosch's influence was strong. It is also seen in the *Dulle Griet* (Fig. 662), dated 1562, in the Musée Mayer van den Bergh, Antwerp. Ostensibly this represents Mad Meg, Roaring Meg, who tackles even the Devil in his lair; it has also been considered to illustrate the proverb: "If you go to Hell, go sword in hand." The ravaging corruption of avarice may also be symbolized. This, too, is full of Bosch-like combinations, presented against a colorful red setting.

However, not all of Bruegel's work is so fantastic or composed with such airless space and

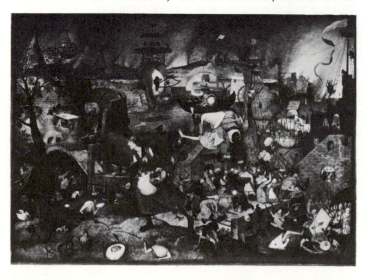

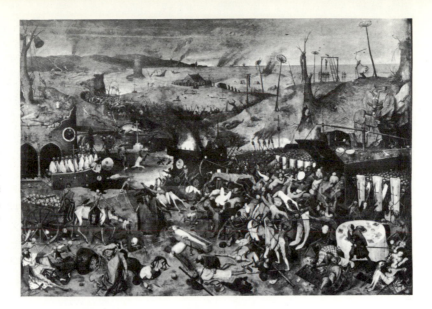

663. PIETER BRUEGEL. *Triumph of Death. c.* 1562. Panel, 46 × 63 ³/₄″. Prado, Madrid.

crowded surfaces. The *Combat between the Israelites and Philistines* (*Suicide of Saul*) in Vienna, signed and dated 1562, with the death of Saul and his armor-bearer at the left of the landscape (I Samuel 31: 1-6) is conceptually and stylistically different from the *Dulle Griet* or the *Fall of the Rebel Angels*. Here he has shown a vast landscape with reminiscences of the Italian trip in the forms and in the conception of nature. It is also different in the latter respect from the paintings in which Altdorfer presented hordes of soldiers rushing across the landscape. Bruegel's landscape is not expressive of a mystic world with a soul and existence of its own, but he did see the world as possessing an underlying order. Man's appearance and actions participate in that world order, instead of manifesting a rootless existence on its surface, as Altdorfer's cosmology implies. Man's activity is no greater and no more important than any other natural activity, as Bruegel has already indicated in the *Fall of Icarus*. According to some modern scholars, Bruegel believed that it is man's moral duty to overcome his foolishness and sinfulness, in keeping with the free-will philosophy upheld by his friend Dirck Coornhert, but the character of the paintings seems at variance with this opinion.

A biting commentary, basically unrelated to fools or to sin, appears in the Prado *Triumph of Death* (Fig. 663), of about 1562. The theme of the Dance of Death is transformed with caustic mockery and united with the Triumph of Death into an encyclopedia of the varieties and possibilities of meeting death. Organized with a repetition of the high horizon, tilted plane, and crossed diagonals, the whole sad story is fascinatingly told, with often humorous detail, for this is clearly an exaggeration with a mordant undertone. Some of the ways of death are natural, but many are witness to man's inhumanity to man. The grim tale is told with the suggestion—and no more—that death is also a Last Judgment from which no one is saved, as towns burn and ships sink. Monarchs, clerics, the rich, the indolent, and the poor alike are taken by death whether it is met in brave or cowardly fashion, as in the lower right-hand corner.

The implications of man's place in the world may have conditioned the Berlin painting of *Two Monkeys*, which is signed and dated 1562. The two creatures, chained in a window embrasure with a view of Antwerp in the distance, have been interpreted, in relation to the political situation of the times, as the two provinces of the Netherlands fettered under Spanish domination. It may be more exact to view this as a general statement of the imprisonment of man in the city; in the distance, where boats and birds sail by, are liberty and the vast expanse of nature, which the base passions (long symbolized by the monkey) prevent him from achieving. The futility of worldly goods also seems to be expressed by the nutshells here, which is interesting in that Bruegel moved in the following year from busy Antwerp to Brussels.

The pessimism one can associate with the *Two Monkeys* seems also to have affected the painter when he conceived the *Tower of Babel* (Fig. 664), in Vienna, of 1563, which was probably modeled on the Colosseum in Rome. The horizon is

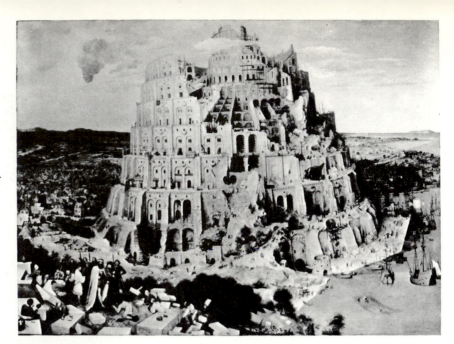

664. PIETER BRUEGEL. *Tower of Babel*. 1563. Panel, 44 ⁷⁄₈ × 61″. Kunsthistorisches Museum, Vienna.

below: 665. PIETER BRUEGEL. Detail of the *Tower of Babel* (Fig. 664).

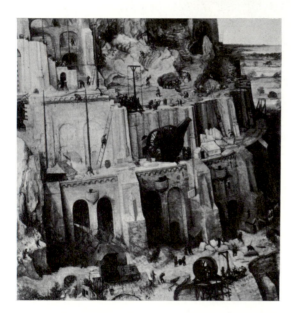

lower than in previous works, but the painting is still encyclopedic in character. A roster of the building trades and other activities of man are portrayed with careful attention to detail. The slight tilt imparted to the structure conveys a sense of the futility of man's efforts, even though the monarch in the left foreground exemplifies Christ's injunction to Peter to build upon a rock. Man can build vast worldly structures, but they are never completed, for ambition outrides abilities. The whole concept is presented with superb detail (Fig. 665). Like so much of Bruegel's work, this needs to be read as one

reads an engraving. A later version, of about 1567, in Rotterdam, presents the same basic idea, except that the building, constructed like a ziggurat, is more remote from the spectator and looms up from the lowered horizon as an even more telling witness of man's futility. Both works suggest the conceptions of Jan van Eyck, whose disguised symbolism also employed Romanesque forms to indicate the era *ante legem*.

An unusual production for Bruegel is his London *Adoration of the Magi* (Fig. 666), signed and dated 1563. The rather heroic Child, recalling Romanist works, contrasts with the other figures, including the Virgin, Joseph, and the Bosch-derived, almost stupid Magus in vermilion with his golden cup. The extremely elongated Negro Magus stands at the right, and above his head is seen a caricatural, unshaven face. Unidealized, seemingly bewildered, and certainly stupid, this figure wears gigantic glasses and peers out into the freer space of the center of the panel. The upper edges are tightly crowded. Like no other work that has been seen, it is almost an anti-Adoration of the Magi in its Manneristic exaggerations.

In 1564 Bruegel signed and dated the *Road to Calvary* (Fig. 667), in Vienna. This work also includes archaistic ideas in the sorrowing group about the Virgin in the lower right-hand corner, which is represented as entirely separate in perspective, size, costume, and action. The major part of the panel resembles a Sunday outing of country people, brought into focus at the junc-

ture of the diagonals of the composition with the scene of Christ carrying the Cross. Suggesting a Flemish landscape, yet not making an exact portrayal, Bruegel achieved depth and space in a new way by making the foreground group a *repoussoir* device. It sets off the main action (which may be why Bruegel archaized the group) that begins beyond them with the man on the white horse looking back at the fighting peasants. From that point we are truly immersed in the landscape, which is an off-center, "two-hole" type with the illusion of natural lighting carefully restricted to the far distance. Through atmospheric perspective and the diminishing size of human forms Bruegel created the feeling of a vast landscape, within which he balanced the mourning group by the basically fantastic, upthrusting rock form crowned by a windmill. Immediacy is given to the subject by projecting the scene into what seems a specific time and place. A vast horde of people animates the landscape, which is dotted with suggestive notes in the form of the wheels upon which people were tied and left to die, a grim reminder to the people of Bruegel's day of the terrors of Spanish rule. Storm clouds gather on the far right as natural forecasts of the impending drama.

Philip II, a religious fanatic, had no understanding of his Flemish subjects. His harsh measures were increasingly opposed by the Netherlanders, and increasingly harsh measures were instituted in retaliation. Activation of the Inquisition brought death to thousands, and revolt was widespread. On April 5, 1566, the rebels formulated the famous "Compromise," in

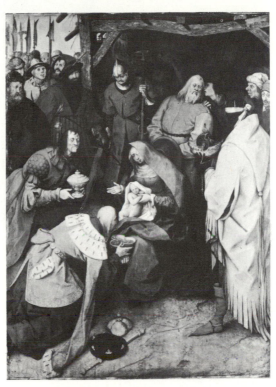

666. PIETER BRUEGEL. *Adoration of the Magi.* 1563. Panel, 42 1/2 × 32 1/2". National Gallery, London.

which they decided to expel the Inquisition. They adopted the badge of beggar's garb, possibly commemorated by Bruegel in the painting of *Crippled Beggars* of 1568, in the Louvre, in which the various classes of society are apparently indicated by the hats of the cripples. A wave of iconoclasm in 1566 resulted in widespread destruction of paintings and images in the

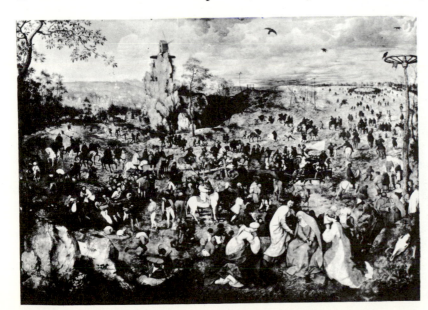

667. PIETER BRUEGEL. *Road to Calvary.* 1564. Panel, 48 3/4 × 67". Kunsthistorisches Museum, Vienna.

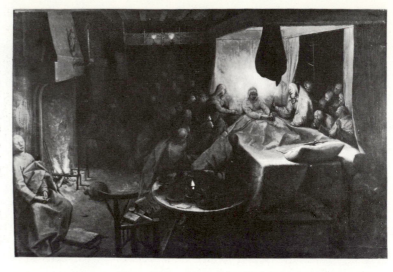

churches, and Philip had to send for Spanish troops to come from Lombardy. They put down the insurrection with such cruelty that the term "Spanish fury" is still meaningful in the Netherlands today. Bruegel was active during this time.

About 1564, he had made a grisaille of the *Death of the Virgin* (Fig. 668), one of only two works in which there is a definite, naturalistic light source. It is a masterful night scene, unique in his art.

In 1565 Bruegel was apparently commissioned to paint a series of the *Months* for Niclaes Jonghelinck of Antwerp. It may be, as Tolnay holds, that Bruegel executed only six paintings, each of which portrayed the activities of two months and that the painting representing April and May has been lost. The concept of the months as landscapes had begun with Jean Pucelle,

had been continued by his followers, restated in naturalistic form by the Limbourgs, and then passed into Flemish miniature painting, to be revived at the end of the 15th century and in the early 16th by such outstanding miniaturists as Simon Bening. In the *Hennessy Hours*, in Brussels, Bening's superb naturalistic scenes (Fig. 669) possess a delicacy and naturalism of detail that are equal, if not superior, to many a larger work. Bruegel revived the form in these large landscape paintings and gave them a broader meaning.

Everywhere in this cycle of paintings man is seen as a peasant living and working close to the soil, never idealized and never portrayed as an individual but always as a type. The *Hay Harvest* (Fig. 670), now in Prague, seemingly representing the months of June and July, is without doubt the earliest in the series, for it adheres to the landscape forms seen in the earlier works of the Patinir type. It presents man in accord with nature, but nature is the most important factor. Bruegel was concerned with nature's inexorable cycle, in which man merely takes advantage of her abundance in this season. In design the movement down and out into distant space is less ordered than in the later works in the cycle.

The *Wheat Harvest* (Fig. 671) in New York, dated "...LXV," shows peasants at work, asleep, eating, while children are at play in the distant village. August and September are characterized here by the warm yellows and tans set against the distant greens and cooler tones of the hazy estuary landscape. In the foreground a completely relaxed, sleeping peasant, sprawled out with

closed eyes and open mouth, demonstrates the magnificence of Bruegel's draftsmanship. The figure is rendered as a combination of silhouette and localized modeling. The design of other figures also excites our admiration, for example, the woman with her back to us, wearing a yellow blouse and white apron over her dark skirt.

Spatial movement is indicated by the man trudging up through the perspectively organized cut in the wheat and by the connecting elements on the left; on the right the bundles of cut grain carry us back to the church seen through the patterned trees. The forms in the middle distance on the right set the scale for the far distance beyond. The pattern of spatial recession is a subtle variation upon the earlier method of landscape construction; here the *repoussoir* tree is set close to the middle, and the depth of the valley is less than in other works.

The *Return of the Herd* (Fig. 672), in Vienna, apparently represents the months of October and November. It plays another variation upon the landscape scheme, this time a reversal of the movement, so that the eye is made almost to double back on its "tracks" to be caught by the distant river and carried diagonally into space. The closer, warm, and lighter tones are set against the cool, darker tones to augment the spatial drama. Again line, silhouette, and delicately textured surfaces add pleasurable variation to the surface pattern. Seizing with incredible skill the characteristic movements of men and animals, Bruegel imparts a veracity to the whole. His subdued color tonalities create the feeling of late fall, and the spirit of the season is

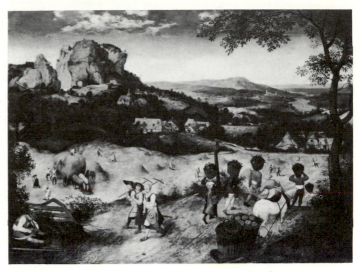

above: 670. PIETER BRUEGEL. *Hay Harvest.* 1565. Panel, 46 × 63 ³/₈″. National Gallery, Prague.

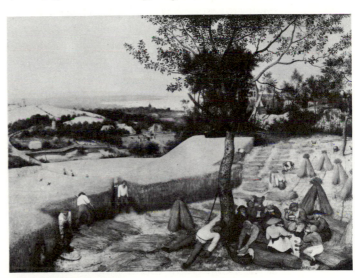

above: 671. PIETER BRUEGEL. *Wheat Harvest.* 1565. Panel, 46 ¹/₂ × 63 ¹/₄″. The Metropolitan Museum of Art, New York (Rogers Fund).

left: 672. PIETER BRUEGEL. *Return of the Herd.* 1565. Panel, 46 × 62 ⁵/₈″. Kunsthistorisches Museum, Vienna.

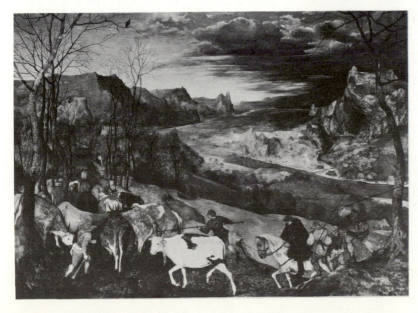

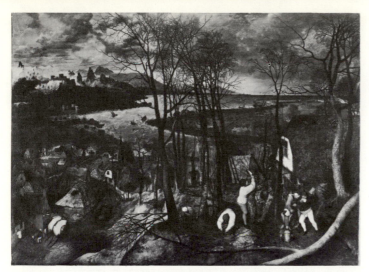

673. PIETER BRUEGEL. *Dark Day*. 1565. Panel,
46 1/2 × 64 1/8". Kunsthistorisches Museum, Vienna.

reinforced by the grandeur and sweeping drama
of the cold, dark-green mountain background.

The months of December and January are
represented in the *Hunters in the Snow* (Pl. 31,
after p. 308), in Vienna, a work so fine it estab-
lished a genre, the winter scene. Drawing upon
his Alpine landscape sketches, Bruegel made this
a variation upon the view down, out, across the
valley, and up again. It is a carefully worked
out, masterful composition, in which the barren
trees set the scale and engender movement into
space by their gradual diminution in size as they
recede. The activities of men are consonant
with the season. Bruegel used delicate tones of
color to create not only a sense of depth but also
the feeling of winter by picking out his warmest
notes in the foreground and varying cooler,
gray-green tones in the background. Once
again his universal lighting, now low in tone,
evokes the sense of cold, sunless, wintry days.

The *Dark Day* (Fig. 673), in Vienna, charac-
terizes late February and early March. A storm
on the bay in the distance makes sailing hazard-
ous, while men in the foreground trim the trees
in anticipation of spring and collect firewood.
Roiled clouds and raw winds are much in evi-
dence, and snow still covers the heights at the
left. At the right a child with a Carnival crown
carries a lantern against the gloom of the day.

The series of the months as seasonal activities
is reminiscent of the medieval depictions of the
labors of the months, but Bruegel laid far greater
stress upon the physical nature of the time por-
trayed. Though simplified in form and reduced

in numbers, his figures are animatory devices;
they are still incidental to the concern for the
character of nature even when individually pre-
sented larger in size. The peasants are much as
they were in medieval works, mere symbols for
the activities of the particular time of year; but
Bruegel modernized the stylistic expression of
the conception with consummate artistry.

He gave other themes a like contemporaneity,
as in the *Numbering at Bethlehem*, in Brussels, of
1566. The action takes place in a snow-covered
Flemish village. Again Bruegel used a high eye
level for the scene, but its manifold human
activities are seen on a normal eye level.
Actually it is another "season" painting com-
positionally related to the *Hunters in the Snow*,
for the religious subject is merely an excuse to
create a wonderful variety of motifs and sur-
faces. Growing out of the engraver's method of
presentation, the motifs, movements, colors, and
forms were meant to be read, though not at the
expense of the careful unification of composition.

Close in time, conception, and technical de-
vices of presentation is the *Massacre of the Inno-
cents*, in Vienna, about which Van Mander had
remarked on how well Bruegel had painted the
mother imploring for the life of her child. There
can be little doubt that Bruegel was intention-
ally making a comment on his own times when
he set the scene in a Brabantine village in the
midst of winter. The sheer beauty of the pre-
sentation, however, relieves the modern viewer
of a sense of horror. We feel sympathy, yet little
revulsion, being entranced by the variety of fig-
ures and color movements, the contrast of
warm house fronts and snow-whitened roofs,
and the magnificent organization of the build-
ings leading back to the mass of men in blue-
gray armor, whose delicate screen of lances
echoes the tree branches on either side. The
whole village is capped by the essentially unmod-
ulated gray-green sky that so gently acts as a
foil for the patterned warmth of the foreground.

John the Baptist Preaching in the Wilderness
(Fig. 674), in Budapest, signed and dated 1566,
comments even more pointedly on the oppres-
sive Spanish rule. The theme of John's preaching
was used earlier by artists to express the new re-
forming spirit, the direct communication be-
tween the prophet and his people; now the
scene is a clandestine meeting of peasant rebels
presented with a great sense of actuality. Instead

of being set in a generalized wilderness, the preaching takes place not far from a town, visible in the background, and the suspicious man peering at us from around the tree at the left seems to check our credentials. The device of large forms in the foreground and a rapid diminution in scale of the figures, with pale, upturned faces, adds to the feeling of urgency and creates a dramatic depth and balanced surface design.

This device also appears in a work of the same year that has no political overtones, the Detroit *Wedding Dance* (Fig. 675). Here Bruegel set himself a distinct artistic problem—to paint the rhythms of the dance.[4] The solution of the *John the Baptist Preaching* seems to have served as the basis of its organization. The curving rhythms set up by the dancing figures in the foreground are continued into depth by white kerchiefs and red hats and vests that diminish in size as they wind back among the trees toward the high horizon and return to the foreground again on the left-hand side. Movement is emphasized by two new devices, the enlarged, vigorously moving foreground figures and the strong downward tilt of the foreground plane. A partial stabilization of the design is achieved by the two inactive figures on either side of the foreground. Again Bruegel presents the peasant as expressive of a part of nature, but now the type is monumentalized. Little interest is taken in individual psychology. A dispassionate observation of the activity is dominant. No rapport is felt with the dancers as people; by accentuating their peasant

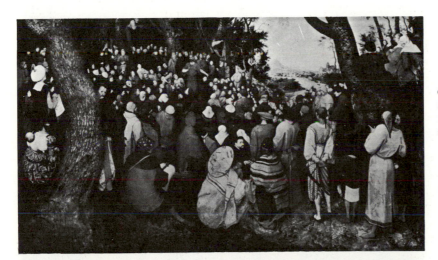

674. PIETER BRUEGEL. *John the the Baptist Preaching in the Wilderness.* 1566. Panel, 37 3/8 × 63 1/4". Museum of Fine Arts, Budapest.

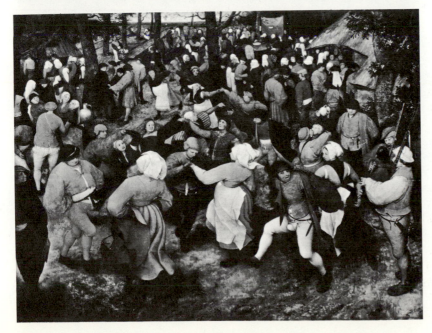

675. PIETER BRUEGEL. *Wedding Dance.* 1566. Panel, 27 × 62". The Detroit Institute of Arts.

actions Bruegel has created a caricature, in which each and every figure is in one way or another stupid and insensitive to anything other than base reactions. The uninhibited peasant is portrayed as an unthinking beast expressive only of the force of life.

Bruegel changed to a large-figure style and lowered the horizon but retained the same animating spirit in the signed but undated *Peasant Dance* (Fig. 676) in Vienna. The large figures rush into the scene to join what one feels will be a stomping dance, for which nature seems to have intentionally designed their big feet. This spirit also governs the Vienna *Peasant Wedding Feast* (Fig. 677), with its *repoussoir* group at

lower left, where a man fills a jug, as pies are brought in on a door taken off its hinges to serve as a tray for the gargantuan hunger of these lusty sons of the soil.[5] As in the *Peasant Dance*, large color areas enliven this large-figure design (inspired by the Marriage at Cana theme), with its diagonal movement of rapid recession, which recalls a similar movement and similar *repoussoir* pouring figures in Tintoretto's later Last Suppers. However, in place of the dramatic lighting of the Italian, Bruegel still employed his universal lighting to heighten the pattern and variety of his surface design. Magnificently designed, the painting includes truly droll elements, such as the bagpiper—an important fig-

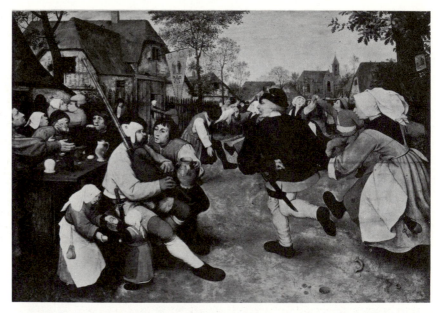

676. PIETER BRUEGEL. *Peasant Dance. c.* 1566–67. Panel, 44 ⁷/₈ × 64 ¹/₂″. Kunsthistorisches Museum, Vienna.

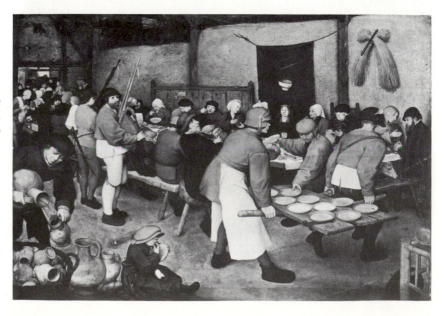

677. PIETER BRUEGEL. *Peasant Wedding Feast. c.* 1566–67. Panel, 44 ⁷/₈ × 64 ¹/₈″. Kunsthistorisches Museum, Vienna.

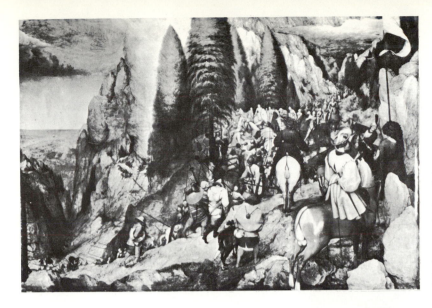

ure in the color spotting—who looks with unconcealed longing at the pies going past him; the plump, simpering, stupid bride; and the child eclipsed under a man's hat, licking his plate. In the background the forceful diagonal movement is stopped by the crowd of spectators peering into the room.

Van Mander relates that Bruegel went on trips disguised as a peasant to observe country manners. The result is very clear in the group of works described.

The dated late paintings show that Bruegel was almost simultaneously working in two different manners, but the large-figure type came to dominate. The *Conversion of Saul of Tarsus* (Fig. 678), in Vienna, was painted in 1567. Placed in an Alpine landscape, the figure of Saul is almost lost in the middle ground. At the right a rider on a piebald horse acts as the *repoussoir* element, and a more distant horseman in a direct rear view leads the eye toward the center of the action. In design, light, and space this is a variation of the conception of the *Return of the Herd*. The trees in the center stabilize the contrasting and dramatic side movements.

In the same year Bruegel completed the large-figured *Land of Cockaigne* (Fig. 679), in Munich. The theme of the land where nothing has to be done and food falls into one's mouth occurs in all the folk literature—Flemish, French, German, and English. Pies fall off the roof into the mouth of the knight, and wine pours into the mouth of the student, while the peasant laborer on his flail and the soldier beyond him have gorged themselves to sleep. A little cooked egg on legs runs up to be eaten, a plucked and cooked

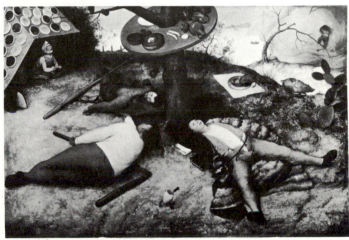

chicken lays its neck in the plate, a cooked pig runs by with a knife conveniently tucked into its skin, and in the background a figure is just emerging from a mountain of blancmange with a big spoon in his hand. Having eaten all the way through it, in a moment he will turn around and eat his way back. As in the Detroit *Wedding Dance*, a strongly tilted ground plane is employed, a Manneristic aspect of Bruegel's art.

The larger scale of the figures in the *Land of Cockaigne* is employed again in the *Parable of the Bird's Nest* (Fig. 680), of 1568, in Vienna. Illustrating the Flemish proverb that he who knows of the nest knows it, while he who robs it has it, Bruegel symbolized the topsy-turvy world in which the race goes to those who take what they can get their hands on, and a ditch awaits those who stand and only look on. The large figure is unaware of the ditch before him. This figure, more strongly modeled than previous forms, is

set before a beautifully painted landscape outside Brussels, with a soft lighting that shows an incipient change from Bruegel's normal universal illumination.

This almost idyllic setting is close in spirit to the painting of the landscape in the *Parable of the Blind* (Fig. 682), in Naples, of 1568, illustrating the moral that when the blind lead the blind, both fall into the ditch, undoubtedly a reference to the character of the times. The leader has already fallen in, and the others follow in a mag-

nificent descending composition. As sharp as it has been at any time before, Bruegel's meticulous portrayal of the blind was based on acute observation. This bitter, ironic commentary on mankind is presented with consummate coloristic skill and selectivity, the delicate light purples of the foremost figures creating a slightly stronger forward movement than the cooler tones of the garments at the rear of the procession. The figure design is set against landscape elements including trees and a church, and the device of opposed opened and closed areas effects an occult balance. Compositionally this represents another forward step in the art of Bruegel, though the way had been prepared by the *Parable of the Bird's Nest* of the same year and, a year earlier, by the *Misanthrope*, now in Naples. The inscription on the last painting reads, "Because the world is so untrue, I go in mourning." Because of his assumption of the conscience of a conscienceless world the misanthrope is having his purse cut.

Bruegel willed his wife what was certainly his last work, the *Magpie on the Gallows* (Pl. 32, after p. 308), of 1568, in Darmstadt. Van Mander said that by the magpie Bruegel meant the gossips, but it seems that there is a larger meaning than this. The work is a step beyond the *Parable of the Bird's Nest*, for the tendency toward an atmospheric landscape noted there receives its final and most complete statement in paint of what had appeared in his drawing from almost the very beginning. That there is a commentary here goes without saying: Despite the magpie and, more important, despite the gallows—that symbol of man's meddling with the rhythm of nature—life goes on, as the dancing peasants who participate in that rhythm make abundantly clear. From a high vantage point we see that the actions of men, implied by the gallows and even by the dancing figures, count but little in the vast panorama of a nature that is beautiful, serene, and triumphant over the pettiness and transience of man's movements over its surface.

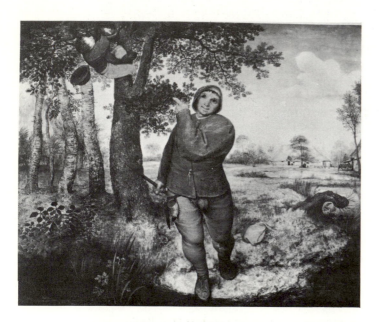

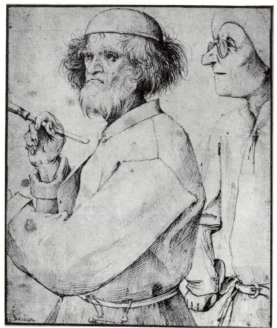

above: 680. PIETER BRUEGEL. *Parable of the Bird's Nest.* 1568. Panel, 23 1/4 × 26 3/4". Kunsthistorisches Museum, Vienna.

left: 681. PIETER BRUEGEL. *Artist and Connoisseur.* c. 1567. Pen drawing, 10 × 8 1/2". Albertina, Vienna.

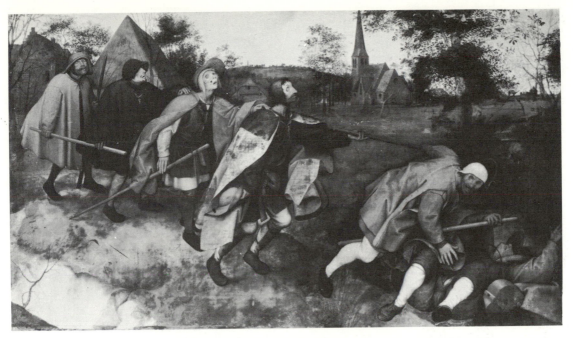

682. Pieter Bruegel. *Parable of the Blind*. 1568. Canvas, $33^7/_8 \times 60^5/_8''$.
Museo-Gallerie Nazionale di Capodimonte, Naples.

Bruegel has again dealt with the dominance of nature, now in a style that is proto-Baroque. His large figures have been built up and then reduced; the horizon started high, has been lowered, and now rises again. But the conception of the landscape has changed. It is no longer based on the revived medievalism that animated his earlier encyclopedic conceptions. Through the increased use of a naturalistic chiaroscuro the feeling of dispassionate observation has been replaced by a feeling of involvement. Light suggests a continuity of actual and pictorial space that draws us inward to participate in its fluidity and movement. Within it the peasant's features are no longer recognizable, for these figures are no longer merely peasants; they are animating notes on the far-spread and continuous natural surface that stand for a generalized mankind in accord with nature. Thus Bruegel, it seems, ended on a far more optimistic note than has been seen throughout his artistic career.

His drawings also show that he saw very clearly the world around him. They reveal his penetrating observation of life before its transformation into his paintings. Caricature occasionally enters, as in the *Artist and Connoisseur*, in which both subjects are amusingly presented, with a dyspeptic misanthropic artist and an un-

critical, enthusiastically ignorant onlooker (Fig. 681). The *Beekeepers*, in Hamburg, reveals his underlying interest in fantasy, even though the clarity of analysis matches that in his drawings of peasants. His engravings, such as *Lean Fare and Fat Fare*, lived on to influence Hogarth, for one; many, including his own sons, copied his conceptions in engraved and painted form.

Bruegel's paintings present a point of view shared by no one of his Mannerist contemporaries—Frans Floris, Marten de Vos, Jan Metsys, Bartholomaus Spranger, to name a few. Theirs was too strongly allied to the past and to the artistic movement of the day. Bruegel's art and vision—individual, distinctive, complex, and original—were not only greater but were also inherently secular and autonomous, as theirs was not. Appealing strongly to the following age, which collected his works and their innumerable copies, this same secular and autonomous character has made Bruegel's work seem closest to our own period of all that has been seen since Jean Pucelle. The striking contemporaneity of his work is also a sign that an era had come to a close. His pictures show that historical change had again achieved a significant magnitude. Within the continuum of art a new era was at hand.

SELECTED BIBLIOGRAPHY AND NOTES

ABBREVIATIONS

The system of abbreviations is patterned after that used in the *Art Bulletin* and the *American Journal of Archaeology*

AB	*Art Bulletin*
Ap	*Apollo*
AQ	*Art Quarterly*
BAntFr	*Bulletin de la Société Nationale des Antiquaires de France*
BIRPA	*Bulletin de l'Institut Royal du Patrimoine Artistique*
BMMA	*Bulletin of the Metropolitan Museum of Art*
BBelg	*Bulletin des Musées Royaux des Beaux-Arts de Belgique*
BMQ	*British Museum Quarterly*
BurlM	*Burlington Magazine*
ClevMB	*Cleveland Museum Bulletin*
Com	*Commentari*
Con	*Connoisseur*
GBA	*Gazette des Beaux-Arts*
GoyaRevA	*Goya, Revista de Arte*
EWA	*Encyclopedia of World Art*
JKS	*Jahrbuch der Kunsthistorischen Sammlungen in Wien*
JWarb	*Journal of the Warburg and Courtauld Institutes*
KonstT	*Konsthistorisk Tydskrift*
MA	*Magazine of Art*
MarbJb	*Marburger Jahrbuch für Kunstgeschichte*
MünchJb	*Münchener Jahrbuch der Bildenden Kunst*
OHoll	*Oud-Holland*
Pan	*Pantheon*
Para	*Paragone*
PrtCollQ	*Print Collector's Quarterly*
RA	*Revue des Arts*
RL	*Revue du Louvre*
Scrip	*Scriptorium*
ZfKunstW	*Zeitschrift für Kunstwissenschaft*

GENERAL BIBLIOGRAPHY

A. Michel, *Histoire de l'art*, Paris, 1905–29; U. Thieme and F. Becker, *Allgemeines Lexikon der bildenden Künstler*, Leipzig 1907–50; E. Mâle, *L'art religieux de la fin du moyen âge en France*, 4th ed., Paris, 1931; H. Van Hall, *Repertorium voor de Geschiedenis der nederlandsche Schilder-en Graveerkunst*, The Hague, 1936–49; F. Mather, Jr., *Western European painting of the Renaissance*, New York, 1949, repr. 1967; O. Benesch, *The Art of the Renaissance in Northern Europe*, Cambridge, Mass., 1947, repr. 1967; H. Wehle and M. Salinger, *Metropolitan Museum of Art, A Catalogue of Early Flemish, Dutch, and German Painting*, New York, 1947; P. Bautier et al., *Dictionnaire des peintres*, Brussels, n. d. (c. 1951); E. Panofsky, *Early Netherlandish Painting: its Origin and Character*, Cambridge, Mass. 1953; D. Diringer, *The Illuminated Book*, London, 1958, new ed., 1967; H. T. Musper, *Gotische Malerei nördlich der Alpen*, Cologne, 1961; H. Focillon, *The Art of the West*, II, *Gothic Art*, ed. J. Bony, London, 1963; W. Stechow, *Northern Renaissance Art 1400–1600*, Englewood Cliffs, N. J., 1966 (Sources and Documents in History of Art series); J. Pope-Hennessy, *The Portrait in the Renaissance* (Bollingen Series 35, 12), New York, 1966; W. Wixom, *Treasures from Medieval France*, Cleveland Museum of Art, 1967.

PART I: THE FOURTEENTH CENTURY AND THE INTERNATIONAL STYLE

CHAPTER 1: FRANCE AND THE NETHERLANDS

C. Dehaisnes, *Histoire de l'art dans la Flandre, l'Artois, et le Hainaut avant le XVe siècle*, Lille, 1886; C. Dehaisnes, *Documents et extraits divers concernant l'histoire de l'art dans la Flandre, l'Artois, et le Hainaut avant le XVe siècle*, Lille, 1886; G. Vitzthum, *Die Pariser Miniatur-malerei*, Leipzig, 1907; A. W. Byvanck and G. J. Hoogewerff, *La miniature hollandaise et les manuscrits illustrés du XVe au XVIe siècle aux Pays-Bas septentrionaux*, The Hague, 1922–26; H. Martin, *Joyaux de l'enluminure à la Bibliothèque Nationale*, Paris, 1928; P. Lemoisne, *Gothic Painting in France*, Florence, 1931; H. Labande, *Les primitifs français*, Marseilles, 1932; C. J. Hoogewerff, *De Noord–nederlandsche Schilderkunst*, I, The Hague, 1936; A. W. Byvanck, *La miniature dans les Pays-Bas septentrionaux*, Paris, 1937; J. Dupont and C. Gnudi, *Gothic Painting*, Geneva, 1937; C. Gaspar and F. Lyna, *Les principaux manuscrits à peintures de la Bibliothèque Royale de Belgique*, Paris, 1937–45; C. Sterling, *La peinture française: Les primitifs*, Paris, 1938; L. Réau, *French Painting in the XIVth, XVth and XVIth Centuries*, London, Paris, New York, 1939; C. Sterling, *La peinture française: Les peintres du moyen âge*, Paris, 1941; A. W. Byvanck, *De middeleeuwsche Boekillustratie in de noordelijke Nederlanden*, Antwerp, 1943; D. Miner, ed., *Walters Art Gallery, Illuminated Books of the Middle Ages and Renaissance*, Baltimore, 1949 (exhib. cat.); G. Ring, *A Century of French Painting, 1400–1500*, London, 1950; J. Porcher, ed., *Bibliothèque Nationale, Les manuscrits à peintures en France du XIIIe au XVIe siècle*, Paris, 1955 (exhib. cat.); J. Porcher, *French Mediaeval Miniatures*, New York, n.d. (1960); V. Denis, G. Knuttel, and R. Meischke, "Flemish and Dutch Art," *EWA*, V, 1961, 408–09; P. Pradel, "French Painting," *EWA*, V, 1961, 656–58; V. Oberhammer et al., *Europäische Kunst um 1400*, Vienna, 1962 (exhib cat.); P. Verdier, ed., *Walters Art Gallery, The International Style: The Arts in Europe around 1400*, Baltimore, 1962 (exhib. cat.); D. Diringer, "Miniatures and Illumination," *EWA*, X, 1965, 147–57, 165–71; M. Meiss, *French Painting in the Time of Jean de Berry*, London, New York, 1967.

1. For the tax reports see H. Bouchot, *Les primitifs français, 1292–1500*, 3d ed., Paris, 1904.

2. L. Delisle, *Recherches sur la librairie de Charles V*, Paris, 1907.

3. E. Millar, *The Parisian Miniaturist, Honoré*, London, New York, 1959.

4. J. Porcher, *Bibliothèque Nationale, Les manuscrits à peintures en France du XIIIe au XVIe siècle*, Paris, 1955, item 33, *Vie de St-Denis*.

5. J. Porcher, *Les manuscrits à peintures*, item 26, *Chansonnier de Paris*. See also J. Porcher, *French Mediaeval Miniatures*, New York, n.d. (1960), 51–55.

6. K. Morand, *Jean Pucelle*, Oxford, 1962. Pucelle was recorded in Paris possibly as early as 1319. The account book of 1319–24 of the Confraternity of St-Jacques-aux-Pèlerins carries the note of a large payment to Pucelle for the design of its seal. The *Hours of Jeanne d'Evreux* have been identified with the "Heures de Pucelle" inventoried in 1402 in the collection of John, Duke of Berry. See also C. Nordenfalk, "Maître Honoré and Maître Pucelle," *Ap*, LXXIX, 1964, 356–64.

7. E. Millar, *An Illuminated Manuscript of "La Somme le Roi" attributed to the Parisian Miniaturist Honoré*, Oxford, 1953.

8. C. Sterling in V. Oberhammer et al., *Europäische Kunst um 1400*, Vienna, 1962, 66–78 (exhib. cat.).

9. F. Wormald, "The Wilton Diptych," *JWarb*, XVII, 1954, 191–203; M. Rickert, *Painting in Britain, The Middle Ages*, Harmondsworth, Baltimore, Melbourne, 1954, 170–72.

10. For the Brussels *Hours* see C. Gaspar and F. Lyna, *Les principaux manuscrits à peintures de la Bibliothèque Royale de Belgique*, I, Paris, 1937–45, 399–409, pls. XCIII, XCIV.

11. M. Meiss's review of the 1955 Paris manuscript exhibition in *AB*, XXXVIII, 1956, 187–96.

12. E. Panofsky, *Early Netherlandish Painting: Its Origins and Characters*, Cambridge, Mass., 1953, 141–43.

13. E. Panofsky, *Early Netherlandish Painting*, 112–14.

14. On Joseph's hose see: J. de Coo, "De unieke voorstelling van de 'Jozefskousen' in het veelluik Antwerpen-Baltimore van ca. 1400," *OHoll*, LXXIII, 1958, 186–98; J. de Coo, "De voorstelling met de 'Jozefskousen' in het veelluik-Antwerpen-Baltimore toch niet uniek," *OHoll*, LXXV, 1960, 222–28.

15. On Malouel and the Limbourgs see M. Rickert, review of
F. Gorissen, "Jan Malwael und die Brüder Limbourg," *AB,*
XXXIX, 1957, 73-77.

15a. For the St. Denis panel as a work by Bellechose alone see
N. Reynaud, "A propos du Martyre de St. Denis", *RL,* XI, 1961,
175-76.

16. A Madonna and Child panel in Berlin that is close to Malouel is
discussed by M. Meiss and C. Eisler in "A new French Primi-
tive," *BurlM,* CII, 1960. 232-40.

17. For Avignon see. H. Labande, *Les primitifs français,* Marseilles,
1932.

18. J. Porcher "Limbourg," *EWA,* IX, 1964, 251-56.

19. The documents related to the Duke's manuscripts were published
in J. Guiffrey, *Inventaires de Jean, Duc de Berry,* Paris,
1894-96.

20. For the *Bible Moralisée* see J. Porcher, *French Mediaeval Minia-
tures,* New York, n. d. (1960), 65.

21. For the St. Jerome frontispiece see O. Pächt, "Zur Entstehung
des Hieronymus im Gehäus," *Pan,* XXI, 1963, 131-42; M. Meiss,
"French and Italian Variations on an Early Fifteenth-century
Theme: St. Jerome and His Study," *GBA,* ser. 6, LXII, 1963,
147-70.

22. F. Winkler, "Paul de Limbourg in Florence," *BurlM,* LVI, 1930,
95.-97.

23. J. Porcher, *Les belles heures de Jean de France, Duc de Berry,* Paris,
1953.

24. For the Master of 1402 see B. Martens, *Meister Francke,* Hamburg,
1929; criticism in J. Porcher, *French Mediaeval Miniatures,*
58, 91.

25. J. Porcher, *French Mediaeval Miniatures,* 58.

26. For the *Book of Hours of Charles the Noble* see *Clev Mus Bul,* LI,
1964, 53-54.

27. E. Spencer, "The Master of the Duke of Bedford: The Salisbury
Breviary," *BurlM,* CVIII, 1966, 607-12.

28. Related to the Bedford Style is that seen in several other manu-
scripts of the same decade: the *Missal of St. Magloire* (Paris,
Arsenal, Ms. 623) by the Magloire Master, who was still working
as late as 1422, when he illuminated the *Hours of Charles VI*
(Vienna, Ms. 1855); the *Bible Historiée* that once belonged to the
Duke of Berry (Paris, Arsenal, Ms. 5057-58); the *Térence des
ducs* (Paris, Arsenal, Ms. 664), which is rather conservative in
style except for the Adelphi scenes in the early Bedford style
(which Meiss in his exhibition review of 1956, *AB,* XXXVIII,
1956, 187-96, attributed to his Luçon Master); and others.

29. R. Schilling, "The Master of Egerton 1070," *Scrip.* VII, 1954,
272-82.

30. For Christine de Pisan, see L. Schaefer, "Die Illustrationen zu den
Handschriften der Christine de Pisan," *MarbJb,* X, 1937, 11-13.

31. E. Panofsky, *Early Netherlandish Painting,* 59.

32. J. Porcher, *The Rohan Book of Hours,* London, 1959.

33. G. Ring, *A Century of French Painting, 1400-1500,* London, 1950.

34. For the Seilern *Hours* see R. Schilling, "A Book of Hours from
the Limbourg Atelier," *BurlM,* LXXXI, 1942, 194-97.

35. For the Guillebert de Mets Master see F. Winkler, *Die Flämische
Buchmalerei,* Leipzig, 1925, 25; L. Delaissé, *La miniature fla-
mande, le mécénat de Philippe le Bon,* Brussels, Amsterdam, 1959,
17-19. (exhib. cat.).

36. F. Lyna, "Les miniatures d'un ms. du 'Ci nous dit' et le réalisme
préeyckien," *Scrip.* I, 1946-47, 106-18.

37. For the problematical location of the Deguileville manuscript,
see L. Delaissé, "Les miniatures du 'Pèlerinage de la vie humaine'
de Bruxelles et l'archéologie du livre," *Scrip.,* X, 1956, 233-50;
V. Oberhammer *et al., Europäische Kunst um 1400,* 178-179, no.
122 (exhib. cat.).

CHAPTER 2: BOHEMIA

A. Matěcěk and J. Pesina, *Czech Gothic Painting, 1350-1450,* trans.
J. Houra, Prague, 1950; A. Kutal in *Musée des Arts Décoratifs, L'art
ancien en Tchécoslovaquie,* Paris, 1957 (exhib. cat.); J. Krofta, in
Palais des Beaux-Arts, Les primitifs de Bohême, Brussels, 1966 (exhib.
cat.).

1. A. Friedl, *Magister Theodoricus,* trans. I. Gottheimer, Prague, 1956.
2. For Bohemian (and German) miniature painting see. H. Wege-
ner, "Buchmalerei," *Reallexikon zur deutschen Kunstgeschichte,* II,
Stuttgart, 1947-48, 1479-1504, 1516-24.
3. H. Sharon, "Illuminated Manuscripts at the Court of King Wen-
ceslaus IV of Bohemia," *Scrip.,* IX, 1955, 115-24.

4. O. Pächt, "A Bohemian Martyrology," *BurlM,* LXXIII, 1938,
192-204.

CHAPTER 3: AUSTRIA AND GERMANY

F. Burger, H. Schmitz, and I. Beth, *Die deutsche Malerei vom aus-
gehenden Mittelalter bis zum Ende der Renaissance,* Berlin, 1913-19;
C. Heise, *Die Norddeutsche Malerei,* Leipzig, 1918; C. Glaser, *Die
altdeutsche Malerei,* Munich, 1924; W. Worringer, *Die Anfänge der
Tafelmalerei,* Leipzig, 1924; O. Pächt, *Österreichische Malerei der
Gotik,* Vienna, 1929; C. Glaser, *Les peintres primitifs allemands,* Paris,
1931; A. Stange, *Deutsche Malerei der Gotik,* Berlin, Munich, 1934-
60; K. Oettinger, *Altdeutsche Maler der Ostmark,* Vienna, 1942;
F. Winkler, *Die altdeutsche Tafelmalerei,* 2d ed., Munich, 1944;
M. Levey, *National Gallery Catalogues, The German School,* London,
1949; A. Stange, *German Painting of the XV-XVIth Centuries,* Lon-
don, 1950; A. Stange, "Gothic Art," *EWA,* VI, 1962, 589-92, 617,
618; S. Waetzoldt, "German Art," *EWA,* VI, 1962, 168-71, 173-77.

1. K. Oettinger, *Hans von Tübingen und seine Schule,* Berlin, 1938;
M. Levey, *National Gallery Catalogue, The German School,* Lon-
don, 1949; V. Oberhammer *et al., Europäische Kunst um 1400,*
120-24, nos. 54-57 (exhib. cat.).
2. V. Oberhammer *et al., Europäische Kunst um 1400,* 118-19, no. 53.
3. H. Platte, *Meister Bertram; Bilderhefte der Hamburger Kunsthalle,*
I, Hamburg, n.d. (c. 1959?).
4. For Cologne painting see O. Förster, *Das Wallraf-Richartz
Museum in Köln,* Cologne, 1961; V. Oberhammer *et al., Euro-
päische Kunst um 1400,* 133-34, no. 68.
5. For Westphalia, Middle and Upper Rhine, see V. Oberhammer
et al., Europäische Kunst um 1400.
6. B. Martens, *Meister Francke,* Hamburg, 1929; A. Stange, "Frater
Francke," *Kindlers Malerei Lexikon,* II, Zurich, 1965, 438-50
(adoption of H. Reineke's thesis that Francke was a Dominican
monk).

PART II: THE FIFTEENTH CENTURY

W. Conway, *The Van Eycks and Their Followers,* London, 1921;
P. Clemen, ed., *Belgische Kunstdenkmäler,* I, Munich, 1923;
M. J. Friedländer, *Die altniederländische Malerei,* Berlin, Leyden,
1924-37, I-VI, IX, XIV (also *Early Netherlandish Painting,* Vols I and
II, trans. H. Norden, Brussels, Leyden, 1967); F. Winkler, *Die alt-
niederländische Malerei,* Berlin, 1924; Fierens-Gevaert, *Histoire de la
peinture flamande,* Paris, 1927-29; Carel van Mander, *Dutch and
Flemish Painters* (trans. of the *Schilderboeck*), trans. C. van de Wall,
New York, 1936; G. J. Hoogewerff, *De Noord-nederlandsche Schilder-
kunst,* II, The Hague, 1937; L. van Puyvelde, *La peinture flamande,
au siècle des Van Eyck,* Paris, 1953; *Les primitifs flamands, I, Corpus de
la peinture des anciens Pays-Bas méridionaux, Publications du Centre
national de Recherches "Primitifs flamands"* [1, A. Janssens de Bisthoven
and R. Parmentier, *Le Musée Communal de Bruges,* 2d ed. Antwerp,
1959; 2, C. Arù and E. de Geradon, *La Galerie Sabauda de Turin,*
Antwerp, 1952; 3, M. Davies, *The National Gallery, London,* Ant-
werp, 1953-54; 4, C. Eisler, *The New England Museums,* Brussels,
1961; 5, H. Adhémar, *Le Musée National du Louvre,* I, Brussels, 1962;
6, R. van Schoute, *La Chapelle Royale de Grenade,* Brussels, 1963;
7, J. Lavalleye, *Le Palais Ducal d'Urbin,* Brussels, 1964; 8, V. Loe-
winson-Lessing and N. Nicouline, *Le Musée de l'Ermitage, Leningrad,*
Brussels, 1965; 9, J. Bialostocki, *Les Musées de Pologne (Gdańsk,
Kraków, Warszawa),* Brussels, 1966;] II, *Répertoire des peintures fla-
mandes des quinzième et seizième siècles;* J. Lavalleye, *Collections d'Es-
pagne,* 1-2, Antwerp, 1953-58; E. Michel, *Musée National du Louvre,
Catalogue raisonné des peintures du moyen âge, de la renaissance et des
temps modernes, Peintures flamandes du XVe et du XVIe siècle,* Paris, 1953;
R. Genaille, *De van Eyck à Bruegel,* Paris, 1954; M. Davies, *National
Gallery Catalogues, Early Netherlandish School,* 2d ed., London, 1955;
P. Fierens, ed., *L'art en Belgique du moyen âge à nos jours,* Brussels,
1956; M. J. Friedländer, *From Van Eyck to Bruegel,* London, 1956;
J. Lassaigne and R. Delevoy, *Flemish Painting,* I, Geneva, 1956;
L. van Puyvelde, *The Flemish Primitives,* Brussels, 1958; P. Core-
mans, ed., *Detroit Institute of Arts, Flanders in the Fifteenth Century:
Art and Civilization,* Detroit, 1960 (exhib. cat.); V. Denis, G. Knut-
tel, and R. Meischke, "Flemish and Dutch Art," *EWA,* V, 1961,
409-12, 430-32, 449-50; M. Meiss, "Highlands in the Lowlands':
Jan van Eyck, the Master of Flémalle and the Franco-Italian Tradi-
tion," *GBA,* ser. 6, LVII, 1961, 273-314; J. Folie, "Les œuvres
authentifiées des primitifs flamands," *BIRPA,* Brussels, VI, 1963,
183-256.

CHAPTER 4: THE MASTER OF FLÉMALLE

1. C. Sterling, *La peinture française: les primitifs*, Paris, 1938, 61.
2. For the symbolism of the *Mérode Altarpiece* see: M. Schapiro, "*Muscipula Diaboli*: The Symbolism of the Mérode Altarpiece," *AB*, XXVII, 1945, 182–87; M. Freeman, "The Iconography of the Mérode Altarpiece," *BMMA*, XVI, 1957, 138–40; M. Schapiro, "A Note on the Mérode Altarpiece," *AB*, XLI, 1959, 327–29.
3. C. de Tolnay, "L'autel Mérode du Maître de Flémalle," *GBA*, ser. 6, LIV, 1959, 65–78; C. de Tolnay, "Supplément concernant l'autel Mérode du Maître de Flémalle," *GBA*, ser. 6, LV, 1960, 177–80. See also C. Gottlieb, "The Brussels Version of the Mérode Annunciation," *AB*, XXXIX, 1957, 53–59
4. That the Von Werl work probably came from Rogier's shop, seems to be supported by the fact that Friedrich Herlin, that ardent Rogier follower, copied the figure of John in his altarpiece of 1459 for the Herrgottskirche in Nördlingen.
5. M. Davies, *The National Gallery*, London, 1953–54, I, 49–69.
6. The modern view of the Master of Flémalle was proposed in C. de Tolnay, *Le maître de Flémalle et les frères van Eyck*, Brussels, 1939.

CHAPTER 5: THE VAN EYCKS

1. The most complete recent bibliography on the Van Eycks since Panofsky and L. Baldass (*Jan van Eyck*, London, 1952) is O. Kurz, "Van Eyck," *EWA*, VI, 1961, 323–31. See also V. Denis, *All the Paintings of Jan van Eyck*, New York, 1961.
2. For the documents see W. Weale and M. Brockwell, *The Van Eycks and Their Art*, London, 1912.
3. M. Meiss, "Light as Form and Symbol," *AB*, XXVII, 1945, 145–47.
4. F. Lyna, "L'œuvre présumée de Jean van Eyck," *Scrip*, XVI, 1962, 93–94.
5. An Adam Dumont, court painter to Philip the Good, may be Lyna's "Du Mont." Adam Dumont is traceable in Dijon after mid-century.
6. P. Coremans, *L'agneau mystique au laboratoire, examen et traitement*, Antwerp, 1953.
7. M. Dvořák, *Das Rätsel der Kunst der Brüder van Eyck*, Munich, 1925.
8. J. Desneux, "Underdrawings and *Pentimenti* in the Pictures of Jan van Eyck," *AB*, XL, 1958, 13–21.
9. J. Seznec, *The Survival of the Pagan Gods*, New York, 1953; J. Seznec, "Myth and Fable," *EWA*, X, 1965, 463–82.
10. For the symbolic elements in the Detroit *St. Jerome* see I. Bergström, "Medicina, Fons et Scrinium: A Study in van Eyckian Symbolism and Its Influence in Italian Art," *KonstT*, XXVI, 1957, 1–20.
11. E. Panofsky, "A Letter to St. Jerome: A Note on the Relationship between Petrus Christus and Jan van Eyck," *Studies in Art and Literature for Belle da Costa Greene*, Princeton, 1954, 102–08.
12. P. Durrieu, *Heures de Turin*, Paris, 1902.
13. G. Hulin de Loo, *Heures de Milan*, Brussels, 1911.
14. F. Lyna, "Les Van Eyck et les 'Heures de Turin et de Milan,'" *BBelg*, Brussels, 1955, 1–3 (Miscellanea Erwin Panofsky), 7–20; F. Lyna, "Elisabeth de Görlitz et les 'Heures de Turin et de Milan,'" *Scrip*, XV, 1961, 121–25; F. Lyna, "L'œuvre présumée de Jean van Eyck", *Scrip.*, XV, 1961, 93–94.
15. L. Baldass, *Jan van Eyck*, 92–94.
16. A. Châtelet, "Les enluminures eyckiennes des manuscrits de Turin et de Milan-Turin," *RA*, VII, 1957, 115–63.

CHAPTER 6: ROGIER VAN DER WEYDEN

1. E. Panofsky, *Early Netherlandish Painting*, 249.
2. For Rogier's biography see. G. Hulin de Loo, "Rogier van der Weyden," *Biographie nationale de Belgique*, XXVII, 1938, 222–24.
3. For the earliest paintings by Rogier see. K. Birkmeyer, "Notes on the Two Earliest Paintings by Rogier van der Weyden," *AB*, XLIV, 1962, 329–31.
4. C. Eisler, *The New England Museums*, Brussels, 1961, 71–93.
5. R. van Schoute, *La Chapelle Royale de Grenade*, Brussels, 1963, 87–109.
6. K. Birkmeyer, "The Arch Motif in Netherlandish Painting of the Fifteenth Century," *AB*, XLIII, 1961, 1–20, 99–112.
7. J. Breckenridge, "'Et Prima Vidit': The Iconography of the Appearance of Christ to His Mother," *AB*, XXXIX, 1957, 9–32.
8. L. Delaissé, *Miniatures médiévales*, Geneva, 1958, pl. 27 (color).

9. E. Panofsky, "Two Rogier Problems: The Donor of the Hague *Lamentation* and the Date of the *Altarpiece of the Seven Sacraments*," *AB*, XXXIII, 1951, 33–40.

CHAPTER 7: THE SECOND GENERATION

1. J. Lejeune, "Le Premier des Petrus Christus et 'La Vierge au Chartreux,'" *BBelg*, Brussels, 1955, 1–3 (Miscellanea Erwin Panofsky), 151–70.
2. C. de Tolnay, "Flemish Paintings in the National Gallery of Art," *MA*, XXIV, 1941, 174–200.
3. P. Kelleher, "*Madonna and Child in a Gothic Interior* by Petrus Christus in the William Rockhill Nelson Gallery of Art," *AQ*, XX, 1957, 112–16; R. Koch, "A Rediscovered Painting by Petrus Christus," *Con.*, CXL, 1957, 271–76.
4. Illustrated in Friedländer, *Altniederländische Malerei*, I, pl. 65.
5. A. Châtelet, "Albert van Ouwater," *GBA*, ser. 6, LV, 1960, 65–78; J. Snyder, "The Early Haarlem School of Painting," *AB*, XLII, 1960, 39–49.
6. W. Schöne, *Dieric Bouts und seine Schule*, Berlin, Leipzig, 1938; F. Baudoin and K. G. Boon, eds., *Palais des Beaux-Arts, Bruxelles, Museum Prinsenhof, Delft, 1957–58, Dieric Bouts*, Brussels, 1958 (exhib. cat.); V. Denis, *Thierry Bouts*, Brussels, 1957; H. Adhémar, *Le Musée National du Louvre*, Brussels, 1962, I, 33–65; R. van Schoute, *La Chapelle Royale de Grenade*, Brussels, 1963, pp. 29–57.
7. J. G. van Gelder, "Het zogenaamde portret van Dieric Bouts op het 'Werc van den Heilichen Sacrament,'" *OHoll*, LXVI, 1951, 51–52.
8. J. Snyder, "The Early Haarlem School of Painting," 49–55.

CHAPTER 8: THE SECOND GENERATION

1. J. Lavalleye, *Juste de Gand, peintre du duc Frédéric de Montefeltre*, Louvain, 1936.
2. G. Hulin de Loo, *Pedro Berruguete et les portraits d'Urbin*, Brussels, 1942; D. Angulo Iñíguez, "Pintura del renacimiento," *Ars Hispaniae*, XII, Madrid, 1954, 89–90; *Musée de Gand, Juste de Gand-Berruguete et la cour d'Urbino*, Brussels, 1957 (exhib. cat.); K. G. Boon, "Bouts, Justus of Ghent and Berruguete," *BurlM*, C, 1958, 8–15; J. Lavalleye, *Le Palais Ducal d'Urbin*, Brussels, 1964.
3. R. Koch, "The Salamander in Van der Goes' *Garden of Eden*," *JWarb*, XXVIII, 1965, 323–26 and Appendix (by H. Kessler).
4. For symbolism in the *Portinari Altarpiece* see R. Walker, "The Demon of the *Portinari Altarpiece*," *AB*, XLII, 1960, 218–219; M. McNamee, "Further Symbolism in the *Portinari Altarpiece*," *AB*, XLV, 1963, 142–43; R. Koch, "Flower Symbolism in the *Portinari Altar*," *AB*, XLVI, 1964, 70–77. See also F. Winkler, *Hugo van der Goes*, Berlin, 1964.
5. J. Destrée, *Hugo van der Goes*, Paris, Brussels, 1914.

CHAPTER 9: GEERTGEN TOT SINT JANS AND THE MASTER OF THE VIRGO INTER VIRGINES

1. R. Koch, "Geertgen Tot Sint Jans in Bruges," *AB*, XXXIII, 1951, 259–60.
2. For Geertgen's development see J. Snyder, "The Early Haarlem School of Painting," *AB*, XLII, 1960, 113–32.
3. W. M. Conway, *Woodcutters of the Netherlands*, Cambridge, 1884.

CHAPTER 10: HANS MEMLINC

1. V. Denis, "Hans Memlinc," *EWA*, IX, 1964, 729–35.
2. J. Białostocki, *Les Musées de Pologne*, Brussels, 1966, pls. LXXX–CCXXXI.

CHAPTER 11: THE MINOR MASTERS AND MANUSCRIPT ILLUMINATION IN FLANDERS

1. For the minor masters see H. Wehle and M. Salinger, *Metropolitan Museum of Art, A Catalogue of Early Flemish, Dutch, and German Painting*, New York, 1947; C. Eisler, *The New England Museums*, Brussels, 1961, 94–111; P. Philipot, "La fin du quinzième siècle et les origines d'une nouvelle conception de l'image dans la peinture des Pays-Bas," *BBelg*, XI, 1962, 3–38.
2. W. Gibson, "A New Identification for a Panel by the St. Barbara Master," *AB*, XLVII, 1965, 504–06. The central panel is probably the Adoration of the Magi in the Casa Colonna, Rome, cited by F. Zeri ("Un trittico del 'Maestro di Santa Barbara'," *Para.*, IX, 1960, 41–45).

3. For manuscript illumination in Flanders see F. Winkler, *Die Flämische Buchmalerei*, Leipzig, 1925; P. Durrieu, *La miniature flamande au temps de la cour de Bourgogne*, 2d ed., Paris, Brussels, 1927; F. Lyna, *De vlaamsche Miniatur van 1200 tot 1530*, Brussels, Amsterdam, 1933; L. Delaissé, *La miniature flamande, le mécénat de Philippe le Bon*, Brussels, Amsterdam, 1959; F. Unterkircher, *Bibliothèque Nationale d'Autriche, Manuscrits et livres imprimés concernant l'histoire des Pays-Bas, 1475–1600*, Brussels, 1962 (exhib. cat.); G. J. Hoogewerff, "Geldersche miniatuurschilders in de eerste helft van de XVde eeuw," *OHoll*, LXXVI, 1961, 3–49.

4. The attribution of the works of Mazerolles to Liéven van Lathem was made by A. De Schrijver in an unpublished doctoral dissertation at the University of Ghent, 1957 (*De miniaturisten in dienst Karel de Stoute*). See L. Delaissé, *La miniature flamande*, 102.

5. O. Pächt, *The Master of Mary of Burgundy*, London, 1948.

6. F. Unterkircher, *Manuscrits et livres imprimés*.

CHAPTER 12: GERARD DAVID

1. For the most complete recent bibliography on Gerard David see H. Adhémar, *Le Musée National du Louvre*, I, Brussels, 1962, 110–12.

CHAPTER 13: HIERONYMUS BOSCH

1. The basic modern book on Bosch is C. de Tolnay, *Hieronymus Bosch*, Basel, 1937; rev. ed., *Hieronymus Bosch*, Baden-Baden, 1966. See also D. Bax, *Ontcijfering van Jeroen Bosch*, The Hague, 1949; L. B. Philip, "The Prado *Epiphany* by Jerome Bosch," *AB*, XXXV, 1953, 267–93; C. D. Cuttler, "The Lisbon *Temptation of St. Anthony* by Jerome Bosch," *AB*, XXXIX, 1957, 109–26; C. D. Cuttler, "Witchcraft in a Work by Bosch," *AQ*, XX, 1957, 129–40; J. Combe, "Hieronymus Bosch," *EWA*, II, 1960, 570–80; L. Baldass, *Hieronymus Bosch*, New York, 1960; R. Delevoy, *Bosch*, Lausanne, 1960; C. D. Cuttler, review of Baldass and Delevoy, *AJ*, XX, 1961, 246–49; S. Sulzberger, "Jérôme Bosch et l'enluminure," *Scrip.*, XVI, 1962, 46–49; K. G. Boon *et al.*, *Jheronimus Bosch*, 's-Hertogenbosch, 1967 (exhib. cat.).

CHAPTER 14: THE PAINTERS OF FRANCE

1. See previous bibliography on France, Chapter 1; also P. Pradel, "French Art," *EWA*, V, 1961, 658–62; M. Roques, *Les apports néerlandais dans la peinture du sud-est de la France, XIVe, XVe, et XVIe siècles*, Bordeaux, 1963

2. W. Hinkle, "The Iconography of the Four Panels by the Master of St. Giles," *JWarb*, XXVIII, 1965, 110–44.

3. For Fouquet see P. Wescher, "Jean Fouquet," *EWA*, V, 1961, 511–14.

4. For Master François see D. Miner, ed., *Illuminated Books of the Middle Ages and Renaissance*, Baltimore, 1949, nos. 109, 111, 112; J. Porcher, ed., *Les manuscrits à peintures en France du XIIIe au XVIe siècle*, Paris, 1955, 117–19, 128–31 (exhib. cat.).

5. R. Limousin, *Jean Bourdichon*, Lyon, 1954.

6. O. Smital and E. Winkler, *René duc d'Anjou, Le livre de cuer d'Amours éspris*, Vienna, 1927.

7. For the Master of Moulins, see M. Huillet d'Istria, *La peinture française de la fin du moyen âge (1480–1530)*, Paris, 1961; C. Sterling, "Du nouveau sur le Maître de Moulins," *L'œil*, no. 107, 2–15, 65–68; M. Huillet d'Istria, "The Problem of the Master of Moulins," *BurlM*, CVI, 1964, 43–45. For Perréal, see C. Sterling, "Une peinture certaine de Perréal enfin retrouvée," *L'œil*, nos. 103–04, 2–15, 64–65.

8. A. Châtelet, "A Plea for the Master of Moulins," *BurlM*, CIV, 1962, 517–24.

9. M. Laclotte, *L'école d'Avignon*, Paris, 1960.

10. C. Sterling, "L'auteur de la 'Pietà' d'Avignon: Enguerrand Quarton (Charenton)," *BAntFr*, 1959, (appeared in 1961), 213–23.

11. C. Sterling, *Le "Couronnement de la Vierge" par E. Quarton*, Paris, 1939.

12. E. Harris, "*Mary in the Burning Bush*: Nicolas Froment's Triptych in Aix-en-Provence," *JWarb*, I, 1938, 281–86.

12. C. Sterling, "Josse Lieferinxe, peintre provençal," *RL*, XIV, 1964, 1–22.

CHAPTER 15: SPAIN AND HISPANO-FLEMISH PAINTING

1. C. R. Post, *History of Spanish Painting*, II–XII, Cambridge, Mass., 1930–58; J. Gudiol, *Spanish Painting*, Toledo, 1941; J. Lassaigne,

Spanish Painting, I, Geneva, 1952; D. Angulo Iñíguez, "Pintura del rinascimiento," *Ars Hispaniae*, XII, 1954; J. Gudiol, "Pintura Gotica," *Ars Hispaniae*, IX, Madrid, 1955; J. Gaya Nuño, *La pintura española fuera de España (Historia y catálogo)*, Madrid, 1958; R. dos Santos, *Historia del arte português*, Barcelona, 1960; J. Dominguez Bordona, "Miniatura," *Ars Hispaniae*, XVIII, Madrid, 1962; M. Laclotte, ed., *Trésors de la peinture espagnole: Eglises et musées de France*, 2d ed., Paris, 1963 (exhib. cat.); J. Gudiol and S. Alcolea, "Spanish and Portuguese Art," *EWA*, XIII, 1967, 313, 314, 322–24.

2. J. Porcher, *Le bréviaire de Martin d'Aragon*, Paris, n.d.

3. J. Gudiol, *Luis Borrassá*, Barcelona, 1953.

4. J. Gudiol, *Bernardo Martorell*, Madrid, 1958

5. For the Walters Gallery *Madonna and Child*, see P. Verdier, ed., *The International Style: The Arts in Europe around 1400*, Baltimore, 1962.

6. Related in figure type to the Eyckian New York diptych panel of the Crucifixion, the *Descent from the Cross* in the Muntadas Collection, Barcelona, was attributed by Post (*History of Spanish Painting*, VII, 1, fig. 2) to Luis Dalmau. The work thus aids in dating the New York diptych as a work of the early 1430s, when Dalmau was visiting the shops in Bruges.

7. B. Rowlandson, *Jaime Huguet*, Cambridge, Mass., 1932; J. Gudiol and J. Ainaud, *Huguet*, Barcelona, 1948; J. Ainaud, *Jaime Huguet*, Madrid, 1955.

8. J. Gaya Nuño, *Fernando Gallego*, Madrid, 1958.

9. J. Gudiol, "El pintor Diego de la Cruz," *Goya RevA*, no. 70, 1966, 208–17.

10. For Sithium see *Flanders in the Fifteenth Century*, 197–99.

11. For Juan de Flandes see Post, *History of Spanish Painting*, XII, 2, Appendix, 1958; E. Bermejo, *Juan de Flandes*, Madrid, 1962.

12. R. dos Santos, *Nuño Gonsalves*, London, 1955.

13. For Berruguete see chap. 8, note 2; also M. Laclotte, ed., *Trésors de la peinture espagnole*, Paris, 1963, 39–45.

CHAPTER 16: PAINTING IN GERMANY AND AUSTRIA

1. In addition to previous bibliography see M. Weinberger, *Nürnberger Malerei an der Wende zur Renaissance*, Strasbourg, 1921; E. Buchner and K. Feuchtmayr, *Oberdeutsche Kunst der Spätgotik und Reformationszeit (Beiträge zur Geschichte der deutschen Kunst*, I), Augsburg, 1924; E. Buchner and K. Feuchtmayr, *Augsburger Kunst der Spätgotik und Renaissance (Beiträge zur Geschichte der deutschen Kunst*, II), Augsburg, 1928; H. Busch, *Meister des Nordens: Die altniederdeutsche Malerei, 1450–1550*, Hamburg, 1943.

2. For Lochner see M. Levey, *The German School, National Gallery Catalogues*, London, 1949, 59–62; O. Förster, *Stephan Lochner*, Bonn, 1952, 3d ed.; O. Förster, "Stefan Lochner," *EWA*, IX, 1964, 215–17.

3. Thieme-Becker, XXXVII, 1950.

4. For an aspect of Witz's influence, see C. Sterling, "Josse Lieferinxe, peintre provençal," *RL*, XIV, 1964, 13–14.

5. K. Gerstenberg, *Hans Multscher*, Leipzig, 1928.

CHAPTER 17: PAINTING IN GERMANY AND AUSTRIA

1. For the Cologne masters see F. Baudoin and K. G. Boon, *Dieric Bouts*, Brussels, 1958, 80–82. (exhib. cat.).

2. E. Buchner, *Martin Schongauer als Maler*, Berlin, 1941; J. Baum, *Martin Schongauer*, Vienna, 1948; F. Winzinger, "Martin Schongauer," *EWA*, XII, 1966, 793–97. For his prints see pp. 303-08.

3. H. Bossert and W. Storck, *Das mittelalterliche Hausbuch*, Leipzig, 1912; E. Panofsky, *Early Netherlandish Painting*, 324; E. Solms-Laubach, "Nachtrag zu Erhard Reuwich," *ZfKunstW*, X, 1956, 187–92; A. Stange, *Der Hausbuch Meister (Studien zur deutschen Kunstgeschichte*, 316), Strasbourg, 1958; H. T. Musper, *Gotische Malerei nördlich der Alpen*, 41–42; J. Hutchison, "The Housebook Master and the Folly of the Wise Man," *AB*, XLVIII, 1966, 73–78.

4. E. Hempel, *Das Werk Michael Pachers*, 4th ed., Vienna, 1943; K. Noehles, "Michael Pacher," *EWA*, X, 1965, 896–99.

CHAPTER 18: PRINTING AND PRINTS

1. For broad coverage of the history of printing and prints see A. Bartsch, *Le peintre-graveur*, Vienna, 1803–21; J. Passavant, *Le peintre-graveur*, Leipzig, 1860–64; W. Schreiber, *Manuel de l'amateur de la gravure sur bois et sur métal au XVe siècle*, Berlin, Leipzig, 1891–1910; P. Heitz, ed., *Einblattdrucke des fünfzehnten Jahr-*

hunderts, Strasbourg, 1899–1938; C. Dodgson, *Catalogue of Early German and Flemish Woodcuts Preserved in the Department of Prints and Drawings, British Museum,* London, 1903–11; M. Lehrs, *Geschichte und kritischer Katalog des Deutschen, Niederländischen, und Französischen Kupferstichs im XV. Jahrhundert,* Vienna, 1908–34; A. Schramm, *Der Bilderschmuck der Frühdrucke,* Leipzig, 1920—; A. M. Hind, *A History of Engraving and Etching,* 3d ed., Boston, 1923, repr. New York, 1963; A. Delen, *Histoire de la gravure dans les anciens Pays-Bas,* I, *Des origines à 1500,* Paris, 1924; W. Schreiber, *Handbuch des Holz-und Metalschnittes des XV. Jahrhunderts,* Leipzig, 1926–30; D. Hunter, *Paper Making through Eighteen Centuries,* New York, 1930; A. Blum, *On the Origins of Paper,* New York, 1934; C. Dodgson, *British Museum, Woodcuts of the XV Century in the Department of Prints and Drawings,* London, 1934–35; A. M. Hind, *An Introduction to a History of Woodcut,* Boston, 1935, repr. New York, 1963; C. Zigrosser, *Six Centuries of Fine Prints,* New York, 1937; C. Schniewind, *Art Institute, Chicago, The First Century of Printmaking, 1400–1500,* 1941 (exhib. cat.); C. Zigrosser, *The Book of Fine Prints,* 2d ed., New York, 1948; F. Hollstein, *Dutch and Flemish Etching, Engravings and Woodcuts,* Amsterdam, 1949–56; F. Hollstein, *German Engravings, Etchings and Woodcuts,* Amsterdam, 1954–62; C. Petrucci, "Engraving and Other Print Media," *EWA,* IV, 1961, 748–65; 783–85; A. Stevenson, "The Quincentennial of Netherlandish Block Books," *BMQ,* XXXI. 3–4, 1967, 83–87.

2. A relationship with Mainz has been asserted by H. Lehmann-Haupt in *Gutenberg and the Master of the Playing Cards,* New Haven, 1966.

3. M. Geisberg, *Der Meister der Berliner Passion und Israhel van Meckenem,* Strasbourg, 1903; M. Geisberg, *Kupferstich der Frühzeit,* Leipzig, 1923.

4. M. Geisberg, *Die Kupferstiche des Meisters E. S.,* Berlin, 1924; E. Hoffman, "Some Engravings Executed by the Master E.S. for the Benedictine Monastery of Einsiedeln," *AB,* XLIII, 1961, 231–37; A. Shestack, ed., *Master E.S.,* Philadelphia, 1967 (exhib. cat.).

5. Hollstein, *Dutch and Flemish Etching,* XII.

6. H. Meier, "Some Israhel van Meckenem Problems," *PrtCollQ,* XXVII, 1940, 27–67; F. Carrington, "After a Lost Original, 'Twelve Scenes from Daily Life' Engraved by Israhel van Meckenem," *PrtCollQ,* XXVII, 1940, 321–36.

7. For bibliography of the Housebook Master see Chap. 17, note 3.

8. J. Hutchison, "The Housebook Master and the Folly of the Wise Man."

9. M. Lehrs, *Der Meister L C Z und der Meister W . . . B,* Berlin, 1922.

PART III: THE SIXTEENTH CENTURY

CHAPTER 19: ALBRECHT DÜRER

1. See previous bibliography; see also W. Deusch, *German Painting of the 16th Century,* London, 1936; E. Buchner, *Das deutsche Bildnis der Spätgotik und der frühen Dürerzeit,* Berlin, 1953; S. Waetzoldt, "German Painting," *EWA,* VI, 1962, 177–81, 200; M. Laclotte, ed., *Petit Palais, Le seizième siècle européen, Peintures et dessins dans les collections publiques françaises,* Paris, 1965–66 (exhib. cat.); M. Whinney, A. Blunt, and C. White, "The Renaissance outside Italy," *EWA,* XII, 1966, 121–55.

2. E. Panofsky, *The Life and Art of Albrecht Dürer,* 3d ed., Princeton, 1948, 4th ed., 1955; Jan Białostocki, "Albrecht Dürer" *EWA,* IV, 1961, 512–31.

3. Quoted with permission from Sebastian Brant, *The Ship of Fools,* translated into rhyming couplets, with introduction and commentary by Edwin H. Zeydel and with reproduction of the original woodcuts, New York, 1944, new ed., New York, 1962.

4. J. Poesch, "Sources for Two Dürer Enigmas," *AB,* XLVI, 1964, 78–82.

5. Attributed to Dürer's pupil, Hans Baldung, by H. Tietze and E. Tietze-Conrat, according to the Albertina Collection's catalogue of German drawings of 1933. The authorities of the Albertina Collection follow Tietze and Tietze-Conrat, though Winkler twice rejected the attribution (1938, 1957).

6. F. Winzinger, "Albrecht Dürer in Rom," *Pan,* XXIV, 1966, 283–87.

7. For Dürer's writings see W. M. Conway, *The Writings of Albrecht Dürer,* New York, 1958 (repr. of *Literary Remains,* Cambridge, 1889), with introd. by A. Werner.

8. E. Panofsky, *Studies in Iconology,* New York, 1939, new ed., New York, Evanston, London, 1962, chap. VI.

CHAPTER 20: GRÜNEWALD

1. K. Sitzmann and E. Battisti, "Grünewald," *EWA* VII, 1963, 182–91; A. Schädler, "Zu den Urkunden über Mathis Gothart Neithart," *MünchJb,* ser. 3, XIII, 1962, 69–74.

2. For a relationship to Dürer and the sources of the Temptation scene, see C. D. Cuttler, "Some Grünewald Sources," *AQ,* XIX 1956, 101–24.

3. So far as is known Grünewald had no pupils nor direct followers. Closest to his spirit was Jerg Ratgeb, who was hanged and quartered at Pforzheim in 1526 for his participation in the Peasants' Revolt. Ratgeb was born about 1480 in Schwäbisch-Gmünd or Herrenberg; he worked in Strasbourg, and also in Heilbronn, Frankfurt (where between 1514–17 he painted some now much damaged frescoes of eremitical life), and Herrenberg. For Herrenberg he painted an altarpiece, dated 1519, now in Stuttgart. The Resurrection panel shows Grünewald's influence in the aureole of light around Christ's head and in the actions of the soldiers, though the scene takes place in daylight. Ratgeb's strange lights and delicate though angular forms also seem related to the expressive spirit found earlier in the middle Rhine region (for example, in Hans Hirtz, possibly identical with the Master of the Karlsruhe Passion panels). Ratgeb's color is flatter and less sonorous than that of Grünewald, and he was open to other influences, the Herrenberg Altarpiece predella, for example, being based on Dürer's 1513 engraving of the *Angels with the Sudarium.* At the same time, his spacious landscape backgrounds are closer in feeling to contemporary work in the Netherlands than to that in Germany. Against his backgrounds he set elongated, angular bodies sparsely modeled. The Renaissance ornament and architectural elements visible in his work seem to have been derived from prints, though he transformed his borrowings by dramatic perspectives and strong actions.

CHAPTER 21: LUCAS CRANACH THE ELDER

1. For the Danube school in general see *St. Florian and Linz, Die Kunst der Donau-Schule,* 1965 (exhib. cat.).

2. G. and K. Noehles, "Lucas Cranach the Elder," *EWA,* IV, 1961, 64–70.

CHAPTER 22: ALBRECHT ALTDORFER

1. G. and K. Noehles, "Altdorfer," *EWA,* I, 1959, 221–26.

CHAPTER 23: HANS BALDUNG GRIEN

1. C. Koch, *Staatliche Kunsthalle, Karlsruhe, Hans Baldung Grien,* 2d ed., 1959 (exhib. cat.).

CHAPTER 24: THE DÜRER SCHOOL, DANUBE-STYLE FOLLOWERS, AND SWISS PAINTING

1. For the Dürer school see P. Strieder, ed., *Anzeiger des Germanischen National-Museum, Meister um Dürer,* Nuremberg, 1961 (exhib. cat.).

2. See chap. 21, note 1.

3. K. Oettinger, "Zu Wolf Hubers Frühzeit," *JKS,* Bd. 53, N.F. XVII, 1957, 71–73; G. Künstler, "Wolf Huber als Hofmaler des Bischofs von Passau Graf Wolfgang von Salm," *JKS,* Bd. 58, N.F. XXII, 1962, 73–100.

CHAPTER 25: PAINTING IN AUGSBURG

1. F. Grossmann, "Holbein," *EWA,* VII, 1963, 586–97; *Hans Holbein der Ältere und die Kunst der Spätgotik,* Augsburg, 1965 (exhib. cat.).

2. A. Burkhardt, *Hans Burgkmair der Ältere,* Leipzig, n.d.

3. P. Halm, "Hans Burgkmair als Zeichner, Teil I: Unbekanntes Material und neue Zuschreibungen," *MünchJb,* ser. 3, XIII, 1962 75–162.

4. C. Glaser, *Die Altdeutsche Malerei,* Munich, 1924.

5. P. Ganz, *The Paintings of Hans Holbein,* London, 1956; F. Grossmann, "Holbein," *EWA.*

6. For Holbein's anamorphic images see E. Samuel, "Death in the Glass—A New View of Holbein's 'Ambassadors,' " *BurlM,* CV, 1963, 436–38.

CHAPTER 26: THE NETHERLANDS

1. In addition to previous bibliography see J. Held, *Dürer's Wirkung auf die niederländische Kunst seiner Zeit,* The Hague, 1931; M. J. Fried-

länder, *Die altniederländische Malerei,* VII–XIV, Leyden, 1934–37; G. J. Hoogewerff, *De Noord-Nederlandsche Schilderkunst,* III–V, The Hague, 1939–47; R. Parks, ed., *John Herron Art Institute, Holbein and His Contemporaries,* Indianapolis, 1950 (exhib. cat.); L. van Puyvelde, *La peinture flamande à Rome,* Brussels, 1950; G. Marlier, *Erasme et la peinture flamande de son temps,* Damme, 1954; J. Leymarie, *Dutch Painting,* Geneva, 1956; J. Lassaigne and R. Delevoy, *Flemish Painting,* II, *From Bosch to Rubens,* Geneva, 1958; R. van Luttervelt *et al., Rijksmuseum, Middeleeuwse Kunst der noordelijke Nederlanden,* Amsterdam, 1958 (exhib. cat.); V. Denis G.Knuttel, and R. Meischke, "Flemish and Dutch Art", *EWA,* V, 1961, 412–15, 417–18, 426–27, 430–34, 449–51; L. van Puyvelde, *La peinture flamande au siècle de Bosch et Breughel,* Paris, Brussels, 1962; H. Pauwels, ed., *Musées Royaux des Beaux-Arts de Belgique, Le siècle de Bruegel, la peinture en Belgique au XVIe siècle,* 2d ed., Brussels, 1963 (exhib. cat.); P. Philipot, "Le Portrait à Anvers dans la seconde moitié du XVIe siècle," *BBelg,* XIV, 1965, 163–96.

2. K. G. Boon, *Quinten Massys,* Amsterdam, n. d.; L. Malle, "Quinten Metsys," *Com,* V, 1955, 79–107.

3. J. F., *Petit Palais, Le seizième siècle européen,* Paris, 1965–66, 158–59 (exhib. cat.).

4. L. van Puyvelde, "Eduardo Portugalois," *Pan,* XVIII, 1960, 288–90; L. Reis-Santos, *Eduardo, O Português,* Lisbon, 1966.

5. A fourth signed work by Patinir has been discovered by G. Marlier (*Erasme et la peinture flamande de son temps,* pl. 15) in a Belgian collection. See also R. Koch, "La Sainte Baume in Flemish Landscape Painting of the Sixteenth Century," *GBA,* ser. 6, LXVI, 1965, 273–82. R. Koch, *Joachim Patinir,* Princeton, 1968.

CHAPTER 27: FLEMISH MANNERISTS AND EARLY ROMANISTS

1. Gossart's chief pupil was Jan van Scorel. On Gossart himself see G. von der Osten, "Studien zu Jan Gossaert," in M. Meiss, ed., *De Artibus Opuscula XL, Essays in Honor of Erwin Panofsky,* New York, 1961, 454–75; F. Winkler, "Aus der ersten Schaffenszeit des Jan Gossaert," *Pan,* XX, 1962, 145–55; H. Pauwels, H. R. Hoetink, and S. Herzog, *Jean Gossaert dit Mabuse,* Rotterdam, Bruges, 1965 (exhib. cat.).

2. J. Białostocki, "New Observations on Joos van Cleef," *OHoll,* LXX, 1955, 121–29; H. Gerson, "Joos van Cleef," *OHoll,* LXX, 1955, 129–31.

3. L. Baldass, "Die Entwicklung des Bernart van Orley," *JKS,* N.F. XIII, 1944, 141–91.

CHAPTER 28: DUTCH MANNERISTS AND EARLY ROMANISTS

1. In addition to previous bibliography see F. Winkler, "Zur Kenntnis und Würdigung des Jan Mostaert," *ZfKunstW,* XIII, 1959, 177–214.

2. N. Beets, *Lucas van Leyden,* Amsterdam, 1940; M. Friedländer, *Lucas van Leyden,* Berlin, 1963; K. G. Boon, "Lucas van Leyden," *EWA,* IX, 1964, 349–53.

3. Hoogewerff dates the *Self-portrait* 1515–16, Friedländer between 1508 and 1512, Beets 1509–10, and De Jonghe between 1518 and 1519.

4. A. C. Esmeijer and S. H. Levie, eds., *Centraal Museum, Jan van Scorel,* Utrecht, 1955 (exhib. cat.).

CHAPTER 29: LATER ROMANISTS AND THE RISE OF GENRES

1. In addition to previous bibliography see J. Bousquet, "Marten van Heemskerk y el manierismo nórdico," *GoyaRevA,* 1958–59, 274–78.

2. I. Bergström, *Dutch Still-life Painting,* New York, 1956, 12.

3. E. Panofsky, *Renaissance and Renascences in Western Art,* 2d ed., Stockholm, 1965, 190.

4. G. Marlier, *La Renaissance flamande, Pierre Coeck d'Alost,* Brussels, 1966.

5. J. Lejeune, ed., *Lambert Lombard et son temps,* Liège, 1966 (exhib. cat.).

6. G. Washburn, "Genre," *EWA,* VI, 1962, 86–91, 107.

7. K. Clark, "Landscape," *EWA,* VIII, 1964, 11–15.

8. R. Genaille, "L'œuvre de Pieter Aertsen," *GBA,* ser. 6, XLIV, 1954, 267–88, 305–08.

CHAPTER 30: PIETER BRUEGEL THE ELDER

1. In addition to previous bibliography see G. Marlier, "Peeter Balten, copiste ou createur?" *BBelg,* XIX, 1965, 127–41.

2. F. Grossmann, "Pieter Bruegel the Elder," *EWA,* II, 1960, 632–51; F. Grossmann, *Bruegel, the Paintings: Complete Edition,* London, 2d ed., 1966.

3. L. Munz, *Pieter Bruegel the Elder, the Drawings,* trans L. Hermann, New York, London, 1961; H. A. Klein, ed., *Graphic Worlds of Peter Bruegel the Elder,* New York, 1963.

4. E. Scheyer, "*The Wedding Dance* in the Detroit Institute of Arts: Relations and Derivations," *AQ,* XXVIII, 1965, 167–93.

5. W. Gibson, "Somes Notes on Pieter Bruegel the Elder's *Peasant Wedding Feast,*" *AQ,* XXVIII, 1965, 194–208.

INDEX

References are to page numbers, except for color plates, which are identified as such. Black-and-white illustrations are designated by *italic* page numbers, textual references by lightface numbers. The names of artists are given in CAPITALS; titles of works of art are in *italics*; and smaller works within these works follow in roman type.

Adolf, Prince of Burgundy 427
Adrian VI, Pope 450
Aegidius, Petrus 418
AERTSEN, PIETER 443, 458–460, 466; *Butcher's Shop* 459; *Christ in the House of Mary and Martha* 460; *The Cook* 460; *Egg Dance* 460; *Old Peasant Woman* 459; *Peasant Interior* 459
AKEN, ANTHONIS VAN 153
Albergati, Cardinal Niccolò 102, 105
Albrecht, Duke of Prussia 397
ALBRECHT MASTER *Annunciation* 275
ALLYNCBROOD, LOUIS *Crucifixion* 246
ALTDORFER, ALBRECHT 319, 339, 352, 357, 381–388, 406; *Allegory of Poverty and Riches* 387; *Battle of Alexander* 386–387, Pl. 27; *Birth of the Virgin* 385; *Christ on the Mount of Olives* 383; *Danube Landscape* 385; *Dead Foot-Soldier in the Forest* 382; *Holy Night* 383; influence of 389, 392, 398; *Life of St. Sebastian* 384; *Lot and His*

Daughters 387; *Pine Tree* 382; *Prayer Book* of Maximilian, work on 382; *Rest on the Flight into Egypt by a Fountain* 382; *St. Florian Legend* 384; St. Florian Passion panels 383; *St. George in a Wood* 382; *Satyr Family* 382; *Susanna at the Bath* 386
ALTDORFER, ERHARD 398
AMBERGER, CHRISTOPH 397, 401, 406–407; *Christoph Fugger* 407
AMSTEL, JAN VAN see BRUNSWICK MONOGRAMMIST
Andachtsbild 63, 165
ANGELICO, FRA 119, 147, 168
Angelroth, Balthasar 408
Anjou, Louis I of 14
Anjou, Louis II of 12, *36*, 39
Anjou, René of 224, 230, 233, 235
Anthony, Grand Bastard of Burgundy 126
Antiquity 76, 192, 325, 327, 328, 330, 336, 339, 351, 406, 424, 426, 427,

430, 431, 449, 454, 455 471, 472
ANTWERP MANNERISTS 435
APELLES 102
APT THE ELDER, ULRICH 401
Aquinas, St. Thomas 6, 105, 142, 203
Aragon, Cardinal Louis of 84
Aragonese style 250
Ars Moriendi 199, 202, *298*
Arras, Matthias of 44
Arras Sketchbook 198
Artist, concept of 102, 319, 323; status of 7; patronage of 66
Astrology 203, 206–209
Aubert, David 185
Austrian painting 51–53, 275–276, 284–288, 397–398
Avignon, School of 230; *Altarpiece of Boulbon* 231

Baelwael, Aegidius 140
BAERZE, JACQUES DE 22, 74
Baldass, Ludwig van 107, 108

BALDUNG GRIEN, HANS 358, 388–394; classical themes of 393; *Adam and Eve* (woodcut) 392; *Adam and Eve* 393; *Adoration of the Magi (Halle) Altarpiece* 388; *Ascension* 392; *Bewitched Groom* 394; *Christoph, Markgraf von Baden* 391; *Coronation of the Virgin Altarpiece* 391; *Crucifixion* 389; *Death and the Woman* 392; *Holy Family* 390; *Lamentation* (painting) 390; *Lamentation* (woodcut) 390; *Graf von Löwenstein* 391; *Luther as a Monk* 393; *Nativity* 392; *Philip the Warlike* 391; *Prayer Book* of Maximilian, work on 390; *Rest on the Flight into Egypt* 390; *St. Christopher* 389; *Three Ages of Man* 394; *Three Ages of Woman and Death* 389; *Wild Horses* 394; *Witches* 390
BALTEN, PIETER 469
BARBARI, JACOPO DE' 337, 339, 354, 373, 375, 427, 430, 441; *Victory and Glory* 339
Baroncelli, Maria 153, 171, 179
Baroque, anticipation of 431, 447, 453, 455, 485; late Gothic counterpart of 165, 191, 261, 275, 284, 305, 395, 397, 428
Bas-de-page 9, 10, 11, 106, 121
Basel, Council of 268
BASSA, FERRER 238
BATAILLE, NICOLAS 14
Bavaria, Jacqueline of 72
Bavaria, John of, Count of Holland 83, 106
BAVARIAN MASTER *Crucifixion* 53
Beaujeu, Anne of 226
BEAUNEVEU, ANDRÉ 8, 18, 47, 64; *Psalter of the Duke of Berry*, Isaiah 18
BECK, LEONHARD 312, 401
Becket, St. Thomas à 61, 63
Bedford, John of Lancaster, Duke of 34
BEDFORD MASTER 34–35, 38, 39, 97, 107; *Bedford Breviary* 35; *Bedford Hours* 34; *Book of the City of Women* 35; *Book of the Hunt* 34; *Dunois Hours* 107
BEER, ARNOLD DE 456
BEER, JAN DE 435; *Adoration of the Magi Triptych* 435
BEHAM, BARTHEL 396–397, 465; *Ludwig X of Bavaria* 396
BEHAM, HANS SEBALD 350, 396–397, 465; *Head of Christ* 396
BELLAERT, JACOB 146
BELLECHOSE, HENRI 25, 72; *Martyrdom of St. Denis* 24
BELLINI, GIOVANNI 342
BENING, ALEXANDER (SANDERS) 147, 154, 160, 189
BENING, SIMON 89, 189, 429, 478; *Grimani Breviary* 89, 189; *Hennessy Hours* 189, 478
BENSON, AMBROSIUS 197, 417
BERMEJO, BARTOLOMÉ 256–258; 260; *Descent into Limbo* 258; *Pietà* 257; *St. Engracia* 257; *St. George* 258; *St. Michael* 256

BERRUGUETE, PEDRO 148, 259–260; *St. Eulalia Retable* predella panels 260.
Berry, John, Duke of 6–8, 18–20, 27, 28, *39*, 48, 106, 220, 410
Berthoz, Hippolyte de, and Elizabeth Keverwyck 156
BEUCKELAER, JOACHIM 459, 460; *Christ in the House of Mary and Martha* 460; *Egg Woman* 460
Biblia Pauperum 141, 142, 234, 298
Binchois, Gilles 102
Bisticci, Vespasiano da 147
Bladelin, Pierre 120, *121*
BLES, HERRÍ MET DE 426, 435, 460–461; *Copper Mine* 461
BLONDEEL, LANCELOT 95, 450
Bohemian painting 12, 44–50; influence of 51–53, 55; *Krumau Virgin and Child* 85; *Model Book* 54; *Passional of Abbess Kunigunde*, Christ appearing to the Virgin 45
BONDOL (BANDOL, BOUDOLF), JEAN 8, 12–14, 15, 18, 47, 64; *Apocalypse Tapestries* 14; *Bible Historiée*, Charles V, and Jean de Vaudetar 13; *Bible of Jean de Sy*, Parting of Lot and Abraham 13; *Cité de Dieu* 15
Bonhominis, Alphonsus 206
Bonkil (Boncle), Edward 156, *157*
BOQUETAUX MASTER 12–15, 34; *Works of Guillaume de Machaut*, Amour and her children 15; see also BONDOL
BORRASSÁ, LUIS 239, 240; followers of 240; *Archangel Gabriel Retable* 239; *Beheading of John the Baptist* 239; *St. Peter Retable* 240
BOSCH, HIERONYMUS 67, 69, 142, 153, 165, 198–211, 310, 418, 423, 424, 426, 431, 474; *Christ Carrying the Cross* 210–211, Pl. 17; *Conjurer* 207; *Crucifixion* 200; *Death of the Miser* 201; *Ecce Homo* 200; *Epiphany Triptych* 211; *Garden of Earthly Delights* 210–211; *Haywain* 202; influence of 436, 443, 445–446, 457, 470, 473–474; *Intemperance* 203; *Last Judgment* (lost) 198; *Marriage at Cana* 200; *St. John on Patmos* 201; *Seven Deadly Sins* 199; *Seven Sacraments* (lost) 199; *Ship of Fools* 203; *Temptation of St. Anthony* 204–206; *Vagabond* 205
BOTTICELLI, SANDRO 67, 105, 165
Boucicaut, Jean le Meingre, Maréchal of 36–37
BOUCICAUT MASTER 34, 36–39, 52, 105; *Book of Hours* (Oxford, Bodleian, Douce 144) 38–39; *Book of Hours* (Paris, B.N. lat. 1161), burial scene *38*; *Book of Hours* (Paris, Mazarine 469) 39; *Boucicaut Hours*, Maréchal de Boucicaut and his wife, *36*, Nativity *37*, Visitation Pl. 4, *Dialogues of Pierre Salmon* 38; *Les Grandes Heures*, reception of the Duke of Berry into Paradise, *39*; *Livre des Merveilles* (with Bedford Master) 38
Bourbon, Cardinal Charles II of 220, 225

Bourbon, Jeanne de, Queen of France 16
Bourbon, Pierre II, Duke of 226
Bourbon, Suzanne, Princess of 226
BOURDICHON, JEAN 220–222; *Hours of Anne of Brittany*, Anne of Brittany in prayer *221*; *Hours of Charles VIII* 222; *Hours of Frederick II of Aragon*, stigmatization of St. Francis, *222*
BOUTS, AELBRECHT 135, 144, 146; *Assumption Altarpiece* 146
BOUTS, DIRK 69, 128, 135–146, 147, 150, 233; *Deposition Altarpiece* 137, copy 136; *Entombment* 138; *Infancy Altarpiece* 136–137; *Hell* 142; influence of 148, 151, 159, 163-166, 168, 175, 182-183, 199, 201, 252-253, 278-281, 303, 307, 419, 425, 448; *Justice of Emperor Otto III* 143, 144, Pl. 12; *Last Supper Altarpiece* 139, Pl. 11, panels from 140–142; *Madonna and Child* (Florence) 136; *Madonna and Child* (New York) 136; *Martyrdom of St. Erasmus* 138; *Paradise* 142; *Portrait of a Man* 139, *143*; *Virgin and Child* 143
BOUTS, THE YOUNGER, DIRK 135, 144–145, 151; *Behold the Lamb of God* 145; *Christ in the House of Simon* 145; *Moses and the Burning Bush* 145; *Nativity* fragments *(Madonna of Humility; Joseph)* 145; *Pearl of Brabant Altarpiece* 144; *Pietà* 145; *St. Christopher* (attrib.) 145; *Virgin and Child and Saints* 145
BRAMANTE, DONATO 384, 386, 452
BRAMANTINO 408
Brandenburg, Cardinal Albrecht von 358, 370, 396, *370*
Brant, Sebastian see *Narrenschiff*
BRÉA, LOUIS *Pietà* 233
BREU THE ELDER, JÖRG 398, 401; *Zwettl Altarpiece* 398
Breydenbach, Bishop Bernard von see REUWICH, ERHARD
BROEDERLAM, MELCHIOR 21–25, 50, 55, 72; Dijon altarpiece panels *22*, Flight into Egypt Pl. 2
BROEDERLAM "Entourage" 23–24; *Nativity* 23; *St. Christopher* 23; Walters Gallery Panels *(Annunciation; Christ on the Cross)* 23
BRONZINO, ANGELO 397, 465; *Ugolino Martelli* 397
BRU, ANYE *Martyrdom of St. Cucufas* 259
BRUEGEL THE ELDER, PIETER 320, 416, 455, 457, 460, 468–485; *Adoration of the Magi* 477; *Artist and the Connoisseur* 484; *Battle in the Bay of Naples* 471; *Beekeepers* 485; *Big Fish Eat the Little Fish* 470; *Blind Leading the Blind* 485; *Children's Games* 473; *Combat of Carnival and Lent* 473; *Conversion of Saul* 483; *Crippled Beggars* 477; *Dark Day* 480; *Deadly Sins* 470; *Death of the Virgin* 478; *Dulle Griet* 474; *Fall of Icarus* 471; *Fall of Rebel Angels* 474; *Hay Harvest* 479; *Hunters in the Snow* 480,

Sedano Triptych 192; *Virgin and Child* 196; *Virgin and Child with Bowl of Milk* 197; *Virgin and Child with Saints* 195

DELFT, COPPIN 224

Delisle, Léopold 20

DELLI, DELLO 238, 250

Demons 31, 207, 305, 307, 315

Denis the Carthusian 142

Desplá, Luis 257

DESTORRENTS, RAFAEL 238–239; *Missal of St. Eulalia* 238

DESTORRENTS, RAMON 238

Destrée, Jules 159

Détente 168, 185

DEUTSCH, NIKLAUS MANUEL 399–400; *Judgment of Paris* 400; *Temptation of St. Anthony* 400

Diaphragm arch 14, 38

Dinteville, Jean de 413

DONATELLO 277, 349

DORNICKE, JAN VAN 435, 455

DREUX, JEAN (also DREUX JEAN) see MASTER OF GIRART DE ROUSSILLON

DUCCIO 5, 10, 237

Dudzeele, Josine de 178

DÜRER, ALBRECHT 69, 83, 93, 161, 165, 199, 209, 264, 299, 303, 315, 319, 321–357, 359, 371, 380, 404, 411, 424, 441, 449; *Adam and Eve* 344; *Adoration of the Magi* 336; *Adoration of the Trinity* 346, 347, Pl. 23; *Angels with Sudarium* 350; *Apocalypse* 334, 337; *Battle of Sea Gods* 325; *Bernard von Resten* (?) 354; *Castle at Trent* 326; *Christ among the Doctors* 343; *Christ with Victory Standard* 338; *Couple Taking a Walk* 323; *Crucified Christ* 340; *Death of Orpheus* 325; *Dream of the Doctor* 332; *Dresden Altarpiece* 329; dry point, use of 348; *Drunken Silenus* 325; *Dürer's Mother* 351; *Erasmus* 355; etched works of 351; *Fall of Man* 339; *Feast of the Rose Garlands* 342; *Four Apostles* 355, 357; *Four Witches* 327; *Frederick the Wise* 329; *Great Horse* 340; *Great Passion* 333, 348; *Green Passion* 339; *Head of Christ* 340; *Heller Altarpiece* 345; *Hercules and Cacus* 328; *Hercules at the Crossroads* 329; *Hieronymus Holzschuher* 356; writings 357; *Holy Family in a Landscape* 323; *House by a Pond* 331; influence of 359, 364, 368, 373–375, 383, 388–391, 394–399, 408, 416, 418, 421, 427, 428, 431, 433, 436, 439, 441, 456, 458; *Innsbruck Courtyard* 326; *Jabach Altarpiece* wings 336; *Knight, Death, and the Devil* 349; *Lamentation* 335; *Last Supper* 355; *Lucas van Leyden* 444; *Life of the Virgin* 338, 347; *Lion* 325; *Little Horse* 340; *Lobster* 325; *Madonna and Child with Monkey* 331; *Martyrdom of the Ten Thousand* 344; *Melanchthon* 356; *Melencolia I* 349; *Memento Mei* 341; *Men's Bathhouse* 326; *Monstrous Sow of Landser* 325; *Narrenschiff* 324; *Nativity* (1504) 336;

Nemesis 337; *Nude* (Bayonne) 327; *Nude* (Paris) 327; *Painter's Father* (London) 330; *Painter's Father* (Uffizi) 329; *Paumgärtner Altarpiece* 335; *Willibald Pirckheimer* 340, 354; *Prodigal Son* 328; *Rabbit* 338; *Rape of Europa* 325; *Rape of the Sabine Women* 327; *Reflecting St. Jerome* 355; *Rhinoceros* 353; *St. Anthony before a City* 353; *St. Eustace* 336, 337; *St. Jerome* 326; *St. Jerome* (woodcut) 324; *St. Jerome in His Study* 349; *St. Philip* 355, 357; *Satyr Family* 341; *Sea Monster* 330; *Self-portrait* (Vienna) 321; *Self-portrait* (Erlangen) 322; *Self-portrait* (Madrid) 322; *Self-portrait* (Munich) 322; *Self-portrait* (New York) 322; *Self-portrait* (Paris) 322; *Small Passion* 347; *Terence Writing* 324; *Trinitarian Pietà* 348; *Ulrich Varnbuhler* 355; *Venetian Woman* 325; *View of Arco* 326; *Virgin and Child with Dragonfly* 326; *Virgin and Child with the Siskin* 343; *Wire-drawing Mill* 331; *Michael Wolgemut* 351; *Women's Bathhouse* 326; work for Maximilian 352; writings of 357; *Young Woman* 343

DÜRER, HANS 342, 397

DUMONT, ADAM 86, 222; *Three Marys at the Sepulcher* 86

Dunois, Jean, Count 97

Dutch painting 42–43, 166–167, 185, 190, 438–457, 461–463; *Book of Hours* 105

Dvořák, Max 95, 107

EGERTON MASTER 35

Egmond, Jan van 448–449

Elizabeth of Görlitz 106

ENGELBRECHTZ, CORNELIS 440–441; *Constantine and St. Helen* 440–441, Pl. 30; *Crucifixion* (Leyden) 440; *Crucifixion* (New York) 441; *Feeding of the Ten Thousand* 440; pupils 440

Erasmus 354, 407, 409, 414, 418, 423

Este, Francesco d' 125–126

Etampes, count of 128

Etampes, Robinet d' 19, 106

EYCK, HUBERT VAN 84, 86–90, 92–95; *Annunciation* 89

EYCK, HUBERT VAN and JAN VAN 20, 83, 88, 90–95, 96, 101, 109; *Ghent Altarpiece* 88, 91, 93, 94

EYCK, JAN VAN 69–70, 80–107, 217–218, 229, 262, 320, 354, 459, 476; *Niccolò Albergati* (drawing) 102; *Niccolò Albergati* (painting) 102; *Annunciation* 86; *Annunciation* (grisaille) 89–90; *Giovanni Arnolfini and His Wife* 97; *Christ Carrying the Cross* (copy) 104; *Crucifixion* (Berlin copy) 104; *Dresden Altarpiece* 100; *Ince Hall Madonna* 95; *Baldwin de Lannoy* 101–102; influence of 108–111, 116, 118, 121–122, 127–128, 131–133, 149, 151, 152, 160, 168, 170–171, 177, 179, 191, 245–248, 266, 276, 279; *Leal Souvenir* 102; *Lucca Madonna*

97; *Madonna in a Church* 85; *Madonna of Canon George van der Paele* 98–99, Pl. 8; *Maelbeke Triptych* 105; *Man in Red Turban* 103; *Margaret van Eyck* 103; revival of 177, 180, 413, 418, 428, 433, 458; *Rolin Madonna* 96; *St. Barbara* 99; *St. Jerome in His Study* (copy?) 104; *Stigmatization of St. Francis* (copies) 103–104; *Turin-Milan Hours* 19, 89, 105, 106–107; *Virgin and Child with Saints and Donor* (with Petrus Christus) 104; *Virgin at the Fountain* 101

Eyck, Lambert van 84

Eyck, Livinia van 84

Eyck, Margaret van 84, *103*

FABRIANO, GENTILE DA 118, 163

Fazio, Bartolommeo 83, 118

Ferdinand I, King of Austria 397

Ficino, Marsilio 67, 203

Filarete, Antonio 83, 215

Fillastre, Guillaume 187, 213

FIORENTINO, ROSSO 465

FIRENZE, ZEBO DA *Hours of Charles the Noble* 34

FLANDES, JUAN DE 237, 256; *Christ Crowned with Thorns* 256; *Palencia Altarpiece* 256

Flemish anonymous, *Chroniques de Hainaut*, Philip the Good receiving the book 116

Flemish painting 21–25, 70–185, 190–211, 416–437, 455–461, 467–485; see also Netherlandish painting

Floreins, Jan 173

FLORIS, FRANS 456–457, 467–468, 474, 485; *Falconer* 468; *Falconer's Wife* 468; *Fall of the Rebel Angels* 467; *Feast of the Sea Gods* 467; *Last Judgment* 467

FOUQUET, JEAN 215–221, 463; *Antiquités Judaïques*, Fall of Jericho 220, Pl. 18; *Book of Hours of Etienne Chevalier*, Job 219, St. John on Patmos 218, Virgin and Child 218; *Charles VII* 215; *Grandes Chroniques de France* 219; *Guillaume Jouvenal des Ursins* 217; drawing for 217; *Melun Diptych* 216; *Nouans Pietà* 220; *Pope Eugenius IV and Nephews* (lost) 215; prayer books, work on 219–220; *Self-portrait* 216; *Statutes of the Order of St. Michael*, frontispiece for 220; *Trial of the Duke of Alençon*, frontispiece 219

FRANCÉS, NICOLAS 250

FRANCESCA, PIERO DELLA 224, 235

Francis I, King of France 397, 433, 465

Francis II, King of France 465

Franco-Flemish painting *Coronation of the Virgin* 24

Franco-Italian painting *Fishing scene* 26

FRATER FRANCKE see MASTER FRANCKE

Frederick the Wise, Elector of Saxony 329, 373

FREDI, BARTOLO DI 23

French painting 11–12, 15–17, 25–26, 33–34, 212–236, 463–466